Magritte

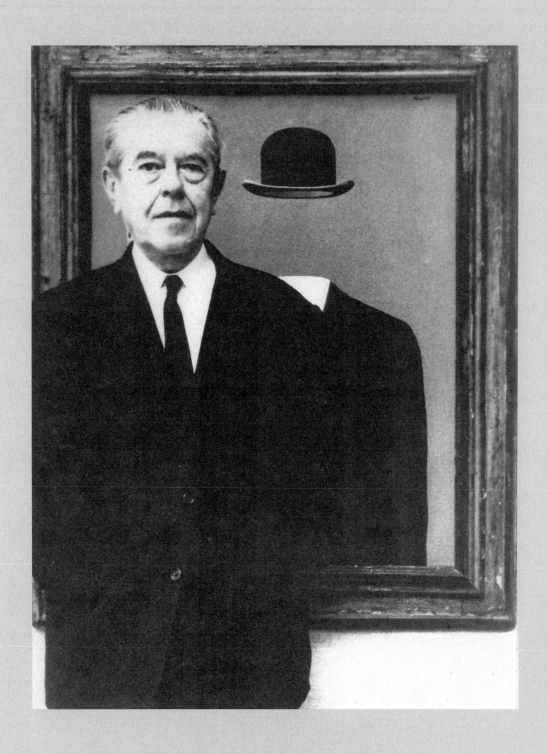

Magritte

..

A LIFE

Alex Danchev

with Sarah Whitfield

Pantheon Books New York

All rights reserved. Published in the United States by Pantheon Books,
a division of Penguin Random House LLC, New York, and distributed in Canada
by Penguin Random House Canada Limited, Toronto.

Pantheon Books and colophon are registered trademarks of
Penguin Random House LLC.

Library of Congress Cataloging-in-Publication Data
Names: Danchev, Alex, author. Whitfield, Sarah, [date].
Title: Magritte : a life / Alex Danchev ; with Sarah Whitfield
Description: First edition. New York : Pantheon Books, 2020. Includes bibliographical
references and index.
Identifiers: LCCN 2020008917 (print). LCCN 2020008918 (ebook).
ISBN 9780307908193 (hardcover). ISBN 9780307908209 (ebook).
Subjects: LCSH: Magritte, René, 1898–1967. Painters—Belgium—Biography.
Classification: LCC ND673.M35 D36 2020 (print) | LCC ND673.M35 (ebook) |
DDC 759.9493--dc23
LC record available at lccn.loc.gov/2020008917
LC ebook record available at lccn.loc.gov/2020008918

www.pantheonbooks.com

Jacket images: *Hegel's Holiday,* 1958, by René Magritte, and *The Masterpiece,* 1955
(signature detail only), by René Magritte © 2020 C. Herscovici / Artists Rights Society
(ARS), New York. Print: Luisa Ricciarini / Bridgeman Images
Jacket design by Kelly Blair

Printed in Canada
First Edition

9 8 7 6 5 4 3 2 1

For Sarah, Jemma, and Izzy

Men always count more than ideas. For me ideas have always had eyes, nose, mouth, arms, and legs.

—ITALO CALVINO, *Hermit in Paris*

Contents

List of Illustrations xi

Preface xxv

Introduction xxvii

1. His Secret Jungle 3

2. Normal Madness 31

3. Cupid's Curse 59

4. The Aura of the Extraordinary 87

5. Charm and Menace 118

6. The Cuckoo's Egg 154

7. Through the Keyhole 193

8. Surfeit and Subversion 233

9. The True and the False 271

10. 1948–1967 310

Magrittiana: A Note on Sources 353

Acknowledgments 359

Abbreviations 363

Notes 367

Index 419

Illustrations

All images are by Magritte unless otherwise specified.

COLOR INSERT

1. *La Durée poignardée* (1938). Oil on canvas, 147 x 99 cm, The Art Institute of Chicago. © ADAGP, Paris and DACS, London 2021 / image: © Photothèque R. Magritte / Adagp Images, Paris (2021).

2. *Au seuil de la liberté* (1930). Oil on canvas, 114 x 146 cm, Museum Boymans-van Beuningen, Rotterdam. © ADAGP, Paris and DACS, London 2021 / image: © Photothèque R. Magritte / Adagp Images, Paris (2021).

3. *Les Rêveries du promeneur solitaire* (1926). 139 x 105 cm, Private Collection. © ADAGP, Paris and DACS, London 2021 / image: © Photothèque R. Magritte / Adagp Images, Paris (2021).

4. *La Robe d'aventure* (1926). Oil on canvas, 80 x 120 cm, Collection of Kawamura Memorial DIC Museum of Art. © ADAGP, Paris and DACS, London 2021 / Image courtesy of The Collection of Kawamura Memorial DIC Museum of Art.

5. *L'Histoire centrale* (1928). Oil on canvas, 116 x 81 cm, Private Collection. © ADAGP, Paris and DACS, London 2021 / image: © Photothèque R. Magritte / Adagp Images, Paris (2021).

6. *L'Inondation* (1928). Oil on canvas, 73 x 54.3 cm, Private Collection, Brussels. © ADAGP, Paris and DACS, London 2021 / image: © Photothèque R. Magritte / Adagp Images, Paris (2021).

7. *Les Amants* (1928). Oil on canvas, 54 x 73, Museum of Modern Art, New York. © ADAGP, Paris and DACS, London 2021 / image: © Photothèque R. Magritte / Adagp Images, Paris (2021).

8. *Les Amants* (1928). Oil on canvas, 54 x 73 cm, Australian National Gallery,

Canberra. © ADAGP, Paris and DACS, London 2021 / image: © Photothèque R. Magritte / Adagp Images, Paris (2021).

9. *Le Temps menaçant* (1929). Oil on canvas, 54 x 73 cm, Private Collection. © ADAGP, Paris and DACS, London 2021 / image: © Photothèque R. Magritte / Adagp Images, Paris (2021).

10. *La Tempête* (1931). Oil on canvas, 45 x 55 cm, Wadsworth Atheneum Museum of Art, Hartford, CT. © ADAGP, Paris and DACS, London 2021 / image courtesy of Allen Phillips\Wadsworth Atheneum.

11. *L'Homme du large* (1927). Oil on canvas, 139 x 105 cm, Musée Magritte Museum, Brussels. © ADAGP, Paris and DACS, London 2021 / image: © Photothèque R. Magritte / Adagp Images, Paris (2021).

12. *Un Peu de l'âme des bandits* (1960). Oil on canvas, 65 x 50 cm, Private Collection. © ADAGP, Paris and DACS, London 2021 / image: © Photothèque R. Magritte / Adagp Images, Paris (2021).

13. *La Jeunesse illustrée* (1936). Gouache on paper, 36 x 52 cm, Musée d'Art Wallon, Liège. © ADAGP, Paris and DACS, London 2021 / image: © Photothèque R. Magritte / Adagp Images, Paris (2021).

14. *Cinéma bleu* (1925). Oil on canvas, 69 x 54 cm, Private Collection. © ADAGP, Paris and DACS, London 2021 / image: © Photothèque R. Magritte / Adagp Images, Paris (2021).

15. Cover of the book *Fantôma*s by Pierre Souvestre and Marcel Allain, ed. Fayard, Paris / artist: Starace, Gino (1859–1950). © Leonard de Selva / Bridgeman Images.

16. *Le Retour de flamme* (1943). Oil on canvas, 65 x 50 cm, Private Collection. © ADAGP, Paris and DACS, London 2021 / image: © Photothèque R. Magritte / Adagp Images, Paris (2021).

17. *Tentative de l'impossible* (1928). Oil on canvas, 116 x 81 cm. Galerie Isy Brachot, Paris-Brussels. © ADAGP, Paris and DACS, London 2021 / image: © Photothèque R. Magritte / Adagp Images, Paris (2021).

18. *L'Esprit de géométrie* (1936). Gouache on paper, 37.5 x 29.4 cm, The Tate Gallery, London. © ADAGP, Paris and DACS, London 2021 / image: © Photothèque R. Magritte / Adagp Images, Paris (2021).

19. *Portrait of Georges Eekhoud* (1920). Oil on canvas, 55 x 38 cm, Archief en Museum Voor Het Vlaamse Cultuurleven, Antwerp. © ADAGP, Paris and DACS, London 2021 / Courtesy of Menil Archives, The Menil Collection, Houston.

20. *Portrait of Magritte* by Flouquet. Courtesy of Menil Archives, The Menil Collection, Houston.

21. *Portrait de E. L. T. Mesens* (1930). Oil on canvas, 73 x 54 cm, Private Collection. © ADAGP, Paris and DACS, London 2021 / image: © Photothèque R. Magritte / Adagp Images, Paris (2021).

22. *La Bonne Nouvelle* (1928). Oil on canvas, 73 x 54 cm, The Menil Collection, Houston. © ADAGP, Paris and DACS, London 2021 / image: © Photothèque R. Magritte / Adagp Images, Paris (2021).

23. *Jesus Christus* by Gabriel Max Veil of Veronica Veraikon. © PRISMA ARCHIVO / Alamy Stock Photo.

24. *Le Chant d'amour* by Giorgio de Chirico (1914). 73 x 59.1 cm, Museum of Modern Art, New York / Nelson A. Rockefeller Bequest. © DACS 2021/ Image © Boltin Picture Library / Bridgeman Images.

25. *Couture Norine* (projet publicitaire pour Norine) (1926). Gouache, water color, and India ink, 118 x 80 cm, Private Collection. © ADAGP, Paris and DACS, London 2021 / image: © Photothèque R. Magritte / Adagp Images, Paris (2021).

26. *La Femme cachée* (1929). Oil on canvas, 73 x 54 cm, Private Collection. © ADAGP, Paris and DACS, London 2021 / image: © Photothèque R. Magritte / Adagp Images, Paris (2021).

27. *Découverte* (1927). Oil on canvas, 65 x 50 cm, Musée Magritte Museum, Brussels. © ADAGP, Paris and DACS, London 2021 / image: © Photothèque R. Magritte / Adagp Images, Paris (2021).

28. *Jeune Fille mangeant un oiseau* (Le Plaisir) (1927). Oil on canvas, 74 x 97 cm. Kunstsammlung Nordrhein-Westfalen, Düsseldorf. © ADAGP, Paris and DACS, London 2021 / image: © Photothèque R. Magritte / Adagp Images, Paris (2021).

29. *La Trahison des images* (1929). Oil on canvas, 60 x 81 cm, Los Angeles County Museum of Art. © ADAGP, Paris and DACS, London 2021 / image: © Photothèque R. Magritte / Adagp Images, Paris (2021).

30. *L'Annonciation* (1930). Oil on canvas, 114 x 146 cm, Tate Gallery Trustees of the Tate Gallery, London. © ADAGP, Paris and DACS, London 2021 / image: © Photothèque R. Magritte / Adagp Images, Paris (2021).

31. *L'Évidence éternelle* (1930). Oil on canvas, 22 x 12 ; 19 x 24 ; 27 x 19 ; 22 x 16; 22 x 12 cm. The Menil Collection, Houston. © ADAGP, Paris and DACS, London 2021 / image: © Photothèque R. Magritte / Adagp Images, Paris (2021).

32. *L'Empire des lumières* (1954). Oil on canvas, 146 x 114 cm, Musée Magritte, Bruxelles. © ADAGP, Paris and DACS, London 2021 / image: © Photothèque R. Magritte / Adagp Images, Paris (2021).

33. *Le Modèle rouge* (1953). Oil on canvas, 72 x 48.5 cm, Moderna Museet, Stockholm. © ADAGP, Paris and DACS, London 2021 / Image © Moderna Museet, Stockholm, Sweden/akg-images.

34. *Le Modèle rouge* (1935). Oil on canvas mounted on board, 60 x 45 cm, MNAM, Centre Georges Pompidou, Paris. © ADAGP, Paris and DACS, London 2021 / image: © Photothèque R. Magritte / Adagp Images, Paris (2021).

35. *Le Modèle rouge* (1937). Oil on canvas, 180 x 134 cm, Museum Boymans-van Beuningen, Rotterdam. © ADAGP, Paris and DACS, London 2021 / image: © Photothèque R. Magritte / Adagp Images, Paris (2021).

36. *Les Valeurs personnelles* (1952). Oil on canvas, 80 x 100 cm, Museum of Modern Art, San Franciso. © ADAGP, Paris and DACS, London 2021 / image: © Photothèque R. Magritte / Adagp Images, Paris (2021).

37. *Le Survivant* (1950). Oil on canvas, 46 x 36.8 cm, Private Collection. © ADAGP, Paris and DACS, London 2021 / image: © Photothèque R. Magritte / Adagp Images, Paris (2021).

38. *Le Mal du pays* (1941). Oil on canvas, 100 x 81 cm, Private Collection. © ADAGP, Paris and DACS, London 2021 / image: © Photothèque R. Magritte / Adagp Images, Paris (2021).

39. *Les Compagnons de la peur* (1942). Oil on canvas, 70.5 x 92 cm, Private Collection. © ADAGP, Paris and DACS, London 2021 / image: © Photothèque R. Magritte / Adagp Images, Paris (2021).

40. *La Mémoire* (1942). Oil on canvas, 75.5 x 55.5 cm, location unknown. © ADAGP, Paris and DACS, London 2021 / image: © Photothèque R. Magritte / Adagp Images, Paris (2021).

41. *Flora* by Titian (1517). Oil on canvas, 79.7 x 63.5 cm, The Uffizi Gallery, Florence. © Fine Art Images/Heritage Images/Getty Images.

42. *Woman with a Mirror* by Titian (1515). Oil on canvas, 99 cm × 76 cm, The Louvres, Paris. © Leemage/Corbis via Getty Images

43. Copy of Titian by Magritte (1944). Oil on canvas, 65 x 50 cm, Private Collection. © ADAGP, Paris and DACS, London 2021.

44. *L'Art de vivre* (1948). Gouache on paper, 57.2 x 74.1 cm, Musées Royaux des Beaux-Arts de Belgique, Brussels. © ADAGP, Paris and DACS, London 2021 / image: © Photothèque R. Magritte / Adagp Images, Paris (2021).

45. *La Famine* (1954). Oil on canvas, 46 x 55 cm, Private Collection. © ADAGP, Paris and DACS, London 2021 / image: © Photothèque R. Magritte / Adagp Images, Paris (2021).

46. *Le Monde invisible* (1954). Oil on canvas, 195 x 130 cm, The Menil Collection, Houston. © ADAGP, Paris and DACS, London 2021 / image: © Photothèque R. Magritte / Adagp Images, Paris (2021).

47. *Le Tombeau des lutteurs* (1960). Oil on canvas, 89 x 116 cm, Private Collection. © ADAGP, Paris and DACS, London 2021 / image: © Photothèque R. Magritte / Adagp Images, Paris (2021).

48. *La Lunette d'approche* (1963). Oil on canvas, 175.5 x 116 cm, The Menil Collection, Houston. © ADAGP, Paris and DACS, London 2021 / image: © Photothèque R. Magritte / Adagp Images, Paris (2021).

49. *La Grande Famille* (1963). Oil on canvas, 100 x 81 cm, Private Collection. © ADAGP, Paris and DACS, London 2021 / image: © Photothèque R. Magritte / Adagp Images, Paris (2021).

BLACK-AND-WHITE ILLUSTRATIONS IN TEXT

Frontispiece. *Magritte et "Le Pèlerin"* by Lothar Wolleh (1966). Photograph by Lothar Wolleh. © Lothar Wolleh / Photothèque R. Magritte / Adagp Images, Paris (2021).

xxviii *La Trahison des images* (1929). Oil on canvas, 60 x 81 cm, Los Angeles

County Museum of Art. © ADAGP, Paris and DACS, London 2021 / image: © Photothèque R. Magritte / Adagp Images, Paris (2021).

xxviii *Golconde* (1953). Oil on canvas, 80.7 x 100.6 cm, The Menil Collection, Houston. © ADAGP, Paris and DACS, London 2021 / image: © Photothèque R. Magritte / Adagp Images, Paris (2021).

xxxiv *Magritte et "Le Pèlerin"* by Lothar Wolleh (1966). Photograph by Lothar Wolleh. © Lothar Wolleh / Photothèque R. Magritte / Adagp Images, Paris (2021).

15 *Zigomar—Leon Sazie* (1909–12). © Collection Christophel / Alamy Stock Photo.

23 Sheet music: "Norine Blues" (music by P. Magritte, words by René Georges) (1925). Print / Zinocgraphy, Musée Magritte Museum, Brussels. © ADAGP, Paris and DACS, London 2021 / image: © Photothèque R. Magritte / Adagp Images, Paris (2021).

23 Sheet music: "Marie Trombone Chapeau Buse" (music by P. Magritte, poem by P. Colinet), illustrated by Magritte (1936). Sheet music, 35.3 x 24.9 cm, Private Collection. © ADAGP, Paris and DACS, London 2021 / image: © Photothèque R. Magritte / Adagp Images, Paris (2021).

29 Front cover of Nick Carter (no. 37): *Nick Carter's Clever Decipher*. SABAM, Belgium and DACS, London, 2011.

36 *The Wave* by Vartan Mahokian (1869–1937) (c. 1926–27). Oil on canvas. Image courtesy of Ara Hakobyan.

39 Tortoise, and separate view of a walled, coastal town in the Veneto by Melchior Lorck (1542–1588). Charcoal, heightened with creamy-white bodycolour, on blue paper, 18.9 x 20.8 cm, British Museum, London. © The Trustees of the British Museum.

39 Competition of balloons. Paris, aerostatic park of the Bois de Vincennes, 1900. Photograph. © Roger-Viollet / TopFoto.

40 Montgolfier balloon. From Gaston Tissandier's *Histoire des Ballons,* Paris, 1887 © Universal History Archive / Getty Images

44 Poster advertising Alcyon cycles: Faber (1909), Lapize (1910), Garrigou (1911) 1911 (color litho). © Bridgeman Images.

45 *Fantômas* by Juan Gris (1915). Oil on canvas, 59.8 x73.3 cm, National Gallery of Art, Washington D.C. © Bridgeman Images

45 René Magritte, *René Magritte and The Barbarian* [*Le Barbare*], London Gallery, London, 1938 (detail). Private collection, Courtesy Brachot Gallery, Brussels. Original photograph, 43.2 x 33.2 cm. © ADAGP, Paris and DACS, London 2021 / image: © Photothèque R. Magritte / Adagp Images, Paris (2021).

47 *Le Changement des couleurs* (1928). Oil on canvas, 54 x 74 cm, Private Collection. © ADAGP, Paris and DACS, London 2021 / image: © Photothèque R. Magritte / Adagp Images, Paris (2021).

49 Photograph of himself (1922). © ADAGP, Paris and DACS, London 2021.

51 *Les Vampires* 1915 Musidora (1915). © Collection Christophel / Alamy Stock Photo.

53 *The Vampires*—cover of *Marie* (1926). © ADAGP, Paris and DACS, London 2021.

56 *The Lady Vanishes* (1938). From left: Dame May Whitty, Michael Redgrave, Catherine Lacey. © Everett Collection Inc / Alamy Stock Photo.

56 *Vierge retroussée* in *Le Surréalisme au service de révolution*—May 1933. © ADAGP, Paris and DACS, London 2021.

60 *Les Roses*. Gouache, Private Collection. © ADAGP, Paris and DACS, London 2021 / image: © Photothèque R. Magritte / Adagp Images, Paris (2021).

65 *La Lecture défendue* (1936). Oil on canvas, 54 x 73 cm, Musée Magritte Museum, Brussels. © ADAGP, Paris and DACS, London 2021 / image: © Photothèque R. Magritte / Adagp Images, Paris (2021).

65 *L'Amour, Georgette* (1928). Photograph. © ADAGP, Paris and DACS, London 2021 / image: © Photothèque R. Magritte / Adagp Images, Paris (2021).

65 *L'Ombre et son ombre*—(1932), attributed to Paul Nougé. Private collection. Image courtesy Brachot Gallery.

68 Georgette, 1922. Photograph. © ADAGP, Paris and DACS, London 2021 / image: © Photothèque R. Magritte / Adagp Images, Paris (2021).

75 Vintage advertisement poster for Cinzano (c. 1910). © mooziic / Alamy Stock Photo.

90 *Les Extraterrestres II* (Paul Colinet, Marcel Lecomte, Jacqueline Delcourt, Georgette Magritte, René Magritte) (1930s). Photograph. © ADAGP, Paris and DACS, London 2021 / image: © Photothèque R. Magritte / Adagp Images, Paris (2021).

93 Photo of Magritte (c. 1920). © ADAGP, Paris and DACS, London 2021 / Image Courtesy of Archives Brachot.

93 Photo of Magritte (1965). © ADAGP, Paris and DACS, London 2021 / Image Courtesy of Archives Brachot.

97 *Le Civilisateur* (1946). Gouache on paper, 40 x 58.5 cm, Private Collection. © ADAGP, Paris and DACS, London 2021 / image: © Photothèque R. Magritte / Adagp Images, Paris (2021).

105 *La Gare* (1922). © ADAGP, Paris and DACS, London 2021.

107 *Jeune Fille* (1922). © ADAGP, Paris and DACS, London 2021.

108 *Femmes* (1922). © ADAGP, Paris and DACS, London 2021.

112 *Paul-Gustave van Hecke and his wife Norine De Schrijver* by Frits Van den Berghe (1924). Oil on canvas, Collection KMSKA.

121 Magritte's wallpaper designs (three images) for the company UPL (1922). Gouache on paper, Musée Magritte Museum, Brussels. © ADAGP, Paris and DACS, London 2021 / image: © Photothèque R. Magritte / Adagp Images, Paris (2021).

122 Alfa Roméo, advertisement from *Englebert* magazine, no. 59–60 (1924). Lithograph, 20 x 28 cm, Bibliothèque royale Albert, Brussels. Alfa Romeo adver-

tisement. © ADAGP, Paris and DACS, London 2021 / image: © Photothèque R. Magritte / Adagp Images, Paris (2021).

122 *Revue de Mode: "Psyché"* (1925). Print / Zincography. © ADAGP, Paris and DACS, London 2021 / image: © Photothèque R. Magritte / Adagp Images, Paris (2021).

124 *Belga,* advertisement for Belga cigarettes (1935). Gouache on paper, 32 x 29 cm. Belga cigarette advertisement. © ADAGP, Paris and DACS, London 2021 / image: © Photothèque R. Magritte / Adagp Images, Paris (2021).

126 *La Robe musette de Norine* (advertisement for Norine) (1924). Gouache, watercolour and India ink on paper, 46 x 30 cm, Private Collection. © ADAGP, Paris and DACS, London 2021 / image: © Photothèque R. Magritte / Adagp Images, Paris (2021).

127 *Le Jockey perdu* (1926). Oil on canvas, 65 x 75 cm, Prviate Collection. © ADAGP, Paris and DACS, London 2021 / image: © Photothèque R. Magritte / Adagp Images, Paris (2021).

130 *Lautréamont: Les Chants de Maldoror* (1948). Drawing. Illustration for book by Lautréamont. © ADAGP, Paris and DACS, London 2021 / image: © Photothèque R. Magritte / Adagp Images, Paris (2021).

132 *La Lumière du pole* (1926–7). Oil on canvas, 139 x 105 cm. © ADAGP, Paris and DACS, London 2021.

132 *Le Sens de la nuit* (1927). Oil on canvas, 139 x 105 cm, The Menil Collection, Houston. © ADAGP, Paris and DACS, London 2021 / image: © Photothèque R. Magritte / Adagp Images, Paris (2021).

134 *Pour l'année 1928 la maison Samuel vous présente quelques manteaux* (illustrated brochure) (1927). Print, 22 x 15.5 cm, Archives et Musée S. Samuel et Cie, successeurs, Brussels. © ADAGP, Paris and DACS, London 2021 / image: © Photothèque R. Magritte / Adagp Images, Paris (2021).

142 *Le Chevalier du Couchant* (1926). Oil on canvas, 131 x 104 cm, Private Collection. © ADAGP, Paris and DACS, London 2021.

142 *Portrait de Paul Nougé* (1927). Oil on canvas, 95 x 65 cm, Musée Magritte Museum, Brussels. © ADAGP, Paris and DACS, London 2021 / image: © Photothèque R. Magritte / Adagp Images, Paris (2021).

145 Paul Nougé with René and Georgette Magritte, bicycling in Ostende. Photograph. © ADAGP, Paris and DACS, London 2021 / image: © Photothèque R. Magritte / Adagp Images, Paris (2021).

146 René Magritte, Marthe Nougé, Georgette Magritte, Paul Nougé, Betty Magritte. Photograph. © ADAGP, Paris and DACS, London 2021 / image: © Photothèque R. Magritte / Adagp Images, Paris (2021).

147 *L'Assassin menacé* (1927). Oil on canvas, 152 x 195 cm, Museum of Modern Art, New York. © ADAGP, Paris and DACS, London 2021 / image: © Photothèque R. Magritte / Adagp Images, Paris (2021).

150 *Fantômas I—À l'ombre de la guillotine—Louis Feuillade—1913.* © Kino International.

150 *La Vierge corrigeant l'enfant Jésus devant trois témoins (A.B., P.E. et le pentre)* (1926) by Max Ernst. © ADAGP, Paris and DACS, London 2021/ image courtesy of Museum Ludwig, Köln / Cologne, Ankauf / Acquisition 1984 / ML 10056 © Rheinisches Bildarchiv, Sabrina Walz, rba_d048643_01.

152 *Les Jours gigantesques* (1928). Oil on canvas, 116 x 81 cm, Private Collection. © ADAGP, Paris and DACS, London 2021 / image: © Photothèque R. Magritte / Adagp Images, Paris (2021).

155 Paul Magritte, in a black armband, surrounded by three paintings and a drawing by René Magritte (c. 1924–5). © ADAGP, Paris and DACS, London 2021 / image: © Photothèque R. Magritte / Adagp Images, Paris (2021).

156 *Le Bouquet* (1937). Photograph by Magritte. © ADAGP, Paris and DACS, London 2021 / image: © Photothèque R. Magritte / Adagp Images, Paris (2021). © ADAGP, Paris and DACS, London 2021 / Image Courtesy of Archives Brachot.

156 *Le Géant*—Paul Nougé on the Belgian coast (1937). Photograph by Magritte.

157 *Les Voyantes* (1930). Photograph by Magritte. © ADAGP, Paris and DACS, London 2021 / image: © Photothèque R. Magritte / Adagp Images, Paris (2021).

157 *La Reine Sémiramis* (1947). Photograph by Magritte. © ADAGP, Paris and DACS, London 2021 / Image Courtesy of Archives Brachot.

158 *La Joie de vivre* (1928). Photograph. © ADAGP, Paris and DACS, London 2021 / image: © Photothèque R. Magritte / Adagp Images, Paris (2021).

158 Camille Goemans writing. Photograph. © ADAGP, Paris and DACS, London 2021 / image: © Photothèque R. Magritte / Adagp Images, Paris (2021).

159 *Les Objets familiers* (1928). Oil on canvas, 81 x 116 cm, Private Collection. © ADAGP, Paris and DACS, London 2021 / image: © Photothèque R. Magritte / Adagp Images, Paris (2021).

160 *The Mysterious Suspicion: After Magritte, October 1974* by Patrick Caulfield (1936–2005), (1974). Acrylic on canvas, 274.32 cm x 152.4 cm, Virginia Museum of Fine Arts, Richmond. © The Estate of Patrick Caulfield. All rights reserved, DACS 2021, Image: Virginia Museum of Fine Arts, Richmond. Gift of Sydney and Frances Lewis Photo: Travis Fullerton © Virginia Museum of Fine Arts.

165 *La Clef des songes* (1927). Oil on canvas, 38 x 55 cm, Staatsgalerie moderner Kunst, Munich. © ADAGP, Paris and DACS, London 2021 / image: © Photothèque R. Magritte / Adagp Images, Paris (2021).

165 *La Clef des songes* (1930). Oil on canvas, 81 x 60 cm, Private Collection. © ADAGP, Paris and DACS, London 2021 / image: © Photothèque R. Magritte / Adagp Images, Paris (2021).

167 *La Clef des songes* (1935). Oil on canvas, 41 x 27 cm, Collection of Jasper Johns. © ADAGP, Paris and DACS, London 2021.

168 *Le Mois des vendanges* (1959). Oil on canvas, 130 x 162 cm, Private Collection. © ADAGP, Paris and DACS, London 2021 / image: © Photothèque R. Magritte / Adagp Images, Paris (2021).

169 *Je ne vois pas la (femme) cachée dans la forêt* (1929). Photograph. © ADAGP, Paris and DACS, London 2021 / image: © Photothèque R. Magritte / Adagp Images, Paris (2021).

171 *L'Image en soi* (1961). Oil on canvas, 65 x 50 cm, Private collection. © ADAGP, Paris and DACS, London 2021 / image: © Photothèque R. Magritte / Adagp Images, Paris (2021).

177 *Le Genre nocturne* (1928). Oil on canvas, 81 x 116 cm, Unknown Collection. © ADAGP, Paris and DACS, London 2021 / image: © Photothèque R. Magritte / Adagp Images, Paris (2021).

181 *Le Miroir vivant* (1928). Oil on canvas, 54 x 73 cm, Private Collection. © ADAGP, Paris and DACS, London 2021 / image: © Photothèque R. Magritte / Adagp Images, Paris (2021).

184 *La Saison des voyages* (1927). Oil on canvas, 50 x 65 cm, Private Collection. © ADAGP, Paris and DACS, London 2021 / image: © Photothèque R. Magritte / Adagp Images, Paris (2021).

184 *Le Prince des objets* (1927). Oil on canvas, 50 x 65 cm, Private Collection. © ADAGP, Paris and DACS, London 2021 / image: © Photothèque R. Magritte / Adagp Images, Paris (2021).

186 *Les Chasseurs au bord de la nuit* (1928). Oil on canvas, 81 x 116, cm, Private Collection. © ADAGP, Paris and DACS, London 2021 / image: © Photothèque R. Magritte / Adagp Images, Paris (2021).

186 *La Gravitation universelle* (1943). Oil on canvas, 100 x 73 cm, Private Collection. © ADAGP, Paris and DACS, London 2021 / image: © Photothèque R. Magritte / Adagp Images, Paris (2021).

186 *Le Destructeur* (1943). Photograph. © ADAGP, Paris and DACS, London 2021 / image: © Photothèque R. Magritte / Adagp Images, Paris (2021).

191 *Les Mots et les images* (in *La Révolution surréaliste*, no. 12, December 1929). Drawing. © ADAGP, Paris and DACS, London 2021 / image: © Photothèque R. Magritte / Adagp Images, Paris (2021).

196 Surrealist chessboard (1934). Photomontage; gelatin silver print, 46 x 30.2 cm. © Man Ray 2015 Trust / ADAGP, Paris—DACS, London—2021, image: Telimage, Paris.

197 *Le Pêle Mêle de Scutenaire* (1934). Photomontage. Photomontage: © Estate of Louis Scutenaire / image: © AML (Archives et Musée de la Littérature).

197 *Le Rendez-Vous de chasse*, 1934. Photograph by Jos Rentmeesters. © ADAGP, Paris and DACS, London 2021 / image: © Photothèque R. Magritte / Adagp Images, Paris (2021).

199 *La Magie blanche, portrait de Paul Éluard* (1936). Drawing. © ADAGP, Paris and DACS, London 2021 / image: © Photothèque R. Magritte / Adagp Images, Paris (2021).

201 René Magritte embracing *L'Évidence éternelle* at the London Gallery, 1938. Photograph by Cami Stone. © ADAGP, Paris and DACS, London 2021 / image: © Photothèque R. Magritte / Adagp Images, Paris, (2021)

201 *Les . . . Naissent en Hiver* (1930). © ADAGP, Paris and DACS, London 2021.

204 Two images of *L'Évidence éternelle,* in the cellar of 135 rue Esseghem, 1930–1931. Photograph by Cami Stone. © ADAGP, Paris and DACS, London 2021 / image: © Photothèque R. Magritte / Adagp Images, Paris (2021).

205 Magritte painting *La Clairvoyance,* Brussels, 1936. Photograph by Jacqueline Nonkels. © ADAGP, Paris and DACS, London 2021 / image: © Photothèque R. Magritte / Adagp Images, Paris (2021).

205 Paul Nougé, portrait photographique de son double portrait peint par Magritte, en 1927. Photograph. © ADAGP, Paris and DACS, London 2021 / image: © Photothèque R. Magritte / Adagp Images, Paris (2021).

206 top left: *Le viol* (1934). Pencil on paper, 36.5 x 25cm, The Menil Collection, Houston: © Photothèque R. Magritte / Adagp Images, Paris (2021).

207 Six drawings for Madame Edwarda (de Georges Bataille) (1941). Pen and ink on paper, 40 x 30 cm, Private Collection. © ADAGP, Paris and DACS, London 2021 / image: © Photothèque R. Magritte / Adagp Images, Paris (2021).

210 *Le Pont d'Héraclite* (1935). Oil on canvas, 54 x 73 cm. © ADAGP, Paris and DACS, London 2021.

211 *L'Éternité* (1935). Oil on canvas, 65 x 81 cm, Museum of Modern Art, New York. © ADAGP, Paris and DACS, London 2021 / image: © Photothèque R. Magritte / Adagp Images, Paris (2021).

213 *Les Affinités électives* (1933). Oil on canvas, 41 x 33 cm, Private collection. © ADAGP, Paris and DACS, London 2021 / image: © Photothèque R. Magritte / Adagp Images, Paris (2021).

214 *Le Séducteur* (1950). Oil on canvas, 48.2 x 58.4 cm, Virginia Museum of Fine Art, Richmond. © ADAGP, Paris and DACS, London 2021 / image: © Photothèque R. Magritte / Adagp Images, Paris (2021).

215 *Le Coup au coeur* (1952). Oil on canvas, 46 x 38 cm, Collection Richard S. Zeisler, New York. © ADAGP, Paris and DACS, London 2021 / image: © Photothèque R. Magritte / Adagp Images, Paris (2021).

215 *La Main heureuse* (1953). Oil on canvas, 50 x 65 cm, Galerie Isy Brachot, Brussels. © ADAGP, Paris and DACS, London 2021 / image: © Photothèque R. Magritte / Adagp Images, Paris (2021).

218 *La Réponse imprévue* (1933). Oil on canvas, 81 x 54 cm, Musée Magritte Museum, Brussels. © ADAGP, Paris and DACS, London 2021 / image: © Photothèque R. Magritte / Adagp Images, Paris (2021).

221 *L'Espion* (1928). Oil on canvas, 54 x 73 cm, Mayor Gallery, London. © ADAGP, Paris and DACS, London 2021 / image: © Photothèque R. Magritte / Adagp Images, Paris (2021).

222 X-radiograph of René Magritte's *L'Annonciation* taken by the Conservation Department of the Tate Gallery. © ADAGP, Paris and DACS, London 2021 / image courtesy of David Sylvester's Catalogue Raisonné Research Papers, the Menil Archives, The Menil Collection, Houston / Tate Gallery, London.

230 *Mica Magritte* by Joseph Cornell (1963). Collage composed of cut and pasted paper elements, with graphite, gouache and yellow pencil, on incised

tan wove paper, adhered to a wood panel, 305 x 228 mm, The Art Institute of Chicago, Chicago. Restricted gift of Mr. and Mrs. Edwin A. Bergman in memory of Joseph Cornell, 1976.23. © The Joseph and Robert Cornell Memorial Foundation/VAGA at ARS, NY and DACS, London 2021, Image: The Art Institute of Chicago / Art Resource, NY.

231 *Negotiable Space I,* by John Stezaker (1978). Collage, 20.6 x 25.3 cm, The Approach, London. © John Stezaker Courtesy of the artist and The Approach, London.

236 Edward James and Magritte painting (1939). Photograph. © Norman Parkinson / Iconic Images.

242 *Les Vacances de Hegel* (1958). Oil on canvas, 60 x 50 cm, Galerie Couleurs du Temps, Genève. © ADAGP, Paris and DACS, London 2021 / image: © Photothèque R. Magritte / Adagp Images, Paris, (2021).

243 Letter to Maurice Rapin dated May 22, 1958, about *Les vacances de Hegel.* Manuscript. © ADAGP, Paris and DACS, London 2021 / image: © Photothèque R. Magritte / Adagp Images, Paris, (2021).

244 *Shoes* by Vincent Van Gogh (1886). Oil on canvas, Van Gogh Museum, Amsterdam. © Bridgeman Images.

244 Floyd Burroughs photographed by Walter Evans in *Let Us Now Praise Famous Men* (1941). © Sepia Times/Universal Images Group via Getty Images.

246 *La Philosophie dans le boudoir* (1947). Oil on canvas, 80 x 60 cm, Private Collection. © ADAGP, Paris and DACS, London 2021.

247 Cover of *The Female Eunich* (1970). © World History Archive / Alamy Stock Photo.

247 *L'Amour désarmé* (1935). Oil on canvas, 72 x 54, Location unknown. © ADAGP, Paris and DACS, London 2021 / image: © Photothèque R. Magritte / Adagp Images, Paris (2021).

256 Drawing illustrating "chaise" (1938). Location unknown.

257 Vika Celmins with her outsize comb. © Vija Celmins, Courtesy Matthew Marks Gallery / image: San Francisco Museum of Modern Art.

260 *Le Drapeau noir* (1937). Oil on canvas, 54 x 73 cm, Scottish National Gallery of Modern Art, Edinburgh. © ADAGP, Paris and DACS, London 2021 / image: © Photothèque R. Magritte / Adagp Images, Paris (2021).

261 *L'Échelle du feu* (1934). Gouache on paper, 18 x 22.5 cm, Private Collection. © ADAGP, Paris and DACS, London 2021.

265 Sheila Legge in Trafalgar Square. Photograph by Claude Cahun (1994–1954). Courtesy of the Jersey Heritage Foundation.

267 The Surrealist Group, London 1936. Photograph. © akg-images / WHA / World History Archive.

272 *Les Extraterrestres III* (Paul Colinet, Marcel Lecomte, Jacqueline Delcourt, Georgette Magritte, René Magritte). (date unknown). © ADAGP, Paris and DACS, London 2021 / image: © Photothèque R. Magritte / Adagp Images, Paris (2021).

275 *La Reconnaissance infinite* (1933). Oil on canvas, 97.5 x 73 cm, Private Collection. © ADAGP, Paris and DACS, London 2021 / image: © Bridgeman Images.

276 *Ceci est un morceau de fromage* (1936). Oil on canvas, 10.3 x 16.2 cm, The Menil Collection, Houston. © ADAGP, Paris and DACS, London 2021 / image: © Photothèque R. Magritte / Adagp Images, Paris (2021).

277 *Le Principe du plaisir* (1937). Oil on canvas, 73 x 54 cm, Location unknown. © ADAGP, Paris and DACS, London 2021 / image: © Photothèque R. Magritte / Adagp Images, Paris (2021).

278 *Les Liaisons dangereuses* (1936). Gouache on paper, 41.3 x 29 cm, Musée Toulouse-Lautrec, Albi. © ADAGP, Paris and DACS, London 2021 / image: © Photothèque R. Magritte / Adagp Images, Paris (2021).

281 *Le Vrai Visage de Rex* (Léon Degrelle and Adolf Hitler) (c. 1937). Antifascist poster. Color lithograph on paper, 80 × 57.3 cm, Archives de la Ville, Brussels. © ADAGP, Paris and DACS, London 2021 / image: © akg-images.

286 *Raminagrobis* (1946). Gouache on paper, 40.7 x 59.2 x cm, Private Collection. © ADAGP, Paris and DACS, London 2021 / image: © Photothèque R. Magritte / Adagp Images, Paris (2021).

287 Paul Gustav van Hecke, Brussels, Belgium (1944). Photograph by Lee Miller. © Lee Miller Archives, England 2020. All rights reserved. Leemiller.co.uk.

289 *La Fée ignorante ou portrait d'Anne-Marie Crowet* (1956). Oil on canvas, 50 x 65 cm, Collection privée (en dépôt au Musée Magritte Museum, Bruxelles). © ADAGP, Paris and DACS, London 2021 / image: © Photothèque R. Magritte / Adagp Images, Paris (2021).

289 *Le Galet* (1948). Oil on canvas, 100 x 81 cm, Musée Magritte Museum, Brussels. © ADAGP, Paris and DACS, London 2021 / image: © Photothèque R. Magritte / Adagp Images, Paris (2021).

295 *La Liberté des cultes* (1946). Oil on panel, 24 x 33 cm, Private Collection. © ADAGP, Paris and DACS, London 2021 / image: © Photothèque R. Magritte / Adagp Images, Paris (2021).

302 Untitled watercolor signed "Picasso" (c. 1943). © ADAGP, Paris and DACS, London 2021 / image courtesy of the Menil Archives, The Menil Collection, Houston.

302 Untitled watercolor signed "Picasso" (c. 1943). © ADAGP, Paris and DACS, London 2021 / image courtesy of the Menil Archives, The Menil Collection, Houston.

302 Untitled watercolor signed "Klee" (c. 1943). © ADAGP, Paris and DACS, London 2021 / image courtesy of the Menil Archives, The Menil Collection, Houston.

306 Ithyphallic firefighter (c. 1943). © ADAGP, Paris and DACS, London 2021.

307 The Surrealist Group in front of La Fleur en Papier Doré tavern, Brussels (1953). Photograph by Van Loock. © RMFAB, ACAB, Brussels.

315 *Perspective: Le balcon de Manet* (1949). Oil on canvas, 80 x 60 cm, Location

Unknown. © ADAGP, Paris and DACS, London 2021 / image: © Photothèque R. Magritte / Adagp Images, Paris (2021).

320 *Souvenir de voyage* (1951). Oil on canvas, 80 x 65 cm, Private Collection. © ADAGP, Paris and DACS, London 2021 / image: © Photothèque R. Magritte / Adagp Images, Paris (2021).

321 *Journal intime* (1951). Oil on canvas, 80 x 65 cm, Private Collection. © ADAGP, Paris and DACS, London 2021 / image: © Photothèque R. Magritte / Adagp Images, Paris (2021).

322 *La Voix active* (1951). 39.5 x 31. 5 cm, Saint Louis Art Museum. © ADAGP, Paris and DACS, London 2021 / image: © Saint Louis Art Museum, Gift of Mr. and Mrs. Joseph Pulitzer Jr. 4:1960.

328 The Surrealist Group, March 1953. Photograph. © ADAGP, Paris and DACS, London 2021.

333 Magritte on a ladder proudly demonstrating the dimensions of his fresco, *Le Domaine enchanté,* at the Casino Knokke, in 1953. Photograph. © ADAGP, Paris and DACS, London 2021 / image: © Photothèque R. Magritte / Adagp Images, Paris (2021).

336 *L'État de veille* (1925). Gouache on paper, 14.5 x 18.8 cm, Private Collection. © ADAGP, Paris and DACS, London 2021 / image: © Photothèque R. Magritte / Adagp Images, Paris (2021).

338 *Madame Recamier de David* (1967). Bronze. 197 x 196 x 50 cm. Centre Georges Pompidou, Musée National d'Art Moderne, Paris. © ADAGP, Paris and DACS, London 2021 / image: © akg-images.

339 *La Joconde* (1967). Bronze, 248 x 177 x 99.5 cm, Private Collection. © ADAGP, Paris and DACS, London 2021 / image: © Photothèque R. Magritte / Adagp Images, Paris (2021).

342 Advertising leaflet (spoof) announcing Grande Baisse (huge reductions) 30 June 1962. © ADAGP, Paris and DACS, London 2021 / image courtesy of the Menil Archives, The Menil Collection, Houston.

343 *Le Spectre* (1948). Oil on canvas, 14.5 x 17.4 cm, Collection Courtesy Galerie Arlogos. © ADAGP, Paris and DACS, London 2021 / image: © Photothèque R. Magritte / Adagp Images, Paris (2021).

349 Magritte with *L'Aimable Vérité,* 1966. Photograph. © ADAGP, Paris and DACS, London 2021 / image: © Photothèque R. Magritte / Adagp Images, Paris (2021).

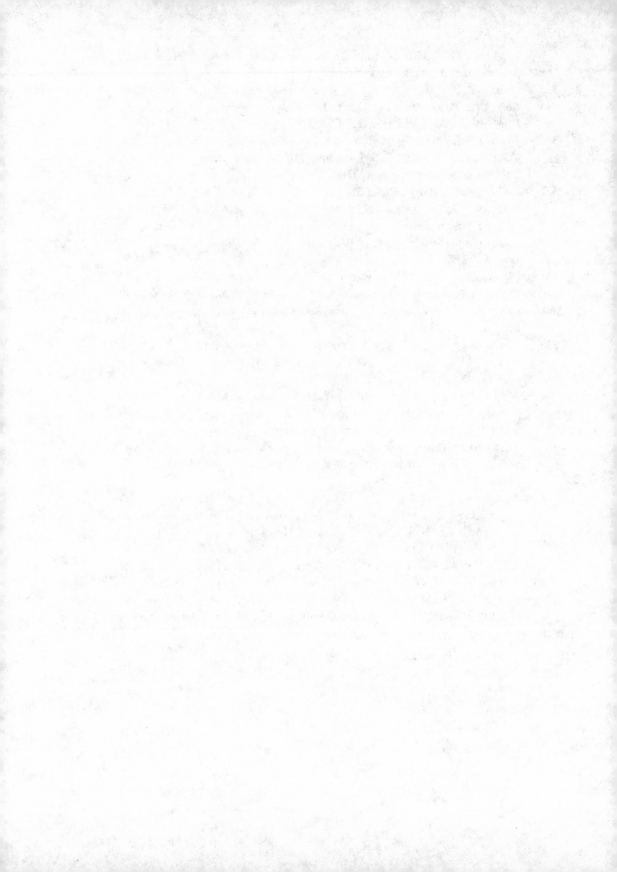

Preface

No sooner were the last rays of the Sunlit period extinguished than the bilious ??? of the Vache period ???. In March and April 1948." These few words and question marks bring Alex Danchev's manuscript to its untimely close. His final chapter was to begin with a description of the exhibition of Magritte's so-called *vache* paintings that opened at the Galerie du Faubourg, Paris, in May 1948. The first of the questions he appears to be asking himself is how to describe the works shown there; the second is more ambiguous—was he wondering how to translate the word "vache"? (Finding the correct translation for a word, a title, or a phrase, mattered to him.) Or was he questioning his own use of the word "period"? Was he perhaps asking himself if a series of works produced in five feverish weeks could really constitute a "period"? Whatever these question marks stand for, their meaning is now lost. The more interesting and far trickier question is how Alex Danchev planned to tackle the last twenty years of Magritte's life. All we know is that he intended to cover these years in a single chapter (and to follow that with another chapter exploring the major influence of Magritte's work on younger artists as well as on advertising and popular culture). It was decided to follow the first part of his plan—to cover the missing years in one chapter. Completing the narrative meant making the best use of available facts, while exploring Magritte's influence on the art and culture since his death required a more subjective approach and would not necessarily reflect Danchev's own views. The final chapter, written by me, serves as an addenda to the main text, bringing the story of the artist's life to its conclusion. Alex's tone and his range of reference cannot be imitated, nor can we know how much his familiarity with the French language let alone his extensive reading

around and often beyond the subject would have brought new knowledge and a fresh perspective to an account of Magritte's last years. What is certain is that his book fills a large gap in Magritte studies. His wide knowledge of the period and his gift for narrative will put to rest the idea that Magritte's outwardly uneventful life, which was lived almost entirely in Brussels (except for the three years he spent in Paris between 1927 and 1930), lacked the richness and variety to bear the weight of biography.

During the four or five years that Danchev worked on the book he amassed an impressive archive of material (which will join his other papers kept at the University of St. Andrews), and I am enormously grateful to Dee Danchev for allowing me free access to his files. Without her generous and unfailing help my task would have been that much more difficult.

—SARAH WHITFIELD

Introduction

René Magritte is the single most significant purveyor of images to the modern world. His paintings and his propositions are part of our culture. His personal iconography, his surreal sensibility, his deadpan melodrama, his trompe l'oeil effects, his cleverness, his outrageousness, his subversiveness (he is one of the great subversives of our time): all this is now inescapable. Contemporary life is replete with Magritte and his sensibility. His paintings are legends. *La Trahison des images* (*The Treachery of Images*): a pipe, captioned "This is not a pipe." *L' Empire des lumières* (*The Dominion of Light*): a street in darkness under a daylight sky. *L'Évidence éternelle* (*The Eternally Obvious*): five panels showing parts of a naked woman, from head to foot. *La Durée poignardée* (*Time Transfixed*): a train coming out of a fireplace [color plate 1]. *La Modèle rouge* (*The Red Model*): a pair of boots-turned-feet, complete with toes. *Le Domaine d'Arnheim* (*The Domain of Arnheim*): a shattered window, the shards of glass showing the view outside. *La Clef des songes* (*The Interpretation of Dreams*): objects labeled, as in a bag ("The sky"), a penknife ("The bird"), a leaf ("The table"), and a sponge ("The sponge"). *Golconde* (*Golconda*): is it raining men in bowler hats and overcoats—or are they ascending to heaven?

The fruits of Magritte's stunning imagination have revolutionized what we see and how we understand. He was always on the lookout for what had never been seen, as he put it, and he was intensely interested in the relations of word and image: "An object is never so closely attached to its name that another cannot be found for it." Ludwig Wittgenstein's philosophical investigations are not so far from Magritte's. Some of their propositions are remarkably similar. Magritte's art is a cross between Wittgenstein's thought and *Alice*

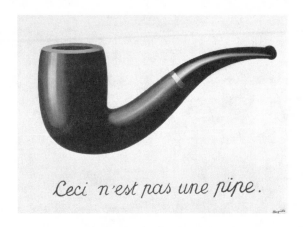

Ceci n'est pas une pipe.

in Wonderland, with a seasoning of surrealism, a pinch of eroticism, and a sizzle of dread.

· · ·

Born in Lessines, Belgium, in 1898, Magritte was a man of many parts. To all outward appearances, he was a placid petit bourgeois who kept a modest house in a nondescript Brussels suburb. As a young man, he worked full-time designing wallpaper; he also created posters and designs for the Brussels couture house Norine. He married his childhood sweetheart, Georgette Berger, and they socialized mainly at home. He had no studio. He set up his easel in a corner of the dining room. He painted in suit and tie and slippers. He made no noise. He was the epitome of respectability. At the appointed hour he walked the dog. He cooked (cheese fondue, chocolate mousse), religiously following the recipes. He was solicitous to his wife. He played chess each week at the Café Greenwich. He read.

Yet Magritte, who produced his first surrealist paintings and collages in 1925, was fundamental to surrealism, and surrealism was fundamental to him. He and Georgette passed three turbulent years in Paris, between 1927 and 1930, at the height of the surrealist fever—an experiment that was not entirely a success. Magritte was out of place in Paris. When he fell out with André Breton, "the Pope of Surrealism," at an evening gathering, Magritte was excommunicated for years. Nonetheless, he maintained an arm's-length dialogue with Breton, who began collect-

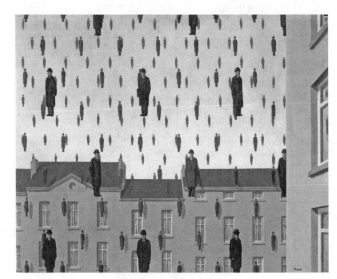

ing Magritte's paintings as early as 1928; this was a dialogue of crucial importance for surrealism and for modernism in general.

Magritte was more comfortable as the king of the Belgians. He represented an antipode to Paris and metropolitan hegemony. From the tables of the Café Flore, Brussels was a backwater and Magritte a provincial. He spoke with a heavy Walloon accent, as Parisian intellectuals could not fail to notice. But Magritte had his own gang. In Paul Nougé he discovered a literary guru akin to Valéry; in the writer Louis Scutenaire a kind of Boswell; in the young surrealist acolyte Marcel Mariën a collaborator and disciple. Magritte and his group gained a certain independence. The importance of this devoted band of accomplices, referred to as "*la bande à Magritte*" (all of whom wrote about him, each in their idiosyncratic fashion),[1] was vital to the artist, who was at once their director and their fascinator.

. . .

By the early 1930s Magritte was already a major artist, though he still had difficulty making ends meet. His first one-man show in the United States was at the Julien Levy Gallery in New York in 1936. He had fourteen works in the International Surrealist Exhibition in London the same year. In 1939 he designed a poster for the Comité de vigilance des intellectuels antifascistes. Five days after the German invasion of Belgium in May 1940, fearful that he would be picked up for his political statements, he left Brussels for France, traveling first to Paris and then to Carcassonne. He returned to Brussels in August. There he painted out the war. In 1943 he entered his "Renoir period," in which he adopted the manner (and palette) of late Renoir, in order to bring a little pleasure into the world, as he claimed. These "sunlit" paintings, as he called them, were intensely disliked by a number of his admirers, including Georgette; the period ended four years later. In 1945, *Le Drapeau rouge* (*The Red Flag*) announced that Magritte had joined the Belgian Communist Party. After about eighteen months his enthusiasm for the party and its people waned, but not his faith in communism itself.

In 1948, for his first one-man show in Paris, he exhibited works done for the occasion in five weeks flat—aided and abetted by Scutenaire—in a flamboyant caricatural style dubbed "*vache*" (cow): a provocation aimed at the high-and-mighty Parisians. The exhibition was coolly received; nothing was sold.

But Magritte remained true to his vision, and over the next twenty years the word spread to the United States. In 1965 a major retrospective at the Museum of Modern Art in New York traveled all over the country; two years

later another major retrospective was held at the Boijmans Van Beuningen Museum in Rotterdam and the Moderna Museet in Stockholm. Magritte himself visited the Gibiesse foundry in Verona to correct the wax models for sculptures of a selection of his signature works. In 1967 he died suddenly of pancreatic cancer. The sculptures were cast after his death.

. . .

Along this long road to recognition as a major artist, Magritte remained a multipurpose master, whose practice embraced fine and graphic design. He produced commercial artwork under the imprint of Studio Dongo, which was simply a shed at the bottom of the garden. Studio Dongo specialized in "Stands, Displays, Publicity Objects, Posters, Drawings, Photomontages, Advertising Copy." He created posters for Alfa Romeo, wallpaper for Peters-Lacroix, catalogs for fashion houses, shop window displays, sheet music covers for his brother Paul, and book covers. His cover design for Breton's *What Is Surrealism?* (1934) was based on his subversive image *Le Viol* (*The Rape*), in which a woman's face is replaced by her sex.

The urge to analyze or preferably to psychoanalyze Magritte has proved hard to resist. The closest thing to a founding myth derives from Magritte's mother's disappearance when he was thirteen, and especially from the description of her body, pulled from the River Sambre seventeen days later, with her face covered by her nightdress. Magritte had a consuming interest in revealment and concealment. In a rare unscripted radio interview, discoursing on mystery—his favorite subject—he mentioned a painting called *La Grande Guerre* (*The Great War*), a portrait of a bowler-hatted man whose face is hidden by an apple. "At least it hides the face partly," explained Magritte. "So you have the apparent face, the apple, hiding the visible but hidden, the face of the person. It's something that happens constantly. Everything we see hides another thing, we always want to see what is hidden by what we see. There is an interest in that which is hidden and which the visible doesn't show us. This interest can take the form of a quite intense feeling, a sort of conflict, one might say, between *the visible that is hidden and the visible that is apparent*."[2] Magritte's art is full of the visible that is hidden.

. . .

Magritte was well defended, but he was also something of a showman, punctiliously rehearsed. His public life was a kind of performance art—a model for Gilbert and George—the suit, the bowler hat, the unvarying

regime: always the same dog (a Pomeranian), always the same name (Loulou or Jackie), always the same walk, immortalized in a Paul Simon song.[3] He played chess with Marcel Duchamp—almost an allegory of modern art. The squares on his chessboard were marked with handwritten comments such as "escape square," "lost square," "square of salvation," "square of no hope." He enjoyed scandalizing his friends with pranks and practical jokes: he would kick a visitor from behind and pretend nothing had happened; he would lie down on the floor of a taxi, like a dog; he would let each plate crash to the floor while washing up, until Georgette objected. Magritte was ostentatiously devoted to his dogs. Where he went, they went; where they could not go, he would not go. If they were not permitted in the restaurant, he dined in the kitchen. When he flew to the United States, Loulou was on board.

. . .

Magritte's painting borrows freely from both film and photography, genres that influenced him deeply, and in which he participated. His paintings share the deadpan of silent films; his silent films share the bizarrerie of the paintings. The films animate the paintings, as if splicing them together into a kind of tragi-comic strip. As home movies, they afford a glimpse of Magritte at play. Like John Ford, he had his own stock company. In total, more than three hours of his short films have been preserved, in the archives of the Royal Museum of Fine Arts and the Film Museum in Brussels, and the Flemish Broadcasting Company. Jef Cornelis has made a compilation of extracts, *A Weekend with Mr. Magritte* (1997); and there is also a documentary, *René Magritte, cinéaste* (1974), by Catherine de Croës and Francis de Lulle.[4] Other documentaries were made about him, with his collaboration, notably *Magritte, ou la leçon des choses* (*Magritte, or the Lesson of Things*, 1960), by the anthropologist Luc de Heusch, and *Magritte: The Middle Class Magician* (1964), by George Melly and Jonathan Miller, for the BBC.[5]

Magritte lent himself to portraiture, by some of the most adventurous photographers of the day, including Bill Brandt, Georges Thiry, Raoul Ubac, and Man Ray himself. In 1965 he colluded in a suitably off-beat series in his own home, by Duane Michals.[6] A selection of his own photographs from 1928 to 1955 was published in 1976, bearing the quintessentially Magrittian title *La Fidelité des images* (*The Faithfulness of Images*)—a title supplied by Scutenaire, who also furnished the captions.[7] Magritte continued to play with the possibilities of the medium all his life.[8] Sometimes photographs echo paintings; sometimes they testify to the nature of his relationship with Georgette; sometimes both. "Plagiarism is necessary, progress implies it,"

said Isidore Ducasse, alias the Comte de Lautréamont, and Magritte certainly knew his Lautréamont: his illustrated edition of *Les Chants de Maldoror* is a classic—but he gave much more than he took.[9] Marcel Broodthaers made no fewer than eight films featuring the signature pipe, including one called *This Wouldn't Be a Pipe* (1970).[10] Magritte haunts the imagination of film-makers from Alfred Hitchcock to David Lynch. He feeds *The Simpsons:* one episode features his painting *Le Fils de l'homme* (*The Son of Man*), an earlier version of *La Grande Guerre*, the face masked by an apple; the title sequence of another has a Magrittian couch gag, captioned "Ceci n'est pas un couch gag." Like all great artists, his posthumous productivity knows no bounds. A collaboration with Alain Robbe-Grillet, *The Fair Captive*, was issued first in a novel (1975) and then as a film (1983), both of them punctuated by Magrittian images and pervaded by that familiar yet disturbing atmosphere ("steeped in a surreal eroticism," according to the *Independent Film Quarterly*).[11]

Magritte, with his photographic memory and photographic eye, would never have called himself a philosopher, but he did call himself a thinker—a thinker in paint. When Foucault suggested an affinity with the writer Raymond Roussel, Magritte responded, "I am pleased that you recognize a resemblance between Roussel and whatever is worthwhile in my own thought. What he imagines evokes nothing imaginary, it evokes the reality of the world that experience and reason treat in a confused manner."[12] Magritte could be a little Delphic, but for the most part his writing is admirably direct. He wrote a great deal: hundreds of letters, many of them published (in French) or available in the archives; a variety of short texts, including detective stories; revolutionary thoughts on the relations between words and images; and an intriguing essay in autobiography—probably inspired by his surrealist stablemate Max Ernst, and more distantly by Edgar Allan Poe.[13] His *Écrits complets* (1979) run to more than seven hundred pages.

When an American correspondent asked what lay behind a certain image, he replied, "There is nothing 'behind' this image. (Behind the paint of the painting there is the canvas. Behind the canvas there is a wall, behind the wall, there is . . . etc. Visible things always hide other visible things, but a visible *image* hides nothing.)" Images may have nothing to hide, but they are not innocent. *La Trahison des images* is one of Magritte's basic propositions. It is matched by a kind of picture-object, *Ceci est un morceau de fromage* (*This Is a Piece of Cheese*), a painting of a piece of cheese, the tasty morsel on a pedestal, under a glass dome: a readymade and a cheese board, all in one. This piece of cheese looks too good to be true, like pop art Gorgonzola, while an earlier version looks exactly like a quarter of Brie. A cheese is a cheese is a cheese, but

a pipe is not always a pipe. In *Liberté de l'esprit* (*Freedom of Mind*), it is one of the most eroticized objects ever held in the palm of the hand.

A measure of Magritte's influence is the fascination he holds for artists of all sorts. Mark Rothko once said, "Magritte, of course, is a case apart, but there's a certain quality in his work which I find in all the abstract painting that I like. And I hope that my own painting has that quality."[14] He was an inspiration for Jasper Johns and Robert Rauschenberg; both collected his work. In the mid-1960s Johns acquired *La Clef des songes*, a word painting, and a page of sketches; he received *Les Deux Mystères* (*The Two Mysteries*), a ballpoint-pen drawing of the pipe motif, as a gift from the artist himself.[15] Andy Warhol was a devotee. Marcel Broodthaers appropriated his iconography and copied what he was trying to do: "Magritte aimed at the development of a poetic language to undermine that upon which we depend."[16] Henri Michaux wrote a brilliant analysis of his art.[17] Jeff Koons is another admirer and collector.[18] John Berger's *Ways of Seeing* (1972) begins and ends with Magritte: from *The Key of Dreams* (*Le Clef des songes*) to *On the Threshold of Liberty* (*Au seuil de la liberté*) [color plate 2].

And in the wider "pop" culture, the Beatles were fans. When John Lennon invited Yoko Ono to his house for the first time, the first thing he said when she arrived was, "I think of myself as Magritte." Yoko herself is reported to have a fine collection. Paul McCartney bought his first Magrittes from the New York art dealer Alexander Iolas in 1966; he continues to collect to this day. When the contents of Magritte's studio were auctioned, after Georgette's death, Linda McCartney acquired his easel, work table, palette, paintboxes, paints, brushes, and other paraphernalia, including a pair of tortoiseshell spectacles, for Paul.[19] Magritte's apple—perhaps a descendant of the apple that fell on the head of Isaac Newton—takes its place in a symbolic lineage that carries through to the ubiquitous logo of the Apple Corps, just as the sky bird logo of Sabena Airlines derived from his *Oiseau de Ciel* (*Sky Bird*)—"a contract which put a good deal of butter on my spinach," as the artist reported—and the CBS logo of an eye in the sky bore an uncanny resemblance to his *Le Faux Miroir* (*False Mirror*); not to mention countless book covers, album covers, posters, and commercials of all kinds.[20] The canny advertiser has launched countless advertising campaigns. He is the man who brought the frisson of the surreal to Madison Avenue. Magritte sells cars and cartoons, sex and subversion. He is high-concept and low-toned. His influence on our culture is all-pervasive. In ways that we now take for granted, René Magritte is the dream merchant of our time.

. . .

In his own time, surrealism could not contain him. Magritte lived in the real world. He scorned the subconscious, and left nothing to chance. His paintings are as much calculation as they are hallucination. The images are instantly legible and infinitely perplexing. They pose some basic questions about the relation between image and reality; the power of mystery; the nature of authenticity. Magritte said that painting is the visible description of thought. Brush in hand, he was among the most extraordinary thinkers of the twentieth century.

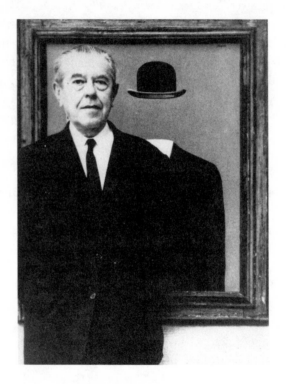

Magritte

1.

His Secret Jungle

Magritte's account of his origins was accurate enough, as far as it went, though he was prone to embellish it. Half seriously, half derisively, he liked to entertain the fancy that the Magrittes were descended from the same family as General Jean-Auguste Margueritte (1823–70), "the tragic hero of the charge of Reichshoffen," as Magritte recounted it, "a propos of which the King of Prussia, the future Kaiser Wilhelm I, had said that 'it was as fine as it was futile.'" If this had been true, Magritte could boast that he was related to the general's sons, Paul and Victor, preferably the latter, author of *La Garçonne* (1922), rather primly rendered as *The Bachelor Girl*, a novel about the intimate life of a "liberated woman." It had so scandalized the reading public that Victor Margueritte, scion of the tragic hero, was struck off the lists of the Legion of Honor for having "insulted French womanhood"—a story that must have appealed to Magritte enormously.[1]

General Margueritte lived and died according to his reputation—or his name—though Magritte had conflated two different cavalry charges. Both took place during the Franco-Prussian War (1870–71): the charge of the cuirassiers of Reichshoffen, as they are known, on August 6, 1870, commemorated in a painting by Aimé Morot; and the charge of the French cavalry at Sedan, a month later, where the king of Prussia was moved to exclaim at their courage, in the words carved on their memorial, "Ah! Les braves gens!"

On both occasions the French found themselves in dire straits. The most competent and experienced of their commanders at Sedan, General Auguste-Alexandre Ducrot, summed up the situation in a sentence: "Nous sommes dans un pot de chambre, et nous y serons emmerdés." ("We're in a chamber

pot, and they'll shit on us.") Bereft of alternatives, he turned to "that resource of despair: the cavalry." The cavalry charge was a strategy of last resort. Some generals still thought of it in terms of shock and awe, dazing and destabilizing the enemy for long enough to enable the infantry to reorganize (or retreat). In fact it was an irrelevance. It was magnificent, but it was not war. It was madness, as Michael Howard's account of the proceedings at Sedan makes plain: "With his artillery shattered and his infantry nearly overwhelmed Ducrot could only turn to the last, most splendid, most useless weapon of all: the cavalry of General Margueritte."[2]

. . .

Sedan was a disaster for the French. They lost both the battle and the war. Margueritte, who went out ahead of his men to reconnoiter, died of his wounds a few days later. By an irony of history that Magritte would surely have appreciated, he missed the charge that made his name; nevertheless, he had conducted himself with conspicuous gallantry.

As a student Magritte is said to have painted a cavalry charge of his own, and had himself photographed in front of it.[3] But while Margueritte (or Marguerite) figures large as a variant spelling in the seventeenth and eighteenth centuries, Magritte's forebears were all humbler folk—foot soldiers, as it were, rather than generals—tenant farmers, nail makers, millers. They had been established in the village of Pont-à-Celles, near Charleroi, some thirty miles south of Brussels, ever since one Jean-Baptiste (or Jean) Margueritte moved there from nearby Gouy-lez-Piéton in 1710. Intriguingly, Jean's father appears as Martin Magritte in the proceedings of a feudal court at Gouy in 1665, together with his two brothers, as vassals of a fiefdom previously held by their parents, Pierre Magritte and Antoinette Baudhier.[4] These records have only recently come to light. Nothing more is known of Pierre Magritte; for the time being, he enjoys the privilege of being the earliest documented ancestor of the ancestor-averse René Magritte.

Transplanted to Pont-à-Celles, Jean Margueritte (1680–1761) became a tenant farmer, courtesy of his wife, Ursule Francquart, who had inherited the tenancy of a farm called Les Roquettes.[5] He also became *échevin*, or "magistrate." His son Hubert followed in his footsteps. Hubert Margueritte (1715–89) in his turn had three sons, who worked the farm together. It is in this generation that the form of the name seems to have stabilized, following the local dialect that tended to shorten "Margueritte" to "Magritte." Thus the three sons were known as *"les Magritte des Roquettes,"* which had a certain ring to it, or simply *"des Roquettes."* This sort of naming or nicknaming was

very common. All the children of a later Magritte, a miller, were known as *"del Meunière,"* as if to classify the species. Another brood was dubbed *"les Oui-oui,"* to indicate that they were promising. Some Magrittes gained the soubriquet *"de Cantibroutch,"* suggesting that they were prone to ramble or rave; others, by marriage, *"de Raffinet,"* that is to say lofty or haughty.

Les Magritte des Roquettes made their presence felt. Jean-Baptiste Magritte (1767–1833) was mayor of Pont-à-Celles from 1808 to 1818. Martin Magritte (1772–1849) had no children, but Louis-Joseph Magritte (1769–1849) had twelve, of which eight were boys—and he had seventy-two grandchildren. Henceforth, there was no getting away from the Magrittes of Pont-à-Celles. Magritte was not the only member of his family who fantasied a more rarefied history: in the family and beyond, their provenance was the stuff of legend, suggestively linked to the French Revolution of 1789. According to the version with which Magritte himself was familiar, and which was repeated by his wife, Georgette, to the art connoisseur Harry Torczyner, the three brothers were supposed to be political exiles from France, after the Terror, on account of their revolutionary sympathies.[6] Or, with a Napoleonic twist, as peddled by his cousin Aline Magritte (1898–1982)—who was born in Pont-à-Celles— they arrived in Belgium as soldiers in the service of the emperor in 1792 and stayed on. Such stories were commonplace at the time. Magritte's contemporary Georges Simenon—a novelist and an admirer of the painter—was born in Liège; his family claimed descent from a Breton soldier in Napoleon's army by the name of Simonon, who is supposed to have broken his leg in the retreat from Moscow, in 1812, stopped for the night in a village near Liège, and never left. In the case of the three Magrittes, the story is entirely without foundation. The historical connection, such as it is, probably derived from an act of spoliation that became a folk memory. When the French entered Pont-à-Celles for a second time, in 1794, they attacked the farm, put the outhouse to the torch, and ransacked the village. The precincts of Les Roquettes became known as *"l'entrée des Français."* But in truth, the most exciting thing about the Magrittes was their nickname. Disappointingly enough, they were not revolutionaries in exile, but sober-sided pillars of the community. Apart from the fact that Jean-Baptiste christened his youngest son Napoléon, there seems to be nothing more to say.

After three generations of farming, the Magritte brothers had apparently saved enough to help their children acquire a stake of their own. According to the records of the land registry, most of them had a plot of land, often with a house on it, and perhaps a workshop, for nail making in the winter months (a traditional activity). Two were innkeepers. Some were farmers. Some were flour merchants or millers; one had his own windmill. Albert-Joseph Magritte

(1802–63), Magritte's great-grandfather, was a miller, working in his brother's windmill. But change was coming. Further generations broke with tradition.

Nicolas Joseph Ghislain Magritte (1835–98), Magritte's grandfather, became a tailor. Moreover, he was not tied to Pont-à-Celles. He moved around in order to find work, and, as like as not, a wife. In 1868 he married Marie Françoise Rose (1841–1929) in Villers-Perwin, a few miles away and the bride's family home. They lived first in Pont-à-Celles, then in the neighboring village of Buzet, then in Gilly, on the outskirts of Charleroi, where Nicolas died on February 18, 1898, nine months before the birth of his grandson. His death was the trigger for a sequence of domestic realignments.

No sooner was he in his grave than his son, Léopold François Ghislain Magritte (1870–1928), Magritte's father, married Adeline Isabelle Régina Bertinchamps (1871–1912), in Gilly. After the wedding, Léopold's widowed mother and sisters decamped to Soignies, where they opened a small shop, Au Bas National. Two years later, in 1900, the older sister, Maria Marguerite Ghislaine Magritte (1869–1938), Magritte's aunt Maria, married Firmin Desaunois (1870–1929), the foreman of a tannery in Soignies. Magritte had fond memories of Uncle Firmin, with his drooping moustache and willingness to play; he taught them the game of "cheat," involving the moving of buttons up and down on squared paper. Others remembered the situation differently. Behind the parlor games and the moustache, the atmosphere in the family home was oppressive: long afterward, Firmin's workmates talked of the couple's avarice, his obsessive concern with money, the depressions that led to his periodic stays in a rest home, her alcoholic tendencies. It may be no coincidence that Maria's mother and younger sister, Flora Théophénie Marie Ghislaine Magritte (1872–1945), Magritte's aunt Flora, abandoned the boutique and opened a shoe shop nearby, Au Nul S'y Frotte (No Rubbing There).

Aunt Flora was a character; she played her part. Considered mad by her contemporaries, she became madder as the years went by. Magritte's sister-in-law got to know her in her old age, after she had left the shop and found shelter in Brussels. "She was a weird one. She used to talk to me about dealing on the stock exchange, all the while living, scrimping, and saving, like a real pauper. She always regarded me with deep suspicion, I'm not sure whether it was because of her age or her nature. I remember her sitting in a chair next to the stove. Sometimes when I went to see her, she would wave the poker at the sky, chanting a magic spell to ward off bad luck, which began *Cuckold, cuckold . . .*" The Belgian surrealist writer Louis Scutenaire recorded Magritte saying something similar: "He spoke of his last visit to the old soul, who talked a lot about evil people, the evil eye, witches and wizards of all sorts. She taught him a warped prayer against such eventualities, which I can-

not resist reproducing: '*Cuckold, cuckold!* By the living gods, I summon you, you can only approach my house ten steps forward and ten steps back, until you have counted the rugged rocks, the grains of sand in the sea, the feathers of the cockerel, and the drops of water in the river.' "[7]

Magritte visited her once more, accompanied by his brother Paul, the morning after she died, on November 29, 1945. Marcel Mariën was with them. Their purpose was to shake down the place, in case their mad aunt had a hidden stash of loot. According to Mariën, they went so far as to lift up the body in order to search the bedding. "All this amid gales of laughter and entirely innocent jocularity."[8]

Flora, a spinster, was nicknamed "Flora Nul S'y Frotte." According to a traditional proverb, "À femme sotte, nul ne s'y frotte." ("No one rubs up against a madwoman; that is, everyone gives her a wide berth.") Character-istically, Magritte turned the nickname into "Vas-T'y Frotte." ("Go and have a good rub.")[9] Among friends, he relished a little vulgarity—"he liked his vulgarity vulgar," as the artist William Copley observed.[10] He used to repeat his aunt's Walloon nickname, "*Can'à croles*," meaning "curly cunt."[11] Like Georges Simenon, the creator of his near homonym Maigret—a coincidence he also relished—Magritte savored the sound of certain expressions or bastard-izations, often a wicked form of Walloonerie, an in-joke, a private language. When the mother figure in his autobiographical novel *Pedigree* acknowledges that she cheats her husband and her tenants ("I'm going to *clip* them, I'm going to *clip* them all, whoever they are"), Simenon uses the Walloon word *strogner* (*rogner*, "to clip somebody's wings").[12] Magritte for his part was excessively fond of the Walloon word *stropiat* (*estropié*, "crippled, disabled, maimed"). *Le Stropiat* became the title of a prankish painting. Spying a jogger in the street, he would say, "Tiens, v'là un stropiat!" ("Look, there goes a cripple!") Some words tickled his fancy: *Piedboeuf* (literally, "beef-foot"), which he pronounced *Pied-de-boeuf*, was the name of a beer; Magritte amused himself by painting labels reading *bière de porc* (pig beer) or *confiture de cheval* (horse jam), spoof products that doubled as coarse jokes (pig piss and horse shit) and, perhaps, a kind of posthumous revenge on his product-obsessed father.[13] Some words he took against, and pronounced with exaggerated distaste, owing to their unsa-vory associations: *finance*, *stratégie*, *persillère* (veined or marbled). Others never passed his lips, because they "degraded" those who uttered them: *câble* (cable), *antennes* (antennae), *contacter* (to get in touch with someone), *dépan-ner* (to help someone out), "as if they were a vehicle" (the same word is used of vehicle repairs). Magritte cherished the revelation in *Might as Well Be Dead*, a mystery novel by Rex Stout, one of his favorite authors, that the fastidious private eye Nero Wolfe charged a client a substantial premium for saying that

he had "contacted" somebody. "One man who made 'contact' a verb . . . had paid an extra thousand bucks for the privilege, though he hadn't known it."[14]

But despite this, Magritte also mangled words deliberately, making something like spoonerisms ("the shoving leopard" rather than "the loving shepherd"). Mocking organized religion, as he mocked all organized activities, he never spoke of "the papal ablutions" but always "the papal albutions." He specialized in disarming or disorientating substitutions. "In his dialectical love of *le mot juste*," as Scutenaire put it, he would say "stumbling block" (*pierre d'achoppement*) rather than "touchstone" (*pierre de touché*).[15] Names were fair game; few survived his mischievous misappropriations. When the English singer and film critic George Melly introduced him to a pretty girl called Robin Banks, Magritte was enchanted: he misheard the name as "Robbing Banks."[16] Sense and nonsense were meat and drink to him. He loved Lewis Carroll's *Alice's Adventures in Wonderland* (1865), for its combination of charm and menace, as he wrote tellingly, and its play with words.

> "When *I* use a word," Humpty Dumpty said in a rather scornful tone, "it means just what I choose it to mean—neither more nor less."
> "The question is," said Alice, "whether you *can* make words mean so many different things."
> "The question is," said Humpty Dumpty, "which is to be master— that's all."[17]

Magritte considered these questions more deeply than most. Few painters trafficked so expertly in the power of the word and its place in the world. His word paintings were revolutionary. He found his watchword (and the title of a celebrated painting) in *The League of Frightened Men* (1935), known in French as *Les Compagnons de la peur* (1939), where Nero Wolfe delivers himself of his dyspepsia: "All written or printed words, aside from their function of relieving boredom, are meaningless drivel."[18]

In one of the insights that pepper the writings he called his *Inscriptions*, Scutenaire, who would become one of Magritte's most faithful chroniclers, reflected that Magritte's way with words was entirely characteristic: the habitual distortion or perversion betrayed a deep-seated contrariness, but also a spring-heeled inventiveness, in life as in art.

"Mixing with René Magritte for seventeen years," he wrote in the early 1940s,

> I'm convinced that his painting proceeds in large measure from his rooted tendency to warp the form of words and above all to alter their

meaning, if possible, in a contradictory sense: to say "the point of view of Sirius" instead of short-sighted, category instead of phenomenon, ephemera instead of infinity.

This tendency is not confined to words, it governs his actions: in the company of people he despises, he attacks Eugène, whom he respects; he travels to London because he doesn't fancy going there.

So it goes with elements of his painting, which he distorts. And the miracle—or the supreme logic—is that, as a result, aided by our awareness of the contradiction, the object, like the word, the composition, like the action, asserts its own reality that is almost a reflection of the real world to which we spend our days adapting as absentmindedly as possible.[19]

Magritte's father, Léopold, was a chancer—"*un bluffeur*," as they called him. In the early days he called himself a merchant tailor or commercial traveler, swiftly gravitating to self-made man. In later years he would give the benefit of his experience to his neighbor, François Sacrez, father of Magritte's boyhood friend Paul Sacrez. His unvarying theme was the need to go it alone in order to make money—real money. "Look, François, why stay on the payroll? Set up on your own, it's the only way to make money!" "But I've got a wife and children, I'm hanging on for the end of the month!" Sacrez would protest. "But it's so easy, François: you go to Venice, you buy a boatload of cauliflowers at, say, fifty centimes. You resell them in the market here. How much are cauliflowers here . . . ? Say for example seventy-five centimes. Well, you've made twenty-five centimes per cauliflower. There are two thousand cauliflowers, so in a quarter of an hour you've made more than you can make in a month on the payroll."[20] Capitalism made simple, according to Léopold.

Twice in his life he made and lost a fortune. He liked to swank—"*My* sons won't have to work for a living"—though in truth he lived a rackety life, trailing his family in his wake.[21] When he married Régina Bertinchamps, on March 2, 1898, his wife was prevailed upon to borrow 5,000 francs from her mother, as a kind of back-door dowry, to tide them over until Léopold could make his own way in the world. As a commercial traveler he was of no account, and very nearly of no fixed abode. He had been on the road for several years, without success, before trying his hand as a tailor, first with his father, then on his own. After the wedding, he and Régina lived for a few months in Saint-Gilles, a suburb of Brussels, before moving to Lessines. No sooner were they installed in the rue de la Station than their firstborn arrived, at eleven in the morning on November 21, 1898: René François Ghislain Magritte (1898–1967), a thinker, betimes a painter, but first of all a holy terror.

After a year and a half in Lessines the family returned to Gilly, where

Magritte's two brothers were born: Raymond Firmin Ghislain Magritte (1900–70) and Paul Alphonse Ghislain Magritte (1902–75). All the children of this generation, and the previous one, had "Ghislain" attached to their names, as a form of protection (or superstition). Ghislain was a seventh-century Belgian saint, whose intercession was sought to ward off convulsions in children. Too many of Magritte's forebears had died in infancy—five of his grandfather's sixteen children, and his father's younger brother, Fernand Albert Ghislain Magritte, aged seven months. Sometimes superstition failed.

The mouths to feed were multiplying, and the merchant tailoring was not prospering. It was time to move on. Régina's brother Albert lived in Châtelet. The ground floor of his house doubled as a butcher's shop. When he opened new premises in a better neighborhood, the Magrittes took over his house in the rue des Gravelles in the lower part of the town, bordering the River Sambre. Albert Bertinchamps (1873–1930) was a good sort; he knew a lot of people. He also found his brother-in-law some new business contacts. After a brief and inglorious period selling insurance, and then sundry commodities of vaguely exotic provenance—coffee and soap from the colonies—Léopold finally got his foot in the door. He was taken on by the firm of De Bruyn of Termonde, near Ghent, manufacturers of coconut oil, "Cocoline" (a margarine so derived), and a range of other products. In the beginning, he acted as a sort of roving sales rep, hawking De Bruyn's wares across the country. At last he had struck it lucky. "Usines J. E. De Bruyn" had discovered a new process and a new market. They were expanding at a terrific rate. Their factories spread as smoothly as their margarine, in Germany, in Austria, in Switzerland, in England; later they became an important division of Unilever. Their man in Châtelet expanded with them: he became inspector general of De Bruyn factories all over Europe. Commercial traveling took on a whole new meaning. There was a general in the family after all.

In a few short years Léopold Magritte amassed his first fortune. By 1911 he was living high on the hog. He had a house built farther along the rue des Gravelles; the family moved up in the world, from number 77 to number 95, though the Inspector-General himself was seldom at home. He played the horses. He played the field. Léopold was a skirt-chaser, as they used to say in the street. His demeanor did not endear him to his fellow man. "He would go past, with his stiff bearing, his haughty look, always decked out in a morning coat and top hat, or dressed up in a suit and tie and a bowler [a derby]." On Sunday afternoons, when all Châtelet turned out for a stroll to Carnelle, where there were fairground attractions for the children and stands with suitable refreshments for the adults, he would arrive in a horse-drawn carriage (strictly speaking, a donkey-drawn cart). He took great pains to rise above the

hoi polloi; he treated the townsfolk with disdain. They cordially reciprocated. "There he goes proud as a lord." "He wore his Sunday best every day of the week." "I can still see him, with his low-crown topper; it was held on with four pins."[22]

De Bruyn products were of particular interest to grocers and pâtissiers, but they also had other uses. Raymond Pétrus lived all his life in the rue des Gravelles, a few doors down, at number 86; he was one of Magritte's closest boyhood friends. He remembered a room in the Magritte house crammed with samples. "There were boxes and packing cases, and inside there were white metal containers of Cocoline, and advertising posters too. I remember all that very well, because René and I played with it, climbed on it, made tunnels through it, and we were coated, coated in it, it was like lard. And when I came back home after playing with the Cocoline, well, I got a good hiding, I was absolutely coated in it!"[23]

René's experience of life at number 95 was rather different. Léopold was imperious in his domain, wherever it might be. He alienated his colleagues by treating them like simpletons: "You know nothing about it. Let me do it."[24] In his own home he brooked no argument, or so he imagined; but his back was turned too often for him to succeed as a strict disciplinarian, and he was too self-centered to make a good parent. Between his absences and his dalliances, he had neither the time nor the inclination for the correction of his harum-scarum offspring. As a father, he was at once remote and overbearing, oblivious and spoiling. When the boys were ill, he dosed them with potions he concocted himself. He fancied himself as a hypnotist; his library consisted chiefly of works on hypnotism and spiritualism. If the Sacrez family came round for a meal, their son was expressly forbidden from touching a drop of anything prepared by Monsieur Magritte. He was also forbidden from reading any of the books. "You'll go mad," his father told him.[25]

Léopold always addressed his own children with the formal *vous*, never *tu*. He banned the use of Walloon slang in the house, a prohibition honored more in the breach than the observance. Otherwise, consistency was at a premium. His diktats counted for little. The Magritte ménage was an anarchic one. His sons grew up in an atmosphere of domestic upheaval. In good times, they had money to burn. In bad times, they were thrown on their own resources. The keynote of their early lives was turbulence. Their father and his antics fascinated and embarrassed them in equal measure. He was pushful, prideful, rapacious—a player, a braggart, a card, a compromised figure, a laughingstock. At home, he was an object of barely disguised derision. They called him *le dab*, that is to say *le dur*, meaning "the tough nut," or "the hard case." In later life, Magritte affected not to remember his father's name.[26] In

fact, he remembered all too well. In Homer's *Odyssey*, one of the most heavily annotated books in his library, he marked Athena's winging words to Telemachus, son of Odysseus and Penelope:

So how can your journey end in shipwreck or defeat?
Only if you were not his stock, Penelope's too,
Then I'd fear your hopes might come to grief.
Few sons are the equals of their fathers;
Most fall short, all too few surpass them.[27]

His mother was a different matter. Régina was the very opposite of her pushy husband. She was prayerful, dutiful, heedful. Most of all, she was fragile. She might have been characterized (or stigmatized) as "delicate." She seems to have been prone to depression; with the passage of time, she succumbed more and more to that condition. She had grown up in the bosom of her family. She was especially close to her mother, Émilie Éloïse Nisolle (1848–1905), daughter of the patriarch Placide Nisolle (1827–1907), Magritte's godfather, a considerable personage who made his name in livestock, and founded a dynasty of butchers. Her father, Victor Joseph Bertinchamps (1842–94), who passed away some years earlier, was first a sandcaster and then a butcher; her brother Alfred, who married Florine Nisolle, was a butcher; her mother's four brothers were butchers; her father's sister also married a Nisolle (a butcher). Régina, they said, was a true Nisolle. Her mother afforded her some protection from the vagaries of married life, and possibly from the burdens of life in general. She kept Régina and Léopold afloat financially. She lived with them in Lessines and in Gilly. When they moved to Châtelet, she found a house a few doors down the street. Régina seems to have depended on her. In retrospect, it is tempting to speculate that her mother's death, in 1905, followed by that of her beloved grandfather two years later, knocked away two of the props vital to her struggle for some sort of equanimity.

Régina's struggle was an epic one, which she ultimately lost. "In 1912," Magritte recorded matter-of-factly in "Lifeline," his autobiographical sketch, "[H]is mother Régina did not want to live any longer. She threw herself into the Sambre." It has been well observed that he related this tragic event rather in the manner of Félix Fénéon, whose "novels in three lines" were culled from announcements in *Le Matin*.[28] The story as it unfolded was covered briefly in the local papers. The report in *Le Rappel de Charleroi* ran as follows:

Disappearance. The disappearance is reported of Régina Bertinchamps, wife of Magritte, resident in Châtelet, rue des Gravelles 95, who

has not been seen since 4.30 in the morning on Saturday [February 24, 1912].

Age: forty; height: 1 metre 62 [5 feet 4 inches]; fairly stout build; black hair and eyebrows; clothes: red and white striped dressing gown, white cotton night dress embroidered around the neck; black woollen stockings; gold wedding ring engraved 2.9.98 [2.3.98].

This woman was neurasthenic and had on several occasions displayed her intention to put an end to her life.[29]

By the end of the nineteenth century, "neurasthenic" was a common usage, with all-purpose credentials. Neurasthenic was a stronger term than "delicate," with a dash of cod psychology and a tincture of euphemism. It shielded against the stain or shame of madness, and covered a multitude of sins—not least, the sin of suicide. It offered not so much explanation as absolution, or at least mitigation, on grounds of diminished responsibility. Contemporary reports of Régina's death included a further mitigating circumstance: "an attack of fever" was adduced as a precipitating cause. *Le Rappel* continued the story:

> A fortnight ago, we reported the disappearance of Madame Régina Bertinchamps, wife of Magritte, who, in a sudden attack of high fever, had stolen out of the house, in the middle of the night, and never reappeared. At 11.00 yesterday morning [March 12, 1912] the body of the unfortunate woman was pulled out of the waters of the Sambre.[30]

What with the fever and the neurasthenia, in other words, the poor unfortunate was not responsible for her actions, notwithstanding the element of subterfuge or calculation entailed in her disappearance. The notice of the funeral arrangements made reference to "an accidental death," backdated to March 12, the day the body was recovered. Such tactful obsequies permitted a funeral service in the parish church, and a decent Christian burial.

If decency and Christianity were as important to Régina as she seems to have conveyed, then she must have been sorely tried by her family. Living with Léopold was not all jam and kippers. Whatever her feelings, he had no wish to be under the thumb of his wife, or his mother-in-law, in matters spiritual or sensual. He read a fiercely anti-clerical rag, *La Gazette de Charleroi*. He was openly contemptuous of any authority figures, including his sons' teachers, who grew tired of his hectoring. He did not scruple to sell pornography when times were hard and he could sell nothing else. The more money he made, the more he flaunted his independence, his free-thinking, his own brand of moral

squalor. He was a bad example for the children, as his wife was painfully aware, not only because of the gambling and the philandering and the disparaging, but also because of the way he had of enlisting them to reject and defy authority. Régina's cousin Marie Nisolle visited her often, becoming a kind of confidante. What Régina confided was distressing: that Léopold was cruel to her; that he liked nothing better than to shock or scandalize her; that he hit her. When Marie visited the house after Régina's body was recovered from the river, she saw pornographic prints hanging on the bedroom walls. When she asked the boys for some explanation, René told her, "It's our father, he got us to spit on the cross in front of maman."[31]

. . .

Régina set great store by appearances. She wanted the boys to have a Christian upbringing, to practice Christian virtues, to go to a good school, to apply themselves diligently, to learn to behave, and not to blaspheme. None of that came to pass. The word on the street was that the Magritte boys were *Tchaukîes* or *Tcherokis* (Cherokees): savages possessed by the devil. The chief of this marauding band was the tribal elder, René, the ringleader.

This ringleader started school when he was nearly seven, in 1905. For six years he went to the École moyenne de l'État in Châtelet. The testimony of his classmates is unanimous: for René, schooling was an affair of little consequence. Victor Frisque was in the same class for five years and shared a desk with him for one of them. "René, he was always busy colouring in pictures and telling stories, he was a joker who wasn't interested in lessons, he talked to me a lot about Zigomar. I can still hear him shouting *Zigomar!* and chanting *Zi-go-mar-peau-d'an-gui-lle*, and *Fan-tô-mas*. Zigomar was a bandit, a hero of the adventure stories that they showed at the cinematograph; I can still see the posters with the big Z."[32]

Zigomar was the creation of the writer Léon Sazie. He was more than a bandit. According to his publicity, he was the king of crime in a red cape, he was immortal as the sun, he was always different and always the same, he was Zigomar! He appeared originally in serial form in *Le Matin*, and then in longer installments (over a hundred pages), in 1909–10. *Zigomar peau d'anguille* (eelskin) was first published on May 10, 1912. It had a big buildup in *Le Matin*:

> Against spies, against bandits on a grand scale, bravery, even audacity, is not enough. One must pit tenacity against guile, subtlety against trickery, intelligence against the ingenuity of evil! And that's just why Paulin

Broquet may be the only man physically and morally capable of combating the Great Zigomar, who has sworn to kill him! Will he succeed? You will find out, readers, after 10 May, by continuing to read PEAU D'ANGUILLE![33]

The Great Zigomar had much to recommend him. He was a kind of caped crusader for evildoers. He had style. So did the stories, which were told with considerable panache. The writing ran to different dialects, and even some bilingual play on words ("Broquet is broken!"). The cast of characters offered several incidental pleasures. *Zigomar peau d'anguille* even features a character called Marguerite, a farmer's daughter from Alsace: "A fine woman, serious, devoted to her masters, irreproachable . . . with only a single failing . . . an excessive fondness for Alsace liqueur . . . damson gin was her favourite vice."[34]

Above all, Zigomar had a gang. Thirty years later, an animated Magritte told Marcel Mariën all about it. "Zigomar, he had a gang, and did you know that their rallying cry was *Z'à la vie, Z'à la mort*." All his life Magritte had his own gang; he was an uncomfortable follower. As a boy he could think of nothing better, and a gang of three lay ready to hand. The Magritte brothers were born, or reborn, under the sign of Zigomar. René made the rallying cry

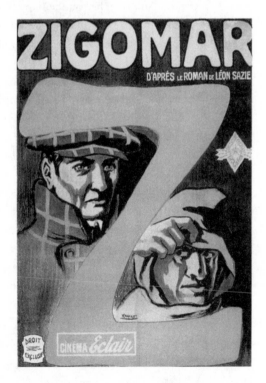

his own. "Hi! Hi! Hi!" exclaimed Raymond Pétrus, on hearing it again, echoing down the decades. *Z'à la vie! Z'à la mort!* "That was René's cry! Hi! Hi! Hi! Sacré René, va!"[35]

At the time, other members eluded him. He continued to be friends with Raymond Pétrus, even though Raymond's mother would not have the Magrittes in the house—except for René, to scoff escaroles (endives) on Thursdays, when they had only a half day of school—but contact with his classmate Victor Frisque ceased abruptly. "My parents forbade me to see them," recalled the elderly Frisque, with some embarrassment, "because, in Châtelet, the Magrittes . . . were regarded as *a bad lot*."[36] The Magrittes modeled themselves on the original. "Curiously

enough," notes the *Dictionnaire du français non conventionnel*, "Zigomar and his gang were not merry pranksters, but cruel and heartless villains."[37] In fact René himself was something of a prankster, or practical joker, and proud of it; the habit persisted in adulthood. If some of that could be put down to high jinks, the time-honored testing of patience and pushing of boundaries, there is no denying a certain heartlessness to the acting out, with scant regard for the insult offered or the offense given, especially to his mother. Not to mention a streak of cruelty.

At large, he was a notorious scallywag. The journalist and writer Ernest Degrange, who grew up with him in Châtelet, enjoyed recounting how young René used to string up live cats on the cords of local doorbells and clamber over the rooftops.[38] His bosom pal Raymond Pétrus, who went to great lengths to protect Magritte's reputation from some of the more outlandish stories told against him, is the principal source for two of the most bizarre (or macabre): that he let the family's donkey starve to death after torturing it in the back garden, and that he dug up a corpse from a grave in the local cemetery.

Pétrus thought his behavior with animals was strange:

> He always had dogs, all kinds of dogs, especially little ones. He also had a big black dog, Frida, a sheepdog, then for a long time Titi, a little dog. And then he rounded up all the dogs that looked as if they had been abandoned. How many times did I hear him say: "Look at the little dog I found," and he would look after it, feed it, they would play together. And then, *fini*! He left the dog without food, and the dog that scratched at the door . . . No! René wouldn't look after them any more, it was over . . .
>
> The outhouse at the back of number 77 was for the donkey. And that's where it died of hunger! They bought a donkey to pull the little cart with rubber tyres, in order to go for a ride to Carnelle. Ouh! How it suffered with them, the donkey! Ouh! How they made it suffer. And then they let it die of hunger . . . on purpose!

As for the corpse, there are different versions, and ingrained hesitations, but they all agree on the thrust of the allegation. Pétrus himself prevaricated. "Don't believe everything they tell you," he cautioned Jacques Roisin, who wrote an account of Magritte's early life "He was my friend, and people tell tales . . . It's even said that René had wanted to dig up a corpse. It's Lempereur who spread things like that, you shouldn't repeat all that." Émile Lempereur was the local historian. On the subject of Magritte he was not always reliable, but he had deep roots in Châtelet, and a profound understanding of

the mores of the community. He knew everyone, including Pétrus, who told him the story of the corpse, a story well attested by elderly Châtelettians. "It was the gravedigger who discovered it," resumed Pétrus at length. "He caught René Magritte in the cemetery, although he had no call to be there." What the gravedigger discovered was a body partially disinterred. Whether René was caught in the act is not clear; in any event he fled. According to some, he went back later to finish the job, only to be collared again by the tenacious grave-digger.[39] Whatever the truth of the matter, Magritte himself never spoke of it. There were other things in that category in his early life—the unspeakable, if not the unpaintable. In this instance, it appears, there was no lasting damage. That seems to be the beginning and end of his career as a grave-robber, but graves and graveyards, coffins and confinement, stuck fast in his imagination. "I have no bone to pick with graveyards," said Beckett.[40] Magritte might have said the same.

The sacrilegious theme recurred. "One day, at school," Victor Frisque recalled, "I told René that my brother-in-law had brought home some things for mass: pewter censer, cross, ciborium . . . 'You could bring them round to my place,' said René, 'and we could *hold a mass*.'" Celebrating mass, it transpires, was one of his specialities. "So I went round to his place," con-tinued Frisque. "He had designed a chasuble [a vestment] on the back of a Cocoline poster . . . this is how we did it: the hole, the two shoulder pieces, and here a nice scrolled cross. And we sang mass in chasubles, with the things I'd brought round." To general consternation, mass was celebrated in the street. Pétrus remembered him on the steps of the Magritte house, setting out his stall: "giant sheets of paper, posters for Cocoline, I think, that he'd painted red *to make church curtains*. He'd made himself vestments, and off he went, he celebrated mass. In the street, everyone would say: *I d'vé sot, I d'vé sot!* [*Il devient sot*—"He's gone mad!"] and *Ça y est, li v'là co!* [*Le voilà encore*—"There he goes again!"].[41]

Somewhat similar but secular performances were held regularly in the house or the back garden. Another of his boyhood friends remembered the theater Magritte:

> Some days we'd go with other children to the Magritte house to see the little theatre that René had made. He had constructed it with wood from the boxes of Cocoline, and he himself had produced a series of painted decorations on little advertising posters. René had cut out and painted little characters of paper and cardboard that he'd parade on the stage whilst he spoke the dialogue.[42]

At home it was much the same. He set up an altar in his bedroom. Before meals, "all of a sudden he would cross himself ten or twenty times, at top speed, making such faces that the maid would say to his mother: 'Madame, I will not be left alone with your eldest, he is mad!'"[43] His father taught him to be an insolent young pup. Paul Sacrez was at the house one day, listening to René's brother Paul play the piano, when Léopold Magritte broke in: "Paul, where is René? He's brought crowds of friends home, and left them to it!" "I think he's on the balcony," said Paul. "On the balcony, what's he doing there?" Léopold went to see for himself. Out on the balcony, he found René with his trousers down. "What the hell are you doing, René?" "I've got piles, my bottom's burning, I'm putting some Vaseline on it." "On the balcony!?" "So where would you suggest I do it? The house is full. All the same I'm certainly not going to do it in front of everyone."[44]

The scatalogical theme was if anything even worse. Everyone knew his taste for practical jokes involving excrement, urine, the sabotage of public toilets, and the diligent monitoring of septic tanks. René Magritte and *"les farces aux crottes"* or *"la blague aux waters"* could have served as the next thrilling installments of the serials that he devoured in his room. The depredations of the Magritte gang in this realm were all too familiar to the people of Châtelet. René and his brothers would run through the streets shouting, "Fire! Fire!" Gingerly, inhabitants would peep out of the front door to find a burning newspaper on the step, and then, once they'd stamped out the flames, concealed under the paper, a dollop of excrement. The gang would fling the stuff over the roof of the house so that it rained down in the street. Or they would put yeast down the toilets of the cinema, on a day when the septic tank was full, so that a frothy, noxious slime oozed across the auditorium and lapped at the feet of the elderly pianist, Constantin Petit, who was tormented mercilessly by the brothers throughout the film.

The ruse with the yeast was repeated all over the town. On another occasion the target was a café. One of the locals heard the story from his mother: "It was during the Palm Sunday Parade. The Magritte gang had put yeast down the toilets of the Café Canada, in the place Saint-Roch, and the toilets had overflowed through the café and into the square. In any event my mother thought of René Magritte as a marked man because he pulled off hoaxes that no one else would have dared to try at the time, about which she would rather have remained silent." These escapades gave ample scope for his cheek. "One day the gang from the lower town went to a café in Upper Châtelet, put half a kilo of yeast down the toilets, and then went and sat down with their drinks. 'You'll tell me when he's going to arrive?' said one. 'Has he decided to come?' asked another. Both were thinking of the overflow of the toilets. They showed

such signs of impatience that the proprietress said to them: 'If you like, when he gets here, I can give him a message.' 'That is kind, Madame,' said René Magritte on his way out of the door, 'when you see him, you can tell him that we've already left.' "[45]

Slipping away like Zigomar must have satisfied him every bit as much as it mortified his mother. He was incorrigible, and he reveled in it. The only thing he did not do was drink alcohol. According to Pétrus, "René was not a drinker."

> Bohemian, yes, but not a drinker. None of us knew how to drink. If he had had two or three glasses, he would have been ill. I well remember, because we had a few feasts down there, in the cellar of number 95. One of us had stolen a steak from his father, another had taken potatoes from his mother, I had got a bottle of wine, my father was a great wine-lover, a bottle of Vosne-Romanée, one of the most expensive Burgundies, and another had a bottle of cognac, it was Georges Piétrons. And by the time we left, we were all crawling around ill, we were so drunk.[46]

School did not save him. He was obviously very bright, unlike his brothers, and in spite of all, his results in the first few years of primary school were by no means terrible. (Raymond and Paul, by contrast, performed abysmally throughout.) In year two he was placed sixth overall in his class. In year three, he was third. In year four, he was sixth. That year, remarkably, he won a prize for "conduct and application," and his name crops up elsewhere in the end-of-year prize giving. A breakdown of the results suggests a commendable effort across the board, though it does not reveal any special aptitude for his future profession: Religion, average; French, first honorable mention; Flemish, fifth prize; Arithmetic, second prize; Natural Sciences and Hygiene, second prize; History, fourth prize; Geography, fourth prize; Handwriting, sixth prize; Drawing, third prize; Gymnastics, sixth prize; Music, fourth prize. The rot set in when he turned eleven (in 1909). That year, he did not sit any of the exams, and was unplaced. Life was changing. Conduct was suspect. From now on he preferred to play truant and go out on the town, in Charleroi, or to lounge on his bed reading penny dreadfuls and pornographic magazines, courtesy of his father *le dab*. There would be no more school prizes.

He turned thirteen on November 21, 1911. His mother disappeared three months later. Was she overmatched by her husband, her children, her eldest, . . . life? Very possibly. However, it may be that she didn't have much support—that Léopold Magritte did not know what to do with his depressive wife, or his ungovernable brats, and that he did not much care. Alternatively,

it may be that he did his best to look after them, and provide for them, but that he was baffled and frustrated by the marriage he had made and the situation in which he found himself, especially when his much-vaunted commercial enterprises came crashing down around his ears. There is some evidence that Régina herself was not only depressed but suicidal, over a long period, and her inadequate husband had to find a way of coping with that, on top of everything else. Did he, too, despair, in the long nights? Years later, Georgette heard from Jeanne Verdeyen, the children's governess and Léopold's mistress, and later his common-law wife, that Régina had made at least one attempt to kill herself, and that consequently she was locked in, for her own protection.[47] The neighbors would surely have had some inkling of such goings-on, but on this subject they were determinedly mute. The indefatigable Jacques Roisin elicited a harrowing account from the next generation: "The only thing I can remember and that my mother often repeated is that Madame Magritte suffered," Jean-Marie Collard, a neighbor's son, stated painfully. "She suffered because the Magritte children got up to all sorts, they had wicked ideas, the father too: they locked Madame Magritte in the cellar and the poor woman cried 'Help! Help! They've locked me up!' as she clutched the bars of the window. What can you do when faced with that kind of thing?"[48]

According to Pétrus, she also tried to drown herself in the water tank in the cellar. However that may be, she was locked in her room at night. Her youngest, Paul (whose pet name was Popol), slept in the same room, perhaps as comfort, perhaps as canary. Her disappearance was clearly premeditated.

On the night in question she had evidently got hold of a key. Popol (then nine years old) woke up in the early hours, found himself alone in the room, and raised the alarm. Léopold and the boys searched the house, in vain. It was the yapping of the dog, Titi, that led them outside, as Pétrus relates:

> In the house, when they found the mother gone, it was the little dog Titi that followed her tracks, and they followed the dog. . . . René came to tell me the next morning. "You know what happened last night?" . . . Madame Magritte had gone out into the garden, then, at the bottom of the garden, she had taken the alleyway, *la rwalle aux Stronjs* as they call it, she had crossed the rue des Gravelles and gone down the alleyway to the Sambre. At the end of the alleyway, there was a low wall, and when the Magrittes got there, Titi climbed up on the wall and barked, barked. . . . "That's how we knew that she had thrown herself into the Sambre," said René. And right enough, they found her body a few days later at La Praye, on the other side of the bridge [the Pont de Fer].[49]

Her body was recovered about a kilometer downstream. After eighteen days in the river, buffeted by the current and battered by the traffic of barges and dredgers and other craft, it cannot have been a pretty sight. Found by a dredger, it was hauled out with the aid of a boathook. One of the dredger's boats had hit her head. Nevertheless, the boatmen recognized her, and the cry went up, "Albert Nisolle, Albert Nisolle, the Magritte woman has been found, the Magritte woman has been found!"[50] Albert Nisolle was Régina's uncle and lived nearby. Like the rest of the clan, he was a butcher; he worked in the abattoir at La Praye, where the body was pulled out of the water. Jacques Roisin managed to track down someone else who was working at the abattoir that day, Arnould Leroux, known as "Nounoul," then a small boy, who used to fetch and carry for his father as he learned his trade. When he heard the cry, he immediately thought that they must have found a body, and raced out to see what he could see. As the Magritte woman was being laid out on the quayside, Nounoul was there. He remembered her bare feet dangling in the water, and that he could not see the rest of her clearly because the body had been covered with a blanket or a coat. He remembered her nightdress hanging down underneath her as they lifted her up to carry her to the stables behind Albert Nisolle's house. He did not remember seeing any of her immediate family. He certainly did not remember seeing the Magritte boys. That was the very reason the body was taken to Albert Nisolle's, as a temporary resting place, until the formalities were completed and she could be reclaimed by the family. That afternoon Régina's brother Albert came to identify the body and sign the necessary paperwork. The funeral service was held two days later—a plain act, plainly recorded: "Bertinchamps, Régina, wife of Magritte, with no Last Rites."

She was buried in Châtelet cemetery, an interment *en pleine terre*, as they say. No vestige of it survives, not even a location. For whatever reason, Léopold Magritte did not purchase a plot of her own for his wife. Sooner or later, therefore, the remains were removed to a communal grave, and the original burial place reused. In the end, Régina Bertinchamps achieved her melancholy purpose. She disappeared without a trace.

What exactly her eldest son saw or heard or made of it all has been a matter of intense speculation, given the traumatic nature of the events, and the enigmatic character of his work. *Les Rêveries du promeneur solitaire* (1926) [color plate 3], for example, serves only to fuel such speculation, now reinforced by the uncomfortable knowledge that the view of the river and the bridge in the painting is almost a mirror image of the view of the Sambre and the Pont de Fer, looking back from the very spot where his mother's body was recovered, as Jacques Roisin has pointed out.[51] The painting is known in

English as *The Musings of a Solitary Walker.* Did Magritte muse on this? The title was stolen from *Les Rêveries du promeneur solitaire* (1782) by Rousseau, whose own mother died when he was a week old, but the solitary walker was a quintessentially Magrittian figure, at once anonymous and instantly recognizable, by his habit, his haircut, his aspect, and his attitude.[52] As Samuel Beckett wrote, such a figure is "[s]een always from behind whithersoever he went. Same hat and coat as of old when he walked the roads. The back roads. Now as one in a strange place seeking the way out. In the dark. In a strange place blindly in the dark of night or day seeking the way out. A way out."[53] He might be a stock character or a stand-in, or both, a Magrittian everyman or a disguised self-portrait—a *portrait manqué* or "failed" portrait, as Magritte's friend and artistic collaborator Paul Colinet called them. A portrait of the artist with his back turned, or his face masked, had a powerful appeal for Magritte. It evoked the elusive Zigomar, or another fictional character whom Magritte was enamored of—Fantômas, the master of disguise.

Appearing and disappearing at the same time was one of Magritte's best tricks. In *Boulevard Jacqmain* (1953), a roman à clef of *la bande à Magritte* signed by Irène Hamoir but written by Louis Scutenaire, her husband, Magritte appeared under the transparent alias of "Gritto." "Gritto incognito" is a handle that would suit him very well.

As for the loss of his mother, Magritte is hard to read. Setting aside the paintings, ambiguous as they are, he seems to have said nothing to anyone about her suicide, or his feelings in the matter, for nearly thirty years. After the recounting of the night before, he divulged nothing more to Raymond Pétrus, then or since. "That's true," said Pétrus, with feeling, in old age, "yes, it's true. René never showed any emotion, I never even saw him cry, although us kids in the street, we cried for two weeks and stayed in, we were so alarmed to have heard such a thing. 'Maman Magritte has committed suicide!' No, it's quite right, I must say . . . and he never spoke of his mother again."[54] He resumed his savage ways. That summer he failed his first year of secondary school.

Apparently he maintained his silence even with his beloved Georgette, who heard about his mother's suicide from Scutenaire. When she raised it herself, at Scutenaire's urging, Magritte merely observed that there were some things that one didn't discuss.

His brother Paul adopted precisely the same attitude. Some part of Paul remained forever Popol: he never grew up. He declined to follow any profession, except that of life enhancer, or entertainer; he kept his friends and relations entertained for decades. He played the piano. He wrote the music for "Norine Blues" (1925), the words credited to the phantom René Georges (a combina-

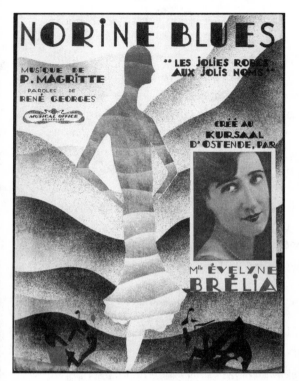

tion of René and Georgette), the sheet music cover illustrated by the real-life René Magritte; and for "Marie Trombone Chapeau Buse" (1936), a poem by Paul Colinet, also illustrated by Magritte. This latter might almost be construed as a failed homage to Léopold Magritte and the thrill of the chase:

in the great cherry wardrobe
under your man's stovepipe hat
dances a family of grey mice
Marie Marie Marie who smiles
give your man his nightcap.[55]

As Bill Buddie, he wrote a foxtrot called "A Little Nest" (1930) and a melody called "Slow for Two" (1937). As Paul Magritte, he wrote a variety of other numbers, among them "Maldoror," "Miroir du desert," "Je speak no English," "Si les femmes étaient agents de police," "Albertine," "Scholastique," "Spring in Sahara," "Daisy," "Des trucs, des choses et des machines," and "Passe-moi la main dans les cheveux." He was a minor composer. He was a minor poet. Perhaps that is unduly harsh: a kinder interpretation sides with Scutenaire's mock review: "Paul Magritte was a poet without equal, as great in style as in invention. There is no one I would rank higher."[56]

. . .

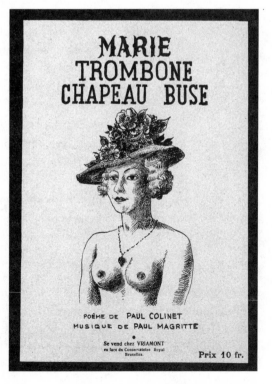

Paul truly excelled at taking his ease. "His natural talent for doing nothing," in Mariën's words, must have stood him in good stead when he was rejected for military service in 1939. "As far as he is concerned, the word 'unfit' cannot but be fittingly applied."[57] He appears in *Boulevard Jacqmain*, in character, as the Marquis. He was a puckish humorist, a dedicated absurdist, a practicing surrealist—a surrealist in being, as André Breton might have said. His tone of voice is captured in his responses to a questionnaire in *Le Savoir vivre* (*Good Manners*), a spoof cooked up by Magritte and his friends after the Second World War. The questionnaire was a spoof, too, inviting tongue-in-cheek responses, though they were prepared to entertain more serious ones. They put four questions to artists and writers far and wide, and published a selection of the replies to these: What do you hate most? What do you like most? What do you wish for most? What do you dread most? Magritte's responses centered on his detestation of the past:

> I hate my past and that of others. I hate resignation, patience, professional heroism, and all the obligatory fine feelings. I also hate the decorative arts, folklore, advertising, announcers' voices, aerodynamics, boy scouts, the smell of naphtha, current affairs, and drunks.
>
> I like subversive humour, freckles, women's knees and long hair, the laughter of children at play, a young girl running in the street.
>
> I wish for true love, the impossible and the chimerical.
>
> I dread knowing exactly my limits.[58]

Paul's responses were equally characteristic:

> [Hate]: The self-centred man.
>
> [Like]: Poetic invention. A grand piano. A horse. Sorrel.
>
> [Wish for]: That the human race transforms itself into vegetables and the like: the innocents, the poets and the anarchists into lovely flowers; the bastards and the pious into leeks and turnips; the financiers, the politicians and the grenadiers into stink bombs.
>
> [Dread]: The brutes and also the beastliness that paralyze handsome deeds.[59]

Man and boy, Paul was a lifelong member of *la bande à Magritte*. It would be too much to say that Paul never again found himself alone, as he did on the night of February 24, 1912, but it is noticeable that he attached himself to his big brother ever after. Wherever René went, Paul went. (Even to Paris.) In later life Magritte found Paul amusing—by contrast with his other brother,

Raymond, whom he found boring, or worse, and who was always kept at a distance.

Raymond, who had an attack of polio at eighteen and continued to suffer complications from it as an adult, had seized his chance to leave home at the earliest opportunity, taking a position as a salesman with a pharmaceutical company. He dealt in perfume essences. In the fullness of time he became a well-to-do businessman. By all accounts, his main aim in life was to get rich. He succeeded. He married Joséphina Vandaelem, a shorthand typist, in 1932, in Brussels, and they had a daughter, Arlette. She remembered him as distant, almost shuttered; as a child, she did not see much of him. "My father had very little contact with me (he could hardly bear children) and never talked to me about his own childhood."[60] He also seems to have inherited a certain disdain for his fellow man, including his older brother. According to Raymond, "Mon frère, c'est un ***."[61] If he was in some ways inhibited, it is said that he took after his father in other ways, in particular as a womanizer; there is talk of a fling with the boss's wife, and of further embarrassments. His other conquests were acquisitions, and intelligent ones. Whatever René may have thought of him, when his older brother became a painter he began to acquire Magrittes, as soon as he could, notwithstanding the well-advertised shortcomings of the artist. One of his first purchases was *La Robe d'aventure* (*The Garment of Adventure*, 1926) [color plate 4], painted shortly before the solitary walker, presenting another naked body laid out for our inspection, this time on the water, encased in a vestment that might be a shroud; an Ophelia figure floating downstream to her death, perhaps, eyes closed, attended by a giant aerodynamic turtle, which appears to have left its natural element to overfly the adventurer, skimming so low that its front flipper almost brushes her thigh.[62]

If Raymond was rather unsympathetic, Paul was exactly the reverse. Magritte genuinely enjoyed his company. They were blood brothers, in every sense, as Scutenaire remarked.[63] Yet perhaps there was something more. Paul worked his passage, in his minstrel way. But he needed looking after, financially and otherwise; Magritte obliged, even in straitened circumstances. In the modern idiom, Magritte was there for Paul—all his life, but for one night.

Paul married late. In 1942 he wed Elizabeth van de Gevel, known as Betty, a sensible woman who appears to have been an ideal mate. Betty was from Rotterdam. She knew practically nothing about his past, as she was the first to admit. She found out about his mother's suicide from a reference in a catalog and a conversation with Georgette. "Paul was very discreet," she told Jacques Roisin. "And then there were things that he never spoke about."[64]

So it was with Magritte. Once only, Scutenaire succeeded in getting something out of him, in the course of their freewheeling conversations about his

life and times, for the book that became *René Magritte*, first published in 1947, though it was written earlier, in 1942. Scutenaire's account of that conversation became famous. Despite its silences, its oddities, and its inaccuracies, it was so well turned, so compelling, so satisfying, that it held the field, unchallenged, for half a century:

> Still a young woman, his mother committed suicide when he was twelve.
>
> She shared a room with her youngest child, who, finding himself alone in the middle of the night, roused the family. They searched in vain all over the house; then, noticing footprints on the doorstep and the pavement, they followed them as far as the bridge over the Sambre, the local river.
>
> The painter's mother had thrown herself into the water, and when they recovered the body, her face had been concealed by her nightdress. They never knew whether she had covered her eyes in order not to see the death that she had chosen, or whether the swirling currents had veiled her thus.
>
> The only feeling that Magritte remembers—or imagines he remembers—in connection with this event is one of intense pride at the thought of being the pitiable centre of attention of a drama.[65]

As a more recent authority on Magritte, the art critic David Sylvester, has underlined, "Magritte's story as told suggests (as it did to Scutenaire) that he was present throughout the unfolding of events in a few dramatic hours. The story's imagery is brilliant, mythic in its poetry. The veiling of the face by the nightdress is an inspired mixture of the complacently romantic and the shockingly erotic: the poignant idea of the woman whose delicate sensibility prevents her from facing up to her chosen death; the frisson, at once Oedipal and necrophilic, of a pubescent boy's glimpse of his dead mother's torso laid bare."[66]

At what stage Magritte saw his mother's body, and in what state of undress, it is impossible to be sure. Contrary to long-standing supposition, over-stimulated by the Scutenaire version, he may never have seen it for himself. It is highly unlikely that he was present at the very moment his mother was fished out of the swirling currents, which was the moment most likely to deliver what the Scutenaire version promises: the veiled head and the bare torso. Thereafter the vision fades. She was identified almost immediately ("the Magritte woman has been found"), and by the time the body was laid out on the quayside it had been covered up, as Nounoul testified with great convic-

tion. In any event, it seems Magritte was not there. He could have asked his uncle Albert (or someone else) about the gory details, or the look on her face, as Sylvester speculated, and been comforted (or fobbed off) with the white lie that it was difficult to tell because her nightdress had ridden up over her head. In years to come he could easily have heard other tales of that sort. Jeanne Verdeyen is said to have parroted a somewhat similar story. In a momentary loss of inhibition at the very end of her life, Georgette let slip that her husband never did see the body, but heard about it, years later, from a local fireman.[67] Of course, this too could be secondhand (twice over): Georgette may have had it, not from Magritte himself, but from another source; and even the fireman may not have been a direct witness.

Notwithstanding the storytelling, it remains possible that he caught a glimpse of the body in Albert Nisolle's stables, or elsewhere on its journey that day, though that too seems unlikely, especially if it was collected from the stables by the undertakers and not by the family. That day was a Tuesday; Magritte should have been at school. In the circumstances, if he got anywhere near the body, he would have been closely supervised; and it would surely have remained covered. After the undertakers' ministrations, it was customary for a body to lie in the house, in an open coffin, in order for people to pay their respects and for family and friends to take their leave of the deceased. Whether custom was followed in this case is very doubtful. Eighteen days in the water was a long time; another two days on land before the interment was even longer. Léopold Magritte wasted no time on grieving, and he gives no sign of staging any show. Everything points toward the need for dispatch. The timing of the funeral arrangements suggests that the coffin was already at the church, or the cemetery, with the lid firmly closed. The formal announcement appeared in the *Gazette* the next day:

> The funeral, followed by the interment, will take place on Thursday the 14th inst., at 9.00 in the morning, in the parish church of SS. Peter and Paul in Châtelet.
>
> Foregather at the home of the deceased, 95 rue des Gravelles, at 8.45.
>
> Friends and acquaintances who may not have received a letter of notification, through oversight, are requested to accept the present announcement in lieu.[68]

Scutenaire never knew the truth of the matter. He remained curious about it to his dying day (August 15, 1987, exactly twenty years after the passing of his friend Magritte). Allowing for some literary legerdemain, he reported faith-

fully what Magritte told him, as he always insisted. The Scutenaire version was an inspired version, in more than one sense: it was inspired by Magritte.

It was another retelling, or reimagining, of Magritte's past, the past that he so detested, with reason. The images it conjures resemble nothing so much as the artist's own paintings. They appeared in spate in 1928—a very good year—the year his father died. *L'Histoire centrale* [color plate 5], for example, which he thought of, revealingly, as *La Femme voilée* (*The Veiled Woman*), depicting a woman of fairly stout build with her head covered, her hand at her throat, attended by two of his totems: a small suitcase and an enigmatic tuba. In this picture the woman is clothed; she is wearing a dress or a shift.[69] In *L'Inondation* (*The Flood*) [color plate 6], she is naked. What is more, only the lower half of her body is visible. The upper half is shrouded in mist. Her right arm has disappeared. She has lost her head. Her left hand rests proprietorially on a tuba. Her pubic hair glows bright as the tuba, as if on fire. She might be posed, *contrapposto*, if only we could see the rest of her. Behind her is a lagoon, or a watery grave.[70]

Magritte's violent source-world was rich and strange. However we may speculate about the artist's mother, the veiled woman may equally have been inspired by Nick Carter, "*le grand détective américain*," as illustrated in one of the dime novels that Magritte bought in Le Passe-Temps, a paper and joke shop in the rue Neuve, and carried off to consume in the privacy of his room. Nick Carter was on his mind when he was making or meditating these paintings. The front cover of *Les Initiales mystérieuses* features a dead broad splayed out on a shop floor, fully clothed, her head "veiled," à la Magritte, or, more precisely, wrapped in a cloth, very like the disturbing series of *Les Amants* (*The Lovers*) that he produced at the same time, kissing or standing cheek to cheek (cloth to cloth) [color plates 7 and 8].[71]

Magritte was an avid reader of detective stories all his life. He also fancied himself as a writer of them. He seems to have tried his hand at a few as a youngster, signing himself "Detective Renghis" (a contraction of René and Ghislain). In 1927 he started a Nick Carter story of his own. Unfinished, it remained in his bottom drawer until it was eventually published posthumously in 1969 by Marcel Mariën:

> The world resembles Nick Carter, the detective who recently arrived from America. His eyes took in the town as carefully as they took in the countryside. The objects that surrounded him seemed not to claim the usual movements from him. His movements were like those of an automaton, he followed a straight line and moved all of the furniture or the walls which happened to be in his way. The dark creases that cov-

ered his face became transparent in the electric light. His room was in shadow, and when he put on the light to examine a document, or to check his weapons, you could see the curtains of his office through his face.[72]

Magritte, for his part, often adopted the "ingenius disguises" he admired in characters like his Nick Carter as he fenced artfully with interviewers. Once Scutenaire's book was out (in 1947), and the suicide referred to in Magritte's "Esquisse auto-biographique" autobiographical sketch of 1954, it became public knowledge. Still it took a bold interviewer to broach the subject. Magritte could be charming, when he put his mind to it. He was habitually lucid. But he disliked interviews, particularly the unscripted kind; he objected

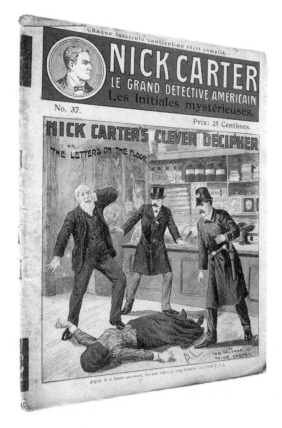

to being ambushed. He abhorred small talk, especially if it was being recorded. He was quite capable of performing on radio or television—performing Magritte—but the constraints of the media irritated him beyond measure. Given the questions in advance, he might well prepare meaty answers. Otherwise, he spoke to the point, but said little. It was as if he had no views to inter, as Beckett once said.

Very occasionally, he was led to say more. Once in a while, he would muster a pronouncement. In 1961, in the course of a long conversation, Jean Stévo ventured to ask "if his mother's suicide in the waters of the Sambre had marked him deeply." He replied,

Of course, those things you don't forget. Yes, it left its mark, but not in the way you think. It was a shock. But I don't believe in psychology, any more than I believe in will power, which is an imaginary faculty. Psychology doesn't interest me. It claims to reveal the flow of our thoughts and emotions. Its efforts are contrary to what I know; it seeks to explain a mystery. There is only one mystery: the world. Psychology is concerned

with false mysteries. No one can say whether the death of my mother had an influence or not.

During my adolescence I experienced things of the order of the deflated balloon, the locked chest. Very often, I had the feeling (I have it still) of being in a world of mystery: a street, a face, the sky appear to me in unknown, private guise. So it is that thought resembles the world.[73]

"He did not speak about things that touched him deeply," reflected Georgette. "He painted them away."[74]

2.

Normal Madness

The locked chest and the deflated balloon were Magritte's two earliest memories. He insisted on this throughout his adult life. These objects were carriers of meaning and repositories of feeling. They were spied very early indeed—if not from the cradle, exactly, then when he was young. They were things he saw—or thought he saw—and yet also apparitions, or visitations, of such an order that they demanded to be seen (and stored away). They were mysterious, thereby fulfilling the first require- ment for his art. They were more than mysterious, they were miraculous, almost dreamlike, a quality that in time would become one of Magritte's bêtes noires. He explained this to an interviewer in 1965, toward the end of his life:

> "You dream a lot, I see, Magritte?"
> "I dream like everyone else, and on that subject I think it is worth not- ing that my painting is not 'dream painting.'"[1]

"The first sense I had and that I remember was the sense of mystery," Magritte told another interviewer. "I felt that sense looking at a chest which appeared, one day, next to the cot in which I lay. That chest was the first object that instilled in me the sense of mystery."[2]

Was it a treasure chest, like those in *The Thousand and One Nights* or *Treasure Island*, two of his favorite books? According to the "Biographical Notes" he composed for Irène Hamoir, in 1956, it was a large wooden chest. If it was three and a half feet long, three feet wide, and two and a half feet deep, it bore an uncanny resemblance to the one unearthed in "The Gold-Bug," by

his beloved Edgar Allan Poe, which featured in the *Histoires extraordinaires* that he knew so well.

It was firmly secured by bands of wrought iron, riveted, and forming a kind of trellis-work over the whole. On each side of the chest, near the top, were three rings of iron—six in all—by means of which a firm hold could be obtained by six persons. Our utmost united endeavours served only to disturb the coffer very slightly in its bed. We at once saw the impossibility of removing so great a weight. Luckily, the sole fastenings of the lid consisted of two sliding bolts. These we drew back—trembling and panting with anxiety. In an instant, a treasure of incalculable value lay gleaming before us. As the rays of the lanterns fell within the pit, there flashed upwards, from a confused heap of gold and jewels, a glow and a glare that absolutely dazzled our eyes.[3]

The mystery of the locked chest may never be solved, though Magritte's work is fertile with associations. "The mere word *treasure*, read with the eyes of a child in the Arabian tale," was enough to enchant the poet Paul Valéry.[4] Perhaps the same was true of Magritte. If treasure was his heart's desire, Ali Baba or Long John Silver might answer; or *Gaspard the Nightwalker*, the prose poems of Aloysius Bertrand, which would provide the inspiration for a suite of piano pieces by Maurice Ravel, and later still for an oil painting and a gouache by Magritte. As Bertrand wrote, "He opened the chest: there was treasure for all, a pile of sacred vases, doubloons, a torrent of pearls and a river of diamonds."[5] In his forties, Magritte went back to the Arabian tale as well. "I've started rereading *The Thousand and One Nights*, with pleasure," he informed his good friend Paul Nougé when he was in his late forties. "How long will it last?"[6] Not as long as *Treasure Island*, it turned out: according to Scutenaire, *Treasure Island* was the book Magritte remembered with more pleasure than any other. According to André Bosmans, he reread it every year. He was only too familiar with the dead man's chest: "Fifteen men on the dead man's chest— / Yo-ho-ho, and a bottle of rum!"[7]

Perhaps he never did open it. Satisfying the desire ruins the mystery. But not long after he took up a brush in his teens and early twenties, he began to toy with the possibilities of containers of all kinds, not to mention the disposal of the body that might lie inside. Coffin associations are inescapable. In *La Grande Nouvelle* (*Sensational News*), a boxlike container houses a skeleton bird, of jaunty mien, as if doing its best for the display case that has been made for it, or having its picture taken. In *L'Homme célèbre* (*The Famous Man*), a somewhat similar container, more oblong and upright, houses a shady bilbo-

quet. In *Le Dormeur téméraire* (*The Daring Sleeper*), the eponymous sleeper is bedded down in an oblong wooden box that is distinctly coffin-like.[8]

In his life of Magritte, Scutenaire relates two coffin tales. Both are characteristic, and could have Freudian associations; but they smack more of surreal farce than psychological trauma. The first involves Magritte bedding down in a coffin of his own.

> While he was spending a few days with a cabinetmaker, this artisan put the finishing touches to a coffin for a fat, rich giant.
>
> Lured by the comfort and opulence of the coffin, the painter wouldn't rest until he had lain down and—it being four o'clock—had his tea there, with the lid down. The hearse was not due to collect it until the next day, giving the family time to gaze down upon the dear departed right up until the last minute.
>
> His meal over, he got out of the coffin, very spry and well satisfied. A little later, however, he was seized by such terror at the thought of the experience that he went almost a week without wanting to stretch out or take food.

The second story is equally bizarre. It begins, promisingly, "One day a policeman died on the second floor of the building where Magritte lived on the ground floor."

> For reasons of prestige and convenience, the family of the deceased asked the artist if he would let them use his living room for the public viewing of the coffin.
>
> Not much bothered about doing his neighbours a good turn, by rights Magritte would have liked to refuse. However, the pleasure of having a dead man at home with him, right next to his bedroom, almost within arm's-reach, soon swept him along—permission was granted to set up the bier.
>
> And it was in this funeral chamber that the painter received his usual visitors; the mood was never more delightful than that evening.[9]

In Magritte's accounts of his childhood memories, the chest was followed by the memory of the hot-air balloon. "I was amazed to see, from my cot, some men carrying a deflated balloon that had landed on the roof of our house," Magritte reminisced to his interviewer. "Later, I felt more anxious than elated, without any particular reason." He must have elaborated this story further to Scutenaire, who spun a more colorful version of it. "A balloon landed

on the shop where he lived; the deflated envelope had to be brought down from the roof, and that long limp thing that the wry-faced men in peaked caps with ear-flaps and leather jackets had to drag downstairs, seemed to him extraordinary."[10]

The story of the balloon sounds a little too good to be true, though in the annals of ballooning it was by no means impossible. Magritte was never very specific about where or when it took place. He may not have known. If it was in Gilly, as Scutenaire assumed, he would have been just one year old when they arrived from Lessines in 1900 and five when they left for Châtelet in 1904. In those years hot-air balloons were regularly to be seen in the skies overhead, and they were regularly in trouble. The annual hot-air balloon festival in the center of Charleroi, about two miles away, was a major attraction, extensively covered in the local papers, *La Gazette de Charleroi* prominent among them. Every year, as it seemed, the intrepid balloonists got into difficulties, with the wind or the rain or the telegraph wires. Every year there were reports of balloons drifting out of control over Gilly. All of which lends the story circumstantial credibility, and local color to Magritte's memories, but there are no reports of a balloon crash-landing anywhere in the town, let alone on the roof of 185 Chausée de Fleurus, the Magritte family home. Léopold Magritte would surely have had something to say if it had.

Verification of this tale, however, may be beside the point. Perhaps the infant Magritte was simply absorbing what he heard going on around him, or the stories he was told, reinforced by all manner of captivating images in circulation at the time. A popular series of collecting cards illustrating scenes from the early history of ballooning featured several on the theme of the end: "Mort de Pilâtre de Rozier et de Romain," "Mort de Harris," "Mort de Mme Blanchard"—the celebrated daredevil Sophie Blanchard, who specialized in firework displays from her balloon, in the Luxembourg and Tivoli Gardens in Paris, accompanied by an orchestra in the bandstand below; a dangerous stunt, given the source of the hot air, and in the end a fatal one. On a sultry summer night in the Tivoli Gardens, in 1819, the hydrogen in the mouth of her balloon caught fire. The flaming balloon dropped onto the roof of 16 rue de Provence, near the present Gare Saint-Lazare. Mme Blanchard was not severely burned, but she was tangled in the rigging of the balloon. She slid down the roof, hung there for a moment—the dramatic scene depicted on the card—and fell onto the cobbled street. Her fiery descent was a gift to the mythologists. Mme Blanchard was immortalized.

"Throughout history," writes the celebrated biographer and historian of the period Richard Holmes, "dreamlike stories and romantic adventures have always attached themselves to balloons. Some are factual, some are pure

fantasy, many (the most interesting) are a provoking mixture of the two. But some kind of *narrative basket* always seems to come tantalisingly suspended beneath them. Show me a balloon and I'll show you a story; quite often a tall one."[11] The story of a small boy in a runaway balloon is one such: a version of what Holmes calls "the falling dream"—in this case, falling upward into space, or flying. Jean Bruno's fable *Les Aventures de Paul enlevé par un ballon* (1858 and much reprinted), with beautiful illustrations by Desandre, is an exemplar that Magritte might have known. It is possible that the young René was taken outside to see one of those strange monsters drifting by. Perhaps it loomed so large that it gave him a fright. Perhaps it was low enough for him to wave to the otherworldly balloonists in their gondola or basket, to catch something of the look on their faces, to envy them their earflaps, and to covet their paraphernalia. Perhaps he saw one through the window, from the safety of his bedroom, which was not so safe after all. Perhaps he was feeding his imagination, and his anxieties, as children do.

He may well have seen a deflated balloon, close up, in Châtelet. In 1911, when he was twelve, the Châtelet festival organizers gave their permission for a balloon to make an ascent from the place Saint-Roch (where the Magritte gang sabotaged the café toilets). In the event, the balloon only just cleared the roofs of the houses in the rue de Namur; almost immediately it began to lose height, got caught in some fruit trees, and ended its voyage squashed ignominiously against the front of a house in the rue de l'Église, slowly deflating. The balloonists emerged unscathed,[12] and the local residents had an unbeatable view of the whole affair. It so happened that Magritte's uncle Albert and aunt Florine lived in the rue de l'Église. Their two sons, Gaston and Georges, were about Magritte's age. It would be very surprising if the Bertinchamps brothers and the Magritte brothers did not go and inspect the carcass.

More mundanely, in the Brussels suburb of Jette, where Magritte lived after he was married, in the 1920s, the Esseghem gasworks was also a filling station for hot-air balloons, which took off on test flights from the open fields nearby, attended by crowds of whooping schoolchildren. On at least one occasion, something went badly wrong. Shortly after beginning its ascent, a balloon crashed against a gasometer, fatally injuring the pilot.

The balloon image shadowed Magritte all his days. Joseph Montgolfier's famous formula for a hot-air balloon, "a cloud in a paper bag," would have appealed to him.

And the sky, from his earliest work, is full of surprises. It is shape-shifting, revealing, and deceiving. In *Le Temps menaçant* (*Threatening Weather*, 1929) [color plate 9], which Magritte painted in August 1929, the cloudless sky is filled with three outsize objects we had overlooked: a torso, a tuba, and a

chair, hanging in the air like a mirage or a vision, or perhaps a thought. For all his antipathy toward fanciful interpretations of his work, Magritte was prepared to say of another painting that the clouds looked like thoughts—and to cite Henri Michaux, who had expressed a very similar idea in a penetrating essay on his painting.[13] The ghostly trio dominate the sky (and the picture). As objects, they look remarkably convincing, yet curiously insubstantial. They have a cloudlike aspect; they are clouds and not clouds. The sky is an accommodating medium, but its status is moot. The boundaries between solid and void, inside and outside, make-believe and true-life, remembered and invented, are never fixed: they are porous. The Magrittian sky is malleable, metamorphic, muscular—*Les Muscles célestes* (*The Muscles of the Sky*, 1927) have something resembling legs—so much so that it could resolve itself into building blocks, a little like Lego, which was patented at almost exactly the same time as Magritte made blocks of sky his own artistic territory. In *La Tempête* (*The Tempest*, 1931) [color plate 10], a painting of clouds and blocks of sky in a dark room, threatening weather gives way to disturbing storm. For many years it hung in his bedroom.[14]

Magritte himself pointed out in "Lifeline," a lecture he gave in 1938 and probably the best self-accounting we have, that his sky is not the sky of the traditional artist-painter. "Where necessary, I used light blue"—as in *Le Temps menaçant*—"unlike those bourgeois artists, never using it as the occasion to show off such and such a blue against such and such a grey, according to my

inclinations."[15] For Magritte, the sky is blue, the leaves are green, and the sea is often copied from the same picture postcard—*La Vague* (*The Wave*), an undated oil by a traditional artist-painter of the sea, Vartan Makhokhian.[16] But there is also a place for the sky-bottle, the leaf-bird, and the seaman who doesn't much resemble the common Jack Tar, as *L'Homme du large* (*The Man from the Sea*, 1927) [color plate 11] goes to show.[17] Whatever their origins, these early creations were on no account to be reduced to symbols, as he explained to a sympathetic curator, late in life, after a rare visit to a museum:

> I visited the exhibition "The Role of Dreams" with interest; it seems to me very well done. However, I must point out a mistake: in one vitrine there is a notice describing the objects represented in my paintings as "symbols." I should be grateful if you would ensure that it is corrected. They are *objects* (grelots, skies, trees, etc.) and not "symbols." In the representational arts, symbols are for the most part employed by artists who are very respectful of a certain way of thinking: that of endowing an object with some conventional and commonplace meaning. My conception of painting, on the other hand, tends to restore to objects their value as objects (which never fails to shock those who cannot look at a painting without automatically thinking how it could be Symbolic, Allegoric, etc.).[18]

For Magritte as for Beckett, "no symbols where none intended."[19] This was something he cultivated from the beginning: objects are objects. A steam engine is a steam engine and not a phallic symbol. Indeed, in Magritte's hands the object is not only restored but revivified. It is the *ne plus ultra* of objects. A steam engine coming out of a fireplace is more of a steam engine than it ever was on the rails. "A familiar object which we previously ignored, moves us, once displaced," wrote Nougé, in the course of his call and response with Magritte. "The object exists as an object and moves us by its hitherto unregarded virtues."[20] His own imagination as to these virtues ran purposefully off the rails. "In order for the objects which were revealed to us in childhood to continue to have the same power of revelation for us, they must be given new functions," he declared; "so, for example, a link is created between a house and musical instrument, and a bilboquet is turned into a creature from a new mythology."[21]

Many Magrittian objects, like his balloons, were sourced from an encyclopedia. Most of them came from one encyclopedia in particular—Larousse. This was the golden age of the encyclopedia, and Larousse was ubiquitous, omniscient, inexhaustible, a cornucopia of arcana, and, like his favorite

books, a means of escape. Magritte quoted one of its maxims in his later writings: "'Journeys are a useful diversion from distress,' says Larousse, whose gigantic works indicate a normal madness, a stubborn determination to 'chase away dark thoughts.'"[22] As a child, Magritte would have been familiar with the *Nouveau Larousse illustré* (1897–1904), and perhaps also the daddy of them all, the *Grand Dictionnaire universel du XIX siècle* (1865–76). He plundered the *Petit Larousse illustré* (1916) for inspiration from the very beginning, as Marcel Lecomte confirmed.[23] He also had recourse to an edition of *Larousse Universel* (1922–23), a copy of which remained in his library all his life. He could easily have come by its big brother, the six-volume *Larousse du XXe siècle* (1928–33). He possessed a copy of *L'Art des origines à nos fours* (1932), a two-volume survey; he may even have sampled more rarefied productions like the *Larousse ménager, dictionnaire illustré de la vie domestique* (1925). For Magritte, Larousse was a treasure house, or yet another treasure chest. (It was also a cultural benchmark. When a new edition came out, the adult Magritte combed through to see if he was in it, alongside Maginot, Mahler, and Mahomet. He was disappointed. Come 1959, André Breton was in. Magritte was not.)

Magritte did not go to the encyclopedia for information. He went for inspiration: for models to work from. He went for the pictures. He may even have colored them in. Typically, the entries in Larousse are illustrated with line drawings, sometimes grouped together for purposes of classification ("furs," "music," "sign systems," "common birds"), in a full-page spread. The illustrations are accurately drawn and meticulously captioned; the subjects are disassembled and labeled. They are a gift for the copyist. The skeleton bird in the box in *La Grande Nouvelle* (1926) is a faithful reproduction of the bird skeleton in an anatomical drawing in Larousse. The low-flying leatherback turtle skimming the woman on the water in *La Robe d'aventure* (1926) is not just any old turtle; it is very much a *sphargis*. That it is airborne is no less startling than that it resembles an airship or dirigible, for example the *dirigeable rigide "Méditerranée"* or the *zeppelin "Nordstern,"* as pictured in the encyclopedia. It is at once a turtle balloon and another species of the legendary family, like Melchior Lorck's flying tortoise, or the *rukh* (roc), the giant bird that can carry an elephant in *The Thousand and One Nights*. If the *rukh* could rescue Sinbad, perhaps the *sphargis* could rescue Salome, or even Régina. More prosaically, the same applies to all the other balloons: the *ballon sphèrique de La Vaulx* appears to be the model for the balloon in most of Magritte's paintings, while the *montgolfière de Pilâtre de Rozier et du marquis d'Arlandes* is the spitting image of the montgolfier in a portrait he made of his friend Harry Torczyner, a New York lawyer.

ASCENSION CAPTIVE EXÉCUTÉE PAR PILÂTRE DE ROZIER DANS LE JARDIN DE RÉVEILLON AU FAUBOURG SAINT-ANTOINE A PARIS, LE 17 OCTOBRE 1783.

Through the years, when Magritte was stumped for a title, a look through Larousse might prompt a new thought. *Un Peu de l'âme des bandits* (*A Little of the Outlaws' Souls*, 1960) [color plate 12] was a title lifted by Scutenaire from a book about *la bande à Bonnot*, a gang of thieves active in Belgium and France in 1911–12, notorious alike for their anarchism and their devotion to motorcars—an intoxicating mix of social conscience and shootouts, expropriation and mayhem, free love and getaway cars. *La bande à Bonnot* were well known to *la bande à Magritte*. They had started out nearby, in Charleroi, home of Marie Vuillemin ("Marie la Belge"), mistress of Octave Garnier, Bonnot's never-say-die sidekick. *La Capture de Bonnot*, a film of his last stand, on April 28, 1912, was shown in the Grande Brasserie Nationale de Charleroi, with live orchestral accompaniment. According to one of his schoolmates, Magritte himself was there to see it.[24]

Magritte in those years was only a part-time terror: throughout his adolescence he had a secret vice—he was learning to paint. As he confirmed in his autobiographical sketch, "[I]n 1910, in Châtelet, . . . the twelve-year-old René Magritte coloured in pictures and took lessons in painting. A teacher from a school in Dampremy, near Charleroi, came each week to give lessons to the young ladies of Châtelet. Apart from the teacher, René Magritte was the only representative of the male sex in the makeshift school, which occupied two

rooms on the first floor above a sweet shop." A little later he furnished some supplementary detail (tongue in cheek?). "On Sunday mornings, he went to a painting class, where the master taught poker-work and the decoration of umbrella-stands."[25] The place name would have stuck in his mind, given the collision of fine art and violence he perhaps associated with it: it was in 1911 that *la bande à Bonnot* robbed the parish church of Dampremy, killing the priest by smashing his skull.

Coloring in was a serious occupation. His pal Victor Frisque joined in:

> I would sometimes go round to René's house and we would colour in together. With big crayons to sharpen, we enjoyed colouring in pictures. That's how we became friends, we realized that we both liked colouring in. At his place René would colour in all the pictures he could find, in books, in magazines, even in the newspapers. There were also the pictures that he bought in Le Passe-Temps, which were called "chromos" [chromolithographs, meaning postcards or small-scale reproductions of paintings or picturesque scenes]. One day, when I was his desk mate, I noticed one of his beautiful Caran d'Ache crayons, a rose madder of which he was very proud, and I stole it. That afternoon, I put it back in Magritte's box: I had a guilty conscience. . . . I never saw Magritte himself draw, I mean do drawings, or paint, except for the time we held a mass [when he made the decorations], that was the first time I went to his house.[26]

For purposes of coloring in, the dictionaries in his father's library came in very handy, Larousse included, but there was more scope in magazines. Magritte mentioned in particular the illustrations in *Le Magasin pittoresque*, and the rebuses in *Les Belles Images* and *La Jeunesse illustrée* (*Youth Illustrated*)—later appropriated as the title of a painting, or possibly a rebus of his youth [color plate 13].[27] In comics, after Nick Carter and Nat Pinkerton, he remembered "Les Pieds Nickelés," who made their debut in *L'Épatant* in 1908, and who returned to his consciousness forty years later, as he got to work on the caricatural paintings of his *vache* period.[28]

The early painting lessons with the young ladies may or may not have yielded any finished works. There are at least four pretenders to the title of the first Magritte: two landscapes, dated 1910, offered later to the Musée des Beaux-Arts in Brussels by their aged owner, who claimed to have found them in a flea market in Souvret, near Pont-à-Celles, in 1929 or 1930, a chronology that could conceivably square with the death of Magritte's grandmother (in 1929), whose family lived in the area; a still life with flowers in a vase, dated

1910, said to have been in the possession of a traveling salesman who had received it straight from the hands of Magritte's mother, in exchange for a pound of butter; another landscape, this one more "Dutch" (complete with windmill), from another flea market, dated 1910, but copied from a painting of 1912; and a "View of Bruges" (a canal, a bridge), undated, supposedly a gift from the artist to Jules Goffin, headmaster of the École Moyenne in Châtelet, later sold at auction in Liège.[29] The last was not included in the *catalogue raisonée*.

Magritte never said a word about the drawing lessons at the École Moyenne—half an hour a week, taken by one of the form masters, Lucien Delchevalerie ("Delche" for short). According to Victor Frisque, they did not amount to much. "For the first lessons Delche taught us to sharpen a pencil. Then we had to draw geometric forms, and more geometric forms: lines, squares, circles. . . . Not until much later did we move on to objects. Only in secondary school were the lessons taken by a proper drawing teacher, Monsieur Bois d'Enghien, and that was in a dedicated space for lessons with plaster casts which served as models."[30] When the family returned to Châtelet in 1914, after living for a time in Charleroi, Magritte stopped coloring in and started painting. More to the point, he decided to become a painter. Testing the water, and perhaps the attitude of his father, he painted a picture. That is to say, he copied a picture. This canvas, *Chevaux affolés fuyant une écurie en feu* (*Frightened Horses Fleeing a Burning Stable*, 1914), was nothing if not a statement—or a declaration of intent—two and a half meters in length and one and a half meters in height. It was copied from an identical (but smaller) painting by Jef Vanderveken (1872–1964), who was himself an accomplished copyist and forger, specializing in the Flemish masters, like Jan van Eyck and Rogier van der Weyden. According to Albert Chavepeyer, who watched him do it, Magritte worked from a chromo of the original. The "first picture" is doubtless as provisional as the first Magritte. If this is the one, it is a fitting genealogy.

Its reception was equally striking. The painting was exhibited for the first time at 95 rue des Gravelles, the Magritte family home, by the proud father of the artist. When Jacques Roisin asked Raymond Pétrus who came to see it, he received the crushing reply: "The neighbours!"[31] They liked what they saw. The first exhibition was a resounding success. More importantly, something about the painting, perhaps its very ambition, persuaded Léopold Magritte that this was a venture worth backing. An artist in the family—an artist who could sell—that was an investment. He considered sending his son for a year of training in Italy, a small price to pay for a stake in such a market. As Pétrus remembered it,

His father was very ambitious, a *seigneur*. He wanted his sons to become someone important, I don't know . . . an engineer, for example, is very important, or something else, but *someone*. So when he saw his son's big painting, and people came to see it, that decided him to accept that René might be a painter, and then he encouraged him. But what seemed strange to me was that René hadn't given anyone any warning, and then he showed me his painting, and it still seemed strange to me that he hadn't said anything about it before.[32]

However quietly he had come to it, the young Magritte was a budding artist, mad for the marvelous and avid for other worlds. His first balloon painting suggests a significant route to enchantment: *Cinéma bleu* (1925) [color plate 14], the look of it much indebted to Marcel L'Herbier's extravaganza, *L'Inhumaine* (1924).[33] At thirteen, René discovered a new world: film. In April 1912, a month after his mother was laid to rest, a cinema opened its doors in Châtelet, in an imposing building on the banks of the Sambre, around the corner from the rue des Gravelles. It was owned and operated by a man named Zénon Emplit. Magritte went every week to the Cinéma Emplit, as often as not with his newfound friends the Chavepeyer brothers, who lived at the other end of the street. Albert, Émile, and Hector Chavepeyer were all artistically inclined. They were not part of what became known as the Magritte gang—they were a gang of their own—but they were all besotted with films. Magritte had encountered Albert at the World's Fair in Charleroi the previous year, where they were both devotees of Zénon Emplit's "cinema stall." When the cinema came to Châtelet, they were over the moon. Albert recalled their passion for films and film posters:

> The big posters in Châtelet advertised the films that were coming to Emplit, and René and my brothers loved to study them. There were also publicity posters inside the cinema. One of them made a tremendous impression on us. It was an advert for Alcyon cycles, showing a cyclist with four heads, those of the stars of the Tour de France, Octave Lapize, François Faber, Cyrille van Hauwaert and Lucien Petit-Breton. The Cinéma Emplit was the cause of my infatuation with posters and from then on I wanted to be a poster designer. René adored the film posters and the publicity posters. He became a film fanatic. He would sometimes see the same programme at the Emplit several days running. He also went to Charleroi to see the reconstructions of spectacular events, shown on a big screen in the street, like the surrender of the Bonnot gang. But his passion reached its height when they screened the adventures of Fantômas.[34]

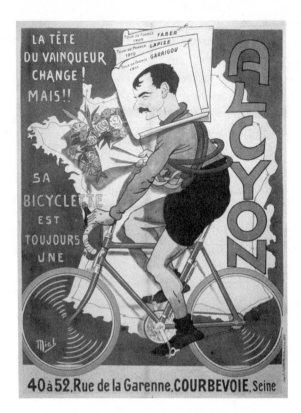

LA TÊTE DU VAINQUEUR CHANGE ! MAIS!! SA BICYCLETTE EST TOUJOURS UNE ALCYON

TOUR DE FRANCE 1909 FABER
TOUR DE FRANCE 1910 LAPIZE
TOUR DE FRANCE 1911 GARRIGOU

40 à 52, Rue de la Garenne, COURBEVOIE, Seine

Fantômas, the Emperor of Terror, made his debut in the stories written or dictated by Pierre Souvestre and Marcel Allain. The first of these, *The Genius of Crime*, appeared in 1911. So did the phantom himself. All of a sudden, he was everywhere—on billboards, on kiosks, in the Métro, at the station—a masked man, immaculately turned out in top hat and evening dress, bestriding Paris like a colossus, against a blood-red sky; a picture of suavity, his chin resting in his gloved hand, his free arm outstretched behind him, clenching a bloody dagger [color plate 15]. This was the front cover of the first book, made up as a poster. The image was unforgettable. The poster was a sensation. The message was clear. Fantômas was abroad.

Pulp fiction had never had it so good. Thirty-two books were published over the period 1911–13, as a monthly serial, each one in a lurid new cover. Magritte could hardly wait. He watched the posters spread like a contagion all over Châtelet. He gobbled up the books. He drooled over the covers—*The Severed Hand*, in particular, but also *The Masked Jockey*, and *The Deadly Bouquet*, which partially conceals the face (and poisons the unsuspecting victim).[35] He was often to be found with his nose pressed against the window of Le Passe-Temps, his source of supply, where they had installed a full-color plaster model of the Master of Disguise. He was hooked.

He was not alone. Fantômas was a phenomenon. Famously elusive, he slipped the bounds of bourgeois morality; he mocked the canons of good taste; he defied the dry-as-dust distinctions between high and low culture. His fan base was extraordinary. Franz Kafka was a Fantômas fan. Guillaume Apollinaire founded the Société des amis de Fantômas, with Pablo Picasso, Max Jacob, and Maurice Raynal. Blaise Cendrars declared that "Fantômas is the *Aeneid* of modern times."[36] Robert Desnos composed the "Ballad of Fantômas" for performance on the radio, directed by Antonin Artaud, with music by Kurt

Weill. Raymond Queneau contemplated a *Life of Fantômas*. After reading the thirty-two volumes four times, he settled for a statistical analysis of his crimes. Perhaps surprisingly, the principal finding was that Fantômas failed in nearly one in four of his attempted murders (seventy-three successes against twenty failures), though in the latter part of his career the success rate rose significantly,

to 87.5 percent.[37] Man Ray made a portrait photograph of Raymond Queneau called "Fantômas-on-the-run." Juan Gris painted a cubist *Fantômas* (1915), with pipe, newspaper, and book cover, showing only a black opera mask—the grin after the phantom has vanished (NGA).[38] Yves Tanguy painted a fantasist *Fantômas* (1925–26), complete with naked victim, oozing blood.

Magritte painted a realist Fantômas, *Le Barbare* (*The Barbarian*, 1927), depicting the head and shoulders of the emperor of the poster: the masked man, in close-up, materializing out of a brick wall. This painting was destroyed in a bombing raid on London during the Second World War, but not before the artist himself had been photographed beside it, in a bowler hat and a sharp suit, mimicking the pose. In

1943, he did it again. *Le Retour de flamme* (*The Flame Rekindled*) is a faithful reproduction of the iconic image—"the *Fantômas* poster, painstakingly transposed onto canvas," sniffed the critic Georges Marlier—but for a crucial substitution. The master criminal is disarmed, as

David Sylvester nicely observes: his dagger has metamorphosed into a rose [color plate 16].

The young Magritte seems to have learned passages of the books by heart.

Forty years on, when he renewed acquaintance with Charles Alexandre, an inseparable friend of his student days, Alexandre's opening gambit was the single word, "Fantômas!" Magritte shot back, "What did you say?" And they were off, rehearsing the famous opening dialogue:

"I said: Fantômas."
"And what does that mean?"
"Nothing. . . . Everything!"
"But what is it?"
"Nobody. . . . And yet, yes, it is somebody!"
"And what does the somebody do?"
"Spreads terror!"[39]

Later still, in 1966, Jacques Goossens asked him the best question Magritte may ever have been asked in an interview: "Are you Fantômas?" Magritte replied: "That's a very good question, because you seem to believe that I could be Fantômas. Well, if I think of Fantômas, I could say that I am Fantômas in a certain fashion, but one can be someone other than oneself in two ways: truly believing, like a madman, for example, who believes he is Fantômas himself, or else as one might say, like a poet, who thinks Fantômas, and that thought is not imaginary, it's a real thought. So, how can I respond: I *know* I'm not Fantômas, but when my mind thinks Fantômas, it *is* Fantômas."[40]

That answer carries a distant echo of a Fantômas story of Magritte's own from a prolific creative time: "Un Coup de théâtre," a vignette first published in 1928, the year he turned thirty. It focuses on Fantômas's nemesis, Inspector Juve of the Sûreté, forever in hot pursuit . . .

Juve has been on the trail of Fantômas for some time. He crawls along the broken cobblestones of a mysterious passage. To guide himself he feels his way along the walls. Suddenly a gust of hot air hits him in the face. He comes nearer. . . . His eyes adjust to the darkness. Juve makes out a rough-hewn door a few feet in front of him. He takes his coat off, wraps it around his left arm, and gets out his gun. As soon as he is through the door, Juve realizes that his precautions were unnecessary: Fantômas is close by, fast asleep. Juve quickly ties up the sleeper. Fantômas dreams on, about his disguises, perhaps, as usual. Juve, greatly pleased with himself, mutters a few ill-advised words. The prisoner gives a start. He wakes

up, and, once awake, Fantômas has ceased to be Juve's prisoner. Juve has failed, yet again. There is only one way for him to achieve his aim: Juve will have to find his way into one of Fantômas's dreams—he will try to be one of the cast of characters.[41]

The reckless sleeper dreams of his disguises. He has been identified with the runaway balloonist in the intriguing small oil painted that same year. In *Le Changement des couleurs* (*Change of Color*), a moment of high drama is enacted in the upper left corner, almost out of the frame: a balloonist in a jumpsuit (or a heavy disguise) has launched himself into space.[42] We surmise that he has leaped from the basket of his balloon, whose rigging seems to have unraveled, or been severed. Only the basket is visible, slightly askew, still suspended by strands of rigging; the balloon itself is out of the picture. The posture of the man is strangely purposeful. He is poised, controlled, as if he has leaped for the nearest cloud, which looks almost solid enough to support him. He is not in anguished free fall, like the gallant Lieutenant Harris in the collecting card. He is in a horrific state of suspension that would have done credit to Poe, whose classic balloon tale, "The Unparalleled Adventure of One Hans Pfaall," also featured in the *Histoires extraordinaires*.

Is this picture, perhaps, Magritte's version of a falling dream? It is tempting to interpret it as a recollection of his childhood—a recovery of a memory—especially as he may well have been brooding on childhood, and memory, after the death of his father on August 24, 1928. If so, it is not recol-

lected in tranquillity. There appears to be no boundary of any kind between the solid wooden floorboards of this interior and the gaping void beyond. It is as if one side of the building is missing, or a stage flat has been removed. The effect is disquieting. What is to become of the balloonist? Can he really leap to safety? Surely not. Yet such a predicament would not have fazed Fantômas, or Zigomar, who would no doubt live to fight another day. And what of us, the helpless onlookers, where are we? Can we move closer, the better to see, perhaps even to assist? If we walk the plank, or the floorboards, what then? As so often in Magritte, the threshold is a fateful one. Across the threshold lies the unknown. Obliteration or liberation.

Le Changement des couleurs is also a Conradian picture. Like Lord Jim, the balloonist has abandoned a sinking ship—so he believes. He has jumped. He must live or die with the consequences. "Strange," muses Conrad in his mesmerizing way, "this fatality that would cast the complexion of a flight upon all his acts, of impulsive unreflecting desertion—of a jump into the unknown."[43] Magritte was steeped in Joseph Conrad. So were his friends. Those tales of the sea and sky filled a shelf in his library: not only *Lord Jim*, but also *The End of the Tether, Twixt Land and Sea, Tales of Unrest, Youth, Heart of Darkness, The Shadow-Line, The Nigger of the "Narcissus,"* and a well-thumbed copy of *Typhoon*, translated by André Gide.[44] He and Marcel Lecomte used to read them aloud to each other. Lecomte claimed to have found the title for Magritte's painting *L'Homme du large* (*The Man from the Sea*) from those readings.[45] Conrad was irresistible. He plumbed the destructive element, and the secret chambers of the heart. "A man that is born falls into a dream like a man who falls into the sea. If he tries to climb out into the air, as inexperienced people do, he drowns." He spoke to the capacity for fidelity as a condition of human distinction. He spoke to tragedy, and the lure of a watery grave. He spoke to self-creation, and self-deception, to yearning, and to callow youth.[46]

Magritte's fascination with Fantômas and the more sophisticated Conradian variety of adventure was not simply a boyish craze for daggers and derring-do (and body parts). It was intimately bound up with the persona of *"le brigand sublime,"* in Scutenaire's characterization, and also with Magritte's ongoing project—to cultivate not mere mayhem but sedition. In his "Notes on Fantômas" (1928), Magritte observed, "His central command was composed of young *tziganes* [gypsies]. They obey a code, despite the rather brutal suddenness with which they burst into the history of crime." The young gypsies were a kind of *bande à Fantômas*, the inner circle of the notorious *bande de chiffres* (henchmen) mobilized by the master manipulator in the service of his diabolical pursuits. *Le Grand Robert de la langue française* reports gravely that "*tziganes* were often persecuted on account of their reputation as

sorcerers and pilferers." The combination of black magic and light fingers, devilment and dazzlement, must have been a seductive one for Magritte. Outsiders and outlaws, close-knit, code-bound, huggermugger: that was always his ideal sodality. Fantômas lured him into the underworld. There he remained for a long time, revelling in transgression. In the process he learned something else that he made his own. Fantômas is everywhere, but nowhere to be seen; he is visible yet invisible, there but not there, like the invisible ink on his visiting card. Magritte would have loved such a visiting card. He adopted the persona instead, handing out a suitably villainous photograph of himself. Fantômas was not exactly a role model, but he was a sort of avatar. After Fantômas, Magritte took on another of his aliases: *L'Insaisissable*—unseizable—elusive. The *tziganes* became his accomplices; the opera mask metamorphosed into the bowler hat.

The *Fantômas* books, however, were only the curtain raiser. The films, directed by Louis Feuillade, were the main event, and profoundly influential on the young Magritte. Five were released in quick succession, in 1913–14, *Fantômas*, *Juve contre Fantômas*, *Le Mort qui tue*, *Fantômas contre Fantômas*, and *Le Faux Magistrat*. Each of these was a serial in three to six episodes. They were made fast, but they were the very opposite of B movies or quota quickies. "*Fantômas* is the first great movie experience," David Thomson has written, "Feuillade the first director for whom no historical allowances need to be made." His films were amazingly bold. "In the silent era Feuillade was without rival or peer at letting the black cloak confound morale. For the first time, it was hard to tell entertainment from subversiveness."[47]

Feuillade did not stop there. Hard on the heels of *Fantômas* came *Les Vampires* (1915–16), a serial in ten episodes, beginning as it meant to go on with *La Tête coupée* (*The Severed Head*) and ending with *Les Noces sanglantes* (*Blood Wedding*), including along the way such enticements as *La Bague qui tue* (*The Killer Ring*) and *Les Yeux qui fascinent* (*The Hypnotic Gaze*). *Fantômas* was based on the books by Souvestre and Allain; *Les Vampires* was all his own work. Feuillade was a true *auteur*. What he turned out was something more than a few episodes strung together as a serial. It was an

oeuvre, a body of work by the same hand and eye and ethic. Feuillade imagined a whole moral (or immoral) universe, and magicked it onto the screen. His films are capers. At the same time they are moral tales—fables—Sheherazade at twenty-four frames a second, crackling with social and political tension. Thomson's appreciation is apt: "Fantômas and the Vampires were criminal gangs intent on gaining material and psychological power over a decadent bourgeoisie. Their names show how far they are destructive angels, dreaded and craved by their victims. And Feuillade's inventiveness—of plot, action, and visual revelation—has exactly the same inspiration as the gang's plans: a cheerful contempt for society that gains as much from anarchism as it looks forward to Dada and Surrealism." Black magic was laced with black humor, so dear to the heart of the surrealists. Feuillade's criminals were no ordinary criminals. They were "glowing black humourists with all the ambiguous charm of Dracula."[48]

Feuillade's secret was to find a way to combine photographic realism, on the set and on location, with an astonishing repertoire of the fantastic. His moral universe is a shadow play full of fabulous creatures—the ballerina as vampire bat, seducing her prey as she pirouettes—and his mean streets are around the next corner. What goes on before our eyes is extraordinary, yet his films have a deadpan quality to them, as if hallucinatory experience is the most natural thing in the world. Nougé's percipient remark on Magritte, "the universe is altered, there are no more ordinary things," is prefigured in Feuillade. Surreal events unfold in banal settings. A man presses a button at his desk, and a cannon comes out of the fireplace, all set to destroy the cabaret next door. Before the cannon is fired, however, the proprieties must be observed. The curtains are pulled back and the window is opened. Once the cannon has done its job, the window is closed, and the curtains are drawn.[49] The director Alain Resnais, who grew up on Feuillade, was struck by "that prodigious poetic instinct that allowed him to fashion Surrealism as easily as he breathed. We owe some extraordinary sequences to his flair for arranging meetings of 'an umbrella and a sewing machine on a dissecting table.'" Georges Franju, who remade one of Feuillade's films, called it "fantastic realism," noting shrewdly that for all the action, there is also a certain suspension, not to say suspense. "He left on me the impression of a magic that was black and white and silent. In his shots where nothing happens, something can occur that profits from this nothing, this inaction, this void and silence, something profits precisely from the waiting, from inquietude. This something is called mystery." For Jacques Prévert, Feuillade worked in black and white and gray, and he spoke in "the Esperanto of silence."[50]

The Vampires added a tremendous erotic charge. When it came to icons,

Fantômas met his match in Irma Vep, incarnated by the divine Musidora. Everyone, but everyone, fell for Musidora. "Musidora, how beautiful you were in *The Vampires*!" hymned Robert Desnos, ten years later. "Do you know how we dreamt of you, and how, when evening came, you entered our bedroom without knocking, in your black catsuit, and how, on waking next morning, we searched for traces of the worrying sneak thief who came to us in the night?"[51] How many men had such a dream. How many women, too. Louis Aragon and Breton wrote a screenplay for Musidora, *Le Trésor des jésuites*, but not before Colette had written *La Flamme cachée* for the woman who was said to be her lover.[52] No one could resist Musidora, not even the real-life prefect of police, who was minded to suppress *The Vampires*, as a threat to public safety (and public morals), but was persuaded otherwise after a visit from Musidora herself. As vampire in chief she is incandescent. Irma Vep romps through the social register, possessing and enslaving any man who might be of use to her, and freely disposing of all the rest. She is gloriously lascivious—her act at the Howling Cat nightclub is not to be missed. She is knowingly rapacious—as she makes off with the map of buried treasure she winks, twice, at the audience. She is at once vamp and tramp. For lustful adolescents like Magritte she must have been a revelation. And a regular torment.

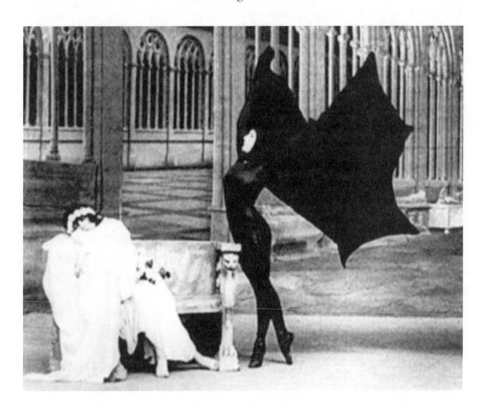

Words, too, gain magic powers in the art of Feuillade, in a way that seems notable in relation to Magritte. Words in the films materialize and metamorphose like objects. Fantômas himself is first revealed when his name materializes on his visiting card, only to dematerialize, like its owner. The mysterious Irma Vep is unmasked, verbally, while we watch, goggle-eyed. As an investigative journalist puzzles over a poster of the nightclub singer, the letters of her name rearrange themselves into a confirmation of her identity: we see that IRMA VEP is an anagram of VAMPIRE. This celebrated sequence is not only a virtuoso piece of stop-action animation, but also a powerful visualization of the journalist's dawning realization. It is as if we can read his mind. The outcome is as thrilling and disturbing as the director intended. In Feuillade's films the locus of the word is radically uncertain. The writing is on the wall—literally—scrawled in front of a captive banker, as though an intertitle has invaded the action. The relationship between word and image is called into question. These are silent films. Words are magical but expendable. Names play tricks.

Feuillade—though forgotten for some decades in France, before the first Cinémathèque revival of *Fantômas* in 1944, and unknown in Britain and United States until the 1960s—casts a long shadow. His influence on Fritz Lang and Alfred Hitchcock was decisive, as David Thomson has underlined. "All the roots of the thriller and suspense genres are in Feuillade's sense that evil, anarchy, and destructiveness speak to the frustrations banked up in modern society. Even the originality of Lang and Hitchcock fall into place when one has seen Feuillade: [Lang's] Mabuse is the disciple of Fantômas; while Hitchcock's persistent faith in the nun who wears high heels, in the crop-spraying plane that will swoop down to kill, and in a world mined for the complacent is inherited from Feuillade."

His influence on René Magritte was equally decisive. In the 1930s the painter Arshile Gorky was in the habit of saying that he was *with* Paul Cézanne for a long time. Magritte was *with* Feuillade for even longer, though the relationship started when he was rather older than is generally realized. The first *Fantômas* film opened in Paris in 1913, when he was fourteen, but it took two years or more for it to reach the Cinéma Emplit in Châtelet. Albert Chavepeyer had a clear memory of seeing the films with Magritte, in sequence, as they came around. That is entirely possible, though they would not have seen *Le Mort qui tue* (the third in the series), which Chavepeyer remembered, and which provided indelible images for the image bank, until 1915 at the earliest. Charles Alexandre, likewise, vividly recalled his friend's infatuation with Fantômas—as witness the dueling dialogue—but Alexandre did not become thick with Magritte until 1918.[53] In other words, even if he saw the films of

The Vampires only once, as soon as they came out, it means that he had a drip feed of Fantômas and company throughout his teens, possibly even into his twenties.

His response was not long in coming. A Fantômasian figure, or perhaps a Vampire, appeared for the first time in his work on the cover of a new review, *Marie* (1926), in a sort of stand-off with a striped bilboquet, which looks as if it was itself inspired by the décor in *The Vampires*. The figure is clad in the regulation costume of their order, the black catsuit, complete with cowl or balaclava; sometimes a looser-fitting hood with eyeholes. This fetishistic disguise lent them a certain sexual allure, and also an intriguing ambiguity. Like Irma Vep herself, voluptuous as she is, she exudes an air of ambiguity, even androgyny; this would be true of other mysterious Magritte figures as well. In the series of paintings that followed, like stills from a film, *La Voleuse* (*The Thief*), *Le Supplice de la vestale* (*The Torturing of the Vestal Virgin*), and *L'Homme du large*, the element of mystery is pronounced, as is the element of suspense, ratcheted up in *L'Homme du large* [color plate 11], who looks as if he is about to pull a lever, or throw a switch, on a piece of wall. He may be opening a window. He may be detonating a bomb. His state of mind is unknowable. His expression is impossible to read—his head is a block of wood, decorated with curlicues. In any event it seems we are privy to a fragment of a story, or a memory, for the piece of wall in question is floating in space, free of any wires or connections.[54] Thirty years later, taxed with an interpretation that leaned heavily on a battery of associations with alchemists, occultists, hermetic books, and the obiter dicta of André Breton, Magritte tried gently but firmly to disabuse the overeager:

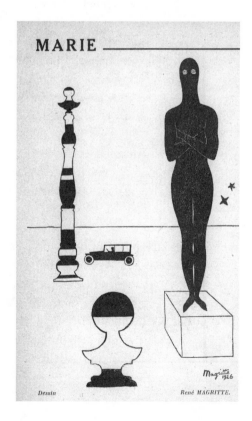

MARIE

Dessin René MAGRITTE.

> The connections you find between my painting and alchemy testify to an interest in alchemy and in my painting. You see a sort of marriage that does not offend against common decency between the alchemists' hope and my lack of hope or hopelessness. As for mystery, I can deduce nothing; that

would be to misunderstand its essence. The identity of visibly familiar figures evokes, *de facto*, their mystery. In painting, I can show only the visible. (The invisible, that is to say what light cannot illuminate, cannot be represented in painting.)

For me, it's not a question of mastering secrets like the alchemists—there is nothing there that we need to know or learn—but of *discovering* the way to paint images in which the unknown cannot be reduced to the knowable.[55]

There are no clues, Magritte liked to say, only false clues. Nonetheless, there are gestures, and Magritte learned many from Feuillade. It was the best education he received—the most constant and the most potent—and it was these lessons he took most to heart.

Magritte was a moviegoer all his life. Like the moviegoer of Walker Percy's novel, he would go and see anything. Almost anything.

The fact is that I am quite happy in a movie, even a bad movie. Other people, so I have read, treasure memorable moments in their lives: the time one climbed the Parthenon at sunrise, the summer night one met a lonely girl in Central Park and achieved with her a sweet and natural relationship, as they say in books. I too once met a girl in Central Park, but it is not much to remember. What I remember is the time John Wayne killed three men with a carbine as he was falling to the dusty street in *Stagecoach*, and the time the kitten found Orson Welles in the doorway in *The Third Man*.[56]

Magritte knew that shot. *Stagecoach* was one of his favorite films. (It is known in French as *La Chevauchée fantastique*, a title that might have appealed to him, notwithstanding his disapproval of the fantastic.) "I've seen *Stagecoach* numerous times," he told Henry Torczyner, "and even rented it to screen at home."[57] Magritte was a John Wayne fan. Few things in life gave him as much pleasure as the discovery that John Wayne was a Magritte fan. He often rented films to screen at home, with friends, on a 16 mm sound projector, with a two-meter-wide screen, acquired in 1958. The first one he showed was *The Marx Brothers Go West* (1940). Even the hardline surrealist revolutionaries liked the Marx Brothers, though in Christian Dotrement's considered opinion *A Night in Casablanca* was superior to *The Marx Brothers Go West*, as he reported to one of their meetings.[58] In this as in other things, Magritte begged to differ.

In the 1950s, Magritte also directed his own home movies, with a stock

company, à la Feuillade or Ford, made up of his accomplices and a favored few invited guests. These were silent comedies, or tableaux vivants. Magritte loved silent comedies. He was especially fond of Charlie Chaplin (known as "Charlot"), Chester Conklin, Harry Langdon, Max Linder, Mack Sennett, and Fatty Arbuckle's perennial rival Al St. John (known as "Picratt"). He had a weakness for slapstick, and pratfalls, though he also appreciated grace, and disgrace, under pressure. His small private collection of 8 mm shorts included one Max Linder, *Max joue le drame* (1910), one Picratt, *Cine-roman* (1920), and two early Chaplin films, *Charlot policeman* (*Easy Street*, 1917) and *Charlot fait une cure* (*The Cure*, 1917).[59] It was dominated by Laurel and Hardy: *Son Altesse royale* (*Double Whoopee*, 1929), *Oeil pour oeil* (*Big Business*, 1929), *Laurel et Hardy Musiciens* (*Below Zero*, 1930), *Laurel et Hardy Carottiers* (made for the French market, with Laurel and Hardy speaking phonetic French, in 1931), *Laurel et Hardy Menuisiers* (*Busy Bodies*, 1933), *Patrouille de nuit* (*The Midnight Patrol*, 1933), and *Le Bateau hanté* (*The Live Ghost*, 1934). Like Maigret, Magritte adored Laurel and Hardy.

Magritte never hid his love of film, but in later life he was apt to be a little disingenuous about his tastes, insisting over and over again that he only wanted escapism, of a defiantly cloddish kind. Provoked by François Truffaut's *Les Quatre Cents Coups* (1959), he let off steam to André Bosmans, in a letter notable for its forgetfulness about his own delinquent youth:

> I can't believe that there will be much interest in *Les 400 coups*. For it's a film "sans cinéma," but instead amply furnished with an "edifying" theme, and what's more, falsely edifying because such a film will delight delinquent youth. The tributes of the cinema "intelligentia" [*sic*] made me rightly apprehensive that I'd only be bored by this "moral" film, and given the intelligentia's tastes, there was no lack of boredom. "Moral" film (or instructive or aesthetic film) always lacks the morality of film, which consists simply in film capable of amusing or interesting us. "Moral" cinema is not cinema: it's a boring caricature of a boring course in moral philosophy. Like the boring course, it's short on morality. I consider true cinema to be such films as *Coup dur chez les mous* [1956], *Madame et son auto* [1958], *Babette s'en va-t-en guerre* [1959]. "True" because no pretension to anything other than to amuse us, so not deprived of their essential morality.[60]

He warmed to his theme with a diatribe on Hitchcock—in Magritte's usage, "Hichkoc"—provoked this time by *Psycho* (1960). After half a century, Fantômas was still the gauge:

Hichkoc is an imbecile of great talent; his latest film *Psycho* proves it. The talent is great because during the film we experience two or three seconds that are extraordinary. The imbecility is demonstrated by a sequence at the beginning of the film that cannot be justified by anything to do with the "subject": it shows an almost naked man on a bed with a scantily clad woman, and has no purpose other than to present that lifeless scene. It complicates the subject, "crime film," by foregrounding madness. Here the crime film is confused with a so-called psycho-drama. What is essential to the crime film is the criminal (stupid, violent, etc.) and not an inmate of a lunatic asylum. It's only too clear that to pass muster, Hichkoc has pandered to the taste of the "serious" public which demands from the cinema a caricature that it, the public, takes for the expression of profound thought. That public dismisses Chaplin (the early films) or Fantômas. It imagines it's participating in intellectual life when it listens to the chatter of cinema experts.[61]

As auteur, Hitchcock did not pass muster. "Très bien comme cinema," Magritte reported, on *The Paradine Case* (1947). "But what quackery!" James Agee returned a very similar verdict: "Hitchcock uses a lot of skill over a lot of nothing."[62] Swayed perhaps by a preference for Marlene Dietrich over Kim Novak, Magritte found *Stage Fright* (1950) more interesting than *Vertigo* (1958)—a film often touted as owing something to his own paintings. Magritte and Hitchcock had more in common than at first appears, not least the nun in high heels, revealed in *The Lady Vanishes* (1938), but originally defrocked in *La Vierge retroussée* (1933).[63]

 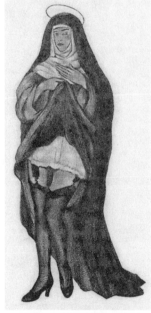

Fritz Lang, on the other hand, was for Magritte a key figure, of whom there is barely a whisper in his own chatter. Writing in 1942, Scutenaire identified the films "most congenial to him" as Fritz Lang's *Spies* (1928) and Carl Dreyer's *Vampire* (1932).[64] Whatever we make of these nominations—on the face of it not the most apropos—they serve as a reminder that Magritte's habitual recommendations on films to see ("*à voir*") were not confined to *Madame et son auto*. A list of "interesting films" he compiled in the 1960s included *Alexander Nevsky* (1938), by Sergei Eisenstein (*version originale*); *The Stranger* (1946), by Orson Welles; *Stalag 17* (1953), by Billy Wilder; *Last Train to Gun Hill* (1959), by John Sturges; and *Our Man in Havana* (1959), by Carol Reed, as well as a smattering of smaller fry, and a reminder of his passion for detective stories, hard-boiled and soft-centered, such as Maurice Leblanc's "gentleman thief," Arsène Lupin, who finds his place on the list with *Signé Arsène Lupin* (1959) by Yves Robert.[65] If the 1960s witnessed a certain relaxation, in the 1940s he was still passionately engaged. "A rough idea," he wrote to Mariën: "About Belgian cinema: The peculiarly Belgian blunder of expressing comically feelings that should be expressed dramatically. It differs from the French blunder, incarnated for example by Marcel Carné (*Les Visiteurs du soir*), who fails to achieve the unintentionally comic and delivers a gloomy world-weariness."[66]

In the 1920s and '30s (a time when he also began painting prolifically, having discovered surrealism around 1925), Magritte seems to have seen practically everything of consequence. He went to Antwerp to see *The Cabinet of Dr. Caligari* (1919), by Robert Wiene; he sought out everything by G. W. Pabst, in particular *Pandora's Box* (1928) and *The Threepenny Opera* (1931). He surely compared notes with Nougé, who was a student of film, along with everything else. Nougé's occasional writings on the cinema have been surprisingly little noticed; they include a very short story about Buster Keaton.[67] At the Cabaret Maldoror in Brussels, in 1925, Nougé introduced a screening of *Genuine: A Tale of a Vampire* (1920), by Wiene; there followed *La Dixième symphonie* (1918), by Abel Gance; *Broken Blossoms* (1919), by D. W. Griffith; *El Dorado* (1921), by Marcel L'Herbier; and *Kean* (1924), by Alexandre Volkoff.[68] Of the other heavyweight foreign directors of the day, Magritte was also familiar with Luis Buñuel (a Fantômas fan), who made his début with *Un Chien Andalou* (1928), in collaboration with Salvador Dalí.[69] Magritte had met Buñuel, and had decided views on his work. On *Los Olvidados* (1950), for example, as a surrealist film: "It is not a Surrealist film. Some images in this gangster film can be taken for the expression of a Surrealist aesthetic, but Surrealism is not an aesthetic. It is a state of revolt that should not be confused with irrationality, cruelty, or scandal. Like the victims of a common misunder-

standing, Buñuel has confused the non-conformism of current thought with that thought itself. He has made use of the portrait of a wretched society to give free rein to routine sadistic pleasure."[70]

Congenial or uncongenial, the importance of these films for Magritte was far outweighed by other examples of Fritz Lang's gripping offering: *M* (1931), with Peter Lorre as the murderer threatened or tormented by his own urges; above all, the disciple of Fantômas, Dr. Mabuse. Lang eventually made three Mabuse films, and Magritte made a point of seeing each one. The first, *Dr. Mabuse the Gambler* (1922), was fundamental. Dr. Mabuse exercises his evil genius by targeting the rich, the weak, and the venal. According to tradition, he is everywhere present but nowhere recognizable. "Who is he?" someone asks. "Nobody knows. He is there! He stands over the city like a huge tower!" He overpowers his subjects psychologically, with his staring eye, by hypnotism and telekinesis and mind games over the tables, a little like a demonic Léopold Magritte, the gambler. He seduces important women and rattles important men. *Mabuse* runs for well over three hours, in two parts. It is a relentless onslaught. The themes of enclosure and claustrophobia emerge with compelling force—this film ends with Mabuse, insane, in a locked room—but it is the manner that rivets the attention: the stringent control of mood, the intense refinement of style. Lang was already a master prestidigitator, aptly described as the Edgar Allan Poe of the cinema. David Thomson remarks on "the assurance that comes from a world built entirely on sound stages and from his ability to make the emotional and moral resonance of interiors so clear."[71] Such was Magritte's ambition.

He never gave up on the cinema. It was not only a form of schooling; it was his memory chest and his narrative basket. As for his actual schooling, in 1912 he was taken out of the École Moyenne in Châtelet and entered in the Athénée Royal in Charleroi. For a few months he traveled to and fro by bus and train. In 1913 what remained of the Magritte family left Châtelet-la-Morte and moved to Charleroi. That same year, Magritte met a girl at the Charleroi Fair and achieved with her what both always claimed to be a sweet and natural relationship. They saw each other almost every day, on their way to school. She was his first love, and very likely his last. In the fullness of time she became his wife, his muse, his Musidora. Each week they went to the cinema—the cinema that was their cinema—the Cinéma Bleu.

> We are right at the beginning, you see.
> As if before everything. With
> a thousand and one dreams behind us and
> without act.[72]

3.
Cupid's Curse

Her name was Georgette Berger. When they met at the fair, in August 1913, she was twelve and he was fourteen. She caught his eye in the famous *carrousel-salon*, the main attraction at the fairground at that time. It was more than a mere merry-go-round: it was a transport of delight. A marquee was erected around it, like a circus tent, decorated with scenes of chariot races in an arena, the charioteers resembling Cherokee Indians. The ticket booth stood in the middle of a grand entrance, complete with columns. Inside was another world. There was a wooden apron all around, which made a dance floor; there were ceiling lights, panel mirrors, refreshment stalls, seats, streamers, seductions of all kinds. Music blared from a mechanical organ, which was accompanied by a live cornet player. The merry-go-round itself was steam driven; one of the hands had the job of keeping the boiler fed with briquettes. The *carrousel-salon* was also a *carrousel-ascenseur:* the wooden horses went up and down, in time-honored fashion, as they went around and around.

"Coming for a spin?" Magritte asked.[1] She accepted. So it began. Their year of bliss at the Cinéma Bleu was abruptly terminated when the Germans invaded Belgium in 1914. The consequent disturbances flung them apart, and they lost touch for six years. They were reunited in Brussels, in 1920, when Georgette was nineteen and Magritte was twenty-one. One day, out of the blue, they bumped into each other in the Botanical Gardens. That evening Magritte brought his sweetheart two roses, painted on a piece of paper. The next day he was waiting for her after work.[2]

This time they were determined to be together. Whether or not they were ever officially engaged, they were certainly courting; there was an understand-

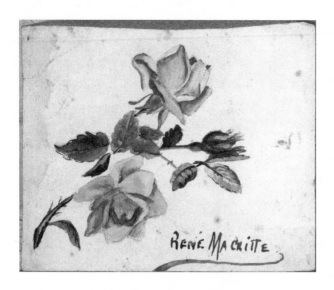

ing between them that they would get married as soon as they could, once Georgette had reached the age of twenty-one and Magritte had completed his military service and secured enough of an income for them to live on. Early in 1922 they began furnishing an apartment in Jette-Saint-Pierre. At his post in Geilenkirchen, near Aachen, Magritte dreamed of domesticity. "Soon 'Maître Binon' will be papering our future nest," he wrote. "When I think of the happy times we'll spend together, my heart is fit to burst with joy."[3] These preparations were made in secret, at least on Magritte's side. There remained the ticklish question of what his father would say, or, possibly, pay. Magritte plainly hoped that his father would stump up, and cushion them, as his father understood only too well. Léopold Magritte cannot but have recalled the 5,000 francs he extracted from his mother-in-law when he got married, and baby René was on the way, a lifetime ago.

Out of cowardice or calculation, Magritte postponed an introduction until the last minute, when he was away on military service. Finally, Léopold himself requested Georgette's presence at home one evening. It was their first meeting—the first inspection. The following morning she sent Magritte an account of what took place:

> At 8.00 I rang the bell at your house your father was alone he asked me to sit down and said. "Well then, Ma'amselle, I asked you to come in connection with René, he wants to get married but René is a child. He doesn't understand the value of money. Because he's earning 450 francs a month he thinks he'll be able to support a family. He doesn't know how dear everything is." He went on to quote so much for this, so much for that, etc., etc. Of course what could I say to that? You, you weren't used to stinting yourself, he wouldn't like to see you reduced to poverty. You weren't cut out for work. He has a lawsuit coming up in court, and as soon as it's settled, he wants to buy another factory in your three names (brothers), I replied that you wouldn't know how to run a factory. And

that the money wouldn't last for ever: then he said that you wouldn't have to work, he replied: "René, René, yes but *Raymond* that boy at his age can already run such a business like that with his eyes shut." And then you will not stay long in your present job at Vilvorde, he'll get you out of that—and when his case is settled he wants to send you to Italy for a year.

After these declarations, some of them surprising (a year for Magritte in Italy!) but all of them characteristic, Léopold proceeded to set out his conditions, as Georgette related: "In any event he will not stop us courting but he doesn't want us to be married (1) before his case is concluded. (2) before your throat is completely cured, because it seems you need more treatment." Magritte had just had his tonsils out—a painful operation.[4]

Georgette's letter crossed with one from her best beloved:

Are you happy my dear little fiancée? We'll soon be married, and wild with joy, and love each other always—

I wish it were tomorrow already to know what my father told you, I can't think that he was displeased with you, because he had only to see you to be very happy that I love you and you love me.[5]

He was right; despite Léopold's misgivings, the banns were read ten days later. They were married on June 28, 1922, at the Église Royale de Sainte-Marie in Schaerbeek, following a civil ceremony at the Maison Communale in Saint-Josse-ten-Noode, the district where the Magritte family had been living for the past two years.

Georgette Marie Florence Berger (1901–86) was born in Marcinelle, on the outskirts of Charleroi, on February 22, 1901. Her father, Florent Joseph Berger (1875–1938), began as a weigher of carcasses and graduated to butcher, with his own shop. Her mother, Léa Payot (1874–1919), a seamstress, helped to run the shop. Georgette was close to her elder sister, Léontine (1896–1980), who looked out for her. Léontine was very capable; she had a will of her own and a good head for business. In 1919 their mother died young, possibly from influenza. Very soon, their father announced that he was planning to remarry. Léontine decided that the time had come for her to leave home and make her way in the world. She took Georgette with her. They both found jobs in the Coopérative Artistique in Brussels, a general store for artists' supplies. A popular version of Magritte's reunion with Georgette (who herself recounted different versions of their meeting over the years) has him coming into the Coop to buy materials. He invites her to his exhibition. She is too shy to go. He returns the following week. And ever after.

In 1928 Léontine married Pierre Hoyez, a musician who worked mainly as a violinist in cinema orchestras—his chief recommendation, as far as Magritte was concerned—and also turned his hand to a little carpentry. By 1939 she was able to raise enough money to set up on her own. She opened Maison Berger, a shop specializing in artists' supplies. Maison Berger was very much a family business. It became a remarkably successful one. Georgette worked there part-time until the late 1950s—thirty years after Magritte found his way as an artist—on Monday, Wednesday, Thursday, and Saturday afternoons, from three until seven, for 20 francs an hour. Pierre Hoyez made the stretchers; Georgette attached the canvases. Maison Berger kept Magritte supplied with everything from paints to plaster casts, which he used as models or turned into Magrittes: heads, often bloodied; torsos, black and white, with or without balloons; reproductions of the Venus de Milo, known first of all as *L'Avenir des statues* (*The Future of Statues*), a title suggested by Nougé, then as *Les Menottes de cuivre* (*The Copper Handcuffs*), a title found by Breton, at Magritte's request; death masks of Napoleon, Pascal, and Robespierre, usually painted with sky, or, in the case of *Hommage à Pascal*, peppered with darts.[6] According to Magritte's young friend and neighbor Jacqueline Nonkels, who did the accounts, Léontine imported all of her paints from France, and continued to do so, clandestinely, throughout the Occupation. Consignments of black-market paint were organized by a certain plumber, who had to be kept sweet. Léontine paid Magritte to do a couple of paintings for him, *L'Île au trésor* (*Treasure Island*, a bevy of leaf-birds) and *La Femme du soldat* (*The Soldier's Wife*, a supple nude). The plumber was evidently not a man to be kept waiting. He carried off *L'Île au trésor* while it was still wet.[7] After Magritte's death, Georgette bought them back.

In terms of quality, Léontine's supplies left something to be desired. When Magritte discovered Winsor & Newton paints, in the 1930s, thanks to the largesse of his patron Edward James, Léontine had to source them from one of her competitors. Nevertheless, in the postwar period Maison Berger went from strength to strength, expanding into new premises and establishing a kind of concession, managed by Hoyez, in the very citadel of artistic creation, the Académie des Beaux-Arts. Léontine prospered accordingly. Her brother-in-law had made her a present of several works over the years. Now she began to buy and sell Magrittes, and even to commission them.[8] She ordered a fire-bottle (as distinct from a sky-bottle or a woman-bottle—these were images that Magritte notably painted directly on glass bottles), and a painting to mask an interior window in her shop. Not only did she specify the dimensions, she went as far as to suggest something in a "cubist" style. Magritte gave her a neo-realist apple, inscribed "Ceci n'est pas une pomme."[9]

Georgette did not have a good head for business. Nor, by all accounts, for anything else. She is often characterized as empty-headed. "Georgette wasn't a complete idiot," said David Sylvester, "she could play the piano very nicely."[10] That may be to underestimate her, or at any rate the role she played in Magritte's life. According to legend, they were inseparable. The legend was assiduously propagated by the couple themselves. "René Magritte re-encountered Georgette strolling in the Botanical Gardens," he recorded in his autobiographical sketch, "and never left her unless compelled to do so." It was perpetuated wittingly or unwittingly by others. A series of photographic shoots contributed something to this, most famously Duane Michals's *Visit to Magritte* (1965), shoots in which Magritte himself was a canny collabora-tor. Paul Simon's hit "René and Georgette Magritte with Their Dog After the War" (1983) was inspired by one such photograph. The song itself was per-haps the single most successful statement of their case, as Georgette may have recognized when she let Simon know how much she enjoyed it.

> *Side by side*
> *They fell asleep*
> *. . . Decades gliding by like Indians*
> *Time is cheap*
> *When they wake up they will find*
> *All their personal belongings*
> *Have intertwined*[11]

They were intertwined. For more than forty years they were almost always together, often in the same room. "He always preferred to paint in the room where I was," she told Sylvester in conversation. "Always."[12] Magritte seemed to find it increasingly difficult to be apart from her, or to leave his room. "I think of painting as something that happens to a man working in a room," said Frank Auerbach, "alone with his actions, his ideas, and perhaps his model."[13] Magritte was alone with his wife.

"He didn't have a sense of family and loved only his wife, his Loulou, his hearth and home, to the exclusion of things," Georgette observed to the writer René Passeron, soon after her husband's death, speaking of herself in the third person, oddly like Magritte did at times himself. " 'When I *go* away,' he would say, 'the best moment is when I return.' "[14] There is indeed a sense that they voiced each other, or that she voiced him, as though she herself had nothing to say. If she chose self-effacement, she also submitted to self-exhibition, at his pleasure. She was his model, and later his mouthpiece. Her version of Magritte is well meaning, even lionized, yet narrowing. It was almost as if she could not

cope with complexity or tension, as, for example, her insistence on his lack of interest in politics—a classic misrepresentation—suggests. She was part of the gang and the stock company, ex officio, but she was never as assertive or as risqué as Scutenaire's wife, the writer and journalist Irène Hamoir, who received her own suggestive tribute in paint, and who was encouraged to eat an equally suggestive banana on film.[15]

Despite this, Georgette was omnipresent. There are countless images of her in Magritte's work—her body is both a temple and a template. There are comparatively few portraits, as such, but painting her, in 1928, in his carpet slippers, was a real labor of love. She was a kind of ideal—his kind of ideal—as *Tentative de l'impossible* (*Attempting the Impossible*) tends to suggest [color plate 17]. She embodied that ideal in perpetuity, in spite of her limitations, and imprinted herself on Magritte and his work, in every medium. Her presence is simultaneously physical and spectral. To all intents and purposes she is in his painting but not of it, just as she was in his gang but not of it. Scutenaire and others thought that she did not understand her husband's work and only began to appreciate it when it turned into gold, as they would say, late in life.[16]

"The marriage was childless," records the *catalogue raisonné*. "Early on there was a miscarriage which, Georgette told us, left Magritte determined not to put her health at risk again with a further pregnancy." Nothing more was vouchsafed on that subject; nothing either of Georgette's feelings in the matter. "He has no children," Scutenaire reported blankly. If asked, Magritte was inclined to parry the question, or to philosophize, jesting seriously, "I don't have enough confidence in life for that. I always expect the worst. The minute you're in the cradle, you're ready for the grave."[17] Cyril Connolly famously remarked that "there is no more sombre enemy of good art than the pram in the hall."[18] There would be no pram in this relationship.

Georgette may have been empty-headed, but she had backbone, and, when it came to it, an unexpected persistence (or stubbornness). In the early years of their marriage, she irritated Léopold Magritte by repeatedly taxing the indigent Popol with the need to find a profession—a futile endeavor—and by encouraging her husband to stick with a steady job in a wallpaper factory. ("*My* sons won't have to work for a living.")[19] Later on, though she always disclaimed any interference in his painting, she registered a strenuous objection to a change in Magritte's style, once it became clear that the new style was to all intents and purposes unsaleable. "René, paint roses like everyone else if you want to sell your paintings."[20]

After Magritte's death, in 1967, Georgette did her level best to preserve the relationship in aspic. The house remained just as he had left it, down to the unfinished work on the easel: a memorial, almost a shrine. Georgette was

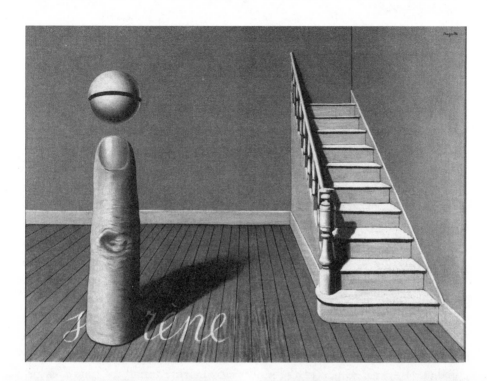

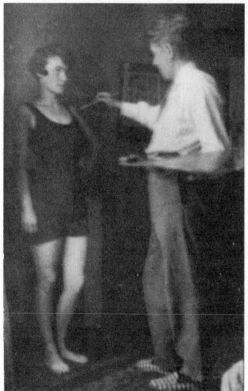

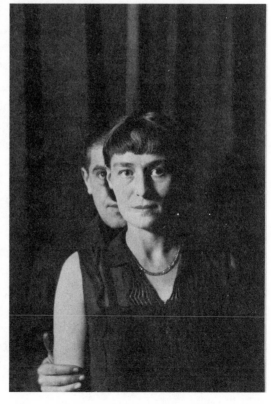

lonely. During the twenty years of her widowhood, however, she succeeded in alienating virtually all of their old friends, even Hamoir and Scutenaire, with her thoughtless inattention, and her incautious authentification of doubtful or unfinished Magrittes. The Scutenaires would tell of seeing her at home, pulling sketches out of a drawer and signing them, saying, "Now, I am Magritte." When she thought that David Sylvester had authenticated a chalk drawing, she wrote to him, "You must not become more catholic than the Pope. I should be grateful if in future you would abstain from making such pronouncements."[21]

In the beginning, René and Georgette adored each other. That is what they told each other. No doubt there was an element of reassurance in such declarations: reassuring oneself as well as one another. Perhaps that was her role—to adore and be adored. To be the object of adoration of the brash young Magritte was not an unmixed blessing, if some of their friends are to be believed. In time, as the carousel went round, the adoration solidified into something like devotion. Magritte devoted himself to Georgette. Georgette devoted herself to Magritte. Georgette, in being, offered a reassuring element of stability. It was for him to provide for her, in so many ways. That could be demanding, even boring, but it afforded a semblance of normality, regularity, predictability, a regimen of the kind that Magritte found in some measure congenial, or at least supportable, whatever he might say. Scutenaire calls him a martyr to boredom. Luc Sante calls him a visionary of boredom. His account of his day:

> I got up at 9.00, I took a little turn round the dining room and the kitchen, I went and had a look at the garden. At 11.00, my wife, who isn't well, went to bed. As for me, I worked on my gouache, it's a second grinding [*une mouture*, "a rehash of a painting"] for my exhibition. At 2.00, Georgette got up and I made dinner. Afterwards, I took the dog out. Brr! And then Georgette went to visit her sister. It's rotten, it's dismal. Ah! How boring it is, it's dreadful, depressing, life is intolerable.[22]

He often did the cooking: it staved off the boredom. "Art and boredom," reflects Valéry. "An empty place, an empty time, are unbearable. The ornamentation of these emptinesses comes of boredom—just as the vision of food comes of an empty stomach."[23] Making a dish of pork with cabbage purée, rabbit with prunes, or *morue à l'espagnole*, the pièce de résistance of Chéri-Bibi, Gaston Leroux's fatalistic hero ("who eats enough for six")—feeding others pleased him inordinately. He was a vicarious glutton; he liked to watch people eat. He followed the recipe to the letter, the novel open in front of him:

600 grammes of unsalted cod
600 grammes of potatoes
500 grammes of tomatoes
400 grammes of red peppers
40 grammes of onions
10 grammes of garlic
10 grammes of flour
2 decigrammes of freshly ground pepper
salt
bouquet garni
breadcrumbs

"Try it," Leroux urges mischievously, in a footnote, "and let me know how it turns out!" According to Marcel Mariën, it was delicious.[24]

It would be too easy to say that Georgette was Magritte's rock, but it is true that he clung to her. What she provided was a sort of sanctuary. For the Magritte brothers, the love of a good woman was a prize worth having. Paul's wife Betty observed sympathetically that the boys had not known maternal love. Georgette, too, had lost her mother. Was the absent yet present mother another dimension of the relationship? Did they mother each other? Magritte's disturbing image of the baby cradling the mother, *L'Esprit de géométrie* (*The Mathematical Mind*, 1936/7), with its title drawn from Pascal's *Pensées*, was originally called *Maternité* [color plate 18].[25]

The young Georgette was cute at twelve; at nineteen, she was ravishing. Ravishing, indeed, must have crossed his mind, however pure their courtship. The young Magritte was precociously attuned to the erotic. Perhaps the most significant site of memory of his adolescence was the old cemetery in Soignies, where he used to spend the school holidays with his spirit-raising aunt Flora, his long-suffering grandmother, and his woe-betiding godparents. The cemetery (or the memory) is evoked twice in "Lifeline," as a rite of passage. First he sets the scene, which is nothing short of supernatural:

As a child, I used to play with a little girl in the old disused cemetery of a provincial town. When we could lift the heavy iron gates, we would go down into the family vaults, and then come back up into the light to find an artist from the capital, painting in a very picturesque avenue, with broken stone columns scattered among the dead leaves. The art of painting seemed to me vaguely magical, and the painter endowed with superior powers.

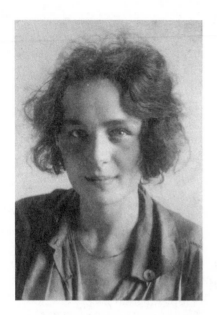

A little further on, he reaches his early twenties, when he was madly in love with Georgette, and dabbling in futurism:

> In a state of real intoxication I painted a whole series of Futurist pictures. However, I don't think I have ever been an orthodox Futurist, because the lyricism I wanted to achieve had an unwavering focus unrelated to Futurist art. It was a pure and powerful feeling: eroticism. The little girl I got to know in the old cemetery was the object of my reveries, caught up in the bustle and excitement of stations, fairs and towns that I created for her. Thanks to that magical painting, I recaptured the feelings I had in my childhood.[26]

Whatever happened in the old cemetery, it was a memorable experience. The testament to eroticism notwithstanding, Magritte's account tends to infantilize it. The original encounter probably took place during the All Saints' Day holiday or the Christmas holiday following the death of his mother, that is to say November or December 1912, when Magritte turned fourteen. The little girl in question, Emilie Crox, the daughter of the *gardien* of the cemetery, was a year older. Emilie was not so little, nor Magritte so childlike, as he seems to convey. Did he talk to his friend Pierre Bourgeois, "the first to write poems inspired by the young painter's experiments," about his experiences in the cemetery?

> *Où se connurent-ils pour s'aimer ainsi?*
> *Dans la divination d'un peintre.*
>
> *Where did they meet, to love each other so?*
> *In the painter's divining mind.*[27]

He must have talked to Scutenaire, who has a Delphic passage, possibly an in-joke, on the aftermath:

> After the lost day at the bottom of the deserted tomb, in the old cemetery of the village where he spent the holidays on dubious pleasures in

the company of a little blond girl, in the evening he would apply himself to saying his prayers, with spirit and contrition, kneeling at the head of the bed.

Some mornings, in front of the mirror in his little bedroom, he made faces that distorted his features, grimaces that he has not given up in middle age. Other mornings, he would study himself in the mirror, pale and solemn, with the firm intention in his eyes and his heart to be good, to live better; today, still, with a conclusive gesture and a determined nod of the head, he likes to make good resolutions.[28]

No further information about Magritte's experiences in the cemetery has come to light—though the artist from the capital has now been identified as Leon Huygens—but one tale of the teenage Magritte relates to precisely this period. One day the budding artist dashed off a portrait sketch of a local girl, supposedly a neighbor of his aunt's, and offered it to the object of his attentions. The girl promptly tore it up, in high dudgeon. It showed her from behind, on her knees, cleaning the pavement. So indecent was the pose, they say, "that you could see her stocking-tops."[29] Thirty years later, *L'Invention du feu* showed a naked woman on her knees before a snouted bilboquet. Magritte's notes on titles record: "The astonishing discovery of fire. Thanks to the rubbing together of two bodies, suggests the physical mechanism of sexual pleasure."[30]

Sketches of the stocking-top sort had become an obsession. Any of the boys who sat next to him in class at the Athénée in Charleroi could testify that he spent all his time drawing naked women in his textbooks, in his exercise books, unfazed by reprimands from the teachers. Perhaps this is what he meant by his cryptic reference to that school, "where he startled his French teachers with his rather strange compositions."[31] Some of his classmates thought that he was expelled, if not for his compositions, then for his conduct. The studied *je-m'en-foutisme* was surely calculated to infuriate the teachers. Even the boys were put off by his recalcitrance, and the mania for obscenity. Fernand Richelet shared a desk with him the year he arrived:

We were just about pals, René Magritte and me, no more. I used to see him sometimes in the rue du Fort [where the Magrittes lived] without playing with him, when I went to see pals over there. His father was a butter merchant. Actually, the schoolchildren formed completely separate groups, according to social status above all. And then . . . well . . . there weren't many who mixed with Magritte because . . . he talked only

about women and about obscene things all the time. So, at that time, you know . . . he was considered strange by the class, and very few pupils dared to have anything to do with him.[32]

There is no record of any formal expulsion, though he could simply have been asked to leave, or not to return. In any case, he lasted only two years at the Athénée Royal. His record there was a disgrace, deliberately flaunted: the first year he was very nearly bottom of the class, with 33 percent overall. In Religion he got 31 percent, despite his (alleged?) evening penitence. The next year he dropped Religion, but did even worse, with 27 percent overall. There was one exception to this catalog of failure. In Drawing he was top of the class, with 85 percent. The drawing teacher, Arthur Kokkelkoren, nicknamed "the Dabbler" ("Le Croqueux"), was notorious for his frightful physiognomy and soulless pedagogy. The monumental tedium of his lessons had continued unchanged since time immemorial. The boys were required to draw a series of objects, over and over again, with colored pencils: an apple, a bust, a flowerpot . . .

But drawing objects over and over again was meat and drink to Magritte. As for the naked women, he was still at it a few years later, when Charles Alexandre lent him a copy of *Mafarka Le Futuriste* (1909), an overheated imbroglio of sex and subjugation by the Napoleon of futurism, F. T. Marinetti. " 'Let me bite your breasts, which gleam with fragrant gum, and your arms, twined like lianas round my neck! O you Cissus creeper, I want to drink from your wounds, more sovereign for thirst than blood oranges!' . . . And meanwhile, with a very gradual motion of her silky and terrible arm, Coloubbi was still drawing Mafarka's mouth toward her breasts. Suddenly he leapt to his feet in horror, crying: 'Oh, do not repeat my mother's gesture!' "[33] Magritte embellished the text at the appropriate moment with a woman with a naked breast.

The ignominious end of his school career coincided exactly with the German invasion of Belgium in August 1914. As the occupiers spread out across the country, the Magrittes executed a strategic withdrawal to Châtelet, returning to the haunted house in the rue des Gravelles. In this no-man's-land, Magritte seems to have had a fallow year, free of institutional confinement. He took full advantage of it. There was mischief to be made in Occupied Châtelet, like old times, with a new twist. At one stage the town suffered a plague of flies. Notices appeared urging the residents to do their civic duty, following the maxim "Tuez les mouches ou les mouches vous tueront." ("Kill the flies or the flies will kill you.") At the École Moyenne, someone substituted "Boches" for "*mouches.*" The authorities were not amused. The culprit was urged to come forward; to encourage the others, a number of the children were rounded up,

but no one stirred to confess. According to his pal Raymond Pétrus, the culprit was the master criminal Magritte. "I was born in the dark and in the rain," the detective writer Georges Simenon liked to say, "and I got away. The crimes I write about are the crimes I would have committed if I had not got away. I am one of the lucky ones. What is there to say about the lucky ones except that they got away?"[34] Perhaps the same is true of lucky René Magritte.

Apart from Boche baiting, René in his teens had plenty of time and plenty of source material for his predilections. Thanks to his father, Magritte had been wallowing in pornography from an early age. Balloonists were not the only kind of card he collected. He was already an aficionado of racy postcards and pornographic prints [cf. *La Lectrice soumise* (*The Subjugated Reader*)]. He retained an interest in pornography all his life. Among intellectuals of his acquaintance, that was not uncommon. Typically, Nougé made a study of pornography, and sexology more generally; one of his many sidelines was the writing or rewriting of lesbian erotica, posthumously collected as *Érotiques* (a title he would surely have found wanting, if the allusive and complex ones he came up with for so many of Magritte's paintings are anything to go by). Two of the most distinguished figures in Parisian literary circles, Georges Bataille and Jean Paulhan, were deeply interested in pornography. In his own writing, Bataille elevated it to a kind of art form—originally a pseudonymous one. *Histoire de l'oeil* (1928) was published under the pseudonym of Lord Auch, *Madame Edwarda* (1937) under the pseudonym of Pierre Angélique. Bataille was also interested in Magritte and planned to write a book about him. Regrettably, illness intervened; we have nothing but cryptic notations. "If his eroticism is sovereign," mused Bataille in *Les Larmes d'éros*, "it is only to the extent that it is poetry. The eroticism cannot be entirely revealed without the poetry."[35] The admiration was cordially returned. As late as 2011, Magritte's illustrations for *Madame Edwarda* were curtained off, behind warnings of moral turpitude.[36]

Magritte's tastes ran to rather less exalted forms. In the Brussels suburb where he lived from the 1930s to the 1950s, the dentist, Joseph Stiernon ("José la Souplesse" in *Boulevard Jacqmain*), showed pornographic films in his attic to a select few, including *la bande à Magritte*. The dentist also kept a tame bird of prey, which roamed free around the house. Magritte relished this kind of thing—"glimpses of the always-more-successful surrealism of everyday life," in the words of the poet Elizabeth Bishop.[37]

Closer to home, the Magritte brothers had always taken a keen interest in their father's womanizing. After their mother's death, it continued without interruption. "Papa's mistress" was the subject of endless speculation, and even some boasting, especially by René and Raymond, who let it be known

among their friends that each of them was "the happy Hippolytus of this new Phaedra," as Patrick Waldberg put it, after Euripedes. Many years later one of Magritte's classmates put it more plainly: "Do you know who René Magritte is? Someone who sleeps with his father's wife! Yes, Monsieur, he took advantage of his father's absences to do that. His mother was dead and his father married a strange woman who was also René Magritte's mistress. That's who René Magritte is!"[38]

"Strange women" did enter the Magritte household. Léopold Magritte engaged a domestic servant, Marie Molle, who lived in during the week. No hint of impropriety attaches to her; by all accounts she was an irreproachable person, scrupulously house-proud—according to her grandson, "you had to have a bath before she'd let you in the house." She was sorely tried by the Magritte family, who gave her a good reference when she decided to leave their employ.[39]

Then, in 1912, Léopold advertised for a housekeeper for the father and "three good boys," a description that made them all laugh like hyenas. For this unenviable task he selected Jeanne Verdeyen, known to the boys as "La Jeanne" and to the cocky René as "Ma Jeanne," a twenty-eight-year-old widow with an infant son in tow. She was from Walcourt, near Charleroi, the daughter of Jean-Baptiste Verdeyen, a sculptor; she had married Georges Tilman, a cabinetmaker, who died when their son Armand was only four months old. La Jeanne was resourceful; she had to be. She moved in. Soon enough she took on another demanding role. She became Léopold's mistress, and in due course his common-law wife. For better or worse, she was with him until the end. She also became the target of teenage braggadocio and scurrilous gossip. She was already well established when Charles Alexandre met the family, a few years later, once they had moved to Brussels:

When we came in, the family was at table, having dinner, and Magritte said: "Charles, let me introduce you to my father, his mistress, his mistress's child, we don't even know the father's name, and my berk of a brother Raymond!" The father was busy drinking his soup; he banged his plate down on the table, yelling, "Berk yourself, you come here bothering us with strangers. Bugger off, damn you!" We went up to the second floor to René's studio-bedroom: two rooms, the floors covered in rag rugs: in the first, his easel was set up, with lots of canvases; we hardly ever went in the other, where René slept on the rugs, without a mattress. Popol, the youngest brother, had a corner of the landing that led to the first floor; there was a camera on a tripod with a candle on top, in front of a tent

with an awning, and Popol slept in the tent. The whole of the first floor was the father's domain; no one went there.[40]

The boasting was nothing more than wish fulfilment. Papa's mistress, it is safe to say, did not share her favors with René Magritte. "What I crave," wrote Flaubert, at seventeen, "is a woman beautiful and ardent and whorish through and through."[41] Magritte might have said the same. Satisfying the craving was another matter. What practical experience he had in the field is difficult to determine with any precision, but he was not wholly innocent. He knew the red-light district of Charleroi of old; he made haste to get to know the one in Brussels, near the Gare du Nord. He liked to pass the time of day with prostitutes, or to pretend that he did. When he first went to Brussels, he would lead his friends through the red-light district, greeting the prostitutes as if he knew them. "That amused him greatly; he would laugh as much as the prostitutes."[42] He had enough pocket money to visit them if he was so inclined. He was fascinated by the very idea of prostitution, the commercial as well as the carnal aspect—what Flaubert called the clink of gold:

It may be a perverted taste, but I love prostitution, and for itself, too, quite apart from its carnal aspects. My heart begins to pound every time I see one of those women in low-cut dresses walking under the lamplight in the rain. . . . The idea of prostitution is a meeting place of so many elements—lust, bitterness, complete absence of human contact, muscular frenzy, the clink of gold—that to peer into it deeply makes one reel. One learns so many things in a brothel, and feels such sadness, and dreams so longingly of love![43]

There was the example of René's father, a serial offender, still in the game. There was an element of competition with Raymond (two years his junior) in the sport of skirt chasing. The competition may well have extended to losing their virginity. In the circumstances, it is easy to imagine a good deal of ribaldry around the house. When he reencountered Georgette strolling in the Botanical Gardens with her sister, he is supposed to have informed them nonchalantly that he was on his way to visit his mistress.[44] Even after he resumed his relationship with Georgette, he was not above writing to a painter friend about one of the models they used, as if revealing the identity of a new conquest, "Her name is Augusta! And strange to say you knew her, she's the little brunette who came to pose with her sister, they're back."[45] It is clear that there was talk among his friends about the lure of the red lights, and the attendant

risks. Raymond Pétrus had bittersweet memories of lecturing first René and then Raymond Magritte on the dangers of consorting with prostitutes. "Cut out that sort of thing. You're always at it! What will that get you? A disease!" According to Pétrus, that is exactly what came to pass: both of them contracted syphilis. Jacques Roisin heard this from a number of people in Châtelet when he began to investigate Magritte's early life in the 1980s. It was confirmed by the son of the family doctor, on his deathbed.[46]

This doctor is a person—a personage—of considerable interest. Alphonse Thibaut was a savant, a bibliophile, a music lover, and a connoisseur of painting, whose private collection included a portrait of himself by the Belgian expressionist painter Pierre Paulus of Châtelet. He was also a specialist in venereal disease. In fact, he had written a book on the subject, *Le Fléau de Cupidon* (*Cupid's Curse*), the title drawn from *Love's Labour's Lost*. Dr. Thibaut was a cultured man, and an unusually enlightened one. He was prepared to consider performing an abortion (then illegal). It was an essential part of his practice to get to know his patients; he would talk to them of art and literature as well as illness and medication. He seems to have taken Magritte under his wing; he even introduced him to his daughters. The young rake would call on him from time to time. They would converse; Magritte would browse in the books and records in the library. There was ample opportunity for him to be treated for syphilis, discreetly enough, in the course of these visits. Shortly afterward, it transpires, a pair of paintings by the unknown artist René Magritte found their way into Dr. Thibaut's collection: *Rivière sous un ciel nuageux* (*River with Stormy Sky*) and *Rivière bordée de peupliers* (*Poplars by a River*), both dated 1916—traditional landscapes, painted from nature, as like as not, showing distinct promise. For the authors of the *catalogue raisonné*, and perhaps for the good doctor himself, their style called to mind painters of the Hague School such as Jacob Maris.[47] According to his son Walter, Thibaut received the paintings as a consideration for curing the young artist of *une maladie d'amour*.[48]

Discretion may have been the better part of valor, but it is not automatically to be assumed that Magritte was upset or ashamed. Maupassant was exultant: "I've got the pox! At last! Not the miserable hot piss, not the bourgeois cockscombs, not the leguminous cauliflowers, no, no, the real thing, the one that killed François I. And I'm proud of it, by thunder! And on top of that I scorn the bourgeois. Hallelujah, I've got the pox, and therefore I'm no longer afraid of catching it!"[49] He was by no means the only one. Proud or cowed, in 1918 Magritte entered a competition to design a poster publicizing a government campaign against venereal disease. His design was inspired by Leonetto Cappiello, who revolutionized advertising posters in the early years

of the twentieth century, with spectacular designs for major brands such as Bouillon Kub, Campari, Cinzano, and many more, which would be forever associated with Cappiello. Magritte was among other things a poster artist; Cappiello was another unsung influence. His submission featured a skeleton in a tuxedo, playing the violin, enveloped by a seductive mermaid. It was unsuccessful. Magritte gave the drawing to his friend Charles Alexandre, perhaps by way of tacit caution. *La maladie d'amour* did not reappear in his work until *L'Arc-en-ciel* (*The Rainbow*, 1948), a garish gouache featuring a variety of moral characters, carefully labeled (*Le Sybarite*, *Le Dévot*), together with *L'Avarié*. *L'Avarié* was the term used by Dr. Thibaut for syphilis.[50]

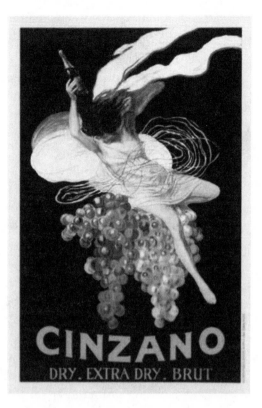

. . .

By the time René gave paintings to the doctor, he had been painting for several years. His old friend Victor Frisque remembered, "One day, during the war, I bumped into René in Châtelet and I asked him, 'What's become of you?' And he told me that he'd begun to paint. 'On your own?' 'Yes, but I go and get advice from Defoin about mixing the colours.' "[51] He did not have far to go. Conveniently enough, the painter Félicien Defoin lived at 44 rue des Gravelles. His métier was the decoration of churches, but he was also an accomplished watercolorist. Indeed he was a professional all-rounder. He painted landscapes on commission; he gave lessons; he was expert in the preparation and mixing of colors. He must have been a great help to young Magritte.

The resources of the rue des Gravelles could only take him so far. After a year in Châtelet, he had upped and left for Brussels in November 1915, on his own, bound for 122A rue du Midi: digs for students at the Académie des Beaux-Arts down the road. He was just seventeen. Officially, there is no trace of him as a student for the academic year 1915–16. Like Fantômas, he was everywhere and nowhere. Given the testimony of his fellow traveler as a free student, Léon Pringels, a versatile artist and something of a child prodigy (he

was admitted on the strength of his portfolio at the age of fourteen), it seems that Magritte started attending classes at the Académie almost immediately.

Pringels had a vivid memory of their first encounter. "I was coming out of a class when René Magritte came up to me and held out a pornographic magazine. It was *Sourires de France*, which his father edited or distributed. 'This is what my father does,' he said. And he asked me to provide him with some drawings, because he was looking for illustrators on behalf of his father. And me, just a lad in short trousers!"[52] Later they found themselves on the same course. "I had taken along to one of the first classes a roll of blue-tinted canvas and some tins of enamel that I'd found in an attic, and I'd painted on that support," Pringels recalled. "The following day all the colour had slid to the bottom of the canvas, in a little sausage shape, and the whole class were waiting to see my reaction. Then someone behind me said: 'It's an architect's canvas, and you've put the enamel on the smooth side, intended for Indian ink.' It was the student Magritte. Then he gave me a series of lessons in technique: 'Colour is nothing more than a mixture of powder and linseed oil.' Thanks to his excellent advice, I was able to make colours myself."[53]

Relations were not always so amicable. "At that time René Magritte was an unsavoury character," Pringels would declare. "Once he'd got his hands on his allowance from Châtelet, where his father lived, he'd go to the butcher and buy three or four metres of saveloys, and he'd come to the Académie with them trailing behind him like a long tail attached to his trousers. Many of us were starving and we had to put up with this spectacle of saveloys rolling in the dust. . . . Some got their teeth into them; not me, I preferred to go hungry."[54] During the first year of his studies Pringels fell ill. He was suffering from malnutrition.

Magritte took a course in fauna and landscape, with Emile Van Damme-Sylva, a disciplined instructor and an accomplished painter of cattle grazing in the fields. This was drawing of an entirely different order, from photographic reproductions of plants and animals.

Interviewed on television in 1966 by Jacques Goossens, Magritte was surprisingly complimentary about the teaching at the Académie:

> The first course I took was a course in drawing given by a very conscientious old gentleman, Van Damme, I don't know whether anyone remembers that name, and there I learned to draw, which seems to me extremely important for a painter. To learn to draw is absolutely indispensable, just as for a writer to learn grammar, for example.
> Was the instruction high-quality?
> Ah! Yes, it was very conscientious instruction, and that was only in

drawing. Then, according to the programme, there were courses in litera-
ture given by [Georges] Eekhoud, and then courses in anatomy, perspec-
tive, everything a painter needs to know something about.[55]

Magritte was officially registered as a student from the beginning of
the next academic year, 1916–17. He took Van Damme's course again (vol-
untarily), together with a course on ornamental composition, given by Gis-
bert Combaz, a prominent exponent of art nouveau, and also a noted poster
designer. This time he sat the exams. He was placed first in Ornamental Com-
position and ninth in Fauna and Landscape. From April to September 1917,
however, he interrupted his studies and went back to Châtelet. It is not clear
why. In the 1917–18 academic year the pattern was repeated, though this time
he did not leave Brussels, perhaps because the rest of the family had now set-
tled there for good. He took another drawing course, Life Studies, given by
Constant Montald, a symbolist with an affinity for Puvis de Chavannes; early
in 1918 he abandoned it. The Académie closed altogether for several months in
1918 because of a fuel shortage. Magritte re-registered in September 1919, to
take Montald's course in decorative painting. That Christmas he was placed
eighth. There is even a suggestion that he continued to attend classes during
the academic year 1920–21, while he was on military service, by permission of
his commanding officer. He never did sit the final exams.

Magritte always emphasized the "intermittent" character of his engage-
ment with the Académie, as confirmed by Léon Pringels, who pointed out
that he never appeared in any of the class photographs because his attendance
was "too irregular."[56] Of course it is possible that the irregularity had to do
with the usual diversions of student life, as Magritte himself suggested. "Dur-
ing the war of 1914–18, I was registered at the Académie in Brussels," he told
another interviewer. "I stayed there two years. I was then living alone in a
very free and easy boarding house and I didn't go very often to classes. I led
an extremely happy life, centred of course on my painting, but also on pints of
beer, interminable discussions with pals, in a word, the life of a not very stu-
dious student."[57] It is also possible that the irregularity had to do with extra-
curricular activities of a more carnal nature, involving prostitutes or (more
likely) models, now freely available, as he liked to claim; or commissions for
his father or himself, as Pringels's memory of "the pornographic magazine"
might suggest; or simply getting on with his own painting. In 1917 he pro-
duced at least one sizable canvas influenced by Combaz, and possibly by Bon-
nard, *Woman by a Garden Seat*. He is said to have signed up for Decorative
Painting that same year, but Montald determined that he was not ready, and
he was reassigned to the drawing class. The drawing class was not lacking in

distinction. Among the students was Paul Delvaux, nicknamed "Basket-Feet" by Magritte, on account of his flat feet—the mockery of Delvaux went back a long way. Nevertheless Magritte may have felt thwarted, or relegated, though it did not deter him from trying again.

The prolonged interruptions in his student years remain a little puzzling. Discounting the loose talk, he was deadly serious about his art. Intermittently, he was studious enough, as his results go to show. Could the intermissions have had something to do with the syphilis? The treatment prescribed by Dr. Thibaut centered on regular dosages of mercury, administered by injection, ingestion, or direct application. It was intensive at first, for a minimum of four months. It then continued over a long period—two years was not considered long enough—at intervals, on an almost seasonal basis; depending on the progress of the disease, it was often resumed in the spring or the autumn.[58]

It is true that Magritte was involved in other activities. He did secure commissions, from various quarters, as Charles Alexandre recalled:

> Magritte mostly painted nudes. Every so often he would propose to clients of his father's to do a portrait of their daughter for a certain sum of money, and arrange for the delivery of the finished painting. Some were returned, in anger, because their daughter had been painted nude, or because there had been carrying-on with certain girls . . . but it's none of my business. It's true that one day I went to René's place with a friend. Magritte was painting a nude young girl. In our presence he finished the canvas, and then disappeared into the next room with his model, telling us solemnly: "And now, gentlemen, the artist is going to screw the model."[59]

Léon Pringels was full of stories like this, about Magritte's rapaciousness, fired by his salacious talk. From the studio, "a window gave on to a little courtyard at the back of the house, and we could see into an ironing-shop. On one of the very first days, Magritte was watching those young girls hungrily, when all of a sudden, he said to me: 'I'm going to jump one.' Without further ado, he climbed out of the window, shinned down the drainpipe. . . . I could hear the cries of the young girls. . . . Soon afterwards, I saw Magritte come back up the drainpipe, and in through the window. Covered in sweat, he said to me, adjusting his trousers, 'I managed to trap one of them on the stairs.' "[60]

However shocking and reprehensible if true, these stories should not necessarily be swallowed whole. Pringels was perhaps too credulous; and Magritte was good at feeding his friend's fancy of what debauchery might be.

Magritte also fed him a little gravy, on the side. When he secured a commission from the Germans for a consignment of cinema posters, Magritte got Pringels to make them, under supervision, while he lay on the bed, smoking, and scandalizing his accomplice with outrageous propositions ("Burn all the museums!") and anticlerical asides ("Hang all the priests!"). The Germans paid 25 francs for the job lot. Magritte gave Pringels seven for his trouble.[61]

There was also literary activity. Repeating the name of Georges Eekhoud in the interview with Jacques Goossens was not accidental. Eekhoud was a big name in Belgian literature, mentioned in the same breath as Maurice Maeterlinck, Émile Verhaeren, and Georges Rodenbach. He was a controversial figure, who spoke and wrote his mind, without fear or favor. He had characterized his native Antwerp as "a new Carthage," a monument to selfishness and self-regard, a town in thrall to the law of the jungle, opulent, flashy, licentious, avaricious, heartless.[62] He had written openly of homosexuality and been prosecuted for it. He had contributed a preface to a sadomasochistic novel. He had espoused pacifist, anarchist, and internationalist principles. He had no truck with militarism, nationalism, or patriotism. He had no time for scoundrels.

Eekhoud had been teaching at the Académie since 1902. During the Occupation, a majority of the faculty at the Free University of Brussels refused to teach, since they were manifestly unfree, but a dissenting minority continued to offer extramural evening classes, and invited Eekhoud to join them. He did so with a will. His classes were packed, but his action was regarded by the authorities of both institutions as tantamount to collaboration, if not high treason. Eekhoud proceeded to compound the offense by publicly affirming that "not all Germans are murderers," and insisting on teaching Goethe. In 1919 he was compulsorily retired by the Académie, against his will. He was sixty-four—a year younger than Van Damme, who remained peaceably in post. This was the tinder for what became known as "the Eekhoud affair."

Eekhoud had a loyal following among the student body. There were protests and demonstrations. The organizers, "Les Amis de Georges Eekhoud," began meeting in the Roi-d'Espagne tavern, in the Grand Place, to plot their next move. These fervent young bloods included writers and poets like Charles Alexandre, Pierre Bourgeois, Pierre Broodcoorens, Léon Chenoy, Aimé Declercq, and Jules Vingternier; an architecture student, Victor Bourgeois (elder brother of Pierre); a sculptor, Dolf Ledel; and a few painters—Pierre Flouquet, Henri Kerels, and Magritte. On March 27, 1920, they organized a "democratic and artistic demonstration of sympathy" for Eekhoud, at the Lyric Theatre, Schaerbeek, under a banner bearing the legend "ONE DAY

PERHAPS I SHALL BE WORTHY OF THE POOR AND THE PARIAHS,"
a quotation from his work.[63] Magritte painted a vigorous portrait of the honorand, one of four presented to him on that occasion [color plate 19].

Carried away by the standing ovation given to Eekhoud by an enthusiastic crowd, Magritte thought that the demonstration was a great success. Alas, their efforts came to nothing. Eekhoud was replaced by Edmond Cattier, "an incontinent pisser and soporific lecturer," who bore the brunt of student resentment. "Vive Eekhoud!" "À bas Cattier!" Unwisely, Cattier slapped one of the students, and responded in kind—"Boches! Activistes! Vendus!"—thereby stigmatizing the protestors as Judases or traitors, and antagonizing even more.

The organizers were already fast friends. Magritte made a point of seeking out writers rather than painters for his pals—a lifelong preference. When Pierre and Victor Bourgeois founded a short-lived review, *Au Volant* (1919), "René Maguerit" was on the editorial board. Pierre Bourgeois and Pierre Broodcoorens acted as witnesses at his wedding; he painted their portraits. Charles Alexandre was one of those taking Eekhoud's evening classes:

> At this class, I met Aimé Declercq, passionate about literature, like me. As we came out one evening, . . . we decided to form a literary group called "Questions." I took Declercq to the cafés I went to, above all the Diable-au-Corps where all the young intellectuals went: students, journalists, artists, writers. . . . That place was legendary in Brussels; it was said that students had made off in Sarah Bernhardt's car when she visited the capital, and driven it to the Diable-au-Corps. Among other students Declercq and I got to know there was a young painter who had just quit Constant Montald's course at the Académie: René Magritte. Very often we stayed to talk and drink after the curfew hour imposed by the Germans, and spent the night in the café, all of us stretched out on blankets on the floor. René and I became inseparable. We'd meet at my place or at the café. Sometimes I used to go to the studio in the rue des Alexiens where Flouquet and Magritte would paint and I'd read them my poems.

Philosophers, too, were part of the interminable discussions. "One day, René arrived at my place, all het up, and asked me, 'Look, Charles, do you believe that I exist?' Then, insistent: 'Yes, but how can you be sure that I exist?' And finally: 'Yes, but can *I* be sure?' "

> Actually we'd spent the previous night talking to philosophy students. They had spoken of Descartes' doubt and his *cogito ergo sum*. Someone

had quoted a painter's observation: "If I paint a horse, I haven't got a horse, but a painting of a horse." And of course we'd talked about the famous story of the Dutch painter Frans Hals, who, after having a meal at an inn, shouted "I've left the money on the table" as he was leaving. And the innkeeper thanked him, since he saw on the table the gold Louis that Frans Hals had painted. Once he realized his mistake, they say that he caught up with the painter and said to him: "Are you Frans Hals or are you the devil?" All that went into the mix for René.[64]

Like many other students at the Académie, Magritte attended Eekhoud's courses from time to time, without formally registering; he also accompanied Alexandre and Declercq to the evening classes. After the demonstration of sympathy, he was one of a group of loyalists who met on Friday evenings at the Café du Téléphone to present their work in progress before the august professor, and to discuss new writing. Their antennae were well tuned; they were among the first to recognize André Baillon, the novelist of delirium, who knew from personal experience the meaning of the expression he used with such relish, "*perdre la boule*" ("go bonkers").[65]

As for the studio in the rue des Alexiens, Magritte took it on with his fellow students Pierre Flouquet and Léon Pringels during the 1917–18 academic year. According to Pringels, "In class I was friendly with Pierre Flouquet, a Christian like me; Flouquet was a Frenchman who had come to Brussels shortly before the war with his family: his parents ran a domestic employment agency for Catholics. Magritte too became friendly with Flouquet. So it was that Magritte, Flouquet and I opened a studio in the rue des Alexiens during that year at the Académie. It was a big room on the first floor, above a stove-maker."[66] Magritte seems to have regarded this studio much as he did the Académie itself, coming and going as he pleased. It was Flouquet who colonized the studio; Magritte had other places to paint (the studio-bedroom at home). As he noted laconically in his autobiographical sketch, "[H]e worked for a while in the studio that Pierre Flouquet had decorated with avant-garde frescoes." He made free with the materials, and possibly the models. Flouquet complained that Magritte availed himself of canvases that he, Flouquet, had prepared for his own use; or that he appropriated paints and other supplies. Sharing a studio could be something of a trial. However, they forged a bond. For a few years they were the best of friends and comrades in arms. Magritte rallied his friend when he was low ("Come on, be strong, accept the inevitable and develop your willpower"). Flouquet wrote quite naturally to Georgette of "my brother René."[67] In December 1919 and January 1920, Magritte, Flouquet, Peter De Greef, and Henry-Valéry Vander Poorten had a group show at

the Centre d'Art in Brussels—not paintings but posters—followed by an exhibition of Magritte's and Flouquet's paintings: the exhibition that Georgette was too shy to attend. Afterward, Flouquet painted a faceted portrait of Magritte, "in memory of his old Bé-Bé" [color plate 20].[68]

In 1921, Magritte "was miserable for a few months in a stinking barracks in Antwerp, where he had to undergo military service and shameful promiscuity."[69] He was sustained by his correspondence with Georgette, then his fiancée, but perhaps even more by his correspondence with Flouquet, who had already been called up. Magritte was on active service as a militiaman in Tenth Company, Third Battalion, Eighth Line Regiment for ten months, from December 1920 to September 1921, and then for the month of March 1922—but not very active service. He was stationed first in Brussels, then in Antwerp, then at the Beverloo Camp in Leopoldsburg (motto: "Proud to Serve"), then in Mönchengladbach, and for the final month in Geilenkirchen. Despite his complaints, it was for the most part a cushy number. Militiaman Magritte spent more time on mapmaking than on guard duty.[70] Many years later, when André Bosmans was called up, Magritte sent him a sardonic admonition:

I'm surprised at your horror of an institution that bears such eloquent witness to the infantilism of the "right-thinking" mentality. As a disciple of Père Ubu, you need feel no regrets or disagreement with the army, since its rules and regulations are in such close accord with the spiritual system of that great thinker. A Belgian general, acquainted with Père Ubu's teachings, would carry his notions still further, so as to make their effects more awkward than they are at present for poets subject to military service.

"I had the same experience," but without taking a tragic view of the dense stupidity on display in the barracks. On the contrary, I approached it as a "nuisance" that I had to "defuse" as far as possible. There are various ways, and a little of your intelligence should be enough to suggest effective ones. As I was already "an artist-painter," I did a portrait of my commanding officer, worthy to figure in Père Ubu's collection, and this brought me almost complete freedom for quite a time. I was also "transferred" to an office job in the Ministry of War, on a "conjugal" basis; that is, I slept at home and had my meals there, and was obliged to put in only a few hours a day at the Ministry. I took advantage of any possibility of skiving. I even managed to avoid the remaining office hours by inventing obligatory visits to the doctor. The "nuisance" still existed, of course, even though it was reduced by the pleasure of "conning" the "brass," but I didn't regard it as a tragedy, like you.

"Leaders of men" know nothing of Père Ubu's creatures. "Honour and country" is what they think. What a tragedy for us it would be to find ourselves out there.[71]

Magritte was lucky enough to find two officers sympathetic to his plight and alive to his talents: Captain Albert Tahon and Captain Alphonse Dierickx. Tahon commissioned portraits of himself, his fiancée, her mother, and her sister—and let him work on them during duty hours. Dierickx commissioned a portrait of himself; two more resulted from frequent invitations to the house of his future wife. These well-heeled house parties also yielded two paintings of a young woman at a piano, realized in a post-cubist style indebted to Albert Gleizes, whose *Woman at the Piano* (1914) Magritte surely knew, especially as he made a close study of Gleizes's doctrinal text, *Du Cubisme et des moyens de le comprendre* (1920), his copy littered with cubist women, cubist pianos, and cubist paraphernalia sketched in the margins.[72]

Magritte was not proud to serve. Whatever he might say to Bosmans, his letters to Georgette often sound piteous or woebegone. "I've had only one little card from you this week!" he moaned, from Beverloo, "and that asked me again to write more often!" He had been busy making arrangements for her to visit, escorted by Popol, and "my second mother," Jeanne. "If you don't come and see me on Sunday, I'll be very unhappy, and only a long letter, very long, will console me. And also to hear your dear voice, you can telephone me (from the Gare du Nord for example) at 10 on Sunday morning."[73] Partway through that long stint of ten months, he poured his heart out to Flouquet, the believer, whose response was one of the very few letters he ever preserved. The younger man responded almost as a father confessor:

> You no longer believe in the soul, you say. . . . By your own admission, you're unhappy, you're suffering. The scepticism with which you've cloaked yourself is suddenly pierced by the tiniest thing. You lay yourself open to me, and your tragic mask is that of everyman . . .
>
> In this instance I want to consider only your artistic and moral suffering. Firstly to give you solace, if that's possible, let me proclaim the confidence I have in you. Yes, I believe in *your character*, I believe in *your talent*. I believe in it, and if I tell you this, it's not at all in the spirit of flattery, I'm true to the aim of restoring your initial confidence, because, mon cher René, if you make a beautiful work either in intense despair or in great joy, allow me in friendship to wish you the second of those states.
>
> . . . *Create*, there's the *remedy*, that human aptitude for devising a thousand plans, to create, isn't it a reminder of outer space, a need for

elevation, a sort of purification of moral turpitude . . . perhaps. Mon cher René, why despair, in four months you'll be able to devote yourself entirely to your art, you'll be able to express yourself with complete freedom, to go and finish your studies in Paris, to travel. . . . And if your soul is suffering, it's because it's crushed by that khaki tunic that is like a lead weight on your imagination . . . for four more months.[74]

Four months later, as he reemerged into the world, he wrote to Flouquet,

> The letter I've just received from you is further proof that you are a true friend and that you understand me extremely well.
>
> I love Georgette more and more, only, whereas when I was a soldier I had scarcely any time to work and thought it possible to lead a bourgeois life without going on with painting, now that I can work it seems to me impossible. My father, whom I persuaded to come with me to the Musée Moderne this morning, had to admit that one can create art "with crude brushstrokes" etc., on seeing pictures there which I myself find insufficiently "finished" in the good sense of the word. So he is allowing me to paint as I wish—for how long I don't know, but it will always be like that. So, armed with some good paints and canvases, I shall shortly begin a big picture which I've been thinking of for a long time: a barrel organ in the street with women wearing vermilion head-scarves, a wind that livens things up, children dancing, others looking on . . . , bystanders, trees, houses, sun! The future seems to me no less tragic in spite of all this, but at any rate I'm working now and if I produce a beautiful work that will be something.

> There is no trace of a big picture with a barrel organ—a surprisingly conventional conception—perhaps because it rapidly became clear to him that he would have to find a job. Thanks to Victor Servranckx, with whom he had overlapped at the Académie, he found one almost immediately, in November 1921, as a designer for Peters-Lacroix, a leader in wallpaper. He started on 2 francs an hour, making 450 francs a week—the sum deemed insufficient for married life by his father—but in next to no time he was advanced to 3 francs an hour, making 600 francs a week, enough to support a wife but a monopolizing commitment. He wrote again to Flouquet about the impasse in his painting:

> If I'm producing nothing it's because I'm not living at the moment. I'm simply loving, and that is what brings us close to the absolute, and as

soon as I've secured our material future, which is one aim, I shall have to find another to live by, and that will be to make Georgette as happy as possible and in the calm of a nice steady bourgeois life I shall of course devote myself during my leisure hours to *the work that I want to leave after me.* These are not mere words, because every evening after having looked for employment I notch up yet another day without "artistic production" and it always fills me with *fear* which, the longer I have to wait, will be transformed into redoubled energy.

Besides, if I had the means I would work [that is, paint]. My father is having financial difficulties; as you know, he is involved in a lawsuit with his former partners, and the money he gives me is enough for minor expenses but a long way from providing me with the wherewithal for what I need—paints, canvases, models.[75]

Magritte's father was now running through his second fortune. It was the beginning of the end.

The first fortune had lasted some three years. It disappeared in a puff of smoke. In January 1914 a fire at the Cocoline factory at Termonde destroyed the factory and destabilized the De Bruyne empire. The Germans did the rest. Léopold Magritte was let go. The inspector general lost his position and his livelihood. He moved sideways into bouillon cubes, becoming a representative for the famous Maggi company. Ever restless, he began to manufacture his own stock, at home, for soups and stews. When Charles Alexandre was introduced to the family, in 1918, he was also given a tour of the interior courtyard, a necropolis of meat bones and vegetables, and the old stables, where pot-au-feu was being brewed. One of Magritte's party tricks was to urinate on the vegetables. "And afterwards, they'll make canned food with it!"[76]

Léopold kept afloat. But there was a frenetic quality to his wheeling and dealing, and a sense of risk, reflected in the frequent displacements of those years, flitting to and fro between Châtelet and Charleroi, gravitating to the capital but moving around, as if wary of commitment. He was always unable to settle. In 1920, a second fortune fell into his lap. Charles Alexandre was a fascinated spectator:

Magritte *père* was a captain of industry. After the war, he pulled off a terrific coup. He offered to buy a factory that made fats from a former partner who had to flee Belgium during the catastrophe, for a derisory sum. Then he made use of a dishonest procedure called "faire de la cavalerie" [something like a pyramid scheme]: he created a limited company from capital that he didn't have, but which corresponded to a higher

price . . . and resold the factory! Léopold Magritte became a millionaire. And we used to see the father set off for the races in a frock coat, with his topper and his gloves, and Raymond with him, dressed exactly the same. This coincided with the Magrittes' move to the avenue du Boulevard [in Saint-Josse]. Every day was a holiday, the Magrittes would come down to the Welcome, the café on the ground floor, where they would serve themselves, shouting: "And two champagnes on the Magritte account." They would go at all hours to the patisserie on the Boulevard for croissants, tarts, and other pastries: "It's on the Magritte account." Every night it was "open house" at the Magrittes', as we all used to say: each of them would bring his friends home for a sumptuous spread. Léopold and his son Raymond would strut about proudly.[77]

The second fortune lasted no longer than the first. By 1923, his former partners had gained the upper hand; creditors were circling. The champagne years were over. The Magritte account was closed. There would be no more factories.

Overnight, as it seemed, the ostentation ceased. Léopold and his ménage melted away to the rue de Brugeman in Schaerbeek, leaving a number of sealed packing cases with a friend. In February 1924 he was off again, to the place de la Reine in Schaerbeek; in January 1925, to the avenue de la Couronne in Saint-Josse; in November 1926, to the avenue Georges Rodenbach in Schaerbeek, where he came to rest. This time there was no way back. His efforts to make use of Raymond's commercial contacts to market whisky samples came to nothing. His finances never recovered. Neither did he. When he died, of a heart attack, on August 24, 1928, La Jeanne was suddenly destitute. There was not even enough to pay for the funeral—Régina's revenge, perhaps, from beyond the grave. *His* sons were notably reluctant to step in. Eventually, Raymond took charge of the arrangements, and shouldered the cost. Magritte's second mother ended her days in abject poverty, preyed on by her alcoholic son, Armand, and left to fend for herself by the three "good boys" she had helped to bring up. Georgette took pity on her and gave her a radio set.

The packing cases were never reclaimed. One was found to contain commercial correspondence. The others were full of photographic plates, of a pornographic nature.

4.
The Aura of the Extraordinary

Magritte's friendship with Flouquet did not last. The confessional relationship could not last, perhaps, beyond the enforced separation of military service. Letter writing was conducive to unburdening. The intensive correspondence of that unsettling period offers intriguing glimpses of soul searching or stocktaking on Magritte's part, at once emotional and intellectual, reinforced by his reading. The past figured large, whether he liked it or not. The future, too.

His reading was as zealous as his cinema going. As with films, so with books: he was apt to scoff at fine words, fashionable authors ("as for Camus, he strikes me as a load of rubbish"), the bourgeois and the *bien pensant*, and any suggestion of arid booklore—"and all the rest is literature"—even as he read. The historian Richard Cobb identified "a certain *esprit frondeur*" among the Belgians, as they contemplated their European neighbors, in particular the French: "a desire never to be taken in; a very basic common sense; a refusal to be unduly impressed, whether by uniform, titles, or literary reputation; a large reservoir of scepticism; a sense of humour, inclined to be scatological."[1]

Magritte often read for several hours a day. In years to come he made a point of following up Nougé's recommendations, just as he sought out Fritz Lang's films. André Bosmans remembered him combing the bookstalls in the market: "One day, in an old market in Brussels, Magritte dug out of a box . . . a copy of [J.-K. Huysmans's] *Les Soeurs Vatard* [1879]. He carefully extracted the book, and gave it to me, saying: 'Buy this book.' . . . Magritte even liked J.-K.'s Catholic books!"[2] As a young man he browsed far and wide. Convalescing after the operation to remove his tonsils, he read a life of Cézanne, most probably Gustave Coquiot's picturesque account, first published in 1914,

and reissued in 1919. Cézanne died in 1906; he was already a sort of king among painters, as Coquiot describes him, and also a fabled temperament, as he described himself—"the sublime little grimalkin" of D. H. Lawrence's marvelous characterization, "small, timorous, yet sometimes bantam defiant." It was the bantam defiance that captured Magritte's attention. Coquiot had visited Cézanne's stamping ground in Aix-en-Provence and come back with a collection of tales about the legendary master, recounted with relish in the book, and repeated with equal relish by Magritte to Flouquet. "When a bourgeois whom he secretly despised asked him what he painted his backgrounds with, Cézanne replied: 'With s—t.' When Cézanne entertained a friend, the debate was so fierce that the firemen and the police rushed over, thinking there was a fire, when it was pipe-smoke escaping through the window, or a murder, he had such a mouth on him." If this was the artist's life, then Magritte was all for it. "When are we going to do the same?" he asked Flouquet wistfully.[3]

"Get hold of *Le Coq et l'arlequin* [1918], by Jean Cocteau, without fail," he instructed Flouquet on another occasion, "there are amazing things in it: DON'T MAKE ART ACCORDING TO ART etc."[4] He went overboard on "the divine Baudelaire," copying out one of the *petits poèmes en prose* from *Le Spleen de Paris* (1869) in its entirety. The one he fastened on was "L'Étranger":

"Tell me, enigmatic man, which do you love best, your father, mother, sister, brother?"

"I have no father, mother, sister, brother."

"Friends?"

"There's a word whose meaning eludes me."

"Your country?"

"Wherever that may be."

"Beauty?"

"I would happily love her if she were a goddess and immortal."

"Money?"

"I despise, as you despise God."

"Well, remarkable stranger, what do you love?"

"I love the clouds . . . the clouds passing . . . there . . . away over there . . . the marvellous clouds!"[5]

Is this profound sense of dislocation the root of the blank denials of the later interviews—the fugue-like forgetfulness about his father, the terminal silence about his mother? Magritte, too, had trouble with "friends." During their fraternal phase he sent Flouquet a shortlist of those with whom he intended to break, in view of their moral failings. Karel Maes, for example, a

fellow student at the Académie and an abstract painter of some accomplishment, was characterized as "[a] pigmy professor, genius, very obtuse geometrical mind, who has nothing much to say because he hasn't got a thought in his head—I wanted to overcome my antipathy toward him, but his attitude sometimes makes me *despise* him."[6] And yet nothing came of these threatened exclusions. The traffic with Maes continued unabated. In the event, Flouquet himself was the first to go.

When it came to Magritte's break with Flouquet, each man had a different story to tell. The precipitating cause of the breach between the two friends was Flouquet's objection to Magritte's "disrespectful behaviour" toward Georgette. In the first instance this seems to have meant little more than a continuation of his cavalier treatment of the shared studio. Apparently Flouquet did a portrait of Georgette, which he gave to Magritte. Shortly afterward he visited their apartment and noticed that it had disappeared. He asked what had happened to it. Magritte replied that he had run out of canvases. He had painted over it.

Worse, much worse, was to follow. According to Léon Pringels, the crunch came when Flouquet discovered that Magritte shut Georgette in the coal bunker, just for fun. Flouquet was outraged. Evidently he did not understand his enigmatic friend so well after all. He decided to sever contact. His response speaks of a sense of personal betrayal. Flouquet seems to have regarded Magritte's conduct as an affront, not only to his wife, but also to his "brother." Strange to relate, Magritte himself may have encouraged such a perception. Flouquet was demobilized first. Still on active service, Magritte solicited his help in looking after Georgette. "My dear friend, I'd like you to take Georgette home whenever you have the time, because I'm so afraid that she's weary, you would be doing me a big favour. . . . Dear Pierre, will you look after her if she needs you."[7] He also encouraged Flouquet to keep him informed about what Georgette was doing and saying. As things turned out, his devoted correspondent may well have felt that he had been used.

There are various reports of Magritte's disrespectful behavior towards Georgette in the early years of the marriage, some of them stemming from Georgette herself. They may be exaggerated. They may have grown in the telling. In any case, the principal witness is not Pierre Flouquet, nor Léon Pringels, but a young friend, Jacqueline Nonkels. Jacqueline was a long-standing participant-observer of the Magritte household and the Magritte gang. She appeared in the staged photographs and the home movies. She had her portrait painted. She worked for Georgette's sister. She was devoted to Georgette, but she remained on excellent terms with Magritte. In short, she was intimately familiar with both parties. She was also a reliable witness.

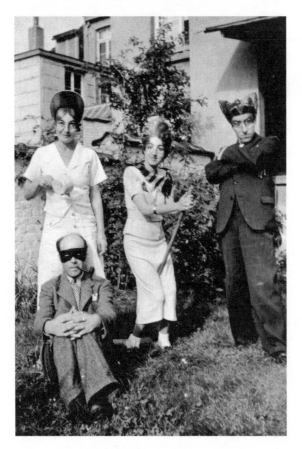

The reports suggest that Magritte's behavior toward Georgette followed the pattern of his father's behavior toward his mother—behavior that the young Magritte must have witnessed. Just as Régina confided in Marie Nisolle, Georgette confided in Madame Nonkels, Jacqueline's mother, who lived downstairs. These conversations sometimes took place in front of the young Jacqueline, who was all ears.[8] According to the old Jacqueline, her parents were scandalized by what they heard, the burden of which was that Magritte was abusive toward his wife. In this controversial version of the marriage, he drank and was sometimes violent. He locked her in the apartment while he went out on the town with his friends. Monsieur Nonkels was sufficiently incensed to stage a kind of protest. Magritte was in the habit of leaving canvases on the stairs to dry as he finished them. Once, while he was out, Jacqueline's father turned them all to face the wall.

For Magritte, his erstwhile friend and confessor was now beyond the pale. Flouquet mutated from painter to poetaster. He created *Le Journal des Poètes* as a vehicle. At the same time he moved sharply to the right, rediscovering his roots in blood and soil, and becoming a devout, not to say sanctimonious, Catholic. All of this was anathema to Magritte. After the Second World War, he savaged *Le Journal des Poètes* as *Le Jour nul des Poètes*. Flouquet's "Open Letter to L'Abbé Morel," a spoof written by Magritte, mercilessly satirized the intimacies of the ex-soulmates. "I have done some rash things, perhaps even— some might say—some indiscreet things. Happily, the successive victories of the 'Allies' have opened my eyes, and led me to re-examine my artistic conscience. Thus far I am entirely at ease, no one dreams of disturbing me, a charitable wind blows and soothes me. I was readily absolved, through the grille in the parish confessional, for my spiritual activities as an uncommitted collabo-

rator."[9] In private, Magritte did not mince his words: Flouquet was "Fascist and Catholic 100%." He was certainly a collaborator, a vocal apologist for the new order, fortunate indeed to receive absolution wherever he could find it. Under the Occupation he edited *Reconstruction*, the official journal of the CGRP, the Agency for the Restoration of the Nation. In its pages he gave himself the space to wax lyrical about the war as an opportunity for "the harmony of renewal," moral, spiritual, and municipal, such as the creation of hygienic, orderly, and green cemeteries.[10] In 1952 he received last rites, from an unexpected quarter—Magritte declared him dead, or at any rate lifeless. Magritte also declared himself unmoved. In fact, Flouquet was very much alive. Either way, there was no letup in the derision. When Magritte completed a mural for the casino at Knokke, in 1953, the reverse merman with the fish head was said to resemble Flouquet.[11] A decade later, Flouquet had shrunk to "the poet for priests"—the ultimate insult.[12]

Flouquet, for his part, exercised considerable restraint, publicly lauding Magritte's work over a long period. In 1923 he praised "the inquisitive searcher, in whom passion is *measured*." In 1925 he wrote a rave review of the sets for a double bill of one-act plays, Herwarth Walden's *Glaube* and Max Deauville's *Rien qu'un homme*—Magritte's sole experiment in stage design— "thrilling magic . . . innumerable strokes of inspiration . . . the designer has not yet said his final word. . . . The painter Magritte has saved the work: *the sets have saved the play*!" He let fly only once, in a review of Magritte's first one-man show, in 1927, the show in which he came out as a surrealist. In Flouquet's eyes, surrealism was thoroughly decadent. Among many stinking reviews, Flouquet's was egregiously the worst. Magritte's current painting, he announced with exquisite distaste, was *anti-painting*. "Anti-painting, because painting of a complacent restlessness, cultivated for its unreality and its strangeness, purveyed for its *succès de scandale*. . . . Even on the level of the absurd, it is a long way from his philosophico-literary surrealism, at once ill-considered and derivative, to the theories done to death by the likes of Chagall and Chirico." The peroration was a model of truculent disdain. "To be sure, I firmly believe that when it comes to certain psychological landscapes imprinted with a subjective poetry, Magritte can realise his true character, purged of any trace of facility. But taken as a whole, his current painting, in the hands of literary advisors and mercenary dealers, scandal and specious experience, disgusts me."[13]

In the meantime, Magritte was making more consequential friends, who remained friends, or goads, all his life. The first of them was Édouard Léon Théodore Mesens (1903–71), familiarly known as E.L.T., an impossibly sophisticated sixteen-year-old who went to see Magritte's joint exhibition

with Flouquet at the Centre d'Art, in 1920, and stayed on. Many years later he remembered the Magrittes as reflecting "the diverse and contradictory influences of Matisse, Gleizes, Lhote and the Italian Futurists, whose paintings Magritte knew only through half-tone reproductions." He also made passing reference to Delvaux, by way of comparison. When he offered this in a biographical essay on Magritte for a volume on contemporary Belgian painters, in 1946, Magritte sent him a sheaf of sharply worded corrections—"at that stage I hadn't *heard* of Matisse or *Lhote*"—deploring any reference to Delvaux, Delvache, or Delboeuf, the source (the sauce) of remorseless puns. "Encore du veau! Je propose de servir du boeuf ou de la vache."

Magritte also took issue with Mesens's characterization of him as a dandy. He did not refuse dandyism, as such, proposing instead *dandyisme théâtral* (theatrical), *dandyisme voyant* (loud), or even *dandyisme de cow-boy*. Ever since Baudelaire's essay on Constantin Guys, extolling the ideal artist as "The Painter of Modern Life" (1863), dandyism was to be taken seriously, "for the word 'dandy' implies a quintessence of character and a subtle understanding of the entire moral mechanism of the world; with another part of his nature, however, the dandy aspires to insensitivity, and it is in this that Monsieur G., dominated as he is by an insatiable passion—for seeing and feeling—parts company decisively with dandyism."[14] Something of the same was true of Monsieur M. As befits a devotee of John Wayne, however, *dandyisme de cow-boy* died hard. When he eventually found himself in Texas, in 1965, he adopted a bootlace tie, a cowboy shirt, and a cowboy hat (from Stelzig Saddlery Co., in brown felt, lined in red satin), with his customary dark suit, and brought them home with him. "I take up the biro," he wrote to Scutenaire, "in order to prepare you to see me in a real cowboy hat, and beneath, a shirt with steel buttons." Unabashed, Mesens made a few concessions, but republished the essay after Magritte's death, complete with almost all of the passages to which Magritte had taken exception.[15]

Mesens was five years younger than Magritte, no more intelligent, but sophisticated. When they met, he was preparing himself for entry to the Brussels Conservatoire. He had been composing seriously since the age of fourteen, if not before, specializing in pieces for piano and settings of poets such as Apollinaire or Tagore. He had the nerve to approach anyone, whoever and wherever they might be. He and Magritte began to talk about futurism; in a trice he led the way in writing to Marinetti himself, soliciting futurist enlightenment. Marinetti obliged with a deluge of catalogs and manifestos. Not content with bagging the futurists, Mesens went to Paris to meet the Dadaists, in particular their capo and impresario, Tristan Tzara, who wanted nothing more than to "marinate Marinetti in his own sauce," as one of his confederates

put it. Making use of his contact with the composer Erik Satie (who was favorably impressed), Mesens launched himself on the society of the avant-garde. As he recorded spaciously for his résumé:

> First trip to Paris [1921]: Satie takes him to lunch in Constantin Brancusi's studio, visits the first Man Ray exhibition with him . . . and recommends him to Francis Picabia. He meets a man with a monocle at the corner of the rue Delambre and the boulevard Montparnasse, stops him and says to him: "You are Tristan Tzara," which gives rise to a new friendship. Tzara introduces him to Marcel Duchamp and Georges Ribemont-Dessaignes. He returns to Brussels, reviled by his friends, with the exception of Magritte, for having hobnobbed with Dadaists.[16]

Mesens himself was a one-man avant-garde, not only a composer but at various times a pianist, a journalist, an editorialist, a gallerist, a collagist, and a watercolorist, writing poetry with his left hand while otherwise occupied with his right. In this maelstrom of creativity there was a current of dilettantism. The little magazines are long forgotten. The poetry is dead on the page. Some of the collages hold up, though they are not

in the Max Ernst league. Much of the rest has disappeared without trace. His métier was not in making, however much he might have wished it, unless it was in making waves, or reputations. He truly excelled as a kind of talent spotter, in the show business sense, and was in every sense an exhibitionist. Moreover, he had deep pockets, and was prepared unashamedly to put his money (and, if necessary, his parents' money) where his mouth was. He made a noise; his taste, his purse, and his enterprise saw to that. Unlike Magritte, he was the very picture of a bon viveur—a lovable stylist with a strong thirst. Later on he had a fling with Peggy Guggenheim. When she first published her memoirs, in 1946, he appeared thinly disguised as "Mittens," "a gay little Flamand, quite vulgar, but really very nice and warm."[17] As animator, promoter, and collector of Magritte, he was beyond compare, streets ahead of his contemporaries.

The two of them hit it off immediately. One night, together with Pierre Bourgeois, the director of the Centre d'Art, they embarked on a marathon round of carousing and conversing. Mesens was always a good boulevardier, and Magritte was much taken with the enchanting mix of anarchist patter with piano accompaniment. Years later Magritte bragged that he arranged for Mesens to lose his virginity that same night, with a barmaid who performed her duties with the practiced automatism of a switchboard operator: a traumatic experience for the young aesthete, which put him off any further exploits of that sort for at least a year.[18] Whatever the truth of this tall story, Mesens emerged unscathed, if not triumphant. Before long he became the lover of Honorine Deschryver, creator of the fashion house Norine, and also the protégé of her husband, the wealthy Paul-Gustave van Hecke (who knew all about the affair). "Nono" and "Tatave" were nothing if not worldly. This power broker couple were in the business of making or remaking modernism in Brussels. Their patronage would have a determinative effect on Magritte's career. Their fluctuating fortunes served to ensure that Magritte and Mesens would remain somewhat mixed up together in some of their affairs for mutual and general advantage, as Churchill once said of America and Britain.

Already, a connection had been made. Magritte introduced Mesens to his father—rather more expeditiously than he introduced Georgette—who was persuaded to employ him as a piano teacher for Paul. He replaced the classical pianist Hortensia Gallemaert, the butt of classical practical jokes by the Magritte brothers, who was given two paintings by Magritte himself, by way of compensation.[19] Mesens was an instant success with Popol; Magritte joined in their sessions. The three of them composed some ditties, singing along together as a Dadaist barbershop chorus.

When you come to Brussels
Be sure to come and see us-els
If you like beer and whatchamacallit
We'll help you empty out your wallet
So come here for a holiday
And give Aunt Hortense a stiff lay.[20]

As a token of friendship, Mesens composed a short piece for oboe and bassoon that he played on the piano at Magritte's wedding.

Relations between them were not always so harmonious. Their correspondence over the years was by turns tetchy, inquisitorial, and vituperative. The exchange over Magritte's influences was all of a piece with a form of aggravated one-upmanship, pursued to the end, mitigated by an inextinguishable affection, and alleviated by a certain irreverence. "I have tried too in my time to be a philosopher," Mesens might have said; "but, I don't know how, cheerfulness was always breaking in."[21] Magritte's autobiographical sketch was originally written for the catalog of his retrospective at the Palais des Beaux-Arts in Brussels, in 1954, a retrospective masterminded by none other than E. L. T. Mesens, and hailed by Geert Van Bruaene as "a public confession."[22] It appears that Magritte could not resist having a little fun at the mastermind's expense. When they first met, he wrote, "young Mesens took things very seriously, and old Magritte introduced him to humour by playing innocent practical jokes on him, which annoyed the young musician."[23] Mesens's riposte was entirely characteristic. It came in a magazine article published to coincide with the exhibition, in the form of a portrait of the artist as a young man: "He seemed to us extremely elegant. He had suits made to measure, which were so nipped in at the waist that they gave him the look of a pregnant girl. Every Sunday his father crimped his hair with curling tongs. At that time he also wore button boots with pearl-grey spats, and crowned this whole get-up with an enormous wide-brimmed Borsalino: a first-communion cake under a cheese dome!"[24]

In 1930 Magritte painted a portrait of Mesens [color plate 21]. It is a curious amalgam of visual gags, sly jokes, and cryptic avowals. First of all, the painting looks like a pastiche of a poster advertising "REVOLVER" (printed in large letters across the bottom, like a brand name), or indeed the immaculate Mesens himself. "REVOLVER" is a reference to a postcard from the artist, addressed to "Monsieur E. L. T. Mesens, fabricant de REVOLVERS GUIMAUVE et de POULES SIFFLETS" (marshmallow revolvers and whistling hens). Mesens appears in the guise of a magician, about to perform his

next trick. In one hand he is balancing a strange apparatus (a trap of some kind?)—a dog's head and a block of wood on a short plank.[25] His other hand grasps a string, which seems to be attached to the plank, or to the dog's head, such that, if he pulls the string, the trap will be sprung, or the dog's jaws will open wide, in a rictus grin.

The dog's head is smeared with blood. Its tongue is hanging out. Its look is disquieting; its very presence bizarre. It might be an aerial dog, straight out of Kafka's "Investigations of a Dog," but for the plain fact that it is a Pomeranian, bearing a striking resemblance to the Magrittes' beloved Loulou. Before and after the war, it was always René and Georgette Magritte and their dog; and it was always a Pomeranian (known in French as *un loulou de Poméranie*). The original Loulou was black; the next one, called Jackie, was reddish brown; the one after that, also called Jackie, was white; the last one was black. When Jackie II died, in 1955, Magritte wrote to Mesens:

> Little Rikiki is dead. Georgette has been very upset and I must say that I have found the loss more difficult to bear than, for example, an operation I might have to undergo, which at least could only be carried out with my agreement. The most unbearable part is not the fact that Jackie's death took place without my agreement, but the cruelty displayed by the mystery in which we live, which I find totally incomprehensible.
>
> Contrary to my "doctrine" with regard to sadness, to provide a lively distraction for Georgette in her grief, I have rented a new apartment from 15 December. She will have to busy herself with it and brood less on death.[26]

It seems that Mesens understood. So did they all, after a fashion, if they were to engage with Magritte. His accomplices received regular bulletins on the dog. In 1944 he began a new series of portraits, of animals. The portrait of a horse was called *Le Météore* (*The Meteor*). The portrait of a dog was called *Le Civilisateur* (*The Civilizer*). The sitter was Jackie II. Every dog has its day. "I've started on a new picture in the horse series, with rare enthusiasm and good quality. Nougé, who has seen the initial stage, thinks it's of the greatest importance," Magritte informed Marcel Mariën. "It seems odd to see the worn-out human figure, then objects, replaced by animals which seem better able to suggest life. (Real life, as opposed to that fashioned by statesmen and soldiers.)"[27]

Everywhere Magritte went the dog was sure to follow, "wretchedly, after the fashion of Pomeranians," according to Samuel Beckett.[28] Magritte made a point of checking in advance. If the dog was refused admission—in cinemas,

in cafés, in restaurants, in bars, in hotels, in galleries, in museums, even in airplanes—Magritte would not go. Informed that dogs were not allowed in the Galerie Charpentier, in Paris, he remarked, "That's a great pity for little Loulou, he hasn't seen the Surrealists."[29] In extremis, Madeleine Scholzen the maid would go, too, in order to keep the dog company. Jacques Roisin interviewed her in retirement. "I worked for the Magrittes for over thirty-five years," she told him, "and I was the dog's governess!"[30]

On one occasion George Melly and his girlfriend Robin Banks succeeded in enticing René and Georgette and their dog to spend an evening at La Fleur en Papier Doré, the establishment run by a portly angel by the name of Geert Van Bruaene. Van Bruaene was Magritte's friend. He ran a succession of outré establishments—Le Cabaret Maldoror, La Vierge Poupine (the chubby virgin), L'Agneau Moustique (the mosquito lamb). He had a good eye, a jovial mien, and a nice line in epigrammatic wit. ("Everyone has the right to twenty-four hours of freedom a day.") As a gallerist, he was a dedicated avant-gardist. In 1926 Magritte was able to study Ernst's "frottages," *Histoire naturelle*, at the Cabaret Maldoror, where Van Bruaene also showed Kandinsky and Klee, not to mention Magritte and Servranckx, alongside the latest foreign films. He dealt in Magrittes whenever he could. He had the unusual distinction of contributing to one. Around the frame of *La Bonne Nouvelle* (*Good News*), in Van Bruaene's spidery hand, is inscribed "je te passe la plume, ma pauvre

amie, enchantée de tant et tant de conscience des détresses. Geert." ("I hand you the pen, my dear friend, enchanted by so much awareness of distress.")[31] Van Bruaene was a kind of court jester to the surrealist group in Brussels. He would surely have been enchanted all over again to find *La Bonne Nouvelle* in pride of place on the wall in Andy Warhol's *Flesh* (1968), as the hustler Joe Dallesandro strikes poses, buck naked, for an avid portraitist [color plate 22].

At La Fleur en Papier Doré, a good time was had by all. "Magritte enjoyed himself," Melly remembered. "It was almost midnight when, because it was pouring with rain, he telephoned for a taxi. The driver proved to be a surly fellow and growled that Loulou was not to be allowed on the seat. Having first helped Georgette into the cab, Magritte deliberately walked Loulou up and down the gutter. When at last he impassively joined his wife, he sat Loulou next to her while he himself lay recumbent at their feet. The taxi-driver . . . was so thrown by this 'solution' that he drove off without a word."[32]

Silent comedy was Magritte's *violon d'Ingres*—like all his interests, pursued with intense concentration. If the dog was his child substitute, it was also his supporting act.

The dog is not the only puzzle in the portrait of Mesens. The legend inscribed across the top of the painting, "À LA HAUTEUR DES CIRCON-STANCES" ("EQUAL TO THE OCCASION"), is unexplained. There is a literary reference that would have been familiar to both of them: in Jules Verne's celebrated tale *Around the World in 80 Days*, one of the chapters is entitled "Où Phileas Fogg se montre à la hauteur des circonstances" ("In which Phileas Fogg shows himself equal to the occasion"). Beyond that, there is a real-life event of vital importance to Magritte, and in its way of comparable significance to Mesens—something akin to a founding act.

"Through a combination of circumstances," wrote Magritte in his autobiographical sketch, "the painter suddenly secured a contract with P.-G. Van Hecke and the new gallery, Le Centaure, in the avenue Louise in Brussels."[33] That was at the beginning of 1926. He remained under contract for four years. During this seminal period—much of it spent in Paris—he produced some 280 paintings, nearly a quarter of his lifetime production. Small wonder he went on to boast, "[H]e was capable of doing sixty paintings in a single year, some of them very large." By the end of 1929, however, in the wake of the Wall Street crash, all of his backers had failed. Magritte was cut loose. With no ready source of income, he and Georgette were dependent on handouts from her sister and food parcels from her father, the butcher. Magritte was reduced to selling books from his library by the suitcase full. No one was buying paintings. Even in better times, no one was buying Magrittes. Of about 225 paintings delivered to Le Centaure or Van Hecke since 1926, more than

two hundred remained unsold. Others were gathering dust in his apartment. In desperation, he appealed to Nougé for help: "Do you think I might stand a chance if I applied for a job as a commercial artist, salaried if possible, in a big store like Bon Marché or Innovation [in Brussels]? I believe you know people who might be able to give you some information about this? You would be doing me a great favour, I need hardly say, if you could look into it."[34]

Nougé spoke to Mesens about Magritte's plight. Mesens made him an offer. "If you had a certain number of canvases available which you could part with *freely*, would you document them for me . . . , and I may perhaps find a group of collectors, which would enable me to buy them en bloc." Relief was at hand. Magritte replied, "It is good, I can see, to be counted among your friends; it encourages me to rise above these difficult times. I should be ashamed to show a lack of staunchness in view of the example you set." It transpired that he was sitting on eleven canvases. Among them were four early masterpieces. These paintings were as yet untitled; Magritte offered a thumbnail description of each. "Eye of sky." "Room with walls made of sky, fire, paper cut-out, façade of house, woman's breasts, forest, planks. On the floor stands a big cannon pointing at these things." "Woman's body made up of 5 small pictures." "Landscape with apparition of bilboquets, a paper cut-out, grelots in the background." As for the price, "I could let them go for 4,500 francs (French), exactly the price I was to have been paid under the terms of my contract."[35] Mesens was punctilio personified, but he was not a man to haggle. He bought the lot, sight unseen, for the asking price.

Mesens the magician had turned his best trick. He had shown himself equal to the occasion. The portrait was a tribute. So, too, the Pomeranian, offered up in accordance with surrealist tradition: the chance meeting of a dog's head and a block of wood on a short plank.

Mesens was just getting started. In the course of 1932–33 all three of the Brussels dealers who had Magritte under contract between 1926 and 1929 were compelled to liquidate their stocks. Most of these works were sold at public auction. But not the Magrittes. The director of Le Centaure feared that they would go for a pittance—supposing any bidders could be found. Behind the scenes, the gallery did not share Van Hecke's enthusiasm for Magritte. According to the assistant director, Jean Milo, "When the Centaure went bankrupt, we had to sell everything, and we had accumulated over 150 Magrittes, some of the worst [of the stock]." Milo continued:

> Magritte's paintings didn't sell, and we had pressed him to increase his output from that stipulated in the contract, because we knew that we'd have to reduce them to find a buyer and so balance the books. No doubt

that's why Magritte, who didn't like being tied to a contract, knocked off his pictures in a few hours. The Haesaerts brothers and I, we thought that work of Magritte's was like Auguste Mambour's: a dead loss! Paul Haesaerts said one day to Schwarzenberg [the founder of the gallery], who showed us the latest arrivals from Magritte: "Walter, old chap, your Magrittes, they're shit!" So, when the gallery failed, I proposed that we withdraw the Magrittes and the Mambours from the collection, to avoid the entire sale becoming a fiasco.[36]

Mambour seized the opportunity to buy back a lot of his own work. Magritte was in no position to do the same. Jean Milo was instructed to dispose of them privately, en bloc. In cahoots with Claude Spaak, Mesens bought 150, for either 5,000 or 10,000 Belgian francs—insider accounts differ. Spaak put up half the money but took no more than a dozen choice paintings; he became an influential ally and patron.[37] Even if it was the higher figure, at hardly more than 60 francs each, these were bargain-basement Magrittes. (At the sales, some of the Ernsts went for over 1,000 francs, some of the Chagalls for as much as 4,000.) Over the next few months Mesens mopped up about twenty more, from Van Hecke's collection. By the time it was all over, he had amassed the greatest collection of Magrittes the world had ever seen, or, rather, the greatest collection of Magrittes the world had never seen. In the years to come he set about rectifying that omission.

In the meantime he offered some tasters to friends, at the knockdown price of 50 francs apiece. This bounty enabled Nougé to acquire three of his favorite works, *Les Grands Voyages*, *Le Double secret*, and *Les Muscles célestes*— works that his own writings helped to make famous. Magritte's brother Raymond snapped up four, including *La Robe d'aventure*, the woman on the water, with the flying turtle. Suzanne Purnal, later Madame Paul Delvaux, bought one. The chess master Denis Marion bought two, *Campagne* and *Découverte*. Contemplating the former, his mother observed sniffily that it could have been dashed off on a summer's night (as the saying goes). When Nougé came to call, Marion repeated his mother's verdict. Nougé took the painting off the wall, crossed out the title on the back, and substituted *Peint sur une nuit d'été*, adding the initials R.M. and P.N., as if to certify the change, or the unauthorized collaboration.

. . .

When Magritte first encountered Mesens, in January 1920, he was little more than a tyro with bravado. He had the gift of the gab. He stood out from

the crowd. "Magritte was completely non-conformist," recalled Charles Alexandre, "even in painting circles. They favored hats, floppy neckties, beards, but René wore a suit. They would all say: 'My canvases.' He would say: 'My pain-tings, *you know*,' in a Charleroi accent. He was very ironic, sarcastic, he wanted above all—I'm going to use his own words—'to do what isn't done.'" Léon Pringels was forced to agree, whatever his moral scruples. "René Magritte," he pronounced, "it was the world turned upside down."[38]

At that time, Magritte had produced about twenty paintings, according to his *catalogue raisonné*. There may have been more, lost or destroyed, offloaded or orphaned, overlooked or overpainted. Newly discovered works continue to surface, and sometimes to spring a surprise. Magritte's copy of *Jesus Christus*, by the Austrian painter Gabriel Max (1840–1915), surfaced as recently as 2005; it has been dated c. 1918. It seems to have been copied from a postcard [color plate 23]. Like chromos, postcard reproductions were a prime source for the impoverished artist. Students could riffle through boxes full of them outside the Coopérative Artistique or the neighboring Maison d'Art Arekens (where the expert Mia Vandekerckhove found this one). Following examination by the Comité Magritte, the authenticity of this canvas is not in doubt, but its rudimentary provenance is a sharp reminder of the contingent fate of the early work. "According to information supplied by Paul De Grauwe, Leuven, the painting belonged to his maternal grandfather, Prosper Van de Weghe, who lived in Schaerbeek, where he served as the sacristan of Sainte-Marie [the church in which Magritte and Georgette were married]. In recognition of his services, the curé gave him the painting."[39] As a copy, it does not have much to recommend it, but it may well have served as inspiration for future Magrittes.[40] And it was openly avowed. In the upper right-hand corner is inscribed "MAGRITTE/RENÉ—D'APRÈS/GAB MAX."

In art and life, Magritte was obviously talented, but essentially unformed. He had made a start on the self-fashioning, and the self-examination. He had read some Nietzsche. "*What does your conscience say? You should become who you are.*"[41] Who was he? He was an artist—of that he was convinced—and what is more, an artist of high ambition. "As for the impossibility of laughing at the moment," he replied to a lament from Flouquet, "it's very understandable, given that we have an artistic ideal to achieve, and the recognition of our poverty of means, . . . but the end is never reached, and so much the better, for that proves that our ideal is pitched high, higher than the others." A visit to an exhibition of "Parisian Cubism" ("Picasso, Survage, Metzinger, Léger, and Others") at the "new club," the Sélection Atelier d'Art Contemporain—a gallery launched by Van Hecke and André de Ridder in connection with their review 'Sélection' founded in June 1920 —provoked a

roar of defiance—"*Mais nous sommes plus forts!?!?*"—as if a distant echo of the bantam Cézanne.[42]

What kind of an artist, however, his conscience failed to specify. His style, his subject, his signature, his allegiance, his modus operandi, his direction of travel: everything was still up in the air, like a cloud, or a balloon. That troubled him. "I've got doubts about my art," he admitted, "because my work isn't consistent—these are worrying questions, to which there's no answer. Consequently I've got doubts about others too. But of course 'the academicians' are of no interest to me."[43] Ever practical, he applied himself to the poverty of means. "My colours have now changed—no longer pure tones, but a range of patches . . . I'm using van Dyck brown (it's very warm), raw sienna, ivory black. Soon I'm going to use bitumen." He set himself exercises in style. "Here's what I was thinking of doing":

Trying, yes trying, to represent on canvas:
1. The abstract interior realm of feeling.
2. The realm of volume, the barber moving round one with the mirror.
3. The realm of the mirror,
so these three kingdoms.[44]

The anxieties persisted. "As you can see I search a lot and never stick with the same means of expression." "As you will have realized, my technique has changed again since *Les Forgerons* [*The Blacksmiths*, 1920]. Tell me what you think."[45] Anxiety mixed with deep dissatisfaction. Flouquet was shocked by "his disgust at what he'd painted . . . a terrible confession."[46] At almost exactly the same time Kafka confided to his diary:

Everything he does seems to him to be extraordinarily new, but also, in keeping with such an impossible wealth of new things, extraordinarily amateurish, scarcely tolerable even, incapable of becoming part of history, breaking the chain of the generations, interrupting for the first time the music of the world down to its deepest depths, though up till now it had always been faintly sensed. Sometimes in his arrogance he is more afraid for the world than for himself.[47]

Magritte was keenly aware of the work of other artists and was not above borrowing from them. When he was starting out, for example, Max Ernst was far ahead, and Magritte was accustomed to raiding his work. The encomium to Ernst and his elaborate and arcane collages made from old magazine

engravings in "Lifeline" is revealing: "Scissors, paste, images and genius effectively superseded brushes, paints, models, style, sensibility and that [dreadful] sincerity demanded of artists."[48] Except for the fact that he used brushes and paint, Magritte might have been talking about himself. For a tyro artist, Ernst's collages were earth-shaking. One of them may even have fed into *La Robe d'aventure* and Magritte's experiments with flight: *L'Avionne meurtrière* (*The Killer Plane*, 1920). In return, Ernst's remark about Magritte, "whose pictures are collages entirely painted by hand," was endlessly repeated.[49] Magritte grew tired of that aperçu, and also perhaps of Ernst's waggish one-upmanship. When he swapped a painting of his own for an Ernst, in 1937, he promptly sold the Ernst to pay for a new bathroom.[50] Yet his estimation of Ernst never wavered. He wrote tellingly of his fellow artist in 1958 for a book celebrating him:

> Max Ernst's painting shows the world which exists beyond madness and beyond reason. It has nothing to teach us, but it is aimed straight at us and that is why it is able to surprise and enchant us. . . .
> Max Ernst has that "reality" which can awake our faith in the marvellous, should it fall asleep, and which will not be isolated from life *in the present*, where it is to be found.[51]

To become who you are, in that present Magritte wished to inhabit fully, was easier said than done. He had no other ambition, unless it was the nice steady bourgeois life extolled in his letters to Flouquet—if those cosy professions of faith are to be given the same weight as *the work that I want to leave after me*. For all the display, and the horseplay, he was not lacking in application, or elevation. Harking back once more to his encounter with the painter in the old cemetery of Soignies—his first intimation of what an artist might be—Magritte remembered him, not simply painting, but "*toiling away*, you know, and that made a deep impression on me."[52] The bravado was a smokescreen. Magritte's doubt was not the equal of Cézanne's anguished questioning, but it was real enough. He was not all mouth; he was made of sterner stuff. "Artists who are content merely to hone their gifts eventually come to little," cautioned Simon Leys, in consideration of "The Belgianness of Henri Michaux," their compatriot and contemporary, whose meditations on Magritte's paintings, *En rêvant à partir de peintures énigmatiques* (1972), are so poetic and so profound. "The ones who truly leave their mark have the strength and the courage to explore and exploit their shortcomings. Michaux sensed this from the outset: 'I was born with holes in me.' And he knew in an

inspired way how to take advantage of it. 'I have seven or eight senses. One of them is the sense of lack.'" At bottom, Leys concluded, "Belgianness is a diffuse awareness of a lack. The lack, first and foremost, of a language."[53]

When Magritte went to Paris in 1927–30, that lack was dramatically exposed, in a variety of ways. Meanwhile, there was a more fundamental requirement. What he lacked, first and foremost, was a language in which to express himself on canvas; and then a language in which to explain himself in print. He lacked the images; he also lacked the words. What he needed was inspiration. It was not long in coming.

Magritte soaked up sources as efficiently as Mesens would later mop up Magrittes. He was voracious. And pragmatic, as well, taking advantage of opportunities as they arose. In February 1920 he took the opportunity to hear Theo van Doesburg lecture on *De Stijl*. There were only about fifteen in the audience at the Centre d'Art, but they included Alexandre, Pierre and Victor Bourgeois, Flouquet, Maes, Mesens, and Servranckx, as well as another member of the *De Stijl* group, Georges Vantongerloo. The silver-tongued lecturer was simultaneously a constructivist and a Dadaist. Under the assumed name of van Doesburg he edited *De Stijl* in Amsterdam. Under the heteronym I. K. Bonset (possibly an anagram of *Ik ben zot*, "I am foolish") he published *Mécano* in Leiden. In his spare time, under the pen name of Aldo Camini, he wrote severe anti-philosophical screeds inspired by the futurist Carlo Carrà in metaphysical mode. He was an avant-garde whirlwind, and a brilliant publicist, whatever the cause. He made an impression on the audience at the Centre d'Art. According to Alexandre, "It came as a shock for us."[54] If Magritte was shocked, he remained semi-detached. Constructivism was another ingredient for the pot-au-feu of precepts simmering in his studio. Cubism and futurism counted for more; possibly even Flemish expressionism. What stayed with him was Vantongerloo's reading of Paul Éluard's poetry afterward. Later reinforced by the reading aloud with Marcel Lecomte, lines from Éluard—"In the darkest eyes, the lightest lie concealed"[55]—lodged in his memory for the duration.

When it came to artistic movements, or currents, or tribes, Magritte was ecumenical: he took from them all. Not surprisingly, the critics had difficulty pinning a label on him. Over the next few years, before he found himself (or they found him), he was dubbed a fantasist, an abstractist, a neo-cubist, and even an abstract expressionist.[56] The general perplexity was well summarized by his friend Pierre Bourgeois ("the first to write poems inspired by the young painter's experiments"), reviewing an exhibition of young artists at the Galerie Giroux, in Brussels, in January 1923. Bourgeois was a good foil for Magritte; ever since 1918 they had engaged in spirited debate over the situa-

tion in which they found themselves, and the way forward. "Our discussions revolved around 'modernism' in art, understood as a concern to provide the arts with a new and 'avant-garde' form," remembered Magritte. "It was then that Bourgeois showed me the illustrated catalogue of a Futurist exhibition. For me, that was a revelation." In October 1920 they had gone together to a congress of modern art in Antwerp. Magritte returned home on his own, unimpressed. "They can all go to hell with their congress. . . . Christ almighty, I'd be ashamed to have put myself out for so little and I've spent 50 francs which could have been used to buy some decent paint." Pierre Bourgeois knew him well. "The case of René Magritte is a curious one," he reflected. "His general conception of artistic creation spurs him to the most relentless experimentation: imbued with modern art, he always gives the impression of being a maverick among modernist experiments. How to classify him?"[57]

Magritte showed four paintings at that 1923 exhibition: *La Gare* (*The Station*), *Nocturne*, *Jeune Fille* (*Girl*), and *Femmes* (*Women*). Pierre Bourgeois regretted the omission of *Le Boulevard*, "so moving in its sober and ardent construction through colour."[58] These were recent works—very recent. They had tales to tell.

The Station is painted on the other side of a picture by Karel Maes, dedicated to Magritte. Evidently an accommodation had been reached with the pigmy professor, or Magritte had so far swallowed his distaste as to reuse

Maes's canvases—just as he did Flouquet's—and even to collaborate, under the name Maes-Magritte. "I want to see you tomorrow Tuesday at my place between 6 and 6.45 in the evening," Magritte instructed Mesens in December 1921. "I shall show you my latest canvas, which was inspired by a Bach Beethoven Wagner recital I heard last Saturday, and which Maes did with me—'COLLABORAÏREN.'" This was *Le Récital*, the composition known only from a sketch in a letter to Flouquet.[59] Intriguingly, one of the paintings he gave Hortensia Gallemaert in exchange for her piano lessons, *L'Arlequin*, was signed "MK" on the back—a reversed KM, the usual signature of Karel Maes? Magritte enjoyed trading under different names; or appearing, Fantômas-like, in different guises.

Magritte's notion of collaboration was a rather elastic one, involving some sleight of hand. In September 1920 he cheerfully informed Flouquet by postcard that he had finished a sketch Flouquet had begun, "like in the good old days." Was this a habit of Magritte's? Did Flouquet approve? Was it mutual—a kind of dialogue or duologue? A newly discovered drawing, signed "René Magritte 1920," has been duly authenticated; but the *catalogue raisonné* itself draws attention to the possibility that the drawing is not entirely in Magritte's hand, suggesting that it may well have been begun by Flouquet.[60] Such was the slippage between them in this period that, half a century later, Pierre Bourgeois himself could not remember which of them had painted his portrait. Collaboration shaded easily into appropriation. Magritte put his own signature on the cinema posters made by Pringels under his supervision. He did the same a little later with sheet music covers made by Peter De Greef. The signature itself was a gesture, or a *jeu d'esprit*. One of the paintings he gave to Charles Alexandre was signed "F. Rostsaert Paris 1916." For Magritte, the very idea of the artist-creator was a movable feast, as Charles Baudelaire-Nougé could confirm. This was a good game, so long as he was the appropriator and not the appropriated. It was a question of who had the last word. When *Force of Habit* was exhibited in Paris, in 1962, complete with added bird and Ernstian emendation, it appeared in the catalog as a work by Max Ernst, "in collaboration with René Magritte," which may have been Ernst's position but was surely not Magritte's. When Dorothea Tanning showed Magritte what Ernst (her husband) had done to the painting, he gave a forced laugh and walked away. "But he must have hated it," she concluded feelingly.[61] She was right. Five years later, works by Ernst and Magritte appeared side by side in a surrealist exhibition in Brussels. One in particular was of special interest to both artists. According to Marcel Mariën, the work identified there as *The Forest* by Ernst was in fact by Magritte—one of his wartime fakes. Magritte himself

was at the opening. As he went past *The Forest*, he was heard to crack, "That one, that's a great Max Ernst!"[62]

The Station was bought by the singer Évelyne Brélia (Evelyne Bourland) and her husband, the composer and conductor Fernand Quinet. Évelyne Brélia was Belgium's leading interpreter of avant-garde songs in the 1920s. She did several good turns for the whole family in that period. She commissioned a portrait. She interpreted Popol's "Norine Blues." She gave Georgette singing lessons. She was one of Magritte's earliest collectors—the earliest, he liked to say—and one of the boldest.[63]

At the time, Magritte considered the painting *Jeune Fille* (1922), which he showed at the Galerie Georges Giroux, a sort of breakthrough. "I would have you know that ever since the *Jeune Fille* which your eyes beheld with such pleasure in my house when we last saw each other," he wrote to Alexandre, "the conscientiousness with which I executed that work (my first work) has not abated, and thanks to that I feel I am in possession of the personal skill that can express the real me—and I would have you know that those who express their real selves are geniuses—?!?" For a significant moment, then, *Jeune Fille* took its place as his first "first painting," ahead of the other candidates, *La Fenêtre* (*The Window*, 1925) and *Le Jockey perdue* (*The Lost Jockey*, 1926). The celebratory letter to Alexandre contained an invitation to Christmas dinner, the first in the marital home, planned as a lavish affair:

Potage aux pois cassés, croutons
Homard en mayonnaise
Vin blanc
Boudin frit, compôte de pommes
Rosboeuf, chicons au gratin, pommes nature
Fruits—gâteaux—café
Vin—cigarettes

To this repast Magritte invited Messrs Alexandre, Bourgeois, Flouquet, Mesens, and Servranckx, together with sisters and spouses. He also invited them to contribute "the modest sum" of 20 francs each.[64]

Jeune Fille reappeared in *Femmes*, as the figure on the right of that sportive trio. David Sylvester remarks on "a succulent realization of the stylized pubic hair"—one of Magritte's specialities—and on the sexiness of the work more generally. In a rather different register, Pierre Bourgeois remarked on much the same thing. "Then we see him investigating the eternal female nude and expressing his feverish passion with an insistent love. To intensify the rhythmic significance of the bodies, triangles and colored patches constitute a simple and melodious background to them. A passionate and cerebral life thus affirms its provocative unease."[65] Perhaps Magritte himself spoke true, after all, when he recalled the little girl he played with in the old cemetery, the subject of his reveries ever since: "However, I don't think I was a very orthodox Futurist because the lyricism I wanted to master had an unvarying centre, unconnected with artistic Futurism. It was a pure and powerful feeling: eroticism."

These paintings testify to Magritte's continuing interest in futurism, lyricism, and eroticism, not necessarily in that order. *The Station* (and its counterpart, *The Locomotive*) might be described as post-futurist. *Jeune*

Fille is almost postcoital. There are hints of constructivism, and also traces of cubism—especially in *Femmes*—clearer still in another work of the same period, another three women, anonymous and curvaceous, arrayed suggestively in an interior, a work entitled *Le Thé* (*The Tea*), which seems to pay tribute, gastric and stylistic, to Léger's *Le Grand Déjeuner* (*The Big Lunch*, 1921).[66] Léger went into the pot, along with the journal in which that painting first appeared, *L'Esprit nouveau*, the tribune of a new movement, "purism."

Purism was a reaction to cubism and the Great War—a bid to put both behind them—led by the painter Amédée Ozenfant and the architect Charles-Édouard Jeanneret, better known as Le Corbusier. They championed traditionalism, even classicism, with a formal emphasis on clean lines, refinement, visual clarity, and purity, while at the same time embracing new technologies, new materials, and the machine aesthetic. Magritte's approach to purism was decidedly impure. As if to demonstrate his eclecticism, or possibly his irresolution, all the while he was painting the recent work he was also writing a tract, *L'Art pur: défense de l'esthétique* (1922). His collaborator in this venture was Victor Servranckx, the outstanding geometric abstract painter of his generation in Belgium. At that stage Servranckx outranked Magritte in every respect, though he was only one year older. As an artist, he had already found his way. At the Peters-Lacroix wallpaper factory, he was artistic director and in effect Magritte's superior. He was wise beyond his years. (He bought wisely at the Centaure sales, and made a killing.) Servranckx was the senior author, and very likely the prime mover, though it is almost impossible to isolate their respective contributions, and in a sense the issue is immaterial: negotiations with a publisher fell through, and the tract remained unpublished in their lifetimes.

L'Art pur is not very purist. It is more *défense de l'esthétique* (the original title) than manifesto or manifestation of purism. It has some affinity with that doctrine, in its dismissal of the secondary and the ornamental, among other things; but in tribal terms it is non-doctrinaire, emphatically rejecting any sort of stylistic or iconographic prescription. For the rest, it is trenchantly written, with acerbic asides that may safely be attributed to Magritte. The painter, it holds, "should be familiar with technique, MASTER not SLAVE of his métier. Virtuosity is for certified idiots." It concludes with the aid of a quotation from *Le Coq et l'arlequin*:

> "In art, any proven value is vulgar."
> Aesthetic emotion is felt by the sentient viewer.
> THE FORMAL PROBLEM MUST BE RESOLVED PAINTBRUSH IN HAND.[67]

Before he was a surrealist, Magritte was if anything a syncretist.

Some time during the latter part of 1923 he came face-to-face with his destiny, in the form of a painting by Giorgio de Chirico, who was one of the painters most admired by the Paris surrealists: *Le Chant d'amour* (*The Song of Love*, 1914) [color plate 24]; to be more precise, a black-and-white reproduction of that painting in the review *Les Feuilles libres*, a very contrasty reproduction, as Sylvester has it, which only heightened the drama of the outsize objects suspended in the foreground of one of de Chirico's "metaphysical landscapes"—a plaster head that looks like a cast of the Apollo Belvedere, a rubber glove that looks like one of those worn by surgeons, and a green orb that looks like a medicine ball.[68] He was shown it by Lecomte, or Mesens, or both. He was overwhelmed.

Magritte's discovery of de Chirico (and thereby himself) is one of the great myth-making moments of modernism. It was at once an epiphany and a hard slog. Like Georges Braque's discovery of Cézanne, a shattering moment was parlayed into a transformative experience: a revelation of affinity and a process of anamnesis, a "memory" of what he did not know he knew. "The discovery of his work overturned everything," Braque told an interviewer. "I had to rethink everything. I wasn't alone in suffering from shock. There was a battle to be fought against much of what we knew, what we had tended to respect, admire, or love."[69] So it was for Magritte—the shock, the struggle, the shedding of the old skin, the trying on of the new. Some of this was sudden and uncontrollable: by his own account, Magritte was moved to tears. The implications were profound. They would take time to absorb. Like Cézanne, de Chirico could not be grasped in an instant. "I sensed that there was something more secret in that painting," said Braque of de Chirico's work. It was similar for Magritte. There was more at stake than plaster heads, rubber gloves, or medicine balls.

 Magritte always spoke of de Chirico as his one and only master. As a rule, he was exceedingly parsimonious in his assessment of other artists, past and present. In his own time, de Chirico (1888–1978) and Ernst (1891–1976) appear as the only two he admired, more or less unconditionally.[70] He was prepared to concede some historical importance to Marcel Duchamp (1887–1968). "He has shown that very banal objects can acquire precious charm, thanks to very small modifications: in Paris, for example, he has a sealed bottle which contains nothing but air, with a sticky label which says AIR DE PARIS."[71] He admired Duchamp's underlying intellectual seriousness (and his chess). Duchamp was one of the very few painters whose thoughts he quoted approvingly—"that fine *pensée* of Duchamp's, 'Since there are no solutions, there are no problems.'" He would surely have endorsed Duchamp's

exasperation: "I am sick of the expression *bête comme un peintre*—stupid as a painter."[72] He esteemed Francis Picabia (1879–1953), more than he let on, for his art and for his attitude—his delight in giving gratuitous offense. It was Picabia who published Duchamp's iconoclastic and now iconic portrait of a moustachioed Mona Lisa, on the cover of his review, *391*, to which Magritte himself contributed a few pallid epigrams borrowed from the barbershop chorus with Mesens. ("I like beer and hollyhocks." "A man in his birthday suit.")[73] At first, he was very taken with the work of Salvador Dalí (1904–89)—as Dalí was equally taken with the work of the man he identified as "Renné Margueritte"—but he was soon disillusioned. He came to feel that Dalí was superfluous, as he was fond of saying, and, furthermore, unworthy of his talent. Dalí was one of those who had taken his place in the sun. "In your account of the visit you paid to the exhibition of so-called 'fantastic' art at Ostend," he reprimanded André Bosmans in 1959, "you forgot to mention the one who seems to me to be the first to keep in mind—before me, Ernst, and the superfluous Dalí—Chirico."

> He is really the first painter who thought to make painting speak of something other than painting. "Objectively," if that's possible, I would then say that Ernst *sometimes* has a reality that wakes our faith in the marvellous if it goes to sleep. I would further remark that Dalí is superfluous: that burning giraffe, for example, is a stupid caricature, an unintelligent exaggeration—because facile and unnecessary—of the image I painted showing a piece of paper in flames and *a key in flames*, an image I then refined further by showing only a single object in flames: a trumpet.
>
> For some time, also, Dalí has demonstrated that he is well and truly in that sordid world in which one can have an audience with the Pope and prize historico-religious painting without a shred of the religious feeling that would justify that way of "being"—which is truly the sign of rampant superficiality.[74]

Magritte was strongly averse to imagined communities and invented traditions, especially national subcultures. "Grouping artists because they are 'Walloons' or because they might be, for example, 'vegetarians,' doesn't interest me at all (although 'vegetarian' artists would have a slight superiority over 'Walloon' artists: a good joke)."[75] He followed Henri Michaux's maxim: "Always keep a reserve stock of maladaptation."[76] Magritte did not believe in Belgianness. "Belgian" was another label, foisted on him without much forethought. "I'm often asked if I see myself as the heir to the great Belgian painters. Why Belgian, exactly? For me, Belgian painting is only one episode

among others in the general history of art. And Bosch is mentioned . . . Hieronymus Bosch [1450–1516] lived in a world of folklore and phantasms. I live in the real world."[77] Nevertheless, having due regard for his patrimony, he canvased as an influence the daring Frits Van den Berghe (1883–1939), from Ghent, another in the Van Hecke stable, *Portrait of P.-G. and Norine Van Hecke* (Antwerp), who had impressed him from an early age.[78] He is also said to have admired Antoine Wiertz (1806–65), and may well have drawn on his work, in particular a nude with the suggestive title of *La Liseuse du romans* (*The Reader of Novels*).[79]

He had little to say about his preferences, even in private. Some of what he did say came as a surprise. "My first visit to the Louvre would be enough to teach me English," he told Lecomte, in 1923. "*La Source* by Ingres is the finest picture I've seen so far, along with a virgin and child by Baldovinetti. The 'Greek postures' are presented too theatrically to move me. The Mona Lisa had in front of her an imitation done by one of the too many people who go in for that kind of sport. A few Cézannes, not very important, and Monet, who is fairly workmanlike when you see a work in colour."[80] Later on, when Marcel Mariën asked him what he liked, he mentioned Jacob van Ruysdael (1628–82), in particular *The Jewish Cemetery*, the subject of a penetrating essay by Goethe, which he may have known. ("The tombs in their ruinous condition even point to something more than the past: they are tombstones to themselves.")[81] He also mentioned the paintings of Lionello Balestrieri (1872–1958), which he knew from postcards; he was especially fond of *The Farewell* and *Beethoven* (*Kreutzer Sonata*). That was about all Mariën could get out of him. He had a certain weakness for Botticelli (1445–1510), adapting the famous *Primavera* for his own purposes in *Le Bouquet tout fait* (*The Ready-Made Bouquet*, 1956). When he paid a fleeting visit to the Uffizi Gallery in Florence, however, his only recorded reaction was derision: "I saw Botticelli's *Primavera*, it's not

bad, but it's better as a postcard. Apart from that, there are a few good pieces of painting, but mostly a lot of rubbish."[82] He never seemed to buy anything, even when he had the means. Unaccountably, in the late 1950s he tried in vain to locate a particular canvas by the futurist Luigi Russolo, *Aspiration*.[83] Exchanges came and went, like the Ernst for the bathroom. The house was full of trinkets. The paintings on the walls were Magrittes, including an imitation Klee, for whom he had scant regard ("purely decorative, nothing more").[84] As if to defy convention, the only work by another artist that he kept and displayed for the duration was a photograph by Man Ray, a Venus de Milo with makeup: spectacular eyebrows and gorgeous painted lips.

The precedence accorded de Chirico, therefore, was all the more remarkable. Once alerted, Magritte must have seen him everywhere. The first issue of *La Révolution surréaliste*, the surrealist house journal and hymn sheet, appeared in December 1924. A dream of de Chirico's was included. For Magritte there was a curious paternal resonance: "I think that my father is no longer in the patisserie, that he has fled, that he will be chased like a bandit, and I wake in the anguish of that thought."[85] Thereafter de Chirico featured regularly in its pages, in words and images, including even a selection of his poetry. The fourth issue contained two of his *pensées*, dated 1913. They appear to have helped Magritte to understand what it was he was trying to do.

What is necessary, above all, is to rid art of everything known up till now, every subject, every idea, every thought, every symbol must be put aside.

Thought must completely detach itself from everything that we call logic and sense, completely free itself of all human constraints, such that things appear to it in a new light, as if illuminated for the first time by a shining constellation.[86]

By the time he came to compose "Lifeline," in 1938, Magritte had learned to talk Chirico; he had mastered the language in which to convey what the Chirican project signified. He had the advantage of an interpreter. In May 1924 the review *Sélection* published an article on de Chirico by René Crevel, with six illustrations, one of which was *Le Chant d'amour*. Magritte would not have missed it. (Mesens was on the editorial board of the journal, and Magritte had seen the exhibition of Parisian cubism in its gallery space.) Crevel's approach to de Chirico was a striking mix of the personal and the philosophical. He insisted on the foundational importance of "the first impression." Revelation was paramount, however mysterious it might appear to the stunned spectator. On this account, de Chirico was indeed a revelator, an artist of the

extraterritorial, if not the extrasensory: like an archaeologist, he exposed the metaphysical foundations of the city, as if rescuing Pompeii from the ashes. In a word, he materialized on canvas what Crevel called "the noumenal."[87] In other pieces he wrote more straightforwardly about himself, in the third person, as Magritte would do in his autobiographical sketch. "One day, in front of a painting by Giorgio de Chirico, he had a vision of a new world." So armed, "he abandoned once and for all the old logico-realist attic, understanding that it was cowardly to confine himself to quibbling mediocrity." For Crevel, de Chirico's pictures were entrancing—he longed to walk into them—and above all uplifting. They make us "more worthy of the search for the absolute in which a Kant could feel his spirit grow in the fever of the noumenal."[88]

Here is Magritte's cherished "mystery" by other means. Magritte lived in the real world, but not the realist one. He was not much troubled by philosophy, as yet, though in due course he would tackle Kant's *Critique de la raison pure*, and a lot more besides, while at the same time reading detective novels concealed in the dust jackets of the philosophy books given to him by Paul Colinet. He did not speak of the noumenal. He spoke of poetry. And, equally characteristically, *thought*. "When I first saw the reproduction of Chirico's painting *Le Chant d'amour*, it was one of the most moving moments of my life: my eyes *saw* thought for the first time."[89] In "Lifeline" he delivered a verdict of startling sweep and declaratory force. Revelation and revolution were conjoined:

> In 1910, Chirico played with beauty, imagining and achieving what he wished: he painted *Mélancolie d'une belle après-midi* [known in English as *Melancholy of a Beautiful Day* (1913)] in a landscape of tall factory chimneys and walls stretching to infinity. He painted *Le Chant d'amour* in which we see surgeon's gloves and the face of an antique statue brought together. This triumphant poetry supplanted the stereotypical effect of traditional painting. It represented a complete break with the mental habits peculiar to artists who are prisoners of talent, virtuosity, and all the little aesthetic specialities. It was a new vision through which the spectator recognizes his own isolation and hears the silence of the world.[90]

Magritte never recanted his veneration of de Chirico, despite the pervasive doubts in surrealist circles about the trajectory and temperament of the great progenitor. The doubters had invested heavily in de Chirico's earlier work—precisely the period of *Le Chant d'amour*. Ten years on, at the very moment Magritte was making his acquaintance, they had begun to think that

he had turned into a menial parodist of his earlier self. Éluard had a clutch of classic de Chiricos in his collection, including *Mélancolie d'une belle après-midi*.[91] Breton, too, collected de Chirico; *Le Cerveau de l'enfant* (1914) hung above his bed. His pronouncements on the artist follow a pattern that became depressingly familiar. "Giorgio de Chirico" (1920) hailed him as a kind of prophet. "I believe that a veritable modern mythology is being formed. It falls to Giorgio de Chirico to fix it indelibly in our memory." *The Manifesto of Surrealism* (1924) signaled reservations, still rather veiled, about de Chirico ("so admirable for so long") and a long list of others, including Max Ernst. *Le Surréalisme et la peinture* (1928) contained an anathema on "the surrender" of his later work—"the least one can say is that inspiration is totally lacking and that a shameless cynicism is flagrantly evident"—not to mention his "complete amorality."[92] André Breton was nothing if not a moralist, with a fine line in disdain. "It has been said that I change men the way most people change socks. Kindly allow me this luxury, as I can't keep wearing the same pair forever: when one stops fitting, I hand it down to my servants."[93] He was also an authoritarian, or rather a disciplinarian. Few escaped the lash of his tongue. Miró was charged with "infantilism," Dalí with "self-kleptomania." Excommunication was a common fate. No wonder he was dubbed "the Pope of Surrealism."

Magritte would have none of this. Twenty years on, *La Mémoire* (*Memory*) showed a bloodied plaster head, as if in kinship. During the preparations for his retrospective at the Museum of Modern Art in New York, in 1965, he wrote to the organizer, James Thrall Soby:

> It was in 1922 [1923] that I became acquainted with the works of de Chirico: a friend showed me a reproduction of his painting *Le Chant d'amour*, which was a revelation for me, and which I still consider to be a work of the greatest painter of this age, in the sense that it's all about the primacy of poetry over painting and the various ways of painting: Chirico was the first to consider *what has to be painted* rather than *how to paint*.[94]

That became the critical distinction. Pursuing the question of "influence," at Soby's behest, Magritte elaborated to Harry Torczyner:

> If influence there is—it is very possible—there is no resemblance, however, between *Le Jockey perdu* and the paintings of Chirico. In the final analysis, the influence in question is confined to a great emotion, a marvellous revelation, of seeing for the first time in my life a truly poetic

painting. Over time, I too began to give up experimenting with painting in which *the way of painting* took priority. Now I can see that since 1926 I was more concerned with *what has to be painted*. That didn't become clear for quite a while after having experimented "instinctively" with what has to be painted.[95]

What has to be painted meant that he would concentrate on the object or the problem at hand, eschewing "all the little aesthetic specialities." Thus, to take the example he gave, his sky was always the same sky blue, and his sea was always the same sea green, topped by the same cresting wave—copied from a postcard. That was de Chirico's lesson: a style that did not call attention to itself, a transparent style, "a style without ceremony, a style as emphatically direct as that of a comic strip."[96]

The shock of de Chirico and the impact of *Le Chant d'amour* cannot be gainsaid. The title alone must have given him pause. De Chirico's way with titles prefigures Magritte's. If he *saw* thought, he also *heard* silence. In de Chirico's parlance, still life was "silent life." He watched television with the sound turned down.

What exactly Magritte saw in that painting is more difficult to determine. Given that the revelation came from a monochrome reproduction, it can hardly be the colors. Magritte seems to have been immune to the charm of the red rubber glove, ubiquitous in de Chirico, even when it appears as a red hand—as it does in *L'Énigme de la fatalité*, where it could almost be a severed hand, an echo of Fantômas and *La Main coupée*. It was not the objects themselves, however outlandish. In "Lifeline" Magritte referred to "surgeon's gloves," in the plural, rather than the singular. What he originally wrote was "boxing gloves." (The mistake was corrected by Mariën.) Coming from a devoted admirer, such carelessness is perplexing, especially as de Chirico's rubber gloves might very well have reminded him of Fantômas's skin gloves—human skin—worn in order to leave someone else's fingerprints on the victim, in *Le Mort qui tue*. The point he sought to make in "Lifeline" was not about the objects, as such, but their juxtaposition ("we see surgeon's gloves and the face of an antique statue brought together").[97] It is our encounter with their encounter that is the source of the "surprise" that was another of Apollinaire's lessons for the surrealists. "The strangeness of the artistic enigmas that M. de Chirico offers us is still lost upon the majority," Apollinaire remarked presciently in 1914. "This painter draws upon that most modern of resources, surprise, to depict the fateful nature of modern things."[98] For Magritte, things were fateful indeed. De Chirico's paintings were chock full of them. Magritte

would have relished Jean Cocteau's dictum: "Death is the only piece that moves freely in any direction on Chirico's chessboard."[99]

Not only the pieces, moreover, but also the squares they occupy. "I think every image calls into question with more or less force the idea of space," said Magritte in 1947. "Chirico did just that. He made space 'live' by peopling it with extraordinary objects which gave 'perspective' a new face."[100] That is a good summary of Magritte's experience of *Le Chant d'amour*. De Chirico's metaphysical landscapes may be derived from one piazza or another in Florence or Turin, as he claimed, or from the "mysterious feeling" he discovered in Nietzsche, as he also claimed; they may be "the streets of some noumenal city," as René Crevel proposed.[101] The congested metaphysical interiors may be studios and more than studios. Inside or out—it is often hard to tell—they have an otherworldly quality, a sense of suspended animation, like a film set or a crime scene. Or a Magritte.

De Chirico was an inspiration and a liberation. "Each one of us carries within himself a productive originality which is the very core of his being," affirmed Nietzsche, "and if he becomes aware of this originality, a strange aura, the aura of the extraordinary, shapes itself around him."[102] The discovery of de Chirico enabled Magritte to become aware of his productive originality. As Mesens suggested of his friend, quoting Kafka, "From a certain point on there is no return. This is the point to reach."[103] De Chirico was his chrysalis. He emerged as Magritte. "I couldn't paint like Chirico," he explained, much later. "I was searching for something to paint, you know, following the example of Chirico, and it wouldn't do to paint what Chirico painted."[104] His painting was his own. Elated or uplifted, he made his "*moi*." Magritte, too, rose to the occasion. Slowly, slowly, the aura of the extraordinary began to wrap itself around him.

5.

Charm and Menace

The revelation of de Chirico had a startling effect: Magritte all but stopped painting. In 1924 he produced only a handful of pictures—four or five, including *La Femme ayant une rose à la place du coeur* (*The Woman with a Rose Instead of a Heart*); in 1925, around a dozen, including *Cinéma bleu* and *La Fenêtre* (*The Window*). This was a lengthy pause for thought.

He was very attached to the woman with a rose instead of a heart. Twenty years later, he worked for a while on a project to illustrate the fairy tales of Madame d'Aulnoy, who was mentioned by Magritte in the same breath as Lewis Carroll; and then on a rather similar commission from Van Hecke to illustrate William Beckford's Gothic novel *Vathek*—"one of the most beautiful books in the world."[1] Neither of these projects came to fruition. As a spin-off from the former, he produced *Le Roman populaire* (*The Novelette*), a novelettish picture of a woman with a rose embedded in her hair.[2] When he submitted his designs for *Vathek*, Van Hecke readily accepted them all, bar one, for which he requested a more "oriental" substitute, "*dans le genre fantastique.*" Magritte was extremely put out by this response. He went as far as drafting a reply and sending it first to Mariën. It read as follows:

> I am pleased to learn that the twelve drawings for *Vathek* will not undergo any modifications. It would no doubt have been possible to redo a complete series of these drawings, taking account of some new external element to be incorporated (as I did in certain paintings, for example *Les Bons Jours de Monsieur Ingres* [*Monsieur Ingres's Good Days*], *Le Retour de flamme*, *Le Traité de la lumière* [*Treatise on Light*], but since the text

is already an external element, I would have been confronted by complicated and perhaps contradictory requirements.

As regards the drawing under discussion, I am certain of its poetic force: what inspired me was not the oriental character of the girl Beckford talks about (given that a character of that kind is very banal and hardly emphasized in *Vathek*, a book completely devoid of any realist concern with local color), but a combination of elements capable of conveying a sense of charm. The image I proposed comes from way back: it first began to make its presence felt in a little picture of 1924 (a longhaired girl with a rose instead of a heart), then when I was planning to illustrate the tales of Madame d'Aulnoy, in which a girl living in that enchanted world was shown as in the drawing in question. Then, giving up on illustrating the tales, I painted a picture, *Le Roman populaire*, which was a tangible sign of the importance I attach to this image. Then a kind of fate willed that I should find in *Vathek* the trace of a girl who is always the same for me. The feeling is by no means circumstantial, and as so often perhaps the discussion has touched on something fundamental.[3]

Magritte had no truck with *le fantastique*. "I am not 'a painter of the fantastic,'" was his withering response to someone else who had the gall to solicit a contribution from him in that vein. "The vulgarity and triviality of the fantastic seem to me to go without saying."[4] *Le charme*, on the other hand, was a positive virtue. For Magritte, "charm" was a kind of litmus test. In his mature formulation: "As far as possible, I try to paint only pictures which evoke mystery with the precision and charm necessary to the life of the mind."[5] It was also a political instrument, or a subversive agent. In the middle of a furious argument with André Breton about the nature and purpose of surrealism, in 1946, he insisted, "To provoke 'a serious crisis of conscience' by means of charm . . . is a far cry from the 'disturbing' effects so dear to the show-offs. Charm and menace combined can reinforce each other. Fairy tales, *Alice [in Wonderland]*, and more recently, the film *Peter Ibbetson* are examples."[6] When he painted a picture of a little castle perched on top of a huge boulder hanging in the air above the usual wave, in 1959, he called it *Le Château des Pyrénées* (*The Castle in the Pyrenees*), after a novel by Ann Radcliffe, known in French as *Les Visions du château des Pyrénées*. The painting was for Harry Torczyner, who had asked for something to cover a window in his New York office. "It is in the nature of an 'apparition,'" Magritte informed him, "which Ann Radcliffe would have liked, I think, if her book . . . allows us to know what she really liked." Torczyner, who had been born and educated in Antwerp, was not familiar with the English author Radcliffe. Magritte explained:

"Radcliffe's *Château des Pyrénées* is a romantic 'Gothic novel' which has the charm and the flaws of a literary school that is not immune to gaudiness. You may perhaps be disappointed when you read it, but delighted by the atmosphere it conjures up." Magritte himself would probably have been tickled to know that the book is a fake. It is not by Ann Radcliffe, but by Catherine Cuthbertson, a "Radcliffe imitator" of modest renown. Appropriately enough, the visions are castles in the air. Magritte's apparition, however, is the real thing.[7]

Notwithstanding Magritte's feelings for her, the woman with a rose instead of a heart was a letdown on first acquaintance. "Lifeline" testified to the letdown, and the hard slog.

> I began to produce pictures with a new aim, but in my old style of painting; the contradiction made the research very difficult: my efforts to demonstrate the evident existence of an object were neutralized by the abstract image I was using to represent it. The rose that I put in place of a heart in the bosom of a naked girl did not produce the overwhelming effect I had expected.
>
> Subsequently, I introduced into my paintings objects with all of the details they show us in reality, and I soon saw that this was the only way my experiments could rise above the level of images and take on the real world.[8]

That sounds simple enough, but it was not. Taking on the real world demanded a certain something—gravitas, perhaps, or a combination of charm and menace—which Magritte had not yet acquired. The heart transplant (or the rose transplant) evidently left something to be desired. The siren *Song of Love* haunted him still. The struggle continued.

There were other obstacles in his path. The most basic was how he was going to live—not in the elevated realm of Maurice Barrès and *le culte de moi*, but in the cold light of day, after throwing in his job at the wallpaper factory. "René Magritte found the factory as unbearable as the barracks," runs his autobiographical sketch. "He left after one year of employment, and tried to make a living out of doing mind-numbing work: posters and designs for advertising." In fact he was there for two years; and he seems only to have quit on the spur of the moment, after a quarrel with the director. "He was extremely condescending towards me, and I have never been able to tolerate that," Magritte told an interviewer, much later. "So I left his factory, where in any case I was beginning to get bored, and struck out on my own."[9] Independence was all very well, but the side effects were severe. "The artist must be able to live from the product of his labour," *L'Art pur* declared roundly, in

Marxian terms.[10] Perhaps Victor Servranckx, with whom Magritte wrote that text, could work that trick which he could not.

. . .

As with the "intermittent" character of his engagement with the Acadé-mie—an intermittence diligently pursued for some six years—Magritte always contrived to emphasize the alienating character of his experience of commercial art, beginning with wallpaper design at Peters-Lacroix. "Your commuting from Paris to Versailles reminds me of my daily trip from Brussels to Vilvorde when I had to go and design wallpaper in a factory," he wrote sympathetically to Maurice Rapin in 1956. "I didn't have any greater liking for that work than you do for the research or analyses you do in your bosses' laboratory."[11] The mainstays of his former employment found their place on the list of pet hates. "I also hate the decorative arts, folklore, advertising."

His application belied his disdain. So did the product. Magritte's wallpaper designs were not particularly distinctive—as if to acknowledge the anonymity of the factory, his name appears as Margritte, Margriet, and Margerit—but it is clear from his correspondence that he set out to master the intricacies of this new metier, and its peculiar discipline must have been a valuable lesson in composition. The designs migrated into his art: one gouache was painted to look like a papier collé or a collage, owned by Victor Servranckx. Thereafter he diversified, with great success. His skills in graphic design were harnessed by a variety of clientele to advertise everything from fast cars to fur coats, toffees to cigarettes, Pot-au-feu Derbaix to Persan Bitter de marque. The Magritte touch

worked for the Festival Mondial du Film et des Beaux-Arts Bruxelles and the Comité de Vigilance des Intellectuels Antifascistes. And for all kinds of music, from *Marches des Snobs* to *Marie Trombone Chapeau Buse*, *L'Heure du Tango* to *Sarabande Triste pour piano*. He designed at least twenty-five sheet music covers for L'Art Belge between 1924 and 1930, including *Cinq Mélodies Orientales* (1924) for Fernand Quinet and *Norine Blues* (1925) for Évelyne Brélia, and a further sixteen for Éditions Modernes between 1933 and 1938, under the pseudonym Emair (a phonetic transcription of his initials reversed). He fulfilled any number of commissions for Norine, "the Chanel of the north," eye-catching advertisements that were all over the magazines and reviews of the period: *Sélection*, *Le Centaure*, *Variétés*, *Cahiers de Belgique*, to say nothing of *Psyché*, "*le miroir des belles choses*." The cover of the March 1925 issue of *Psyché*, "Tea for Two," featured "an afternoon ensemble, dress and coat, in flowing black and multi-coloured crêpe de Chine, created by Norine," evoked by Magritte.[12] He even designed a coquettish mannequin head for a hat stand (in *Variétés*, June 1928). So far from being disengaged or disaffected, he was a model of professionalism. The sheer profusion of this work is already cause for remark. Its prolongation throughout the interwar period (and beyond) is a sharp reminder of the extreme precariousness of Magritte's financial situation

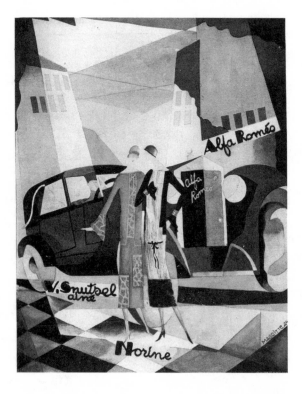

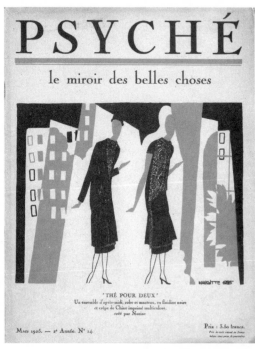

as a painter—that is to say, as an *artiste-peintre*, another label he would have scorned—until the 1950s, if not later. Painters have always been part of the "precariat." Magritte was practically a life member.

If he regarded some of the assignments as jobbing, or slumming, others clearly piqued his interest. Commercial art and design led naturally to a kind of cross-fertilization. The artwork, even the advertising, did not issue in isolation. It may have been an economic necessity, but it was also a stimulus to creativity, an invitation to experimentation, linked inextricably to his easel painting and to his papiers collés and collages. Magritte started working in papier collé in 1925. Over the next two years he produced thirty of them, in a sustained burst, whereupon he dropped it. He did not take it up again until the end of the 1950s. Papier collé was another mode of experimentation—another way out of the impasse de Chirico, via Ernst, with an admixture of André Derain. "Lifeline" paid tribute to them all:

> In illustrating Paul Éluard's *Répétitions* [1922], Max Ernst demonstrated magnificently that one could easily dispense with everything that lent traditional painting its prestige, by means of the overwhelming effect of collages made of prints from old magazines. Scissors, paste, images and genius effectively superseded brushes, paints, models, style, sensibility, and that great sincerity demanded of artists.
>
> The works of Chirico and Max Ernst; certain of Derain's pictures, among others *L'Homme au journal* [*Man with a Newspaper*], in which a real newspaper is put in the hands of a painted figure; Picasso's discoveries; the anti-artistic activity of Marcel Duchamp, who proposed in all innocence to use a Rembrandt as an ironing board: these were the beginnings of what we now call "Surrealist painting."[13]

Derain's *L'Homme au journal*, otherwise known as *Portrait du chevalier X*, metamorphosed into Magritte's *L'Homme blanc* (*Man in White*), taken by his friends to be a portrait of Marcel Lecomte, its first owner. The family resemblance is clear, just as it is in *La Fenêtre*—Magritte's second "first painting"—for which he borrowed the window, the curtain, and the view from Derain, and the hand and the bird from Ernst, and managed by the skin of his teeth to make a Magritte of it.[14] More persuasively, in one of the papiers collés the clouds metamorphosed into floating bilboquets (or flying machines), à la Ernst, while the picture frame within the frame borrowed from de Chirico [CR 1602]. This papier collé, like almost all Magritte's papiers collés, made use of sheet music from *The Girls of Gottenberg* (1907), a musical comedy by George Grossmith Jr. and L. E. Berman—apparently an arbitrary selection.

The sheet music was used to paper the bilboquets. By accident or design, the legible lyrics on the highest cloud bilboquet read, "For . . . the trees . . . say what you please," which seems strangely apt, as well as euphonious; while on a toothy bilboquet in another example there is the line "Fancied in my foolish way that I loved a w—an."[15] The sheet music could also take bird or human form; or it could be cut out as curtains; or take shape as an inscrutable object that looks a little like the neck and scroll of a violin, sprouting out of the ground, with vestigial branches or growths, complementing the arboreal bilboquet [e.g., *Untitled papier collé* 1926 or 1927].

The papiers collés were deeply indebted to Ernst, as Magritte acknowledged, and yet they had a nerve or a verve all their own. Ultimately, they were a sideline. Experientially, it was a productive one. The papier collé was also a kind of calling card. When Magritte decamped to Paris, in 1927, he took with him *Nocturne*, the papier collé counterpart of *Campagne*, the painting that could have been dashed off on a summer's night (and retitled accordingly by Nougé).[16] *Nocturne* was snapped up by André Breton. It was the first Magritte to enter his collection. Others quickly followed.

Cross-fertilization extended to Magritte's accomplices. Commercial art was a close-knit affair, involving his wife, who also modeled for the cigarette advertisements; his brother Paul, who aided and abetted in so many of these activities; and his co-conspirator, Nougé. Sometimes they fulfilled a specific commission. Sometimes they had ideas of their own. The ideas were not commonplace. Nougé's idea for a poster advertising Sunlight soap: a bar of

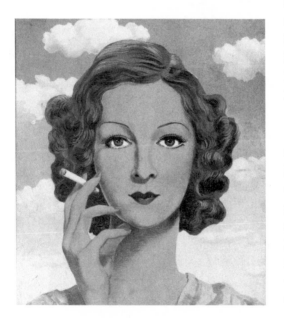

soap surrounded by three hands— the black hand of the worker, the red hand of the murderer, and the white hand made by a little Sunlight soap. Magritte tried this out, and sent Nougé a report on the results:

I did the poster with the hands, on a black background, with white lettering. The impact was striking, of the same order as a successful painting. But the public absolutely insists on mediocre things. At Sunlight, they rejected the proposal, for a different reason than that which might have been expected: this poster had too much impact; it

would be good for the launch of a [new] line. This house [Sunlight] only wants the most discreet adverts. As for Bon Marché, they wanted to modify the original proposal: to have a camel shadow, a veiled woman, etc. All that isn't very encouraging. Truly, it's only on very rare occasions that one can hope to get a striking idea through. At Tabacofina, they rejected the proposal for a "Message from the Orient." They've already used this idea of an oriental prince who brings a European woman a packet of cigarettes. In colour, the design produced a strong contrast between the two persons. I gave the man a mysterious character; he seemed to have come from a strange country. The colour of his face made him a very different person from the white woman who saw him arrive. (I'm enclosing the complete copy with this letter.) When he saw the design, cold, without any warning, my brother [Paul] immediately spoke of magic.[17]

The commercial work quickened the magic. It also served to establish the motifs. An early series of adverts for Norine, in 1924, introduced the motif of a painter and his canvas—a painting within a painting—while a photograph of a real-life mannequin modeling an ensemble called "Le Signal" introduced the artist himself: Magritte appears or disappears behind a screen in the background. A scarlet woman bilboquet, minimally draped in a length of fine stuff, embodied "Couture Norine" for a generation [color plate 25]: a whiff of eroticism and surrealism was the perfect combination. The painting *Il ne parle pas* (*He Is Not Talking*) may be modeled on a work of de Chirico's, but it also seems to make use of the mannequin head—and to prefigure one of the best photographs of Magritte and Georgette, *L'Ombre et son ombre*, one behind the other, the shadow and its shadow.[18] *Le Jockey perdu* meets his fate in oil paint and in papier collé. Likewise the solitary walker. Magritte chanced his arm in more than one medium. He also disclosed something of himself. The chanciness and the boldness were emphasized by his allies: perhaps they were responding to what he told them. Magritte always prized *Le Jockey perdu*—his third "first painting." Was that his self-image at the time? His subsequent reflections in the autobiographical sketch are rather Delphic, and not entirely serious: "In 1925, still plagued by want and financial misery, René Magritte could only paint, think, and see his friends in his spare time. He finished a painting, *Le Jockey perdu*, conceived without any aesthetic intention, with the sole aim of RESPONDING to a mysterious feeling, a 'motiveless' dread, a sort of 'call to order' that impinged on his consciousness at certain non-historic moments and directed his life from the beginning."[19]

From the outset, he was publicly identified with that dark horse. One of his closest friends, Camille Goemans, who became his dealer in Paris, wrote

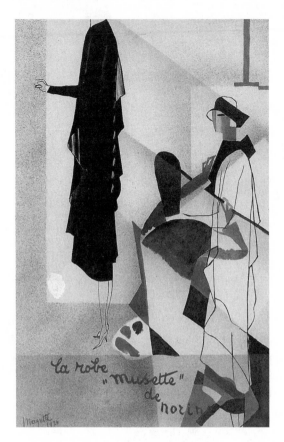

La robe "musette" de nori[...]

of "René Magritte, hurtling recklessly into the void," his character mirroring his creation in *Le Jockey perdu*. His patron Van Hecke enlarged on this in an intriguing profile, "René Magritte, painter of abstract thought," in *Sélection* (1927), the first such treatment to appear in print. Van Hecke continued the metaphor: "Klee and Chirico, the starters, signalling 'the off,' Magritte was at that very moment the jockey who strayed. But who strayed the better to seek the supreme but vain fate of the loner. An adventure to be essayed on his own course, a corrugated iron track vanishing into the woods, where the blank and impervious bilboquets sprout their green designs. There he found his sphere, cold and exact, and surely as difficult to invent as to discover."[20] These flights may well have taken their inspiration from *The Divine Comedy*, which opens with just such an image:

> *Half-way along the road we have to go,*
> *I found myself obscured in a great forest,*
> *Bewildered, and I knew I had lost the way.*[21]

If the jockey was a stand-in for Magritte himself—a stunt double—it would help to explain his preoccupation with this image, to which he returned at intervals for the next thirty years, on one occasion explaining that "the jockey has got lost through his own stupidity."[22] It would also underline his insecurity. The horse and jockey were lifted from Larousse, from an entry on "The Races," where they are losing by a length. Magritte was anxious to avoid the same fate.

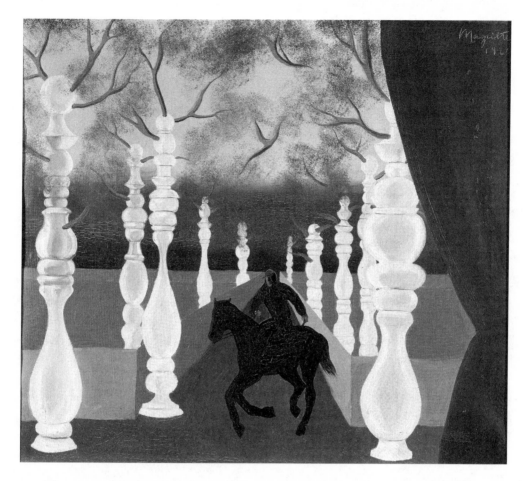

The omens were not good. His father had gambled and lost; his race was run. He himself was a rank outsider, and an unknown quantity and he was aware of others who were further along—older and bred well for surrealism—notably Jean (Hans) Arp and Joan Miró. Arp in particular was a fascinating study, for his work in every medium—when they met in Paris, Georgette did the sewing for a number of his string reliefs—and also for his words. Arp could write, as Magritte longed to write, with penetration and precision and wit. In 1926 Arp wrote entrancingly of trees and leaves: "[L]eaves never grow on trees, like a mountain in a bird's-eye view they have no perspective. The onlooker is always in the wrong vis-à-vis a leaf. As for branches trunks and roots I declare that they are bald men's lies." In 1933 and again in 1946 he wrote suggestively of stones: "[T]he stones are as tormented as flesh . . . The stones have ears to eat the exact time." In 1961 he wrote equally suggestively of Magritte:

I haven't seen any of Magritte's works for a long while now, but I'm convinced that he is still a top personality of our era. Era—this word may sound too important for our fleeting times, which for the most part offer mere imitations of imitations, unless one sees them as a natural phenomenon such as one rain imitating another rain.

I am certain that Magritte will not take a canapé in order to cut it in half and find a can and an ape. Magritte will water the canapé to make an orange tree grow from it.

See you later. I'm off to my garden to pick not marguerites but a few secular firs to offer them as a token of esteem to my friend Magritte.[23]

And then there was Delvaux, the decorator, also in the wings. For Magritte the stakes of entering this field were high. Paul Valéry's empathic understanding of the situation of the young Baudelaire serves to illuminate his thinking:

> Baudelaire's problem must have posed itself in these terms: "How to be a great poet, but neither a Lamartine, nor a Hugo, nor a Musset?" I do not say that this was a conscious aim, but it was a necessary one, even an essential one, for Baudelaire. It was his *raison d'État*. In the field of creation, which is also the field of pride, the need for self-differentiation is inseparable from life itself. Baudelaire wrote of his project in the preface to *Les Fleurs du mal*: "For a long time illustrious poets have shared the most flowery provinces of the realm of poetry. So I will do something else."[24]

Magritte, likewise, would do something else. His problem must have posed itself in analogous terms: how to be a great painter, but neither a de Chirico, nor an Ernst, nor a Derain—nor any other name from the roll call of painters past, living or dead. The past masters were so much compost. They could fertilize their own fields. Magritte had other trees to water.

He had to find his voice as a painter. At the same time, he was in revolt against the very idea of the painter, and of painting, traditionally conceived: the style, the sensibility, the sincerity, and all the little aesthetic specialities. He contributed a text on the subject to *Adieu à Marie* (1927), the valedictory number of *Marie*, a little magazine founded by Mesens the year before. The text has been well described as a gnomic utterance. It is couched as a series of propositions, or denunciations, the first of which reads, "Painting attracts your admiration through resemblance to things whose originals you do not admire." Here Magritte is plagiarizing one of Pascal's famous *pensées*: "What vanity painting is, which attracts admiration by resembling things whose orig-

inals we do not admire!" The assault continues: "The word 'painting' is ugly. One thinks of oppressive weight, sometimes pretension." Painters come in for similar treatment: "A lot of painters are tormented by scruples, but, after all, they are in a unique situation. They get themselves forgotten. They are forever unheeded."[25]

. . .

Magritte distrusted "originality" as much as he distrusted fantasy.[26] Plagiarism (and self-plagiarism) became a way of life, as prescribed by Isidore Ducasse, the self-styled Comte de Lautréamont. "Plagiarism is necessary. Progress implies it. It closely grasps an author's sentence, uses his expressions, deletes a false idea, replaces it with the right one."[27] Lautréamont was the author of *Les Chants de Maldoror* (1869) and *Poésies* (1870). Rediscovered by the avant-garde in the 1920s, these works rapidly achieved canonic status. They were rightly regarded as source books for surrealism, and much else besides. They gained from the author's brief span and morbid reputation. Scutenaire was not alone in thinking that the life and work of Lautréamont— whose real name was Isidore Ducasse (1846–70)—a perfect match, eclipsing even that of Baudelaire or Rimbaud. Nougé's "Éloge de Lautréamont" (1925) considered him as a precursor, a guarantor, and a witness.[28]

Lautréamont's fingerprints are all over the thought crimes of the surrealists. He achieved a kind of angelic truth, as Breton said. *Maldoror* contains the classic picture of a young man, "fair as . . . the chance meeting on a dissecting-table of a sewing machine and an umbrella!" His expressions are freakish: "Each time I read Shakespeare it seems to me that I cut to shreds the brain of a jaguar." His descriptions are delicious: "Descriptions are a meadow, three rhinoceroses, half a catafalque. They can be memory, prophecy. They are not the paragraph I am on the point of concluding."[29] The *Poems* are not poems but maxims. Lautréamont practiced what he preached: his maxims plagiarize or "correct" passages from Descartes, Pascal, La Rochefoucauld, Vauvenargues, La Bruyère, and others. Pascal was one of his favorites. It may well be that Magritte's introduction to Pascal in particular, and philosophy in general, came from his reading of Lautréamont. His introduction to Lautréamont, in turn, owed something to Nougé and Scutenaire. They were steeped in *Maldoror* (*l'aurore du mal*, "the dawn of evil"); they read it and reread it all their lives. "To read *Les Chants de Maldoror actively*," reflected Nougé, in 1941, "developing one's own muscular sympathies, one gets an idea of what the hygiene of pure will would be like." Lautréamont joined Valéry in his personal pantheon. Just as Nougé identified with Valéry as "*moraliste de la vie*

intellectuelle," he identified with Lautréamont as *un activateur*—more than an activist, an *activator*, a kind of chemical reagent, stimulating the brain, charging the consciousness, fizzing in the body politic.[30] For Scutenaire, *Maldoror* was at once a reprimand and a commandment. "I think Lautréamont's writings serve to open our eyes to the atrocity of man's condition," he wrote, "in order that we may try to live better."[31]

As for Magritte, in 1945 he produced a set of pen and ink drawings to illustrate *Maldoror*, an edition eventually published in 1948, shorn of the preface on which Nougé and Scutenaire had both labored. Nougé's draft concluded, "René Magritte's drawings, which illustrate the present work, aim to represent the extreme point of the dialectical movement from evil towards good, joy, and grace."[32] After interviewing Harry Torczyner for the position of ambassador, in 1957, Magritte presented him with a copy of that book, as a seal of office, or a symbol of their understanding. As Torczyner remembered their exchange,

> "Where did my travels take me?" continued Magritte. "Was I, like Maldoror, in Madrid today, St Petersburg tomorrow, Peking yesterday?" "No, no, you'll find me in Brussels today, Abidjan tomorrow, then Moscow, Jerusalem, even Paris."
>
> "You must travel the skies for me," replied Magritte. "It would be a pleasure to discover vicariously distant lands and barbarous tribes. Since

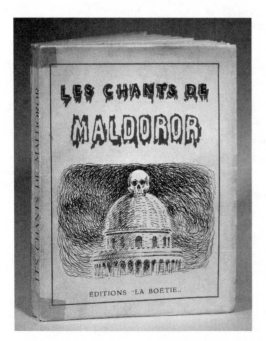

you live in the United States, you could also give me news about my dealer, my pictures, my friends, my critics. You could send me reports, minutes, and dispatches." "So an ambassador to the United States is what you need?" "Exactly," he said, and burst out laughing.[33]

Lautréamont's lesson was that almost anything could be plagiarized, corrected, or adapted to the purpose. Poetry was there for the taking, or the making. "Poetry must be made by all," decreed the *Poems*. "Not by one."[34] Such a procedure did not necessarily entail bastardizing Baudelaire or pillaging Pascal. The meanest of materials might

serve. This spoke directly to Nougé, who copied out the prescription for plagiarism in his journal, and who picked up the gauntlet that Lautréamont had thrown down. Nougé's Lautréamontism (as he called it) was an essential part of his poetics and his politics: "My circumstances, the humdrum circumstances of my life, have meant that everything that I've done of any worth has always been under the sign of *subversion*, of criminal action."[35] One manifestation of this—a type of "*publicité transfigurée*," or advertising transformed—was a series of posters, or billboards, with fateful slogans. For example:

THIS
BOULEVARD
CLUTTERED
WITH
CORPSES
LOOK
YOU
ARE
THERE

That one was wheeled through the streets of Brussels on a handcart. The reaction in the boulevards was disappointing. Many simply took it as an advertisement for a new film.[36]

Magritte for his part was completely sold on "*la publicité transfigurée*," whatever the public might say. Transformation was exactly what he was trying to achieve. Nougé's modus operandi matched his temperament and his means. The pastiche advertising in the portrait of Mesens was imbued with the same spirit ("À LA HAUTEUR DES CIRCONSTANCES REVOLVER"). Subversion laced with derision seemed an appropriate response to the existing order, social and political.

That order sometimes offered unheralded opportunities. One such was a commission to design the annual catalog of the Brussels furrier S. Samuel et Cie. Magritte's first attempt at this unlikely vehicle was in 1926. The designs he produced for Samuel were almost identical to the designs he produced for Norine. They were accompanied by fragments of faux advertising copy ("that allure, that slightly haughty air"), attributed to Camille Goemans, which parodied the advertisements in upmarket magazines like *Vogue*.[37]

Whether or not the catalog had any impact on the fur trade, it certainly had an effect on Magritte's painting. In *La Lumière du pôle* (*Polar Light*), a work later acquired by Sophia Loren and Carlo Ponti, naked bodies like tailors' dummies are cut away, fractured and fragmented, while a giant bird

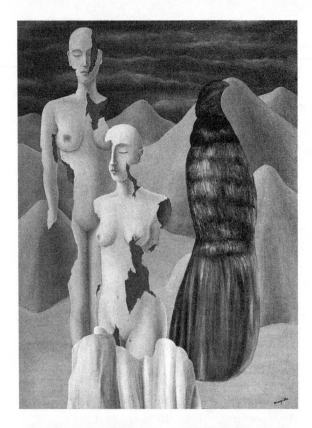

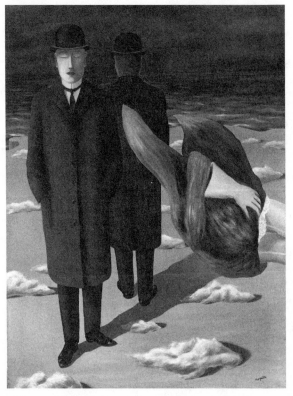

woman in a fur cape averts her gaze. In *Le Sens de la nuit* (*The Meaning of the Night*), a mysterious fur-covered body part levitates, stage right; a disembodied hand or glove appears to pull up the fur, revealing a flash of lace petticoat and silk stockings. Nearby, a man in an overcoat and bowler hat keeps his eyes tight shut and his coat primly buttoned. The coat buttons the wrong way, as if borrowed from one of the tailor's dummies. His doppelgänger looks out to sea, his back turned to the fur flying in the foreground. Fleecy clouds lie underfoot. Marooned in this casebook of Freudian fetish objects, the man looks preternaturally serene. He might almost be pleased with himself. These paintings were made in late 1926 or early 1927. They carried an electric charge. Others produced at around the same time delivered a similar jolt. Among them were the three descendants of Fantômas and Irma Vep, *L'Homme du large*, *La Voleuse*, and *Le Supplice de la vestale* (*The Torturing of the Vestal Virgin*).[38] Things were looking up.

Magritte was commissioned again by Samuel, now Müller Samuel, the following year. This time the catalog turned into something entirely different. Goemans gave place to Nougé. Flibbertigibbet advertising copy

gave place to aphoristic commentary, reverberating with the images, but set on the facing page, like poetry, or maxims, or the tablets of some scripture. Nougé also furnished a sort of prologue and epilogue. The prologue opened with a warning that must have come as a shock to any unsuspecting reader, browsing innocently through the catalog in the hope of finding a fur coat.

> Once forced to make your mind up, choosing is a serious business.
> No room, then, for boldness beyond what fashion dictates
> Yet the slightest distraction, the first sign of recklessness, is the stuff of boldness
> All things are worth watching over.

The gemlike epilogue, surely an ironic reflection on the whole affair, was entirely characteristic of its author: "and there's always an opportunity to go that bit further."[39] Magritte surpassed himself. He could hardly do otherwise. Working in papier collé, he produced a virtuoso sequence of images, echoing and in some cases anticipating oil paintings. There is an arresting vision of a model who has lost her head to a cutout of a car, a papier collé that is also a self-portrait, featuring a bisection of Magritte's own head—a photograph with his eyes closed—a taster of things to come. Nougé's response to this: "What we guess, perhaps, is what she is thinking. Dressed like that, she is beyond explaining." Later in the sequence, the models are replaced by bilboquets, birds, and the strange jigsaw-like shapes much favored by Magritte in this period. "Here the last likeness disintegrates," intones the commentary. "There are no longer any ordinary things."[40] Nougé, too, was practicing his composition.

The catalog, put together like a small loose-leaf album and tied with pale green cord, comes wrapped in plain covers. The names Magritte and Nougé nowhere appear, but there is no mistaking the authors. This is *publicité* well and truly *transfigurée*—surrealist entryism by other means. The Catalogue Samuel, too, was a calling card. As soon as he got to Paris, Magritte showed it to Breton and Aragon, who were much impressed.[41] It has recently been republished in facsimile, and still packs a terrific punch. Baudelaire once characterized some Goya lithographs as "vast pictures in miniature."[42] Much the same could be said of the Catalogue Samuel, which would have been received with delight by the elite customers, who would surely have recognized its originality.

By 1927, Magritte had so far overcome his handicap that it was as if he had never felt the need to pause for thought. The paintings came thick and fast. He had a deadline to meet: his first one-man show, at the Galerie Le Centaure, in

Ce que l'on devine est peut-être ce qu'elle pense. Ainsi vêtue, elle se passe d'explication.

NOVELTY (gazelle zibelinée)

Elle invente le monde en toute sécurité. Ses rêves la protègent aussi bien qu'un manteau.

STAR (astrakan garni vison)

Brussels, scheduled to open on April 23, 1927. He also had a financial incentive: from the beginning of 1926, his contract with Van Hecke and Le Centaure guaranteed the purchase of his output, giving him a monthly stipend in return for his oils on canvas, with supplementary payments for works on paper. The

contract stipulated the number of paintings—which the gallery then tried to ratchet up. It is not clear whether it also provided for differential payments according to size, offering an incentive to work on larger canvases, and—it has sometimes been suggested, even by Mesens, in his more waspish moments—tending to a certain redundancy, or superfluity, or gigantism. Magritte's actual output does not support such claims; but there is a dearth of documentary evidence, and in particular no written contract has survived. According to Georgette, there was only ever a gentlemen's agreement. If Jean Milo's rather prejudiced account is to be trusted, the terms of Le Centaure's contracts were comparatively generous, at least for established names. Frits van den Berghe and Gustave de Smet received 5,000 Belgian francs a month for their oils on canvas. Additionally, van den Berghe was paid 500 francs for a painting on paper; de Smet, 250–500 francs for a gouache. According to Milo, Magritte was required to deliver more for less: something like half those rates.[43]

Financially, therefore, the agreement was double edged. Whatever the exact figures, it afforded a degree of security when he needed it most. It answered the question of how to live, first in Brussels, and then in Paris, where the exchange rate worked in his favor. Yet it also indentured. If in the course of 1926 he fulfilled the terms of his contract, that suggests he was required to deliver some fifty paintings a year. Perhaps that was not entirely unreasonable, especially if there was some flexibility, but it was already a high rate of productivity. Under contract, there was no room for slacking. In effect, he was doing piecework. The contract was a boon—and a boost to his self-confidence—but it was open to exploitation and, as it transpired, cancellation. He lost no time in moving to a bigger apartment, but he was not cut out to be a wage slave, even if his class sympathies were with the proletariat.

The surge in production testified to an even more momentous development. Magritte had found his most important interlocutor and expositor: Nougé. The relationship waxed and waned, but Nougé remained a vital force in his art and life, even when they were not on speaking terms. In the early years—the years of discovery, from the formation of the Belgian surrealist group in the autumn of 1926 and into the early 1930s—their dialogue was one of the great artistic dialogues of the modern age, comparable in inventive spur and creative yield to the dialogues between Paul Cézanne and Emile Zola, Charlie Parker and Dizzy Gillespie, Franz Kafka and Max Brod, or Laurel and Hardy, as Walter Benjamin once suggested: "And concerning the friendship with Brod, I think I am on the track of truth when I say: Kafka as Laurel felt the onerous obligation to seek out his Hardy—and that was Brod."[44] In order to realize his goal—in order to realize himself—Magritte, too, felt the onerous obligation to seek out his Hardy. That was Nougé. In 1927 they embarked on

an intensive period of collaboration that produced some of Magritte's finest work, and also the single most significant work ever written about him, profoundly influencing everything that came after—Nougé's seminal text, *Les Images défendues*, extensively trailed in *La Surréalisme au service de la révolution* in 1933 (illustrated by Magritte's image of the Virgin Mary in a state of undress, otherwise known as *La Vierge retroussée*), and eventually published in 1943, in mutilated form. Restored by Mariën, the complete text appeared for the first time in Nougé's *Histoire de ne pas rire* (1956), a compendium of his work, republished in 1980. In 1997, *Les Images défendues* reappeared in a collection of his writings on Magritte. With fitting irony, the collection was called *René Magritte* (*in extenso*), though it runs to a little over a hundred pages. Nougé's words are precious stones.

Nougé's long engagement with Magritte was unexampled; but it was symptomatic of a certain trend. Magritte fascinated the most capacious intellectuals of the age. André Breton continued to monitor his activities (and collect his work) even when they were barely on speaking terms. Georges Bataille wanted to write a book about him. Michel Foucault succeeded. He finds his place in Jacques Derrida's *The Truth in Painting*, after Cézanne's famous declaration to Émile Bernard, "I owe you the truth in painting and I shall tell it to you."[45] There has always been a temptation to underestimate Magritte, on account of his supreme legibility; a temptation only reinforced by his sheer ubiquity. His most penetrating latter-day expositors have not been taken in. They have done him the honor of taking him seriously.

Paul Nougé (1895–1967) was formidable. Everyone who ever had anything to do with him could agree on that. He was recognized in his day as a towering intellect, a polymath whose powers of detection rivaled those of Walter Benjamin.[46] Unlike Benjamin, his fragmentary oeuvre has never been translated into English. Even in his own tongue, he has fallen into disuse—a sorry state of affairs. In 1972 Susan Sontag noted that Nougé was a forgotten writer.[47] The same is true today. For Magritte, and for a whole generation, he was a beacon of hope—a prophet, an oracle—at once activator and exemplar. Among the interwar avant-garde he was peerless. His reputation was founded on "two qualities not readily interfusable," as Herman Melville has it, "prudence and rigour."[48] Intellectually voracious, aesthetically daring, congenitally exact, he was like a grandmaster of all he surveyed. His penetration was remarkable. Like Benjamin, he inquired deeply into almost anything. His "Notes on Chess" began, typically, as a refutation of Edgar Allan Poe's assertion in "The Murders in the Rue Morgue" that "the higher powers of the reflective intellect are more decidedly and more usefully tasked by the unostentatious game of draughts than by all the elaborate frivolity of chess." The

"Notes" were published posthumously, with Magritte's murderous *Check-mate* on the cover.

> In chess, the most difficult conquest is that of freedom. It exists only at the extremes. Thanks to naïveté, ignorance, it is found in the novice. It reappears in the masters. It disappears in the middle, under the weight of half-baked study, drills, and clichés. Truth that far exceeds the chessboard, truth infinitely more general. Poetry, painting, war, revolution.[49]

Nougé bowed to no man. His extraordinary acuity and singular timbre compelled attention across the Continent. "Not only the strongest head in Surrealism in Belgium (long coupled with Magritte), but one of the strongest of our time," testified the French poet Francis Ponge in 1956. "How better to define it—that head—than by the properties and virtues of a touchstone, that is to say, as a sort of basalt, black, very hard, whose touch is feared by everything made of debased gold. Completely irreplaceable, as we can see."[50] Ponge had shared a bottle with Nougé during the war; the regard was mutual. His tribute was doubly (and deliberately) appropriate, because it was patterned on a passage from one of Nougé's favorite books, *Monsieur Teste* (1896), by Paul Valéry. The passage captures exactly Nougé's self-image and self-abnegation; his attitude to acclaim, applause, or approbation. He cared nothing for any of that. Uncannily, it also seems to capture Nougé's phrasing, with its characteristic *emphasis*. He might have written it or corrected it himself: "I dreamt then that the strongest heads, the cleverest inventors, the finest connoisseurs of thought should be the unknowns, the misers, the men who die unconfessed. Their existence was revealed to me by that of the dazzlers, who are a little less *solid*."[51]

Nougé, a biochemist by profession, had all the makings of a character in a novel—a Russian novel, perhaps, with his affinity for the fundamental. He was a man for first principles. Preferably, something prior to first principles. Mesens observed justly that he was less interested in finding things than in *inventing* things. Publicly and privately, Nougé's reflections on that subject were part of his inspirational appeal. "We know very well, my dear friend," he wrote to Magritte, "that what we have to do is to invent a universe and not to describe it." The echo of Marx's *Theses on Feuerbach* (1888)—"The philosophers have only interpreted the world, in various ways; the point is to change it"[52]—was unmistakable. One of Nougé's most celebrated pronouncements was the clarion call issued in a public lecture that came to be known as the Conférence de Charleroi (1929), ostensibly an analysis of music as a mode of expression, later published under the title "Music Is Dangerous" (1946):

"The time has come to realize that we are also capable of inventing emotions, perhaps even basic emotions comparable in power to love and hate."[53]

Nougé worked nearly all his life in the Laboratoire de Biologie Clinique in Brussels. He mended the world in his spare time. As often as not, he was present at the creation. In fact he helped to shape it. In 1919 he was a founding member of the Belgian Communist Party. He knew revolutionary politics and their attendant pettifogging from the inside. A few years later he was a founding gangmaster of the Belgian surrealist group—not so much a group as a muddle of groupuscules, until Nougé got hold of them. In the self-regarding circles of the avant-garde, he appeared on the scene as if by magic, fully armed, as the éminence grise behind *Correspondance* (1924–25), a review in the form of a series of color-coded tracts, written in rotation by Goemans, Lecomte, and Nougé himself. They were distributed anonymously, at ten-day intervals, to prominent European intellectuals. Sometimes they seemed to wax philosophical, sometimes polemical. They had a deft line on rival initiatives. ("7 *Arts* amused us, mildly, but the future of new art hardly concerns us. Besides, art is demobilized; what matters is to live.") They were not merely *jeux d'esprit*. Their underlying purpose was more serious and more subtle: they corrected the texts of the very intellectuals to whom they were addressed. Thus the quintessentially Nougian proposition, "We helped each other to invent two or three efficacious ideas about reality," corrected a text by Jean Paulhan, in which he had remarked, "We won't set straight the people who make bad books if we keep telling them that they're making clogs: we must help them to invent two or three sound ideas on language."[54]

Correspondance made an impression, even in Paris. Breton and Éluard, no less, went posthaste to Brussels to meet the authors, in the hope of enlisting their support. Nougé was willing to cooperate, within bounds, though he was never willing to surrender his autonomy, to Breton or anyone else. He believed in collective action, but he walked by himself. When his ally Marcel Lecomte presumed to *tutoyer* him—to address him informally as *tu* rather than *vous*—Lecomte received a note in the mail from Nougé:

A small confidence, mon cher Lecomte:
it is true that people *do* call me tu, but only with my consent.
For the rest . . .
Bien cordialement votre
Paul Nougé[55]

Magritte addressed him as *vous* for twenty years.

. . .

Nougé was capable of writing wonderful letters—he wrote some to Magritte—but his usual modus operandi was the note, invariably handwritten. When Pierre Bourgeois ventured to ask if he was indeed the author behind *Correspondance*, he replied,

> No, mon cher Bourgeois, I am not the author of my tracts. This note itself is not in my hand. As for the author, a modest young man, no doubt a little *distrait*, I am really not sure whether he is worth getting to know . . .
>
> I must once again pay tribute to your perspicacity, mon cher Bourgeois, and ask you to accept the sincere good wishes of
>
> Paul Nougé[56]

He was quick to take the measure of possible collaborators. It was Nougé who recruited André Souris, during a Schoenberg concert at the Salle du Conservatoire in Brussels. The proceedings were interrupted by howls of protest from the audience. Amid the chaos, Souris heard an imperious command from the gods, "Listen, you little rascal, wait for me at the exit."[57]

It was in the mix with Souris and Nougé that Magritte honed his views about the liberating power of metaphor and metamorphosis as a reactive agent, a force multiplier for the imagination. An excited Souris hastened to relay the gist of a conversation he had with Magritte to Nougé:

> René thinks that the use of metaphor in language may be motivated by a profound desire for a change in the usual order of things. To say "a golden sky or a blood-red sky" would be the equivalent of wishing that it really might be so, and even believing for a moment that it is. But any such wish is assailed by a contrary feeling, the fear that it really is so. The conflict can be speedily resolved by the very idea of the metaphor, "linguistic device," safety-valve and exegetes' pastime. One explanation of my painting, continued René, may be deduced from this process; it would suffice to delete the last phrase. If I paint a blood-red sky, that's what it really is. There is no more metaphor.

When Nougé showed him this summary, Magritte was much impressed. He proceeded to develop the thought.

I saw the letter that you'd sent to Nougé on the subject of that idea of the metaphor. I must say you've put the essence of it remarkably well. Pursuing it further, I also think that if the secret desire that justifies the use of the metaphor is acknowledged as real, one can also understand why we are startled by any object shown in isolation, in an unfamiliar context: the secret desire for a change in the order of things is fulfilled by the sight of the new order (the isolation). . . . We are troubled, all of a sudden, by the fate of an object which we had previously overlooked.[58]

Nougé himself was a reactive agent in these crucial conversations of ideas. And it was he who inducted Scutenaire into the gang, following the latter's initial approach, by the alarming expedient of calling on him unannounced. "My visitor was beyond reproach," recorded Scutenaire, "had read all my poems and praised me for having written them. When I told him not to infer from references to the Virgin Mary, baby Jesus and a few wise men that I was a Catholic, he told me not to worry, that idea had not crossed his mind. He had the most beautiful face I'd ever seen. That encounter took place in the course of 1926 [1927], and I hope that Paul Nougé will never die."[59]

It was also Nougé who edited *Adieu à Marie*, having effectively ousted Mesens from the editorial chair. "Now, Master Mesens (whom I judge at his true value) is generously opening up to us the next number of *Marie*, to the extent of our being able to insert whatever we like and reject whatever we dislike."[60] Master Mesens had his uses, but not as editor, nor yet as contributor. Mesens's contributions to the little magazines of the day tended towards Dada folderol. "Et moi aussi je dis: BOVRIL." Nougé abhorred Dada demonstrations and Dada denunciations. "The idea of negation for negation's sake was foreign to him," as Mariën said.[61] Folderol was out of the question. His parody of Mesens was as exact as it was exacting:

Et moi seulement je dis: MESENS
Je dis: mesens
Je dis
Je
je
j

Despite his charismatic intellect and engagement with his peers, Nougé was a difficult man to know, ruined in the end by circumstances and drink. Yet there was an irreducible magnificence to him, an absolute integrity of purpose, stance, and style. He had no time for posturing or preening. He was

committed to a certain idea or ideal of intellectual inquiry. True to his own precepts, he was remarkably self-effacing. His admonition to the surrealists in 1929 became famous: "I should be very glad if those among us whose name has just begun to make a mark would *erase it*."[62]

Nougé was interested in the world, and in changing it. He dedicated his life to invention and subversion. His lodestar was *efficacity*. Action was essential to life. (He put "life" in quotation marks.) "What matters is to live," he repeated, "therefore to act." Nougé rewrote Descartes: "I act, therefore I am." In the only interview he ever gave, a few months before his death, he was asked why he wrote. He replied, "[T]o charm, in the Valéryan sense of the word, that is to say, to influence, to act on the eventual reader."[63] The very idea of the eventual reader was an optimistic one. Pessimism of the intellect was anathema to him. The stringent requirement of efficacity did not weigh him down. On the contrary, he soared, and took others with him. Magritte for his part had a strong pessimistic streak. In the index to his collected writings, the entry on "hope" (*espoir*) reads "see lack of hope" (*désespoir*): truly a counsel of despair. Max Brod recounted a conversation with Kafka that began with present-day Europe and the decline of the human race. "We are nihilistic thoughts, suicidal thoughts, that come into God's head," said Kafka. This reminded Brod of the Gnostic view of life: God as the evil demiurge, the world as his Fall. "Oh no," said Kafka. "Our world is only a bad mood of God, a bad day of his." "Then there is hope outside this manifestation of the world that we know." Kafka smiled. "Oh, plenty of hope, an infinite amount of hope—but not for us."[64] Left to his own devices, Magritte would have sided with Kafka. Nougé offered hope for us. He was a moralizer, as opposed to a demoralizer. It was Nougé who coined the battle cries that Magritte loved to repeat: "We are responsible for the universe." "Everything is still possible."[65]

As activator, interlocutor, and expositor, Nougé was fundamental to Magritte, fundamental to his painting, his thinking, and his being. Magritte's most significant artistic "other," his almost instinctive point of reference, was not de Chirico, but Nougé. De Chirico was, perhaps, *Le Chevalier du couchant* (*The Knight of the West*). Nougé was true north.

Their pact was sealed with a quasi-stereographic portrait of Nougé, painted in 1927. Like the man from the sea, Nougé has his hand on a lever; like Fantômas, he is in evening dress. But the most striking feature of the portrait is that he has a double, or a twin. The painting bears some resemblance to one of the images in the Catalogue Samuel, except that the model in the catalog has a dream double, as it has been called, not a replicant. "A mirror would be useless," reads the commentary. "She is duplicated without difficulty. But that is how marvels begin."[66] Here the split has the connotation of a split personal-

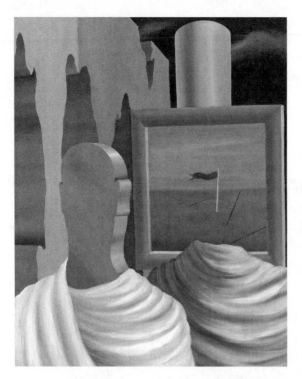

ity. In Nougé's case, however, and in several other cases of doubling in Magritte's work at around this time, there is no suggestion of the stock "psychological" interpretations, which Magritte firmly rejected, just like Kafka. ("For the last time, psychology!") It might be said that Nougé lived a double life, as scientist by day and surrealist by night. Moreover he was keenly interested in the figure of the double. He would have been familiar with Baudelaire's traffic in *la double vie*, and in Valéry's notion of *deux moi*—two selves, or two manifestations of one bundle—which could be crudely assimilated to the interior or pure self (instinctive, unmediated, in deep) and the exterior or social self (variable, modifiable, forgettable, in Valéry's words, seen in relation to others). "*So that makes two of me*," wrote Valéry, "or rather a *me* and a *me*." It is entirely possible that Nougé and Magritte talked about this. "One must go into oneself," said Monsieur Teste, as into the lion's den, "armed to the teeth." Valéry's formulations were appealing. "Le Moi is only relatively precise when designated for external use." "The *moi pur*, if it exists, is not coloured in."[67] Coloring in was Magritte's forte. Or perhaps the doubling of Nougé was a secret they shared, an allusion, or an in-joke. The figure of the double is everywhere in Conrad, the self-styled "homo duplex," and in Poe.[68] Magritte

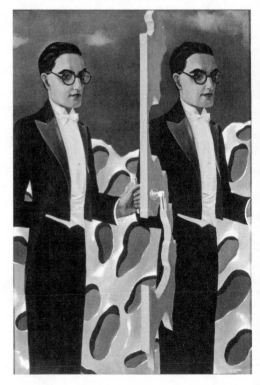

and Nougé were both passionately fond of Poe. The French title of "The Murders in the Rue Morgue" is "Double assassinat dans la rue Morgue"; Nougé is certainly dressed to kill. Doubleness can also be seen as an innate feature of Belgianness, which must embrace two communities, two languages, and two cultures, Flemish and Walloon.

Nougé bought *Le Double secret* (*The Secret Double*), another painting from 1927, as soon as he could, after the failure of Le Centaure, probably in 1932; and he found the title for *L'Imprudent* (*Foolhardy*), another twinned image, of a man with his arm in a sling. Many years later, against his better judgment, Magritte himself was led to offer an interpretation of the latter painting. He began with the idea of a reflection or a mirror image. "If I had to 'interpret' this image, I would say (for instance) that the appearance of the figure acquires its mysterious virtue when it is accompanied by its reflection. In effect, a figure that appears does not yield up its mystery simply by its appearance. If it were *alone*, the figure (in *Foolhardy*) would be reduced to something particular: a slightly comic figure. Alone, it does not evoke what it has in common with all human beings, that is to say their mystery."[69]

Nougé was also interested in the shadow play of images, on film and in life. Soon he began to experiment, subversively, with photography. "Worn down by exceptional cares, some of us stretched out at the seaside," he recorded. "Not for fun or insightful thinking. Someone took photographs. . . . I should love to know in what circumstances Nadar's famous portrait of Baudelaire was taken. Another photograph shows M. walking by a pool of water, his hair flying, intense, stubborn, and preceded by a magnificent shadow. At that moment, I was musing, with no great pleasure, about photographing a small dog in the water."[70] Nougé's photograph was later entitled *The Shadow and Its Shadow*.

Magritte was not short of ideas for paintings. Nougé fed him scenarios, strategies, stimulus material, and suggestions for further reading (and viewing, as for example *La Femme au corbeau*, also known as *The River*, by Frank Borzage). "Allow me to submit for your consideration this passage: '. . . should the following facts turn out to be completely false, the mere idea *of their simple possibility* is every bit as tremendous as their proven, recognized authenticity would be. Besides, once thought, what might begin to happen in the mysterious Universe?'" This was a quotation from Villiers de l'Isle-Adam, an author much cherished by both of them. Magritte responded immediately, and then began to wonder if he had been too hasty. Nougé reassured him: "You would be very wrong if you were to regret what you wrote to me à propos that passage from Villiers that I find so moving. It proves the existence of the spirit, you said. Whoever reads it is transported for a while to a state that allows him

to experience *the sensation of the mind*. That is the crux of the matter, and, if you like, we'll come back to it."[71]

Nougé was one of the main contributors of titles of Magritte's works—he was brilliant at what the friends referred to as "finding" the title for a painting, suggesting relationships between word and image that were not obvious, but mind-opening when articulated. He also gave his friend feedback on the work as it developed. "Your latest experiments seemed to me to be most remarkable," wrote Nougé in November 1927, referring to the metamorphic paintings of the end of that year, in which sky or flesh metamorphose into planks of wood, and prompted some further thoughts:

> To my mind, it would be a mistake to rely only on the introduction of a new element. Remarkable as it may be, and no doubt the equivalent of the bilboquet, however it's important to consider another style. What particularly strikes me is the function you assign to those paper cut-outs, an inexplicable object which serves *to hide*, in fact to suggest more strongly than the image that it conceals, *because it has to be admitted that it conceals nothing*. That, mon cher ami, seems to me to be sign of a new direction which cannot but lead you afresh into the unknown, or if you prefer, the unforeseeable. I would be very surprised if you did not make some important discoveries soon.[72]

Nougé rendered other services. He acted as first reader or redactor of Magritte's writings—Nougé was Magritte's ideal reader—and even letters, if they were important. As late as 1946, Magritte appealed for help: "I've had another letter from B [André Breton]. I'm sending it to you along with a reply that I'd be grateful if you'd go through for weak or redundant passages, because I've written it without any great belief in its usefulness, and that makes me wonder about its 'value.' "[73] He found titles for the paintings. The titles were an art in themselves. Nougé's were classics of their kind (*Au seuil de la liberté, Le Modèle rouge, Le Faux Miroir, L'Empire des lumières*); in the process, he elaborated a theory of the title that has held the field ever since. He collected Magrittes, money permitting, until he could collect them no longer. During the 1950s his obsession with the destructive Marthe Beauvoisin, his addiction to alcohol, and his expulsion from the laboratory where he made his living compelled him to sell them off (the last three to Geert Van Bruaene, for 12,000 Belgian francs). In 1952 these conditions precipitated a rift with Magritte. The relationship was never completely broken—the titles kept on coming—and the rift was never completely healed. For a quarter of a century, however, the painter who was not a painter and the biochemist in the bottle

glasses plotted the overthrow of the existing order, social and political, verbal and visual, and offered a serial demonstration of how it could be achieved.

Nougé's definition of their project underpinned the joint enterprise. "To understand the world by transforming it," Nougé averred in *Les Images défendues*, "that is without any doubt our true function."[74] This was a revolutionary project. It was also a great adventure. "In the astonishing adventure in which we are engaged," wrote Nougé, "I do not really care to define the role of Magritte, and if that role is cardinal, whether he has played it better or worse than any other. Magritte can do without curiosity of that sort, and without praise, I am sure. Is he the greatest painter? A great painter? Is he a painter—or better than that?" Scutenaire's famous paradox is perhaps a brilliant restatement of Nougé's idea: "Magritte is a great painter, Magritte is not a painter."[75]

In the course of that adventure they had a good time. Their revolutionary project was more exigent and more far-reaching than is commonly understood. The character of the relationship is apt to mislead. Making a revolution was nothing if not fun, and Magritte and Nougé had fun together. They went cycling. They paddled in the sea. They acted the goat. They took photographs. They made films. They played postal chess, with predictable results. Magritte was a keen chess player, but no Capablanca. When he offered to paint a portrait of Capablanca, the master who often had a game with him at the Café Greenwich, the master declined. "You see," he explained afterward, "if he paints as badly as he plays." Like it or not, Magritte donated *Checkmate* to his chess club. During the war it was put in storage. After the war it was sold.[76]

The earliest of Nougé's scenarios appear to date from the beginning of 1927. There were five, at least, under the general rubric of "Images peintes" ("Painted Images"). Two of them were painted straightaway; Magritte could have contributed to them. They are graphic, melodramatic, macabre. There is a marked element of perversion—"*le démon de la perversité*," as Poe had it, a title appropriated by Magritte a few months later. The first runs as follows:

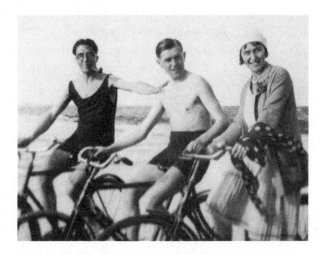

In this room, amidst a minimal litter of underclothing, there is an almost naked woman, a corpse of rare perversity.

Were it not for this dead woman, nothing could dis-

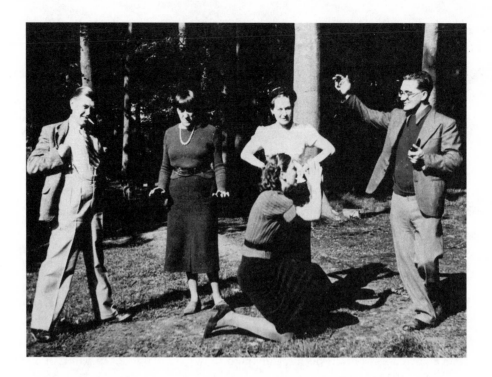

turb so peaceful an interior. Everything in it is restfully neat: the spotless floor, the uncluttered table, a tall pedestal table of dark wood. And with the scarf draped gently round her neck, over her shoulder, over the astonishing wound, it would require a certain effort to imagine a severed head.

On the table—fittingly enough—a meditative cat observes the corpse.

Turning his back on the dead woman, a young man of great beauty, dressed with the most restrained elegance, leaning slightly forward, leaning ever so slightly over a gramophone horn, listens.

On his lips, perhaps a smile.

At his feet, a suitcase. On a chair, his hat and his overcoat.

In the background, at the level of the window sill, four heads stare at the murderer. In the corridor, on either side of the wide-open door, two men are approaching, still to discover the spectacle.

They are ugly customers.

Crouching, they hug the wall.

One of them unfurls a huge net, the other brandishes a sort of club. All this will be called: the murderer threatened.[77]

The work that resulted from this scenario was a major one. *L'Assassin menacé*, or *The Murderer Threatened*, was the star of the show at Le Cen-

taure: forty-nine paintings and twelve papiers collés—all the latest work, introduced by Van Hecke and by Nougé, in signature style. "This painting . . . ceases to defend itself. Aggressive, it assaults us. Better still, it invites oblivion, it seems to dissolve, to reveal itself, to let itself go. It insinuates itself. Suddenly, one notices that its unknown forms have taken over everywhere. Thus it eludes judgement, eludes praise, like René Magritte."[78] Together with *The Secret Player*—in which the aerodynamic turtle makes a triumphant comeback—*L'Assassin menacé* was Magritte's largest canvas to date (roughly two meters long and one and a half meters high). It was also the most important. It was clearly designed to make a statement, and it did. One critic wrote of its "extraordinary guignol." *The Murderer Threatened* was grand guignol indeed.

It was a kind of summation, as Pierre Flouquet noted with disgust in the course of his review, a demonstration of what Magritte had learned about painting (and plagiarizing) thus far. Its importance lay first of all in the incontrovertible fact of its pulling power. It riveted the attention of the crowds at Le Centaure, as Flouquet himself acknowledged:

> *L'Assassin menacé*, in which the anecdote, less veiled than in any other work, constitutes a summation of the most significant kind and out-

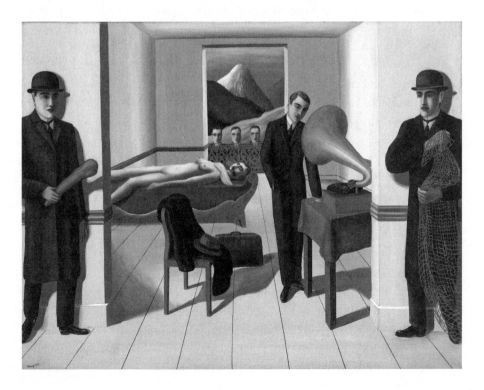

does in discordance the worldly banality of *Le Joueur secret* (*The Secret Player*), attracts the attention of every visitor. Just as a society scandal fills the law courts, when with a clever speech whitewashing the basest crime and unleashing ecstatic applause, the "learned counsel" brings off the acquittal of the elegant crook, the perfumed crowd literally *threatens* the murderer, so densely does it swarm around him and admire him. A few sinewy strokes of composition, warped by hysteria, underline the unhealthy cerebrality of his conception. But in this banal crime, in this "study" for a crime, where is the fine purged drama of the true artistic gesture to be found?[79]

L'Assassin menacé is inimitable Magritte. It is a cocktail of charm and menace and special effects: a picture of suspense and stasis, voyeurism and violence, mood music and malefaction; a puzzle, or a provocation, instantly legible and infinitely mysterious; a grab bag of genres and conventions; a tragedy, complete with the ritual display of the corpse at the center of the drama, but also a murder mystery—Magritte noir. Like many Magrittes, it is staged, even stagey, yet cinematic. Fritz Lang's world built entirely on sound stages finds its counterpart in Magritte's world of crime scenes in tableaux vivants. One of its greatest aficionados was the director Claude Chabrol, the pope of the New Wave. Chabrol drew attention to the doubled detectives. "Another Belgian would call them Dupond and Dupont."[80] Dupond and Dupont—otherwise known as Thompson and Thomson in the adventures of Hergé's Tintin—are, of course, famously incompetent, and perhaps this sense attaches to Magritte's detectives as well.

Chabrol also had a theory about the murder, or rather the murderer. He proposed that the three faces at the rear window were originally four, as suggested by their positioning in the frame (and by Nougé's scenario); and furthermore that the man listening to the gramophone is in fact "the fourth man," who has climbed in through the window, lured by the siren on the sofa, or perhaps by the music—"Roses of Picardy," says Chabrol; the screams of the victim, according to Alain Robbe-Grillet in *La Belle Captive*.[81] This theory gives rise to further speculation. It suggests that things are not what they seem. The naked woman has a past. The moral valence of the onlookers is moot. They cannot be detectives, as Chabrol remarks, because they do not have the hats. Are they stand-ins for Magritte and his brothers? Are they innocent bystanders, like us, or are they, perhaps, voyeurs? Are they further compromised? Are they implicated in the crime? Most disconcertingly, the identification of the murderer is thrown into jeopardy. It could be the man listening to the gramophone, as everyone assumes, who may or may not have been there all along.

Alternatively, it could be that the murderer has fled—to avoid being captured or bludgeoned by Dupond or Dupont—leaving the fey music lover as patsy, spellbound by the turntable, oblivious to his fate.

Chabrol theorized tongue in cheek. But he had a point. "We are shown everything—and nothing," as the art critic John Berger put it. "We see a particular event in its concrete setting, yet everything remains mysterious—the committed murder, the future arrest, the appearance of the three staring men in the window. What fills the depicted moment is the sound of the record, and this, by the very nature of painting, we cannot hear."[82] The silence of the world returns to haunt us.

Chabrol's alternative scenario sounds like nothing so much as the plot of an episode of *Fantômas*. And indeed it transpires that the staging of the painting owes a good deal to the episode that lived longest in Magritte's memory. *L'Assassin menacé* corrects *La Mort qui tue*.[83] It also seems to pay tribute to a painting by Ernst, *La Vierge corrigeant l'enfant Jésus devant trois témoins (A.B., P.E. et le peintre)*, reproduced in *La Révolution surréaliste* in December 1926. Ernst identifies the onlookers as witnesses, implicating Breton, Éluard, and himself, though they do not appear to be paying much attention to the action. In Magritte's painting the gaze is similarly vexed. The three witnesses—if that is what they are—studiously avert their gaze from the murderer, and the victim, and us. Instead their eyes swivel to a corner of the room hidden from view beyond the gramophone. (Is there another body in the corner?) Meanwhile the two detectives stare glassily out of the frame, as if waiting for the end of the record. They stand poised, but their look belies it. They have the air of two stalwarts from central casting. At the end of *The Trial* (1925), Kafka's protagonist, K., suddenly turns to the two men who have come for him, wearing frock coats and top hats that appear to be stuck on, and asks them, "What theater are you playing at?" "Theater?" echoes one, the corners of his mouth twitching as he looks for advice to the other, who acts as if he were a mute struggling to overcome a sudden disability. "They're not prepared for questions," K. says to himself, and goes to fetch his hat. Is that how it will play out? In *L'Assassin menacé*, the action is frozen. The cunning of the painting is to invite us to reconstruct the story—to solve the crime—while at the same time presenting us with a cliffhanger worthy of Louis Feuillade himself. What will happen when the music stops?

L'Assassin menacé was a defining work. It proved Magritte to himself, and to others. But its strength provoked reactions on both sides; for some, it was hard to swallow. "In sum," opined Willem Verougstraete in his review of the Centaure show: "the cerebral secretion of a metropolitan eunuch who, between walls of ghastly hue, has seen his mind purge itself of all matter to the

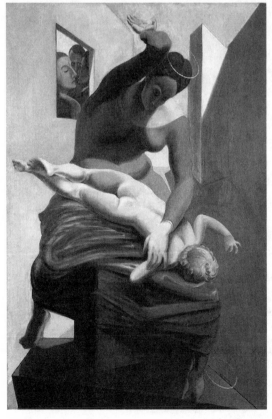

point of total emptiness."[84] "Art critics displayed nothing but contempt for his work," recalled Magritte in his autobiographical sketch. "He was obliged to write unpleasant things to certain journalists who overstepped the bounds of stupidity." Willem Verougstraete surely qualified.

Over time the painting continued to assert its totemic presence, boosted by Van Hecke and Mesens. In 1931 it was exhibited in the window of the Salle Giso in Brussels, during Magritte's one-man show there, while Nougé's incendiary catalog preface called attention to the fact that "certain paintings reach the same pitch, in their own ways, as the fieriest incitements to revolt. They wait only to be heard."[85] Shortly afterward, cruising for cut-price Magrittes, Mesens acquired

both *L'Assassin menacé* and *Le Joueur secret*. In the late 1950s he lent them to the Casino Knokke, then a honeypot for the beau monde on the Belgian coast, where they were displayed as a pair on either side of the main staircase. Mesens was a shrewd lender. In 1954 *L'Assassin menacé* took its rightful place in Magritte's first large-scale retrospective, at the Palais des Beaux-Arts in Brussels, superintended by E.L.T. himself. He then sent it on to another retrospective in the Belgian pavilion at the Venice Biennale. In 1965 he lent it to the Museum of Modern Art in New York, for Magritte's crowning glory and triumphal progress around the United States. The following year he sold it to MoMA. Forty years on, the murderer entered the temple. In 2013–14 *L'Assassin menacé* was exhibit A in "The Mystery of the Ordinary," a collaboration between the Art Institute of Chicago, the Menil Collection in Houston, Texas, and MoMA itself, focusing on Magritte's foundational period, 1926–38. The crowds flocked in. The painting retains its pulling power. The cast is unchanged. The record plays on. The murder is not yet solved.

During the summer of 1927 Magritte and Nougé also collaborated on a spoof, *Quelques écrits et quelques dessins*, purportedly the work of Clarisse Juranville, whose name appeared on the cover. Clarisse Juranville was the author of a well-known school grammar, *La Conjugaison enseignée par la pratique*, on the conjugation of verbs, which went through several editions around the turn of the century. As corrected by Nougé, the grammar contained a sequence of poems in conjugation style, together with five "recently discovered" drawings by Magritte. The poems spoke of their preoccupations, through the medium of Mademoiselle Juranville (mercifully deceased). They also provided a kind of reflexive commentary on the exercise. "From grammars to revolutions," remarked Nougé laconically, "one can assess the merits of the example."

> They resembled everyone else
> They forced the lock
> They replaced the lost object
> They primed guns
> They mixed drinks
> They sowed questions by the fistful
> They retired modestly
> while erasing their signatures.[86]

Some of the poems were set to music by André Souris, in a composition for voice and instruments announced as *Quelques airs de Clarisse Juranville mis au jour par André Souris*, which premiered at the Salle du Conser-

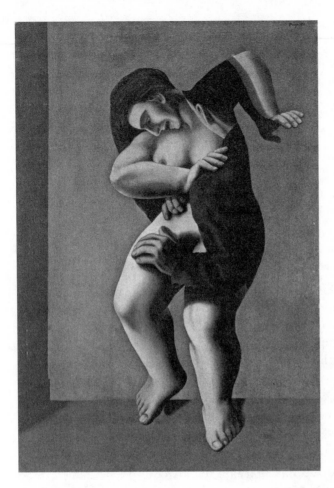

vatoire in Brussels in 1928, and was reprised at the Salle de la Bourse in Charleroi in 1929. Charleroi was an occasion. The regular audience of sedate Sunday evening chamber concert goers was hijacked and held hostage to a surrealist *serate* or performance. On entering the Salle de la Bourse, they were surrounded by a pop-up exhibition of eighteen recent paintings by Magritte, a confrontative selection including *Les Jours gigantesques* (*The Titanic Days*), one of his most brilliant and challenging images, described by the artist himself as an attempted rape—"a more violent effort than hitherto," he told Nougé, "but I feel that the violence here is not merely external."[87] On the program was music by Hindemith, Milhaud, Stravinsky, Schoenberg . . . and Juranville. Trepidatious music lovers had ample time to ponder titanic days. Before a note was played, they were treated to a lecture by Nougé. The Conférence de Charleroi made considerable demands on the audience. "Music raises serious issues," he began. "To my way of thinking, then, these issues lend themselves to serious examination, and in order to avoid them slipping through our fingers, a certain *froideur*." If at this point a shiver ran down the spine of the assembly, it would be difficult to blame them. They had been warned. "I feel compelled also to ask of you a real effort at attention. Better still, a sort of collaboration." Over the next hour and a quarter anyone hankering after a little *froideur* was not disappointed. Nougé spared nothing and nobody. "The human spirit proceeds by shattering inventions," he concluded. "The spirit is at our mercy, and we are all responsible."[88]

With the exhibition at Le Centaure, the Catalogue Samuel, and Clarisse

Juranville, the astonishing adventure was under way. It was the Magrittian revolution. It had his name on it, and without him it would have come to nothing. But it was also a collective endeavor and, at heart, a joint enterprise, founded on the understanding between Magritte and Nougé, a heady mix of telepathy and teach-in. In January 1928 Magritte had another one-man show, at the Galerie L'Époque in Brussels: twenty-three paintings, culminating in *Le Double secret*. Nougé's catalog preface or postface was a declaration of intent, almost a declaration of love; or perhaps the invention of a basic emotion, comparable in power to love—*complicity*.

> Discoursing on friendship, or partaking of it, would no doubt end in hating it and denouncing it.
>
> But it transpires that it can take a singular form that appears rigorously to exclude any indulgence.
>
> It leaves to others the task of assigning tastes and colours.
>
> The spinelessness of habit gives way to the wish for some adventure, some common enterprise, to a sense of risk and opportunity equally shared.
>
> It may perhaps be said that it represents a kind of complicity.
>
> That is why we have no hesitation in calling ourselves here and now the accomplices of
>
> René Magritte.[89]

This declaration was signed by Goemans, Lecomte, Mesens, Scutenaire, and Souris, together with Gaston Dehoy, an associate of the Dadaist Clément Pansaers, and Marc Eemans, who had an ambiguous and ultimately poisonous relationship with those he mocked as "the post-Dadaists," Magritte, Mesens, and Scutenaire, and with Nougé, "the Monsieur Teste of the group."[90] Complicity, with its suggestion of the criminal fraternity and the secret society, was a very Nougéan notion. It captured the spirit of the band. It continues to resonate. "My complicitous friendship," wrote Georges Bataille, "this is what my temperament brings to other men."[91]

The pact was sealed. The revolution had begun, though hardly anyone knew it yet. The Belgian group and their important thoughts and gestures were known mostly only within Belgium; France was the known epicenter of surrealist thought. In any case, the declaration of complicity appeared in Magritte's absence. In September 1927 he flew the coop. He and Georgette moved to Paris. There was a world to win. Or to upend.

6.

The Cuckoo's Egg

They rented a three-room apartment on the top floor of 101 avenue de Rosny, now avenue du Général de Gaulle, in Le Perreux-sur-Marne, some seven miles to the east of the city center, beyond the Château de Vincennes. Le Perreux is now in the suburbs, but then it was barely on the map. It lay far out, beyond the reach of the Métro. To get into town meant taking a bus to Nation and picking up the Métro there, or coming in by train. Either way, it was a time-consuming business.

The move was not a spur-of-the-moment decision. Magritte had a taste of the city on his previous visits, while he was still attending the Académie—Fontainebleau, Versailles, the Louvre. He must have talked to Georgette and to Flouquet about the possibility of gravitating there, after his military service. ("Mon cher René, why despair, in four months you'll be able to go and finish your studies in Paris.") After quitting his job at the wallpaper factory, he scouted for commercial work there, without success. In 1924 Magritte sent a bulletin to Georgette as he pounded the Parisian streets:

> This morning I began to look around. I visited several design studios, two of which held out some hope. The first asked me to do a drawing at home to show them what I can do, on the grounds that my sketches do not give a clear enough indication. The second will write to say whether I can be taken on trial—the pay wouldn't be marvellous, it's lower in the studios than in the factories, I would start at only 600 francs! With Walton and Loreid (Lincrusta) it would be still less because making Lincrusta patterns isn't very hard work . . .

What I've seen of the bustle of Paris that I have to get used to makes Brussels seem very calm and easy-going; in this frame of mind, my weariest times doing posters in Brussels would seem restful compared to the Parisian bustle. I've looked at the latest ideas in posters here, and if I were to use them in Brussels, the effect would be striking, I think; the same goes for glove designs, I've seen some new things. Anyway, my little darling, I think if you were to come to Paris, life would be very hard for you. People here think themselves superior and despise foreigners. Quite a change! Everyone for himself, the fight for survival![1]

On top of that there was the cost of living ("350 francs for a room!"). The scheme was abandoned for the time being. Yet Magritte was not deterred, despite these intimations. Paris was a mecca for artists. Paris was the place to be. To be a painter in Paris was to live the life. To have a show in Paris

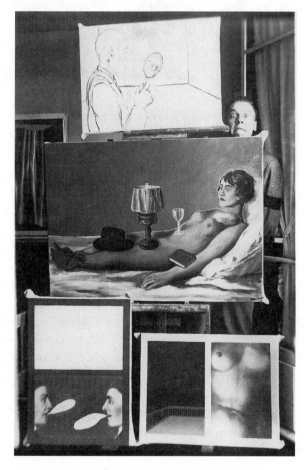

was to arrive. To make a splash in Paris was to break free of factories, design studios, impresarios: to be rid of the poverty of piecework. In Paris, moreover, a painter might also be a thinker. He might find others of like mind. Together they might do great things. They might *act*, as Nougé prescribed. The pull of the arena was too great. The lure of the limelight was too strong. He had nothing to lose but his chains.

They had been apartment hunting for months before settling on Le Perreux. On their reconnaissance trips they would stay with Georgette's relatives, Camille and Germaine Fumière, who lived even farther out, in Saint-Mandé, a spot that could well have led them to Le Perreux. It is clear that they would have preferred somewhere more cen-

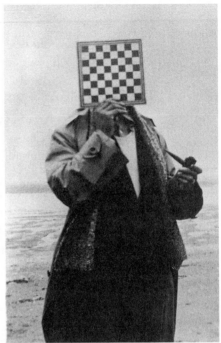

tral, though Magritte later denied it. Ironically, they were offered nothing but artists' studios, which the artist did not want. He painted in the living room, as usual.

The apartment in Le Perreux was to be their nest until July 1930. It must have been crowded. They brought their own furniture, including a piano. Loulou came too, of course. So did Magritte's brother Paul, who rented a room nearby but took his meals with them and played the piano in local bars. Thrown on his own resources, without his usual *bande*, Magritte began to organize the kind of recreations he liked best: slapstick with intimates; theatrical setups in the home (the little theater of his youth translated into adult entertainment)—domestic surrealism, dabbling in photography, and later in film. Magritte was a lifelong shutterbug. In the immediate environs, they were not short of things to do. They could bathe in the Marne and go for walks along the riverbank. They could go to the cinema. If Georgette was away, Magritte would go by himself. He would try anything, but leave at the interval (or sooner) if it did not please him, which he did during a double bill of *L'École des sirènes*, with Bebe Daniels, and *Le Postillon du Mont-Cenis*, with the Hercules-like Maciste (Bartolemeo Pagano). They made periodic trips back to Brussels and Charleroi, though Georgette was more enthusiastic about these than Magritte, who liked to keep them brief. They had a regular visitor: Magritte's friend and com-

patriot Camille Goemans, the linchpin of his life in Paris. For about three years, by virtue of proximity and sympathy, Goemans became his closest collaborator, Nougé excepted. In a certain sense it was Goemans who made the Paris experience possible; and it was Goemans who brought it to a wrenching and involuntary end.

Camille Goemans (1900–60) was never really a member of the gang, though for a formative period in the 1920s he was intimately involved in almost all of their activities. He remained on good terms with Magritte, despite their travails, and continued to promote him until the end, in two notable public lectures, in 1949 and 1956; he appears as a foil in the fascinating documentary *Magritte ou la leçon des choses* (1959), by the distinguished filmmaker and ethnographer Luc de Heusch.[2] Like the others, he was the very model of outward respectability. Their French counterparts rejected whatever might have afforded a "situation" in life. "There is no use being alive if one must work," as André

Breton said. "The event from which each of us is entitled to expect the revelation of his own life's meaning . . . *is not earned by work*."[3] The Belgians by contrast operated under bourgeois cover. Lecomte was a poet, it is true, but also a schoolteacher, and later a consultant to the Musée des Beaux-Arts in Brussels. Scutenaire was a lawyer; he acted as *conseiller* (legal adviser) to the Ministère de l'Intérieur. Irène Hamoir was a journalist at the International

Court of Justice in The Hague. Nougé was a biochemist. In similar fashion, Goemans was a civil servant. In 1923 he abandoned his studies in medicine and law to enter the Ministère de l'Industrie et du Travail. He met Magritte around the same time, at the Salon de la Lanterne Sourde in Brussels. The following year he published a slim volume of poems, *Correspondance*, which served to introduce him to Nougé and Lecomte and made his name.

Goemans wrote comparatively little, but he was not a negligible figure. He had mettle, and acumen. He was a good judge of men and measures. He was permitted to call Nougé *tu*. In 1926 he went into partnership with Geert Van Bruaene in the Galerie de la Vierge Poupine in Brussels. Together they signed up Max Ernst ("Marx Ernst," as he appears in one of Goemans's texts). Following this coup, Goemans resigned from the civil service, preferring showing paintings to shuffling paper. In 1927, all by himself, he agreed to a one-year contract with Jean Arp, for his entire production, in return for a monthly stipend of 1,500 French francs. Goemans was pushy. Armed with Arp, he began working as an independent dealer in Paris.

Two years later, thanks to windfall financial backing from a shadowy Dutchman named Rott, he opened the Galerie Goemans, at 49 rue de Seine, on the Left Bank. In October 1929 the inaugural exhibition showcased

the four artists he had under contract: Arp, Dalí, Tanguy, and Magritte. Together, they were a formidable bunch. The contract with Dalí had been agreed to a few months before, after protracted negotiation. According to Dalí, he received 3,000 francs, in exchange for everything he produced over the summer, with a view to an exhibition later in the year; Goemans had a percentage on each painting sold, and the right to keep three of his own choosing.[4]

The contract with Magritte had only just come into force. It was agreed to in September 1929, after the sudden termination of the contract with Le Centaure in July. It is not clear who made the first move. No doubt Le Centaure were happy enough to be rid of Magritte, the unsellable; but it is equally possible that Magritte himself made the break, after Goemans promised him a contract if he did so. "I've terminated my agreement with Le Centaure," he told Lecomte, "I've more confidence in the Paris dealers."[5] Goemans was as good as his word.

Magritte painted his portrait. Appropriately enough, it is a disguised portrait, called *Le Soupçon mystérieux*. "I've started the portrait of Goemans," he informed Nougé. "The idea is the same as that of *The Barbarian* (Fantô-mas)," the painting based on the famous poster of the master of disguise, clutching a bloody dagger. Here, however, the man is mysteriously empty-handed, without a stain on his character. Goemans also served as a model for other works around this time, including the equally mysterious *Objets*

familiers.[6] In 1973 the British painter Patrick Caulfield was magnetized by *Le Soupçon mystérieux:*

> I've always liked Magritte but what struck me remarkably about this particular image was that it didn't have any of Magritte's trickery and space, and yet had all the power that his imagery has. If you described the painting to someone, a man looking at his hand, one wouldn't think that was remarkable, would one? I thought it was a great achievement to use such a simple image and give it such impact. I thought as I couldn't own the painting I'd like to do a version of it. It *was* about the figure. I added all the trappings simply to confuse the simplicity of the image, which is what makes the Magritte marvellous.[7]

The Galerie Goemans flared and died in a brief span of seven months. The inaugural exhibition coincided exactly with the Wall Street crash. In quick

succession there was a one-man show of Arp, followed by a one-man show of Dalí—the first, and a sensation, heralded in typical fashion by Breton in his catalog preface. "Dalí's art, the most hallucinatory we know so far, constitutes a real threat. Totally new beginnings with obvious bad intentions have just started out. It's a dark joy to see how nothing happens on their path except themselves, and to recognize, in their way of multiplying and *melting*, that they are beasts of prey."[8] Salvador Dalí had arrived. Soon he was as famous as the Marx Brothers, as Goemans said. As if to prove the point, Dalí wrote a screenplay for them, *Giraffes on Horseback Salad*. It is hard to know whether Dalí was made for surrealism or surrealism for Dalí. As he himself observed, "[T]he only difference between me and a madman is that I am not mad." He was sane enough to give a vital stimulus to surrealist objects, "created wholly for the purpose of materializing in a fetishistic way, with the maximum of tangible reality, ideas and fantasies having a delirious character"—the fur cup, the lobster telephone, the four-legged doll—a vogue that Magritte

didn't trouble himself with, give or take the statues and the pots of horse jam. On the other hand, Dalí was mad enough to become obsessed by Hitler, and to accept a medal from Franco. In 1934 he was formally expelled from the surrealist movement, after a short trial. Dalí was unapologetic. He *was* surrealism, and he would take it with him. He rejected any suggestion of Hitler worship, but refused explicitly to denounce fascism. He became more egotistic, more erratic in his behavior—and more avaricious. Breton dubbed him "Avida Dollars" (an anagram of the artist's name).[9]

After the feeding frenzy over Dalí there was a brief intermission before Goemans put on a show of surrealist collages and papiers collés in March 1930. This historic exhibition was devised in conjunction with Louis Aragon, one of the founding fathers of the movement and ultimately one of its greatest heretics, described by Dalí as "a nervous little Robespierre."[10] "We hung a woman on the ceiling of an empty room," wrote Aragon, even before the appearance of *The Manifesto of Surrealism*, "and every day received visits from anxious men bearing heavy secrets."

> We were working at a task enigmatic to ourselves, in front of a volume of *Fantômas*, fastened to the wall by forks. The visitors, born under remote stars or next door, helped elaborate this formidable machine for killing what is, in order to fulfil what is not. At number 15 rue de Grenelle [headquarters of the Bureau de recherches surréalistes], we opened a romantic inn for unclassifiable ideas and continuing revolts. All that still remained of hope in this despairing universe would turn its last, raving glances towards our pathetic stall: *It was a question of formulating a new declaration of the rights of man.*[11]

The exhibition catalog consisted of a substantial essay by Aragon, "La Peinture au défi" (painting under fire, or, the challenge to painting), a major statement on what surrealism or surrealist objects might be. The show contained one work by Magritte, listed in the catalog as a collage, but described by the artist as a painting, "with a missing and irreplaceable word."[12] Compounding the mystery, this untitled work has since disappeared without a trace. On the canvas, it looks as if the missing word is blanked out by three misshapen patches of corrugated cardboard. The painting reads as follows:

LES

———

NAISSENT
EN HIVER

The missing word is presumed to be "Hirondelles." "Les Hirondelles nais-sent en hiver" ("Swallows Are Born in Winter") was a popular song of the period. The word could be guessed, it seems, but not divulged. Proportion-ately, perhaps, Aragon's essay devoted one sentence to Magritte—"Magritte has used papier collé and, very recently, collage of illustrations"—but added a celebrated footnote, matching Ernst's remark about Magritte's painting being collages done entirely by hand: "Is there a connection between collage and the use of writing in painting as practised by Magritte? I see no way to deny it."[13]

With that swan song, the Galerie Goemans closed its doors. Goemans was penniless and homeless. He had been stitched up and spurned. (Adding insult to injury, his companion Yvonne Bernard left him for his backer.) If he was also blameless, that did not prevent him from being arraigned before Breton and company to account for the disappearance of the gallery, which was con-sidered to be a sort of shop window for surrealism. He lodged briefly with the Magrittes before returning to Brussels to face the music there, consoled by a new companion, Sacha Chigirinsky, who later became his wife.

The closure of the gallery was a disaster for all concerned. Magritte's long-awaited one-man show, scheduled for March 1930, never took place. That was a bitter disappointment, not least because Paul Éluard had expressed interest in writing a catalog preface. At the same time, his monthly payments abruptly ceased: the backer withheld the funds. Mutual recrimination ensued. Magritte accused Rott of arbitrarily suspending their agreement, and caus-ing him considerable hardship in the process. Rott accused Magritte of not declaring or delivering all of his production, and thereby failing to fulfill his contract. Given that Magritte had at least eleven canvases on his hands to sell to Mesens in the life-saving deal of June 1930, painted specifically for the one-man show, Rott appears to have been right. In a letter to Nougé—his plea for help in finding work in Brussels—Magritte almost conceded as much.

I forgot to tell you that on returning to Paris [in January 1930, after Christmas in Belgium] I did not receive the monthly stipend on which I was relying. I was met by the most complete bad faith. Rott went as far as to accuse me of not having delivered to the gallery all the canvases I'd done, though it would have been pointless to do so before my exhibition. Stranger still, [Marcel] Fourrier [a lawyer] seemed to find such a reproach valid, and he advises me to wait until Rott is more favourably disposed towards me. I am profoundly disgusted by the whole affair.[14]

Whatever the rights and wrongs of the affair, waiting was of no avail. The closure of the gallery effectively canceled the contract. As Goemans went out of business, so too did Magritte.

Like Van Bruaene, Goemans seems to have dealt in Magrittes, opportunistically, wherever and whenever he could. He was not deterred by Magritte's contractual arrangements with Van Hecke. Neither was Magritte. In the matter of business ethics, Magritte was never very scrupulous, as Mesens reminded him in a scalding letter during one of their periodic disputes. "You may remember that in the past you betrayed our friendship over the Van Hecke-Schwarzenberg contract. Then you betrayed the latter (exclusively business-like in their dealings with you) for Goemans, Van Bruaene and Gaffé etc . . . etc."[15]

The charge had force. It looks as though Goemans sold three Magrittes to the prominent Belgian collector René Gaffé, in 1926 or 1927, behind the backs of Van Hecke and Le Centaure. "Apropos of Magritte," Goemans wrote to another collector, "and *under the seal of secrecy*, I have three enormous pictures of his in view. I chose them myself, some time ago, and Van Hecke doesn't know about them!"[16] This suggests that Magritte allowed Goemans to cherry-pick paintings straight from the apartment, as soon as they were finished—hot off the easel—regardless of his contract. It also suggests that Goemans (and Magritte) had a good eye for the main chance. The selection they made for Gaffé, who often bought in quantity, included the haunting *Rêveries d'un promeneur solitaire*, a painting subsequently acquired by Mesens.

Goemans also promoted Magritte, in a spirit of enlightened self-interest. Shortly before Magritte moved to Paris, Goemans solicited another prominent Belgian collector, Pierre Janlet, to give him a helping hand. The approach gives evidence of continuing traffic in Magrittes:

> Finally, since we are in credit to the tune of 750 francs, may I ask you to be kind enough, if you possibly can, to send or hand over this small sum to René Magritte on my behalf. I'm sorry to be forcing your hand a bit. Magritte is coming to live in Paris and will be leaving Brussels on 10 or 12 September [1927], I think, for good. He will no doubt need this small sum (I owe him more). Help me, if it is not beyond your means. But why not take the opportunity to go and have a look at what he's doing? You will see at my place [in Brussels] a certain number of his pictures, which I think will be an eye-opener for you. Such maturity has suddenly emerged, a sureness that is now unmistakeable.[17]

In Paris, Goemans would buy paintings from galleries and sell them on—an inventory of his stock in 1927 lists works by Arp, Braque, de Chirico, Ernst, and Miró, among others—but he clearly had an understanding with Magritte. On November 1, 1927, only weeks after Magritte was installed in Le Perreux, Goemans sold a hot new painting to Janlet: *La Clef des songes* (known in English as *The Interpretation of Dreams*, or, less fancifully, *The Key of Dreams*), along with a drawing by Miró and two reliefs by Arp, for 1,000 Belgian francs and a painting by Permeke. Janlet and Goemans were thick as thieves; the former could be relied on to keep his mouth shut.[18] As they all knew full well, Janlet had acquired a significant work.

La Clef des songes was Magritte's first word painting. It represented an important breakthrough—the first of many in this astonishingly fecund period. The technique may have been stimulated by films like Marcel L'Herbier's *L'Homme du large* (1920), which featured not only intertitles but also "intratitles," combining text and image. *The Interpretation of Dreams* derived not from Freud but from Artemidorus, and his treatise *Oneirocritica*; Magritte had a copy of the modern French edition in his library.[19] The painting is divided into four panels or compartments. In the upper left is a hold-all labeled "*Le ciel*" ("the sky"); in the upper right, a penknife, labeled "*L'oiseau*" ("the bird"); in the lower left, a leaf, labeled "*La table*" ("the table"); in the lower right, a sponge, labeled . . . "*L'éponge*" ("the sponge"). This uncanny taxonomy found an echo in a short poetic text, "Théâtre en plein coeur de la vie" ("Theater at the very heart of life"), contributed by Magritte to the first issue of *Distances* (1928), a little magazine edited anonymously by Nougé, in cahoots with Goemans:

> A princess doubtless emerged smiling from the wall in a house surrounded by a superb sky. The chosen fruits were laid out on a table, to represent birds. The lighting was understandable, despite a few unaccountable shadows and the lack of depth beyond the open doors. The whole thing was capable of motion thanks to its proportions.
>
> Now the princess runs, a fearless amazon, through boundless fields in search of mysterious proofs. She uses the thoughts and deeds of an infinite crowd of people. She surmounts poetic obstacles: the suitcase, the sky; the penknife, the leaf; the sponge, the sponge.[20]

Word paintings were one of his most fruitful discoveries. Following the breakthrough, the momentum was almost unstoppable. Word paintings poured out of him. Over the next three years he produced more than forty. They varied enormously; in keeping with his usual practice, one of them was

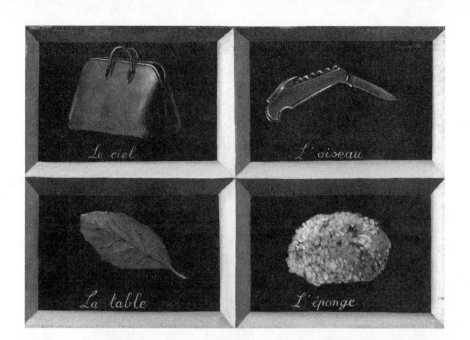

another version of *La Clef des songes* (1930). This time there are six panels, each one an apparent contradiction: an egg labeled "*l'Acacia*" ("the acacia"); a shoe labeled "*la Lune*" (the moon); a bowler hat labeled "*la Neige*" ("the snow"); a candle labeled "*le Plafond*" ("the ceiling"); a glass labeled "*l'Orage*" ("the storm"); and a hammer labeled "*le Désert*" ("the desert"). This version was exhibited regularly over the next decade. In 1936 Nougé entered into a kind of dialogue with it, an attempt to take the measure of its subversive potential, in a text plagiarized by Magritte for his "Lifeline" lecture two years later. Nougé wrote,

> Is it a list of things, some of which are designated by their image, others by their name? Is it a melody, of which the music would be made of objects, and the words remain the words? Is it a poetry machine working in favour of deliberate misnaming? Is it a revolt against speech?
>
> This picture prompts serious thought.
>
> We may be presented with something unknown, being given only its name. We are then faced with an obvious truth: the word can never do justice to the object; it is foreign to it, as if indifferent.
>
> But the unknown name may also hurl us into a world of ideas and images, leading us to a mysterious point on the mental horizon, where we encounter things wondrous and strange and come back full of them.
>
> In response to our secret desires, it may happen in our conversations, it may happen in our dreams.[21]

Interrogation has not ceased. Jacques Derrida had his eye trained on the shoe—"that (dead?) woman's shoe that Magritte entitles *la Lune*."[22] The murderer threatened, once more?

The original version of *La Clef des songes* disappeared into Janlet's collection, until he sold it to Sidney Janis in 1952. In 1954 it surfaced in a revelatory show at the Janis Gallery in New York, *Magritte: Word vs Image*, an exhibition of twenty-one word paintings executed between 1927 and 1930. This exhibition was a classic demonstration of the comparative advantage of having a Mesens as his Maecenas—that is, a collector who gave value to the works by valuing them himself, and knowing it well. The idea came from a visit Janis and his wife paid to Brussels, where they were given a personal tour of Mesens's fabulous collection of Magrittes. By the end of the visit Mesens had come up with *Word vs Image*. No fewer than sixteen of the works came from his own collection. For the first time Janis was able to show two versions of *La Clef des songes*: the one he acquired from Janlet, the other borrowed from the open-handed Belgian collector Philippe Dotremont, who had recently purchased it

from Mesens, for 30,000 Belgian francs.

As far as sales were concerned, the show was a washout. Janis bought one himself; and then another, left out of the return shipment by mistake, at the reduced price of 12,000 Belgian francs. "We have no hope of selling," he wrote stoically to Mesens, "but will accept your suggestion."[23]

But the ripple effect was tremendous. The word spread. Among painters, Jasper Johns had his first lesson in Magrittian at the *Word vs Image* exhibition. He was hooked. As soon as he could afford it, he acquired the third version of *La Clef des songes* (1935), once owned by Peggy Guggenheim. This one reverted to four panels, with the legends in English, for American consumption. In the upper left is a horse's head, labeled "the door"; in the upper right, a clock, labeled "the wind"; in the lower left, a jug, labeled "the bird"; in the lower right, a suitcase, labeled "the valise."

Interestingly, the first Magritte that Jasper Johns really coveted was *Le Mois des vendages* (*The Month of the Grape Harvest*, 1959), which depicts a crowd of bowler-hatted men looking into an empty room through an open window, a little like the witnesses in *L'Assassin menacé*, but without any clues on which to hang a story. Magritte himself was rather pleased with this image. Of his recent work, he thought, "that is the one that best reminds us of how strange reality can be, if one has 'a sense of reality.'"[24] A sequence of Luc de Heusch's documentary plays cunningly on the absence of clues. Magritte and the gang foregather, in order to find a title. The painting is on the easel. Magritte sets the scene. He goes so far as to indicate that the men are not passersby, nor witnesses, nor spectators, nor listeners. There is a pause. At length

he volunteers, "I thought of adding a musical instrument in the corner of the room," to which Goemans replies, "There was no need to suggest the presence of musicians in the room."[25] Musicians or no musicians, it was too expensive for the young Jasper Johns. Magritte's anonymous bowler-hatted man continued to haunt him, as perhaps did the famous pipe. On Johns's talismanic *Flag* (1954–55) it is possible to make out the ghostly words "pipe dream."[26]

Word vs Image also registered with Robert Rauschenberg, who acquired one of the word paintings that had been in the exhibition, *Le Sens propre* (*The Literal Meaning*), depicting an oval panel that might be a mirrorless mirror, across which is written *femme triste*—the picture of a sad woman. Rauschenberg also acquired a happier one: a single section of *L'Évidence éternelle* (1954)—the breasts.[27]

In Paris, the word paintings registered even as they were being made. Breton acquired one in 1928, together with half a dozen other works in the same period.[28] Magritte gave another to Louis Aragon in 1929.[29] One of the most celebrated of them all appeared in the final issue of *La Révolution surréaliste* (1929), in a memorable format: a full-page spread of *La Femme cachée* (*The Hidden Woman*), bearing the legend "*je ne vois pas la [. . .] cachée dans le forêt*" ("I do not see the [. . .] hidden in the forest"), surrounded by iden-

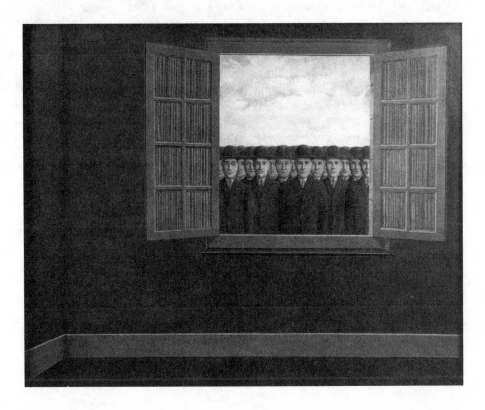

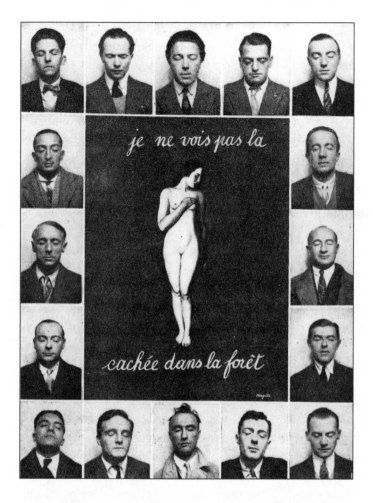

tikit photographs of *la crème de la crème* of the surrealists, with their eyes closed—not onlookers but nonlookers [color plate 26]. The unseeing devotees are ordered alphabetically, giving Breton pride of place in the center of the top row, "carrying his imposing head like a chip on the shoulder," in Man Ray's apt phrase.[30] By accident or design, Man Ray does not figure. The top row features Maxime Alexandre, Louis Aragon, André Breton, Luis Buñuel, and Jean Caupenne; the second, Salvador Dalí and Paul Éluard; the third, Max Ernst and Marcel Fourrier; the fourth, Camille Goemans and René Magritte; and in the bottom row, Paul Nougé, Georges Sadoul, Yves Tanguy, André Thirion, and Albert Valentin.

Regrettably little is known about the genesis of this suggestive photomontage-painting. According to Mariën, Magritte wanted to see *La Femme cachée* reproduced in *La Révolution surréaliste;* it was he who conceived of the photomontage as a means to that end. That sounds very prob-

able. The first issue of *La Révolution surréaliste* appeared in 1924. It had never published anything by Magritte. Five years on, he was nearly desperate to be included. In December 1929 he finally hit the jackpot.

There was a precedent for a photomontage, and indeed for a dream woman. The first issue of the magazine contained a somewhat similar montage, centering on a photograph of Germaine Berton, the anarchist who had assassinated the secretary of the right-wing Action française the year before. This montage was underwritten by a motto from Baudelaire: "Woman is the being who casts the greatest shadow or the greatest light in our dreams."[31] Berton was a surrealist heroine. Her male photo-entourage consisted of the usual suspects, with an admixture of father figures (de Chirico, Picasso, Freud). These images were thumbnail-size head shots, cropped from portrait photographs. Magritte borrowed the idea, and transformed it. The images in his photomontage are more truly mug shots, at once more spontaneous and more uniform. Such images suggest a criminal record, as Roland Barthes divined. They are self-portraits rather than portraits, taken by a machine. The contributors were invited to take pictures of themselves in a photomaton booth, and send them in.[32] Magritte loved these machines. He was not alone. Among his myriad collections, Breton had a collection of vintage photomaton strips.

As for the dream woman, her identity is secure. It is Georgette. Pentimenti reveal that the top line of the legend was originally less cryptic or more explicit: not simply "*je ne vois pas la . . .*," but "*je ne vois pas cette femme*" ("I don't see this woman"), a form of words that reinforces the suggestion that this is not only a new kind of dream woman, but also a new kind of Wanted poster (Have you seen this woman?), just as the photomontage is a new kind of readymade. Like many of Magritte's works, the images are at the same time banal and transgressive, a potent mix. Conceptually, it feeds cleverly on male fantasy—perhaps even pornography, young Magritte's special subject—in particular, Breton's fantasy of a chance meeting with a naked woman in a wood, a fantasy that found expression in two famous books: Aragon's *Le Paysan de Paris* (1926) and Breton's *Nadja* (1928). In the former, Aragon and Breton go for a walk in the woods. "Lost in these woods, under the flames of risk, they seek; awaiting a woman who has not dropped in by chance, a woman with a deliberate purpose, a woman whose sense of life is so all-embracing, a woman so truly ready for anything, that it would be worth turning the universe upside-down for her sake." The unearthly Nadja is a kind of dream angel, an allegory of psychic automatism. Reading a poem quoted by Breton, "her eyes brim and are filled with a vision of a forest. She sees the poet passing near this wood, as though she could follow him at a distance: 'No, he's skirting the forest. He cannot enter, he does not enter.'" Breton himself declares, "I have

always, beyond belief, hoped to meet, at night and in a wood, a beautiful naked woman, or rather, since such a wish once expressed means nothing, I regret, beyond belief, not having met her."[33]

Such a woman was *La Femme cachée*. Not only did Breton reproduce her in *La Révolution surréaliste,* he acquired her for himself.

He lent her out, twice, for a Magritte exhibition in Brussels in 1933 and for the *Exposition internationale du surréalisme* in Paris in 1938. After that, he stopped lending. The woman remained in hiding. Breton's private devotions were clouded by a progressive deterioration, especially poignant in the circumstances: the painting darkened considerably over the years, and the woman threatened to disappear. When he tried to clean it, the surface of the paint began to break up; the disintegration was later arrested by a restorer. Breton was sufficiently exercised to report the matter to Magritte. Nothing daunted, he asked for a replacement. "I thank you for still thinking of giving me a replacement for this canvas of yours which was my special favourite," he wrote, in 1961. "I was pretty sure that you wouldn't be able to recapture the state of mind (forgive the expression, I can't think of another) you were in at

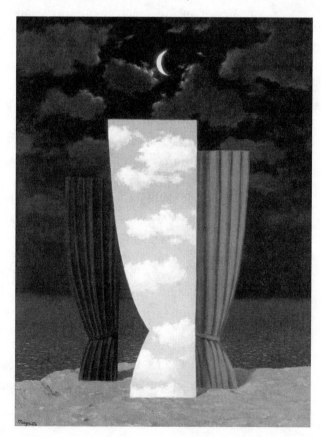

the time. . . . Do you remember that on your last visit to rue Fontaine [his apartment in Paris] you gave me a little gouache of *La Folie des grandeurs* [*Megalomania*]?"

Magritte obliged, with a painting called *L'Image en soi.* "I call it *The Image in itself*—without irony or challenge to a certain kind of logic that we can easily do without," he informed Breton. "I shall say no more about it, apart from hoping that *L'Image en soi* corresponds to *all* your preferences, and can replace the unseen woman in the forest."[34] Was "*all* your preferences" a completely innocent remark? Perhaps. However that may be, Breton turned magnanimous. He was away

when Magritte delivered it, personally, as a surprise. On his return he made haste to express his appreciation, in fulsome terms:

> The "surprise" you had in store for me was total—although in my impatience I couldn't resist the need to have *The Image in itself* described to me in a letter. . . . That brought me a little closer to having a physical idea of it and gave me a foretaste of the emotional experience I would have on seeing it. Besides, nothing was better calculated to confirm my long-held view that it is the indescribable, both in the subject-matter and the way of painting it, *that does everything*, just as in poetry it is *what is unsayable in other terms*. What is indescribable here is the feeling for life and the mystery of life peculiar to a totally exceptional man called René Magritte, of whom I am honoured to be the old comrade and, above and beyond rare storms entirely independent of him or me, the friend.[35]

The mystery of life is marvelously revealed in *La Femme cachée*. The damage to the painting suggests a process of dematerialization; and yet, as David Sylvester eloquently pointed out, dematerialization is also transfiguration. "It is one of those cases in which the impact of natural hazards on artistic intentions has worked so that the loss resulting from fragmentation or blurring is far outweighed by the gain in vibrancy and power of suggestion. . . . Where the body has disintegrated into a web of craquelure, a golden glow issues from the interstices. These broken luminous passages have an effect rather like that of a flaking surface of a battered icon."[36]

Opposite the icon, on the facing page of *La Révolution surréaliste*, could be found Magritte's response to a survey on love. The surrealists were fond of surveys. They were also fond of sex. They conducted research into sexuality, holding uninhibited group discussions on the subject. Breton wrote a book called *Mad Love*. Love was an obvious target. The exercise was governed by Breton's categorical imperatives. "This word, love, upon which buffoons have strained their coarse wits to inflict every possible generalization and corruption (filial love, divine love, love of the fatherland), we are here, needless to say, to its strict and threatening sense of total attachment to another human being, based on the imperative recognition of truth—*our* truth 'in a body and soul,' the body and soul of this human being." The survey posed four questions:

1. What kind of hope do you place in love?
2. How do you envisage the passage from the *idea* of love to the *fact* of loving?

3. Would you accord yourself the right to deprive yourself for a certain time of the presence of the person you love, knowing how much absence can inflame love, yet realizing the mediocrity of such a calculation?

4. Do you believe in the victory of love's glory over the sordidness of life, or in the victory of the sordidness of life over love's glory?

The photomontage-painting of *La femme cachée* could be construed as Magritte's response to the survey. His more conventional response ran as follows:

1. All I know about the hope I place in love is that it only needs a woman to make it real.

2. The passage from the idea of love to the fact of loving happens when a being that has appeared in reality establishes its existence in such a fashion as to be loved and followed into the light or the shadows.

I would sacrifice the freedom which opposes love. I rely on my instincts to make this gesture easy for me, as in the past.

I am ready to foresake the cause I uphold, if it corrupts me in the face of love.

I can't envy anyone who never had the certainty of loving.

A man is privileged when his passion compels him to abandon his convictions to please the woman he loves.[37]

The woman has the right to ask for similar proof, if it serves to exalt love.

3. No. That would be to impose limits, for the sake of experience, to the power of love.

4. Love cannot be destroyed. I believe in its victory.[38]

Magritte was not invited to take part in the discussions on sexuality, held periodically from January 1928. He was invited to take part in a discussion on the thorny issue of collective political action, held on March 11, 1929, at the Bar du Château. The prelude to this meeting was another survey. This one was more ideological—akin to a loyalty test, or a call to order.

1. Do you believe that, all things considered . . . , your activity should or should not be limited, permanently or otherwise, to an individual form?

2. If *yes*, will you undertake, on behalf of what might unite the majority of us, to set forth your motives? Define your position. If *no*, to what

degree do you believe that a common activity can be continued; of what nature would it be, with whom would you choose or consent to conduct it?[39]

These questions were sent to some sixty persons who might have identified themselves as surrealists at one time or another, including the Brussels group, and those who were currently expelled or estranged. Some of them did not reply. Others replied in such a way as to be excluded from the meeting, "by virtue of their occupations or their character" (seven in total, including Man Ray and Tanguy, who both turned up anyway). Magritte evidently passed the test. His reply underlined his belief in collective action, and in political engagement. For Magritte, art and politics were inextricably intertwined. "Collective action might perhaps make a formidable impression. It would obtain a greater hearing for what *Poetry*, for example, can express."[40]

Among his accomplices, Goemans and Souris replied in the same vein. Mesens must have done likewise; he, too, attended the meeting. Nougé did not. This was the occasion for his celebrated admonition to Friar Breton and the French surrealists.[41] His reply was read out at the meeting:

> I should be very glad if those among us whose name has just begun to make a mark would *erase it*. They would win a freedom, in which we could invest some hope. The world offers us many good examples: that of some thieves, certain murderers; that of political parties dedicated to illegal action, awaiting the hour of the Terror. It is of course a question of *the secret spiritual arrangements* of those isolated individuals or organized parties; not of a few anecdotes for men of letters or the strange gallery of historical fossils.

This was received in stony silence. Some months later, it provoked a reaction in *The Second Manifesto of Surrealism*, an unhappy mix of self-justification and purge, also published in the final issue of *La Révolution surréaliste*. Stung, Breton riposted: "Without quite knowing who he is thinking of, in any event I consider that it is not too much to ask anyone to stop making an exhibition of himself so smugly, and perform on stage."[42]

Everyone knew who he was thinking of. The dispute did not end there; it touched on the very foundations of Breton's approach to art and artists. Nougé also took issue with a notion embedded in *Le Surréalisme et la peinture* (1928), Breton's collected thoughts on the subject. This was the "internal model" of the work of art, a notion with a long history. As purveyed by

Breton, the true creative artist, the Nietzschean revaluer of all values, will not seek or find his "model" in the external world, in nature, but instead in the internal world, that is, the self. He will pull out of himself the most delicious and horrible marvels, as Nougé put it. Breton pictured Picasso doing just that, prodigiously, as if by magic. For Nougé (and Magritte), the internal model was tantamount to surrendering to the unconscious, or the occult, as the artist waits patiently for inspiration, or, failing that, a nod, a wink, or a miracle. They found equally objectionable the cult of automatism, with its mediumistic baggage and suggestion of psychic powers. Surrealism was defined, "once and for all," as "psychic automatism" in the *Manifesto*, and elsewhere as "a certain psychic automatism that corresponds rather well to the dream state."[43] Psychic automatism was enough to make Magritte see red. "Automatic writing," beloved of Breton and his brethren, was anathema to Magritte and Nougé both; "automatic painting" was simply ridiculous. Automaticity was supposed to be a vehicle for revelation, because it led straight to hallucination. For Magritte and Nougé, this was the merest flimflam. All talk of hallucination was a distraction. What they were interested in was invention. Invention was hard work. It demanded application, cogitation, *action*. The internal model was a recipe for quietism. In *Les Images défendues*, Nougé offered a trenchant contestation, akin to Valéry's "algebra of acts."

> The idea of the "internal model" could become a dangerous notion. It risks suggesting that the picture exists in the painter's mind before it is painted. The reality is different and infinitely more complex. It is made up of an almost inextricable mix of partial insights, acts, twists, desires, particular pleasures, annoyances, distractions, slumberings, awakenings—in the final analysis, the picture exists.[44]

The meeting at the Bar du Château was not a success. The attendees numbered around thirty—a substantial cull. They had been offered as a theme for discussion "a consideration of the recent treatment of Leon Trotsky," purged by Stalin and sent into exile. On the day, the proceedings began with the reading out of the letters received. The tone was set by the dissident Georges Bataille: "Too many fucking idealists." The planned discussion was shelved; Trotsky would have to wait. An inquisitorial atmosphere prevailed. "First of all," announced Breton, ominously, "the meeting must pronounce upon the degree of individual moral qualification." There must be no pussyfooting. "It is not a question of individual and platonic assertions of a spirit of rebellion and a vague sympathy with the rebellious, but rather an absolute faith in the

social Revolution, an absolute confidence in the rights of the proletariat, and in their strength to impose them." At which point, the record states, "Breton asked if everyone shared that absolute faith. (*Yes, unanimously.*)"[45]

Magritte was part of that unanimity, however dragooned he may have felt. He seems not to have spoken at the meeting, nor to have offered any comment on the proceedings. If he had any sympathy with Georges Ribemont-Dessaignes's contention that there be "a stop put to this testing of hearts and loins," he refrained from saying so. When it came to heart and loin, he was ready and willing, but in his own way and in his own time. His relations with the surrealists devolved into a reciprocal reserve. He kept his distance. They kept theirs. For Nougé, *Distances* was pregnant with meaning; one of his tracts for *Correspondance*, addressed to Breton, among others, was entitled "Pour garder les distances." Magritte took the lesson to heart. Goemans introduced him to Ernst, Arp, Miró. He had cordial encounters with Breton and Aragon. He passed the time of day with Benjamin Péret. In due course he became friendly with Éluard.[46] First Breton and then Éluard began to collect his work. None of this seemed to make any difference. Magritte remained on the outside, looking in. He was not invited to show at the Galerie Surréaliste. He was not involved in surrealist actions. He was not mentioned in the first edition of *Le Surréalisme et la peinture*. In 1945, the second edition of that work boasted a single paragraph on his "object-lessons" and—at Duchamp's instigation—*Le Modèle rouge* (1935) on the cover. It took another twenty years and another edition to register his genius, "or his true common sense, meaning that of the greatest poets."[47]

In the writings of the surrealists, it is hardly an exaggeration to say that Magritte was relegated to a footnote, even while the leaders of the movement bought his works for their private collections. He remained an unperson until well into the 1930s, effaced from the record, like Trotsky. He fared no better with his own compositions. For almost a year he and Goemans worked intermittently on a long short story, "Les Couleurs de la nuit."[48] Eventually they submitted it to Breton and Aragon, guest editors of a special surrealist issue of *Variétés*. It was rejected on account of its length (more than ten pages of the magazine), which was perhaps understandable. Breton then mislaid the manuscript.

In the meantime Magritte and Goemans brought out a series of leaflets, *Le Sens propre*, each one reproducing a painting above a poem written to accompany it; five were published, at weekly intervals, in February and March 1929. Goemans liked to say that the poems were "responses" to the paintings, or that there was a correspondence of some sort between the painting and the poem; he also suggested that the poem fulfilled more or less the same function

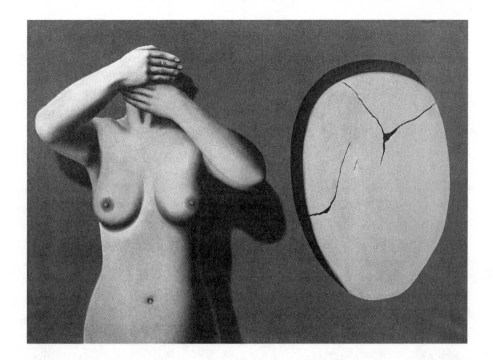

as the title. Be that as it may, the only case of direct address appears to be the painting called *Le Genre nocturne* (*The Nocturnal Kind*) and the poem called "La Charmeresse."

Radiant and upright, the breasts beribboned or, like love, ennobling the torso; in the air primed with the white fuse of day; like the golden fruits of gulfs bridged by luminous intersecting lines, we watch her wake and bend the bow with signs.

For a moment longer, her gaze suspended—tracking into the heart of dawn a tender thought, the memory of a dream where night is braided with sketched gestures and confused sighs—she pauses, knowing how to clothe a profound absence, when she so wishes, with an air of nonchalance.

But when at last the cry comes, rending the blue from feathered arrow to sound machine, to the features devoured by an invisible flame, she slowly makes a wall of her hands; and mouthless face and faceless mouth, she shapes out of shadow a landscape body.[49]

Goemans's effusions were no match for Nougé's scenarios. And there was a further disappointment, almost unmentionable. The original intention was a book. "I've written another poem or two for the book which Magritte and I

will publish together," runs an unsent draft to Nougé. "There is no doubt that we shall encounter enormous difficulties. The cost of publication will be too high for there to be any question of our meeting it ourselves. We shall therefore have to find a publisher. Moreover, I don't think we're likely to get hold of the necessary photographs, owing to the very fact that *Sélection* will retain for its own use a certain number of those we have chosen."[50] *Sélection* published a series of albums on living artists. One was announced on Magritte. It did not appear either.

When it came to the surrealists, Goemans's experience mirrored Magritte's. "I haven't managed to see Breton," he wrote to Nougé a few weeks after his arrival in Paris. "I *requested* an interview through Marcel Noll [manager of the Galerie Surréaliste]. But apparently Breton can't see me until next week. Enough said: that would take too long." Nougé responded with an urgent entreaty: "[B]e *absolutely uncompromising* with the surrealists as to their political situation. We have good reason to be ashamed of them."[51] In France, the political situation of the surrealists turned on the vexed question of their relationship with the Communist Party. Acrimonious debates about their willingness to truckle to the dictates of the party dogged them from the beginning. In Belgium, Nougé and his confederates had a clearer view, born of bitter experience: they should keep their distance.

A little later, Goemans confided to Nougé his reflections on life as a dealer in Paris, or rather as a Belgian in Paris, a pessimistic appraisal notable for its candid perspective on "us" and "them," the Belgians and the French. That perspective was widely shared, on both sides, but rarely voiced. It testified to deep-seated differences, and a recognition that the two sides were not well matched. The characterizations were sharply drawn. The French were megalomaniacal, conspiratorial, and imperial, not to say imperious; they controlled the metropole and, as they supposed, the moral high ground. The Belgians were the poor relations; they were strangers to the metropole and the moral high ground. In the eyes of the French, they did not know how to behave in such places; there was a lot they had yet to learn. They seemed to operate by a different code. It was almost as if they spoke a different language. At the same time, both sides recognized partial exceptions to these rules. Nougé himself was one. ("I have every confidence in Paul Nougé, and no doubt *in him alone*, to define a new point of departure," said Breton in 1940.)[52] The capital itself was essentially contested. If Paris was the proving ground, it was also a kind of meat market, and a graveyard of reputations. Indicatively, perhaps, Nougé went to Paris very rarely: Paris went to him. Nougé knew better. "You have charmed the savage city that has swallowed so many men," he wrote to his friend Baillon in 1920.[53] Others, even avatars, were chewed up and spat out,

like de Chirico, or spat on, like Poe. ("Let us, in passing, spit on Edgar Poe," Breton's notorious aside in *The Second Manifesto*, an injunction comfortably ignored by Magritte.) Goemans's account is a revealing one.

My life is spent coping with petty difficulties which are of absolutely no consequence. Nothing stands out in this monotony. The people I see— scarcely any of whom are of interest to us—when they are not continually going out of their way to disappoint me, don't inspire me much. Breton is as secretive as ever; the dealings it is possible to have with him never change, nor can they modify the impression we had formed of his character and intentions. In fact, it is in my thoughts that I can best size up these various individuals, and a few moments spent meditating on them are more useful to me than their conversation. So I live rather on the fringe, and no doubt they notice it. This attitude is bound to offend them a little. As far as I'm concerned, there can be no other way of treating them. But they wouldn't understand me. *In order to please them, one would have to let oneself be sucked in by them.* I feel less and less capable of doing so. What I attempted two years ago now seems to me impossible. So much for the Surrealists.[54]

Magritte, too, lived on the fringe, in more ways than one. It is impossible to avoid the conjecture that his location in Le Perreux was a psychogeographical expression of his situation vis-à-vis the surrealists under Breton's dispensation. Goemans lived in Montmartre; Ernst and Miró had studios in the same building. Magritte lived on the periphery, beyond the pale. When he and Georgette came into town, they would stay overnight with Goemans before embarking on the long trek home. In these circumstances, socializing with the surrealists was strictly curtailed.

Visitors to Le Perreux were few. One fine day, Paul Éluard brought his current paramour, Alice Apfel ("*la Pomme*"), to meet Magritte. Goemans was present.

Magritte began by showing us his latest pictures, and I can't remember whether the idea came from him first, or whether it was suggested to him by Éluard, but in any case it was agreed that, there and then, he would do a portrait of Madame Apfel, who posed for him with the greatest of good grace. Whereupon, while Magritte was finishing the job, which was to be completed before the end of the afternoon, we went for a walk along the banks of the Marne, nearby.

When we returned, Magritte triumphantly showed us his picture. It

was in its way a sort of masterpiece, in spite of the short time he had spent on it. The resemblance between the model and the portrait was flawless. Indeed, in an unaccustomed act of gallantry, Magritte in his portrait had improved on Madame Apfel's natural charms. Everything in the picture was calculated to please. . . . But . . . Magritte had painted the young Madame Apfel without a hair on her head. Her face presented to our astonished eyes an absolutely smooth skull, a very pretty little skull, to be sure, which unfortunately did nothing to alter the cruel disfigurement Magritte had inflicted on her.

Nevertheless it all ended very happily. Madame Apfel refused the portrait which Magritte so much wanted to give her. Paul Éluard too.[55]

Magritte's sense of humor was not to everyone's taste. There was something remorseless about it, an unforgiving quality, a coarseness reminiscent of *Les Pieds nickelés*. Magritte delighted in the reflex kick up the backside that is the staple of silent comedy. At surrealist gatherings in Paris he was in the habit of teasing or taunting Breton on the subject of religion—taboo in surrealist circles. "Tell me, Breton, what do you think of Jesus Christ?" "Have you thought, Breton, about the mystery of Catholicism?"[56] Breton is said to have taken it in good part, though a more unpromising mode of engagement is hard to imagine. André Breton was as thin-skinned as he was thuggish. He was the very last person to bait in public.

Magritte himself could be abrasive, or at least a figure of mystery. When hurricane Dalí hit Paris, in 1929, his first port of call was the brothel, and then he visited with Miró, his countryman. "We had lunch together," Dalí recorded in his memoirs. " 'And tonight,' he confided to me, 'I'm going to introduce you to Marguerite.' "

> I was sure he was referring to the Belgian painter René Magritte, whom I considered one of the most "mysteriously equivocal" painters of the moment. The idea that this painter should be a woman and not a man, as I had always supposed, bowled me over completely, and I decided beforehand that even if she was not very, very beautiful, I would surely fall in love with her. . . .
>
> In the evening Marguerite came to fetch us at Miró's studio on rue Tourlaque. Marguerite was a very slender girl, with a mobile little face like a nervous death's head. I immediately put aside all thought of erotic experiments with her, but I was fascinated by her. What a strange creature. And to put a final touch to my bewilderment, she did not speak either.

We went out to have dinner. . . . It was beyond doubt the most silent and the most intriguing meal I had ever had in my life, since neither of my friends spoke a word. . . . I not only tried, by visualizing their paintings, to reconstruct hypothetically what they must be thinking from their tics and each of their movements, that all seemed to me unfathomable mysteries, but moreover I was anxious to guess, by piercing through their double silence, the intimate ideological relationship which unquestionably existed between them. I was unable to advance a single step in my hypothesis. . . . It was only a few days later that I learned that there was no connection between Marguerite and the painter René Magritte.[57]

Thereafter Dalí and Magritte met in Goemans's apartment. Dalí was keenly interested in Magritte's paintings. A series of articles he wrote for the Barcelona newspaper *La Publicitat* contains intriguing snippets on Magritte's recent works, including the word paintings. "René Margueritte has finished a painting where 'there is' a person losing his memory, a bird's cry, a wardrobe and a landscape"—a slightly muddled account of *Le Miroir vivant*.[58]

At this stage the admiration was mutual. They hit it off well enough for Dalí to invite Magritte and Georgette to come and stay in Cadaqués, on the Catalonian coast, his family's summer retreat. In August 1929 they took up the invitation, sharing a rented house with Goemans and Yvonne, Éluard and

Gala, Miró, and Buñuel; Loulou and Doumi, Goemans's dog, were also in tow. For a month or more, the two bad boys of surrealism—Dalí the deviant, Magritte the derisive—painted side by side, almost, or at any rate studio by studio. While Dalí worked on *Le Jeu lugubre*, Magritte worked on *Le Temps menaçant*, the painting with the torso, the tuba, and the chair in the sky, snapped up by Éluard.

One day Goemans and Éluard decided to broach with Magritte the delicate matter of his accent. "No one can deny that Magritte is endowed with a fairly pronounced Walloon accent," as Goemans put it many years later, to a Walloon audience. "He has never made the slightest effort to get rid of it; at certain moments he even enjoys exaggerating it, to the point where it becomes almost aggressive."

> We took it into our heads, Paul Éluard and I, . . . to tackle him on the subject. Not that we found the Charleroi accent unsympathetic, but that we felt it was unbecoming for a painter like Magritte, whose mother tongue was French, to have an accent at all. . . .
>
> We had an epic discussion late into the evening, and Éluard and I were wholly disappointed. He intended to keep his accent and had no desire to try to get rid of it, no matter what.
>
> I am sorry to say that his stubbornness had nothing at all to do with love of his country. But he showed us in no uncertain terms that we were wrong to bother ourselves with something of such little importance, and what is more, to place so much emphasis on an indefensible leaning to support class prejudices, social or intellectual, an incomprehensible attitude on our part. I must say we felt briefly ashamed, and the issue of Magritte's accent never raised its head again.[59]

In Paris, accent was not a trivial matter. Bad French smacked of bad manners. Bad manners spoke of insolence, or insubordination, or worse. When the Dadaist poet Tristan Tzara came to Paris from Romania, by way of Switzerland, his accent was so excruciating that Breton would flee to an adjoining room whenever he started to recite, and Aragon claimed that he even had to be taught how to say "Dada" in French. Danton and Robespierre were squeamish about such things.

Breton first courted Tzara ("I think about you as I've never before thought about anyone") and then dumped him, finding him insupportable and ungovernable. It has been said that Tzara was a disappointing mail-order bride. Magritte was not invested with the same expectations, but it may be that there was a certain element of disapproval or displeasure at his general comport-

ment. On closer inspection, this particular Belgian import turned out to be both more and less than the Parisian group might have hoped. His work was extraordinary—important to monitor, fit to collect—his powers of invention apparently limitless. His art was unlike any other, utterly distinctive and profoundly disturbing. His modus operandi, however, was suspect. So was his attitude. Magritte's approach was essentially rational, as Breton later underlined. They knew very well what he thought of automatism. In surrealist terms, Magritte was a maverick, a case apart. In person, moreover, he was apt to grate. He was unclubbable; and, for all his professions of goodwill, intransigent. Certainly he was a disappointing party member, whichever the party, unless it was the *Poetry* party, as a careful reading of his reply to the survey on collective action clearly indicates. Parties were for followers. Magritte made an uncomfortable follower, as his experience with the Communist Party would show. With respect to the surrealists, it was not so much that he wanted to join, or to belong, as that he wanted to be recognized at his true worth, in Nougé's parlance, rather than embargoed as a novice, or patronized as a country bumpkin. Breton's approbation was important to him, partly because he believed that Breton understood what it was that he was trying to do— more exactly, he *wished* that Breton understood what it was that he was trying to do—and partly because he knew that Breton's words carried weight. Notwithstanding Breton's endless tergiversations, therefore, Magritte spent the better part of thirty years soliciting something from him. (He would have dearly loved a catalog preface from Éluard for much the same reason. And because Éluard wrote like an angel. As it was, he had to content himself with two poems.)

Goemans found the attitude of the surrealists intensely frustrating. "I'm on slightly bad terms with the Galerie Surréaliste," he told Nougé in January 1928. "I just wish that they would show Magritte. But there's no accounting for them. They keep changing their minds."[60] Magritte had other fish to fry. He was busy painting, writing, seeking, finding. He resumed work towards the end of September 1927, after the move, with a glad heart. By the middle of December he had completed at least thirty paintings—an average of three a week. The first word paintings appeared in October. In November he made another breakthrough, relayed immediately to Nougé, complete with drawings of the relevant works:

> I think I've made a really striking discovery in painting: up to now I've been using composite objects, or else the placing of an object was sometimes enough to make it mysterious. But as a result of the experiments I've done here, I've found a new potential in things: that is, *gradu-*

ally to become something else; an object *merging* into an object other than itself. For instance the sky allows wood to show through in certain places. This seems to me to be something quite different from a composite object, since there is no break between the two substances, and no border. By these means I produce pictures in which the eye must "think" in a completely different way from usual. Things are tangible, and yet a few planks of solid wood become imperceptibly transparent in certain places; or else parts of a naked woman also change into a different substance. I discovered this as a result of a painting like this: []

All that was necessary, as you see, was to remove the form that separates the planks from the sky, and to merge into one another the things that were separated higher up.

I call these latest things: *L'Illusion modèle* [*The Model Illusion*], *Le Centre de la nature* [*The Heart of Nature*], *La Base du silence* [*The Base of Silence*], *L'Expérience du miracle* [*The Experience of the Miraculous*], *L'Avenir des voix* [*The Future of Voices*], *La Fin du temps* [*The End of Time*], *La Récolte des nuages* [*The Harvest of Clouds*], *La Maladie des planchers* [*The Disease of Floors*], *Les Embarras de la peinture* [*The Predicaments of Painting*], etc.[61]

One of the canvases mentioned here, *L'Expérience du miracle*, was a classic example of Magritte's metamorphic works. As if to make the point, it was soon dignified with the title *Découverte* (*Discovery*): it shows a nude,

the human flesh merging or metamorphosing into wood grain [color plate 27]. Not surprisingly, Nougé only grasped the full force of this discovery when he saw the paintings themselves, but he clearly sensed that something was afoot. "How I like your way of working, mon cher Magritte, this way of precipitating events and turning them to good account. At the moment I can't imagine anything more productive."[62]

Magritte was in the habit of sending Nougé sketches of his latest work, and sometimes photographs, as an aid to their discussions, and an invitation to propose titles (or improve on his own efforts). Nougé responded encouragingly. Occasionally he surpassed himself. One stupendous six-page letter, composed in November 1927, was plainly designed to fire up Magritte for Paris—for the task he had been entrusted. This was the letter in which Nougé spoke of inventing a universe and not describing it. It was the most inspirational letter Magritte ever received. It contained a personal version of the call to invent new emotions. It appealed to Magritte, in effect, to be the best Magritte he could possibly be. It opened in spectacular style, as Nougé mobilized an image of his own, a parable reminiscent of Kafka, as a metaphor for their situation and their struggle:

> Here we are at the foot of the wall, with all the others (our public). There are those who are anxious to know what goes on behind the wall; there are those who are prepared to settle for the wall; there are those who do not care what happens behind the wall, if anything; there are those who don't see the wall; there are those who deny the wall; there are those who deny or refuse even the possibility of the wall. But you, mon cher Magritte, you have constructed an infernal machine, you are a good engineer, a conscientious engineer. You have left nothing undone in order to blow up the wall. That is just your role. You know nothing of the future, or if you allow yourself to predict. . . . The wall is going to be blown up, if your calculations are right, if you have worked well. Whatever is behind it, you will discover with us, you will experience the surprise, the unknown terror. Perhaps you will die; you know nothing of the nature of the risk you run. . . . The best we can hope for is that behind the rubble, *further on*, there are other great walls, the substance and resistance of which we do not know, and which demand of us mischief-making new machines that we will have to invent from scratch. . . .
>
> Why should we not introduce, by prudent machinations, a new love, new passions, new vices, new spiritual forms in the world? . . .
>
> A man moves us by what he *does* but even more by what he *is*.[63]

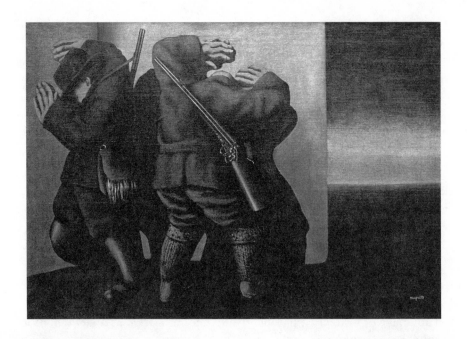

The parable of the wall surely resonated with Magritte. A few months later he produced a powerful image of two armed men walled in—struggling to free themselves from a corner of a wall that ends, as it seems, just beyond their reach. He called it *Les Chasseurs* (*The Hunters*), a title he was not satisfied with. [64] On the back of the photograph he sent to Nougé, he wrote *Les Chasseurs condamnés* (*The Hunters Condemned*). Nougé was much taken with it:

> Thank you so much for drawing me a picture of your latest canvas. I find it absolutely remarkable. I admire the care you have taken to particularize the event, to endow it with the maximum of concrete reality by the precision of certain details, thus guaranteeing, to my mind, the intensity of its effect. I also commend the precaution you have taken to eliminate that third figure which might have produced the impression of a "well-made" picture. I understand this all the better since I have often had occasion to modify in a similar way prose pieces whose perfection was becoming embarrassing, because I felt it might charm or arrest attention to the detriment of what I really wanted to achieve.[65]

Nougé, too, felt the title was lacking. He substituted *compromis* (compromised) for *condamnés* before finding the definitive title in time for its first exhibition three years later: *Les Chasseurs au bord de la nuit* (*The Hunters at the Edge of Night*).

Magritte was not done with the wall. In 1943 he produced a variation of a kind, *La Gravitation universelle* (*Universal Gravitation*), depicting a man with his arm stuck in a brick wall, behind which may be glimpsed a phalanx of tree trunks, or poles, stripped of all life. The man is a hunter (modeled by Scutenaire, in plus fours, with a mop handle for a rifle); his features are contorted in pain or panic or puzzlement. Twenty years later, in the course of an unscripted radio interview, Magritte was provoked to an unguarded statement about the atmosphere or mood of this painting, as an exemplar of a condition fundamental to his work—and perhaps his life—*angst*. The interviewer remarked on the "dreamlike and sometimes nightmarish" quality of his painting. Magritte briskly rejected the dream and queried the nightmare. The interviewer adduced *La Gravitation universelle*, calling attention to the expression of the man, "who is screaming, I think, or at any rate registering his astonishment." "Yes," responded Magritte, "or his embarrassment or fear, his angst."

> Can we use the term nightmare with reference to that universal gravitation? It seems to me that we should distinguish between a nightmare, which may be imaginary, and a necessity of the universe. . . . It is, as it

happens, an example of the angst one may feel in connection with reality. But this angst is only an exceptional moment in one's thought. . . . At the moment I feel no angst, but there are moments when the angst suddenly arises, and then I am certain that what is affecting me is the sense of mystery.[66]

Magritte used the word *angoisse*. Strange as it may seem, he may have picked it up from Heidegger, whom he read extensively in the 1950s. Alternatively, he clearly recognized something in Poe, who speaks of "a kind of nervous restlessness which haunted me as a fiend"—in Baudelaire's translation, "une nerveuse instabilité qui me *hantait* comme une mauvaise esprit," a passage marked by Magritte in his copy of *Histoires extraordinaires*.[67] Whatever its source, it took many forms. On one occasion, the latest batch of sketches sent Nougé back to an earlier work. "They are extremely moving," he replied. "However, in spite of their undoubted efficacity, I cannot help thinking that this is not the direction in which we will make an important discovery, but rather along the track indicated by a canvas I cannot forget: the girl eating a bird. You'll understand immediately what I mean."[68] *Jeune Fille mangeant un oiseau*, also known as *Le Plaisir (Pleasure)* [color plate 28], the second of Nougé's scenarios to be painted, was even more macabre than *L'Assassin menacé*.

> We find her in the heart of summer, in the shade of a sturdy tree thronged with calm birds undisturbed by her presence. Her schoolgirl demeanour would be excuse enough, and her modest dress, her neat hair. It is a familiar picture, an unremarkable encounter in the countryside. But the pallor of the face surprises and compels attention.
> Those half-closed eyes, that tilted head, are not so simple.[69]

Magritte, for his part, pursued his research on words and images. The discoveries he made were momentous indeed.

In the first place he discovered the pipe that is not a pipe, otherwise known as *La Trahison des images (The Treachery of Images*, or perhaps even better, *The Treason of Images*).[70] The idea, the image, and the legend conquered the world. But not straightaway. In May 1929, readers of Dalí's reports from Paris might have noticed a reference to it: "One of Renné Margueritte's latest creations is a painting of a pipe. Below, there is a label which reads 'Ceci n'est pas une pipe.'"[71] In January 1929, a drawing of the image appeared in *Variétés*, with the pipe reversed but the legend already in place. So it seems that the painting emerged sometime during the first few months of 1929, letter perfect,

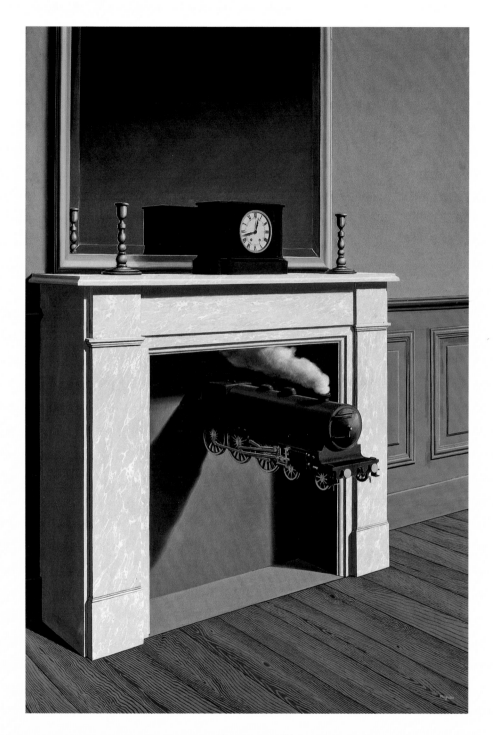

1. *La Durée poignardée* (1938)

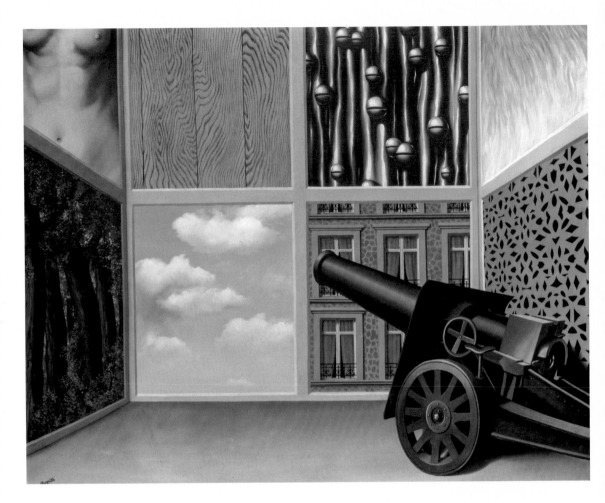

2. *Au seuil de la liberté* (1930)

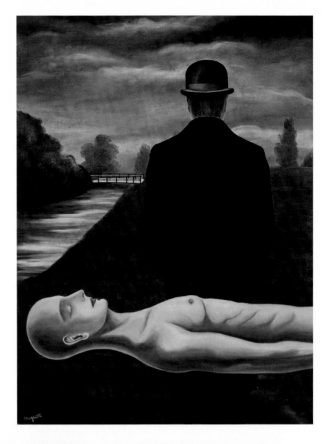

(RIGHT)

3. *Les Rêveries du promeneur solitaire* (1926)

(BELOW)

4. *La Robe d'aventure* (1926)

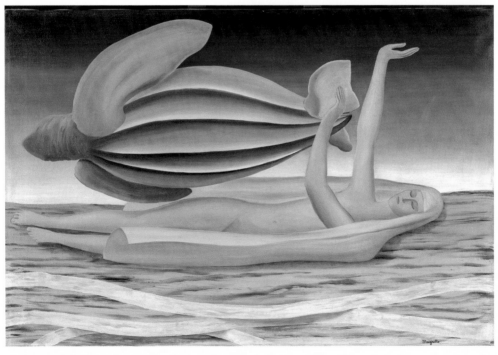

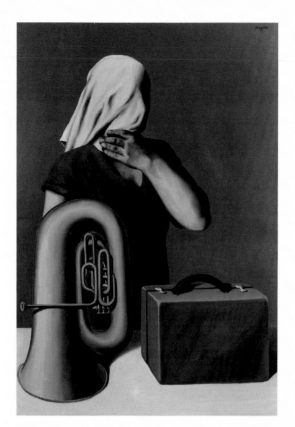

5. *L'Histoire centrale* (1928)

6. *L'Inondation* (1928)

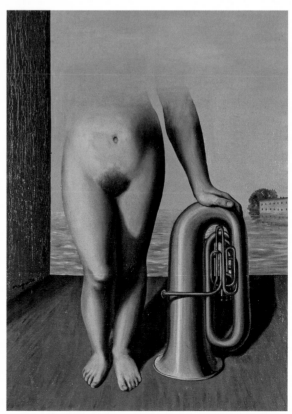

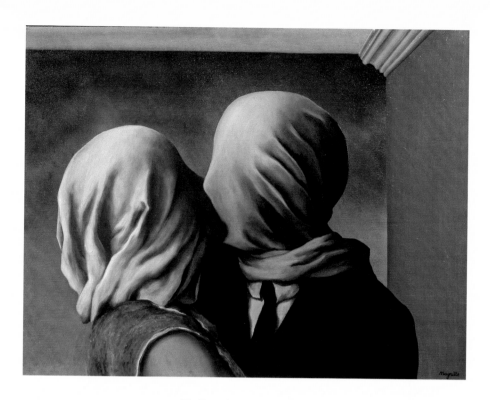

7. *Les Amants* (1928)

8. *Les Amants* (1928)

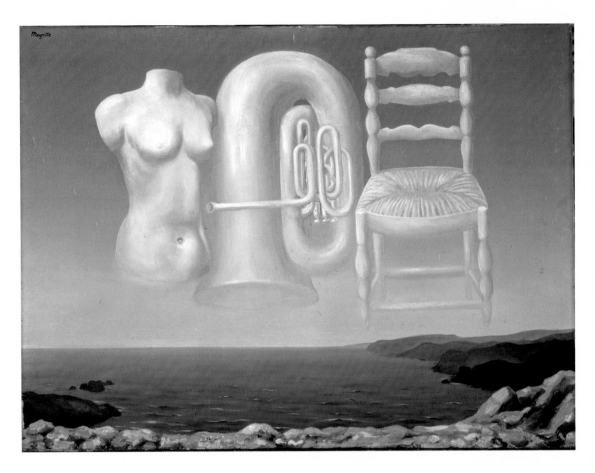

9. *Le Temps menaçant* (1929)

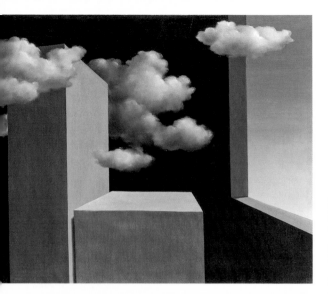

10. *La Tempête* (1931)

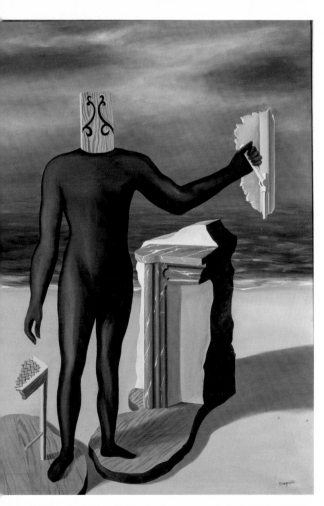

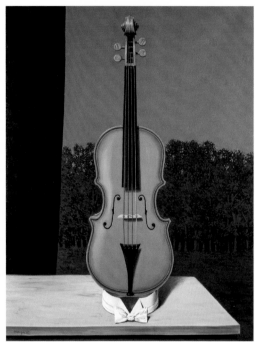

(LEFT)
11. *L'Homme du large* (1927)

(ABOVE)
12. *Un Peu de l'âme des bandits* (1960)

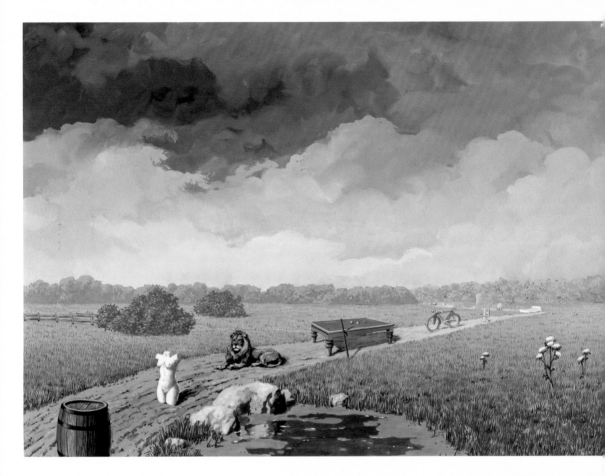

13. *La Jeunesse illustrée* (1936)

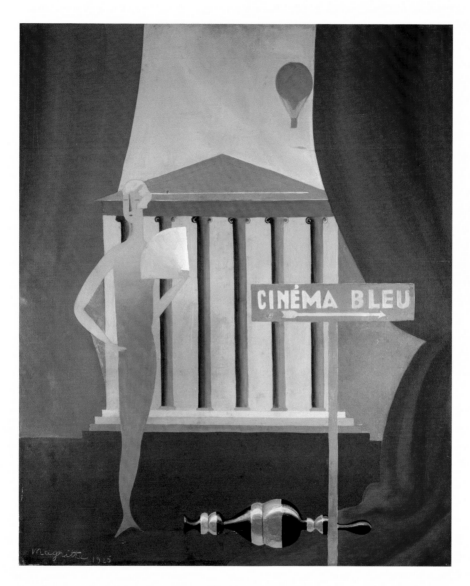

14. *Cinéma bleu* (1925)

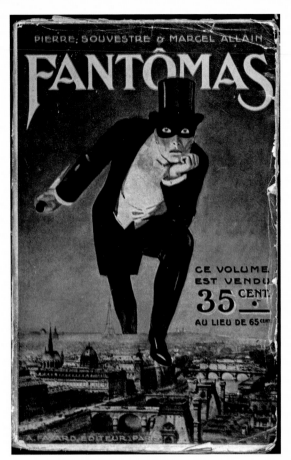

15. Cover of the book *Fantômas*
(1859–1950)

16. *Le Retour de flamme* (1943)

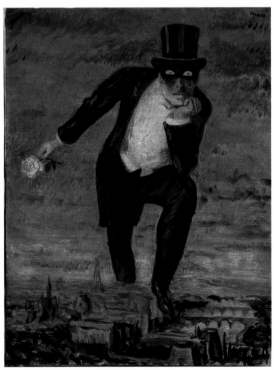

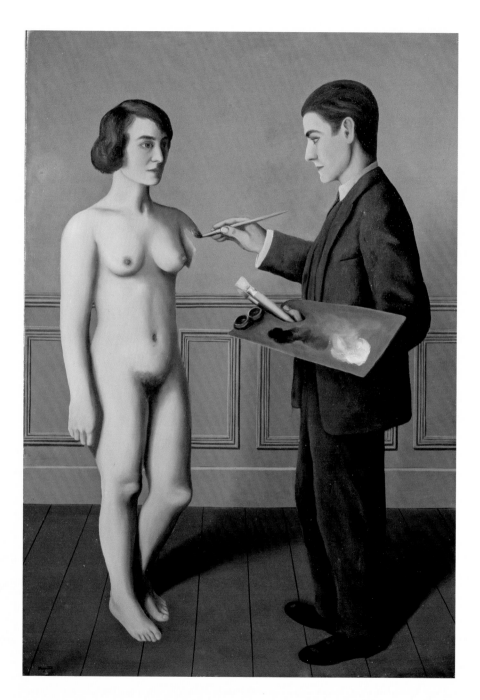

17. *Tentative de l'impossible* (1928)

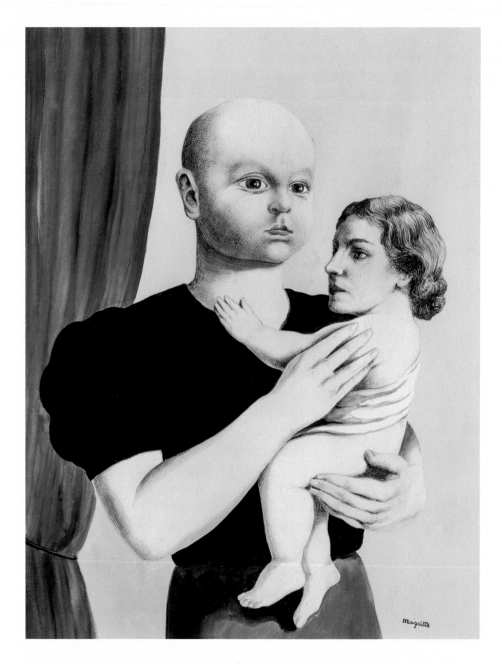

18. *L'Esprit de géométrie* (1936)

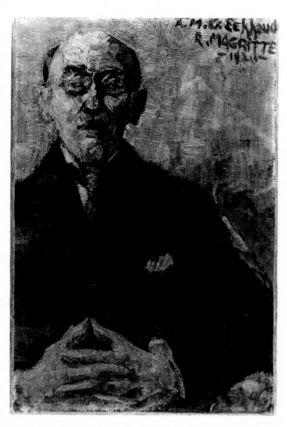

19. *Portrait of Georges Eekhoud* (1920)

20. *Portrait of Magritte* by Flouquet

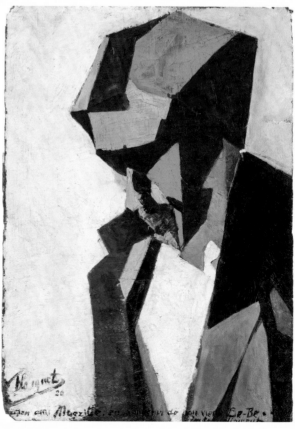

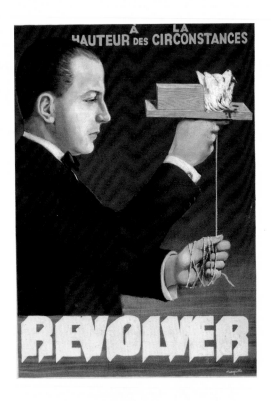

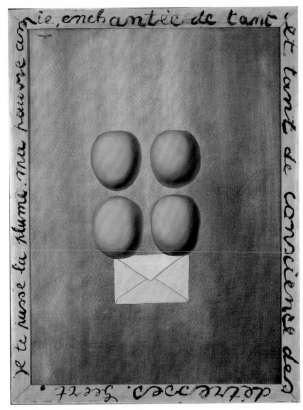

(LEFT)

21. *Portrait of E. L. T. Mesens* (1930)

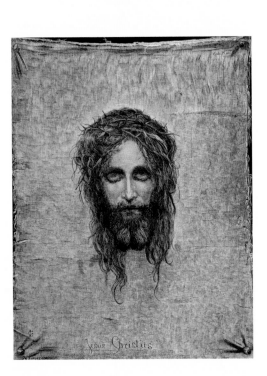

(ABOVE)

22. *La Bonne Nouvelle* (1928)

23. *Jesus Christus* by Gabriel Max

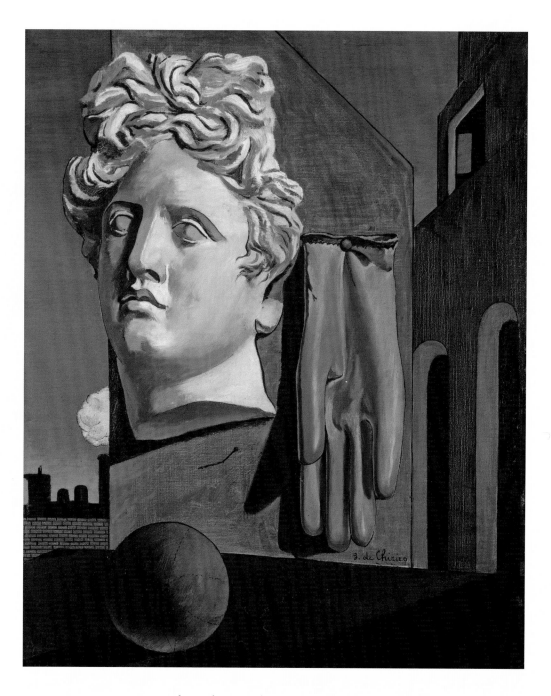

24. *Le Chant d'amour* by Giorgio de Chirico (1914)

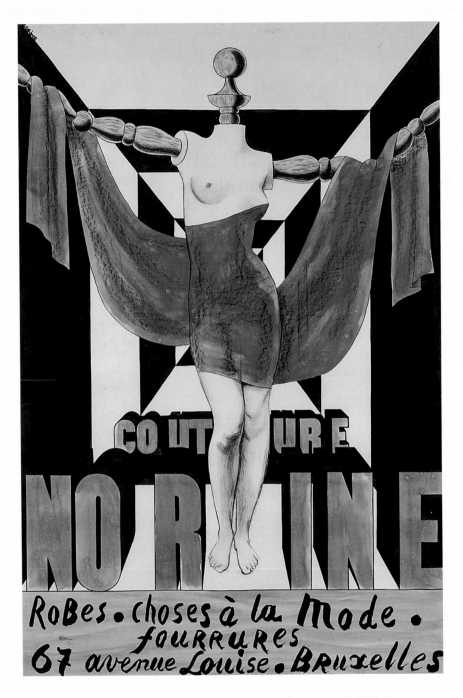

25. *Couture Norine* (advertisement for Norine) (1926)

in all its pristine glory [color plate 29]. It immediately caught the attention of the surrealists in Paris. "Poetry is a pipe," declared Breton and Éluard in their "Notes on Poetry" in *La Révolution surréaliste*.[72] The word spread to Brussels, where the painting was exhibited in a one-man show at the Palais des Beaux-Arts in 1933. Two years later Magritte made an English-language version (just as he did for *The Interpretation of Dreams*) for his first one-man show in the United States, at the Julien Levy Gallery in New York in 1936, a show that was a disappointment to the gallerist, the public, and the artist alike. Nothing was sold, as usual; the reviews were scathing. The English-language version was returned to Magritte. It was acquired by that snapper-up of unconsidered trifles, Geert Van Bruaene, which may well have been a kind of restitution on Magritte's part, for the first of Van Bruaene's many galleries used to display a placard inscribed "Ceci n'est pas de l'art," détourned in turn from Diderot, *Ceci n'est pas un conte* (1772), a trilogy of "moral tales." Alternatively, as the painter Pierre Alechinsky has suggested, the formula may derive from an illustration in *La Nouvelle Médication naturelle*, by F. E. Bilz, another encyclopedic work whose illustrations were ransacked by Magritte. One image bears the intriguing caption "Ce n'est pas un enfant mais un rat" ("It isn't a child, it's a rat").[73]

Meanwhile the fate of the original hung in the balance. For more than twenty years it languished unknown and unregarded, beyond the tiny coterie of the avant-garde. Its rise to world power status began when it was exhibited in *Word vs Image* in 1954, and illustrated for the first time in an influential article by Robert Rosenblum in *Art Digest*.[74] After that there was no stopping it. In intellectual circles it received the ultimate accolade of an extended essay, later a book, by Michel Foucault, *Ceci n'est pas une pipe* (1973). The book was advertised with an unusual addendum, "letters by René Magritte," letters prompted by his reading of Foucault's *Les Mots et les choses* (1966), known in English as *The Order of Things* (1970). If a dialogue between Magritte and Foucault sounds a little far-fetched—as if Cézanne had written back to Merleau-Ponty from beyond the grave—it is but one index of how far the painting and the painter had traveled by the 1970s. The pipe is now one of the most reproduced images in recorded history. It is in every sense a suggestive image; its creative or procreative potential is apparently inexhaustible. The scope for plagiarism is enough to turn the head of any latter-day Lautréamont. Magritte's invention has leached into the global consciousness. The treachery of images is part of the received wisdom of the age. The painting is an icon. The pipe is a meme. More than that, it is an episteme. "The Photograph . . . has something tautological about it," writes Roland Barthes in

Camera Lucida: "[A] pipe, here, is always and intractably a pipe."[75] *Ceci n'est pas* . . . is nothing less than an international social movement. Its followers are everywhere.

Magritte continued his philosophical investigations. In December 1929 he published his famous composition "Les Mots et les images," a résumé of his work in that field, one of the seminal documents of twentieth-century artistic creation. Magritte's propositions on words and images are an exercise in practical reasoning. They have a surprising affinity with Ludwig Wittgenstein's "language games." ("Naming appears as a *queer* connexion of a word with an object." "When I talk about this table, am I *remembering* that this object is called a 'table'?" "Uttering a word is like striking a note on the keyboard of the imagination.")[76] The text had been germinating ever since his arrival in Paris. In November 1927, Nougé sent him the quotation from Villiers, "Besides, once thought, what might begin to happen in the mysterious Universe?"— another observation with a familiar ring. "What is thinkable is also possible," remarked Wittgenstein, which is very nearly something Nougé might have said. Magritte replied,

> I rather regret having sent you that last postcard; what I had to say about the little text you sent me wasn't up to much. I feel I could express myself better with this fragment of a text that I'm writing (it's still only a draft). A piece of writing, without benefit of analysis or synthesis. It would be neither an explication nor a pleasure. But with images (which would appear in the text to designate a state or an object, when its name designates it too generally) to obtain an effect that would shake the reader violently.[77]

Magritte's piece of writing shook readers to the core. It appeared in the jackpot issue of *La Révolution surréaliste*, in a double-page spread, a demonstration piece of interwoven words and images. At first glance, it looked a little like a cross between a puzzle and a comic strip, complete with speech bubbles. Magritte set out to stir things up, but he was serious as could be. In "Lifeline," ten years later, he offered an introduction and a recapitulation:

> The use of speech for the immediate needs of life imposes a restricted meaning on words that designate objects. It seems that everyday language sets imaginary limits on the imagination. But it is possible to create new relationships between words and objects, and to specify certain characteristics of language and objects generally overlooked in the process of everyday life:

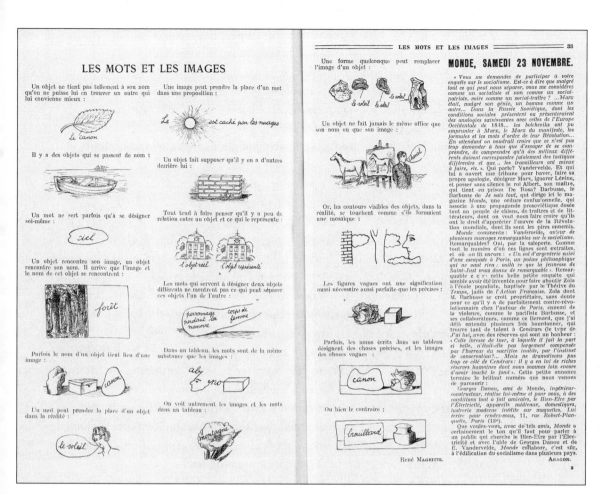

René Magritte, *Les mots et les images*

1. An object is never so closely attached to its name that another cannot be found which suits it better.

2. There are some objects that do without a name.

3. Sometimes the only use of a word is self-referential.

4. An object encounters its image. An object encounters its name. It happens that the image and the name coincide.

5. Sometimes the name of an object can stand in for an image.

6. A word can take the place of an object in reality.

7. An image can take the place of a word in a proposition.

8. An object implies that there are other objects behind it.

9. Everything tends to make one think that there is little connection between an object and that which represents it.

10. The words used to indicate two different objects do not show what may differentiate one of these objects from the other.

11. In a picture, words are of the same substance as images.

12. In a picture, images and words are perceived differently.

13. Any form can replace the image of an object.

14. An object never has the same function as its name or its image.

15. The outlines of the parts of objects that we see in reality are contiguous, as if the parts make a mosaic.

16. Indefinite figures have as necessary and perfect a meaning as definite figures.

17. Sometimes the names written in a picture designate definite things and the images indefinite things.

18. Or vice versa.[78]

"Les Mots et les images" codified the first phase of the astonishing adventure: the revolution of the word. "Now that I've made my point," wrote Breton, "it goes without saying that the floor should be turned over to the painters."[79] Finally, Magritte had taken the floor. But this success with the French surrealists wouldn't last. All of a sudden, he came to grief.

On December 14, 1929, the day before the publication of *La Révolution surréaliste*, Magritte and Georgette were at a small gathering in Breton's apartment, together with Goemans, Éluard, Aragon, and Buñuel. At an early stage in the proceedings Breton remonstrated with Georgette over a cross on a chain round her neck. He demanded that she remove it. Georgette preferred to leave. Magritte went with her. They walked out on André Breton, the surrealists, and the City of Light. There was no going back.

Fours years later, Breton came to Brussels to give a lecture. He took as his title the perennial question "What Is Surrealism?" In Brussels, the short answer was as follows: "It is the cuckoo's egg dumped in the nest (the brood gone), with the complicity of René Magritte."[80] In 1938, in collaboration with Éluard, Breton published the *Dictionnaire abrégé du surréalisme*, a compendium of merits and demerits, in which the principal figures were given personal tags. Some of the tags were mock heroic, some heroic nonsense; some were a poke in the eye. Breton was "the glass of water in the storm." Éluard was "the wet-nurse to the stars." Mesens was "the walrus ear." Miró was "the sardine tree." Magritte's role was redefined. His fate was sealed. He was "the cuckoo's egg."[81]

7.
Through the Keyhole

André Breton once told of a chance encounter with Magritte, at Les Deux Magots, after they had quarreled. Magritte was descending the spiral staircase to the toilets. Breton was ascending, as usual. They came face-to-face. Magritte managed to say hello. Breton put his hand on his heart and said, "What about the heart, Magritte, what does the heart have to say?"[1]

Breton was not an easy man to best.

For Magritte and Georgette the fateful evening in his apartment had begun with a drink at Éluard's, or possibly at Le Cyrano. They took a taxi to Breton's. In the taxi Éluard asked Georgette why she wore such a thing. Georgette did not immediately understand what he was getting at. "What thing?" "Round your neck." "Ah! It was a present from my grandmother, when I took my first communion." "If I were you," said Éluard, "I'd rather wear a brick round my neck." Georgette laughed this off, remarking that it would be difficult to attach a brick to the neck. So ended the conversation in the taxi. She had been warned.

They arrived at the rue Fontaine and joined the party. Breton was circulating among his guests, talking of this and that. Suddenly he broke off, and made an announcement. "Look! There is one among us who is wearing something we ahbor, and we wish that this person would remove the object immediately." Alerted by her exchange with Éluard, Georgette realized that she was the target of this anathema. She stood up and said, "Did you say that for my benefit, Breton, because of my cross?" "Yes," he replied, "and I ask you to take it off immediately." "Ah! No! I'd rather leave than be ordered to remove it." With

that, she left the room. By the time she had got her hat, Magritte was right behind her. They departed, dignity intact, in silence. As they went downstairs, Aragon ran after them, and tried to persuade them to stay. "Magritte, do come back. Pay no attention. You know what Breton's like." Magritte refused all argument. "No, no, I'd rather go." He took Georgette's arm. "Come, my little chicken." That was all he had to say.[2]

Others remembered a blazing row, with Magritte practically calling out his host. ("Breton, you have insulted my wife!")[3] For his part, Goemans allowed them their dignity, but regretted their departure. Stunned into silence at the time, he was dismayed at the turn of events. It so happened that Magritte and Georgette had arranged to spend Christmas in Brussels. They left Paris the following day, as planned, without a word to anyone. Goemans sent a letter after Magritte, trying to talk him round:

> I'm very sorry not to have had the presence of mind to agree on a place where we could have met a bit later on. In any case, if I'd had your cousin's address I would have tried to get in touch with you before you left for Brussels. This is no way to part, even if it's only for a fortnight. But how come these regrets I feel didn't occur to you as well, and that you didn't think of getting hold of me by some means or other? Why didn't you come back to Breton's place that same evening? I am sure in my own mind that neither you nor your wife suffered the slightest insult. Or is one supposed to cultivate the habit of taking the worldly view? I myself found your attitude understandable, in a sense, and I wasn't greatly surprised to see you leave. But having made that gesture of courtesy, can you not bring yourself to admit that there is an element of doubt as to the meaning of that very gesture? Will you allow that one can for a moment doubt your feelings with regard to the object that is the cause of *all* the trouble—the cross, since one must call it by its name?
>
> Please do not let me believe that your departure yesterday was in the slightest degree of a permanent character. Put my mind at rest, *mon cher ami*, and accept my most affectionate good wishes.[4]

Magritte spent Christmas seething. He returned to Paris in the new year. Shortly afterward he informed Souris, "I've seen Goemans, and the repercussions of the incident that befell me in Paris haven't changed. He had nothing new to tell me on the subject. The breach between the Surrealists and me seems definite. . . . I'm working pretty well, with a view to my exhibition. Today I painted a cannon of fairly respectable proportions. I think it will make an impression."[5]

The breach took years to heal. In some respects, it never did. Magritte put a brave face on it, but there is no question that he was extremely upset. According to Claude Spaak, who first met him in 1931 and became one of his staunchest supporters, he talked about it obsessively. The other protagonists may well have harbored private regrets. Aragon recalled going to Brussels and telling Magritte to his face that he thought the whole thing absurd.[6] Breton and Éluard sent copies of their new books, with meaningful inscriptions. *Le Revolver à cheveux blancs* was inscribed "To René Magritte, his friend in spite of everything, André Breton"; *La Vie immédiate*, "To René Magritte, in memory of the time when he was my friend, Paul Éluard." Publicly, they were unforgiving. Their friend remained in quarantine for three years. *Le Surréalisme au service de la révolution*, the short-lived successor to *La Révolution surréaliste*, published another photomontage in 1931, "Au rendez-vous des amis," designed by Ernst. *L'ami* Magritte did not figure.[7]

Amends began to be made in 1933. An invitation was extended to Magritte to contribute to *Le Surréalisme au service de la révolution*, which proceeded to devote several pages of its penultimate issue to him, through the medium of lengthy extracts from Nougé's *Les Images défendues* (illustrated with Magritte's risqué image of the Virgin Mary with her skirts hitched up); the final issue boasted a reproduction of the cannon of respectable proportions, now known as *Au seuil de la liberté*. Magritte was restored to his rightful place in Man Ray's photomontage, *Carrefour*, in Georges Hugnet's *Petite anthologie poétique du surréalisme* (1934). Unbeknown to him, possibly, his place was still highly contingent. In the final stages of assembling the material for publication, Éluard petitioned Mesens: "You must send me immediately, this very day, a photo of either Magritte or Nougé. It should be either full-face or profile, looking towards the right. *As far as possible*, the background should be black—and 7 centimetres square (in consequence of a big head). It's very urgent. Man Ray has done a montage of portraits for the anthology and there's only one place left to fill. You are in, naturally."[8]

It was high time for Magritte's accomplices to engage in the politics of the photomontage. In June 1934, *Intervention surréaliste*, a special issue of the Brussels quarterly *Documents 34*, published "Le Pêle-Mêle de Scutenaire," a riotous photomontage of revolutionary bent, with an all-star cast ranging from Marat (in his bath) to Cornelius Agrippa, embracing Heraclitus, Hegel, Marx, Lenin, and Felix Djerzinski; Achim von Arnim, Freud, Rimbaud, Lautréamont, and Jarry; Gracchus Babeuf, pilfered from Jean Jaurès's *Histoire socialiste;* the Marquis de Sade, attended by satyrs waving snakes; the Bonnot gang; Aragon, Breton, Crevel, and Éluard; and, in the eye of the storm, Magritte, Mesens, Souris, and a saturnine Nougé. *Documents 34* was edited by Mas-

ter Mesens, with Père Nougé as éminence grise. The latter took it upon himself to make an intervention of his own: he arranged for a formal group photograph to be taken in the studio of a Brussels portrait photographer. Entitled "Le Rendez-vous de chasse" ("The Gathering of the Hunt"), it showed off the Brussels group: Mesens, Magritte, Scutenaire, Souris, and Nougé, fronted by Irène Hamoir, Marthe Beauvoisin, and Georgette Magritte (with necklace, but without gold cross); the men each equipped with a luxuriant pocket handkerchief, "the distinctive sign of the procurer," Nougé's second wife noted.[9] This squad appeared in the journal above a snap of a wounded and bandaged Max Ernst, in uniform, from 1914, a photograph sent in by Ernst himself. According to Mariën, Nougé had not forgotten an earlier incident when Ernst had taken umbrage at a letter Goemans had sent him on notepaper bearing the legend "Sold in aid of the Belgian disabled." There was also the later incident with Magritte. "The Meeting of the Hunt" was at the same time an act of civil disobedience, an assertion of Belgian independence, a demonstration of solidarity, and a riposte to Ernst. According to Hamoir, the resolutely retro mise-en-scène was quite deliberate—a dig at the rather precious aestheticism nurtured by the surrealists of Paris.[10]

In the meantime Éluard acquired another Magritte, and began a poem on his painting. A gesture of reconciliation? An act of atonement? Éluard alerted Mesens, who had been acting as a kind of go-between, in terms that suggest they had discussed it before. "If you see Magritte, tell him I have begun the poem. He will have it soon."[11]

The poem took its own sweet time. Entitled simply "René Magritte," it was published in *Cahiers d'art* in 1935, and much reprinted. An English trans-

lation by Man Ray appeared in the catalog of the ill-starred exhibition at the Julien Levy Gallery in New York in 1936. Man Ray's version runs as follows:

> *Stairs of the eye*
> *Through the bars of forms*
>
> *A perpetual stairway*
> *Repose which does not exist*
> *One of the steps is hidden by a cloud*
> *Another by a big knife*
> *Another by a tree which unrolls*
> *Like a carpet*
> *Without gestures*
>
> *All of the steps are hidden*
> *Green leaves have been sown*
> *Immense fields forests deducted*
> *At the setting of leaden rails*
> *Level with the clearings*
> *In the thin milk of the morning*
> *The sand quenches with rays*
> *The silhouettes of mirrors*
> *Their shoulders pale and cold*
> *Their decorative smiles*
> *The tree is tinted with invulnerable fruits*[12]

Éluard appears to have regarded this poem as the opening or reopening of a dialogue. In advance of publication, he sent a copy of the definitive text to Nougé, adding, "I need hardly repeat how curious I am to know what you will make of the poem, and the results you will obtain from this criticism of painting through criticism of the poetry. You know that I consider the latter—especially practised according to your method—infinitely superior to poetry and painting. And necessary, indispensable. But so rare."[13] It appeared in *Cahiers d'art* on the same page as a text by Magritte, "Le Fil d'Ariane" ("Ariadne's Thread"). On the facing page were reproductions of *L'Alphabet des révélations* (*The Alphabet of Revelations*) and *Le Mouvement perpétuel* (*Perpetual Motion*), supplied by Mesens in response to Éluard's request for images. "Ariadne's Thread" spoke to Magritte's conception of poetry as an active agent in the world, in sub-Nougéan style:

But *taking as real* the poetic fact, if we try to discover its *meaning*, we are immediately led in a new direction, away from the barren region that the mind struggles in vain to fertilize. The aim of poetry would then be to understand the secrets of the universe, which would enable us to act on its components. Magic operations would become possible. They would truly satisfy that profound human desire for the marvellous, which has been deceived by miracles, and which was only recently responsible for sordid appearances.[14]

When Éluard cordially agreed to let the poem appear in his exhibition catalogs, a jubilant Magritte expressed his gratitude in the form of a pornographic drawing: a nun masturbating in front of a priest—a peace offering, perhaps, to expunge the memory of the cross.

The dialogue continued. Éluard sent Magritte a copy of *Facile* (1935), a collaboration with Man Ray, in which Éluard's wife Nusch wrapped herself sinuously around the verse. The poetry spliced with the erotic nude photography elicited a paean of praise from Magritte. "How I admire the gift you have for discovering the secrets of life! You have realized the hopes I expressed in 'Ariadne's Thread.' "[15]

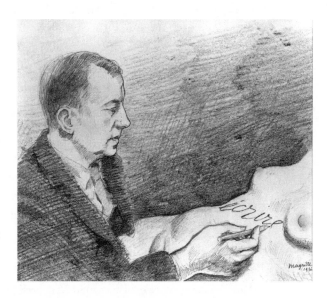

In 1936 Magritte made a portrait drawing of Éluard, entitled *La Magie blanche* (*White Magic*), in which the poet is caught in the act of writing on the body of a naked woman, just below the breasts, the performative word *écrire*. He also furnished illustrations for Éluard's *Moralité du sommeil* (1941) and a new edition of *Les Nécessités de la vie ou les conséquences des rêves* (1946); the frontispiece of the latter was another portrait. Magritte made Éluard a present of a gouache relating to these illustrations. On receipt of his *Choix de poèmes* (1941), Magritte paid him a rare compliment: "You are truly a great painter." As if to return that compliment, the second of Éluard's poems for Magritte came with a well-turned dedication, "To René Magritte, who defends words with images." After a visit to Brussels in 1945, Éluard wrote,

"Kind regards to you both. The ridiculous distance between us has never seemed more unbearable to me."[16]

. . .

Another disappointment that came out of Magritte's dispiriting Paris experience was the cancelation of his forthcoming one-man exhibition at the Galerie Goemans in March 1930. The cannon he had painted was to be fired there, and it would have been quite a show. *Au seuil de la liberté* was a magnificent painting [color plate 2]. It was one of the works purchased by Mesens in June. In Magritte's shorthand: "room with walls made up of sky, fire, a paper cut-out, a house façade, a woman's breasts, forest, planks. On the floor stands a large cannon aimed at these things." It was acquired by the documentary filmmaker Humphrey Jennings (known to Magritte as "Jeninks") in 1936, for £90, and sold in 1948, for £120, "to pay for having my teeth straightened."[17] Jennings was an aficionado, like others involved in the famous GPO Film Unit; Alberto Cavalcanti and Basil Wright were also collectors of Magritte.[18] All of these men were carefully cultivated by Mesens, who published Jennings's musings on Magritte in the *London Gallery Bulletin:*

> In Magritte's paintings beauty and terror meet. But their poetry is not necessarily derived from the known regions of romance—a plate of ham will become as frightening as a lion—a brick wall as mysterious as the night. His painting is thus essentially *modern* in the sense required by Baudelaire. Simultaneously Magritte never allows himself to be seduced by the immediate pleasures of imitation. Precisely his passionate interest in the concrete world has made him remember that a painting itself is only an *image.*[19]

For his one-man show at Le Centaure in 1927, Magritte had produced two huge canvases, *L'Assassin menacé* and *Le Joueur secret* conceived as a pair. For the abortive one-man show at the Galerie Goemans, he repeated this formula. *Au seuil de la liberté* was to have been paired with *L'Annonciation* (*The Annunciation*)—his most impressive painting to date [color plate 30].

That was not all. The work he made in early 1930 gives evidence of a further breakthrough, described by Magritte as "cut-up canvases." There were several of these. The most spectacular was a woman's body: Georgette, of course, in a similar pose to that of *Tentative de l'impossible* (*Attempting the Impossible*). "The woman is represented life-size," Magritte explained to

Nougé. "I show only parts of the body, but situated where they should be: each of these small pictures is framed, and fixed, on a pane of glass."[20] This was *L'Évidence éternelle* [color plate 31], a piecemeal personification of revolution and fun.

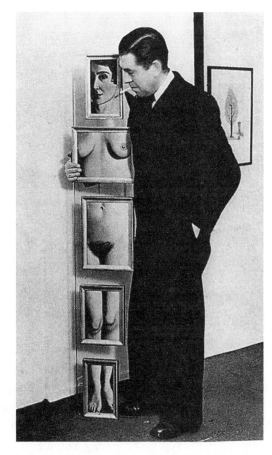

In the wake of the contretemps with the surrealists, Éluard's interest in writing a catalog preface had mysteriously evaporated. Magritte and Goemans asked Nougé if he would oblige. Nougé was more than ready; he was spoiling for a fight. He asked for further information on their conception of the show. "I am convinced that neither of you envisages an 'exhibition' in the ordinary sense of the word."[21] Whether he had some indication that Magritte was planning a demonstration of some sort, we will never know. Magritte sent him annotated drawings of the latest work, highlighting the room with walls and cannon, the landscape apparition, and the cut-up woman, together with the little collage with the word missing, *LES [. . .] NAISSENT EN HIVER.*

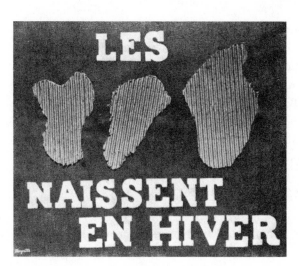

After the closure of the gallery and the cancellation of his contract, Magritte seems to have stopped painting altogether during his last months in Paris. His time was up. His financial situation was desperate. His wife was longing to go home. The providential sale of the eleven paintings to Mesens allowed him to remove his goods

and chattels to Brussels. He quit Paris in the first week of July 1930. The withdrawal was executed in good order, but David Sylvester is surely right to say that it was also a retreat. In terms of exhibitions, sales, deals, and the hard currency of artistry, it was a rout. Magritte had produced some 280 paintings in the living room at Le Perreux, yet he could barely make ends meet. In terms of reputation and *réclame*, he had acquired a small circle of devoted followers—some of them at daggers drawn—but no public. The painter and the paintings remained substantially unknown. With very few exceptions, the 280 paintings had yet to see the light of day. They had not been exhibited or reproduced in any form. They had not been sold. The most recent of them had not even been given a title. All of this must have been a grievous disappointment. If the publication of "Les Mots et les images" and *La Femme cachée* and its photomontage in *La Révolution surréaliste* signaled his arrival, the exclusion he had brought upon himself signaled his departure. Over the weekend of December 14–15, 1929, his world turned. Magritte did not mind being persona non grata, on his own terms. For such a condition to be imposed—by command, as Georgette had said—was an entirely different matter, and one that he bitterly resented.

On the other side of the ledger, there was the remarkable outpouring of painting, including several unimpeachable masterpieces, and an unbroken series of original discoveries—the word paintings, the metamorphoses, the cut-up canvases—to say nothing of the experiments in photography, the excogitations in prose, and the stimulating exchanges with Nougé. In terms of work done, words and images deployed, ideas stirred, mysteries invoked, marvels invented—pipe and all—this is not a negligible achievement. And he knew it. The Magritte who returned to Brussels, his tail between his legs, was a major painter. If he had died in 1930, at the age of thirty-one, his reputation would have been secure—Mesens would have seen to that. The sojourn in Paris, as marginal as he contrived to make it, was the most prodigious period of invention by any artist of the twentieth century, after the wonders of cubism produced by Picasso and Braque in the years before the Great War. The magic of Magritte took time to sink in—perhaps half a century. In the immediate aftermath, resettled in his Brussels suburb, he resumed everyday life. In the remaining months of 1930 he painted precisely two pictures: the second version of *La Clef des songes* and the portrait of Mesens.

Titles for the nameless and faceless from Paris were found by Nougé. "A grelot, a forest, a female torso, a patch of sky, a curtain, a hand, a mountain, in the middle of a pregnant silence," announced *Les Images défendues*. "And the mysterious wind gets up. *The experience* is about to begin."[22] *L'Annonciation* and *Au seuil de la liberté* were typically Nougéan titles; their power of declaration and their richness of association set minds racing just as he proclaimed.

According to Mariën, the latter may well have been derived from a passage in John Buchan's *Prester John* (1910), which came out in French in 1927: "Je n'étais pas encore libre, mais j'avais atteint le seuil de la liberté." In the original: "I was not free, but I was on the threshold of freedom." They were fans of John Buchan. Magritte had a copy of *Les trente-neuf marches* in his library.

When these works were eventually exhibited—not in Paris, but in Brussels—they came with a health warning or exhortation from Nougé:

> Who suspects that this thin canvas rectangle contains something that can change for ever the meaning of justice and love, the meaning, the style and the tension of human existence?
>
> Yet here are all our familiar objects, a chair, meant to invite rest, fruit meant to slake our thirst, a coat meant to ward off the chill of evening or old age, all of them regular features of our daily lives, but evoked here in such a way that, if one then turns back to look at the world, things that had become banal to the point of ceasing to exist for us suddenly take on a formidable and charming solidity, which leaves us guessing as to the new relationships they will have with us. The world has been changed, there are no longer any ordinary things. . . .
>
> Change of décor? Change of show? The doors swing. GO THROUGH OR DIE. So we must change or perish.[23]

At the same time, he joined battle on another front:

> It is no longer a question of deciding if a canvas "can hold up in the middle of a wheat field." Such a concern is exactly on the level of a collector who dreams of matching the colour of a sky with that of his carpet, or the hues of the latter with his mistress's somewhat vacuous eyes.
>
> Such fancies are out of date.
>
> Too bad for the man or the painting that still indulges in such things.[24]

That broadside took up a story told in *Le Surréalisme et la peinture*, about Georges Braque, whom Breton had all but written off, with a rhetorical flourish that became legendary: "I know that not long ago Braque had the idea of taking two or three of his pictures out into the middle of a wheat field to see if they 'held up.' A splendid idea, so long as one refrains from asking oneself in relation to what, compared with what, the *wheat field* holds up. As for me, the only pictures I like, including Braque's, are those that hold up in the face of famine." That passage was marked well by converts and sceptics alike. Pierre Reverdy, a poet of extreme probity and a friend of Braque's, was the only wit-

ness to the demonstration in the wheat field. Many years later he delivered his rejoinder. "I have heard since that it is above all a matter of whether the painting would hold even against famine. Here is my response. Yes, it has held, and against a lot of other things, too, because the canvases are not afraid of anything."[25] Jean Paulhan, author of the celebrated work *Braque le patron* (1945), made it clear that he intended *le patron* in the religious sense, as he put it, like a guru, stating, "I would find it hard to say whether Braque is the most inventive or the most versatile artist of our time. But if the great painter is the one who gives at once the most acute and the most nourishing idea of painting, then without hesitation it is Braque whom I take as master."[26]

Nougé considered the arguments about Braque while he pondered how to round off *Les Images défendues*, writing in his journal,

> Braque secretes his universe like a mollusc its shell. No doubt this is open to generalization: the views of the *Painter*. . . .
> One could perhaps conceive of an ideal Braque who would actually be a mollusc; but an ideal Magritte who would actually be a . . . spider.[27]

The wheat field turned into the backyard. By way of catalog illustration, Nougé selected an installation photograph of *L'Évidence éternelle*—that

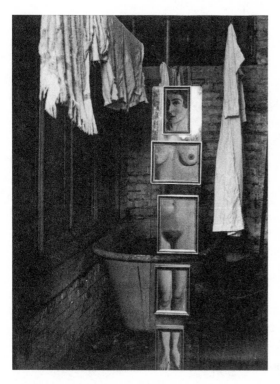
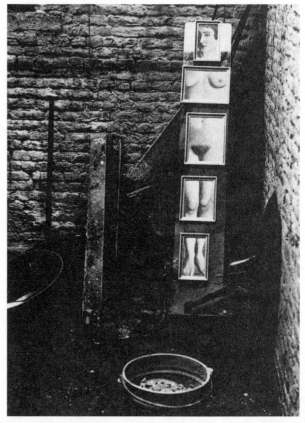

"cut-up canvas of the woman," on a pane of glass—in a backyard, or laundry, with washing on the line. The two conspirators must have been very pleased with this. It was a textbook demonstration of subversion in theory and practice.

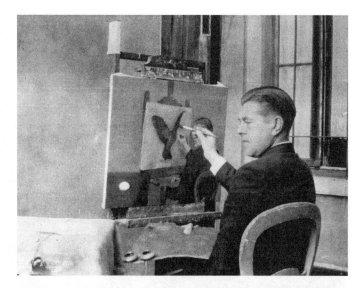

Magritte's pictures held up in the backyard; in the cellar, where Scutenaire found *Panique au moyen âge* (*Panic in the Middle Ages*), trampled underfoot (according to Jacqueline Nonkels, in the studio at the bottom of the garden, under some sacks of coal); and in the pigsty that was Paul Nougé's apartment. In the gallery, on the other hand, they were sometimes covered up, or curtained off, or otherwise sequestered, for their own good, or possibly for public safety. When the Administration Communale of La Louvière acquired *In Memoriam*

Mack Sennett (1936)—the nightdress with breasts, hanging in a wardrobe—the painting was kept in a cupboard and shown only to "knowledgeable voyeurs."[28] In 1934, at an exhibition at the Palais des Beaux-Arts in Brussels, *Le Viol* was shown in a room behind a velvet curtain, in the fetid company of *Le Grand Masturbateur* by Dalí and *La Toilette de Cathy* by Balthus—

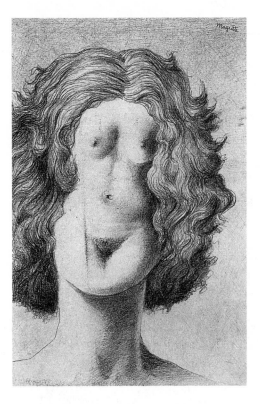

perhaps the reason for its expression of "pursed-lipped disapproval," as John Richardson puts it so neatly.[29] According to Mesens, the director of the Palais des Beaux-Arts considered it unsuitable for children, and even for adults who were not surrealist initiates. In 1937, at an exhibition under the auspices of the New Oxford Art Society, organized by a brilliant all-rounder at Balliol by the name of Denis Healey, the velvet curtain was pressed into service once more, for the same painting, "for fear of shocking the ladies of North Oxford."[30] By 2011, *Le Viol* could appear brazenly uncurtained, but a suite of unusually explicit drawings for a 1941 edition of Georges Bataille's erotic tale *Madame Edwarda* still got the back-room treatment in *René Magritte: The Pleasure Principle* at Tate Liverpool.[31]

The photographs told their own story. Magritte did not maintain the same rate of production as in Paris—over the three years 1931–34 he produced fewer than fifty paintings—but he was by no means idle. A postcard to Lecomte announced his return. "I've found a ground-floor flat with a little garden which is fairly passable. At any rate I think I'll do better in my native land than abroad."[32] As Jan Ceuleers has pointed out, the flat he found was in the same quarter of the same suburb that he had always inhabited. The address was 135 rue Esseghem, in Jette, a dull street in a drab neighborhood chiefly noted for its steam engines and its gasworks. "Gritto" and his gang pass through in *Boulevard Jacqmain* (1953), a spoof crime novel and roman à clef written by Scutenaire, with Irène Hamoir's name on the cover. "There were fields behind fences, stunted poplars and willows, a little tunnel under the railway line, a rutted stony path, a dirty, grassy ditch, two sparrows on a wire, bushes of false acacia with their long black thorns, telegraph poles shiny with tar. The cindery embankment, the railway tracks, a cesspool as big as a man, full of green water. The sun was setting, sick as the March sun, with an escort of droning insects."[33]

Magritte stayed twenty-four years, cramped but happy—almost— reminded perhaps of the grayness of Châtelet. The ground-floor flat gave on to the primal landscape, transposed and transmogrified all his days. Magrittes are everywhere in this part of the world. Golconda is Verviers, as it may be, where bowler-hatted men rain down (or rise up) forever.[34] Magritte makes the weather, as the contemporary poet Anne Carson divines: "It's Magritte weather today said Max / Ernst knocking his head on a boulder."[35]

At 135 rue Esseghem, the setting was conducive to his boredom. The cooped interiors and stifled prospects nourished the realism of his surrealism. "Magritte is never more a realist than when he makes the pocket comb as large as the bed, or shows the breasts hung within the dress in the armoire, or shatters the landscape along with the window glass on which it is fixed," observes

Luc Sante sympathetically. "It is night on Magritte's street and in his house, however blue the sky above."[36] The deathless state of the living quarters was well caught by Scutenaire:

He rents a ground-floor flat which has seven rooms, if you count the corridor, which is shared in part by all the tenants of the building. The sitting room looks onto the street and is elegantly furnished in an 18th-century style, relieved by a big black piano, a modern upright, with white teeth.

The atmosphere of the bedroom, green and blue with touches of red and black, is the same as that in some of his pictures. The window looks out onto the garden.

A tiny private entrance hall holds a coat-stand and a bookcase filled with detective novels.

In the dining room Magritte paints, has his meals, receives visitors, and leads his everyday life. The view from this room once included an aviary full of birds: later, after the birds had flown, the bird-house served as firewood.

Beyond is the small kitchen, with the bathroom and lavatory opening off.

The garden is not very big. At the bottom is a shed-like studio crammed with lumber.

Similarly lumbered is the dormer attic, where the painter deposits the detritus of his daily life, and hangs garlands of celery and onions, the products of his vegetable patch.[37]

The shed-like studio became Studio Dongo, whose headed paper advertised its specialities: stands, displays, promotional items, posters, drawings, photomontages, advertising copy. Magritte was back in business. Family and friends helped out. Paul was a kind of sleeping partner. Raymond put some business their way, and milked his contacts for commissions. Magritte's brother-in-law Pierre Hoyez made the stands. After Paul got married, in 1936, his wife Betty took orders and acted as cashier at trade fairs. Denis Marion gave them an introduction to Tobis-Klangfilm, who commissioned cinema posters. Georges Vriamont, an avid collector of Magrittes, commissioned covers for sheet music scores published by Les Éditions Modernes.

The commercial work did not put much butter on his spinach, as Magritte used to say, but it did enable him to earn a crust. Studio Dongo remained in existence for several years. It was a semi-clandestine operation, named after Fabrice del Dongo, the hero of *La Chartreuse de Parme*, by Stendhal, an author

highly esteemed by Magritte (and by the Paris surrealists). Stendhal is quoted in the manifesto *L'Art pur:* "Beauty is but the promise of happiness."[38] Many years later another quotation acted as a trigger for an enigmatic remark to Maurice Rapin. "I'm struck once again by the resemblance in our thinking," Magritte told him, "when you quote Stendhal: 'There are days when I should have myself chained to the foot of the bed.' I too have a good many dreadful memories, but I can never understand 'repentance.' I feel only remorse."[39]

Magritte's financial embarrassment began to ease in 1935, through the good offices of Claude Spaak (1904–90), a novelist and playwright from a distinguished Belgian family. His elder brother Paul-Henri Spaak became prime minister and one of the founding fathers of the European Union; Paul-Henri, too, had a good eye for art (or a good ear for his brother's advice), for he purchased at least three superior Magrittes: *Le Géante* (*The Giantess*), *La Jeunesse illustrée*, and *Le Chant de l'orage* (*The Song of the Storm*). Claude joined the Palais des Beaux-Arts in 1928 as secretary to the director general. In 1933 he became the first director of the Société Auxiliare des Expositions, under the umbrella of the Palais des Beaux-Arts in Brussels, responsible not only for exhibitions but also for the salesroom, which financed them. One of his least promising salesmen was Mesens, who was not accustomed to start work before midday, when it was soon time for a little preprandial tipple. Mesens was constitutionally incapable of being anyone's employee. As an operator, however, he was undeniably effective. He organized a number of

exhibitions and made a plethora of introductions before departing for London in 1938. It was he who introduced Spaak to Magritte.

In the course of the 1930s, Spaak became Magritte's main private collector. Well over thirty works passed through his hands. Several of these were specially commissioned, including portraits of himself; his first wife, Suzanne, a prominent member of the Resistance, executed by the Gestapo in 1944; their children; Ruth Peters, his secretary, and later his second wife; and various other friends and relations. Moreover it was Spaak who suggested the idea for two of the most intriguing images of this period: *Le Pont d'Héraclite* (*Heraclitus's Bridge*), and *L'Éternité* (*Eternity*). "I am busy at the moment on a rather amusing picture," Magritte told Éluard in 1935. "In a museum, there are three stands against a wall; on the left and the right, statues of Dante and Hercules, and perched in the middle a magnificent pig's head, with parsley in its ears and a lemon in its mouth." Spaak's original idea had been to show two paintings hanging in a museum with a ham pendant between them. In the event, the pig's head turned into a mound of butter, and Hercules turned into Christ. Twenty years later, in 1955, this painting sold at auction for the princely sum of 4.50 Belgian francs. When Magritte was told about this, he replied philosophically, "It will perhaps be a matter for regret that *Eternity* should be sold for 4.50 francs on the open market, but the people who think that my pictures

of that period are the best will be pleased to hear they are so cheap, since they can simultaneously be pleased with the good side of this bad business and pleased with their own views."[40]

Spaak was concerned that Magritte felt compelled to spend so much time on Studio Dongo, in order to make ends meet. He worried that commercialization was crowding out invention—an early intimation of a persistent gripe about Magritte's art. Julien Levy in New York felt similarly. Unlike most of those who made this complaint, Spaak proposed to do something to remedy it. Not only did he buy paintings and commission new work, and encourage his family and friends to do the same; he also gave Magritte a monthly stipend of 600 Belgian francs over the period 1935–38. In addition, he arranged for a small group of colleagues from the PBA (Robert Giron, Suzanne Purnal, and Valentine Paridant) to supplement this with a monthly allowance of 50 Belgian francs over the same period, in return for which each of them received a painting at the end of the year. Spaak's father, who had no love for modern art, contributed an anonymous gift of 300 Belgian francs. By way of thanks, Magritte made the Spaaks a present of *La Révolution*. Come 1938, Spaak offered him a loose contract of 1,500 Belgian francs a month—not too much, as Spaak told Mesens—and gave him complete freedom to sell his work to anyone, whenever he could.[41]

Magritte's productivity picked up. Mesens remonstrated with him for becoming a kind of court painter—"allowing yourself to be treated like a ninny by Monsieur Spaak by accepting 'orders' for paintings, portraits, replicas, etc"—but even Mesens had to concede that Spaak had been both generous and courageous when it came to it.[42] He was in many ways an ideal patron: sympathetic, imaginative, munificent, fertile of ideas. And yet, in a certain sense he need not have worried. Magritte always maintained that what he did was not painting but thinking. For the last few years he had been thinking very hard.

Sometime during 1932, he hit upon a new way of devising images—a new way of working—that led him to what he saw as a new kind of painting. This was the "problem painting," so called because of the methodology, or more accurately the genesis. Magritte would address himself to a "problem" posed by a given object, to which he had to find a "solution"—*the* solution—which would enable him to paint it and to make a Magritte of it. This idea of problem painting was Magritte's invention, a highly original concept that opened new doors in how a painter might process ordinary imagery (an egg, a door), and a kind of self-induced hallucinating. Once the visual solution to the problem had been accomplished to his satisfaction, there remained a subset of the problem: what to call it, that is, to find a title for it.

This way of proceeding came to him, he insisted, following a revelation. "One night in 1936, I woke up in a room where there was a cage with a bird asleep in it. By splendid mistake I saw the cage with the bird vanished and replaced by an egg." That sounds like the beginning of a fairy tale. Musing on the marvelous image hatched from it, *Les Affinités électives* (*Elective Affinities*), Nougé remarked acutely that the cage and the egg are both parables of confinement: "the cage of prison" and "the cage of promise."[43] There may be an element of truth to the tale, inasmuch as there was an aviary at the back of the apartment, as Scutenaire had noted, and Georgette told the authors of the *catalogue raisonné* that the bird in question was her canary. However that may be, Magritte postdated the miracle.[44] As he told it in "Lifeline,"

I woke up in a room where there was a cage with a bird asleep in it. By splendid mistake I saw the cage with the bird vanished and replaced by an egg. I was thus vouchsafed a new and astounding poetic secret, for the shock I experienced was caused precisely by the affinity between two objects, the cage and the egg, whereas previously I caused the shock by bringing together completely unrelated objects. Following this revelation, I tried to discover whether objects other than the cage could also display the same manifest poetic quality produced by the conjunction of the egg and the cage, whether some element peculiar to them and strictly part of their destiny could be brought to light. In the course of my research I became convinced that the element to be discovered, that unique thing obscurely associated with each object, was always known to me in advance, but that

it was as if the knowledge was lost in the depths of my thought. Since my research had to arrive at a single correct answer for each object, my investigations took the form of trying to find the solution to a problem with three given points of reference: the object; the thing associated with it in the shadow of my consciousness; and the light in which this thing should appear.[45]

The problem painting continued to preoccupy him for the rest of his life. Twenty years on, he made an effort to rethink it. In 1952 he founded a miniature review—Jean Paulhan called it the smallest review in the world—*La Carte d'après nature*, which appeared at irregular intervals over the next four years, on a postcard. In the first issue he offered a recapitulation and elaboration of his method of working, giving three examples, each of which had entailed a tortuous process of trial and error—well described by the poet Gaston Puel as a sort of "frantic contemplation"—before finding a solution of beguiling simplicity: *Le Séducteur* (*The Seducer*), the solution to the problem of water, in the form of a ship; *Le Coup au coeur* (*The Blow to the Heart*), the solution to the problem of the rose, in the form of a dagger; and *La Main heureuse* (*The Happy Hand*), the solution to the problem of the piano, in the form of a ring.[46] Curiously enough, his criterion for success devolved into something very like Braque's—whether it holds up—expressed in different language:

I am thinking of new research based on an idea I had about what might make certain pictures valid. Their execution depended on accuracy of the solutions found for problems formulated in the following way: taking an object, or any subject, as a question, it was a matter of finding as the answer some other object, secretly bound to the first by links complex enough to serve as a verification of the answer. If the answer was irrefutable in its obviousness, the bringing together of the two objects was dramatic.

Could the procedure be developed further? Magritte continued:

The dagger may be the answer to the rose, but the rose is not the

answer to the dagger; nor is water the answer to the ship, nor the piano to the ring. This perception opens up the possibility of looking for answers which are at the same time questions solved by the objects which functioned as questions in the first place. Is this possible? It seems to demand that the human will should achieve the quality attributed by Edgar Poe to the works of the Divinity, "in which effect and cause are reversible." If we can conceive of this quality, it is perhaps not impossible that we might acquire it through enlightenment.[47]

The problem of the rose is an excellent example of the delicate mix of thought experiment, image memory, pattern recognition, word association, and metaphorical hopscotch that might eventually produce a Magritte "solution"—in this instance, a ransacking of poetry and memory stretching back twenty years. "The rose is red in the dark too," as Magritte might have said, if Wittgenstein had not got there first.[48] On November 27, 1951, Magritte gave Éluard a remarkably detailed insight into his creative process:

> I must tell you about the following, because you have your share of responsibility for it:
>
> According to a method which is, I think, unique to me, for about two months I have been researching the solution for what I call "the problem of the rose." After completing my research, I realize that I had probably long known the answer to my question, but in an obscure fashion, and not only me, but anyone else too. This kind of knowledge, which seems to be organic, and doesn't rise to the level of consciousness, was always there, from the beginning of every effort of research I've made.
>
> The first indication, jotted down instinctively, when I thought of solving the problem of the rose was this: [a drawing] and that oblique line which starts from the stem of the flower called for long and painful research for its meaning to become clear to me.
>
> Of the many things that I dreamt up I retain these:
>
> that line was the pole of a green flag [sketch]
> or the tower of a medieval castle [sketch]
> or an arrow [sketch]
>
> finally I found: it was a dagger, and the problem of the rose was resolved pictorially

like this: [sketch]

After completion of the research, it can "easily" be explained that the rose is scented air, but it is also cruel, and reminds me of your "parricidal rose." I recall also a passage from Nougé's *Images défendues*, "It is thanks to that heart-wrenching memory that we detect the faint scent of roses"—and a curious fact—in 1942 or 43 I made a picture with the cover of the first volume of Fantômas—but in it I replaced the assassin's blood-stained dagger with a rose. *Mon cher* Paul, I hope that this will please you and I should like it to do so to the point of prompting you *to let me have news of you, and a beautiful title for the picture.*[49]

As it turned out, the title remained moot for months. After long deliberation, one of his friends came up with *The Gift of Prophecy*, which held the field for a while, until Magritte decided to adopt the title found by Nougé the following spring. *The Blow to the Heart*, he declared, "answers the rose with a dagger which grows on the stem of a rose."

It goes without saying that Magritte's problems were no ordinary problems, and that the solutions were out of this world, in more senses than one. The first problem to be deliberately set and solved, in 1932, was the problem of the door, "which called for a hole through which one could pass," as he observed cryptically. The solution was a closed door, clearly an interior door, with a hole in it, "which reveals the dark" (in an alternative formulation, "the void"). The darkness visible is a puzzle, and so too is the hole, which is roughly human size, but misshapen. It can be read as the outline of a couple in a clinch, almost as if they have crashed through, as in a comic strip or a cartoon; or perhaps the missing piece of a giant jigsaw, or the work of a mad cookie cutter. This was *La Réponse imprévue (The Unexpected Answer)*.[50]

That solution was as big a breakthrough in its way as anything in Paris. Magritte realized immediately that he was onto something. In January 1933 he broke his silence and wrote to Breton, thanking him for sending a copy of *Les Vases communicants*, praising it in guarded terms, and taking the liberty of enclosing two small drawings of his latest paintings: *Les Affinités électives* and *La Réponse imprévue* (with the variant title *La Réponse inattendue*). Breton took the bait. When he came to Brussels to deliver a lecture, "What Is Surrealism?," in June 1934, it was published straightaway as a booklet with a cover designed by Magritte. The cover image, insolently repeated on the title page, was *Le Viol*, which Magritte later characterized as the solution to the problem of the woman, but which might better be characterized as the solu-

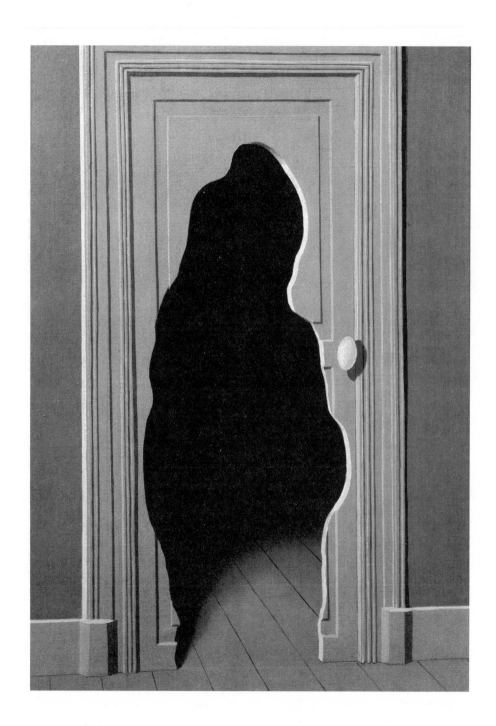

tion to the problem of notoriety. He explained it by letter to Breton, with the aid of a sketch.

It is in line with the research that I told you about recently. I'm well aware that for me it's about a very elementary understanding of things, taken one at a time. In this particular case it concerns the parallels between the disposition of the organs of the face and the woman's body, but I'm struck by the repercussions of the image itself, and also by something that seems to me very important: that one can discover a property that belongs inherently to a given object, which nevertheless seems monstrous or strange when it is brought to light.

"I hope you will be pleased with this cover project," he added, "I also think that it is excellent from the publicity point of view. An image of this sort is not likely to pass unnoticed in a bookshop window."[51]

Breton was very pleased. "I am full of enthusiasm for your drawing. It is a marvellously vital and disturbing piece of work, hard to put out of one's mind. Nothing could better combine all the elements calculated to suit me and charm me. My heartfelt thanks."[52] What is more, this taster of the problem paintings had the desired effect. Breton went on:

We absolutely must find a way of giving the public a better understanding of your most recent research, which, I repeat, seem to me to be of the utmost importance. I have thought of writing about this myself, either separately as I did for *Documents 34* in the case of Giacometti, or for the new edition of *Le Surréalisme et la peinture*, which is coming out in the autumn. I would be pleased if you could sometime repeat briefly in written form the description of the seven or eight pictures or drawings relating to the particular concern you expressed. Could I also ask you to consider sending me a few photographs of your most significant paintings of each period for the new edition? The book is to be reissued in normal format; the text will be revised, that is to say, abridged in places, expanded in others. It is naturally essential that I should deal with you and Dalí. What a pity we still await *Les Images défendues*.[53]

Despite these fine words, it was a long wait. Magritte returned to his keyhole.

. . .

Magritte is the master of the prying eye, the keyhole, the door, the threshold, and the terra incognita beyond. He is perhaps the only artist to rival the greatest of all practitioners in this realm, Franz Kafka, another essentially solitary creator, as Walter Benjamin underlined. Kafka's biographer has a bravura passage on what might be called the problem of the door in his work, equally applicable to Magritte:

> He sought and found an image that united near and far, the mysterious distance of what appears closest to us and the provocative presence of the unattainable, yet *nearly* attainable, off in the distance: a dialectical image, a thought-image. Kafka made intensive use of this image, an image of extreme simplicity and supposed innocuousness: it was *the door*. . . . His works have doors that are not closed and nonetheless remain impassable . . . ; doors that open out into impenetrable darkness . . . ; dilapidated doors that open by themselves . . . or are on the verge of falling apart . . . ; doors that invite torture and death just by touching them . . . ; and finally, doors that alter their degree of accessibility from one moment to the next for no apparent reason.[54]

Magritte, too, dealt in doors and doorkeepers, of all species and none. The attainable and the unattainable is always at issue; the visible and the invisible, the violate and the inviolate, war across the threshold. The nature of the nearly attainable, of inhibition and prohibition, is explored in a long series of unexpected answers, over thirty years. A variation on the original gives a sharper outline to the hole in the door (or the figures who have crashed through it); on the other side, unrelieved gloom. This painting was bought by Julien Levy for $17 in 1936, and sold to Kay Sage for $50 in 1941. *La Perspective amoureuse* offers an entirely different perspective, of darkness into light. Through the hole may be seen a landscape, complete with leaf-tree and house; inexplicably, there is a grelot on the terrace. Magritte himself provided a Delphic commentary on this painting: "It is love which opens up the greatest vistas. Here, the greatest feeling of depth has been suggested by removing part of the panelling of a door, which concealed a landscape consisting of known objects (trees, sky) and a mysterious object (the large grelot lying on the terrace)."[55] The feeling of depth was evidently a source of anxiety; his little text in *Distances* spoke of "the lack of depth beyond the open doors." In *La Bonne Aventure* (*Fortune Telling*) the door is ajar, like the door in the striking opening sequence of Germaine Dulac's film *La Coquille et le clergyman* (1928).[56] A cloud slips through. Beyond lies the open sea. In *La Victoire* (*The Victory*) the door remains ajar, *outside*, in the open air. Another cloud slips through. In *La*

Grand Matin (*The Early Morning*) the door is mostly hole. The sea beckons invitingly. In this instance, the door is open but the way is barred. A tall bilboquet stands sentry, attended by a cluster of leaf-birds. In *La Place au soleil* (*The Place in the Sun*) a small green door opens onto a large blue door, which is closed. In *Le Modèle vivant* (*The Living Model*) the door is a crazy door, jagged at the edges. It is firmly shut.[57] "Nobody else could be granted entry," the doorkeeper tells K. in "Before the Law," the parable repeated in *The Trial*, "for this entrance was meant only for you. I shall go now and close it."[58]

If Kafka's doorkeepers have their counterparts in Magritte's bilboquets, the peephole in *The Castle* has its analog in the keyhole in *L'Espion* (*The Spy*).[59] Through the peephole K. can see the Castle official, Klamm, sitting at a table with his beer. Klamm is facing the peephole, as if posing in a photomaton booth, thus affording K. a "photographic sense of mastery," undermined by Klamm's awkward posture.[60] This may have reminded Magritte of his experience in Paris with Breton, the gatekeeper, laying down the law. Does Magritte's anonymous man (let us call him M.) experience a similar frisson of mastery from his spying? What are we to make of the disembodied head of a woman, resolutely frontal, suspended in the void, a little like the head of Christ in the copy of Gabriel Max? What are we to make of M. himself, suave as he may be? Spying of this sort smacks of deceit, or worse. It may even be against the law. "Before the Law stands a doorkeeper," begins the parable.

Before the Annunciation stand two bilboquets. The bilboquets are nothing if not upright, and difficult to read. Are these two the last word in witness? What exactly are they witnessing? They are a far cry from the jokers who came for the murderer threatened. Are they warders, whippers, assessors—other variants of Kafka's functionaries? Are they doorkeepers to Plato's cave? *The Annunciation* once contained a man reading a newspaper, rather like an official having a beer, in something resembling a cave. "It is as if we are in a cave," Magritte would say, "without any windows."[61]

Kafka and Magritte have more in common than at first appears, even down to the lives they lived, or the methods they pursued. "It is not necessary for you to leave the house," wrote Kafka. "Stay at your table and listen. Do not even listen, only wait. Stay completely still and alone. The world will offer itself to you for unmasking; it can't help it; it will writhe before you in ecstasy."[62] So it was in the dining room of 135 rue Esseghem. Each according to his means dwelled on the laws and the scriptures, on freedom and confinement, on anxiety and paranoia, on identity and anonymity—on the ecstasies of the world and the mysteries of existence. For Magritte as for Kafka, the metaphorical and the literal have the same weight. Magritte, like Kafka, had an intolerance for fast talk and big words. They both leave puzzles without solutions (whatever the method might dictate). *The Murderer Threatened* is

a very Kafkaesque picture. Kafka's aphorisms are very Magrittian images. "A cage went in search of a bird."[63] They may even have drawn inspiration from the same sources. "We can never arrive at the real nature of things from without," wrote Schopenhauer in *The World as Will and Representation*. "However much we investigate, we can never reach anything but images and names. We are like a man who goes round a castle seeking in vain for an entrance, and sometimes sketching the façades."[64]

A painting by Magritte is like the law in Kafka's *Trial*: "[It] does not want anything from you. It receives you when you come and dismisses you when you go."[65] In a talk he gave in 1937—his first public statement on the new method—Magritte offered a paradox of his own on the problem of the door:

> Let us think now of a door-panel: it can open onto a landscape seen upside-down or the landscape can be painted on the door. But let us try something less gratuitous: let us make a hole in the wall next to the panel of the door, a hole which is also an exit, a door. Let us complete the coincidence by reducing the two objects to a single one: the hole appears quite naturally in the panel of the door. And through the hole we shall see darkness. This last image can be enriched if the invisible something hidden by the darkness is lit up, since our gaze always wants to travel further, to see at last the object of our existence, the reason for our existence.[66]

. . .

The Secret Beyond the Door (1948) by Fritz Lang was music to his ears. There remained the problem of the title.

Magritte spoke of "baptizing" his paintings. The titles were an integral part of the process; he took immense trouble over them. Predictably, they are not always easy to translate or interpret. They are unruly, sometimes positively refractory, and especially resistant to any attempt at reduction to a decided meaning. The relationship between the title and the painting is a subtle tussle. They are often cryptic, but they cannot be solved like a crossword. "There are no clues," Magritte would say. "The only clues are false clues."[67] For a sublime painting of a surreal boulder in a stupendous mountain range, he considered and rejected *The Metronome*, *The Good Luck Charm*, *Perfect Harmony*, *Life Together*, *Gold and Silver*, *Fine Words*, *Clear Ideas*, *The Waking State*, *Introduction*, *Representation*, *Patents of Nobility*, *The Indian Mail*, *The Wits*, *The Sash Cords*, *Page 88*, *The Gay Science* (a nod to Nietzsche), *Night and Day* (a nod to Fred Astaire), *Opera*, *The Holy Family*, *Christmas*, and *The Keystone*, before finally settling on *The Glass Key*, originally a Dashiell Hammett story,

then a film noir starring Alan Ladd and Veronica Lake. It is known in French as *La Clef de verre*. Symptomatically, *la clef* is at once the key and the clue, further enriching the meaning of *La Clef des songes*. "There remained the inexplicable mass of rock," wrote Kafka. "The legend tried to explain the inexplicable. As it came out of a substratum of truth it had in turn to end in the inexplicable."[68]

The relationship between the title and the project is even more elusive, as Scutenaire reflected:

> I have always thought that Magritte's paintings are not susceptible to description. So, to talk about the titles without seeing the paintings themselves, or at least reproductions in colour, is quite a challenge. Let us try, with only the words to help us, by taking three apparently straightforward pictures in which the artist has the same purpose: to represent emptiness—not invisibility—by making the difference between the two perceptible to the naked eye.
>
> The first canvas shows the top of the jacket, with detachable collar and tie, topped with a soft hat. Nothing of the face between collar and hat, only the eyes, the nose, and the mouth, painted exactly in place, in the empty space.
>
> In the second, once again the jacket, the detachable collar, the tie, this time topped with a bowler hat; slightly set back, the bust of a naked man whose face fits the space between collar and hat.
>
> The third represents the same jacket, collar, tie and bowler. Next to it, a man's face, which if moved a little to the right would fill the space between the collar and the hat.
>
> The first painting is called *Le Paysage de Baucis* [*Baucis's Landscape*]. The title forces itself on us, shuts out any other. Why? Algebraic brains will imagine that a face consisting only of eyes, nose and mouth in the void is more of a face than completely painted features, and that it was the true landscape, the only "landscape" that Baucis really saw of her beloved husband. Perhaps.
>
> The title of the second painting: *Le Chemin de Damas* [*The Road to Damascus*] is equally necessary. The above-mentioned brains will set out to explain: the suit of clothes is the vision that strikes the naked man as Paul of Tarsus was struck [by a vision of Christ, on the road to Damascus]; or the naked man is the vision that strikes the suit of clothes; or it is the picture that strikes the spectator. Take your pick.
>
> The third canvas is called *Le Pèlerin* [*The Pilgrim*]. Sure enough, for the same brains, the face has left the suit of clothes and has gone on a

pilgrimage, or the suit has abandoned the face. Alas! [Magritte in front of *Le Pèlerin* (Lothar Wolleh, 1967).]

Is it not better to think less and to know that the words *Le Paysage de Baucis*, *Le Chemin de Damas* and *Le Pèlerin* are each a portrait of *Emptiness*?[69]

For Scutenaire, Magritte's titles were a precise transcription of the force of the paintings, as he put it, "the idea, sentiment, vision or will that guided the hand of the painter, rather than the pictorial realization of that force. In any event, they are never descriptive, still less arbitrary."[70] This smacks of predestiny. *Le Paysage de Baucis* was found by the artist's friends François and Evelyn Deknop, from a tale in Ovid's *Metamorphosis*. Magritte wanted at all costs to avoid H. G. Wells's *The Invisible Man* or any of its derivatives. "If *L'Homme invisible* had not been written, no (insoluble) problem would have arisen. An inscription such as, for example, *La Fille du néant* [*The Daughter of Nothingness*] could be considered, but such a usage would be to reduce the image to the level of an illustration, manifestly, although in reality there would have been no question of 'illustrating a theme.'" However unavoidable *Le Paysage de Baucis* came to seem, his first thought was *L'Horreur du vide* (*The Horror Vacui*), a title reminiscent of Poe, though probably derived from Nougé or Valéry, who had each mobilized that very phrase.[71] This was discarded as "too direct," but he continued to entertain other possibilities, notably *Être ou ne pas être* (to be or not to be), before arriving at the definitive solution.[72]

Scutenaire spoke from personal experience. He found many of the titles himself (including *La Clef de verre*, *Le Chemin de Damas*, and *Le Pèlerin*). Many others were found by Nougé, whose mastery of the art was readily conceded by the other members of the gang. According to Sylvester, Scutenaire found around 170, Nougé seventy, Mariën thirty, Colinet fifteen, and various others a few each (he mentions Lecomte, Hamoir, Éluard, Breton, and Bosmans).[73] That almost certainly underestimates Nougé's contribution, quantitatively as well as qualitatively. It was he who coined the idea of the title as a conversational gambit or handle, an idea promoted by Magritte himself in "Lifeline." According to Nougé, the title "protects" the painting, preventing it from falling into bad ways, or being dismissed as a joke, or a matter of little consequence. Perhaps there were precedents of a kind. Nougé would have been familiar with Aragon, who in turn riffed on Magritte: "The title, elevated beyond the descriptive for the first time by Chirico and becoming in Picabia's hands the distant term of a metaphor, with Ernst takes on the proportions of a poem. *Proportions* is to be taken literally: from the word to the

paragraph. No one has done more than Max Ernst to say of his paintings *this is no longer painting.*"[74] When Magritte sent Foucault a reproduction of the pipe bearing the legend "This is not a pipe," he wrote on the back: "The title does not contradict the image; it affirms it all the more."[75]

For Nougé, then, the title is not a commentary on the painting. Nor is it a gloss or explanation. It is "a similar enlightenment to that which emerges from what it names."[76] Enlightenment, however, is a tricky thing. It so happens that the Age of Enlightenment (the long eighteenth century) is known in French as *Le Siècle des lumières.* Plumbing the meaning of *L'Empire des lumières* [color plate 32], Magritte's famous image of the dark street below and the blue sky above, suggests that this title is often misunderstood. The image itself is an essay in noir—Belgian noir—and perhaps in the shiftiness of categories, diurnal and moral: it is beyond good and evil. Magritte has affinities with the ambiguities and neuroses of film noir, as David Thomson has pointed out, and in day-for-night, the way in which light and dark can coexist in the same frame.[77] *L'Empire des lumières* bears some resemblance to a brief sequence in Charlie Chaplin's *The Kid* (1921), in which we see a streetlight and a dark house in the background, followed by a light sky with dark houses below. Magritte may have been inspired by "The Walrus and the Carpenter":

> *The sun was shining on the sea,*
> *Shining with all his might:*
> *He did his very best to make*
> *The billows smooth and bright—*
> *And this was odd, because it was*
> *The middle of the night.*[78]

Or perhaps by "The Sleepwalker Song" in Nietzsche's *Zarathustra* (Nietzsche vied with Lewis Carroll as his favorite source of charm and menace): "You higher men, what do you think? Am I a soothsayer? A dreamer? A drunk? A dream interpreter? A midnight bell? A drop of dew? A haze and fragrance of eternity? Do you not hear it? Do you not smell it? Just now my world became perfect, *midnight is also noon.* Pain is also a joy, a curse is also a blessing, *night is also a sun*—go away or else you will learn: a wise man is also a fool."[79] Magritte détourned Nietzsche (or Carroll) in a little couplet of his own: "There is midnight at noon / And the locomotives return from the sea."[80]

L'Empire des lumières named something, as an image, that now everyone sees, as Susan Sontag remarked.[81]

The title is one of Nougé's. It may well be derived from an evocative phrase in Valéry's *Introduction to the Method of Leonardo da Vinci,* "empires where

light is associated with sorrow." It is usually rendered, apparently straightforwardly, *The Empire of Light*. In French as in English, however, "empire" is an essentially contested concept. As Mariën pointed out, "English, Flemish and German translators go for the sense of 'territory,' whereas the essential meaning is obviously that of 'power' or 'ascendancy.' "[82] Taking its cue from this, the *catalogue raisonné* gives *The Dominion of Light*, though *The Dominion of Enlightenment* might be even better.[83]

. . .

Sometimes the translation itself has achieved the status of accepted usage, even where it traduces the original. *Time Transfixed* has a nice ring to it, and may be Magrittian enough for the tremendous painting of the train coming out of the fireplace—adduced by Magritte as the solution to the problem of the locomotive—but it does not do full justice to the original French *La Durée poignardée* (1938). *Un poignard* is a dagger; *poignardée* means "stabbed" or "knifed," or possibly "impaled." Figuratively, it is a devastating blow, or a terrible torment. "*La jalousie le poignardait*," to cite an example given in Larousse. The painting of this title was bought by Edward James for his London residence. Magritte thought that it ideally would be placed at the foot of the grand staircase, "so that your visitors would be *poignardés* on the ground floor," as he told James, after seeing *The Last Gangster* (1937), with Edward G. Robinson, which featured a very similar staircase.[84]

La durée is more complex, if we are to comprehend its back story. There is indeed a connotation of the passage of time, or a period of time, but the English word *duration* tends matter-of-factly to evoke a period of elapsed time considered retrospectively, which is not usually what the French (or the Belgians) have in mind. In French language and culture, it is little short of a term of art. For the philosopher Henri Bergson, duration meant "invention, creation of forms, continual elaboration of the absolutely new." It possessed "a certain thickness."[85] Duration is a continual flux of lived experience; it is essentially subjective. Time—clock time—is a matter of mechanized measurement divorced from life. Among intellectuals, and even beyond, these ideas were very widely diffused. Bergson won the Nobel Prize for Literature in 1927. In his day he was famous. So was his *durée*. It surfaced even in his own titles: *Durée et simultanéité* (1922). His major books, his leading ideas, even a smattering of his individual formulations would have been known to Magritte, who made reference to Bergson, and had at least two of the books in his library (both annotated).[86] They would surely have been known to Nougé, the omnivore, who found the title.

La durée was freighted with meaning. Moreover, it was closely linked to Bergson's thinking about perception. He conceived of perception in terms of action, not representation. According to Bergson, what we perceive does not exactly match or represent what is there in the real world. Perception yields something other than the real: neither the real nor the unreal, but rather the remembered or the filtered. It is a sort of selection process, dredging memory banks and image banks, involving a remembrance of things past that is almost Proustian, as Proust himself divined. In *Matière et mémoire* (1896), his foundational work, Bergson analyzed this process into a dynamic interaction between "the image retained" (in the memory) and "the image perceived" (in the here and now). The terms of his analysis bear a striking resemblance to Magritte's account of his own method of solving the problem paintings. "If external perception generates the impulses which describe the broad outlines," proposed Bergson,

> our memory runs from the perception to previous images which resemble it and which our impulses have already sketched. Thus it creates afresh a current perception, or rather it duplicates this perception by reflecting either its own image or some image-memory of the same kind. If the image retained or remembered does not stretch to encompassing all of the details of the image perceived, a call is made to the deeper or farther reaches of the memory, until further known details come to be thrown up onto the unknown.[87]

In Magritte's encapsulation, "an unknown image from the shadows is called forth by an image known in the light." As Suzanne Guerlac has pointed out, Magritte's "*visual thought*" can be glossed in relation to Bergson's "*vision* of memory."[88]

If this has affinities with film—silent film—Bergson himself was the first to point out the connection. In his lectures on "Creative Evolution" he described human perception in terms of which Louis Feuillade would have been proud. "Whether we would think it becoming, or express it, or even perceive it," he argued, "we hardly do anything else than set going a kind of cinematograph inside us." Magritte speaks (favorably) of rereading the book that came of those lectures, *L'Évolution créatrice* (1907).[89] Appropriately enough, it may well be that an image memory from *Les Vampires* contributed to *La Durée poignardée*: the image of the cannon coming out of the fireplace, all set to destroy the cabaret next door.

As if to execute the coup de grâce, Bergson unsheathed a dagger of his own. "Past images, reproduced as they are in full detail and in all their shades

of emotion, are images of delusions or dreams; what we call action involves precisely making this memory contract or rather sharpen, more and more, until it presents only the cutting edge of its blade to experience, which it will penetrate."[90]

Thus *la durée poignardée*, according to Bergson.

La durée was already part of the culture—*La Dialectique de la durée* (1936) by Gaston Bachelard was a title with which Nougé was familiar—and it continued to gain currency, for instance in the concept of *la longue durée* advanced by the historian Fernand Braudel. Magritte surely knew the saying "Ciel pommelé et femme fardée ne sont pas de longue durée" (roughly, "Clouded skies and painted ladies do not last long").[91] Most importantly, Bergson's ideas stimulated Valéry to sustained cogitation, argumentation, and refutation. Valéry beat out his thinking in his "analects," as he called them, first collected in 1926 and republished in 1935. "What is an instant [*un moment*]—a lightning flash?" he asked himself, as he reflected on the distinction between time and duration, and our consciousness of them. "Or is it something that could not constitute lasting time [*un temps*], even if accumulated: the opposite of a duration [*une durée*], not an element of it." For Valéry, the primary datum is the moment, perhaps even the accident. That is how we live our lives and fashion our selves. His observation that every life begins and ends in a sort of accident continues: "Whilst it lasts, it is shaped and fashioned by accidents. Friends, spouse, reading, beliefs—in every life chance plays the major part. But this element of chance gets forgotten; we think of our own personal history as a continuous development that is a function of 'time.'" Put differently, and more personally, "I neglect my dozes, my absences, my deep, long, imperceptible changes. I forget that I have a thousand models of death, daily blanks, an astonishing number of gaps, suspensions, unknown, unknowable intervals in my own life." Bergson's lived time runs on like a river, or possibly a train. Valéry's lightning flash privileges intermittence, discontinuity, contingency. If the moment is what matters, "time" itself is a construct, encased in quotation marks.

It followed that "whilst it lasts" could not go unexamined. Valéry applied himself to the *longevity* or *lastingness* of a work of art—another construction of *la durée*—apt for Magritte: "A work of art produces an impression. If it can be defined and classified, it is *over*. It can be relegated to the category: for shelving. If it is *to last*, to achieve a certain intensity and a certain aesthetic effect, it must haunt the memory, it must be impossible to summarize, hard to define; it must be practically inexhaustible. What we call its magic, its beauty, etc., comes from discovering the conditions of this work, and assembling them in the real world."[92]

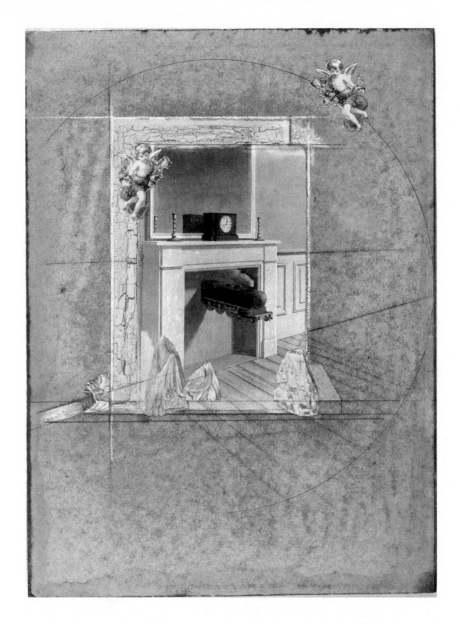

Fundamentally, Valéry was sceptical about the very idea. He could not rid himself of the suspicion that *la durée* was a fiction. He confided to his notebook, "I have never understood whether Bergson's famous '*durée*' was classified among sensations, perceptions—in the symbols or notions introduced for the act of expression—or in condensed observations—or in metaphors. If no precise definition, no real usefulness." In the end, he concluded, they were poles apart. Bergson strove to "fluidify" what he himself strove to "solidify."[93]

La Durée poignardée, therefore, was part of a much bigger conversation than is generally realized—not least, a punctured dialogue between the painter and the philosopher, mediated by the phenomenon that was Paul Valéry, the man who had killed the marionette, as he wrote in *Monsieur Teste*, the inspiration of a generation, with his insistent question: "Que peut un homme?" What is a man capable of? Can he make a masterpiece, a work that will last? A work *pour sa durée*? A work that is timeless? *La Durée poignardée* is a textbook case. It is a painting that is also a reflection on the work of art itself, and its cultural capital. Moreover, it is itself a source of cultural capital. Joseph Cornell and John Stezaker are two of the many who have found inspiration in it.[94] This conversation is not over yet.

Magritte himself remarked that the title *Time Transfixed* "does not seem 'very fortunate.'" He also observed that the title is itself an image, joined to the painted image. "The word *durée* was chosen for its poetic truth," he explained to one philosophically eager inquirer, "not in a philosophical sense in general, nor in a Bergsonian sense in particular." He was happy enough to talk in terms of his "thought," but for Magritte the thought materialized in the image. He himself had not conceived an *idea*, he told his correspondent, he had conceived an *image*. Bergson dealt in ideas. Proust dealt in words. The

painter, the demanding painter, dealt in images. Magritte confessed himself very demanding.[95] In one late interview he summarized his position as follows:

> For me the art of painting is a means of description. It is about describing a thought, but of course not just any thought. I cannot describe a thought such as *la durée*, for example. It's up to the writer to do that. I can only describe a thought which consists of images of what the world makes visible, images of a sky, a tree, a person, an inscription, a solid. However, this thought is not a juxtaposition of visible things. For me, it only deserves to be described if it is inspired, and it is inspired when this thought unites visible things in such a way as to evoke their mystery.[96]

For Magritte, a painting did not simply express ideas—that was too reductive—but it did have the power to create them, as Nougé had prophesied at the very beginning of their association. "After I had painted *L'Empire des lumières*," he wrote to a friend, "I had the *idea* that night and day exist together, that they are one. This is reasonable, or at the very least it is in keeping with our knowledge: in the world, night always exists at the same time as day. (Just as sadness always exists in some people at the same time as happiness in others.) But such ideas are not poetic. What *is* poetic is the visual image of the picture."[97]

In the final analysis, it may be that the spirit of the thing is almost as important as the shades of meaning. A title is not a parlor game, as Nougé might have said. And yet the process of finding one did resemble a parlor game among the accomplices at Magritte's weekly gatherings. *Duration Stabbed*? Too literal. *A Stab at Duration*? Too whimsical. *Daggers Drawn*? Too fanciful. *Stop-Motion*, as in film? Clever, perhaps too clever. *Duration Impaled*? Possibly. *A Dagger to the Duration*, like a knife to the heart? Intriguing, but not quite right. *The Dagger in the Duration*, like the worm in the bud? At last! Alliteration preserved, and a formula redolent of the mystery novels he loved, like *The Hand in the Glove*, or *Die Like a Dog*, or *Trio for Blunt Instruments*.

The title is not the icing on the cake, said David Sylvester, it is the cherry in the cocktail.[98]

8.

Surfeit and Subversion

La Durée poignardée was the seventh or eighth Magritte bought by Edward James, in three rounds of significant acquisitions over the period 1937–39.[1] It turned out to be one of the last. For a few tumultuous months in 1937, James's patronage imparted a new dynamic to Magritte's life—a substantial commission, for an installation in a grand house in Wimpole Street, London; residence there, on his own, for as long as it took; separation from Georgette, with dramatic repercussions—a period of excitation and perturbation in equal measure.

Edward James (1907–84) was an English eccentric with a talent for follies, indoors and out; a certified aesthete; a cross between a "surrealist milord" and an under-laborer in the garden of creation, as he himself suggested in an autobiographical novel, *The Gardener Who Saw God* (1937); a thwarted poet; "a rich pansy," according to Mesens; a *dénicheur*, a bargain hunter, or more precisely a bargain unearther, of beauty and truth, in many forms; a surrealist in adventure, like a pale version of Poe; a self-confessed dissident of a kind, "permanently in revolt against authority," to quote his sympathetic assessment of Leonora Carrington. "So with me also."[2]

He was immensely wealthy and ready to back his fancies. In 1931 he helped John Betjeman to publish his first collection of verse. In 1936 he signed a contract with Salvador Dalí for virtually his entire production, including a regulation lobster telephone and a Mae West lips sofa. Common sense was not his forte, but he had sensibility to spare. His tastes were eclectic; he liked opulence, juxtaposition, ambush. As a student at Christ Church, Oxford, his rooms were a wonder to behold. The bedroom walls were lined with silk, in silver and gray crossed with a diamond weave. The drawing room was full of

Flemish tapestries and deep pile carpets. The ceiling was painted dark purple, with a frieze of lighter purple, and a quotation in gold lettering, saucily attributed to Seneca: "ARS LONGA VITA BREVIS SED VITA LONGA SI SCIAS UTI." (Art is long and life is short but you can make life long if you know how to use it.) Gramophone horns were concealed in busts of Roman emperors. Jazz accompanied the champagne breakfasts. Prudently, he decided he did not want to have any "good pictures," in case the rooms were sacked by the hearties (rugger buggers and the rest), so he chose to hang railway posters by Ben Nicholson.[3] He had the reputation of a brilliant student, but he left without taking his degree—a lifelong theme.

He thought of himself not as a patron or collector on the traditional model but as a full partner in the creative enterprise. He liked the idea of entering into a dialogue with the artists he favored. He was at once sponsor, designer, and co-conspirator. However outlandish his schemes, he had sound instincts. He knew a good picture when he saw one. When it came to Magritte, he was by no means untutored. He had talked to Mesens. He had studied the works in the International Surrealist Exhibition in London in 1936, where Magritte was well represented.[4] They met afterward in Paris. Magritte was under strict instructions from Mesens to behave himself, and to refrain from any of the usual provocations. It worked. "What a nice man he was," said James, somewhat unexpectedly. Magritte could be charming when he put his mind to it. In January 1937 he received an enticing invitation: "I would be delighted if you could come and spend a month or two in London, here at 35 Wimpole Street," wrote James. "You were so kind to me in Paris and took me to all the fine museums. So I should like in turn to show you London and the English countryside with all its beauties, which are many. Write to me giving me the date of your arrival, and spend a month or two at my house, as soon as you can."[5]

The politesse had a purpose. He had broached with Magritte a commission for three panels, as he called them, to be installed behind two-way mirrors in the ballroom, so that they were only visible when the lights behind the glass were switched on. In effect this meant three large oil paintings—*Le Modèle rouge* (*The Red Model*), *La Jeunesse illustrée* (*Youth Illustrated*), and *Au seuil de la liberté* (*On the Threshold of Freedom*). James seems to have had a clear conception of the installation from the outset; he must have explained this to Magritte in Paris, to give him an idea of the nature of the task. Whether he also had views on the subject of the works themselves is less clear. He had seen earlier versions of *Le Modèle rouge* and *Au seuil de la liberté* in London, so it is entirely possible that they discussed those, too, and in fact Magritte had finished an earlier version of *La Jeunesse illustrée* only a few weeks before.

However that may be, Magritte evidently had considerable latitude in what he produced and how he produced it.

The terms were agreed with Mesens, now acting as Magritte's agent in the marketing of his work abroad. James wrote to confirm:

> It would perhaps be better, to avoid any misunderstanding, if I set down now the terms we agreed on for the three panels—that is to say, £250 (two hundred and fifty pounds) in total. But if Magritte pays his travelling expenses, I think it only fair that I should supply the canvases and painting materials. I told him that I would bear the cost of his return journey, should he wish to interrupt his stay and return to Belgium before finishing the panels in one go, so that he would not be obliged to stay in London for longer than was convenient without seeing his family; but now, in view of the fact that the fee agreed between us is already much more than I paid Dalí for the three panels he painted for that same house, perhaps if I supply the painting materials, Magritte would be willing to pay his own travelling expenses.
>
> Delighted at the prospect of making the acquaintance of a painter whose imagination is so poetic and personal, and looking forward to the pleasure of seeing you again.[6]

So Magritte went to Wimpole Street. He was there for about five weeks, in February and March 1937, living in unwonted luxury. From the moment he arrived, according to Mesens, he could not resist acting up. As related by George Melly:

> Dinner that night was elaborate, the company *haut bohème*. The first course was tiny soles in a delicate pink sauce. Magritte helped himself to eight and refused to eat anything more. He was sat next to Edith Sitwell and spent the whole time talking about his constipation.
>
> A day or two later, visiting Magritte to see how it was going, Mesens found him painting a large expanse of sky in a state of irritation. "It's so boring," he kept complaining loudly. "Be quiet," said Mesens anxiously. "You're meant to be a genius."
>
> Another time he came upon Magritte in a corridor, his eye glued to a keyhole [as if to act out *L'Espion*]. Edouard was appalled. "What do you think you're doing?" he hissed. "Watching Mr James's secretary taking a bath," explained Magritte. "But she's very ugly," said Mesens ungallantly. "Yes," said Magritte, "but very hairy." That the painter might have staged these and indeed other events to tease Mesens never occurred to him.[7]

Staged or not, Magritte remained on excellent terms with James (and his secretary) throughout. He was left well alone—there is some suggestion that James preferred the company of Dalí, with all his extravagances, finding Magritte a trifle uncouth.[8] That did not deter him from commissioning a portrait. By way of thanks for his kindness, Magritte presented him with a death mask of Napoleon, one of a number of plaster casts obtained from Georgette's sister Léontine, painted with sky or forest, and known by the generic title of *L'Avenir des statues* (*The Future of Statues*).[9] Magritte had a similar line in the Venus de Milo, known by the generic title of *Les Menottes de cuivre* (*The Copper Handcuffs*), a title found by Breton at Magritte's request. One of the Napoleons (somewhat the worse for wear) was still in Georgette's possession at the time of her death in 1986. Nougé devoted a section of *Les Images défendues* to them:

> The masks of great men, monuments and famous pictures, strengthened by their smooth journey through time, continue to occupy a special place in our minds. This is almost always so without our being aware of it, and whether we think them worthy of contempt, admiration, or indifference.
>
> The aesthete, the Dadaist and the grocer are all the same in front of a Leonardo. The first goes into raptures, the second adds moustaches, the third looks away; and the Mona Lisa goes on smiling at her privileged image. She remains a masterpiece, in our heads as in the Louvre.

This may be the moment to cast doubt on these sumptuous objects that pursue us through history. But the enterprise requires a certain deft subtlety for which we have to wound them without toppling them from the spiritual perch on which they have always stood.

And thanks to Magritte, a plaster cast of Napoleon, Robespierre or Pascal, a woodland vista, a path of sky traversed by clouds and dreams, manages to transfigure the face of death itself in a wholly unexpected way.[10]

Magritte was like a fish out of water in Wimpole Street. Occasionally bored and chronically unsettled, he depended on Georgette to keep him supplied with his favorite crime novels in the series "Le Scarabée d'or" (the name taken from Poe's "The Gold Bug"), which he passed on to his host—a choice selection of English and American authors, including Freeman Wills Crofts, Henry Wade, Jack London, A. E. W. Mason, Raoul Whitfield, Dashiell Hammett, Ellery Queen, Agatha Christie, and Margery Allingham. In later life, Magritte classified books into two categories: the readable and the unreadable. These authors were readable. The unreadable included, for example, Dorothy L. Sayers, "and all the writers-caretakers."[11] Most philosophers were unreadable, though he read a lot of philosophy. He liked Mariën's idea for a racy treatment of the lives of the philosophers. Magritte recommended something in the style of Hammett: "Kant came in. He was thin, neat, and pleasant to talk to. 'For technical reasons, I'm not going out today,' he said."[12] Of his contemporaries, possibly the philosopher he esteemed the most was Jean Wahl, author of *Traité de métaphysique* (1953) and other works. Magritte knew Wahl. Exceptionally, he addressed him as "*cher maître*." Typically, he complimented him on this statement: "Remaining aware of the achievements of the great thinkers, we must look elsewhere for a richer and more adequate view of reality." Magritte sent him some of his own work—"unknown images to evoke that which is known."[13]

Georgette was kept busy. In addition to the crime novels, she had to pack up and post the death mask of Napoleon, and also tear out a page of Larousse and send that—an illustration of a lion, which served as a model for the lion in *La Jeunesse illustrée*.

The food was another problem. Magritte craved home cooking (preferably his own). Whatever became of the sole in pink sauce, and other delicacies, he was unimpressed by English cuisine, as he confided to Georgette. No sooner had he finished the panels than he alerted her to prepare a homecoming dinner for two. He gave detailed instructions on the menu:

First course:
4 hard-boiled eggs with anchovies (anchovies in round bottles)
200 grams of prawns peeled by you, around the eggs, with a sliced tomato
50 grams of green olives, cut in half (the stones removed)
half a grated carrot
2 or 3 lettuce leaves
and mayonnaise

Second course:
2 kilograms of roast beef
chicory
Fried potatoes or croquettes

Dessert:
cake with sponge fingers
coffee[14]

He did a certain amount of socializing. He met Henry Moore—"a sculptor (genus Arp-Picasso), charming, a miner's son, with a young Russian wife with an ADMIRABLY shaped body (genre sturdy wasp)." He saw something of Humphrey Jennings, whom he liked, and "le groupe surréaliste anglais," about whom he was distinctly lukewarm. "Among the group there are likeable characters, indifferent ones, and one or two who are rather unpleasant and stupid." He got to know the young Chilean artist [Roberto] Matta, who lived nearby. ("He does paintings which are a thousand times better than those of Miró.")[15] For the most part, however, he worked. The commission was a challenge: Magritte was determined to rise to it. He made numerous preparatory sketches. He took great pains. These paintings were variants of earlier paintings, but they were no mere rehash.

Le Modèle rouge—the image of a pair of laced leather boots whose front portions are acutally bare human feet—was the solution to the problem of the shoes. It yielded a fascinating and disturbing image. "The problem of the shoes shows how the most barbaric things come to be considered quite respectable through force of habit," said Magritte. "Thanks to *Le Modèle rouge*, we realize that the union of a human foot and a leather shoe is in fact a monstrous custom."[16] There were two earlier versions, executed in 1935 [color plates 33–35].[17] The version for Edward James introduced some intriguing debris, carefully painted and carefully scattered around the shoe-feet: some loose coins, including two realistic pennies; a cigarette butt and a couple of spent matches; and a crumpled scrap of newspaper. In the paper we can make

out an illustration of *Les Jours gigantesques*, Magritte's painting of a rape, a picture within a picture, the image reversed; the newsprint is all but illegible. These leavings could be construed as the dregs of capitalist society, in which case it may be that the coins are a tribute to Marx's "callous cash payment," and the monstrous custom is a product of consumer society—even more monstrous than we suppose. A well-known passage of *The Communist Manifesto* runs as follows:

> The bourgeoisie, wherever it has got the upper hand, has put an end to all feudal, patriarchal, idyllic relations. It has pitilessly torn asunder the motley feudal ties that bound man to his "natural superiors," and has left remaining no other nexus between man and man than naked self-interest, than callous "cash payment." It has drowned the most heavenly ecstasies of religious fervour, of chivalrous enthusiasm, of philistine sentimentalism, in the icy water of egotistical calculation. It has resolved personal worth into exchange value, and in place of the numberless indefeasible chartered freedoms, has set up that single, unconscionable freedom—Free Trade. In one word, for exploitation, veiled by religious and political illusions, it has substituted naked, shameless, direct, brutal exploitation.[18]

Le Modèle rouge might then be almost an allegory of the capitalist system, and its grotesque production; the artist's place within it, as a pawn with superior powers, an agent of subversion, derision, and ironization; and the commission itself, the relations it entailed, and the strange games played in the ballroom of the bourgeoisie—a charade of the *carrousel-salon* of his youth, transformed into something alienated and alienating. Did Magritte discuss it in these terms with his host, a free spirit, alive to the subtle torments of the class system? Once the works were installed, James gave a ball for his niece. "Your paintings caused a great sensation at my ball," he reported. "In the course of the evening, many young English people were converted to surrealism by *La Jeunesse illustrée*. But most of all the human boots melted the hearts of the young couples dancing in their capitalist heels."[19]

In this context, it is an intensely politicized painting: like much of Magritte's work, more *engagé* and politically aware than is generally realized. *Le Modèle rouge* is a classic example of an image that tends to be treated simply as a brilliant conceit—a gag. If the nature and purpose of the work is considered at all, it is apt to be treated as a shock tactic or a practical joke. (For those who find the image repellent, a joke in poor taste.) There are shocks and jokes aplenty in Magritte, but that is not the only way in which he has been downgraded

to a kind of conjuror or prestidigitator, a bluffer like his father. He stands accused of being not so much a painter as an illustrator, an image maker, ripe for replication. With replication comes saturation, it is said, with the result that the potency of the imagery is subject to the inexorable law of diminishing returns. Despite the best efforts of a more recent generation of curators and conservators, the slighting of the painting dies hard. One authority contrasts the "dry realism" of Magritte with the "abstract liquefaction" of Miró.[20] For the guardians of the avant-garde, Magritte's works are "entertainments," like those of Louis Feuillade, or Alfred Hitchcock, or Graham Greene, or John le Carré: well made, by a practiced hand; ingenious, no doubt; entertaining, of course. But essentially lightweight.

The tendency to perceive Magritte's work as entertainment is a category error, confining and in the end belittling. It smacks of vulgarization. It pits fine art against more popular genres, like film noir or even pulp fiction, associations not at all foreign to Magritte, who felt no shame in the mean streets, or for that matter in the gutter, artistically speaking. His work promises violence, contrivance, indifference. It carries the implication of the slick, the formulaic, the meretricious. It is not supposed to be morally serious, politically cognizant, or intellectually demanding. This was Nougé's anxiety about the response to the painting. ("Magritte is not a painter in the sense used by the aesthetes, but a man who uses painting to give us truly astonishing experiences engaging all aspects of our lives.")[21] He feared that the visual pyrotechnics, the transparent style, and the trademark wit would lead to a smile, a shrug, or a quick dismissal. This is perhaps how he came up with the idea of the title "protecting" the painting, that they need protection from the patronizing assumption that the work is all play—playing with words, playing with images, playing with fire, playing with us. More discerning commentators know better. "Magritte is not sentimental, not tragic, not emotional, but hilarious," observes David Thomson, "so long as no one laughs."[22] Yet Nougé had good reason to be concerned. The title may well have helped, but the title was not enough. The famous pipe had a resonant title, *La Trahison des images*. That did not prevent Paul Delvaux from dismissing it in precisely these terms: "'Ceci n'est pas une pipe,' c'est un gag!"[23]

To be sure, the work abounds in playfulness. *Les Vacances de Hegel*, his painting of 1958, testifies to that. Magritte was incorrigible. But the hilarious meshed with the serious. "My latest picture began with the question: how to show a glass of water in a painting in such a way that it would not be insignificant," he explained to Suzi Gablik, tongue in cheek, "or whimsical, or arbitrary, or feeble—but, let us say, a stroke of genius (without false modesty)."

I began by drawing many glasses of water, always with a mark on the glass: [a sketch]. After the 100th or 150th drawing, this mark broadened out: [a sketch] and took the form of an umbrella: [a sketch]. This was placed in the glass: [a sketch] and finally below the glass: [a sketch].

Which is the exact solution to the initial question: how to paint a glass of water with genius? Then I thought that Hegel (another genius) would have greatly appreciated this object, which has two opposing functions: not wanting water (repelling it) and at the same time wanting water (containing it). He would have been charmed, I think, or amused (as on holiday), and I call the painting: *Les Vacances de Hegel* (*Hegel's Holidays*).

Three days later, he wrote a very similar letter, with exactly the same sketches, to Maurice Rapin and to another of Magritte's literary "accomplices," the writer Jacques Wergifosse. The letters, like the paintings, came in series.[24] Hegel, moreover, was not the only luminary thus invoked. Lenin himself was given to using a metaphorical glass of water to make a dialectical point, as Magritte well knew. According to Lenin, to isolate any single definition of a glass of water (to think of it as a container, for example, rather than an instrument to quench thirst) was mere "eclecticism." The dialectic called for a much more rigorous procedure: "To really appreciate an object, you have to fully grasp it, examine all its angles, aspects, connections and 'mediations' with the outside world. Obviously we shall never succeed in doing this exhaustively, but the demand for universality guards us from errors and from the risk of congealed routine."[25] Which sounds very like Magritte's problem solving.

In the case of *Le Modèle rouge*, the shock and the wit combine with biting critique. Revealingly, Magritte's accomplices took it seriously—very seriously. So did Magritte. "With a little more awareness," wrote Paul Colinet, "the worker will see before him the terrible stigmata of his day." Colinet's lucid commentary was taken up and transformed by Nougé into the conclusion of some scintillating reflections on selected works, for an exhibition at the Palais des Beaux-Arts in Brussels in 1936:

Thus the images painted by René Magritte tend to wake us up, to snatch us from the unassuming sleep of automatism and habit.

Whether they charm us, unsettle us, insult us, or assault us, in the end it is always to the benefit of our conscience.

"More consciousness," the poignant appeal of Karl Marx, the old prophet's basic maxim, Magritte cannot be praised enough for having clearly understood it.[26]

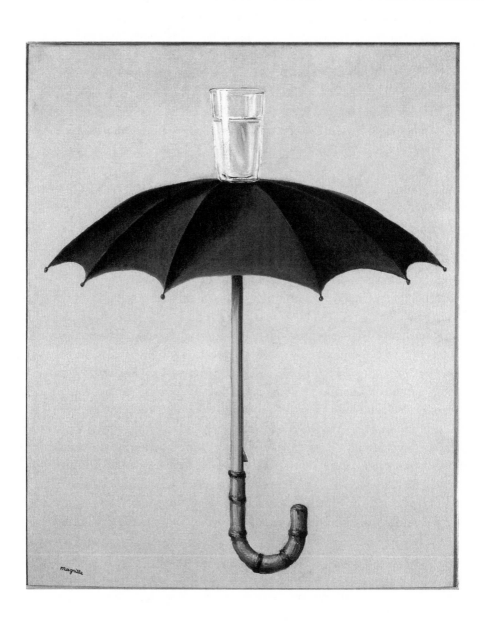

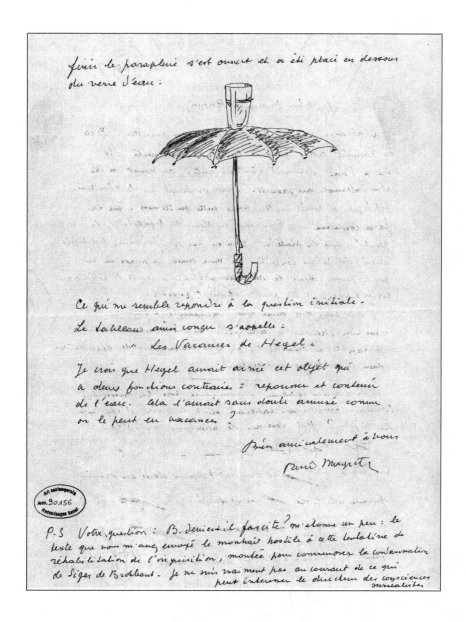

finir le parapluie s'est ouvert et a été placé en dessous
du verre d'eau:

Ce qui me semble répondre à la question initiale.
Le tableau ainsi conçu s'appelle:
« Les Vacances de Hegel »

Je crois que Hegel aurait aimé cet objet qui
a deux fonctions contraires: repousser et contenir
de l'eau. Cela l'aurait sans doute amusé comme
on le peut en imaginer?

Bien amicalement à vous
René Magritte

P.S Votre question: B. devient-il fasciste? m'étonne un peu: le
texte que vous m'avez envoyé le montrait hostile à cette tentative de
réhabilitation de l'inquisition, montée pour commémorer la condamnation
de Siger de Brabant. Je ne suis vraiment pas au courant de ce qui
peut intéresser le directeur des consciences
surréalistes.

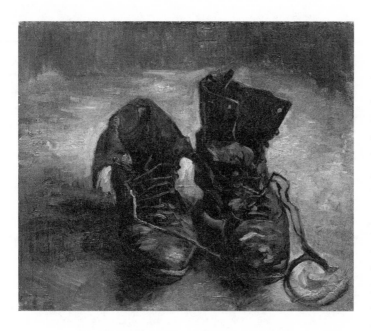

Magritte had broached the cash nexus before, in three works called *La Fissure*, the last of which he made for the American market, changing the Belgian banknote into a trompe l'œil $100 bill. The title found by Nougé came from his reflections on the ruination of capitalist society in the catalog preface to an earlier Magritte show.[27] In *Le Modèle rouge*, the currency is debased. It is after all the *red* model (the title found by Nougé). For anyone attending to signs of weakness in the system, the outlook is encouraging. There is an air of dilapidation, or decay; of things gone by, or gone bad. Magritte's insistent planks of wood have been treated as if the work itself was exposed to the elements. He went so far as to allow the paint to drip, to accentuate the weathering.[28] *Au seuil de la liberté* suffers similar depredations. There are trompe l'oeil cracks in the ceiling. When the cannon fires, the panels of the apparent world will fall down, as John Berger said.

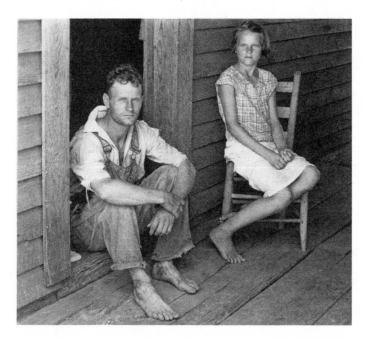

The shoe-feet are more boot-like than ever. They are worker's boots. They are unmistakably Magritte's, though they seem to claim kinship with van Gogh's famous work

shoes, and also Floyd Burroughs's, as photographed by Walker Evans, in the indictment of dust-bowl poverty that became *Let Us Now Praise Famous Men* (1941). There is a family resemblance, a solidarity of the outcast and dispossessed. Magritte's boots are not as bedraggled as van Gogh's, but they have similar trouble with the laces. *Le Modèle rouge* is a picture of impoverishment. Everything in the painting—boots, laces, planks, dregs—speaks eloquently of incongruity in the plush setting of 35 Wimpole Street. Magritte's image is a materialization of a basic issue: human beings feeling comfortable in their skin.

The brilliant conceit is not the point. That would be mystery for mystery's sake, as John Berger argued: "The point is what possibility/impossibility does such an invention propose? An ordinary pair of boots left on the ground would simply suggest that somebody had taken them off. A pair of severed feet would suggest violence. But the discarded feet-half-turned-into-boots propose the notion of a self that has left its own skin. The painting is about what is absent, about a freedom that *is* absence."[29] Nougé understood this very well.

> That our dealings with our fellow men, and with ourselves, are deeply tainted by the social conditions now imposed on us is self-evident.
> Even so, no-one seems to have noticed until now that this perversion extends to our relationship with familiar objects, those objects that we believe to be our faithful servants, and that slyly, dangerously rule us.
> *Le Modèle rouge* shrieks a warning.[30]

Magritte himself was subjected to another reading. In a letter to his accomplices he explained how two Freudian psychoanalysts interpreted *Le Modèle rouge* as a clear case of castration. "You will see from this how it is all becoming very simple," he continued. "Also, after several interpretations of this kind, I made them a real psychoanalytical drawing (you know what I mean): 'canon bibital' etc." (This was presumably Magritte's image of a "porno cannon," a heavy-handed phallic symbol of some kind.) "Of course, they analyzed these pictures with the same coldness. Just between ourselves, it's terrifying to see what one is exposed to in making an innocent picture."[31]

Le Modèle rouge is also a metamorphic painting. For Jacques Derrida, it both mimics and mocks the join, the metamorphosis, between shoe and foot. He fastened on the theme of economic exchange or exploitation. "It also cuts off the shoe-foot at the ankle, at the neck, indicating by this trait . . . that this pair of rising-sided shoes (rising towards what?), now out of use, with empty unlaced neck . . . are still deferring their supplement of property, the revenue on their usury."[32] Derrida drew attention to other variations, for example *La*

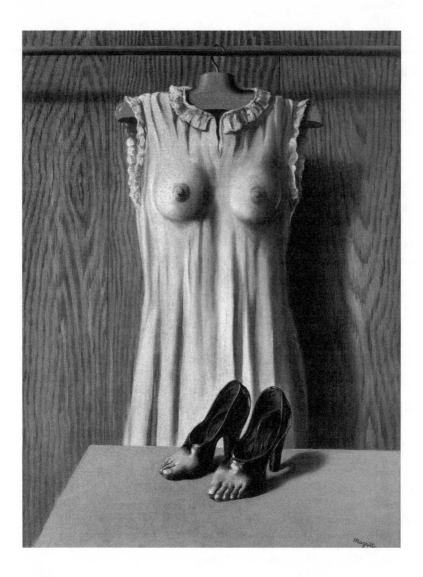

Philosophie dans le boudoir (*Philosophy in the Boudoir*),[33] in which the shoe-feet change gender, as accessories to a nightdress hanging on a rail—a nightdress with breasts, a trope first unveiled (or veiled) in *In Memoriam Mack Sennett*, and much imitated ever since.

In his discussion of the shoe-foot metamorphosis, Derrida might also have mentioned *L'Amour désarmé* (*Love Disarmed*), a picture of shoes with hair flowing from them—that is, locks of hair *wearing* shoes, said to have been inspired by a maxim in La Bruyère's *Les Caractères* (1688), Magritte's bedtime reading: "To judge women one must look them up and down from their shoes to the way they do their hair, much as one measures a fish from head to tail."[34]

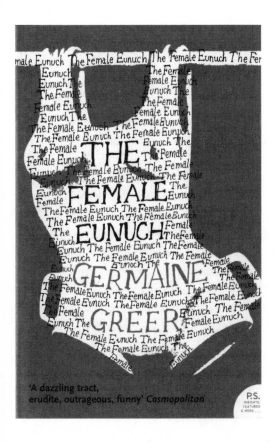

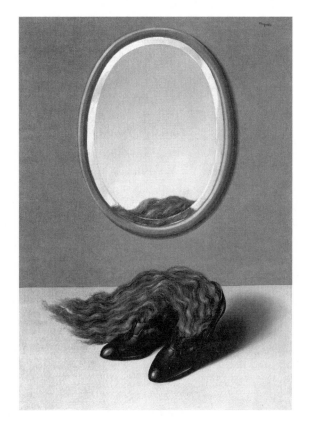

Did Magritte make a connection with a female body in a nightdress, fished from the water, and measured out on the quayside, from covered head to bare feet?

Le Modèle rouge aroused strong feelings—disquiet, discomfort, distaste, even revulsion—when it was first exhibited. "The carnal reality of the human member itself," in Fredric Jameson's words, "now more phantasmic than the leather it is printed on," was hard to stomach. Magritte spoke of the indigestibility of the carnal, à propos *Les Fleurs du mal* (1946): "A statue made entirely of flesh may appear immoral through being too carnal."[35] Indigestion was the aim. "I know some paintings that can really transport people into new realms," wrote Nougé, "while others could not bear the sight for one moment without being overcome by a feeling of mortal shame." This was an integral part of the project: to shake up the spectator; to search to the liver. "Just as illness makes us aware of the existence of the affected organ," in Scutenaire's formulation, "Magritte's painting makes us aware of objects."[36]

Some years later, when his American dealer Alexander Iolas complained that *Les Valeurs personnelles* (1952) made him feel ill, and asked Magritte to

be an angel and explain it to him, he got more than he bargained for. Magritte gave him a short lecture on commodity fetishism. *Les Valeurs personnelles* is ostensibly a picture of some outsize objects in a bedroom: a comb, a match, a glass, a shaving brush, a cake of soap [color plate 36]. George Melly speculated that it was inspired by Mesens's "fetishism of the *salle de bain*"—he used to shave, not once, but three times, with an expensive badger shaving brush and a pack of Gillette razor blades, carefully repacked and reused, according to an occult ritual that he took to his grave.[37] The cell-like interior in the painting bears some resemblance to the artist's bedroom in 135 rue Esseghem. Mysteriously, the walls are papered with Magritte's blue sky; here, too, there are cracks in the ceiling. *Les Valeurs personnelles* (*Personal Values*) is a surreal still life. But it is more than that. It is another brilliant conceit, and another inquiry into power relations and social forces, a parable of production and consumption, a demonstration of the absurdities and iniquities of capitalism—another shriek of alarm. Magritte himself drew the comparison with *Le Modèle rouge*. His response to Iolas began with a blunt rebuttal that spoke to his conviction that art could—and should—play a part in changing society:

About the picture *Personal Values* [. . .] when you look at this picture from the perspective necessary for the acceptance of a work of art, whatever it may be like, you will certainly change your mind. Such a perspective is impossible if the mind is preoccupied with irrelevant, utilitarian and rationalistic considerations. Indeed, from the point of view of immediate usefulness, of what possible relevance is the idea that, for example, a sky covers the walls of a bedroom, a gigantic match lies on the carpet, an enormous comb stands on the bed? Such an idea is *powerless* to solve any utilitarian problem raised by living in society. The individual in society needs a set of ideas such that a comb, for example, becomes a *symbol* allowing a certain combination of events in which he, the individual, manages to act socially through gestures understandable to society: the comb is for combing hair, it is manufactured, it is sold, etc. In my picture, the comb (like other objects) has lost precisely that "social character"; it has become an object of useless luxury, which may leave the spectator "feeling helpless," as you say, or even make him ill. Well, that proves how effective this picture is. A picture that is really alive should make the spectator feel ill, and if the spectators are not ill, it is because (1) they are too insensitive, (2) they have got used to this uneasy feeling, which they take to be pleasure. (My picture, *The Red Model*, of 1935, is accepted now, but when it was new, it made quite a few people feel ill.) Contact

with reality (not the symbolic reality that allows social exchanges and social violence) always makes people ill. Think about it, there is a lot to be said on this subject. But I cannot develop the argument properly in a hasty letter. What is more, all the reasons in the world are powerless to make anyone like anything.[38]

The strength of Magritte's political convictions has always been underestimated, not least because some of his key writings were suppressed or expurgated, by Magritte and his confederates, and then by everyone else. When it comes to publication and dissemination, his words have suffered, and so has he.

On November 20, 1938, on the eve of his fortieth birthday, he gave a lecture at the Musée des Beaux-Arts in Antwerp, illustrated with slides of his work. He called it "La Ligne de vie" ("Lifeline"), a title suggested by a phrase of Nougé's, "*la corde de votre vie*," in an essay on his painting.[39] This lecture was his major statement. In a lifetime of writing, it is the most important declaration he ever made. However, it had a checkered history.

. . .

He received the invitation in April 1938; the fee offered was 600 Belgian francs. Magritte set to, with a will, to give a good account of himself, his outlook, his project, his passage, his modus operandi, his status as a surrealist: in short, his credentials as a revolutionary. "Lifeline" is a serious attempt at self-fashioning and an equally serious attempt at self-explanation, more serious in every way than the "Autobiographical Sketch," which came later, and also more personal. In "Lifeline," there is no question of the third person—the first person rules. The lecture has an urgency, an immediacy, that is partly a function of the historical circumstances, partly a matter of the importance of what he had to say, and partly a consequence of the discourse he chose to employ. "Lifeline" is laced with references to contemporary patron saints of art and thought. Marx finds his place here. As do Nietzsche, Lenin, Valéry, Breton, Duchamp, and Ernst. Among the figures in Magritte's personal pantheon, Baudelaire and Poe receive due acknowledgment.

He wrote it all out in longhand (eighteen pages), as was his wont. Mariën typed it up. Evidently that was only a first draft; Magritte continued to work on it. A few months later he sent an expanded version (twenty-six pages) to Hamoir, who was to type up a reading copy for him. Even as he drafted, he was eager to make arrangements for its publication. He broached the subject with Mesens in London and Éluard in Paris, but nothing came of these over-

tures. In the event, an extract appeared in *Combat* on December 10, 1938, shortly after it was delivered, and a digest in *L'Invention collective* in 1940. The digest was made by Mariën and cordially approved by Magritte, still keen to see something in print.[40] It was eventually published in the American magazine *View*, in 1946, translated by Felix Giovanelli. Unfortunately, Giovanelli had a tin ear. In the context of his spine-tingling intention "to make the most familiar objects scream out loud," Magritte had said, surrealistically, "I found the cracks we see in our houses and faces more eloquent in the sky." This passage was twice despoiled. In the digest, the screaming out loud was lost to an anodyne paraphrase; in the translation, the cracks (*les lézardes*) turned into lizards (*les lézards*). "The lizards we usually see in our houses and on our faces, I found more eloquent in a sky habitat."[41] That may have sounded like surrealism, but it was in fact nonsense. There were lions and leaf-birds in Magritte's menagerie—even in the sky—but no lizards.

Despite its poor translation, the digest has been ransacked and recycled ever since. It has been rightly said that it serves as the principal window through which Magritte's life and work are viewed.[42]

"Lifeline," even in Magritte's time, was full of vexations. He never did see it in print, complete. For several decades, the only available text was a mutilated one. Mariën's digest was a skillful job of work, as Magritte was the first to acknowledge, but it represented only about a quarter of the original. Many things were jettisoned in the process. Furthermore, Mariën took some liberties. Alluding to one of his own paintings, *Les Grands Voyages* (*Great Journeys*), Magritte spoke of "a woman's body floating over a town, a distinct improvement on the angels who never appeared to me." In Mariën's version (in Giovanelli's translation) this became "an initiation for me into some of love's secrets."[43] Most importantly, the digest altered the character of the discourse. It excised almost all of the scorching social and political comment, and also Magritte's fundamental propositions on words and images. Indeed, it was as if expurgated. On the other hand, it supplied an interesting pointer. When Magritte explained his decision to engage more directly with objects in the real world, in order to act on the real world, he passed immediately to his association with the surrealists, "who were giving violent expression to their disgust with bourgeois society." Mariën inserted a didactic reference to "the same will allied to a superior method and doctrine in the works of Karl Marx and Friedrich Engels"—who had not been mentioned by Magritte at all.[44]

A complete reconstruction of the lecture as delivered had to await the publication of Magritte's *catalogue raisonné*, in 1997, half a century later—a magnificent restoration, only slightly marred by a rather ponderous transla-

tion, which contained a number of inaccuracies and a perplexing misreading in the stirring peroration.[45]

Meanwhile another truncated text had appeared, in Scutenaire's book on Magritte, written in 1942 and published in 1947. Scutenaire's version likewise disposed of the social and political comment.[46] This expurgation or self-censorship had to do with the political realities of the day. In 1938, as Magritte delivered his lecture, Hitler was flexing his muscles. In March came the Anschluss, the German occupation of Austria; in September the Munich Agreement, effectively dismembering Czechoslovakia; in November, only days before the lecture, Kristallnacht. "It still holds up, this world, for better or worse," mused Magritte, "but aren't the signs of its future ruin already visible in the night sky?" The ceiling was cracking. The sky was falling. Magritte's question must have struck home to an audience in Antwerp. Sooner or later, the Germans would be coming to Belgium. They had come before, as the Belgians well remembered. Under a Nazi dispensation, Magritte feared that he would be collared for his antifascism. In these circumstances, minimizing any gratuitous offense must have seemed only prudent. Mariën's digest and Scutenaire's manuscript were prepared accordingly.

On the day, Magritte took no such precautions and did not hold back when delivering the lecture. He wrote afterward to Mesens,

> I gave my lecture at Antwerp . . . to a packed house of very attentive listeners. To my astonishment, I was able to speak for 50 minutes in such a way as to keep them interested. There were 24 slides of pictures and drawings. At the beginning, one member of the audience tried to leave as soon as I uttered my third word: Comrades! But since the hall was packed (with people standing), he couldn't do so. During the lecture, one indignant lady managed to get out, together with her daughter. At the end, remarks like the following could be heard: He talks about 1915, why wasn't he at the front? But apart from these amusing incidents, I have the feeling that I made the right impression on the audience of at least 500 people.[47]

Mariën, the sorcerer's apprentice, was in charge of the slide projector. He recalled two other passages that brought an immediate reaction from the audience. The first was a deliberate put-down of "that pest Hitler" and "his handful of fanatics." (Later, "Nazi cretins." Later still, Magritte had a momentary qualm about the title *Hegel's Holidays*, rather than *The Philosopher's Holidays*, because of the Nazi tendency to attribute to Hegel "their taste for gas chambers, stupid racial ideas and cannon-fire.") The second was a provocative

example of how "the picturesque can be effective, provided it is set in a new context, or in certain circumstances. Thus, a legless cripple will cause a sensation at a Court ball."[48]

The first part of the lecture set the scene, pitting surrealism against "realism," the latter depicted as notably unrealistic:

> Ladies, Gentlemen, Comrades,
>
> The old question, "Who are we?" is given a disappointing answer in the world in which we have to live. We are merely the subjects of this supposedly civilized world, in which intelligence, depravity, heroism and stupidity rub along together, the last word in topicality. We are the subjects of this absurd and incoherent world in which arms are manufactured for the prevention of war, science is devoted to destroying, killing, building, and prolonging the lives of the dying, and where the most insane activity is self-contradictory. We live in a world where people marry for money, and where palaces are built and left to decay on the sea-front. It still holds up, this world, for better or worse; but aren't the signs of its future ruin already visible in the night sky?
>
> To reiterate these obvious truths seems naïve and pointless to those who are not bothered by them and who quietly benefit from this state of affairs. Those who live on this disorder are keen to make it last. But their so-called realistic method of retouching the old edifice is compatible only with certain measures that are themselves new disorders, new contradictions. Unwittingly, therefore, the realists are hastening the inevitable collapse of this doomed world.
>
> Other men, with whom I proudly stand, consciously wish for the proletarian revolution that will transform the world, despite the accusation of utopianism levelled against them; and we work towards that end, each according to his means. However, as we await the destruction of this mediocre reality, we must defend ourselves against it.
>
> Nature furnishes us with a dream state, which offers our bodies and minds the freedom that they so badly need. Nature has also been bountiful in creating for the weak and needy the refuge of madness, which protects them from the stifling atmosphere of this world fashioned by centuries of idolatrous worship of money and gods.
>
> The most powerful defensive weapon is love; it takes lovers into an enchanted domain exactly made to measure and admirably protected by isolation.
>
> Finally, Surrealism provides humanity with a method and mental approach suitable for pursuing investigations into realms which have

been ignored or despised but which are however of direct concern to man. Surrealism claims for our waking life a freedom similar to that which we have in dreams. This freedom is latent in the mind, and in practice new technicians need only concentrate on ameliorating some complex or other—the ridiculous, perhaps—and on determining the minor modifications to our habit of seeing only what we choose to see, in order to discover immediately the objects of our desires. Everyday experience, tangled up as it is in religious, civil or military doctrines, permits of these possibilities up to a point. In any event, the Surrealists know how to be free. "Freedom, the colour of man," proclaims André Breton.[49]

The second part struck a more directly autobiographical note, charting Magritte's course from abstraction (as he called it) through cubism, futurism, and purism to something like objectification, down to the mid-1920s.

The third part unleashed his political convictions:

It was then that I met my friends Paul Nougé, E. L. T. Mesens and Jean [Louis] Scutenaire. We were united by common concerns. We got to know the Surrealists, who were giving violent expression to their disgust with bourgeois society. Their revolutionary demands being the same as ours, we joined with them to put ourselves at the service of the proletarian revolution.

It was a failure. The political leaders of the workers' parties proved to be too vain and too slow to grasp what the Surrealists could contribute. Such were the high and mighty who were allowed seriously to compromise the cause of the proletariat in 1914. They were also allowed to indulge in every kind of cowardice and baseness. In Germany, when they represent a well-disciplined body of workers and have the power easily to crush that pest Hitler, they simply yield to him and his handful of fanatics. In France, Monsieur [Léon] Blum [the prime minister] has recently been helping the Germans and the Italians to murder the young Spanish republic; fearing a revolutionary situation, as he says, he seems to ignore the rights and the power of the people by yielding in his turn to a threatening reactionary minority. Note, by the way, that a political leader of the proletariat has to be very brave to proclaim his faith in the cause he espouses. Such men are killed.

The subversive side of Surrealism obviously worried traditional working-class politicians who are at times almost indistinguishable from the most ardent defenders of the bourgeois world. Surrealist thought is revolutionary on every level, and is necessarily opposed to the bourgeois

conception of art. It happens that left-wing politicians agree with that conception, and when it comes to painting, they will have nothing to do with it unless it is well-behaved.

However, for a politician who claims to be revolutionary and who must therefore look to the future, the bourgeois conception of art ought to be anathema, for it is characterized by the exclusive worship of the works of the past, and by the wish to halt the development of art. In the bourgeois world, also, the measure of worth of a work of art is its rarity, its cash-value; its intrinsic worth is of interest only to a naïve and backward few who are as satisfied by seeing a flower in the field as by owning a diamond, genuine or fake. A conscious revolutionary like Lenin gauges cash at its true worth. He writes: "When we have won victory on a global scale, I think we shall build gold urinals in the streets of some of the greatest cities in the world."[50] A senile reactionary like Clemenceau, slavish follower of every bourgeois myth, uttered this demented thought about art: "No doubt I won the world war, but if I have any claim to fame in future history, I shall owe it to my forays in the field of art."[51]

Surrealism is revolutionary because it is implacably opposed to all the bourgeois ideological values that keep the world in the appalling state it is in today.[52]

He then drew breath—and no doubt the audience with him.

The concluding part of the lecture invoked one of Magritte's favorite passages from Nietzsche's reflections on art and artists in *The Will to Power*: "Artists, if they are any good, are . . . strong, full of surplus energy, powerful animals, sensual; without a certain overheating of the sexual system a Raphael is unthinkable . . . and in any event with artists fruitfulness ceases when potency ceases. Artists should see nothing as it is, but fuller, simpler, stronger: to that end, their lives must contain a kind of youth and spring, a kind of habitual intoxication."[53] He also took a swipe at God botherers, right thinkers, and nostrum peddlers, treated as victims of infantile disorders. For Magritte, as for Nietzsche, God is dead. We are on our own.

Over time, the society of the future will gain an experience which will be the fruit of a profound analysis, the possibilities of which are opening up before us. And it is thanks to a rigorous preliminary analysis that the pictorial experience as I understand it can be established here and now. This pictorial experience confirms my faith in the unheeded possibilities of life. All these things to which we have been blind that are now com-

ing to light serve to convince me that our happiness also depends on an enigma bound up with man, and that our only duty is to try to grasp it.[54]

So ended the lecture.

This exposition was immediately followed by the publication of "L'Art bourgeois," a tract written or signed jointly by Magritte and Scutenaire, rejected by *Le Drapeau rouge* (*The Red Flag*), the organ of the Belgian Communist Party; it appeared in the *London Bulletin* in March 1939.[55] The *London Bulletin* was edited by Mesens; as a surrealist paper it was rather good, thought Peggy Guggenheim, "but, like Mesens himself, a little too commercial."[56] Be that as it may, it was an excellent advertisement for Magritte, and it carried some serious pieces. "L'Art bourgeois" repeated several of the motifs of "Lifeline" (intrinsic worth and cash value, real and fake diamonds) and also some of the flourishes (Clemenceau's delirium, Raphael's sexual prowess). As the title suggests, it was couched in more nakedly ideological terms, and was for the most part an orthodox Marxist analysis of the current discontents. "Bourgeois order is nothing but disorder," it proclaimed. "L'Art bourgeois" gave heartfelt expression to the situation of the artist at that juncture, as Magritte saw it; that is, the predicament in which he found himself, as a fully conscious revolutionary, steamed up and raring to go.

It must be realized that the revolutionary artist is heir to a complex of habits and troubled feelings. He is the target of scorn and to some extent prey to the demoralizing effect of obscure and contradictory advice in the midst of which he is lost. His essential freedom is thus threatened. But he rebels against these execrable conditions of life and, with limited means, confronts the suspect ideas of morality, religion, patriotism, aesthetics, imposed on him by the capitalist world.

That is why he comes to resort to scandal (Rimbaud used to write on church walls: Down with God!), which can open certain minds to doubt, by throwing off conformism. That is why he tries to create certain objects (books, paintings, etc.) which he hopes will ruin the reputation of bourgeois myths.

The true value of art is a function of its power of emancipatory revelation. And nothing confers on the artist any superiority whatsoever in the hierarchy of human labour. The artist does not practise the priesthood that is only foisted on him by bourgeois duplicity. However, let him not lose sight of the fact that his effort, like that of every worker, is necessary to the dialectical development of the world.[57]

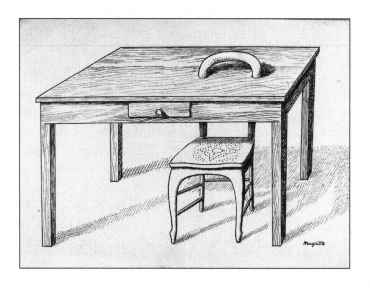

Both "Lifeline" and "L'Art bourgeois" give evidence of Magritte's reading of Marx, not only *The Communist Manifesto* and the *Theses on Feuerbach*, but also *Capital*—at least book one, chapter one, part four of that doorstop tome, "The Fetishism of the Commodity and Its Secret." Marx's approach to the commodity was not so far removed from Magritte's approach to the object, down to the mystery evoked, the terms of analysis, and the examples given. The diamond mentioned in "Lifeline" came from *Capital*, where Marx writes,

> A commodity appears at first sight as an extremely obvious, trivial thing. But its analysis brings out that it is a very strange thing, abounding in metaphysical subtleties and theological niceties. So far as it has a use-value, there is nothing mysterious about it, whether we consider it from the point of view that by its properties it satisfies human needs, or that it first takes on these properties as the product of human labour. It is absolutely clear that, by his activity, man changes the forms of the materials of nature in such a way as to make them useful to him. The form of wood, for instance, is altered if a table is made out of it. Nevertheless the table continues to be wood, an ordinary, sensuous thing. But as soon as it emerges as commodity, it changes into a thing which transcends sensuousness. It not only stands with its feet on the ground, but, in relation to all other commodities, it stands on its head, and evolves out of its wooden brain grotesque ideas, far more wonderful than if it were to begin dancing of its own free will.[58]

If we apply this to *Les Valeurs personnelles*, we are reminded that a comb has use value; it is used to keep the hair in order. In the painting, the comb

has lost its use value; again, "it has become an object of useless luxury," as Magritte explained to his dealer, Alexander Iolas. The same applies to the other objects, as he pointed out. If people began to collect outsize combs, or invest in outsize combs, then no doubt the comb would gain in exchange value, which has little or nothing to do with use value. If combs continued to appreciate, they might eventually be coveted, or traded, like diamonds or pearls—or works of art. As if to prove the point, the artist Vija Celmins appropriated the comb from the painting and produced an outsize one of her own, standing somewhat taller than she did. Celmins is a devotee of Magritte's deadpan, and his object lessons. *Les Valeurs personnelles*, therefore, was highly instructive—the painting and the title (found by Nougé)—especially for Iolas, who loved a good commodity.

Magritte made no secret of where his sympathies lay. His heart beat on the left. His fundamental preoccupation was freedom. Emancipation was axiomatically a leftist project. "Mine is the Communist position," he responded to a survey in *Les Beaux-Arts* in 1935. "My art is valid only in so far as it is opposed to the bourgeois ideology in whose name life is being extinguished."[59] Thirty years later, he could sound as spirited, and as categoric. "I am very meticulous, yes," he told an interviewer.

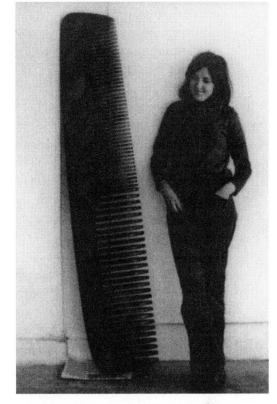

> In life as in my painting. I am also traditionalist, even reactionary: I have a horror of modern furniture, machines, Science with a capital S. In politics, on the other hand, I am resolutely revolutionary. Man belongs to the world, the world does not belong to man. Power, force, conquest, are meaningless words. They mean no more to me than the word subconscious.[60]

In conversation with Patrick Waldberg, at around the same time, he sounded more measured, or possibly more weary. "I'm not a 'militant.' I don't feel I'm equipped with either the ability or the energy for political struggle. However, I stick to what you say I am—I am still for 'socialism,'

that is to say, a system that would abolish inequalities of wealth, hardship, wars. In what form? By what means? I don't know, but that's the side I'm on, despite the setbacks and the disappointments."[61]

Magritte was for socialism in much the same way as Václav Havel was for socialism. As Havel writes,

> I once said that I considered myself a socialist. I was not identify-ing with any specific economic theory or notion (and even less with the notion that everything should belong to the state, and be planned by the state); I merely wanted to suggest that my heart was, as they say, slightly left of centre. Rather than expressing any specific convictions, I was try-ing to describe a temperament, a nonconformist state of the spirit, an anti-establishment orientation, an aversion to philistines, and an interest in the wretched and the humiliated.[62]

This "orientation" of Havel's invites an old question: What is to be done? More to the point, what could Magritte do? For much of the time he might well have subscribed to Antonio Gramsci's formula: pessimism of the intel-lect and optimism of the will. He also seems to have experienced bouts of inertia, or lassitude, some of which may relate to illness or fatigue or a kind of exhaustion, when he felt low, and depleted, as if short of breath and bereft of ideas. "I'm approaching old age (46)," he wrote morbidly to Mariën in 1944. "Another ten years and I'll be 56! Shit! I have backache, I have a constant headache, stomach ache, balls ache! It's raining, it's cold, or it's too hot. I have no money. I'm dissatisfied with my painting (unsatisfied, unappeased). One is always on the qui-vive. Is this all there is? Shit!" At such times he feared a progressive diminution of his creative powers. And at least until the 1950s he could see no end to his straitened circumstances. "My backache is better," he wrote a few weeks later, "but my financial neuralgia persists."[63] Unappeased, his pessimism lurched into something like defeatism. He did not refuse the term. "I would have no confidence in an 'action,' whatever it might be," he told Maurice Rapin in 1957.

> On this subject I am a complete defeatist, to the point where I have neither the means nor the desire to defend that defeatism. I paint without pessimism or optimism, and most of the time I'm preoccupied with the possibilities within my reach. Nevertheless I understand that an action might be exciting for you. In that case one should not give up on it. My defeatism signifies nothing. It's a fact, that's all.[64]

Even after the financial neuralgia had been cured, the inertia returned. "At the moment, I'm pretty exhausted and pretty short of ideas," he informed Harry Torczyner in 1962, as he turned sixty-four. "In any event this birthday coincides with total intellectual vacuity. Fortunately, this has happened to me before and so it does not alarm me (if 'every cloud has a silver lining')."[65] In the end he came to terms with his temperament. "I have neither hope nor despair," as he put it in one of his last letters, in 1967. "I am a defeatist because the bad cannot be conquered by the good."[66]

The recurrent torpor started in the 1930s. On the publication of Breton's *Position politique du surréalisme* (1935), for example, with its nagging question "How to act?," Magritte expressed bafflement to Éluard:

I've received . . . *Position politique du surréalisme* but I confess to being unable to make use of it at the moment. The aim in view seems to me so distant and offering no purchase at all, so that I'm put off. I'm well disposed to this kind of thing, but I can find no means of action. It's like an open door you cannot yet enter, or do not yet know how to enter. I'm very moved by Breton's intentions, but once again I regret having no real means of intervening in the political world. I must say, also, that expressions like "man's freedom" no longer mean much to me now when I try to understand what they signify. It seems to me that they have been too easy a way of disregarding obstacles that are still very present.[67]

From the London Gallery, in 1938, a militant Mesens reproached him for thinking only about money matters, at a time when *"what keeps us busy here, just as much as our day-to-day worries and the poor state of the gallery, is the revolution."* Magritte acknowledged the rebuke. To counter the charge of "inaction," he cited his lecture ("Lifeline") and his continuing efforts to produce work that would elicit a more profound response. He had tried his hand at *Le Drapeau noir* (*The Black Flag*), "which gave a foretaste of the *terror* (without any prettifying) that would result from flying machines," as he explained it, adding, "I'm not proud of it. Terror must not lead us to despair."[68] Magritte was not a war artist, conventionally defined. *Guernica*s were not his style. Like Braque, he observed a sharp distinction between art and current affairs.

As for other forms of direct action, he reiterated his feeling of powerlessness. "There is a revolutionary situation in France, and I really cannot conceive of the ways in which this situation could be transformed into a crushing victory for the proletariat. All I can do is to publish a tract, on which Nougé

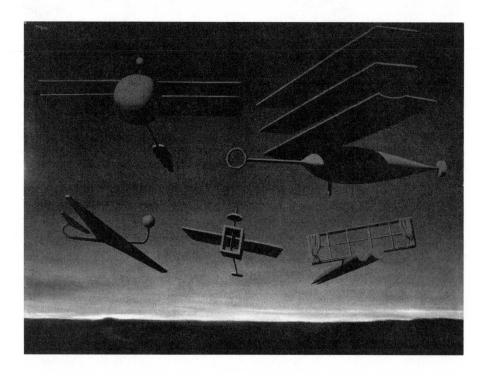

is working, in which we will try to clarify some confused ideas. Perhaps that will contribute to the success we wish for."[69]

Magritte was not above some wishful thinking. He published more tracts than most. During the early 1930s he was a leading member of the Association Révolutionnaire Culturelle (ARC), a Belgian initiative coordinated by Mesens, whose short-lived house journal was *Documents 34* and *Documents 35*. Together with the other members of the gang, Magritte put his name to a tract written by Nougé, "L'Action immédiate," in favor of revolutionary action by poetic means untrammeled by allegiance to any overweening organization or faction.[70] At the head of the article appeared Magritte's *L'Échelle du feu* (*Ladder of Fire*), "which afforded me the privilege of discovering the feeling experienced by the first men who produced a flame by rubbing together two pieces of stone. In my case from a piece of paper, an egg and a key, I caused fire to spring forth."[71]

One form of action would have been to join the party but as his sojourn in Paris had shown, Magritte was not a joiner. He was temperamentally unsuited to be a foot soldier in someone else's army. His experience of the Belgian Communist Party was not a happy one. He did eventually join, with some fanfare, in September 1945, after the liberation.[72] He felt impelled to do so, he told the like-minded Léo Malet, as a bulwark against the forces of reaction. "Reaction

is strong in France as well, it seems. We must be more than ever on our guard. It appears that the government is financing Trotskyite publications in order to foster division among the parties of the left. For my part, I have officially become a member of the Belgian C. P. to help swell the ranks of the 'intellectuals' who join up. I think we must on no account weaken the organized defence against the Fascist peril."[73]

Organized defense, or offense, extended to exhibitions. Magritte was the principal organizer of a surrealist exhibition at the Galerie des Éditions de la Boétie in Brussels, which ran from December 1945 to February 1946, embracing paintings, drawings, collages, objects, photographs, and texts. The catalog had *Le Viol* on the cover. The texts appeared on the walls like interventions or incitements, or works of art. There was another controversial admonition from Nougé, the doyen of erasure:

EXEGETES
TO SEE CLEARLY
CROSS OUT
THE WORD
SURREALISM[74]

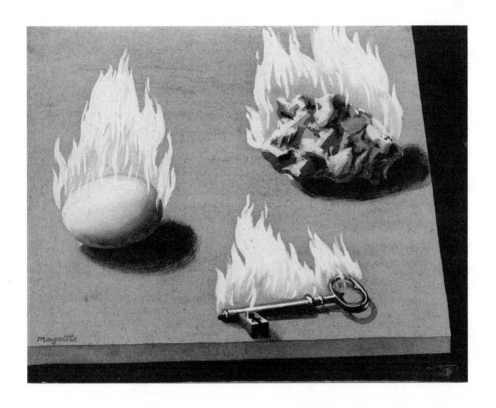

There were two contributions from Marx, the celebrated "PLUS DE CONSCIENCE!" and the second of the *Theses on Feuerbach:* "The question of whether objective truth can be attributed to human thinking is not a theoretical question but a practical question. Man must prove the truth, that is to say the reality and the power, the materiality of his thought, in practice. The dispute over the reality or the unreality of thought, separate from practice, is a purely academic question."[75] There were nuggets of Heraclitus, Lichtenberg, Lenin (the gold urinals), and Lautréamont: "All the water in the sea would not suffice to wash away one intellectual bloodstain."[76] This was not an exhibition. It was a demonstration.

Magritte continued to agitate in his own way. He was highly critical of the party for "taking advantage of artists *who are powerless to invent new feelings* and asking them to engage in political agitation. However, artists cannot go on strike, and it is obvious that political agitation on the part of artists is absurd." Yet he remained in favor of revolutionary action by poetic means. When the dissident Surréalistes-révolutionnaires posed the question "Is provocation still efficacious?," Magritte's answer was yes. "He believed in violent demonstrations. He would like the group to engage in creative activity (whose efficacity is indirect) and provocative activity (whose efficacity is direct)."[77] He practiced what he preached, contributing two paintings to a large international exhibition organized by L'Amicale des Artistes communistes de Belgique, at the Maison de la Presse communiste in Brussels, the premises of *Le Drapeau rouge.* He selected *Le Viol* and *L'Intelligence (Intelligence),* which he described as follows: "Two masked workmen are conversing under the tender gaze of the chandelier with three female heads. In the distance, factories are working in the sunshine."[78] All that is solid melts into air, as Marx might have said; all that is holy is profaned. The organizers were not amused.

Neither was Magritte. The exhibition was visited by the Queen Mother. The fawning coverage of this event in *Le Drapeau rouge* so incensed Magritte that he circulated a letter to prominent party members. It was a blistering attack.

> Dear Comrade,
> Your attention should be drawn to the danger of certain articles in *Le Drapeau rouge,* particularly those that look harmless, as for example the one entitled "The Queen's Visit," published on 22 October [1947].
> While one expects readers of *Le Drapeau rouge* to have enough critical judgement to realize that this is only a propaganda article, we cannot expect those who need to be convinced to have less freedom of mind and be taken in by it. Such clumsy propaganda will be completely ineffective.

As for worker readers, already exhausted, alas, by their stultifying labours, the sports pages are amply sufficient as their ration of "the opium of the people." It is harmful to sow confusion in their minds with articles like the one about the Queen's visit, in which communist artists and fla-neurs are ranged in a semi-circle, and excellent free publicity is given to a particular make of motor car. Such insanity will not give workers a feeling for the seriousness of the struggle in progress when their paper presents an enemy of communism as a delightful person to be honoured in the Party with obsequiousness and love.

On the contrary, it would have been more to the point to use the Queen's visit for definite propaganda purposes by making it clear, with all due propriety, that it was the Queen who had the honour of meeting the Party, and not the Party which had the signal honour of receiving that old whore.[79]

Exhibitions continued to be a bone of contention. In 1950, Magritte submitted a painting for *L'Art et la paix*, under the aegis of the party. The selection meeting was a bear pit. Mariën left an account of the proceedings:

I remember in the fifties, a Communist Party meeting, attended by a score of painters and some political leaders. The aim was to vet pictures intended for an exhibition organized under the aegis of Picasso's dove, flying to and fro in the skies of the Cold War. Among the obligatory daubs, miners' heads, dockers in a mist, working-class interiors, May Day parades, one canvas, and one alone, dominated the scene, Magritte's contribution, which showed a rifle in a room, leaning against the wall, with thick blood running down from the barrel to the butt, making a red pool on the floor [color plate 37].

And so, after a quick glance at each work, all the time was taken up with fierce criticism of Magritte's picture, so that after two hours of ster-ile argument Magritte, Nougé . . . , and myself could only point out how effective *The Survivor* was . . . since of all of them it was the only one to divide opinion and stimulate passionate commentary.[80]

Magritte had had his fill of the party. Disillusion set in early, as he explained to Waldberg:

Nougé and I thought that we would be able to influence the artistic and cultural tendencies of the Party, from within, in a direction more in keeping with our fundamental aspirations. We therefore attended the

meetings of a section specializing in problems relating to Fine Arts and Literature. I was very quickly disillusioned. At the first meeting, a delegate from the Central Committee came to admonish us, with the help of a few "materialist" notions from night school. He saw fit to remind us, delicately, "Never forget that, first and foremost, you are nothing but *fodder*!" The following sessions were hardly more encouraging. We were dealing with the deaf. I was asked to submit one or two proposals for posters. They were all rejected. Conformism was as blatant in this milieu as in the most narrow-minded sections of the bourgeoisie. After a few months I stopped attending, and from then on I had no further connection with the Party. There was no exclusion or break, but, on my part, complete disaffection and permanent estrangement.[81]

Magritte was a maverick. His weapon of choice was the paintbrush. If bourgeois order was nothing but disorder, then it could be subverted, that is, reimagined. "Rejection of the existing order, the desire to cause the ruin of current values or to bring in new ones, the essential subversive intent must make use of every means, whatever the circumstances." This was Nougé's call to arms, founded on Magritte's painting. Magritte, like Nietszche, was a revaluer of all values. Nougé explains:

> Painting must invent images . . . that it is important to test *on the naked eye*. Thus Magritte painting *Les Trois Prêtres* and *La Vierge retroussée* [the nun with her skirts hitched up]. Scandal is devoted to similar ventures. And we are within our rights to demand enough freedom for the painter with regard to his painting that he does not value paintings like these any less than all his other canvases. He completely rejects the hierarchy proposed to him by aesthetes and amateurs. For he knows what that hides, where it leads, in sum, that it is nothing but a cunning ruse by a class who refuse to die. He knows that of all the images that he manages to present to the world, from the roughest to the most refined, the revolutionary spirit that animates them confers a sufficient and equal dignity. Such a sentiment lets us live.[82]

That is what moved Magritte.

That is not the only thing that moved Magritte. According to Marcel Mariën, while he was in London he experienced a kind of coup de foudre. In his autobiography Mariën recounts how, much to his surprise, he was taken into Magritte's confidence one evening in 1938, as they sat by the fire in the apartment in rue Esseghem. It was a Saturday, and Georgette was out.

Magritte told me point-blank of his passion for a young Englishwoman whom he had met on his recent trips to London. I soon gathered—at least this was Scutenaire's view—that this was the model, dressed by Dalí, who had opened the first International Surrealist Exhibition in London [in 1936]. A celebrated photograph showed her among the pigeons in Trafalgar Square, her head completely disguised by a bouquet of roses.

By his own accounts, she was the ideal partner, the one we look for and despair of finding, and he would not have hesitated to join her, had it not been for Georgette, whom he could not abandon. Naturally, I kept quiet, stunned by such a revelation, and besides I had no opinion to offer, even if there had been an opportunity. That is how things stood, and Magritte never reverted to the issue.[83]

The young Englishwoman was Sheila Legge (1911–49), who did indeed appear as the "Surrealist Phantom of Sex Appeal" in Trafalgar Square, on June 11, 1936, to herald the opening of the International Surrealist Exhibition. She was as beautiful as she was accomplished. She had been a member of the organizing committee of the exhibition; she had a "Surrealist Object" in it; and she had written a kind of performance piece, "Statement by the Phantom," for the occasion:

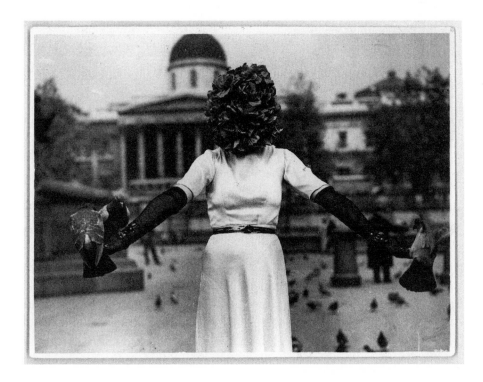

Laughter being very often embarrassment's censorship of emotion expressing the inexpressible, to increase our knowledge of humanity / Surrealists practice unreason . . . / Surrealism is not a practical joke . . . / Its aim is to transform the reality we all know and to create a new, *super*-reality . . . / Things that surround us suddenly possess infinite possibilities and a woman's glove becomes the answer to every riddle . . . / Meret Oppenheim's *My Nurse*, a white pair of shoes tied together with string. "Their meaning" is in their disconcerting effect, in their power to transport the spectator on a different plane where everything is possible and the apparently incongruous title *My Nurse* corresponds to them perfectly. / To such a plane belongs the "Phantom of Sex Appeal," her face *revealed* by red roses, the apparition who stretched out her hands to the pigeons in Trafalgar Square and annihilated reality.[84]

The statement reveals her sophistication (and self-awareness); by accident or design, there is an echo of Nougé's "Everything is still possible." Nor was this her only surrealist writing. "I Have Done My Best For You" appeared in distinguished company in *Contemporary Poetry and Prose* later that same year. Its beginning and end might have appealed to Magritte. "And there appeared unto me a woman with chains upon her wrists, riding on a bicycle; and in her hand a banner bearing these words: THERE ARE NO MORE WHORES IN BABYLON. . . . And on the third day I rose again and sold my wife for thirty pieces of camembert and my infant daughter for three francs fifty."[85]

Sheila Legge was more than a model. She was an intellectual. David Gascoyne was vastly impressed that she was fluent in French and "able to read Raymond Roussel in the original."[86] She was also a paid-up member of *"le groupe surréaliste anglais."* She knew everybody. Inevitably, she knew Mesens, well enough for him to have some hopes of snaffling her as secretary and *vendeuse* for the London Gallery, which would no doubt have boosted sales, but she was not interested. Given his usual modus operandi and propensity to pounce— and the evidence of a defaced picture postcard bearing the suggestive legend "Mesens se jette pour Sheila" (Mesens throws himself at Sheila)—it appears that Mesens had ulterior motives.[87] Certainly he was very taken with her. So were they all. Her name has been linked with David Gascoyne, Roland Penrose, and Roger Roughton, among others, without much foundation. Mesens himself liked to tell the story that one of the British surrealists asked if he could borrow his hotel room for the afternoon, while the International Surrealist Exhibition was on, for a tryst with Mrs. Legge; Mesens cordially agreed,

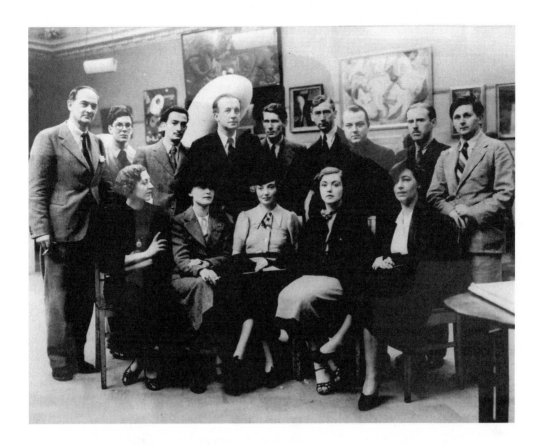

on the condition that the surrealist first wash his feet, for he had a low opinion of *les valeurs personnelles* of the British.[88] "Mrs. Legge" was the usage on which she insisted, though it was in some ways a polite fiction. Soon after she married Rupert Legge (in 1934) she separated from him and went to Paris in the hope of becoming a model for Man Ray. According to Gascoyne, Man Ray found her "not quite his type." Nonetheless he made a striking portrait sketch of her in London.[89]

Mrs. Legge was nothing if not game. It is as if she was seeking something: fulfillment, perhaps. She was avid, fascinating, spirited, sensual. She turned up at an opening at the London Gallery wearing a fashionable knee-length skirt, hitched up to reveal a naked leg with painted designs up her thigh—*La Vierge retroussée* made flesh. Was this Magritte's ideal? They could have discussed Raymond Roussel, author of the surrealist sourcebook *Impressions d'Afrique* (1910) and one of his favorite authors. Thirty years on, when Foucault proposed a resemblance between Magritte's thought and that of Roussel, Magritte replied, "I'm pleased that you recognize a resemblance between

Roussel and whatever is worthwhile in my own thought. What he imagines evokes nothing imaginary, it evokes the reality of the world that experience and reason treat in a confused manner."[90]

If Magritte was smitten with Sheila Legge, it is easy to see why. There is no reason to disbelieve Mariën's account; David Sylvester evidently heard much the same from others (probably the Scutenaires) while he was at work on the *catalogue raisonné*. What followed from this gust of emotional turbulence is another matter. Did he declare himself? What was the response? Were his feelings reciprocated? Did anything happen?

In the nature of the case, it is impossible to rule out a brief liaison of some sort—a fling—but there is nothing solid to support it, and a good deal of circumstantial evidence on the other side. The boldest claim for a full-blown affair, with all the trimmings, was made by George Melly. Melly was not a direct witness; he arrived on the scene after the war. As factotum to Mesens, and later his devoted friend, he was undoubtedly well informed; but his information depended crucially on Mesens's drunken confidences. His own account is picturesque but patchy, and unreliable in detail. On this issue, he had no information at all from Mesens, as he made clear:

> There was one incident in Magritte's life of which E. L. T. must have known, but never discussed with me or even hinted at. On one of the painter's pre-war visits to London under Edouard's aegis, he had a serious affair with a Mrs Sheila Legg[e], a beautiful surrealist groupie, and this one traumatic lapse in what was otherwise a completely uxorious relationship actually put his marriage at risk for some years. As a rule, Mesens (who was on the spot and feverishly interested in everybody's sex life) was far from discreet, but on this occasion, he remained silent as a confessor.[91]

The "serious affair" is pure speculation. Likewise the fallout. Melly also speculated about the reason for Mesens's silence. He considered the possibility that Mesens was in some manner complicit, and feared that he would be blamed by Georgette—the panderer threatened—but Melly was more inclined to think that Magritte as victim of *l'amour fou* contradicted Mesens's image of him (or the image Mesens wanted to convey) as a model petit bourgeois whose audacity was all in the mind. That was precisely the image Mesens purveyed in his late interviews with Melly. As an appraisal of his old comrade, it was not devoid of affection, but it was also tinged with a certain condescension, as if he knew life and Magritte did not. It was in effect the final round

of their peevish altercation. E.L.T. always liked to have the last word. "And he lived with his wife a conventional life in which he was charming with her, full of dainty little attentions which the bourgeois reserve sometimes for their wives. The love of his dog also."[92]

A simpler explanation is that there was nothing to tell. Furthermore, all this speculation tends to ignore the other party, who had a mind of her own. Sheila Legge was mettlesome enough to make choices that might have daunted many others. She was not interested in working for Mesens. She was not interested in Mesens at all, it seems. Was she interested in Magritte? There is no sign of it. The only opportunity they had for a serious affair was the period Magritte spent at 35 Wimpole Street in 1937. For Sheila, "1937 was so depressing . . . ," as she wrote to Gascoyne in 1945, now remarried, after further peregrinations in France and elsewhere.[93] For his part, Magritte wrote to Georgette every day. Of course there may have been things he did not say, but there is no indication in those letters of anything amiss, other than his congenital dislocation. There is also the question of disposition, or availability. Magritte worked most of the time, on his commission, and also on a talk at the London Gallery; for the rest, he was usually chaperoned, by Mesens, or James, or Jennings, or other members of their circle who were deputed to look after him. He could easily have extended his stay, either to perfect the three panels or to work on James's portrait, yet he chose not to do so. On the contrary, he was exercised throughout about the need to minimize the time he spent away from home, not only for Georgette's sake, but also his own; he even returned to Brussels for five days partway through. And he encouraged Georgette to visit him in London, accompanied by the Scutenaires and Colinet, which she did.

It is tempting to say that Magritte had a more meaningful relationship with Edward James than he did with Sheila Legge. The original commission was a real bond, reinforced by the commission of a portrait, which became intimately bound up with a self-portrait. When Magritte mooted the idea of regularizing the relationship, in 1938, asking for an annual stipend of £100, his pitch rested on the assumption that they understood each other as fellow surrealists, just as they had in the matter of the red model and the capitalist heels. As Magritte put it to him,

[Y]ou, along with a few rare men of whom I am one, are a singular society. For us, money is only a means in current use, and nothing more. It so happens that by chance you have more than you need and I don't have enough. It would be perfectly fitting and "above board" for you to

provide me with some, from time to time, as you had begun to do. For my part, I produce objects that are extremely important, whatever the general stupidity may think.[94]

But he had misjudged. His approach was naive; he was reproved for his presumption. Magritte was shocked at the response. James was a rentier after all.

More broadly, Melly was right about the uxoriousness. After his wanton youth, Magritte slipped into a kind of routine, of which marriage was an essential part. Marriage to Georgette was something akin to an insufferable ideal. Magritte would set down tools and dash to the brothel—if Mesens is to be believed—but he did not play the field. There are no stories of the mature Magritte as a womaniser, like his father.

If he chased Sheila Legge, it was most uncharacteristic. On the whole, it seems improbable, despite her charms. Falling for the Phantom would have been quite enough to discomfit Magritte, and to upset Georgette, if she got wind of it. The story he told Mariën as they sat by the fireside was not exactly a love story, still less a love affair. It was a parable of the unattainable.

In *The Will to Power*, a few pages after Raphael's overheated sexual system, there is another marvelous passage on artists and passion. It is a passage Magritte surely knew, but may not have liked so much. "Artists are *not* men of great passion," Nietzsche insists, "whatever they try to tell us and themselves. And that's for two reasons: they lack shame towards themselves (they watch themselves *living;* they spy on themselves, they are too curious) . . . But secondly: (1) their vampire, their talent, usually begrudges them that squandering of force which is passion (2) their artists' *miserliness* shelters them from passion."[95]

Magritte spied on himself. His vampire called him home.

9.

The True and the False

There was, however, a serious affair in the Magritte marriage. It was conducted by Georgette. She had a relationship with Paul Colinet, one of Magritte's closest friends. It was serious enough for Georgette to ask Magritte for a divorce, which he flatly refused to consider. Thereafter it was a taboo subject, a little like his mother's suicide.

It is said to have begun while Magritte was in London in 1937. It may have continued for several years, at least episodically; it may have been suspended for a period in 1938–39, only to resume in 1940. No one knows exactly how long it lasted. There are no clues, as Magritte was fond of saying, in the documentary evidence. Georgette's letters are full of references to socializing with Colinet, usually in the company of the Scutenaires, all very natural. As often as not, they went to the cinema.[1] In the late 1930s Colinet is still to be seen in their photographs, clowning with Georgette and the others, as if nothing had happened. According to Jacqueline Nonkels, it petered out soon after the war. According to Marcel Mariën, it was over by 1941. According to Jacques Wergifosse, another young acolyte-accomplice who arrived on the scene in 1944 and was swiftly taken into Magritte's confidence, there were in effect two rounds, in 1937 and 1940.[2]

Magritte seems to have found out sometime in 1938. It is clear that he regarded it as a betrayal by one of his accomplices. The discovery brought their collaboration to an abrupt end. Unsurprisingly, Colinet was no longer welcome in his house. Magritte began to spy on his wife as well as himself. Georgette adhered to a fixed routine, in all things; the affair was conducted accordingly. At certain times, on certain afternoons, she would set out for the rendezvous, accompanied by Jacqueline Nonkels, who would wait for

her in a nearby café. On one occasion they were tailed by Magritte, who had summoned a policeman—an excruciating embarrassment for all concerned. Was Magritte reminded of his favorite hard-boiled detective novels? Dashiell Hammett's *The Glass Key*, perhaps, described by Raymond Chandler as "the record of a man's devotion to a friend." Or, later, Leo Malet's *La Vie est dégueulasse* (*Life Is Lousy*), oozing with low-life charm and menace. Magritte was enchanted by the bandit's last gasp: "Shoot me in the balls!"[3]

The estrangement between Magritte and Colinet endured for some twelve years. There is an intermission in their correspondence between 1938 and 1950, at which point they resumed their friendship, if anything more complicitous than before. "Years later, Magritte and Colinet again became the best of friends," remembered Mariën, "and when the latter was suffering from the terrible cancer that was to carry him off [in 1957], Magritte was extremely solicitous."[4]

The affair was the cause of carefully muffled domestic strife. According to Wergifosse, Magritte's continuing devotion to prostitutes was in part a kind of revenge on Georgette. In the 1940s and '50s, apparently, this activity was

financed by sales of books from his library, a covert operation undertaken by Wergifosse himself, at Magritte's behest. Wergifosse also intimates that Magritte's periodic lassitude, his *désolant ennui*, was exacerbated by problems of "virility," for which he tried the quack remedy of rubbing his left wrist with a potion that was supposed to revitalize his performance. It is just conceivable that this had some brief psychological effect; Wergifosse records drily that the effect did not last. In the home, it seems, virility remained a problem. In the brothel, the problem disappeared.[5]

It has been suggested that Magritte was taken aback, not by the affair, but by the serious turn it took. On this account, he was first of all complaisant—a Machiavellian interpretation would be that he wished to clear his way or his conscience for Sheila Legge—and even encouraged Colinet (and Georgette) on such a course. David Sylvester goes as far as to say that "he virtually wished on her" an affair, on the strength of a passage in one of his letters from Wimpole Street: "I want you to do wherever possible whatever you can to make my absence less distressing to my wife. I thank you in advance and send you my regards 'bibitals.'"[6] Such an interpretation seems to endow Magritte with more worldliness or deviousness than he possessed. The letter in question was in the nature of a round robin, typed by Edward James's secretary, in English, and full of the usual in-jokes ("canon bibital, etc"); it was sent not only to Colinet but also to Scutenaire and Hamoir. It is reminiscent of his letter to Flouquet, some years before, when he was away on military service. ("Dear Pierre, will you look after her if she needs you.") That was how he enlisted his friends in absentia. Another letter addressed to Colinet alone appears to show that, roughly halfway through his sojourn in London, he suspected nothing and insinuated nothing. He was hoping that Colinet could explain to Georgette the significance of the commission, which meant that he had to take great care with the work, and the sponsor, all of which took time. "Try as far as you can to make my wife understand that my situation is difficult, and delicate," he urged, "but that soon I shall fly to her."[7]

Complaisance, moreover, does not square with a rather different letter that Magritte wrote to Colinet after he discovered what was afoot. Described by Mariën as "a masterpiece of revenge," this letter gave his friend detailed instructions on how to pleasure his wife. Piquantly, after Colinet's death, letters in his possession were returned to the sender. The masterpiece was returned to Magritte. In the circumstances, others might have been tempted to destroy it, or at least to keep it under lock and key. Magritte gave it to Scutenaire, who was delighted with it. It was exactly the kind of gesture they relished.[8] Ten years later, there was another gesture, equally crude. In 1948

Magritte had the time of his life with a burst of anarchic, caricatural painting known as his *vache* period. One of his sketches shows a sow being serviced by a winged phallus. Inscribed on the phallus is the name Colinet.[9]

Paul Colinet (1898–1957) was another maverick civil servant. Ironically, he was employed in the Registry of Births, Marriages, and Deaths. After the war he lost his job, on suspicion of collaboration, because he had continued to go to work during the Occupation. Colinet sued and won. In the process he gained his freedom. He was retired at fifty, in 1948, on a full pension. Thus he had more time for Magritte, and for his own idiosyncratic oeuvre. As Nougé progressively withdrew from the fray, Colinet became an increasingly important sounding board and source of ideas. He was also a source of fun—a recommendation for Magritte and Georgette alike. Colinet was a comedian. He had an almost instinctive understanding of Magritte's sense of humor: he nurtured that too. He had an ear for poetry and an eye for the absurd. Scutenaire christened him "the Don Juan of words."[10] Colinet was a surrealist by proxy. He was more truly a humorist, in the tradition of Lewis Carroll's nonsense rhymes or Ogden Nash's "verse and worse." Silent comedy was music to his ears. There was something of Buster Keaton's impassivity about him, the great stone face set against the dealings of arbitrary fate. He never smiled, but he got laughs. Mariën remembered him lying on his back in his office, waving his legs in the air like Kafka's cockroach, while talking on the phone to his superior. The next minute he would be solemnly reciting Sully Prudhomme's poem "Le Vase brisé." His sensibility appealed strongly to *la bande à Magritte*. Colinet was an invaluable recruit.

He joined the gang in 1933. He did not play a public role in group activities or collective action, but he was soon part of Magritte's magic circle. At once he began to contribute ideas for paintings, usually in the form of sketches rather than scenarios. Magritte would pose a problem, and seek solutions, or treatments:

> The subject of my next picture is *the moon*. It's a question of finding something that really gives us a sense that we're on a round earth. Though it illuminates a scene, the moon shouldn't be on the level of an indifferent spectator, doing nothing but "holding a candle," or simply being picturesque. A moon trap, an incantation, a moon mirror, give a rough idea of suitable lines to pursue.
>
> Would you be kind enough to make a start in your spare moments.[11]

Colinet had the idea for *La Réponse imprévue* (*The Unexpected Answer*, 1933), the misshapen hole in the door; *La Reconnaissance infinie* (*Recon-*

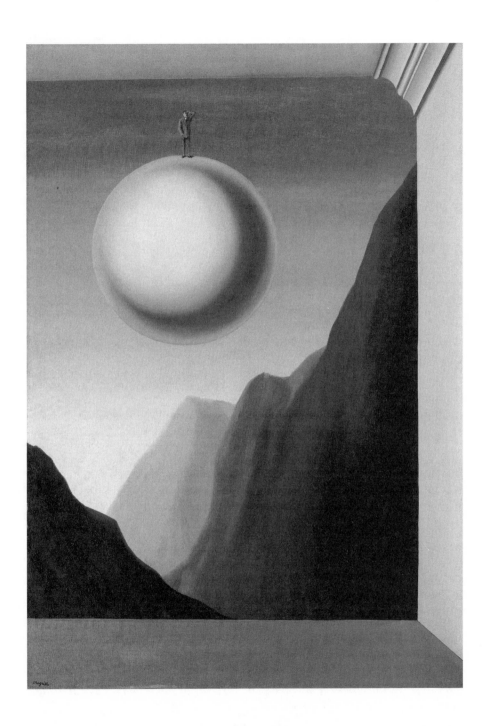

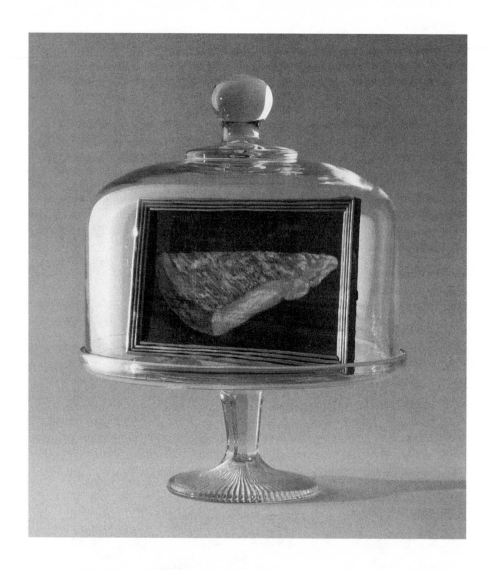

naissance *Without End,* 1933), a sphere floating in space, with a tiny figure on top; *Ceci est un morceau de fromage* (1936), a painting of a wedge of Brie, under a cheese dome; and *Le Principe de plaisir* (*The Pleasure Principle,* 1937), a portrait of Edward James, his head a kind of starburst. He found the titles for *La Jeunesse illustrée, La Thérapeute* (*The Healer*), *Le Chant de la violette* (*The Song of the Violet*), *Les Verres fumés* (*Smoked Glasses*), *La Chambre d'écoute* (*The Listening-Room*), *Le Dimanche des oiseaux* (*Bird Sunday*), *Les Origines du langage* (*The Origins of Language*), *Les Fanatiques* (*The Fanatics*), *La Leçon de politesse* (*Lesson in Politeness*), *La Fontaine de jouvence* (*The Fountain of Youth*), and more. He contributed to *La Vitrine du posticheur* (*The Wigmaker's Shop Window*), a project for an illustrated detec-

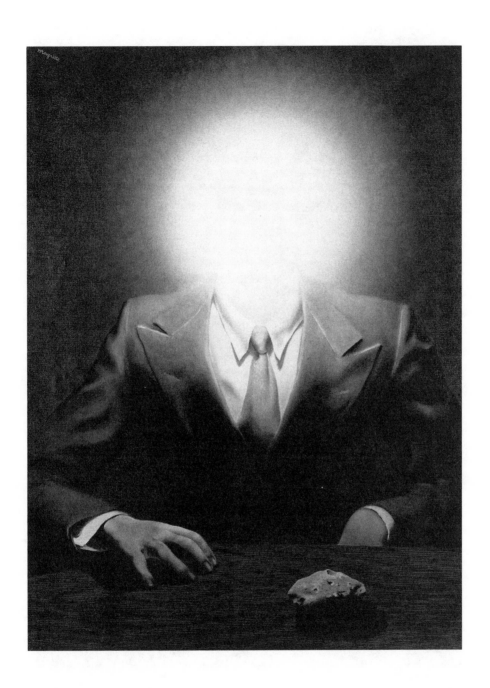

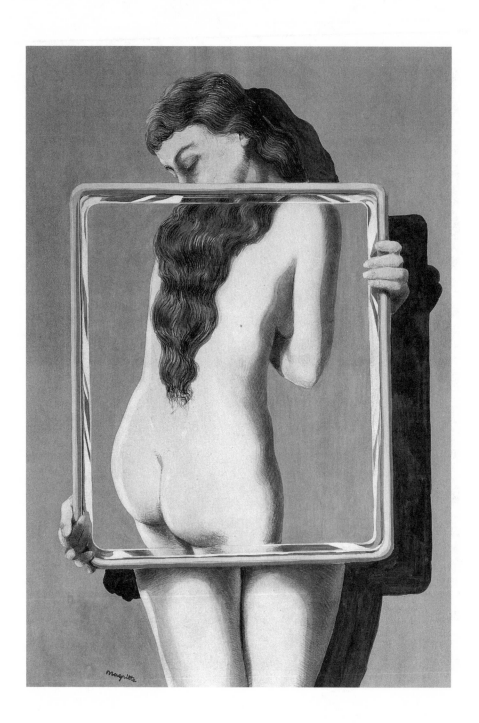

tive novel, with Lecomte and Magritte. He and Magritte exchanged erotic short stories, or drafts, in 1933; Colinet's have some affinities with Magritte's *Les Liaisons dangereuses* (*Dangerous Connections*, 1935), an astonishing representation of the fleshly form, the mirror image, and the look of desire, in which a naked woman holds in her hands her own image, her own body, as she simultaneously averts her gaze and asserts her self.[12] Later on, Colinet was invited to dream up scenarios for Magritte's home movies, in which he also starred. His first publication was the setting of one of his poems to music by Paul Magritte, "Marie Trombone Chapeau Buse" (1936). That same year he acquired two Magrittes, *La Vengeance* and *L'Illumination*, both new works.

After they resumed their collaboration, in the 1950s, Magritte encouraged him to suggest titles *prospectively*, as ideas for paintings. Sometimes these came out of the blue (*The Arrest of Sherlock Holmes*); sometimes they responded to indications from Magritte, as for example something on the theme of assets, or a hat for several people. Certain works developed in dialogue. "I'm planning to paint a picture based on the idea in the drawing of a hen in front of a boiled egg," Magritte informed him in 1957. "Solar and nocturnal variants are possible. If you have a moment of respite from your Carmelite studies, these are the problems to study and the titles to indicate." Colinet suggested *Le Jeu de mots* (*The Word Game*) for this image, which Magritte thought excellent. Once he had completed the picture, however, the hunt for a title began afresh. It was eventually baptized *Variante de la tristesse* (*A Variation on Sadness*).[13]

Creatively, Magritte was in the doldrums in that period, and counted on these relationships with friends when he needed inspiration. He said as much to both Colinet and Torczyner: "Allow me to inform you of my complete vacuity: I'm short of ideas for painting; I found a very apt phrase in the artistic domain, 'He was proud of living on bread and butter.' I hardly need tell you that's not enough."[14] By way of feeding his imagination, Colinet would report things he saw and heard, or possibly invented and embroidered. In the window of a dry cleaner's, he saw a stuffed Pomeranian, with a label bearing the instruction "DRY CLEAN." In a pharmacy, he overheard an exchange between the pharmacist and an old man in a black cloak with an astrakhan collar, wearing the ribbon of the Legion of Honor, who was leaning heavily on an ebony cane with a silver handle, clutching a urine sample. The old man asked if the pharmacist could test his urine. Certainly, said the pharmacist. The old man wanted to know if this service was free of charge. The pharmacist told him that it would be 15 francs. The old man proceeded to explain that he only wanted to know if the urine contained albumin—just that, nothing else—in which case perhaps the test would be free of charge, after all. The

pharmacist politely but firmly reiterated that the charge was 15 francs. The old man took his urine sample elsewhere.[15]

Magritte often engaged Colinet as wordsmith. Like Nougé before him, Colinet was called upon to polish draft letters, and to work up short texts from the germ of an idea, for publication in their little magazines. "Here are a couple of sentences which will perhaps serve as a point of departure for the drafting of a short text," Magritte would write. "Coming out of a kindergarten, a young thinker stands out among his little classmates; he wears a red jacket and blue shorts. A historian leads these children on an introductory. Of course, this is still very rudimentary. There are two words to hang on to: thinker (young) and historian."[16] Like Nougé, Colinet recommended things to read. In 1957 he raved about Borges's *Other Inquisitions*. Magritte was unimpressed. He thought Borges "a trained idiot," who tossed out a profusion of ideas, none of which stuck. "I'm an ungrateful reader," he acknowledged, "and that annoys me, because it makes me look snooty."[17]

It would be no surprise if Colinet's reports or Colinet's texts inspired one of the best stories ever told about Magritte:

> Magritte goes into a grocer's shop near his home to buy some Dutch cheese. The shopkeeper bends over her window display to pick up a round cheese that has already been sliced, but is stopped almost immediately by the painter:
>
> "No, madame. Not that one. Give me some of that one instead."
>
> And he points to a second cheese, also sliced, on a shelf, a little to one side.
>
> "But it's the same cheese!" exclaims the shopkeeper.
>
> "No, madame," Magritte objects once again. "The one in the window has been looked at all day by passers-by."[18]

As for his marriage, it was severely tested in the debacle of 1940. There was nothing inevitable about René and Georgette Magritte and their dog after the war.

The sky fell on May 10, 1940. The German armies overran Luxembourg, slashed through the Ardennes, cuffed the British, French, and Belgian forces into the pocket of Dunkirk, abandoned them to their fate, overwhelmed General Gamelin, imposed an armistice on Marshal Pétain, occupied Paris, and staged a victory parade for the Führer on the Champs-Élysées. Hitler had accomplished in seven weeks what the Germans had dreamed of for seventy years. The French counted 124,000 dead, 200,000 wounded, a field force shattered, and a people humiliated. Rarely has a major power been so cruelly

exposed. Churchill dignified it as the Battle of France. For the Germans it was a walkover. For the French it was not so much a military defeat as a national catastrophe. France had been eviscerated.

The Battle of Belgium was the prelude to that calamitous sequence of events. It lasted precisely eighteen days. The Belgian army surrendered on May 28. By then, Belgium was already a sideshow. Four more years of occupation duly followed.

Magritte feared for his safety. He was aware that he was known as an antifascist. In 1938 he had offered *In Memoriam Mack Sennett* for a sale organized by Achille Chavée, to benefit members of the International Brigade in the Spanish Civil War. In 1939, as part of his show at the Palais des Beaux-Arts, he had exhibited a montage of photographs of the carpet bombing of Granollers, near Barcelona, by the Italian air force. The photographs were accompanied by an epitaph from Nougé:

> *You here*
> *with a full stomach*
> *in Spain, in China*
> *workers*
> *with an open stomach.*[19]

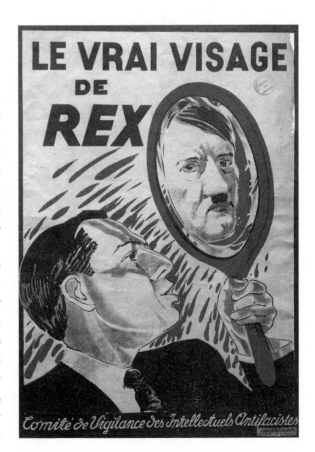

Magritte had called Hitler a pain in the arse. His poster for the Comité de Vigilance des Intellectuels Antifascistes depicted the face of Léon Degrelle, leader of the far-right Rexist Party and later a member of the Waffen-SS, reflected as Hitler in the mirror— "The True Face of Rex."

Magritte also feared that he might be called up once again. The word was that all men under the age of forty-five were to rejoin their regiments. Magritte was forty-one. He had no intention of doing any more military service. He had to flee. On May 15, five days after the German invasion, he left Brussels for France.

Georgette remained behind. Magritte explained to Edward James and Roland Penrose, "Unfortunately I had to leave my wife in Brussels, because she was recovering from appendicitis and could not undertake such a difficult journey."[20] That was a lie. In truth she would not be separated from her sister or her lover. Léontine was her protector, her comforter, her rock, and Léontine was staying put. Colinet, too, saw no reason to quit the capital. Georgette refused to leave. Magritte refused to stay. So they parted.

Keeping up appearances, Georgette, Léontine, and Pierre Hoyez-Berger came to see him off. At the station he discovered that the trains were no longer running. In the melee he bumped into the Scutenaires and the Ubacs, who were also taking flight. (Hamoir's militant past as a member of the Femmes Prévoyantes and the Jeunes Gardes Socialistes also gave cause for concern.) They decided to stick together.

They joined that combination of forced migration and mass flight known as the Exodus. In between arrests as a suspicious alien, Arthur Koestler logged the loss of hope.

> The onslaught on the railway stations. The disappearance of the buses and taxis. The melting away of the town, as if infected with consumption. The tommy-guns of the flics at the street corners. The peculiar glance of the people in the Underground, with the dim candles of fear lit behind their eyeballs. The parachutist scare. The Fifth Column psychosis. The last roundup—and the long-expected, dreaded ring at the door-bell one morning at seven o'clock.[21]

Magritte and the others caught a tram to Enghien, a small town on the way to France. Just outside the town they found that the tramlines had been ripped up by the German bombardment. They set off down the road, suitcases in hand. A truck driver gave them a lift as far as Tournai, near the border. From there they made their way by taxi and on foot to Lille, where they boarded a train for Paris. Throughout this part of the journey, Scutenaire recalled, Magritte showed no fear,

> but rather a jumpiness, a forced cheerfulness, an exaggeration of his characteristic traits: impatience, a taste for organization, a love of change, and a need for stimulation. I can still see him, stopping every three or four kilometres at the door of a farmhouse, to buy a couple of eggs which he swallowed somehow in front of the farm woman, teasing and joking with her, and saying to her and to us (if he said it once he said

it a hundred times): "I'm doing what racing cyclists do, swallowing raw eggs to keep their strength up."[22]

In Paris they split up. Magritte paid a quick visit to Claude Spaak at his country house in Choisel, nearby. Short of money, he wanted to reclaim one of his paintings, in order to sell it to Peggy Guggenheim, who was rumored to be buying works of art before leaving for the United States. Spaak gave him *La Voix des airs* (*The Voice of the Air*). Magritte undertook to replace it, in the fullness of time; he was as good as his word. Returning to Paris, he somehow tracked down Peggy Guggenheim at Lefebvre-Foinet, the framer. When he appeared with the picture under his arm, she had no idea that he had come there expressly to see her. She bought it on the spot, paying cash. Magritte later recorded that "it was sold to Madame Guggenheim, at the time of my exodus to Paris, a few hours before the Occupation in 1940."[23] That was to dramatize a little. In fact the Germans did not take Paris until June 14. Magritte was installed in Carcassonne, in the south, by May 23.

Carcassonne was the home of the writer Joë Bousquet, a bedridden war veteran who owned two or three Magrittes. His house became a destination of choice for the displaced cultural élite: Breton, Éluard, Gide, Paulhan, all passed through. Here Magritte found shelter. Bousquet seems to have thought well of him—"a good man"—or taken pity on him. A few years later, the writer narrowly escaped with his life, after his bed caught fire: "for a moment, I lived in a Magritte."[24] They remained on good terms until the 1950s, when it emerged that Bousquet had been putting it about that, in desperation, Magritte had petitioned not only the princess of Piedmont (who was born in Ostend), but also Marshal Pétain, the bête noire of any self-respecting antifascist. Magritte told the Scutenaires at the time that he was writing to anyone who might be able to help him obtain a laissez-passer to return to Belgium—even the princess of Piedmont—but he categorically denied any dealings with Pétain.[25]

He was certainly desperate. Lines of communication between France and Belgium were not restored until late June. Magritte had to rely on intermediaries to get word to Georgette. He had written to James and Penrose with that in mind. "As you can well imagine, I'm in rather a low state. I feel very isolated, and were it not for the hope of seeing Georgette again some day, I couldn't go on living. That dominates everything now, for me, and if you have some means of letting her know that I'm in good health, I'd be greatly encouraged." James wrote to her from New York in mid-June, and told her that Magritte was safe and well, in Carcassonne, and "devastated to be separated from you at such a time."[26] Georgette remained silent. Over a month later, after the mail

was getting through, Magritte had heard nothing from her. "What goes by the name of love is banishment," says Beckett, "with now and then a postcard from the homeland."[27] There was no postcard for René Magritte.

Spent, he set about reconstituting a circle in exile. After moving out of Bousquet's house into a hotel ("too luxurious for my worse than slender means"), he wrote to the Scutenaires in Saint-Loubes, near Bordeaux. He told them that the Ubacs had just arrived in Carcassonne; they had run into trouble with the authorities. Magritte himself was pondering an invitation from Spaak to come and stay. "I replied asking for more details, because I'm not sure what to do, or whether objective or subjective chance will decree that I should go there. At any rate I'm here in Carcassonne for some time. I wish I could drop dead very soon." Gallows humor had not entirely deserted him: "objective chance" was one of Breton's key concepts. A few days later, he decided not to accept Spaak's invitation. Instead he would try to find something to rent in Carcassonne, with other castaways. "Family life (I'm a good cook) will be no dearer here than anywhere else." At this stage he clearly envisaged a long exile. He was still extremely anxious. "For myself, I'm waiting to hear from various people I've written to. I'm alone, without Georgette, and I have a feeling that I've found the spot I should cling to in order to survive and meet up with her again one day (like a human wreck, according to a fortune-teller, who assures me that I'll see her again)." Very soon he found what he was looking for. "Come quickly. I've rented an empty house. We can live in it together, with the Ubacs."[28]

The Scutenaires responded immediately to his call. After the war Hamoir wrote a brief account of their wanderings:

> Toulouse, Carcassonne; Magritte and the Ubacs were waiting for us at the station. We bought mattresses and provisions, and settled in as best we could. We heard Marshal Pétain's shaky voice on the radio, but also that of the vigorous General de Gaulle. . . .
>
> After two or three weeks in Carcassonne, Magritte, who was itching to get back to Brussels, but who couldn't manage it, because of the lack of any normal means of transport (there was also the problem of the "demarcation line" dividing occupied France from the "free" zones), announced to his friends that he was going to try to make the journey by bicycle and would hire one for this purpose. He did as he said: he hired a bicycle, bought a dozen eggs at the grocer's to live on during the dangerous adventure, and set off one chilly morning, after some outpourings of emotion amounting almost to a dramatic farewell, at least on his side. His companions for their part were sure that they would see him

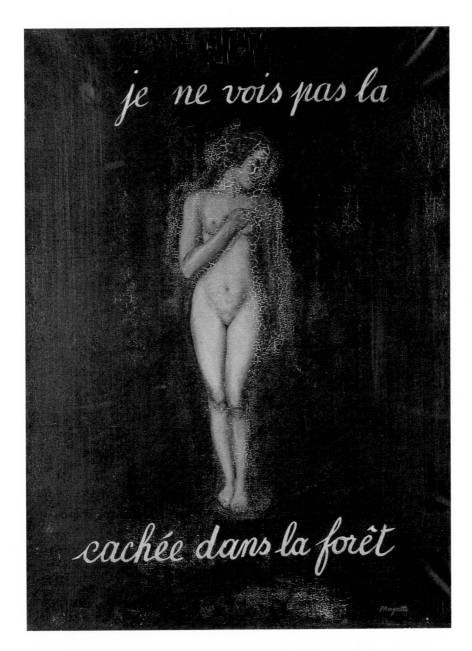

26. *La Femme cachée* (1929)

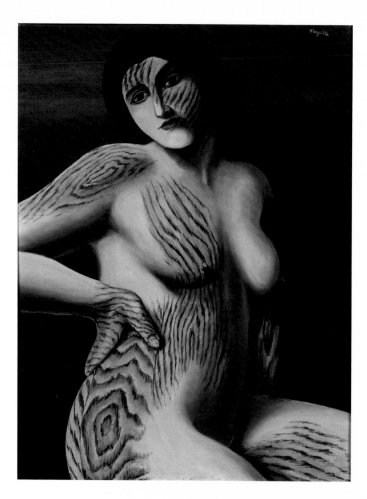

(LEFT)
27. *Découverte* (1927)

(BELOW)
28. *Jeune Fille mangeant un oiseau (Le Plaisir)* (1927)

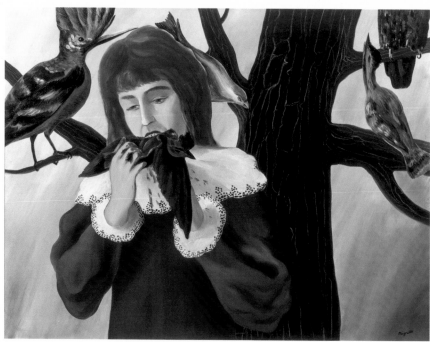

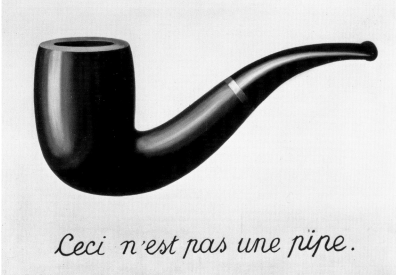

(RIGHT)

29. *La Trahison des images* (1929)

(BELOW)

30. *L'Annonciation* (1930)

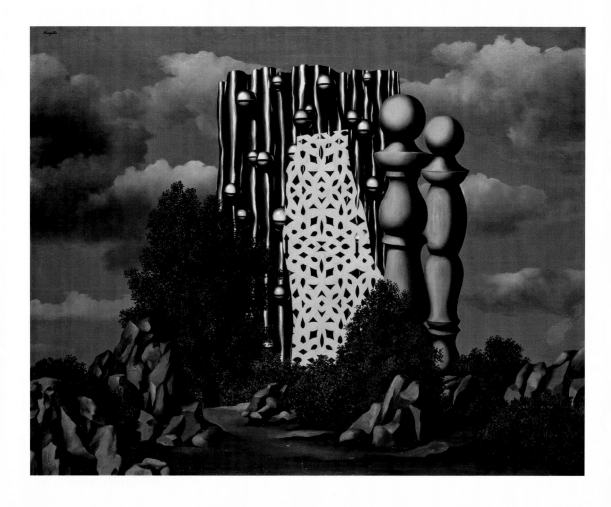

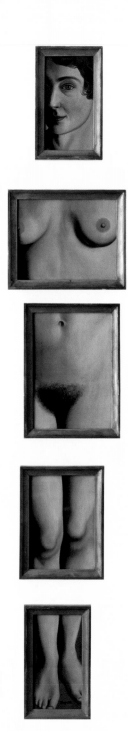

31. *L'Évidence éternelle* (1930)

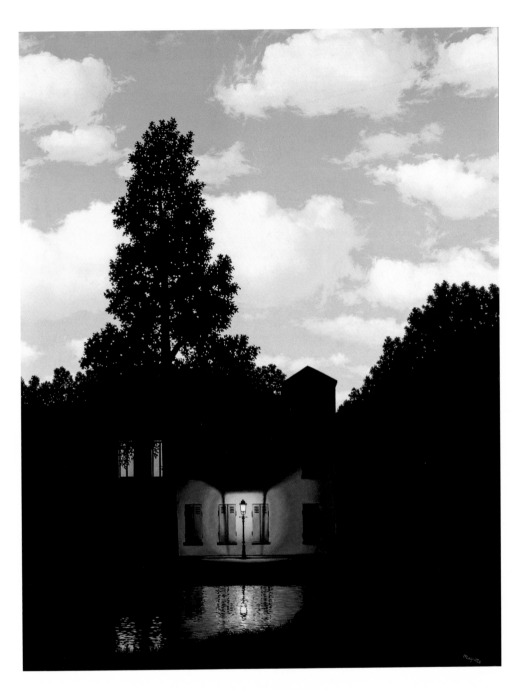

32. *L'Empire des lumières* (1954)

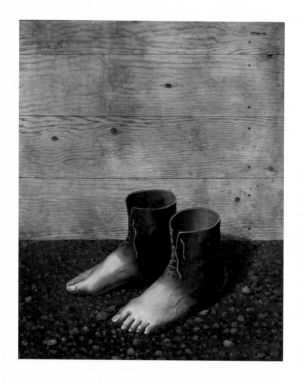

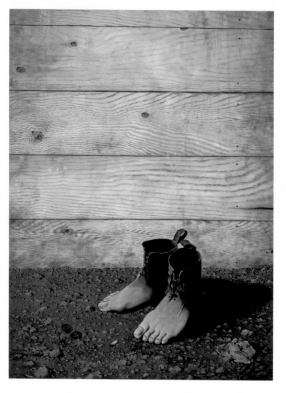

(LEFT)

34. *Le Modèle rouge* (1935)

(ABOVE)

33. *Le Modèle rouge* (1935)

(LEFT)

35. *Le Modèle rouge* (1937)

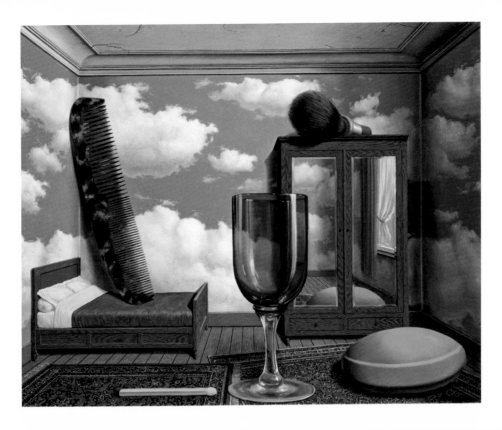

(ABOVE)
36. *Les Valeurs personnelles* (1952)

(RIGHT)
37. *Le Survivant* (1950)

38. *Le Mal du pays* (1941)

(ABOVE)

39. *Les Compagnons de la peur* (1942)

(RIGHT)

40. *La Mémoire* (1942)

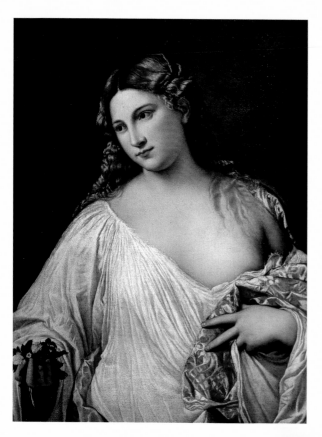

41. *Flora* by Titian (1517)

42. *Woman with a Mirror*
by Titian (1515)

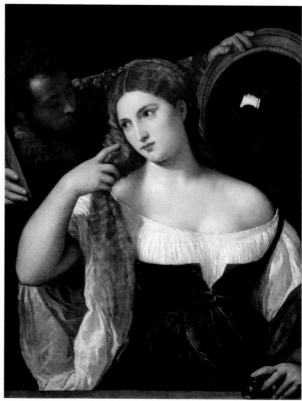

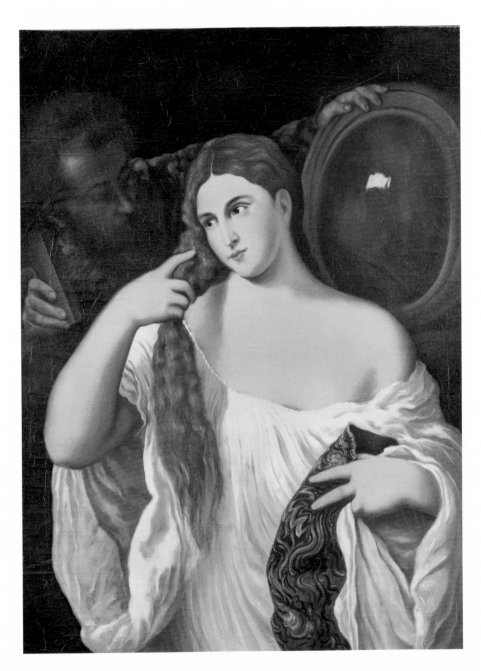

43. Magritte's reworking of Titian (1944)

44. *L'Art de vivre* (1948)

45. *La Famine* (1954)

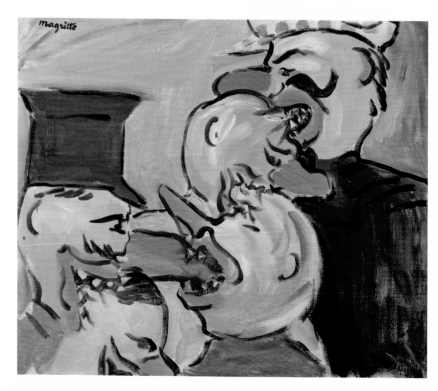

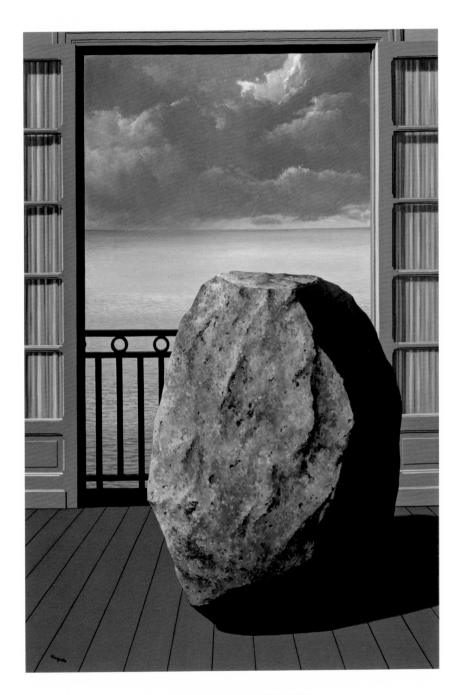

46. *Le Monde invisible* (1954)

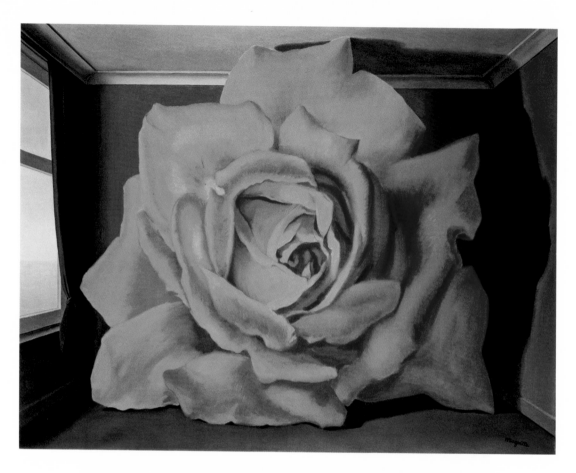

47. *Le Tombeau des lutteurs* (1960)

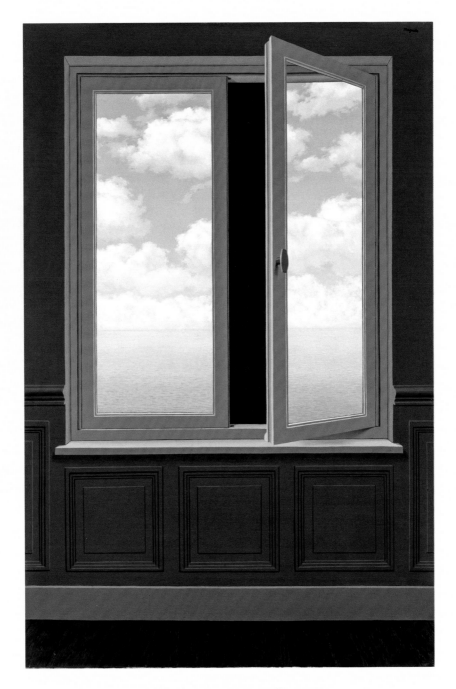

48. *La Lunette d'approche* (1963)

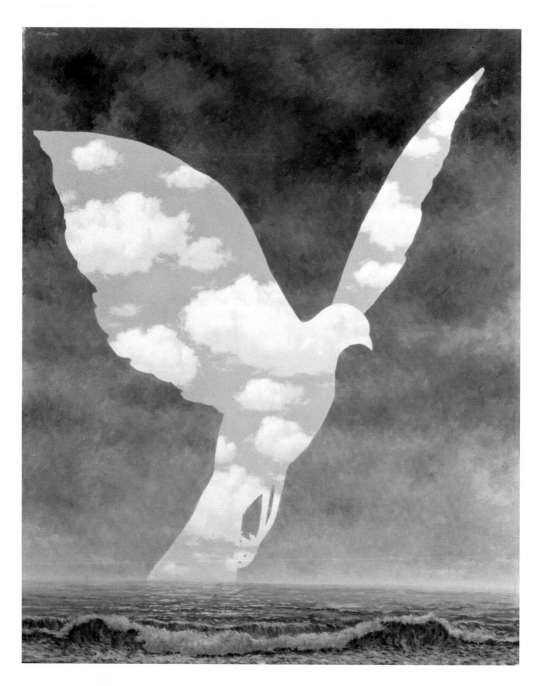

49. *La Grande Famille* (1963)

again before the end of the day. Three or four hours later, he returned, exhausted . . . and crestfallen.[29]

In July the Scutenaires moved on to Nice, where they could stay with relatives. Magritte continued his efforts to return to Brussels. In early August, he was finally able to tell them that he had a sporting chance. An elderly judge from Antwerp was going to help him get his papers stamped by the Belgian consul in Bordeaux; the judge would then drive them back to Belgium. "Keep this letter as a future reminder of how, more or less, I am about to attempt this rather desperate journey." There was a postscript. "If I should die on the way, tell Georgette when you see her again that my last thought will have been of her."[30]

Magritte reached Brussels in mid-August, without mishap.[31] His exile had lasted some three months. In a letter to Mariën, who was in a prisoner-of-war camp in Germany, he reflected on the experience:

In France, of course, there was if anything even more chaos than you found in Belgium. So I had an involuntary sojourn in the Midi, and enormous difficulty returning home. (Georgette was at home in good health and waiting sensibly for me.) I met a lot of people in Carcassonne: Bousquet, for a start. He is confined to bed all the time having been wounded in 1915. He lives in a darkened room and writes a lot. André Gide, and practically everyone from the *NRF* [*Nouvelle revue française*] passed through. Contact is rather disappointing: one has the distinct impression of being in the presence of "men of letters" preoccupied above all with their petty literary affairs. I haven't brought back favourable impressions of France. Unquestionably, I'm very much a man of the north, and it's no doubt on account of this that I haven't been very responsive to "the French mind."[32]

To all appearances, life continued more or less as before. The Scutenaires returned in October, after a train journey lasting seven days and seven nights. The gatherings at 135 rue Esseghem resumed (minus Colinet). "We saw the Magritte-Scutenaires, etc., as of old," reported Ubac, "the session a little less boisterous than before."[33] "Nothing much has changed here," Magritte told Mariën. "I work as usual, Georgette is neither better nor worse, friends are still just the same." Spaak received an equally laconic bulletin. "Here, it's ok. Georgette is well, little Kiki [Jackie the Pomeranian] resists the rigours of winter, Raminagrobis grows in wisdom"—a rare mention of his only cat, immortalized in gouache, larger than life, seated plumply on a railway line.[34] Over

the next two or three years Magritte was anything but boisterous. He seemed to have entered a period of stagnation, or depression. He was still capable of pulling off a striking painting—*Le Mal du pays (Homesickness)*, *Les Compagnons de la peur (The Companions of Fear)*, *La Mémoire*—but they were few and far between [color plates 38–40]. Interestingly, each of these might be construed as a commentary on the times.

Le Mal du pays was begun in the autumn of 1939, at the very moment when the crisis in the heart of Europe came to a head. Two days before Germany invaded Poland, four days before Britain and France declared war on Germany, Magritte wrote to Edward James about a work he believed would introduce a new poetic atmosphere into his painting. "It's set on a bridge, you can see the town in the distance, and in the foreground, a lion lying down, and a black-winged figure leaning on the parapet and gazing into the distance." This was one solution to the problem of the lion. But it was also intended "to put an end to the accusations of trivial jokiness levelled at my paintings."[35] As a title, Magritte tentatively considered *Les Fleurs du mal*. After his return from exile, he continued to work on "the picture of the lion and the birdman," and resumed the search for a title. In December 1940 he tried two new ideas on Scutenaire: *Le Spleen de Paris ou Philadelphie*, a bastardization of Baudelaire; or *La Purée de pois (The Pea-Souper)*, a tribute to London fog. In the end these gave place to *Le Mal du pays*. The painting was bought by Magritte's old

patron Van Hecke, and later acquired by Mesens, who liked to think of himself as the model for the birdman, on Westminster Bridge, in evening dress, in 1937 or 1938.

Les Compagnons de la peur (*The Companions of Fear*) are leaf-birds—in this instance owls rather than doves. Their look is arresting, not to say disquieting. "The owl is never more owl than when it is a leaf," as Henri Michaux has it, "a magisterial unique leaf."[36] The title was appropriated by Scutenaire from the French translation of Magritte's favorite Rex Stout, *The League of Frightened Men.*

La Mémoire features a plaster cast death mask, bleeding from a bullet wound to the temple, in a manner reminiscent of a famous image in Cocteau's *Le Sang d'un poète* (1930), attended by a grelot. The plaster head inevitably recalls the plaster head in de Chirico's *Le Chant d'amour*, the sempiternal grelot substituting for the ball.

For the most part, the work of the early 1940s was more subdued. The times were out of joint. Magritte was out of sorts. He could live and work, more or less undisturbed, and even exhibit, semi-clandestinely, but the Occupation was oppressive. In a world of Nazi cretins, word pictures might be death sentences. The treachery of images took on a new meaning. "Ceci n'est pas une pipe" was an invitation to sedition, and the torturers of Breendonk were not known for their sense of humor. In these circumstances, the politics of the pipe were such that Magritte himself thought it prudent to suppress it, along with *La Clef des songes* and *Le Viol*, when considering illustrations for a little book on his work, with a preface by Mariën. "I'm not very keen . . . to show 'La pipe,'" he told his accomplice, "it might provide an excuse to have me locked up in a madhouse."[37] A climate of fear and poison led to the closure of an exhibition of Ubac's photographs, denounced by Léon Degrelle's lackeys as "an act of spiritual sabotage" and "a base insult to our Flemish artistic tradition."[38] The catalog preface was also condemned. The culprit was Nougé, who delivered himself of a passionate defense of surrealism and humane values. "Today," he announced, "in the eye of an astonishing storm, *l'expérience continue*."[39] "*L'expérience continue*" became another battle cry.

As the war went on, collaborationist voices became increasingly emboldened. Fascist fellow travelers like the Belgian painter and poet Marc Eemans began to speak of "the Walloon" Magritte, in the same tone of voice as "the Jew" Brancusi, as if to underscore his otherness, piling ethnic impurity upon artistic degeneracy. "We are Germans and not Latins," proclaimed Eemans, the turncoat, who had been happy enough to align himself with the accomplices of Magritte in 1928. Come 1940, loyal accomplices could be mocked with impunity. Nougé was worse than Walloon—he was part French, from the Charente. Aged forty-five, he presented himself for military service in France. Amid the chaos, no one knew what to do with him, and he was demobilized a few months later. Under the Occupation he took to writing under the transparent pseudonym of Paul Lacherentais. Always envious of "the Monsieur Teste of the group," Eemans took a sinister pleasure in identifying him. "Oh the prudent pseudonym!"[40]

Eemans was small fry, but pestilent. During the Occupation it was advisable to tread carefully. Afterward, Magritte cut him dead. When Eemans remonstrated that he had not behaved like that during the war, Magritte is said to have admitted that he had been afraid of him. Magritte is also said to have thanked him "for the good turn you did me during the war," a sarcasm that sounds characteristic. Typically, Eemans affected to take it straight, to parlay into his rehabilitation.[41]

Domestically, it is hard to know exactly how things stood. Sooner or later,

Georgette relinquished Colinet and reinstated Magritte as the apple of her eye and the center of attention. That must have been a difficult accommodation, on both sides, as well as a relief. Life went on, as Magritte was keen to stress, but something had dissolved in the process. Symptomatically, Georgette tired of posing for him. He asked Jacqueline Nonkels. She refused, though she sat for a portrait. He asked Eliane Peeters, who lived in another apartment in the same building. She too refused, though she too had her portrait painted.[42] Those portraits were modeled on one of Georgette. But the supple nude who became *La Femme du soldat* (1945) was Agui Ubac; the painting was done from a photograph taken by her husband.

A new version of *L'Évidence éternelle* (1948), the cut-up canvases, depicted the body parts of an unknown model. (As if to add insult to injury, the pubic hair was added by another hand, once the work had cleared U.S. Customs. At the Iolas Gallery in New York the artist in question was known as "the master of the pubic escutcheon.") The luscious blonde who became *La Fée ignorante* (*The Ignorant Fairy*, 1956) was Anne-Marie Crowet, an occasional muse, despite her imperfections— the too-regular features, the too-red lips, the too-perfect hair. "All great masterpieces have their flaws," Magritte

observed wryly. "The model I 'used' was not a schoolgirl (as I would have pre-
ferred). She wanted a portrait of herself. The drawback was that on her way to
me she took care to call at her hairdresser's."[43] The portrait brought in some
money. He also did a close-up of her face—"a mask," as he called it. He was
sufficiently taken with Anne-Marie and her mask to keep it, like a fetish, for
several years. Shortly before his death he made her a present of it.

Images of Georgette were portraits from memory; or attempts to revive
past glories—attempting the impossible, perhaps, as Magritte once said. They
were together forever, but the spark had gone.

. . .

Magritte had been pondering his next move. As so often, it was a
completely unexpected one. In 1943 he produced a painting in a pseudo-
impressionist style reminiscent of late Renoir, run amok. This work inaugu-
rated Magritte's "sunlit" period, a riot of color and relentless optimism that
lasted for about four years. Most of his admirers regarded these apparitions
with consternation; they could hardly wait for him to return to his old style,
and engage once again with the darkness, and the menacing insights of the
mirror. Like Lang, like Kafka, Magritte was noir. For those who would make
a revolution, sunlight smacked of abdication, not to say childishness, and
a culpable lack of social critique. At a meeting of the dissident Surréaliste-
révolutionnaires, Christian Dotrement asked Magritte impudently if he also
wished to see a "yellow Kafka."[44] Collectors were united in their scorn. Van
Hecke wrote to Mesens,

> A major question arises: being stubborn, pig-headed and hooked on his
> present errors (and horrors!), Magritte will insist on exhibiting his recent
> works in New York (and no doubt also with you in London). Alas, his
> [illegible] more and more resembles de Chirico and his parade of horses
> and gladiators, although the latest Magrittes are even worse. To cap it
> all, he flies into a rage at the slightest reference to that. The poor fool
> believes that what he's doing now is the "high point" of his painting.
> Christ, what a catastrophe!

Van Hecke was not the only one to adduce de Chirico as an awful warning.
Mesens himself was outraged. When Wergifosse remarked on the virulence of
his antipathy, Magritte shrugged. "He's protecting his business. He has only
my old paintings to sell."[45]

La Traité de la lumière (*Treatise on Light*) turned *Les Grandes Baigneuses*

into a kind of harlequinade. According to Mariën, Magritte's original idea was to redo a Renoir bather with each part of her body painted a different color. His bather has an orange head, a violet torso, a red right arm, a green left arm, a blue right leg, and a yellow left leg. After that, there was no stopping him. Fantômas himself emerged in sunlit colors, complete with a yellow rose. Mariën explained:

> Fired with enthusiasm, Magritte immediately went on to make other versions, including *La Danse* [*The Dance*] (a standing nude) and *La Moisson* [*The Harvest*] (a reclining nude), and then concluded the experiment by taking the solution to its peak of refinement, since he worked the same transformation on Ingres' *La Source*, an "academic" representation if ever there was one, not only by decking out the girl's body in different colours, *but by recreating the whole picture according to the technique of the Impressionists!* And Nougé, who had already supplied the titles for the previous versions, was to name this last experiment, the subversive profundity of which as usual escapes everyone else: *Les Bons Jours de Monsieur Ingres* [*Monsieur Ingres's Good Days*].[46]

Magritte's collection of copiable postcards included Ingres's *La Source* (1856), a classical nude hoisting an urn of water, which had impressed him on his first visit to the Louvre, twenty years earlier. He had a soft spot for *Les Bons Jours de Monsieur Ingres*, a play on ambivalence, chance encounter, and Courbet's *La Rencontre, ou Bonjour Monsieur Courbet* (1854). It had a checkered history. Some time in the 1950s, Magritte made a present of it to Marcel Lecomte, who sold it in order to pay a hospital bill. Later it passed through the hands of Sylvester Stallone, "the most self-conscious noble savage since Mussolini."[47]

Sunlit painting was not merely an exercise in style. It may have begun as a diversion or a démarche—an appeal to joy and pleasure, and then to charm and menace—but it developed into a doctrine, or at any rate a demonstration, if not an insurrection. By 1946, Magritte's conception of sunlit surrealism had metamorphosed into a takeover bid. Its declared aim was to revive a moribund movement, to recapture the magic, to reorientate the public, and to rebrand the product. Its undeclared aim was to usurp the absolutism of André Breton. That was a tall order. To conduct such a campaign by manifesto was a little like relying on the cavalry of General Margueritte to face down the Prussians. No sooner was the first manifesto drafted than the cause was revealed as hopeless. The objective was beyond reach. The game was up.

At first sight, Magritte took aim at a soft target. "Surrealism . . . *does not*

exist," declared Nougé provocatively. It was in "sullen eclipse," as Georges Bataille had foretold.[48] As an avant-garde movement, it was a spent force. As a revolutionary project, it was null and void. Its plight was well caught in Barnett Newman's poignant insight: "[I]nstead of creating a magical world, the Surrealists succeeded only in illustrating it."[49] Magritte's analysis of their situation was not without merit, but the alternative he offered was never more than half-baked. The intellectual incoherence of his program was reflected in a confusion of terms, and also perhaps a confusion of motives. Magritte wanted to cross out the word itself. "The word Surrealism is already an obstacle," he told the disbelieving Surréalistes-révolutionnaires.[50] As a replacement, he vacillated between "Extramentalism" (defined as "emancipated surrealism") and "Amentalism" (by analogy with atheism). These neologisms were rejected out of hand by Nougé. They sank without a trace; but they spoke of a profound alienation. Magritte was disillusioned with surrealism, as a hegemonic project, under French rule; as a term of art, prey to ossification; and as a personal fiefdom, subject to arbitration by André Breton. "Surrealism has always been Breton," he wrote in frustration to Nougé, as they debated how to proceed, "and we have never done anything precisely to make people think first of us when they use the word. (In the *Conférence de Charleroi* [Nougé's lecture of 1929] the word is not mentioned once.)"

When Breton gave a lecture in Brussels [in 1934] we let him do it, without intervention, etc. Perhaps it's too late to retrieve this venerable term entirely for our own benefit, and perhaps it would be too much of an effort to make the public change its mind about the sense of the word. Would it be simpler to use a new word and save our energy for other things? New ideas call for a new vocabulary and a new name, to avoid confusion.

For my part I buried Surrealism some time ago, my Surrealism and, with even greater justification, Breton's. In any event, pending a better name, or anything else, a crystallization or example, the first manifesto will appear as agreed without the word extramentalism. Next week I'll have a bundle of proofs, and together we'll see who to send them to for signature. In spite of all, I believe it's badly written, if I think of what you write and of the excuses you make every time for writing "so badly" in your letters. . . .

P.S. Would you send me the orchids [*No Orchids for Miss Blandish*, by James Hadley Chase], which interested parties ceaselessly commend?[51]

Magritte was a surrealist according to the law of the heart, and not the rite, as Jean Starobinski once said. His alienation was understandable. Surrealism

was suffering from a hardening of the arteries. But sclerotic surrealism was not about to give way to sunlit surrealism on Magritte's say-so. Breton himself had been in eclipse during the war, but he remained a formidable opponent, especially on his home ground. The contest of words was his life's work.

The first manifesto of "Le Surréalisme en plein soleil" ("Surrealism in Full Sunlight") was signed by the usual suspects—Magritte, Mariën, Nougé, Scutenaire, and Wergifosse—together with Joë Bousquet and Jacques Michel (also known as Jacques Denis).[52] The gospel of sunlit surrealism was very much Magritte's creation, in concert with Mariën and Wergifosse, the latter appointed chief scribe. Magritte fed them ideas.

> To imagine that one can't divert this Impressionist technique to new ends is to manifest a sterile respect for the idea of masterpieces that only the painters of the turn of the century were able to achieve. It is to imagine that this technique was the sacred property of those painters, *and that we know nothing other than things that can or cannot be made use of.* BECAUSE THERE IS NOTHING TO LEARN. "Truth" would not be an object of contemplation, but an object to make use of, dirty materialist, go on with you![53]

Nougé played more of an advisory role. If he was somewhat disengaged from this particular struggle, as Magritte's comments seem to imply, he was sufficiently roused to defend Magritte against Breton in two catalog prefaces, full of original perceptions on Magritte's beliefs, Magritte's skies, Magritte's creatures. These texts lacked nothing in combative spirit: "Here come the tarots, horoscopes, premonitions, hysteria, objective chance, black masses, the kabbalah, voodoo rites, sclerotic folklore, and ceremonial magic. It is out of the question now to cite André Breton, reject."[54] They were the last texts on Magritte he ever wrote.

By the early 1950s the volcano that was Paul Nougé was almost extinct. He was drinking up to six liters of red wine a day. His destructive relationship with Marthe Beauvoisin was very nearly the death of him. He could not live with her and he could not live without her, as one of his friends lamented. He lost his job and his apartment. He sold his last three Magrittes to Geert Van Bruaene for 12,000 Belgian francs. When that was gone, he had nothing. His tongue became more and more ungovernable, his reported remarks more and more hurtful. When Magritte refused to sign a tract: "The poor devil is becoming a hermit." When he heard that Magritte had bought a grand piano: "It's a fine thing to have a grand piano, but you have to know how to make use of it." When asked why he no longer wrote on Magritte: "The good fellow no

longer interests me."[55] There were negligent flashes of the old glory—he could turn out titles and aperçus until the end—but these fitful brilliancies were a painful reminder of what had been lost. "Everything is still possible" was a thing of the past. Nougé was valiant, but bereft. "What remains of a man?" he asked himself in his journal. "A certain agitation in some heads and a little paper blackened."

> The same old life, the same tired guidelines—the moral of the story, the practical application of advice, lessons learnt, questions raised— and a handful of portraits, some apocryphal; the people who exploited us for so long. All that is the heavy baggage we leave behind as we slip out of the hotel door at daybreak. We follow the random twists and turns of an unyielding thread that we alone can see. Our last friends have forsaken us. We do not look back. We move at a surprising pace. Who knows?[56]

Nougé remained a totem, but he became a husk. His absence was acutely felt. If only he had seized sunlit surrealism, taken it by the throat, things might have been different. As it turned out, the manifesto was a fiasco. The proofs were circulated widely, to no avail. René Char said he no longer knew how to sign a manifesto. Marcel Jean pleaded that he did not understand. Hans Bellmer declined, politely. Picabia professed himself delighted, and asked Magritte if he would write a catalog preface for his forthcoming exhibition in Brussels; he never did sign. Mesens refused point-blank to have anything to do with it. His assessment was withering: "I cannot imagine what strange feelings prompted you to give birth to a text which is so badly organized, so badly written—so pointlessly obscure."[57]

The best was yet to come. When Breton read it, he sent a telegram to Magritte and Nougé: "ANTIDIALECTIQUE ET PAR AILLEURS COUSU DE FIL BLANC. VOUS PLAISANTEZ." (Anti-dialectical, and besides a blatant lie [literally, sewn with white thread]. You're joking.) Nougé composed their reply: "MILLE REGRETS LE FIL BLANC EST SUR VOTRE BOBINE." (So sorry. The white thread is on your reel.) The filmmaker Luc de Heusch happened to be present when this telegram was delivered. Breton laughed out loud at the riposte.

The resort to a public demonstration was already a defeat. For three months Magritte had been trying to convince Breton privately of the case for sunlit surrealism. Unaccountably, their discussions in Paris in June 1946 raised his hopes. "He said some very interesting things about my new painting," Magritte reported to Georgette. "It's obvious that he understands it very

well, . . . and from there to liking it . . . is only a step, I think."[58] Impressing Breton remained one of his main goals. He seems to have been oblivious to the contradiction inherent in trying to impress him at the same time as he was trying to propose a new direction for surrealism—perhaps, in Breton's view, to topple him. Magritte had conceded to Nougé his own lack of political nous: here was a case in point. Heedless, he continued his campaign. He sent Breton a letter and also a present: a little picture of a pipe, shining brightly in the sunlit surrealist sky, with an apt title—*La Liberté des cultes* (*Freedom of Worship*).

The painting of my "Sunlit period" clearly runs counter to many of the things we were convinced of before 1940. I think that is the main reason for the resistance it provokes. However, I believe we no longer live to prophesy (always in a gloomy sense, it must be said); at the International Surrealist Exhibition in Paris [in 1938] one had to find one's way around with torches. We had that experience during the Occupation and it wasn't funny. The confusion and panic that Surrealism wanted to arouse in order to put everything in question were much better achieved by the Nazi cretins than by us, and there was no question of avoiding the

consequences. . . . That and the need no longer to believe in change as the key to "progress" seems to me to justify the "emergence" of a new atmosphere in my pictures and the desire really to know it in life. In the face of general pessimism I urge the search for joy, for pleasure. I feel that it lies with us, who know something of *how feelings are invented*, to make joy and pleasure, which are so common and beyond our reach, accessible to us all. It is not a question of abandoning knowledge of objects and feelings that Surrealism has nurtured, but of using it to different ends, or else people will be bored stiff in Surrealist museums just as much as in the others.

Your objection to my new painting is among other things: that you don't experience the physical sensation of pleasure that I try to provoke. In any case there's no mistake: that's what I want to provoke, and if I don't succeed, one can't seriously believe that Matta, Ernst, Victor Brauner, etc., achieve their goals; we know very well what they want, too well in my case.

As for the charge of imitating Renoir, there is a misunderstanding: I've done pictures after Renoir, Ingres, Rubens, etc., but without utilizing the technique peculiar to Renoir; rather it's that of Impressionism, Renoir, Seurat and others included. On this point, certain of my latest pictures, depending on the subject, demand that I employ my old technique (polished, smooth painting), but with lighter colours, severity is banished. SEVERITY IS MORE REMOTE, less calculable.

As you know, I'll be showing in Paris in October. Would you care to do the catalogue preface? Even if you refuse to allow yourself to be seduced by these sun-friendly images, you would enjoy analyzing what is at stake, without taking sides, and giving these images a chance to shine.[59]

This blithe cordiality did not last. Breton was immune to charm and menace alike. Talk of joy and pleasure was so much persiflage. A catalog preface was out of the question, and Magritte was given short shrift. In an interview published shortly afterward, Breton was invited to give a tour d'horizon of surrealist painters. He made no mention of Magritte. His private view of sunlit surrealism was made crystal clear in his remonstrance to Bousquet: "It would be difficult to carry ignominy any further."[60]

The narrative unfolded with the inevitability of Greek tragedy. In the international exhibition of surrealism at the Galerie Maeght in Paris in July 1947, selected by Breton and Duchamp, Magritte was relegated to a retrograde section entitled "Surrealists in spite of themselves," together with a few of the old guard and a motley crew of precursors (Arcimboldo, Blake, Bosch, and the

Douanier Rousseau). In Breton's catalog text, he was relegated to an extended footnote:

> Is there any need to underline that this attitude is diametrically opposed to that adopted recently by certain members of the former Brussels surrealist group, headed by Magritte? After noticing, like us, that certain of our boldest assertions are often confirmed by events to a far greater degree than might have been expected, they have suddenly taken it into their heads to admit into their work only "charm, pleasure, sunshine, objects of desire," to the exclusion of anything connected with "sadness, boredom, threatening objects"! Even though this may represent a desperate effort on their part to bring themselves into line with the resolutions of the Leningrad Writers' Committee (1946), stipulating wholehearted optimism, it is difficult not to see their behaviour as equivalent to that of a backward child who, to make sure that he has a pleasant day, has the bright idea of fixing the needle of the barometer to "set fair."[61]

Magritte was excommunicated, again.

By 1947 sunlit surrealism was on the wane. By 1948 it was over. Few mourned its passing. Some years later Magritte had this to say:

> For the period that I call "Surrealism in full sunlight," for me it was a question of trying to combine two things that are mutually exclusive:
>
> 1. That feeling of lightness, intoxication, wellbeing, that is based on a certain mood and an atmosphere that certain Impressionists or rather Impressionism in general succeeded in bringing out in painting. Without Impressionism, I think we wouldn't understand this feeling for real things that detect colours and nuances, shorn of all conventional associations. Despite appearances to the contrary, the public never liked the Impressionists; they always saw their pictures with an analytical eye—otherwise one would have to concede that freedom had the run of the streets.
>
> 2. The feeling of the mysterious life of things (which should not depend on classical or literary allusions), which is only captured with a certain perceptiveness. Certain pictures of that period succeeded in combining these two mutually exclusive things. I gave it up—why? That's not entirely clear—perhaps because of the need for unity?[62]

When Maurice Rapin asked him why he had embarked on sunlit painting, he responded simply, "For moral reasons." When Rapin asked why he had brought it to an end, he returned the same answer.[63]

Moral or immoral, sunlit painting did nothing to alleviate his "financial neuralgia." And yet *Magritte*, the little book that appeared in August 1943, under the personal supervision of its subject, contained no fewer than twenty color plates—an expensive proposition, all the more remarkable in the middle of the Occupation. The expense must have been borne by Magritte himself. No other party was in a position to cover it, least of all the publishers, Les Auteurs Associés, chosen because they had the necessary authorization from the German censors. Les Auteurs Associés published detective stories; lavishly illustrated artists' books were beyond their means. The provenance of the funds was a well-kept secret. It bore on one of the most intriguing aspects of Magritte's practice—and still one of the murkiest—revealed forty years later by Marcel Mariën, who contributed the preface (vetted by Magritte and Nougé).

In this period of the war Mariën was earning a little pocket money by acting as a courier for the collector René Gaffé's under-the-counter dealings in Paris. There he came into contact with a number of interesting characters, including the Spanish artist Óscar Dominguez, who had a studio in Montmartre. Dominguez had a lucrative sideline in fake de Chiricos and fake Picassos, to which his benevolent friend Pablo turned a blind eye. Fake Picassos were all the rage. "Among Dominguez's entourage," Mariën recalled, "I met another Spanish painter and Surrealist who showed me one day a fake Picasso drawing. He had done it and had not succeeded in selling it in Paris. To help him out, I promised to try in Belgium. It was a drawing from the Cubist period; at any rate that is what it evoked. I showed it to one of the most important bookshops in Brussels. They bought it without hesitation, albeit for a pittance."

> But before that, I showed the drawing to Magritte. Straightaway he offered to do some, which I would offer to *amateurs*, and we would split the proceeds. So it was that, between 1942 and 1946, I sold a significant number of drawings and paintings, attributed chiefly to Picasso, Braque and Chirico, all made by Magritte. The proceeds of this activity not only kept the pot boiling, as they say, but also served to finance various works that we published together, first of all under the imprint of a publisher of detective novels (Les Auteurs Associés), who had the authorization of the German authorities, then under our own imprint, Le Miroir infidèle; this title, I should emphasize, having absolutely nothing to do with the ongoing enterprise of the fake pictures.[64]

According to Mariën, therefore, the two of them entered into a secret compact, at Magritte's instigation, such that Magritte would produce the

goods and Mariën would find a way to offload them. Magritte was the forger. Mariën was the fence.

This compact remained secret, or passed unnoticed, until the publication of Mariën's memoirs in 1983. There he provided some compelling circumstantial detail on the nature of the business and the disposal of the merchandise:

> I remember a Braque still life, a very large format, vertical, which I took one day to the Palais des Beaux-Arts and which elicited a simultaneous cry of admiration from Robert Giron and Max Janlet, who discovered this unknown and superb piece, wholly worthy of *le patron*. Besides it immediately found a buyer. I should say that the fortune amassed by traders on the black market, the principal clientele of the Palais, was particularly vulnerable to the vagaries of war, and all sorts of people were looking for a way of moving into something safer and more durable than paper currency. . . .
>
> One day Magritte was careless enough to send me, in the mail, a postmetaphysical Chirico in two cardboard tubes, one inside the other. What had to happen, happened. The canvas was folded in two, and embellished with an irreparable crack. I took it to the Palais des Beaux-Arts, despite the lamentable accident. But when Giron leaned over to examine it more closely, he exclaimed out loud on discovering, under the cracked varnish, fresh paint. That took place in July 1944, after the Normandy landings and before the break-through at Avranches, as attested by Magritte's letter to me on the 12th of that decisive month of the war.[65]

In fact Mariën had already furnished evidence of their crimes, as his reference to Magritte's letter served to indicate. In 1977 he published all of the letters Magritte ever wrote to him (278 from 1937 to 1962). Six years on, he took a certain pleasure in pointing out that a number of these letters contained "veiled traces of this criminal activity, frequent bizarre metaphors that have not yet stimulated the slightest interest among exegetes."[66] In the one he mentioned, there was even a sketch of *craquelures*. Mariën must have related the events at the Palais des Beaux-Arts culminating in Giron's discovery. Magritte replied:

> For the wounded part, am I to understand that if you touch the cracks you get an idea of the relatively fresh colouring beneath? And how big and significant are they? And what dimensions and importance? Would you do me a summary of the size and nature of these veins? Like this for example:

In any event, to remove the protuberances, the method that I communicated to you is risk-free, though prudence is advisable, and a certain restraint essential.[67]

The recommended treatment was as follows: "It would perhaps be good to rub *the back* of the invalid *gently* with a damp cloth around *the sore parts*, and then to place the piece on a board and let it dry. The procedure could be repeated two or three times, with care, once a day. But I hope the accident isn't too serious?"[68]

Some of his letters were more plain spoken. In May 1944: "I'm still going through an intense crisis of fatigue. I haven't done anything these last few days, except start a Titian and a Hobbema, destined for the sale room; I'm going to try this kind of painting, and if it goes better than Magritte-painting I'll give up the latter because of insufficient rewards." Three weeks later: "I've finished the Hobbema and the Titian; soon I'll hand them over to the saleroom."[69] These works were identified by Mariën as copies of Hobbema's *The Avenue at Middelharnis* (1689), in the National Gallery in London, and Titian's *Flora* (c. 1515), in the Uffizi Gallery in Florence. Thus it appears that Magritte's activities as "copyist" focused on a number of his contemporaries or near contemporaries—Mariën mentions Picasso, Braque, de Chirico, Ernst, Klee, and Matisse, to which we can add Arp, Gris, and Modigliani—with an admixture of old masters (Hobbema and Titian), and at least one tantalizing outlier, Courbet; Magritte forged his notorious *L'Origine du monde* (1866). That may not be an exhaustive list, but it is an extensive one—more extensive than Mariën suggested.

When Mariën marshaled the evidence on Magritte the forger, in 1983, all of those he implicated were dead—in most cases, long dead—as he was well aware. Magritte himself died in 1967. The principal conduit for the contemporary works, Robert Giron, director of exhibitions at the Palais des Beaux-Arts, died the same year. Max Janlet, the prominent collector who joined him in hailing the Braque still life, died in 1976. According to Mariën, *La Fôret* was another fake—"[T]hat's a good Max Ernst," as Magritte had joked when he saw it as part of an exhibition of Ernst's work—fenced by his old comrade Camille Goemans, who died in 1960.[70] The famous Max Ernst was famously disputed. Ernst himself replied in kind ("Ceci n'est pas un Magritte"), but kept his peace; he died in 1976. Of the other targets, Braque died in 1963, Picasso in 1973, and de Chirico in 1978.

One of those most closely involved was still alive, and not to be ignored. Furious at the blackening of Magritte's name, Georgette publicly challenged Mariën's account. Then not content with that, she took more draconian action.

She attempted to suppress his memoirs, halting publication and having copies withdrawn from bookshops. The dispute played out in the courts, and the press, and in a series of bitter exchanges. Georgette's explosive reaction elicited scant sympathy. She received some support from Suzanne Bertouille, who had worked in Robert Giron's office, and who signed an affidavit to the effect that he had not handled any such fakes (at least not knowingly); otherwise, there was a deafening silence. In the end Georgette lost the battle of prohibition and also the war of words. Mariën was cock-a-hoop. He relished a scrap. The underdog against the big battalions; the truth teller against the cover-up; the public interest against the sanctimony and the hagiography—that was his fight. Provoked by the aspersions on his character and the questions about the veracity of his testimony, he divulged some further information. He also turned his fire on "the widow." Maybe, he suggested meaningfully, she had a short memory. It transpired that Georgette herself had acted as courier (perhaps unwittingly) for a fake de Chirico—two horses beside the sea—delivered to Mariën at his hideout in Herenthout, near Antwerp, in July 1944. He was tipped off by a coded reference in one of Magritte's letters: "Georgette is bringing the bread to bake. Still bored stiff."[71]

Additionally, Mariën was a little more precise about the merchandise offered to Giron. He counted two Braques, two or three de Chiricos, and Ernst's *Fôret*. Of the plethora of Picassos, he published a drawing and an oil, apparently executed by Magritte in 1943 and 1944 respectively.[72] He also revealed that these activities continued for much longer than anyone had realized. Pointing to a letter from Magritte dated February 7, 1953, he explained, "I tried one last time to sell two Klee gouaches and a Matisse drawing that Magritte had made and sent to the poste restante in Dieppe where I often stopped off. I showed them to Michel Leiris, whom I'd met several times in the West Indies, with his wife [Louise], the gallery director. But I gave up the idea of placing them in Paris, faced with the extremely sceptical reactions they provoked."[73] How to proceed? Magritte had some suitably guarded suggestions:

> PARIS (the business of the rectangles).
> Art galleries—more or less trustworthy.
> Perhaps Bryen (rue du Dragon 24) [the artist Camille Bryen (1907–77)] might be a source of information and an unidentifiable go-between?
> Breton runs L'Étoile Scellée, [a gallery] in the rue Pré-aux-Clercs, but I think he is to be avoided for all sorts of reasons in the business of non-euclidian rectangles. Whatever the pleasure of dumping an amorphous geometrical form, to my mind the definitive formula should remain unchanged: *Crédit est mort.*

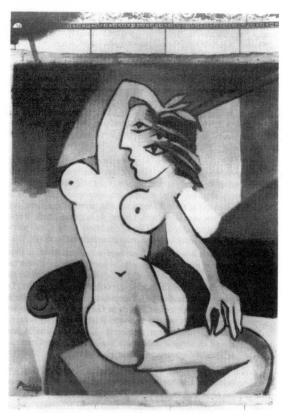

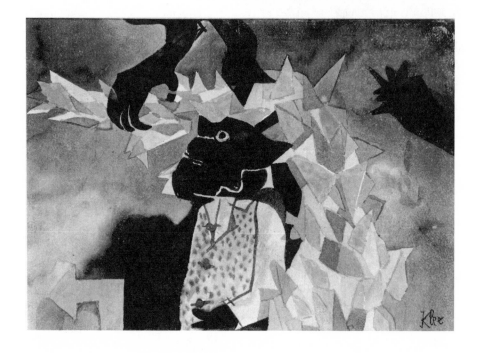

In Brussels, perhaps a De Keyn [Robert De Keyn, the owner of a paint factory, and an important collector of Magrittes, with a taste for nudes], or failing that his Parisian double, could honour an offer brought by a voyager from afar.[74]

Other testimony tends to confirm Mariën's account. Georgette asked David Sylvester not to make any mention of the "non-euclidian rectangles," as a nonissue, even as she lent some color to the story:

> You say that René was *discouraged* by the poor reception and meagre sales of his canvases, and that he made copies of Titian's *Flora*, etc., without signing them. . . . I remember that there was some talk of this at the time, but nothing came of it. It is true that he painted a virgin, which he gave to an old neighbour.
>
> So there's no point in talking about that, it's of no importance. Besides, I never saw René discouraged. He had great force of character, despite all that has been written of his being bored. . . . He may have been *disappointed but never discouraged.*[75]

After Georgette's death, in 1986, "The Remaining Contents of the Studio of René Magritte" were auctioned at Sotheby's in London on July 2, 1987. The remaining contents included household effects. Among them was a watercolor signed "Klee" (estimated at £400–600)—"palpably a fake," in Sylvester's judgment, which had been hiding in plain sight on the stairs for years.[76] According to Paul Magritte's wife Betty (a reliable witness), Magritte gave Paul a painting signed "Juan Gris" to sell. Such a painting has been illustrated in a catalog by Sarah Whitfield: a cubist composition, "dimensions and whereabouts unknown."[77] He also gave Paul a fake Magritte, or at any rate a postdated one, in pseudo-futurist style, entitled *Jeunesse* (*Youth*) and dated 1924, but painted in 1942—a gag, said Magritte, to tickle his fancy. Paul sold that painting, too, some years later; it was donated to the Berkeley Art Museum in 1967.[78]

The *catalogue raisonné* concludes, rather cautiously, "[T]here are a number of reasons for believing that Mariën's allegations were probably well-founded."[79] No further investigations were conducted. It might be observed that Mariën's allegations were also Mariën's confessions, though it is safe to say that Mariën felt no remorse. On the contrary, he presented an aggressive *apologia pro vita sua*, at once co-opting and explaining his partner in crime. "From our point of view, as Surrealists, we had total contempt for the work of art considered at market value regarded as a commercial asset. We made

our own moral code, and it was Magritte himself who had earlier remarked, 'if you buy a fake diamond unawares, you will be just as satisfied, because you have paid the price of the genuine article.'" This was a line from "L'Art bourgeois." It was smartly filched and deployed. It was also taken a little out of context. Magritte had argued that "people do not want a diamond for its intrinsic properties—its authentic qualities alone—but because, as it costs a great deal, it gives the man who possesses it a kind of superiority over his fellow men, and is a concrete expression of social inequality." Besides, he continued, "things have become so absurd that if you buy a fake diamond unawares, you will be just as satisfied, because you have paid the price of the genuine article."[80] As for diamonds, so for paintings. Fakes had exchange value. They gave complete satisfaction to the owner and turned a pretty penny for the forger. This was subversion by other means, functioning as a kind of time bomb, or explosive charge, sapping the existing social order and making a mockery of its inequality. For Mariën, the conclusion was self-evident. Forgery was a victimless crime. He capped his argument with a little parable by Valéry:

> The difference between a fake banknote and a genuine one depends entirely on the forger.
> A man came up for trial accused of forgery, and two bills bearing the same numbers were on the table before the judge. It was absolutely impossible to tell them apart.
> "What am I accused of?" he said. "Where is the evidence of my crime?"[81]

What to make of Mariën? He was one of Magritte's most loyal accomplices until he rebelled. In 1954, they quarreled. Mariën was expelled from the inner sanctum. The quarrel was precipitated by Mariën's growing intransigence. Over the years he had drawn close to Nougé: Mariën venerated Nougé as Nougé venerated Valéry. At the same time he had become increasingly disaffected with Magritte. In the end, there may well have been a streak of envy. Mariën was an artist in his own right, who never had the success he thought he deserved. Furthermore, he resented Magritte's closeness to Colinet. He grew weary of their penchant for philosophizing; he considered their chatter puerile. (He found particularly irksome the repetitive chorus: "There is something rather than nothing.") Ironically enough, what he deplored most was Magritte's willingness to reproduce his own work to order: "to supply copies of his most famous pictures, when he had always detested painting as manual labour, insisting that when he became rich he would paint only the rare pictures that he really believed in."[82]

He became the deep throat of the Magritte gang. He was their scavenger, editor, and publisher. The publications themselves range from the feuilleton to the clandestine compilation. *Sous le manteau de Magritte* (1984) is a title that tells its own story (literally, "under the coat"; colloquially, "under cover," or "on the sly"), the mystery compounded by the identity of the imprint: Editions Fantômas. The most prolific small press engaged in this activity was his own creation. It was called Les Lèvres Nues ("naked lips," with a double entendre or at least a *sous-entendre* of naked labia). Mariën was an incorrigible provocateur. He was a dedicated documentalist and an equally dedicated surrealist, at once keeper of the record and keeper of the flame. But he also had a taste for japes and jackanapery. He liked to make mischief and settle scores. No doubt Magritte came in for some of that in his memoirs. Nougé's disobliging comments are repeated by Mariën. At one point he remarks that a 1937 portrait of Georgette "remained significantly unfinished." Georgette herself donated the portrait in question to the Musée des Beaux-Arts in Brussels. Mariën claims that Magritte told him it was unfinished. Be that as it may, the remark is characteristically tendentious.[83] As Jan Ceuleers has nicely said, "[H]e seized the opportunity to evoke with anecdotes, rumours and well-placed untruths the true life of the painter before his universal consecration."[84]

Mariën's testimony is not to be taken for granted. When all is said and done, however, in the matter of the fakes it seems entirely credible. In sum, the evidence suggests that Magritte tried his hand at copying a wide variety of artists—some of the biggest names in the Western canon—including the two he professed to admire above all others, de Chirico and Ernst. These copies were evidently intended to pass for Picassos or Braques, as it may be. That is to say, they were destined for the salesroom, as Magritte put it; or the black market, which was very much a going concern, as Mariën discovered, in spite of the privations of the Occupation, or perhaps because of them. Alternatively, they relied on the kindness of strangers, or rather accomplices, tapping their own networks to clinch a private sale—a very private sale. Many years earlier, Magritte had called attention to *la bande à Fantômas*. ("They obey a code, despite the rather brutal suddenness with which they burst into the history of crime.") He always fancied himself as Fantômas, outwitting the bumbling agents of the bourgeois state, not to mention the Nazi cretins. Now he could taste it. Employing Georgette as a courier for the de Chirico; conning the avaricious; cocking a snook at the overvalued high and mighty; concocting the works: all that must have been very satisfying. He surely enjoyed the game—it staved off the boredom—but the contemporary copies were made to sell. They were hatched, batched, matched, and dispatched accordingly. They were signed, as appropriate. They were meant to fool the eye, and some

of them did. Unsurprisingly, few of these works have been recovered or reproduced: the visual evidence is still very scanty. As far as we can tell, it appears that they were not very good forgeries. They were good enough, perhaps, in the degraded circumstances in which they found themselves. They were pot-boilers, in more senses than one.

Notwithstanding Magritte's declared intentions, it seems that the copies of the old masters were not consigned to the salesroom after all. Nor were they turned over to Mariën. Of the fate of the Hobbema, we know virtually nothing. Jacques Wergifosse had a clear memory of seeing it hanging on the wall of the living room, to the right of the chimney, at 135 rue Esseghem; he did not remember seeing it again after they moved, in 1954.[85] That is hardly conclusive, but it does suggest that it was not sold (or it did not sell) for at least ten years. Until very recently, the fate of the Titian was equally obscure. For the first time, it is possible to tell its story.

The Titian was consigned to Albert Van Loock, a bookseller and art dealer, and a quasi-accomplice. Van Loock dealt chiefly in prints and drawings; he also built up an enterprising private collection. He began his working life at the Librarie Brissaud, and in due course set up on his own. The Librarie Van Loock became one of the most important in Brussels, dealing in every-

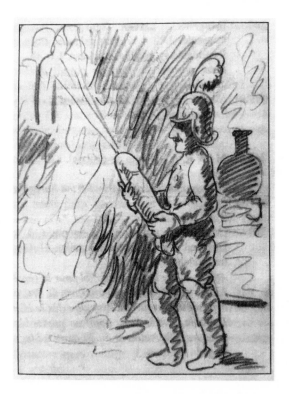

thing from incunabula to *Madame Edwarda*—it was Van Loock who recommended Magritte to Brissaud as the illustrator of that book, and Van Loock who bought the set of erotic drawings that came out of the commission. He may well have bought one or two more besides, including an "ithyphallic firefighter" who appeared at around the same time, on the reverse of a letter signed with the cryptic monogram "M."[86] In the trade he was an expert, widely recognized. In surrealist circles he was equally well connected. It was the same Van Loock who took the celebrated photograph of the gang making merry with Geert Van Bruaene outside La Fleur en Papier Doré. He was on sufficiently good terms with

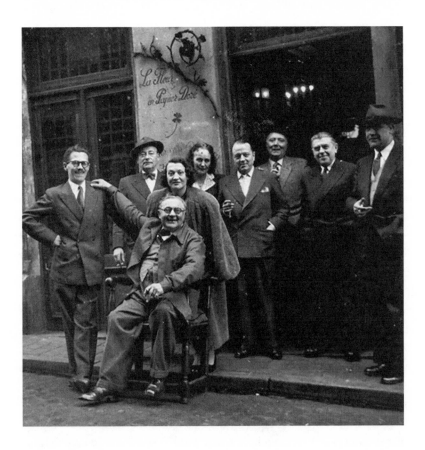

Magritte to be included in the survey in *Le Savoir vivre*, in 1946, on his likes and dislikes, fears and wishes. After seeing one version of *La Fissure*, the work with the trompe l'oeil banknotes, he commissioned another, in Belgian francs, in the hope of selling it to the Banque Nationale. He also acquired a version of the pipe, in a recessive frame designed by Magritte himself. He was thick with Mariën, his erstwhile comrade in arms, whose girlfriend Elisabeth was Van Loock's sister. The hideout in Herenthout belonged to the Van Loock family; Mariën later found employment in the bookshop. The Librairie Van Loock was a safe house. Van Loock himself was a safe pair of hands.

According to his son Claude, who took over the business and became an expert in his own right, the Titian was delivered to his father and stored, rolled up, on top of the wardrobe in his bedroom. Next to it, hanging on the wall, was one of the seventeen oils and ten gouaches of *L'Empire des lumières*, an image that scared the little boy as he eyed it from his bed. Young Magritte had his mysterious trunk; young Van Loock had his mysterious Magritte. The plan was to sell the Titian, discreetly, mining Van Loock's voluminous address book. For one reason or another, that never happened. The Titian remained

on top of the wardrobe for several decades. Late in life, Van Loock remarried. He unrolled the Titian, had it restored, and installed it in his new home.

Albert Van Loock died in 2011. The following year the Titian finally reached the salesroom, sixty-eight years late. It was sold at an auction house called the Romantic Agony in Brussels, as a Magritte, "after Titian," dated 1944 (on the evidence of the letters to Mariën), and estimated at 10,000–15,000 euros.[87] At that price it was a snip. It was snapped up by a discriminating private collector.

Its cover blown, the painting only gained in interest. Its very existence was an important discovery, authenticated by the expert art conservator Mia Vandekerckhove, who was able to examine it after the sale and subject it to a battery of tests. One thing was immediately apparent: it was not what it seemed; or rather it was not what we had been led to believe. It was not simply a copy of *Flora*, as Mariën had maintained, and the *catalogue raisonné* had accepted, and everyone had repeated ever since.[88] Instead, it was a hybrid. Magritte combined elements of two Titians to make his own. He made use of the ravishing Flora, goddess of flowers and prostitutes, but he made more use of *Woman with a Mirror* (c. 1513–15), in the Louvre [color plates 41–43]. His painting was in some sense a new work. In other words, it was an authentic Magritte fake. It corroborated the testimony of Magritte's letters, and substantiated the essence of Mariën's memoirs. It demonstrated beyond doubt that Magritte was engaged in the business of "non-euclidian rectangles." Given its provenance, via Van Loock, it also served to confirm the involvement of his accomplices, whatever the financial reward (in this instance, perennially deferred).

How did he do it? Here we have the benefit of Mia Vandekerckhove's analyses. He worked on a smaller canvas than his illustrious predecessor, thus compacting or compressing the image: Magritte's Titian measures 63.7 x 48.4 centimeters—small for a Titian—whereas *Flora* measures 79.7 x 63.5, and *Woman with a Mirror* 99 x 76.

The work is unsigned, which is as it should be. "Autograph Titians," by the hand of the master, do not boast Titian's autograph, other than the occasional initials TV (Tiziano Vecellio), or a large letter V. The letters V, VV, or VVO, which appear on other Venetian portraits around that time, have been variously interpreted as indicating *virtus vincit* (*omnia*), "virtue is victorious over everything"; *vivens vivo*, "from life by the living"; or *virtus e veritas*, "virtue and truth."

The Titian was a kind of thought experiment, never repeated. It was absorbing while it lasted.[89] It did not lead to the abandonment of Magritte painting, though it was of a piece with other forms of experimentation: from

Renoir to Titian is a spit in the eye. All of this confectionery perhaps sprang from a deeper need than pecuniary gain, or the thrill of an alter ego, or the lure of the underworld. Abraham Lincoln is supposed to have said that, after forty, every man gets the face he deserves. Magritte had not yet got this. But forgery was not his forte. Magritte after Titian was no more convincing than Magritte after Picasso or Magritte after Klee. Faking was his *violon d'Ingres*.

10.

1948–1967

He who laughs last laughs loudest.

Paul Éluard, May 11, 1948[1]

Magritte had waited years for a solo exhibition in Paris. Opportunities had come and gone, beginning with the exhibition planned for January 1930 by his friend Camille Goemans, which never happened after the Wall Street crash and the collapse of Goemans's gallery. With no further prospects of showing his work in the art capital of Europe, Magritte had moved back to Brussels. Then the war intervened, and it was only in June 1946 that he could think of looking for another gallery in Paris. Even then the trip was a decision made on the spur of the moment following some "urging from Georgette."[2]

In a fit of what his old friend E. L. T. Mesens dismissed as "juvenile enthusiasm," he walked into a gallery near the Opéra, where an exhibition of paintings by de Chirico had caught his eye. He introduced himself and immediately proposed an exhibition of his own work. The gallery agreed, but the terms they offered were so outrageous that when Mesens learned what was going on he wrote to Magritte, "On the one hand I congratulate you, but on the other, I am amazed that at your age and with the international reputation you now have, you are still prepared to cough up cash for such a venture . . . At this stage, you shouldn't be asking for an exhibition: the Paris and New York galleries should invite you."[3] Presumably Magritte had been in such a hurry to secure a deal with the gallery owner (whose name he failed to catch properly) and

the owner's associate (a young American whose name completely eluded him) that he hadn't noticed something that might have given him pause: twenty or so of the de Chirico paintings on show were fakes.[4] That attempt having failed he also tried to persuade the more prestigious Galerie Pierre (owned by Pierre Loeb) to show his recent "Renoir" paintings, but nothing came of that either. Now, two years later, when a realistic offer of a Paris exhibition came up, instead of seizing the opportunity to court wider critical approval, Magritte went out of his way to sabotage the whole affair.

Little is known about the director of the small, unassuming Galerie du Faubourg at 45 rue du Faubourg Saint-Honoré, which offered to host the long-awaited Paris exhibition, other than that he was called "Monsieur Buydens." Magritte wrote to one of his contacts asking him to "take the temperature of the place without appearing to do so."[5] Buydens, who, from his name, may well have been Belgian, had proposed showing Magritte's work when he visited Brussels at the beginning of 1948. The exhibition opened on May 11. By the time it closed on June 5 not one of the fifteen oils or ten gouaches shown there had been sold. This was hardly surprising, given that from the start Magritte had planned the exhibition to be "a demonstration of pleasure," knowing full well that "the commercial results, desirable though they may be, do not at the moment seem likely to be considerable."[6] The word *pleasure* suggests that he was thinking of showing his "Renoir" paintings, the ones that had been turned down earlier by Pierre Loeb, but if this had been the plan, he changed his mind. The exhibition was to be something else altogether, a provocation—a show of vulgarity, a crude "Up yours" to Breton and his high-minded circle.

Stung by Breton's brutal condemnation of his vision of sunlit surrealism, in remarks published by Breton the previous year on the occasion of an international exhibition of surrealism at the Galerie Maeght in Paris,[7] Magritte now retorted in a series of brash, cartoonish, slangy pictures he dubbed "*vache*" (literally "cow," but meaning "stupid" or "crass"), painted in the spirit of the popular comic strips Magritte and Louis Scutenaire particularly relished. Scutenaire, his co-conspirator, contributed a catalog text, "Les Pieds dans le Plat," written in an exaggerated Walloon dialect. Its rough street-style prose was another insult directed at the literary refinement of Breton and the Paris surrealists. Breton had likened Magritte's proposals for a new sunlit form of surrealism to those of a backward child "who, to make sure he has a nice day, conceives the bright idea of fixing the needle of the barometer to 'set fair.'"[8] In short, he had accused Magritte of infantile behavior. Magritte's response was to throw that accusation back in Breton's face, upping the stakes by turning to the cartoons of the Belgian comics of his childhood, particularly those which,

according to Scutenaire, "treated mankind with an almost delirious expressionist virulence, frightful distortions in hideous colours."[9] Inspired by a cartoonist like Louis Forton (one of his old favorites), Magritte's *vache* images make the most of the brashness and bravado of children's comics. It is typical of Magritte's love of paradox, however, that the large, splashy patches of color such as those in the gouache *L'Art de vivre* [color plate 44], for example, are as deftly and meticulously executed as any found in a painting by Joan Miró (whose style Magritte may well be parodying here). As it is, parody is given full rein. Take *La Famine (The Famine)* [color plate 45], in which five cartoon characters set about devouring each other, possibly a reference to the ferocious disputes between skeletons, puppets, or masked figures painted by another Belgian, James Ensor. Or, given Magritte's love of animated cartoons, did he have in mind Tex Avery's 1943 *What's Buzzin' Buzzard?*, in which two turkey vultures run around trying to peck each other to pieces? In *Lola de Valence*, a nude, and the most serene of his *vache* works, Magritte borrowed from Matisse (as he did more than once), enlisting the Frenchman's light and fluid style of drawing while lifting the title from a famous painting by Manet.[10] Many of these paintings border on the hallucinatory. The background of *Jean-Marie* (featuring a well-known one-legged Paris painter and renowned transvestite) is made up of strips of scarlet laid over a brilliant orange to form a Scottish plaid "sunset."[11] Faces swell out from breasts, knees, and feet like angry boils ready to be lanced (*Titania*), bulbous noses sprout in triplicate (*Le Stropiat—The Cripple*), a rhinocerous scrambles up a fluted stone column that cracks under its weight (*Le Montagnard—The Mountain Dweller*), a masked policeman brandishes his truncheon in front of the Eiffel Tower (*Flûte!—Drat It!*), and so on.

Magritte executed the *vache* paintings with a manic energy. Scutenaire recalled his state of almost uncontrollable excitement, how as soon as an idea came to him he would race to the telephone in a nearby grocer's shop, rattle off the image to a friend, race back home and paint it, then set off again to the grocer's and triumphantly announce its completion.[12] Breton had failed to notice (or chosen to ignore) that in proposing a new form of surrealism and challenging him to accept it, Magritte was faithfully adhering to the surrealist spirit of permanent revolution. As he told Mariën, "Surrealism is not an aesthetic. It is a state of revolt that should not be confused with irrationality, cruelty or scandal."[13] As it turned out, no visitor to the exhibition cared to see the *vache* paintings in this revolutionary light, except perhaps Paul Éluard, who wrote in the gallery's *livre d'or* (the visitors' book), "He who laughs last laughs loudest." Of all the Paris surrealists, Éluard was the one most sympathetic to Magritte. He not only appreciated him the most but also understood why his relations

with Breton were often so tetchy. Breton thought Magritte uncouth. Magritte thought Breton a snob. Neither was wrong. Bubbling underneath Magritte's relations with the Paris surrealists was the unacknowledged question of class. Camille Goemans relates how he and Éluard decided one day to remonstrate with Magritte about his pronounced Walloon accent, an accent Magritte took pleasure in exaggerating "until it became almost aggressive." "It was an epic discussion," Goemans remembered, "which lasted until late into the evening, and Éluard and I were completely routed. Magritte intended to keep his accent and that he saw absolutely no reason to get rid of it."[14] He also pointed out that by asking him to speak French without his heavy Charleroi accent they were supporting caste prejudice, both social and intellectual. According to Goemans, both he and Éluard retired from the argument, shamed. That "epic discussion" had taken place in the summer of 1929 when Magritte and Georgette, Éluard, and his girlfriend Gala joined Salvador Dalí in Cadaques. Now, nearly twenty years later, Magritte used that perceived "caste prejudice" as a stick to beat Breton and the rest of the French surrealist clique. Through the *vache* paintings, he heckled his Paris audience in the crudest, most aggressively vulgar "accent" he could muster (as his friend the American painter William Copley said, "[H]e liked his vulgarity vulgar").[15]

What Éluard really thought of the *vache* paintings is not known (the quip he wrote in the visitors' book, however prescient, was an equivocation rather than an endorsement), but he was one of the few who understood that it might be premature to pass judgment on the work. As Magritte could not afford to have the pictures sent back to Brussels, he stored them with his wife's relations in Paris, where they remained forgotten until the mid-1950s. Over the next few years younger artists like Jean Dubuffet and Pierre Alechinsky, together with other painters of the influential Cobra group, an artist collective formed in Paris the same year Magritte showed his *vache* paintings, demonstrated through their own freewheeling and spontaneous imagery how in tune with his own time Magritte had been.[16] He later claimed to have given up his short-lived *vache* style for the sake of his Georgette. Discouraged by the harsh reception in Paris, she begged him to return to painting more acceptable works. According to the Belgian writer Jacques Wergifosse, then a young Magritte "disciple," the *vache* episode was not just abandoned: it was ceremoniously dissolved. One day, so Wergifosse recalled, Magritte called a meeting of his brother Paul, Scutenaire, and Wergifosse, and emotionally announced that he would be returning to his old style of painting. He then offered each of his guests a gouache version of *Le Stropiat* (*The Cripple*).[17] Was his choice of souvenir a bitter joke about feeling "crippled" by financial necessity? He made Scutenaire a promise: "I'll find a way to insert something big and really

incongruous now and then. And it won't stop us publishing for fun. It'll be work outside studio hours for me, the way it's outside office hours for Scut."[18] The insolence of the *vache* paintings, and Magritte's exhilaration in executing them, is reminiscent of several notorious episodes from his childhood; this was the equivalent of putting yeast down the toilets or flinging excrement over the neighbors' roofs. But then, as Baudelaire observed, "Genius is no more than childhood recaptured at will."

He gave up the comic violence—but not the comedy. He still had the French art world in his sights; now the attacks would be subversive, the mockery masked by a more conventional technique. Appropriation was the way forward. Thus in *Perspective: Le Balcon de Manet* (1949), four upright wooden coffins replace the four personages in Edouard Manet's *Le Balcon* (*The Balcony*);[19] in *Perspective: Madame Récamier de David* (1950), a coffin reclines on a chaise longue in exactly the same pose as the sitter appears in Jacques-Louis David's famous portrait.[20] François Gérard's portrait of the same sitter, *Perspective: Madame Récamier de Gérard* (1950), meets a similar fate.[21] (This was not the first time Magritte had reworked masterpieces of nineteenth-century French painting: several images from his sunlit or impressionist period (1943–46) had appropriated well-known images such as Ingres's *La Source*,[22] or the various Renoir nudes reproduced in the books he had collected on the subject.) Parody had long been a favorite weapon of the Brussels surrealists. Magritte's treatment of famous French painters had much in common with Nougé's treatment of famous French writers back in the days of *Correspondance*. By interring the men and women painted by David, Gérard, and Manet, Magritte set out to bury the reverence accorded to well-known works of art. The "coffin" paintings proved a more subversive way of taking it out on the French. Mariën recalled the moment he and Nougé were shown the first work in the series: "Magritte began by painting a little gouache with a frontal view of a seated coffin installed in an armchair. I well remember that when Nougé and I saw it together for the first time, our immediate reaction was to burst out laughing." Hardly surprising, given that Magritte's poker-faced humor reflected Nougé's own sense of the ridiculous—and he responded in kind by thinking up the ambiguous title *Perspective*. (He was a Buster Keaton fan, whereas Magritte preferred the slapstick comedy of Laurel and Hardy.) The series of *Perspective* paintings, following on so soon after the *vache* period, was Magritte's way of continuing to mock the values of the Paris bourgeoisie while appearing to repent a moment of folly.

Provocation was the watchword of the Brussels surrealists—and if their means of offending were often crude, so much the better. They liked to live up to the popular French stereotype of an old joke. Question: "What is the

difference between a potato and a Belgian?" Answer: "A potato is cultivated."
Shortly before Magritte had gone in search of a Paris gallery in June 1946,
he had joined with Nougé and Mariën in producing and distributing three
anonymous tracts, "L'Imbécile" ("The Imbecile"), "L'Emmerdeur" ("The
Pain in the Arse"), and "L'Enculeur" ("The Motherfucker"). The content of
these flimsy single-sheet pamphlets was so crude, so coarsely worded (e.g.,
"Every day, at every moment, one patriot at least shits without scruples on the
sacred soil of the fatherland"), that they had hardly appeared on the streets
before they were confiscated by the postal authorities. The tracts were fol-

lowed by a hoax prospectus for a lecture series given by a fictitious Bulgarian sexologist promising live demonstrations (which is said to have provoked a frantic demand for tickets). With these scurrilous episodes in mind, together with the humiliating treatment Magritte had received from Breton, followed by his own failure to interest a major Paris dealer in giving him a show, the *vache* paintings and the fiasco that followed at the Galerie du Faubourg are easier to understand. In fact the Paris episode should be seen as a group manifestation on a par with the offending tracts and the hoax prospectus. Without the collaboration and support of Scutenaire, Colinet, and Mariën—his closest friends and allies—it is unlikely that Magritte would have thrown himself so wholeheartedly into a venture guaranteed to end in critical opprobrium and financial disappointment.

Unlike the *vache* paintings shown in Paris, however, the *Perspective* series was an immediate success. When *Perspective: Le Balcon de Manet* was first shown in 1951 at Iolas's gallery in New York, it was, according to Iolas himself, "the masterpiece of the exhibition." He liked it so much he bought it outright, selling it a few years later to the wealthy Houston collectors Jean and Dominique de Menil.[23] Over the years, Magritte's business relations with Alexander Iolas had evolved into a new kind of collaboration. In 1950, when Iolas and Magritte were in the middle of their increasingly fractious discussions about his forthcoming exhibition in New York, Iolas sent an urgent request: "I am writing to you in connection with roses, because there is a very important lady here who has started a very extraordinary review;[24] she likes roses and I showed her your work out of interest and she asked me if you have painted any pictures with roses . . . if you have any ideas [for pictures] with brilliant roses, let me know immediately because I am absolutely insistent that we should sell her something; she can help us a great deal."[25] Magritte's reply opened with a question many an artist has wanted to put to his dealer: "Do your judgements on my work depend on its power to attract buyers?" And he continued: "I put the question to you because up till now you have advised me not to send pictures with roses, and here you are asking for some because a lady likes roses? I can take this point of view into consideration but in that case we are operating on a purely commercial level, and there is no longer any question of judging my work from an artistic point of view." He goes on to make an important point, reminding Iolas that while older works of his, such as *Le Modèle rouge* (*The Red Model*), had failed to attract buyers when they were new, "Now, with time, buyers like this picture (you have sold quite a lot of replicas), but this does not prove that buyers are now more intelligent than fifteen years ago when no one wanted to buy the first red model." And he tells Iolas, "What you most need are replicas of pictures already known and assimilated."

In spelling out to Iolas what paintings of his the gallery should be selling, Magritte used the word *répliques* (replicas) rather than *variantes* (variations or versions), the word he used more frequently. Iolas had given him his first real chance of developing a market for his work outside Belgium, and he was quick to take advantage. Before long he was in the habit of producing at least two versions of an image he thought would be successful: one for the Belgian market and one for New York.[26] On the whole Iolas turned a blind eye to Magritte selling works behind his back (sometimes these were deliberately misdated on the canvas verso). He continued to encourage him by promising sales, exhibitions, and critical recognition, but, as Magritte was to find out, Iolas could be every bit as slippery as Magritte was himself. Plans for the exhibition, which opened in New York at Iolas's Hugo Gallery in late March 1951, had a rocky start. It had first been discussed in February 1949; then it had been firmly scheduled twice, followed by a long silence on the part of Iolas. A letter from Magritte written on March 9, 1951, shows his frustration with the long unexplained delays:

> Your replies to my letters being notable by their absence, I don't know what suppositions to entertain, and in order to achieve some result I am writing an "official" letter to the Hugo Gallery, asking for this letter to be forwarded to you in case you are absent from New York. . . . It is now completely impossible for me to accept your apparent or real silence any longer. I cannot doubt this time that you, who are my valued collaborator and I hope my friend, will be concerned, by return of post, to improve and rectify an embarrassing situation hardly conducive to the normal output of new masterpieces and deplorable from all points of view.

Iolas's excuse was to plead illness (he had been laid up with flu) followed by a large dose of flattery: "Today is a great day for me," he wrote on March 21, just as the exhibition was finally opening, "I have had your third private view, and I like your pictures a lot better now. The masterpiece of the exhibition is Manet's Balcony. Here we have a painting with new, and very, very strange ideas. If I had ten pictures by you like that one, I would be the happiest man in the world."[27] However, he had failed to let Magritte know when the exhibition was opening (telling him only after the third private view), just as he failed to inform him that he had added some old paintings that, in his own words, "had already been seen and were less impressive," thus diluting the effect the new works would have had if shown on their own. In other words, Magritte, who was used to calling the shots, suddenly found himself at the mercy of others. Events were no longer his to control. But when it came to dealing with Iolas he

was forced to accept that he was not, and never would be, the one in charge. It was Iolas who had the American contacts; he was socially adept as well as commercially astute, and had built up an impressive clientele that included names like Rockefeller,[28] Pulitzer, de Menil. He knew what would sell and who would buy, and he was loath to let any opportunity pass him by. For example, in the autumn of 1953, the New York City Ballet arrived in Brussels to perform at the Théatre de la Monnaie. Iolas, who in his previous life had been a dancer with the company, and was friendly with the star choreographer George Balanchine, seized on their visit as a way of bringing about a collaboration between Magritte and Balanchine that, if successful, might be counted on to bring in more business. He was quite frank with Magritte, telling him, "It is an astonishing chance for publicity and would make your name still better known here. I have asked for 100,000 (a hundred thousand francs) as your payment for the work, and I think you should accept nothing less."[29] Advising Magritte he must on no account sell Balanchine (or the director of NYCB, Lincoln Kirstein) a picture for less than 50,000 francs, he added, "Because I definitely advise you that we must pull it off this year and sell at the same high prices as Picasso, otherwise all our efforts will have counted for nothing."[30] It could be argued that Magritte's submissiveness in his relations with Iolas led to his trying his best to please him, but this would be unfair both to him and to Iolas, who, on the whole, appreciated the power and significance of Magritte's images. If Magritte sometimes gave in to Iolas's pleas for new versions of old images, he was adamant when it came to defending a new work he felt strongly about. *Les Valeurs personelles* (*Personal Values*) [color plate 36], for example, which he offered to Iolas in April 1952, shows a bedroom with walls of sky and five magnified objects: a match, a comb, a wineglass, a bar of soap, and a shaving brush. Iolas agreed to buy the painting on the basis of a sketch and a photograph, but when he actually saw it he was appalled. The colors, he told Magritte, made him feel sick (the bilious pink soap may have been too much for him). "I am so depressed that I cannot yet get used to it," he complained. "It may be a masterpiece but every time I look at it I feel ill. I would be very grateful if you could write to me about this picture because it leaves me helpless, it puzzles me, it makes me feel confused and I don't know if I like it." Magritte replied at length, pointing out that if the painting left the spectator feeling helpless or even ill, "Well, this is proof of the effectiveness of the picture. A picture which is really alive should make the spectator feel ill, and if the spectators aren't ill, it is because 1) they are too insensitive, 2) they have got used to this uneasy feeling, which they take to be pleasure."[31] His argument did little to persuade Iolas, who refused to buy it.[32]

Les Valeurs personelles, one of the masterpieces of the early 1950s, is in a

long line of paintings of that period that set out to jolt the audience out of complacency, to provoke in them feelings of discomfort and unease. Magritte's images of domestic spaces are based on the narrow dark interiors of the houses in Schaerbeck and Jette—the districts in Brussels where he and his friends lived. In works such as *La Chambre d'écoute* (*The Listening Room*), 1952, and *Les Valeurs personelles*, for instance, the comforting familiarity of the known is displaced by anxiety and trepidation. The *Perspective* series of coffin paintings, while humorous in intention, turned out to be a prelude to more forbidding images. Magritte had enjoyed entombing the art of French museums by "revising" the paintings of Manet and David, but parody had its limits. In new works such as *Le Château hanté* (*The Haunted Castle*), 1950, *Le Chant de la violette* (*The Song of the Violet*), 1951, and *Souvenir du voyage* (*Memory of a Journey*), 1952, Magritte gives way to his underlying pessimism by imagining a world turned entirely to stone. Humor has been put aside. The mood is more in tune with a fatalistic text he had written in September 1948:

"This disorderly world which is our world swarming with contradictions still hangs more or less together through explanations by turns complex and ingenious, but apparently justifying it and excusing those who meanly take advantage of it."[33]

Painted in various degrees of *grisaille* (that is to say, executed in shades of gray or another neutral grayish color), these petrified landscapes, figures, and still lifes are somber in both mood and color. Magritte had a particular fondness for grisaille, which may have had its origins in the nineteenth-century engravings of desolate rock-filled landscapes that illustrated the Jules Verne novels he liked so much. The dead moonscapes imagined in both books and film at the turn of the twentieth century, such as Verne's *From the Earth to the Moon* or George Méliès's celebrated one-reel movie, *Le Voyage dans la Lune*, may well have struck a chord with the young Magritte. Another likely source of inspiration was an article by the art historian and critic Carl Einstein on the landscape engravings of the virtually forgotten seventeenth-century Dutch artist Hercules Seghers.[34] This had appeared in the surrealist magazine *Documents* in September 1929, an issue Magritte could hardly have missed. Seghers's rocky landscapes, which "betray a despair that paralyses like a cramp," would surely have appealed to Magritte, as would Einstein's belief that Seghers's images represented "a narrow isolated revolt against everything that can be called Dutch." Here was an old master who, like Magritte, expressed his contempt for the art universally admired in his own time by pronouncing it well and truly dead. As Einstein put it, "[T]he organic continuity of Dutch art congeals into a kind of oppressive, petrified horror." The godforsaken, impenetrable world of rock Magritte imagines could be described in the same way.

Metamorphosis had been a theme Magritte had pursued since his 1927 series of paintings in which skies, landscapes, and figures gradually turn into wood. The "petrification" paintings have the same storybook quality as those earlier works, but the mood is more ambiguous. Even though the world he imagines is empty of life, cold and silent, much like the deserted worlds in Jules Verne's *Voyage au centre de la terre*, it has its moments of unexpected tenderness. In *Journal intime (Private Diary)*, a bowler-hatted man comes to the aid of

a companion troubled by something in his eye, while the rock-strewn world inhabited by another anonymous male couple is relieved by the paradoxically sweet title, *Le Chant de la violette* (*The Song of the Violet*). Like the characters in Beckett's *Waiting for Godot* (published in 1952), these soberly dressed passersby find themselves alone in an indifferent universe.

It is not hard to imagine an interior such as the one seen in *Souvenir du voyage* realized in three dimensions as a large relief sculpture, for example, or, remembering the toy theaters of Magritte's childhood, a stage set for a play by Beckett or Pinter. A round table covered with a tablecloth is placed in front of French windows that open directly onto a rocky cliff face, so close it feels within touching distance. Everything in the painting—book, bowl of fruit, bottle of wine and glass—is made of the same gray stone as the rock pressing relentlessly in from the outside. No still life could be more literally a "nature

morte." The effect would be one of utter despair were it not for the beauty Magritte finds in the meticulously rendered texture and variegated colors of the rock. Stones were of great significance to Magritte. As powerful agents of timelessness and silence, they stood for the qualities he had recognized early on in the paintings of de Chirico, and which had moved him profoundly. A massive boulder dominates *La Voix active* (*The Active Voice*), challenging the viewer to enter into the silent communication implicit in Magritte's observation, "[S]tones reveal to us the perfection of their existence."[35] The rock in *La Voix active*, for instance, assumes the authority of a religious archetype through its magnificent isolation. That's the opinion of the artist Jeff Koons, the owner of several Magritte paintings, who gives as another example the giant green apple filling *La Chambre d'ecoute*. "Everybody can relate to the apple: you can think of the apple within, say, Christianity and the Garden of Eden."[36] Precisely so. In a later work, *Le Fils de l'homme* (*The Son*

of Man), 1964, the symbol of the Fall obscures the face of man.[37] Anticleri-cal Magritte certainly was, but he was not immune to centuries of powerful Christian imagery. Not for nothing have his "stone" paintings been compared to the grisaille backs of the shutters of Flemish triptychs.[38] In 1930 he had painted *The Annunciation*, a title that traditionally demands an unquestion-ing acceptance of mystery. In that work Magritte shows four invented objects (a corrugated-metal curtain, two identical wooden bilboquets, and a paper cut-out), grouped together in the open air, watching and waiting as though in expectation of some imminent and momentous event. As the painter David Salle has pointed out, "[A]mbiguity keeps on giving."[39]

The coffin paintings closely followed by the stone paintings bring into focus one of Magritte's most powerfully expressed and tenacious ideas: our inability to see beyond the world we inhabit.

The 1950s were transformative years. Thanks to Iolas, who was building a steady client base for the artist's work in America, and thanks to Magritte's own circle of collectors and supporters back home, the financial worries that had plagued him for the past twenty years were now less of a burden. America, not Belgium, was to be responsible for Magritte's future prosperity and criti-cal standing. Iolas created a healthy market, and well-connected friends like Jan Albert Goris,[40] a Belgian diplomat who served as cultural envoy to the U.S., worked tirelessly to encourage American museums to show his work, but there is only so much that even the most active art dealer and the most influential friend can do when it comes to establishing reputations. When all is said and done, it is the opinions of other artists that count the most. Enter Marcel Duchamp. As far back as 1915, Duchamp had urged America to believe "that the art of Europe is finished—dead—and that America is the country of the future."[41] Dramatic as his announcement was intended to be, he remained intensely loyal to his European artist friends, acting as a skillful and discreet go-between, making sure they found opportunities in America that otherwise would not have been open to them. When, for instance, the artist William Copley opened his short-lived gallery in Beverly Hills,[42] together with his brother-in-law John Ployardt (who had worked with Walt Disney Studios as an animator and narrator),[43] he relied heavily on Duchamp to provide intro-ductions to major surrealist artists who had taken refuge in America. Through Duchamp, Copley met Iolas, and within six months his new gallery had pre-sented exhibitions by Magritte, Matta, Man Ray, and Ernst. Duchamp's repu-tation was such that one word from him was enough to open any American door.[44] Indeed Jean and Dominique de Menil's interest in Magritte had been "sparked off and legitimised" by Duchamp's own high regard for the artist.[45]

Magritte must have been aware of Duchamp from very early on. When

Mesens paid his first visit to Paris, in December 1921, he had been introduced to Duchamp by Tristan Tzara and would certainly have reported that meeting back to his friends in Brussels. When Duchamp began to be aware of Magritte is less clear, but he recognized an important Magritte painting when he saw one. In 1937 he had arranged for Louise and Walter Arensberg to acquire Magritte's 1929 painting *Les Six Éléments* (*The Six Elements*).[46] The work had previously belonged to Breton, for whom Duchamp had probably acted as an intermediary.[47] Ten years later Duchamp advised his close friend Maria Martins to buy Magritte's second version of *Le Modèle rouge* from the artist's first exhibition at Iolas's Hugo Gallery in 1947 (Breton had chosen it in 1945 as the cover illustration to the second edition of *Le Surréalisme et la peinture*). The common ground between Duchamp and Magritte lay in a mutual desire "to relocate painting in the service of the mind."[48] For Duchamp this was the essential quality for the "post-retinal art" he had aspired to in *The Large Glass*, the 1915 work that Breton, for one, recognized as totally unprecedented. When Duchamp complained that ever since Courbet painting had only been concerned with the eye, he made the point that previously "it had had other functions: it could be religious, philosophical, moral."[49] Besides a desire to return art to a more "functional" purpose, so that it might be seen as a means of enlightenment rather than a source of pleasure, Magritte, like Duchamp, wanted to escape the trap of the artist's "touch," meaning the seductive brushwork of a painter like Monet or Renoir, for instance. He once told an interviewer, "I always try to make sure that the actual painting isn't noticed, that it is as little visible as possible. I work rather like the sort of writer who tries to find the simplest tone, who eschews all stylistic effects so that the only thing the reader is able to see in his work is the idea he was trying to express. So the act of painting is hidden."[50]

Duchamp was undoubtedly helpful to Magritte and did what he could to place his work in important collections, but what he really thought of him remains somewhat opaque. When Iolas asked him to contribute a preface to an exhibition of Magritte paintings at his gallery in March 1959, Duchamp provided a punning text of just eleven words. "Des Magritte en cher, en hausse, en noir et en c uleurs." Like all Duchamp's puns it is nearly impossible to translate, but the gist of it is this: Magritte's pictures are expensive (*cher*) and the prices are going up (*en hausse*), *en noir* (a reference to his drawings), and he fucks the public (*en c uleurs*), the last word being not just a coarse pun on the word for color (*couleur*) but also a knowing reference to "L'Enculeur" ("The Motherfucker"), the title of one of the three anonymous tracts Magritte had published and distributed in 1946 with the help of Nougé and Mariën. Magritte was disappointed. He complained to Torczyner that while he appre-

ciated Duchamp's "unique humour," he had expected a preface and "not something so limited and minuscule as a small rodent."[51] He might have guessed that it was not Duchamp's way to endorse or judge, especially when it came to his fellow artists. In spite of being at the center of the art world, Duchamp was careful to keep a certain distance from it. As one interviewer put it, "He was unwilling to play the game."[52]

If Duchamp held back, a younger generation needed no prompting. In 1962 Torczyner told Magritte, "There is a new school of painting in the US, grouped around the Castelli gallery and who paint huge 'réclames' for Coca-Cola etc. These gentlemen say they admire 'maitre Magritte' and particularly those of his works that contain 'words.'"[53] The "gentlemen" in question included Jasper Johns, Andy Warhol, Roy Lichtenstein, and Robert Rauschenberg. By the early 1960s, Leo Castelli had become the most influential art dealer in America.[54] When critics and artists alike chided him for championing fledgling painters like Johns and Rauschenberg, and for promoting a movement like "pop art," which they felt had unfairly usurped abstract expressionism, he replied that painting was "what artists make of it." "One does not have to like it, but one cannot discard it," he continued. "One can lament a certain fashion, but one . . . just cannot say: 'This is not art, it will go away.'"[55] He was ruthless in defending the artists he believed in: "There are those unsuccessful Abstract Expressionists who accuse me of killing them; they blame me for their funerals," he said. "But they were dead already. I just helped remove the bodies."

The year Castelli discovered Johns and Rauschenberg[56] was also the year *Word vs Image*, an exhibition of twenty-one word pictures realized by Magritte between 1927 and 1930, opened at the Sidney Janis Gallery in New York. The show was a stroke of genius, and the person responsible was Magritte's old friend and adversary, E. L. T. Mesens.[57] Mesens's London Gallery had finally closed down in July 1950,[58] and he was on the lookout for new business opportunities, particularly in his native Belgium. As the owner of more than 150 paintings by Magritte he was now in a unique position to help build the painter's reputation both at home and abroad. As it turned out, what Iolas was to do for Magritte in America, Mesens was to do for him in Europe, starting with Belgium. But in the meantime, why turn down an opportunity to join forces with a New York gallery? The idea for *Word vs Image* was hatched at a meeting in Brussels that Mesens had arranged in order to show Sidney Janis his treasure trove of Magritte paintings. Mesens, who knew better than to go behind Iolas's back, persuaded him that a Magritte show in a rival New York gallery would only serve to strengthen Iolas's own position as the artist's U.S. dealer. Iolas, no fool, agreed. From his point of

view an exhibition made up of some unknown paintings from Magritte's past would probably be a commercial flop, which it was. But, like the exhibition of the *vache* paintings some six years earlier, it was a flop that in time would become a legend. Once again, it was the artists who were the first to respond, who understood that they were seeing something new and extraordinary. In the words of the painter Ed Ruscha, it was through Magritte that young artists like Johns and Rauschenberg were alerted to "some alternative way of thinking that was strong." So impressed were they that by 1960–61 both artists, now on the cusp of huge success, were buying (or trying to buy) works by Magritte. Johns told his biographer, Roberta Bernstein, that the first painting by Magritte he wanted to own (but couldn't afford) was *Le Mois des vendanges* (*The Month of the Grape Harvest*), 1959,[59] a work he would have seen in 1961 at the Galerie Rive Droite in Paris, where he was showing at the time, and where Magritte had shown the previous year. The crowd of identical bowler-hatted men looking into a room through an open window presents a scene that begs an explanation. Johns, one suspects, appreciated the suspense and the ambiguity created by a narrative only half told. (The way Magritte arouses and then frustrates expectations is rather like watching a film and finding the next reel is missing.) He went on to own seven works by Magritte: a word painting, *La Clef des songes* (*The Interpretation of Dreams*), and six works on paper. Rauschenberg, for his part, collected six works: another word painting, also titled *Le Sens propre;* one of the five canvases that made up the 1945 version of *L'Évidence éternelle*, and four works on paper.[60] Ruscha, a younger admirer of Magritte, has a useful word of warning about assumptions too easily made by what he calls "the happy-go-lucky art world." "They want to encapsulate what they think it is all about," he told an interviewer, "so they throw these artists together, and they might put Magritte in there with a pop artist because they sometimes use related imagery and they use irony. So you get a kind of simplistic sifting of thoughts and realities into what they think art is all about."[61] With that in mind, the answer to why Johns was so drawn to *Le Mois des vendanges* is best answered by Magritte himself, who, when complimenting Torczyner on acquiring a preliminary sketch for the painting, told him it was "the one which best reminds us how strange reality can be, if one has 'a sense of reality.'" Younger artists have followed suit. Ruscha saw in his work "all kinds of possibilities." "It can fire off in many different directions," he said, "but he always manages to have a point of view."[62] Jeff Koons admires its "accessibility": "Magritte is very much about the things that we all experience and the sensations of daily life that we all encounter," he told an interviewer. Taking *L'Empire des lumières* as an example, Koons says, "We've all experienced twilight, that moment when it's both light and dark at the

same time. I was thinking, just exaggerate this slightly, with more shadow here, and this would be that moment exactly in the painting. There's a reality in the seemingly unrealistic moments he creates, even though he makes these strange juxtapositions. He predated Photoshop, when you think about it."[63]

The early 1950s saw friendships of many years beginning to fracture. Magritte's growing success at home and abroad was beginning to set him apart from his peers. For a long time now, since his exhibition at the Galerie L'Époque in January 1928, when the brief catalog preface by Nougé had effectively announced the formation of the Brussels surrealist group, Magritte had been at the center of all their joint activity. Nougé, who was indisputably the leader of the Brussels surrealists while at the same time choosing to remain in the shadows, had elevated him to that position when he ended his preface, "[W]e have no reservations about declaring ourselves here and now the accomplices of René Magritte."[64] By the early 1950s Nougé had ceased to participate in any surrealist activity: political activism now kept him busy. He sold the Belgian Communist Party's paper *Le Drapeau rouge*, for instance, and started to learn Russian, and in 1951, he took part in the Tenth National Congress of the Communist Party at the invitation of the Central Committee.[65] By 1953, however, the consequences of Nougé's alcoholism could no longer be ignored. His wretched state is vividly described by the painter Jane Graverol, a close friend of his who was also Mariën's lover at the time. On receiving a telegram from Nougé asking her to come and see him, she arrived at his Brussels home in the rue Le Tintoret to find him almost catatonic and living in squalor: "a house out of a nightmare. Dilapidated furniture; in the main room, sitting at a table, a heavy ponderous man apparently strangely calm, was looking at tiny objects; to the left a bed with a mattress that had been lacerated with a knife, wool and horsehair trailing through the slits; torn sheets hanging down; opposite, the kitchen was a hecatomb of dirty crockery and broken household equipment."[66] Graverol took Nougé and his cat to stay with her in Verviers, "where for a few weeks at my house he experienced a calm the very existence of which he had forgotten."[67] For his part, Mariën gathered together heaps of Nougé's discarded manuscripts and set about finding a publisher. Piqued by a remark by Mesens about Nougé's "literary non-existence"[68] and frustrated by the lack of interest from any publishing house in either Belgium or France, Mariën, who had next to no money, decided to pay for the publication himself, and in 1956 Nougé's writings were published under the title *Histoire de ne pas rire*. Ten years later, and once again at his own expense, Mariën published Nougé's poetic works under the title *L'Expérience continue*. In no small way, he had rescued Nougé from oblivion.

A photograph taken in March 1953 on the occasion of a dinner given

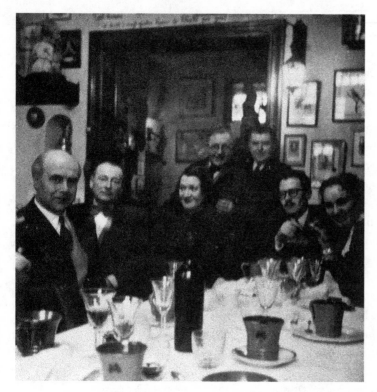

in Brussels to celebrate Mariën's return from sea, where he worked as a kitchen hand aboard a Swedish cargo ship,[69] is one of the last to show the group together, though Nougé was already an absentee. Magritte's ties with Mariën, for many years his closest collaborator and most effective and ingenious "accomplice," would soon unravel. Their differences were ideological rather than personal. Magritte had tried to enlist Mariën's collaboration on a review he initiated in 1952, *La Carte d'après nature*, a publication the size of a postcard. Its inconspicuous appearance followed in the tradition of the small, unpretentious, cheaply produced publications prized by Magritte and his friends. However, Mariën, like Nougé, believed in taking a position that engaged with the political realities of the time, although, as he pointed out to the influential French writer and ethnographer Michel Leiris, the new review he was intending to publish would contain "no element of 'socialist realism' "[70] He named his new magazine *Les Lèvres Nues* (*Naked Lips*), and the first issue appeared in April 1954. Jane Graverol and Nougé were on the editorial board; texts included were by Lenin, Bertolt Brecht, and Nougé. Mariën's own contributions were titled "La Leçon de Maïakovski," "Correspondance avec un homme d'état," and "La Propaganda objective," subjects that leave no doubt as to his political direction. Notably absent in the first issue were any contributions from Magritte, Colinet, Scutenaire, or Irène Hamoir, the old nucleus of the Brussels surrealists. Writing to Gaston Puel in February 1955, Magritte explained his differences with the tone taken by Mariën's new magazine, its political tone in particular: "If at a certain period I had a 'beginner's faith' in an activity involving both social advances and our feelings about life, I now feel no nostalgia for that time of confusion. On the other hand, the present confusion is marked enough

for me not to waste time making it worse (just a little and with no pleasure or interest . . .)."[71]

From now on Magritte's closest friends in Brussels would be Colinet, Scutenaire, and Irène Hamoir. All three continued to support Magritte by supplying ideas for paintings as well as titles, and, from 1956 on, performing in the home movies that were Magritte's new passion. Film had become a distraction almost overnight. Scutenaire compared Magritte, armed with his highly prized 8 mm ciné camera, to the Magritte of the short-lived *vache* period:

> When he was painting, Magritte was calm, often bored by having to "labor" (*oeuvrer*) over the canvas, and open to distractions from outside. It was exactly the opposite when he played the film-director; he became excitable and sharp-tongued, but at the same time he greatly enjoyed himself: perhaps he was never happier than when handling the camera, with the exception of the few months of his "vache period," which sparkled with the delights of discovery.[72]

The "delights of discovery" that Magritte's *vache* paintings share with his home movies came from the endless pleasure he took in slapstick humor. An extract from an illustrated scenario found in an undated letter to Colinet shows the sort of farcical situations Magritte invented for his friends to play out:

> 1. Scut [Scutenaire] as a hunchback (with a cushion on his back under his jacket)
> 2. Colinet appears with a bowler hat and a carrot. He barks in military fashion at Scut who stands to attention with his tongue out
> 3. Colinet calls out gymnastic commands which Scut executes (very clumsily). Goose-step etc.
> 4. Col [Colinet] points authoritatively to a chair. Scut sits down on it. Col. folds his arms. Irine [Irène Hamoir] appears with a shaving kit and lathers Scut's face.[73]

And so on. Magritte ends his letter with the laconic instruction "try to be brilliant." Once again he was the one in charge. He allowed his "actors" some latitude when it came to improvisations, but as Scutenaire saw for himself, "on others he imposed both gestures and expressions as severely as the most implacable director." Not for the first time there are echoes of the homemade toy theater of Magritte's childhood,[74] but what comes across most strongly is

his love of the silent film comedies he saw as a teenager in Charleroi. Scutenaire again: "To watch Magritte behind the camera was a sight for sore eyes: nothing was funnier than his glee when all was going well unless it was his fury when something went wrong. And I liked to hear him declaring: 'It's not a flick I'm making, it's not a movie; this is cinematography.'"[75] It was a craze that lasted barely a year. Colinet fell ill with cancer and died in December 1957. He had been their brilliant clown, a natural comedian. Without him, the fun went out of it, and the ciné camera was put away.

Magritte had now lost three of his closest friends and collaborators: Nougé, Mariën, and Colinet. Other, younger friends appeared on the scene; such as the Paris-based artists Maurice Rapin and Mirabelle Dors, who, under the imprint *La Tendance Populaire*, published six tracts on Magritte between November 1957 and May 1958, with the help of the artist himself. Rapin's commitment to a more populist form of surrealism ended up annoying Magritte, touched though he was by Rapin's support at a time when he was particularly out of favor with the followers of Breton. Then there was André Bosmans, a quiet, reserved twenty-year-old poet who was earning his living as a schoolteacher and a part-time librarian on the outskirts of Liège. This would be a more productive friendship. Mostly conducted through a voluminous correspondence (more than four hundred letters from Magritte),[76] it proved fulfilling on many levels. Bosmans was the least combative of Magritte's collaborators as well as the most obliging and reliable (the forty-year difference in age probably played its part). He was also devoted and hardworking: in November 1960 he had an important role in organizing a retrospective of Magritte's work at the Musée des Beaux-Arts in Liège, and in the summer of 1961 he brought out the first issue of *Rhétorique*, a review he edited in close collaboration with Magritte, who, true to form, provided editorial advice to most of its thirteen issues.[77] According to Xavier Canonne, "[I]t was Magritte who solicited most of the contributions, dealt directly with the printer and paid the bills."[78] He was back in the driver's seat.

Writing had always been a welcome distraction from painting, but in the later years it became a pressing occupation. The number of letters Magritte wrote is astonishing, especially considering his output as a painter (around 1,100 oil paintings and well over 850 works on paper). Letters to Iolas alone ran into the hundreds, and then there were those he wrote to Harry Torczyner.[79] Torczyner had come into Magritte's life when a friend of the former, hearing he was going to Brussels on business, asked him to call on Magritte and collect a gouache she had been promised. That was in October 1957, and until Magritte's death ten years later the two men kept up a regular correspondence (there are more than five hundred letters from Magritte). At their very first

meeting Magritte was quick to spot how this leading multilingual New York attorney with Belgian roots, an international reputation, and worldwide contacts could be useful to him. "You must travel the skies for me," he told Torczyner. "It would be a pleasure to discover through you distant lands and half barbarous tribes. Since you live in the United States, you could give me news about my dealer [Iolas], my pictures, my friends, even my critics. You could send me reports, minutes, dispatches."[80] So Torczyner became Magritte's "goodwill ambassador" as well as a trusted friend, acting as a go-between with various American museums, advising on financial and legal matters, and later writing a monograph on the artist as well as publishing their correspondence. He also acquired a significant collection of Magritte's paintings.

Meanwhile, Magritte had struck up a correspondence with another successful American lawyer, this one from Chicago. Barnet Hodes was a keen if idiosyncratic collector.[81] Through his friendship with William Copley, Hodes had got to know several leading artists, including Duchamp, Ernst, and Matta, and through these contacts had become an enthusiast of surrealism. (He also acted as Matta's lawyer on a couple of occasions.)[82] Hodes had two ambitions: to own a work by each artist represented in the first surrealist exhibition at the Galerie Pierre in 1925, and to acquire small gouache versions of Magritte's major images. So began an unusual collaboration. Hodes placed his orders by post ("ordering his Magrittes like breakfast," according to Copley),[83] and Magritte patiently carried out his requests, politely answering the American's often prosaic and literal-minded questions. Hodes planned to fill the foyer wall of his Chicago duplex with the small gouaches, which, by the time the area was covered to his satisfaction, numbered fifty-three, only three of which were of new images. Each gouache measures 9 x 7 inches, a size that fit neatly in an envelope that could be mailed to America without incurring any problems with customs (or with Iolas). Between 1956 and 1964 Magritte went along with the Hodes "mail orders" although he was not entirely happy with the lawyer's repeated demands for replicas of works he selected from reproductions found in old exhibition catalogs. Exasperation began to creep in. In a letter written in April 1960, he told Hodes, "It is obvious that if I always repaint the same pictures, I might think I had nothing else to paint!"[84] Nonetheless, the fact that Magritte persevered (realizing some of his most delicately executed gouaches along the way) suggests that he found some satisfaction, even amusement, in the idea of creating a "museum" of his work in miniature. (This unique collection of Magritte "reproductions" was eventually broken up by the heirs to Hodes's estate.)

This was not the first time Magritte had been asked to put old images to new use. A few years before Hodes came into his life Magritte had received

a commission from Gustave Nellens, the wealthy proprietor of the casino at the Belgian seaside resort Knokke-le-Zoute to execute a mural for the casino's Salle de Lustre (the "lustre" being a six-ton chandelier of Venetian glass so enormous it earned a place in the *Guinness Book of Records*).[85] Two motives may have encouraged Nellens to approach Magritte. Paul Delvaux, Belgian's other prominent painter at that time (and no favorite of Magritte's), had recently completed a mural in the gaming room of the newly rebuilt Kursaal in Ostend, and Nellens may have been piqued by competition from a Belgian casino larger than his own. Timing, though, was crucial. He approached Magritte in April 1953 and the opening of the Festival d'Été, the Casino Knokke's main social and cultural event of the year, was planned for early July. Attended by celebrities of stage and screen, it offered a chance to show off a major new artwork. However, whether Nellens regarded the mural as art or as merely a decorative background for his opulent crystal chandelier is open to question. When Magritte turned up for the black-tie evening reception on July 4, Nellens (known to his employees as "the Emperor") waved him away with the words "I do not invite my tradesmen." According to Nellens's son Roger, Nellens had been offended by Magritte's demands for more money, possibly as reimbursement for travel expenses (as Nellens claimed) or perhaps (as Magritte later insisted) on behalf of Colinet, who had written the poetic texts accompanying the catalog for the inauguration and had not been paid. The rift was temporary, for they had too many friends in common; Nellens was an old school friend of Torczyner's, and P.-G. Van Hecke was a business partner. Before long, Magritte was back in Knokke spending a couple of weeks at La Réserve, the luxury hotel owned by Nellens.

Such was the scale of the Knokke mural, and the speed demanded by Nellens, that a team of painters was required (Magritte supervised the work closely but did not contribute to its execution). The room with curving corners measures 23.8 x 21.3 meters (roughly 78 x 70 feet), and the mural, which is placed above a coffered dado, runs around the room as a continuous panorama divided into eight sections by flat pilasters. The various scenes, possibly devised with the help of Colinet, were created by bringing together existing images (mostly from the past twenty years) and projected onto the wall to make new "scenarios." The whole scheme is unified by two of Magritte's trademark backgrounds: a blue sky with snowy white clouds, and a red heavily pleated "movie theater" curtain. Although Magritte relied on Raymond Art, the head painter-decorator at the casino, to oversee the team and its equipment, he insisted on using his own special blue for the sky, a paint made up for him by a Brussels paint manufacturer, Astra Pharmaceuticals.

Both the Knokke mural and the Hodes gouaches raise the question of rep-

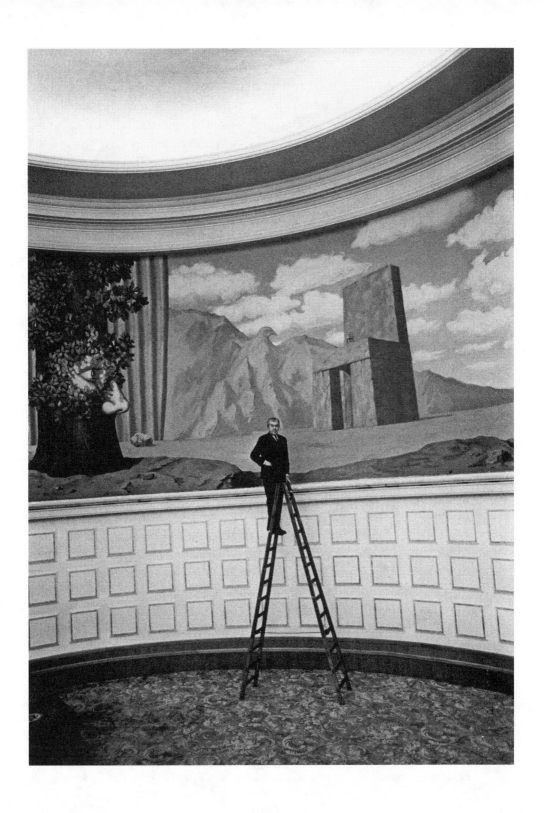

licas or versions of old images. While Magritte's willingness to produce these "*variantes*," as he called them, was mostly a question of commercial expediency,[86] he held that each of his "variations" was a new version of the original rather than a literal copy—and it is certainly the case that later versions of an image can be even more compelling than the original. Take *L'Empire des lumières* (*The Dominion of Lights*),[87] an image that, remarkably, exists in sixteen oil versions painted between 1949 and 1964, as well as in a number of gouaches. The eighth and largest version of the image was painted in 1954 in anticipation of Magritte's forthcoming exhibition that year at the Palais des Beaux-Arts in Brussels—his first major retrospective, and a long-awaited "benediction" by Belgium's art establishment. The exhibition had been planned to coincide with the thirtieth anniversary of the first surrealist manifesto. Magritte could also look forward to another official honor: twenty-four of his works were to be hung together at the 1954 Venice Biennale as the centerpiece of the Belgian pavilion. The selection included the most recent version of *L'Empire des lumières*, the painting of a nighttime scene under a daylight sky, nearly two meters in height, which had already attracted the attention of two potential buyers in Brussels. Once in Venice, Magritte, ever impulsive, promised it to another two collectors, one of whom was Peggy Guggenheim, who, naturally enough, had no idea the painting had been offered to three other parties. The result was that Magritte, having clinched the deal with Guggenheim (he could hardly refuse her), found himself having to produce three more versions in order to extricate himself from an awkward situation. Awkward, but easily remedied. Magritte believed that his paintings did not merely express ideas but had the power to create them. It followed that a particularly powerful image, and one in such popular demand such as *L'Empire des lumières*, would benefit from maximum exposure (the larger its audience, the greater its proselytizing effect). Magritte's unapologetic attitude to repetition was another aspect of his art that found easier acceptance in America than elsewhere. Rothko, one more American painter who greatly admired Magritte, wrote, "If a thing is worth doing once, it is worth doing over and over again—exploring it, probing it, demanding by repetition that the public look at it."[88]

In fact, the popularity of *L'Empire des lumières* has ensured a circulation far wider than Magritte could possibly have imagined. In 1973 the film director William Friedkin based a key scene from his horror movie *The Exorcist* on one of the 1954 versions of the image—a scene that so caught the public's imagination the still was used on the posters and on the DVD/VHS release covers.[89] But only after a fierce argument with Dick Lederer, head of Warner's marketing. Lederer wanted to use the sensationalist image of a little girl's

bloody hand clutching a blood-stained crucifix above the phrase "For God's Sake, Help Her." Friedkin vigorously opposed the idea, telling him, "The ad should understate the film's content," and suggested they use the silhouette of the actor Max von Sydow standing in front of the house in Georgetown, the image directly inspired by *L'Empire des lumières*.[90] Like Magritte, Friedkin understood the power of understatement.

Just as the advertising industry aims to create previously unknown aspirations and desires, so Magritte (who had long ago mastered the tricks of the trade) saw painting as a powerful means of creating thoughts and emotions his audience had not yet experienced, or even dreamed of experiencing. *L'Empire des lumières* was a way of demonstrating that opposites, even the most familiar, are inherently mysterious: "[N]ight always exists at the same time as day," Magritte explained, before adding in parentheses, "Just as sadness always exists in some people at the same time as happiness in others."[91] In a radio interview broadcast in June 1956, Magritte referred to that image, describing his own "great personal interest in night and day" as "a feeling of admiration and astonishment." He saw the natural world above all as a rich source of surprise and revelation. The sulphurous fog in *Le Mal du pays* (*Homesickness*), Mesens told David Sylvester, was inspired by London fogs[92] (which Mesens would have experienced at first hand). Fog was a useful metaphor for the impenetrable: Magritte had painted *Le Mal du pays*, so he told a reporter from *Life* magazine, "to evoke distance because the man is thinking of things far away. The man has wings but they won't help him reach his desires anymore than the lion can. He probably doesn't even know he has wings or that the lion is there. That's the human predicament."[93] When Wergifosse described an optical illusion he had recently witnessed in Liège, Magritte could hardly wait to realize its possibilities. Caught in a heavy mist as he walked along the river Meuse, Wergifosse had watched as the gray walls of a large building on the opposite bank slowly vanished, leaving only the windows visible. The idea of solid walls fading into invisibility was irresistible to Magritte, who promptly executed *L'État de veille* (*The Waking State*), an image based on Wergifosse's account. He responded to nature when nature revealed the unexpected. As he told the young American writer Suzi Gablik, "[O]ptical illusions were the privileged moments that transcend mediocrity. But for that there doesn't have to be art—it can happen at any moment."[94] In fact, Magritte had already painted the phenomenon described by Wergifosse. In *Le Pont d'Héraclite* (*Heraclitus's Bridge*), a work of 1935, a patch of dense white cloud creates the illusion that a bridge arching over a river is only half built. The idea for that painting had come from a friend,[95] just as the idea for *L'État de veille* had originated with Wergifosse. Georgette was adamant that Magritte never made sketches from

nature, although she did concede that when the couple found themselves in the countryside, "he would make a 'monocle' with his thumb and forefinger in order to peer at the landscape, or to examine a stone, a leaf."[96]

Seeing how easily the eye is deceived gave Magritte particular pleasure. Out driving one day he came across a tall conical brick tower that, seen from a certain angle, could also be read as a perspectival view of a paved road. This too was turned into a painting.[97] A couple Magritte spotted one day sitting side by side on a beach is said to have inspired the tender intimacy of the stone pear and apple in the 1963 version of *Souvenir du Voyage* (*Memory of a Journey*).[98] "I retain a memory of visions," was how he put it.[99]

Objects in his paintings frequently take on human attributes. In *Le Monde invisible* (*The Invisible World*) [color plate 46], Magritte borrows one of Matisse's favorite motifs—a room opening onto the sea—to express the affinity between the natural and human worlds. As in *La Voix active* the rock is a silent observing presence, as alive to its surroundings as the model in a Matisse painting. In his 1938 lecture, "La Ligne de Vie" ("Lifeline"), Magritte described his contemplation of a door in an ordinary Brussels brasserie: "The

state of mind I was in at the time made me see the mouldings around a door as being endowed with a mysterious existence, and I remained in contact with their reality for a long time." Intense, almost hallucinatory looking led to revelations of the poetic kind especially valued by the surrealists, among them Michel Leiris, who wrote, "There are moments that can be called *crises*, the only ones that count in life. These are moments when all at once the outside seems to respond to a call we send from within, when the exterior world opens itself and a sudden communion forms between it and our hearts."[100] That opening up, that "sudden communion" between the painter and his subject, is at the heart of *L'Empire des lumières*.

Peggy Guggenheim's version of *L'Empire des lumières* (146 x 114 cm) was not the largest painting Magritte had realized to date, but it signaled a move toward the monumental. Iolas, with the large-scale paintings popular with the American art market of the 1950s very much in mind, encouraged Magritte to be more ambitious. *Le Tombeau des lutteurs* (*The Tomb of the Wrestlers*), 1960 [color plate 47], *La Lunette d'approche* (*The Field Glass*), 1963 [color plate 48], and *La Grande Famille* (*The Great Family*), 1963 [color plate 49], are not only large canvases but the imagery, too, is greatly magnified: a perfect red rose in full bloom fills a room; a double-sided curtain unfurls to reveal a vast seascape, and a giant bird of prey looms over the waves breaking below. A steep increase in Magritte's prices reflects the success of Iolas's strategy. In 1962, for instance, a canvas measuring 116 x 89 cm paid Magritte $2,000, two and a half times the price he achieved in 1959 for a similar size picture; by 1966 that had risen to $7,000 (more than $54,000 in today's money).[101] Iolas had even grander plans in store. He asked Magritte if he had ever thought of making sculpture, to which Magritte replied unhesitatingly that yes, he had. That conversation took place in January 1967. By June that year the eight subjects he had chosen from his own stock of images had been cast in wax by a foundry in Verona. Making the wax molds must have been complicated enough for the foundry, but the three-dimensional version of *David's Madame Récamier*,[102] for example, posed exceptional problems. The chaise longue, coffin, lamp, footstool, had all to be cast separately. Iolas liked to say that these (with the exception of the coffin) were cast from originals contemporary with those in David's painting. Research suggests otherwise. It is far more likely that he had reproductions made from which the pieces were cast.[103] The titles of the bronzes are the same as those of the paintings from which the image is taken: *La Folie des grandeurs* (*Megalomania*), *Madame Récamier de David* (*David's Madame Récamier*), *Les Travaux d'Alexandre* (*The Labors of Alexander*), *Le Thérapeute* (*The Healer*), *Les Grâces naturelles* (*The Natural Graces*), *La Race blanche* (*The White Race*), and *La Joconde* (*Mona Lisa*). Many of

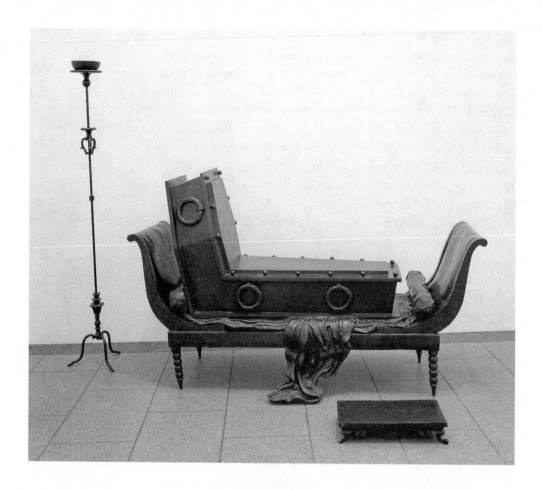

Magritte's images include simple pure forms easily imagined in the round; cubes of sky (as generic as Léopold Magritte's boxes of Cocoline), harness bells, wooden bilboquets, freestanding curtains, rocks, leaf-birds, and leaf-trees. Sculpture was a development waiting to happen—or, rather, waiting for a Midas to appear with the cash to cover the considerable foundry costs. Iolas was now a more than willing Midas.

The sculptures have divided opinion like no other works by Magritte. Even the word *sculpture* seems to some an uncomfortable word to use for these manufactured bronzes. Paul Delvaux, for one, thought so: "One is either a sculptor or one is not," was his withering response. "And if one is not, one should not have sculptures made."[104] Others have been more generous, seeing them as grand embodiments of Magritte's original ideas. For John Updike, the novelist and occasional art critic, *Megalomania* looked far more impressive in three dimensions, standing "as a monument to the female form, as worshipful as a Maillol or a Lachaise."[105] David Sylvester, for his part, regarded

La Joconde as "one of the great successes, despite the fact that the original intention to paint on the bronze had not been carried out."[106] Magritte had leaped at Iolas's suggestion. Suddenly a whole new opportunity for making replicas opened up. But these are replicas with an important difference. They were made by artisans in an Italian foundry, working from drawings made to scale. They were virtually untouched by Magritte himself.[107] However vehemently Magritte rejected the notion of the artist's "touch," every variant, every replica, he made of his paintings is stamped with his own unmistakable fingerprint. As many a forger has discovered, his technique, far from being as anonymous and unremarkable as Magritte liked to make out, is as personal to him—and every

bit as recognizable—as his own handwriting. Like the Casino Knokke mural, the sculptures were another "grand project" devised primarily to satisfy the needs of the sponsor, whether that was Nellens with his love of the grandiose, or, in this case, Iolas with his eye on a new and profitable market.

Magritte's first major retrospective had taken place in Brussels in 1954, but it wasn't long before his success spread far beyond Belgium. Exhibitions and honors began to mount up. In 1960, Dallas and Houston hosted a retrospective; two years later the Walker Art Center in Minneapolis organized their own exhibition, and in 1964 a large retrospective organized by Dominique de Menil was held at the recently opened Arkansas Art Center in Little Rock.[108] The crowning U.S. event, however, was the 1965 exhibition at the Museum of Modern Art, New York, the most prestigious museum of its kind in America, and the first to draw fully on Magritte's work in both American and European collections (greatly helped by Mesens's collection). It was organized by William C. Seitz, formerly the curator of painting and sculpture exhibitions

at the museum, and a champion of American contemporary art,[109] and James Thrall Soby, then chairman of the Department of Painting and Sculpture. Up to then, many American critics had found Magritte hard to place, and Soby was no exception. In 1941 he regarded Magritte as an illustrator whose paintings sometimes "wear thin, like puns too often repeated."[110] Over the years, though, he came to think very differently. Writing to Torczyner in 1965, while he was working on the Museum of Modern Art show (which Torczyner, in his capacity as president of the Belgian-American Foundation, had lobbied hard to get for Magritte),[111] he said,

> I grow more and more fascinated by Magritte's originality of vision and his effect on other artists. For instance, I remember clearly how startled many of us were when Dalí's flaming giraffes with flaming necks appeared on the New York scene in or around 1935.[112] And yet Magritte had been painting musical instruments on fire as early as 1935. Or maybe earlier? It's not that I wish to attack Dalí, much as I dislike what he paints today. But I think it's high time someone pointed out how many of surrealism's pictorial inventions were Magritte's. My very great friend, the late Yves Tanguy, used to remind me of this every time he and I used to look at the marvellous Magritte which hung in his Woodbury, Conn. living room.[113]

Magritte also began to travel abroad, something he had always done his best to avoid. Now it was summers in Nice rather than in Knokke-le-Zoute. He even crossed the Atlantic to attend the opening of his exhibition at the Museum of Modern Art on December 13, 1965. Dalí and Gala turned up at the evening reception to greet a rather surprised Magritte. Dalí's own New York show was to open a few days later at the Gallery of Modern Art (a rival establishment founded by Huntington Hartford, heir to the A&P supermarket fortune). There were more dinners and cocktail parties to attend (Torczyner had made sure of that),[114] leaving no time for Magritte to join the other 1,000 guests at Dalí's opening (the Spaniard's celebrity status was guaranteed to draw the more glittering crowd). The Magritte party flew on to Houston, the home of his loyal collectors Jean and Dominique de Menil. The following April Magritte and Georgette visited Jerusalem, where they stayed at the King David Hotel as guests of the Israeli ambassador to Belgium, Amiel Najar. Both visits were a great success. In New York, Magritte's exhibition was well received, and in Jerusalem he was delighted to find two of his paintings on permanent display at the Israel Museum: *Les Embarras de la peinture* (*The*

Predicaments of Painting), 1927, and *Le Beau Ténébreux* (*Tall, Dark, and Handsome*), 1950.

Photographs of the couple from the mid-1960s show Georgette in a full-length fur coat—a previously unthinkable extravagance. Their new prosperity was further marked by the purchase of a plot of land in Uccle, the smartest district in Brussels, and the engagement of an architect to draw up plans for a house. This was to be in a neoclassical style, and, as Magritte told Torczyner, it "would certainly not be to the taste of a jury of architects nominated by the Guggenheim Museum,"[115] a dig at the controversial New York building designed by Frank Lloyd Wright that had opened in 1959. Instead, the villa (as both the architect and Georgette referred to it) was to reflect an image of solid bourgeois respectability—a smart but unremarkable house, indistinguishable from those of their well-heeled middle-class neighbors. There were to be parquet floors, a marble bathroom, a marble hall, oak doors, and wall-to-wall carpets. Expense appeared to be no object in realizing what Georgette called "our dream villa" ("*la villa de nos rêves*"). The sale of *Le Tombeau des lutteurs* to Torczyner was timely. Asking him for "10,000 kopecks américains, voire 2500 pesetas usa," Magritte explained that his "current bout of venality" could be explained by his newly acquired taste for real estate.[116] All might have gone smoothly except that Magritte turned out to be a nightmare client, demanding endless modifications to the architect's plans, changing his mind on countless minor details, even down to the location of every single electrical point. Those who knew him well would not have been surprised by his obsessive attention to detail, nor indeed by his need to be the one in charge. The project ground to a halt when the architect, frustrated beyond endurance, pointed out how much these changes were costing. Magritte dropped the idea and bought the house they were renting in the rue des Mimosas in the commune of Schaerbeek.[117] His sudden change of mind was not only due to expense. In February 1964 he had a bad attack of bronchitis that left him extremely tired and unable to work. As he told Torczyner,

Is it because of my state of health that I've abandoned the idea of building? Possibly. The prospect of worries, something it seems every builder must face, seems more formidable than rational. In any event, I've notified my architect of this decision, buttressing it with arguments I've tried to make as little "materialistic" as possible. So there's one source of superfluous trouble I've eradicated. Upon thinking about it, the number of possible worries that haunts those who build is too great in relation to the pleasure to be derived.[118]

René MAGRITTE — Les Travaux forcés.

A l'occasion de ma grande rétrospective au Casino du Zoute

GRANDE BAISSE

La pensée est le mystère, et ma peinture, la véritable peinture, est l'image de la ressemblance du mystère avec son reflet ressemblant dans la pensée. Ainsi, le mystère et sa ressemblance ressemblent à l'inspiration de la pensée qui évoque la ressemblance du monde dont le mystère est susceptible d'apparaître visiblement.

De mystère en mystère, ma peinture est en train de ressembler à une marchandise livrée à la plus sordide spéculation. On achète maintenant ma peinture comme on achète du terrain, un manteau de fourrure ou des bijoux.

J'ai décidé de mettre fin à cette exploitation indigne du mystère en le mettant à la portée de toutes les bourses.

On trouvera ci-dessous les éclaircissements nécessaires qui réconcilieront, je l'espère, le pauvre et le riche au pied du mystère authentique. (Le cadre n'est pas compris dans le prix).

J'attire l'attention sur le fait que je ne suis pas une usine et que mes jours sont comptés. L'amateur est invité à passer commande immédiatement. Qu'on se le dise : il n'y aura pas du mystère pour tout le monde.

René MAGRITTE

Quelques suggestions (en format standard) :

	Belgique Fr.	France N.F.	U.S.A. Dollars
LA MEMOIRE			
tête de plâtre tournée vers la gauche	7.500,—	750,—	150,—
tête de plâtre tournée vers la droite	8.500,—	850,—	170,—
LA MAGIE NOIRE			
Offre spéciale : pour toute commande ferme de douze exemplaires, une 13me Magie noire gratuite	6.000,—	600,—	120,—
LA CONDITION HUMAINE			
avec vue sur la mer	5.000,—	500,—	100,—
avec vue sur la campagne	4.500,—	450,—	90,—
avec vue sur la forêt	4.000,—	400,—	80,—
LA FOLIE DES GRANDEURS (ex-IMPORTANCE DES MERVEILLES)			
avec emboîtage supplémentaire	4.000,—	400,—	80,—
avec double emboîtage supplémentaire	4.500,—	450,—	90,—
PORTRAITS EN BUSTE (supplément de 10 % pour les portraits en pied)			
adultes masculins au-dessus de 40 ans	8.000,—	800,—	160,—
adultes masculins au-dessous de 40 ans	6.000,—	600,—	120,—
adultes féminins — jolies	500,—	50,—	10,—
adultes féminins — passables	4.000,—	400,—	80,—
adultes féminins — défavorisées	10.000,—	1.000,—	200,—
enfants sans distinction de sexe	— Prix à convenir —		
GOUACHES TOUS SUJETS à partir de	1.000,—	100,—	20,—
DESSINS à partir de	50,—	5,—	1,—

ET LA FÊTE CONTINUE !

The fur coat, jewels, a grand piano, a new car (a bright red Lancia),[119] a plot of prime real estate—these luxuries were all for Georgette, no doubt Magritte's way of making up for years of scrimping and saving, but his extravagance didn't sit too well with some of his old friends. It was Mariën who delivered the most devastating reproof. With exquisite timing, a spoof advertising leaflet announcing a "Grande Baisse" ("Huge Reductions") of Magritte's paintings was circulated on the morning his large retrospective exhibition opened in Knokke-le-Zoute at Nellens's casino on June 30, 1962. Purporting to be written by Magritte himself, it is a masterpiece of parody. Headed by the reproduction of a photomontage,[120] it kicks off with a spoof text sending up Magritte's style of writing followed by a list of "special offers" on his paintings, such as one free *Magie noire* with every dozen, or a *Condition humaine* with a view of the sea (5,000 francs) or the slightly cheaper view of a forest (4,000 francs). The photomontage shows a 100-franc Belgian banknote with the head of Léopold I, king of the Belgians, replaced by a photograph of Magritte; the caption "Hard Labour" printed underneath refers to the warning printed on every Belgian banknote: "The legal penalty for counterfeiting is hard labour." Magritte would have immediately understood that the banknote together with the caption could mean only one thing: that whoever had produced the leaflet knew of his involvement in an illegal venture ten years earlier, when, with the help of his brother Paul, he had made a large number of counterfeit 100-franc Belgian banknotes.

Mariën's role in the counterfeit-money episode is recounted in his memoir, *Le Radeau de la Mémoire* (*The Raft of Memory*), published in 1983.[121] The 100-franc note, he claimed, had been made by Magritte and printed by Paul on his handmade printing press. Neither admitted outright that they were directly responsible for the forgeries, leaving Mariën to work it out for himself. He would certainly have remembered a small gouache of *Le Spectre* (*The Specter*), a virtuoso copy of a 500-franc banknote Magritte had made a few years before and recently presented to Wergifosse.[122] Mariën was enlisted at the last minute because they needed someone to act as a reliable fence. The plan was to take advantage of

the tourist season by making dozens of small purchases in the seaside resorts around Ostend. If this took place in early June 1953, as Mariën claimed, it would follow that while Magritte was busy supervising the work on his mural for the Casino Knokke, roughly twenty-five miles from Ostend, his "accomplices" were not far away trying their best to unload five hundred or so fake banknotes. Mariën's cut was to be 10 percent of the profit. The whole affair lasted little more than ten days. Finding that they had too many notes to spend locally without arousing suspicion, they moved on to the city of Bruges. It was there that Mariën made a fatal mistake. He and Paul had previously hit on small local shops because the owners usually waited a few days before taking their cash to the bank, whereas the large stores and supermarkets did so on a daily basis. Getting rid of the notes proved arduous. Bored and impatient, Mariën decided to target a large chain store where he could make several purchases in one go. A few days later, on June 12, the Belgian newspapers announced the seizure of a fake 100-franc note by the National Bank. The game was up.

Magritte had no moral scruples about forgery, as his earlier efforts at faking works by Titian, Klee, and Picasso proved.[123] If asked why he painted, he might well have replied as Scutenaire did when asked why he wrote books: "I write for the same reasons which compel others to rob post offices, knock down a police officer or their boss, destroy a social order. Because something is bothering me: revulsion or desire."[124] Like Scutenaire, Magritte considered the social order a system to be continuously challenged and eventually overturned. This, after all, was the accepted surrealist position both politically and morally: as we recall, he told his Antwerp audience in 1938, "Surrealism is revolutionary because it is implacably opposed to all the bourgeois ideological values that keep the world in the appalling state it is in today." To be complicit in a criminal act, however petty, was a different matter. When he set out to make the fake paintings he had been in need of money to pay for various publications, including Mariën's small monograph. But why in 1953, when things were looking up, was he willing to take such a risk? Was it just a game to satisfy his taste for subversion and subterfuge? Or was it Paul who came up with the idea and persuaded his brother to go along? Magritte rarely refused Popol. It remains a puzzling episode that has never been fully explained. Now, ten years later, it came back to bite him.

Magritte allowed Mariën to believe he was behind the fake banknotes (he could hardly have done otherwise), but he never admitted it, just as Mariën did not immediately admit he was responsible for the "Grande Baisse" leaflet.[125] When Magritte, who was in no doubt, challenged him, Mariën denied it. They were quits. Meanwhile, the leaflet had spread far and wide. Breton, like many

others, was taken in. Believing Magritte to be responsible, he wrote immediately to congratulate him on a splendid joke: "What you have said is unforgettable: I was not alone in appreciating it."[126] When apprised of the truth he confessed to finding the humor "in the best of taste . . . and impartial enough to apply both to the stock market rating of others and the very widespread tendency to take oneself too seriously." Magritte may have found the dig at taking "oneself too seriously" a little rich coming from Breton. Meanwhile, the director of the National Bank called in the police (under Belgian law the reproduction of a current banknote in any form constitutes a forgery unless it is printed over with the word "specimen"). They lost no time in telephoning Magritte, who, believing the call to be another prank, responded angrily.[127] In the end, after the police had interviewed various suspects, including Mariën, nobody was charged and the matter was dropped. History, though, has had the last laugh: the 500-franc banknote printed by the National Bank in 1998 to honor the centenary of Magritte's birth proudly displays a photograph of a bona fide counterfeiter.

Magritte put a brave face on Mariën's brilliantly executed joke, admitting that it was "quite funny," but it hurt. Irène Hamoir remembered him looking like "a whipped dog."[128] The jibes about replicas and money were merciless enough, but the leaflet also poked fun at Magritte's recent attempts to explain his work. Mariën's parody was uncomfortably close to the bone: "Thought is mystery, and my painting, true painting, is the resemblance of the mystery to its similar mystery in thought. Thus, the mystery and its resemblance resemble the inspiration of thought which evokes the resemblance of the world, the mystery of which is capable of appearing visibly." Writing was something Magritte took pride in, especially when writing to friends. He was a punctilious correspondent—no letter or card went unanswered—and he expected others to be equally diligent. Letters poured out of him—humorous, reflective, filled with recent thoughts about his latest paintings as well as those in the pipeline, his remarks frequently laced with complaints about his own state of mind and the idiocy of others (reporters and journalists were a favorite target),[129] all expressed directly with great clarity and precision. Writing for publication, however, was another matter. It induced long periods of uncertainty and crippling anxiety, as Camille Goemans had witnessed. "Magritte is perpetually tormented by anxiety, which quite easily turns into anguish. He is forever asking questions, and his mind is never at rest. And it is above all in his writings that we can find the traces of a kind of uneasiness to which he is a permanent prey."[130] In his later years that anxiety increased as he tied himself in knots trying to express abstract concepts such as "mystery," "invisibility," and "resemblance," concepts that he himself had said were "capable of becoming visible

only through painting." Maurice Rapin, who collaborated with him in the late 1950s, found working with him "a laborious undertaking," mainly because, as Rapin told André Blavier, "Magritte preferred to remain silent rather than not say exactly what he thought. Since his thought was often difficult, because of the extreme singularity of his intellectual attitude which denied him recourse to mathematical or philosophical language, we had the greatest difficulty in arriving at the perfect expression we were aiming at and quite a lot of texts never saw the light of day."[131] Before his exhibition at the Museum of Modern Art in 1965, for instance, Magritte wrote at length to James Thrall Soby with suggestions for the essay Soby was intending to publish in the catalog: "Inspired thought *resembles* the invisible when it evokes the mystery of the invisible. This kind of thought can be described by language—which is itself invisible. Inspired thought *resembles* the visible when it evokes the mystery of the visible. This kind of thought has similarities with the visible AND it evokes the mystery of the visible," and so on. (Mariën's parody needed little exaggeration.)

In 1957 Magritte had been elected to the Libre Académie de Belgique, an institution that was founded in 1901 in opposition to the official Académie Royale de Belgique. Members included many of Magritte's friends and acquaintances, and it was there that he met Alphonse de Waelhens, a professor of philosophy at the University of Louvain and author of books on Martin Heidegger.[132] Magritte, an avid reader of philosophy, adopted de Waelhens as a sort of sounding board for his efforts to write about his painting. It doesn't seem to have helped, even after a lengthy correspondence on both sides, but he persisted. At the end of his life he again appealed to the professor for help with a text he was writing for the catalog of his major retrospective at the Boijmans Van Beuningen Museum in Rotterdam, to open in August 1967: "I have only found 'ideas' about the invisible, and very imprecise ones."[133] As it turned out, an intellectual discipline he had always deeply respected could not provide him with the perfect expression of thought he had been searching for. He perhaps overlooked the most obvious answer: that the enduring power of his imagery lies precisely in its independence of language.

As his fame grew, Magritte found himself increasingly caught between the demands of museums and galleries for explanations of his art and his dislike of being thought of as an artist. Following a talk he gave to the Académie Libre, a fellow academician asked him to explain the sources of his "art." Magritte's reply was categorical. He was not an artist, he insisted, and he refused to be called one; he was a man of thought and communicated his thought by means of painting, as others do through music, words, etc.[134] Magritte's defiant view of himself as "a man of thought" rather than an artist explains why he labored

so hard to put his ideas into words. He had always admired philosophers ("we have to be of their discipline"); Plato, he liked to say, didn't use technical language like the modern philosophers, and Socrates "knew a great deal because he knew he knew nothing."[135] He had always preferred the company of writers and poets to that of painters, and now that most of his old "*compagnons de route*" were either dead or no longer around, he was looking for new ways of staving off the boredom and apathy he had always been prone to. He needed new distractions and, above all, a new audience. The Académie offered both.

The main thrust of "Grande Baisse," though, was aimed at Magritte's fast-growing celebrity. David Sylvester, who over the years he spent working on Magritte came to know Scutenaire extremely well, asked him the following question: How did he think Magritte had coped with success? Scutenaire replied,

> In my opinion—but I may be wrong—success gave Magritte a guilt complex, because in his heart of hearts he was unhappy with success. In his early days, when he began doing surrealist things, he painted with the same objectivity as the surrealists, so that his work should change the world, not that his work should bring him money, or honors, or visits, or respect. That didn't interest him, money didn't interest him. As soon as success and honors came, he had the feeling he had made a mistake; he said, "I've painted enough pictures to bring down let's say the throne of China, and instead of that I've got five thousand francs in my pocket."
>
> It bothered him. He was much less agreeable than when he was poor, less warm, less happy with himself.[136]

Torczyner saw things rather differently. He rejected the idea that Magritte wasn't interested in money or success, just as he claimed that the china ornaments, gilded angels, department-store antiques, and other knickknacks decorating the house in the rue des Mimosas had been chosen by Magritte rather than by Georgette, as others believed. Mariën, on the other hand, wanted to put an end "to the myth of a Magritte who revelled in a 'bourgeois' interior, complete with chandeliers and Sèvres porcelain." "In actual fact," he continued, "Magritte lived very simply in a décor devised and planned by his wife, a décor which represented her tastes—which are as good as any others—but to which Magritte was completely indifferent." And, Mariën added, "he would have felt the same about a feudal castle, or a cave."[137] Magritte was perfectly capable of saying different things to different people, but the idea that he was indifferent to his domestic surroundings rings true. More to the point, he enjoyed being free from financial woes every bit as much as he enjoyed indulg-

ing his wife. He even found pleasure, however fleeting, in success: "Vanity! Vanity!" he joked to Torczyner,[138] after returning from a successful exhibition in Paris.[139] He enjoyed the unaccustomed luxury of staying in expensive hotels (where he picked up two "magic" English words: "Room Service"). At the same time, he understood that success was a distraction, a sideshow. And troublesome. He began to be pestered on all sides. Letters throughout the 1960s show the extent to which museums, galleries, clients, publishers, journalists from newspapers, television, and radio, well-meaning fans, and art aficionados invaded his life, leading to endless interruptions and distractions. At one point he told Torczyner that he felt he was turning into King Saul, "that melancholy king who was more concerned with the tumult in his brain than in his own kingdom." Saul, Magritte reminded Torczyner, had been prone to such bouts of fury that he had laid about him with a javelin. "As I have neither a lance nor a javelin, it's my pen or my pencil that goes hurtling across the room, because I cannot stand the poisonous air of business, contracts, arguments, disputes and trials of people whose future deserves no sympathy and whose person inspires absolutely no interest."[140] As Scutenaire witnessed, success did not bring Magritte peace of mind.

Health problems added to his frustration. By 1965 he was receiving regular doses of cortisone to relieve acute rheumatism. Trips to Italian spas failed to improve his condition: in May 1965 he complained that he had returned from a mud bath "cure" in worse shape than when he had left.[141] In June the following year he and Georgette joined Scutenaire and Irène Hamoir in Tuscany, at Montecatini Terme, a spa famous for its thermal waters and treatments. On the way they stopped off in Milan, where they saw Leonardo's *Last Supper*, "very badly damaged by time and the American bombings," as Magritte told Bosmans in a postcard.[142] Looking at the half-ruined painting gave him an idea for a picture. He made a quick sketch of it on a postcard he sent to Bosmans as "proof of the fact that travel broadens the mind, and not only of young people." The sketch was of *L'Aimable Vérité* (*The Endearing Truth*),[143] the masterpiece of Magritte's final years, and the only one based on a work that he had seen in the original (the paintings based on works by Manet, David, Ingres, or Renoir were all done from reproductions). What is remarkable about the tiny pen sketch he sent Bosmans is how little it differs from the finished painting, a canvas measuring 89 x 130 cm. It's as though the image came to him ready-made. The work shows a table covered with a white cloth painted to look as if it is an integral part of the gray stone wall behind.[144] As though to emphasise the point, the rough texture of the wall is visible through the scumbled white of the cloth. Few of his paintings pay such a direct homage to cinema as *L'Aimable Vérité*. The table, with its dazzling white cloth, is raised to eye level

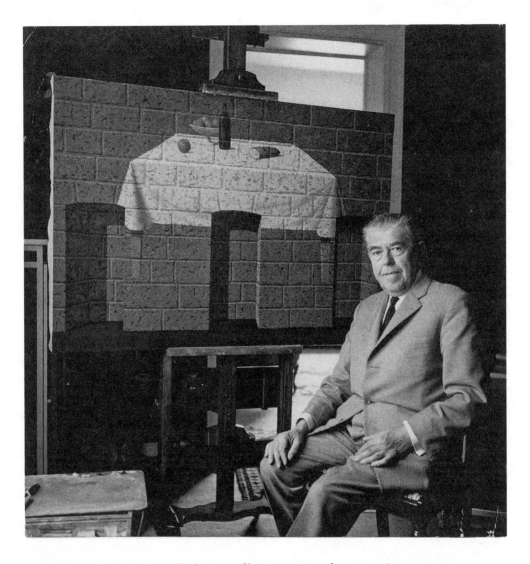

and projected onto the wall the way film is projected onto a cinema screen. Standing in the Cenacolo of Santa Maria delle Grazie in Milan, Magritte may well have been reminded of one cinematic moment in particular—the fleeting shot in Buñuel's *Viridiana* in which the twelve beggars seated around a dining table freeze into the poses of the disciples in Leonardo's painting. A bottle of red wine and a loaf of bread are the only concessions Magritte makes to the religious content of *The Last Supper*, but even these props could be an ironic nod to Buñuel, whose film, made in 1960 in Catholic Spain under Franco and banned by the authorities, was militantly anticlerical. "I was very enthusiastic when I painted *The Endearing Truth*," he told his American friend Suzi Gablik. "Now it disgusts me: the moment of illumination is very brief."[145] It had

always been like that. The moment a painting was finished it had to disappear, "either to be sold or burnt," as Scutenaire put it.

Complaints about the time spent laboring away at the easel pepper his letters to friends. More than once the act of painting is likened to "forced labour." Listening to classical music while he painted helped dispel moments of tedium (that King Saul is said to have taken comfort in music did not escape Magritte). After his death a rumor circulated that Raymond Art, or one of the other painters who had worked on the Casino Knokke mural, had helped Magritte with the late oils, particularly the larger canvases destined for Iolas, such as *L'Aimable vérité*. When asked to confirm the rumor, Raymond Art refused to answer.[146] Indeed, the question was met with silence on all sides. In his last years Magritte probably did take on an assistant from time to time, especially when he damaged his right hand in a fall in early January 1966 (he suffered a broken wrist),[147] but to what extent they helped with the actual painting remains an open question. The question itself, and the smokescreen thrown up around it at the time, shows just how much has changed. Today nobody questions the legitimacy of large artists' studios—some the size of factories—staffed with dozens of assistants, accountants, and business managers. Magritte lived in an age that put enormous value on the artist's brushstroke even though the uniqueness of the painterly gesture was a concept he utterly rejected. Raising such profound doubts about the conventions of painting left him open to the criticism that he didn't belong to the modernist tradition. As it turned out, his resolve to pursue a technique that turned its back on "art" and made a virtue of anonymity accounts in part for his enduring popularity in an age that is as comfortable with the hands-off production by artists such as Andy Warhol, Jeff Koons, and Damien Hirst as it is with artists engaged in film and video.

. . .

Shortly after his return from a trip to Italy toward the end of June 1967, Magritte fell ill. He had been in Verona with Iolas making minor modifications to the first wax casts for the sculptures. The doctors suspected jaundice, and he was admitted to a Brussels clinic. In a letter of August 2, Georgette told Torczyner, "His morale is fairly good and he is being very patient. Thus his condition isn't too serious."[148] Within days, however, he was diagnosed with advanced cancer of the pancreas. An operation was out of the question, and Magritte returned home. "He had gone to hospital by car, he came back in an ambulance," Georgette later said. "He went to bed, fell asleep and never woke again. It was a terrible shock for me. I had never once heard him complain of

any pain and I had no idea he was so ill. Now, all these years later, I sometimes think that he kept quiet about his sufferings during all those months so that I wouldn't worry."[149] Magritte died peacefully in the early afternoon of August 15. Two days later an anonymous appreciation[150] appeared in *La Meuse–La Lanterne:*

> René Magritte (69 years old), one of the masters of surrealist painting, died in Brussels, on Tuesday at 14 hours. He had been in hospital for the last two weeks (in Uccle), where he was being treated for an occlusion of the gall bladder. The doctors had decided it would be unwise to operate. Magritte bore his illness very bravely. One of the last things he said on Monday afternoon was: "I wonder if I will pull through."

He was buried in Schaerbeek cemetery on August 18. In 1986, Georgette Magritte was buried in the same grave.

Magrittiana: A Note on Sources

Wherever possible I have worked from original sources—letters, diaries, memoirs, reminiscences, documents of all kinds—in the original language. All translations are my own, unless otherwise indicated.

In the first instance, I turned to the testimony of the protagonists themselves, public and private, poetry and prose. Surprisingly enough, this yielded copious quantities of material. Unusually for an artist, Magritte himself wrote prodigiously. His *Écrits complets* (1979) run to more than seven hundred pages. These writings include artistic statements, political tracts, philosophical reflections, short stories, film scenarios, manifestos, tributes, talks, provocations, interviews, and responses to questionnaires—theoria, fantasia, minima moralia, and even erotica—but not his letters. Or only incidentally his letters, as quoted piecemeal in the dense undergrowth of annotation by the editor, André Blavier, which runs riot throughout the work, all but throttling the writings. Regrettably, Magritte's letters have never been collected, or selected, notwithstanding an abortive project to do just that in conjunction with the preparation of his *catalogue raisonné*. Even a selection would be a substantial undertaking, as the editors of the *catalogue raisonné* discovered. Already the letters to André Bosmans, to Marcel Mariën, to Mirabelle Dors and Maurice Rapin, to Gualtieri di San Lazzaro, to Harry Torczyner, account for five volumes, not all of them slim (more than four hundred letters to Bosmans in the period 1958–67, nearly three hundred to Mariën in the period 1937–62). Altogether, Magritte must have written thousands of letters—handwritten and posted with typical despatch—notably the intensive, occasionally vituperative exchanges with his animator, promotor, and collector, the exuberant E. L. T. Mesens; the fascinating mix of pulpitry and pettishness in the commerce with his American dealer, the exotic Alexander Iolas ("Alexander the Great"), said by David Sylvester to be like a novel by Balzac; and the incessant traffic with his accomplices, at once uninhibited and cryptic, veering close to a private language, complete with sketches, doodles,

demonstrations, and proofs of paintings. With Paul Nougé, in particular, there was a complicity and a correspondence of capital importance, not only for an understanding of Magritte's long march, but in any accounting of the creative life of the twentieth century.

Abundant as it may be, this material is not easy to parse or decode. It is fragmentary and refractory, and often fugitive. In fact, a good deal of it has been published (in French), in scattered form and small presses, in private and pirate editions, thanks to one man in particular: Marcel Mariën, who was both a surrealist and a documentalist, a player in the game and a chronicler of the time. Chez Magritte, Mariën quickly graduated from apprentice to accomplice, a position he occupied, with aplomb, for many years. As time went by he also drew close to Nougé. His access and his acuity gave him an unrivaled authority as archivist and historian of *L'Activité surréaliste en Belgique* (1979), as one of his collections has it, especially the doings and sayings of *la bande à Magritte*. Yet he did for his elders what no one else had thought to do: he rescued the transactions of Magritte and Co. from the dustbin of history—from the pages of little magazines, printed postcards, cyclostyled sheets and suchlike squibs, from the plethora of private papers, the ephemera of everyday life, the toils of unconcern, carelessness, lassitude, lack of interest, or the bottomless depths of Paul Nougé's bottom drawer. It is to Mariën that we owe the two fundamental collections of Nougé's work, *Histoire de ne pas rire* (1956), containing nearly one hundred pages of disjecta membra on Magritte, and *L'Expérience continue* (1967).

Following in Mariën's footsteps, the Brussels-based publisher Didier Devillez collected and republished a good many of Nougé's writings, making *René Magritte (in extenso)* (1997), and an anthology of Mariën's texts, *Apologies de Magritte* (1994), both used as the standard reference here. Magritte also figures large in Mariën's memoirs, *Le Radeau de la mémoire* (*The Raft of Memory*), the final edition of which is styled "Édition pirate parce que complète" (1988). To these should be added Louis Scutenaire's idiosyncratic vade mecum, *Avec Magritte* (1977), and two documentary works by Harry Torczyner, his ambassador to the United States (as Magritte called him), who became a confidant and a collector, *Magritte: signes et images* (1982) and *L'Ami Magritte: correspondance et souvenirs* (1992). Marcel Lecomte's under-regarded writings, *Le Regard des choses* (1992), contain acute reflections on Magritte. Paul Colinet's forte was as interlocutor and feeder of ideas (and lover of Georgette, the last word in *complicité*); his collected writings are recherché indeed. Irène Hamoir's writings include at least one piece under her name—a potted biography of Magritte—composed or inspired by Magritte.[1]

Hardly any of this material has been translated into English. There is no English edition of Magritte's collected writings, and precious little of his correspondence. There is *Magritte: Ideas and Images* (1977), and *Magritte/Torczyner: Letters Between Friends* (1994), a "concise" (abridged) edition of *L'Ami Magritte*. That appears to be the best we can do. Neither of the two most influential works in the entire literature has ever been translated into English. The first, Nougé's seminal text, *René Magritte ou les Images défendues*, an intellectual tour de force, was first

published in mutilated form in 1943, but extensively trailed ten years earlier in *La Surréalisme au service de la revolution*. The second, Scutinaire's *René Magritte*, an unrivaled testimony from an unbeatable source, at once unapologetic and undeceived, is a droll assemblage of apothegms and affirmations first published in 1947, though compiled a little earlier, and later subsumed in *Avec Magritte*.

Many of these works first saw the light of day while Magritte was still alive to read them, and as often as not to collaborate on them, if *collaborate* is in fact the right word. It was Magritte who inserted his own name in the title of the work Nougé conceived as *Les Images défendues* (and who had the final say on the illustrations), a liberty Nougé never forgave him. He made no attempt to tamper with the text, which he seems to have approved unreservedly, but that was a rare abstention. When Mesens composed a biographical essay for a volume on contemporary Belgian painters in 1946, Magritte sent him a sheaf of sharply worded corrections, bearing on both the expression and the interpretation, for example as to the purported influences on his early work ("at that stage I hadn't *heard* of Matisse or *Lhote*"), or any comparison with Delvaux—"that decorator"—known to Magritte as "Delvache" or "Delboeuf," the source (or sauce) of remorseless puns. "Encore du veau! Je propose de servir du boeuf ou de la vache."[2]

Few attempts on his life escaped his admonitory pen. Twenty years on, he vetted the text of Patrick Waldberg's *René Magritte* (1965), the first sizable illustrated monograph, a celebratory project commissioned by two of his patrons.[3] When the time came (a little late) for his retrospective at the Museum of Modern Art in New York, that same year, he primed James Thrall Soby with ideas for the catalog essay: "In what you write about me, you may be inclined to take into account a few of the ideas that I hold dear."[4] He was centrally involved in Suzi Gablik's *Magritte* (1970), inasmuch as the budding author was his lodger in Brussels for eight months in 1959–60; he also tried to help her find a publisher. In somewhat different fashion, he collaborated with the photographer Duane Michals to create the famous images of *Une visite chez Magritte* (in 1965), as he did with other distinguished photographers and filmmakers, among them Bill Brandt (in 1966) and Luc de Heusch, for the documentary *Magritte ou la leçon de choses* (1960), a portrait of the artist as con man, extravagantly admired even by André Breton. Magritte was image conscious, in every way.

Research on his *catalogue raisonné*, the most extensive investigation of his life and work ever undertaken, got under way soon after his death in 1967. It was published in five outsize volumes over the period 1992–97, the fruit of a twenty-five-year research project, underwritten with extraordinary generosity by the Menil Foundation in Houston, Texas, and masterminded by the redoubtable David Sylvester. A sixth volume was added in 2012, edited by Sarah Whitfield, Sylvester's principal lieutenant in that project, of works newly discovered and authenticated over the period 2000–10. One distinctive feature of the *catalogue raisonné* is a narrative "chronology" of the artist's life, in three parts, distributed across the first three volumes (1898–1930, 1931–48, 1949–67). In total, the chronology amounts to well over four hundred pages. It is at the same time documentary and discursive; it tells

the story and weighs the evidence (and lack of evidence). It is crisp, judicious, and thorough. It quotes freely from the documents; punctiliously, it gives the quotations in the original French and in English translation.

Not content with that magnum opus, Sylvester himself produced a monograph, *Magritte* (1992), the most penetrating study of its kind, at least since Nougé lapsed into silence, or lost interest. ("Le bonhomme ne m'intéresse plus," he is supposed to have said, near the end.)[5] Reflecting later on the unanticipated twists and turns of his own career—"from 1967 on, more than half my working life for more than a quarter of a century was taken over by René Magritte"—Sylvester remarked that he still loved the work; "but the fact remains that I spent years of my life, like Swann, on someone who was not my type."[6] A remark to give any biographer pause.

The *catalogue raisonné* and Sylvester's associated publications transformed the literature. The chronology alone is a major achievement. In terms of the life line, or the thickness of the life story, it rendered all previous accounts obsolescent. More unexpectedly, perhaps, it left all subsequent accounts in the shade. As Sarah Whitfield has lamented, new research on Magritte is conspicuous by its absence.[7] Significant exceptions are few and far between. One is a sort of quest: Jacques Roisin, a psychoanalyst by profession and a sleuth by avocation, spent the best part of thirteen years investigating Magritte's early life, tracing the survivors and their descendants, combing local records, tramping the streets, painstakingly following every lead, to produce a fuller account than anyone believed possible. *Ceci n'est pas une biographie de Magritte* was first published in 1998 and reissued in 2014, as *René Magritte: la première vie de l'homme au chapeau melon* (the early life of the man in the bowler hat), with a genealogical pendant, *Le Fils de l'homme* (the son of man, a play on a Magritte title, among other things). Another recent initiative took up where Roisin left off: *Magritte: The Mystery of the Ordinary* (2013), a collaboration between the Museum of Modern Art in New York, the Art Institute of Chicago, and the Menil Collection, focusing on the years 1926–38—a restaging of that fecund period, buttressed by intriguing new technical analyses.

With regard to archival holdings, the mother lode is in the Menil Archives, which houses the papers of the Catalogue Raisonné Research Project (CRRP), as they call it, together with a number of other collections bearing on Magritte. The CRRP constitutes the single biggest archive of Magrittiana ever assembled, including copies of his correspondence—all that was extant up to the point of publication in the 1990s—and a variety of other documentary delicacies, such as an inventory of his library (since dispersed), complete with indications of pages cut and annotated, and an interview with Georgette on his taste in music.[8] Thanks to the good offices of Charly Herscovici, it is now possible to consult another copy of the correspondence at Nail to Nail in Brussels; but this copy is incomplete, and the rest of the CRRP exists only in Houston. The correspondence is a fundamental source: I worked from the original texts in the archives, wherever possible, though references to extracts published in the *catalogue raisonné* and elsewhere are given in the notes.

There are rich natural deposits in Brussels: the Archives de l'Art contemporain en Belgique (AACB) in the Musée des Beaux-Arts; the Archives et Musée de la Litté-

rature (AML) in the Bibliothèque Royale; the Archives of the Palais des Beaux-Arts (PBA); the collections of the Musée des lettres et manuscrits (MLMB); the holdings of the Musée Magritte in the Place Royale; and those of its bourgeois other, the Musée René Magritte at 135 rue d'Esseghem, in the suburb of Jette, Magritte's address from 1930 to 1954, a place and an experience captured by Jan Ceuleers in a marvelous book. To which should be added the resources of the Musée de la Photographie in Charleroi (MPC), under the benevolent dispensation of Xavier Canonne, including recently acquired Mesens correspondence, as well as important photographic archives bearing on the early experiments of Magritte and Nougé in this sphere—a groundbreaking series later published as *Subversion des images* (1968)—and the riveting documentary work of Georges Thiry and Roland d'Ursel.

The pickings in Paris are not as rich, but still worth the detour: the collections of the Bibliothèque littéraire Jacques Doucet (BD), the Bibliothèque Kandinsky (BK), the Musée des lettres et manuscrits (MLMP) and the Musée national d'art modern (MNAM), in particular, together with the Institute mémoires de l'édition contemporaine (IMEC) in Caen. Anything of consequence from smaller collections elsewhere in France (for example the Léo Malet archives in Montpellier) is usually to be found photocopied in the papers of the CRRP.

In London, the British Library Sound Archives and the Tate Gallery Archives contain various Magritte-related items. In the latter, the David Sylvester Papers now supplement the CRRP. Out of London, the Edward James Foundation in West Dean retains the original records of an extraordinarily interesting chapter in Magritte's life. The Scottish National Gallery of Modern Art in Edinburgh has extensive holdings on surrealism, founded on the Penrose Archive.

In the United States, apart from the mecca of the Menil, the Getty Research Institute (GRI) in Los Angeles has been collecting archival material relating to surrealism in general and Magritte in particular, often from private collections, at auction. In recent years the Getty has acquired caches of Magritte's correspondence with Colinet, Iolas, and Lecomte; the traffic with Colinet is especially revealing. It also has a substantial collection of Mesens Papers. Thanks to Christiane Geurts-Krauss and others, and the enterprise of Phillip Van den Bossche at the Mu Zee in Ostend, there is now more of Mesens in the public domain.[9] However, the Mesens archive remains radically incomplete, and Mesens himself rather elusive. Some of the archive is still in private hands, and unavailable to researchers; likewise his prize collection of Magrittes. Much the same applies to Iolas and Torczyner.

Other important archives and collections have been broken up and sold in the meantime, beginning with "The Remaining Contents of the Studio of René Magritte," at Sotheby's in London in 1987, after Georgette's death. Mariën sold his Magritte letters to his friend Leo Dohmen; they were subsequently dispersed. Another of Magritte's accomplices, Jacques Wergifosse, one of the very few to elude the *catalogue raisonné* team, sold his archive through Michel Lhomme in Liège in 1995. "The Collection of Harry Torczyner, Esq." was auctioned in suitable style at Christie's in New York in 1998. Other private collections have been sold piecemeal ever since, including that of Magritte's brother Raymond, a successful business-

man, who seems to have been estranged from the artist over long periods, or at least kept at one remove.[10] Nevertheless, he continued to acquire (or receive) a significant number of paintings.[11]

Other material in private hands is not quite so inaccessible, thanks to the likes of Philip Morris in the U.S., who was kind enough to share with me his albums of correspondence between René and Georgette Magritte, and above all to Isy Brachot in Belgium, who generously gave me the run of his remarkable archive and equally remarkable library. The Archives Brachot are a treasure trove, not least for the collection of Magritte family photographs, surely the most impressive private holdings in this field. Happily, Isy Brachot and his son Isy Gabriel Brachot are enlightened custodians of their patrimony.

Acknowledgments

My beloved husband, Alex Danchev, died suddenly and unexpectedly after completing chapter nine of this book. Ensuring that his last book saw the light of day has been of primary importance for his family and friends. Heartfelt thanks are due to several people without whose assistance and knowledge it would not have been possible to bring this book to fruition. Firstly to Sarah Whitfield for completing the book by writing chapter ten and providing invaluable assistance with the editing. To Charly Herscovici for his kindness and support. To the translator, Paul Edson, for commenting on Alex's translations from the French. To the picture editor, Lesley Hodgson, for sourcing the illustrations, and to the Magritte experts Jacques Roisin, Mia Vandekerckhove, and Julie Waseige, who generously shared their knowledge.

A debt of gratitude is also due to the following:

Deborah Garrison and Todd Portnowitz at Pantheon and Andrew Franklin and Cecily Gayford at Profile for their excellent editing and support, and Andrew Gordon at David Higham for his wisdom and encouragement.

For assistance and support in the venture: Manu Van Der Aa, Pierre Alechinsky, Lotte Beckwé, Lucie Bennani-Spaak, Nele Bernheim, Mel Bochner, Phillip Van den Bossche, Yves Bossut, Isy Brachot, Isy Gabriel Brachot, William Camfield, Xavier Canonne, Michel Carly, Jan Ceuleers, Anouck Clissen, Elizabeth Cowling, Enrico Crispolti, Eric Decelle, Didier Devillez, Virginie Devillez, Philippe Dewolf, Richard Dorment, Guy Dotrement, Guy Duplat, John Elderfield, Daniel Filipacchi, Marcel Fleiss, Suzi Gablik, André Garitte, Robert Gober, Marie Godet, José Gotovitch, Johan Grimonprez, Clydette de Groot, Rebecca Hellen, Jasper Johns, Brian Klug, Christiane Geurts-Krauss, Michael Kuhn, Hermione Lee, Jacques Lennep, Robert Leuwenkroon, Michel Lhomme, Lisa Lipinski, Margaret MacMillan, Duane Michals, Eric Min, Desmond Morris, Peter Morris, Anne Nelson, Luca Pietro Nicoletti, Gisèle Ollinger-Zinque, Peter J. Pauwels, Benoît Peeters, Antony Pen-

rose, Heiner and Ulla Pietzsch, Michael Raeburn, Francine de Ridder, Charles De Rouck, Arturo Schwarz, Raoul Servais, Francesca Silvestri, Olivier Smolders, Frances Spalding, Anna Steinman, John Stezaker, David Thomson, Charles Trueheart, Peter Vandenabeele, André Vandenbroeck, Claude Van Loock, Jan Vercruysse, Bart Verschaffel, Marcia Vetrocq, Corinne Waldberg, Ian Walker, Lydejette de Weerd.

Among curators, archivists, and librarians: the staff of the American Library in Paris; Véronique Cardon at the Archives de l'Art contemporain en Belgique at the Musées royaux des Beaux-Arts de Belgique, Brussels; Jean Danhaive, Mélanie Michelet, and their colleagues at the Archives et Musée de la Littérature, Brussels; Sofie Ruysseveldt at the Argos Media Library, Brussels; Stephanie D'Alessandro and Allison Langley and their colleagues at the Art Institute, Chicago; Elias Leytens at Bernaerts Auction House, Antwerp; Paul Cougnard at the Bibliothèque Doucet, Paris; Anne Delebarre and her colleagues at the Bibliothèque Kandinsky, Paris; the staff of the Bibliothèque patrimoniale Hendrik Constance, Antwerp; the staff of the Bibliothèque Royale de Belgique, Brussels; the staff of the Bibliothèque Sainte-Geneviève, Paris; the staff of the Bodleian Library, Oxford; the staff of the British Film Institute, London; Sophie Mercier at Casino Knokke; Marie-France Hanon at the Centre des archives communistes en Belgique, Brussels; the staff of the Institute Mémoires de l'édition contemporaine, Caen; Francine Norris at the Edward James Foundation, West Dean; John Langdon and his colleagues at the Hyman Kreitman Research Centre at the Tate, London; Jan Robert, Jan Stuyk, and their colleagues at the Letterenhuis, Antwerp; Joëlle Janssens at the Maison Magritte, Châtelet; David Aylsworth, Geraldine Aramanda, Lisa Barclay, Karl Kilian, and their colleagues at the Menil Archives, Houston, Texas; Dita Amory, Catherine Brodsky, Meredith Friedman and their colleagues at the Metropolitan Museum of Art, New York; Cathérine Verleysen at the Musée des Beaux-Arts, Ghent; Loanna Pazzaglia at the Musée des lettres et manuscrits, Brussels; Elisa Bourdonnay at the Musée des lettres et manuscrits, Paris; André Garitte and his colleagues at the Musée Magritte, Jette, Brussels; Brigitte Leal and her colleagues at the Musée national d'art moderne, Paris; Xavier Canonne and his colleagues at the Musée de la Photographie, Charleroi; Frederik Leen at the Musées royaux des Beaux-Arts de Belgique, Brussels; Erik van Boxtel and Saskia van Kampen at the Boijmans Van Beuningen Museum, Rotterdam; Danielle Johnson and Anne Umland at the Museum of Modern Art, New York; Juana Haba at Nail to Nail, Brussels; Monica Keyzer at *Vrij Nederland*; Veerle Soens and her colleagues at the Archives of the Palais des Beaux-Arts, Brussels; Anne Janssen and her colleagues at Passa Porta, Brussels; Isabelle Chielens at the Romantic Agony Auction House, Brussels; Susan K. Anderson and her colleagues at the Philadelphia Museum of Art; Francisca Cruz at the Sammlung Ulla und Heiner Pietzsch, Berlin; Kirstie Meehan at the Scottish National Gallery of Modern Art, Edinburgh; Natacha Derycke at the Fondation Henri Storck, Brussels; the staff of the University Library, St. Andrews; Pamela S. Johnson at the Dorothea Tanning Foundation, New York.

For grants, fellowships, and residencies given to Alex: the International House of Literature Passa Porta (Brussels) as part of the program "Residencies in Flan-

ders and Brussels," organized by Passa Porta and the Flemish Literature Fund. A Getty Travel Grant. A Visiting Fellowship at the American Library in Paris. The Jacqueline Nonkels Prize from the King Baudouin Foundation of Belgium. And, most munificently, a Leverhulme Major Research Fellowship.

To the University of St. Andrews and especially to the librarians, archivists, and colleagues at the Department of International Relations.

Last, but not least, thanks to all those who provided sustaining support: Roland Bleiker, Jed Boardman, Chris and Jemma Chambers, Mo Chandler, Giles and Suzanne Cooper, Gile Downes, David and Jennie Erdal, Paul Gordon, Sarah Grochala, Christine Hawkins, Keith and June Hopkins, Pam Horrocks, Bruce Hunter, Ajay Jassal, Suzanne Kippenberger, Donald MacEwan, Jo Marks, Elizabeth Martin, Diane Miller, Araceli Montero, Meg Morris, Meg Movshon, Marlene Patrick, Faye Pring, Alistair Ross, Diana Sanders, Adelheid Scholten, Dee Stanfield, and Paul Stoop.

Dee Danchev
Oxford, 2021

Abbreviations

AACB	Archives de l'Art contemporain en Belgique, Brussels
AIC	Art Institute of Chicago
AML	Archives et Musée de la Littérature, Brussels
AS	Marcel Mariën (ed.), *L'Activité surréaliste en Belgique (1924–1950)* (Brussels: Le Fil Rouge, Editions Lebeer-Hossman, 1979)
BL	British Library, London
BLJD	Bibliothèque littéraire Jacques Doucet, Paris
BK	Bibliothèque Kandinsky, Paris
BN	Bibliothèque nationale, Paris
CARCOB	Centre des archives communistes en Belgique
CPB	Parti Communiste de Belgique
CR	*René Magritte Catalogue Raisonné*, 6 vols (Antwerp/Brussels: Mercatorfonds, 1992–2012):

I Oil Paintings 1916–1930 (1992) [CR 1–333] (David Sylvester & Sarah Whitfield)

II Oil Paintings and Objects 1931–1948 (1993) [CR 334–706] (David Sylvester & Sarah Whitfield)

III Oil Paintings, Objects, and Bronzes 1949–1967 (1993) [CR 707–1094] (Sarah Whitfield & Michael Raeburn)

IV Gouaches, Temperas, Watercolours, and Papiers Collés 1918–1967 (1994) [CR 1095–1655] (Sarah Whitfield & Michael Raeburn)

V Supplement, Exhibitions Lists, Bibliography, Cumulative Index (1997) (David Sylvester, Sarah Whitfield, Michael Raeburn, & Lynette Cawthra)

VI Newly Discovered Works (2012) (Sarah Whitfield)

CRRP	Catalogue Raisonné Research Project, Menil Archives, Houston

Ceuleers	Jan Ceuleers, trans. Gus Triandos, *René Magritte, 135 rue Esseghem, Jette-Brussels* (Antwerp: Pandora, 1999) [*Magritte*]
DM	Dallas Museum of Art
EC	René Magritte, *Écrits complets* [1979] (Paris: Flammarion, 2009), ed. André Blavier
FA	*Le Fait accompli*
Gablik	Suzi Gablik, *Magritte* [1970] (London: Thames & Hudson, 1985) [*Magritte*]
GRI	Getty Research Institute, Los Angeles
IMEC	Institut mémoires de l'édition contemporaine, Caen
Larousse	*Larousse du XXe Siècle*, 6 vols. (Paris: Larousse, 1928)
LM	Marcel Mariën (ed.), *Lettres mêlées (1920–1966)* (Brussels: Les Lèvres nues, 1979)
LRS	*La Révolution surréaliste*
LS	Marcel Mariën (ed.), *Lettres surréalistes (1924–1940)* (Brussels: Les Lèvres nues, 1973)
Magritte	*Lettres à André Bosmans 1958–1967* (Paris: Seghers, 1990) [*Bosmans*]; *La Destination: lettres à Marcel Mariën 1937–1962* (Brussels: Les Lèvres nues, 1977) [*Destination*]; *Quatre-vingt-deux lettres de René Magritte à Mirabel Dors et Maurice Rapin* (Paris: Privately published, 1976) [*Rapin*]
Mariën	Marcel Mariën, *Le Radeau de la mémoire* (Brussels: Les Lèvres nues, 1988) [*Radeau*]; *Apologies de Magritte 1938–1993* (Brussels: Devillez, 1994) [*Magritte*]
Menil	Menil Collection/Archives, Houston
MFA	Museum of Fine Arts
MLMB	Musée des lettres et manuscrits, Brussels
MLMP	Musée des lettres et manuscrits, Paris
MNAM	Musée national d'art moderne, Paris
MoMA	Museum of Modern Art, New York
MPC	Musée de la Photographie, Charleroi
MRBAB	Musées royaux des Beaux-Arts de Belgique
MS	Manuscript
Nougé	Paul Nougé, *René Magritte ou les Images défendues* [1943] [*Images*]; in *René Magritte (in extenso)* (Brussels: Devillez, 1997) [*Magritte*]; *Histoire de ne pas rire* [1956] (Lausanne: L'Age d'Homme, 1980) [*Histoire*]; *L'Expérience continue* [1967] (Lausanne: L'Age d'Homme, 1981) [*Expérience*]; *Des mots à la rumeur d'une oblique pensée* (Lausanne: L'Age d'Homme, 1983) [*Mots*]
OC	*Oeuvres complètes*
OPC	Jacques Wergifosse, *Oeuvre (presque) complète* (Brussels: Les Trois Petits Cochons, 2001)
PBA	Palais des Beaux-Arts, Brussels
PC	Private collection
PMA	Philadelphia Museum of Art

Poe　　　　*Histoires extraordinaires* [1856] (Paris: Gallimard, 2010) [*HE*]; *Nouvelles histoires extraordinaires* [1857] (Paris: Gallimard, 2010) [*NHE*]

Roisin　　　Jacques Roisin, *René Magritte: la première vie de l'homme au chapeau melon* [1998] (Brussels: Les Impressions Nouvelles, 2014) [*Magritte*]

Scut　　　 *Irène, Scut, Magritte and Co* (Brussels: MBRAB, 1996)

Scutenaire　Louis Scutenaire, *Avec Magritte* (Brussels: Lebeer Hossmann, 1977) [*Magritte*]

SW　　　　René Magritte, trans. Jo Levy, *Selected Writings* (Richmond: Alma, 2016), ed. Kathleen Rooney and Eric Plattner

Sylvester　 David Sylvester, *Magritte* [1992] (Brussels: Mercatorfonds, 2009) [*Magritte*]

TGA　　　 Tate Gallery Archives, London

Torczyner　Harry Torczyner, *Magritte: signes et images* (Paris: Draeger, 1977) [*Signes*]; trans. Richard Miller, *Magritte: Ideas and Images* (New York: Abrams, 1977) [*Ideas*]; *L'Ami Magritte: correspondance et souvenirs* (Antwerp: Mercatorfonds, 1992) [*L'Ami*]; trans. Richard Miller, *Magritte/Torczyner: Letters Between Friends* (New York: Abrams, 1994) [*Letters*]

Waldberg　Patrick Waldberg, *René Magritte* [1965] (Paris: La Différence, 2009) [*Magritte*]

Notes

INTRODUCTION

1. In addition to Scutenaire, *Magritte*, see, e.g., Mariën, *Radeau*, and Nougé, *Histoire*, containing, among other texts, *Les Images défendues* (1943).
2. Quoted in Sylvester, *Magritte*, p. 24 (emphasis added).
3. Paul Simon's song, "René and Georgette Magritte with Their Dog After the War," is on the album *Hearts and Bones* (1983).
4. See Bart Verschaffel and Jef Cornelis, "The Amateur Films of René Magritte," and Alain Berenboom, "Ceci n'est pas du cinéma," in Gisèle Ollinger-Zinque and Frederik Leen (eds.), *René Magritte* (Brussels: Royal Museums of Fine Arts of Belgium, 1998), pp. 286–91.
5. There is also *Magritte: The False Mirror* (1970), by David Sylvester, for the Arts Council.
6. Duane Michals, *A Visit with Magritte* (Providence: Matrix, 1981).
7. Scutenaire is an indispensable witness. His principal writings on Magritte are collected in *Avec Magritte*, which contains the important text first published as *René Magritte* (1947). Like most of the memoir literature, these writings have not been translated into English.
8. See Patrick Roegiers, trans. Mark Polizotti, *Magritte and Photography* (Ghent: Ludion, 2005).
9. Lautréamont, trans. Paul Knight, *Maldoror and Poems* (London: Penguin, 1978), p. 274 (translation modified). The edition illustrated by Magritte is *Les Chants de Maldoror* [1948] (Brussels: Apollo, 1984). The first book of *Maldoror* was published in 1878. It became an essential source text for the surrealists: "[H]e is as handsome as . . . the chance meeting of a sewing machine and an umbrella on an operating table" was almost a surrealist manifesto in itself. See Alex Danchev, *100 Artists' Manifestos* (London: Penguin, 2011), pp. 241–42.
10. See Thierry de Duve, "This Wouldn't Be a Pipe," in Stephanie Barron and Michel Draguet (eds.), *Magritte and Contemporary Art* (Los Angeles: Los Angeles County Museum of Art, 2006), pp. 95–107.
11. Alain Robbe-Grillet, René Magritte, trans. Ben Stoltzfus, *La Belle captive* [1975] (Berkeley: University of California Press, 1995). A restored print of *La Belle captive* is available on DVD (Second Sight, 2009).

12. Magritte to Foucault, 4 June 1966, in *This Is Not a Pipe* (University of California Press, 1973), p. 58 and *EC*, p. 640. The affinity with Roussel had been noted also by Éluard (see Scutenaire, *Magritte*, p. 18) and by Waldberg, *Magritte*, p. 61, who cites "le Théâtre des Incomparables" in *Impressions d'Afrique* (1910).

13. Respectively, "Nick Carter" (written 1927, published 1969), "Nat Pinkerton" (1953), "Les Mots et les images" (1929), and "La Ligne de vie" (1938), in *EC*, pp. 41–42, 341–42, 60–63, and 103–30. On the provenance of the autobiographical text, see David Sylvester and Sarah Whitfield, "Magritte's Lost Lecture," in Ollinger-Zinque and Leen, *René Magritte*, pp. 41–48; on the plagiarism, see Allmer, *René Magritte*, (London: Reaktion Books, 2019), pp. 112ff. The principal editions of letters include *Quatre-vingt-deux lettres de René Magritte à Mirabelle Dors et Maurice Rapin* (Paris: Privately published, 1976); *La Destination: Lettres à Marcel Mariën* (Brussels: Les Lèvres Nues, 1988); *Sous Le Manteau de Magritte* (Fleury-Mérogis: Fantômas, 1984); *Magritte, Bosmans*; and Magritte, *L'ami*.

14. David Sylvester, *About Modern Art* (London: Pimlico, 1997), p. 29.

15. See Roberta Bernstein, "René Magritte and Jasper Johns," in Barron and Draguet, *Magritte and Contemporary Art*, pp. 109–24.

16. Marcel Broodthaers, "Gare au défi!," *October* 42 (1987).

17. Henri Michaux, *En rêvant à partir de peintures énigmatiques* [1964] (Montpellier: Fata Morgana, 1972).

18. Jeff Koons interviewed in David Sylvester, *Interviews with American Artists* (London: Chatto & Windus, 2001), esp. pp. 355–56, and in *Tate Etc.* 22 (2011), p. 60.

19. Sotheby's, "The Remaining Contents of the Studio of René Magritte," lot 925, London, 2 July 1987.

20. Magritte to Torczyner, 19 September 1966, in Torczyner, *Letters Between Friends* (New York: Abrams, 1994), p. 136.

1. HIS SECRET JUNGLE

1. For the story as told by Magritte, see, Torczyner *Signes*, p. 16. Following Waldberg, the general's given name is incorrect in the literature. Cf. Waldberg, *Magritte*, p. 65; Torczyner, *Signes*, p. 17. Scutenaire admired *La Garçonne* and wanted a copy for his library. *Scut*, p. 145.

2. Michael Howard, *The Franco-Prussian War* [1961] (London: Routledge, 2001), pp. 115, 208, and 215–16.

3. Albert Bockstael to André Blavier, 9 March 1975, quoted in *EC*, pp. 79 and 370. Bockstael was a fellow student of Magritte's at the Académie des Beaux-Arts in Brussels; he dated this work to 1917 or 1918. It is uncataloged. See CR, vol. I, app. 4.

4. Michèle Heck, "L'ascendance," *Cella* (Pont-à-Celles: *Cercle d'Histoire et d'Archéologie de Pont-à-Celles et environs*, 2008, no. 115–116), pp. 9–11.

5. In the account that follows I have mined the testimony gathered by Jacques Roisin in the course of his prodigious research into Magritte's roots, *René Magritte: la première vie de l'homme au chapeau melon*, first published in 1998 and reissued in 2014, and its genealogical pendant, *Le Fils de l'homme* (2014), previously unpublished. This work postdates the CR (see Note on Sources). It transforms our knowledge of his early life. Yet it remains almost unknown in the English-speaking world—it exists only in French. I have also drawn on Émile Lempereur, "Ceci est un Magritte ou derrière les ombres Magrittiennes" (Liege: *La Vie Wallonne*, vol XLIV no. 331–2, 1970), pp. 148–77; and on the genealogical data in Michel Foulon, "Crayon généalogique de la famille Magritte," in *L'Intermédiare des généalogistes*, and Armand Delforge, "L'ascendance pont-à-celloise du peintre René Magritte," in *Cella*.

6. Cf. Waldberg, *Magritte*, p. 65; Harry Torczyner, *Magritte: signes et images* (Paris: Draeger, 1977), p. 16.

7. Betty Magritte (widow of Paul) in Roisin, *Magritte*, p. 111; Scutenaire, *Magritte*, p. 69.

8. Mariën, *Radeau*, p. 201.

9. Roisin gives this as "Vass'T'y Frotte." He underlines Magritte's taste for "the unseemly" (*l'inconvenant*), but does not dwell on its meaning or associations. Roisin, *Magritte*, p. 110.

10. Copley, *Portrait of the Artist as a Young Dealer* (Houston: Rice Museum, September 7–November 11, 1979), p. 20.

11. A *crole* (from the Dutch *krol*) is a curl. *Fer à croles* is a curling iron. *Can'à croles* is a puzzle, unless *can* is simply a euphemism for *con*, or "cunt," in which case the nickname would indeed suggest a crude version of *vagin bouclé* (curly pussy), as Roisin proposes. In Scutenaire's spoof biography, "The Life and Acts of René Magritte of Yore," it is given as *Canakrol*, glossed as "curly pubic hair" in Gablik, *Magritte* (London: Thames and Hudson, 1970), p. 196; there it is the nickname of Georgette's father's second wife (a German).

12. See Luc Sante, "Introduction" to Simenon, *Pedigree,* trans. Robert Baldick (New York Review of Books Classics, 2010), p. xii.

13. *Bière de porc* (CR 689) and *Confiture de cheval* (CR 688), both dated to 1937.

14. Magritte to Bosmans, 19 February 1959, in Magritte, *Bosmans,* p. 31; Scutenaire, *Magritte*, p. 33; Rex Stout, *Might as Well Be Dead* [1956] (New York: Bantam, 1993), p. 6. Magritte read it in French as soon as it came out: Trans. Edmond Michel-Tyl, *J'aurais mieux fait de mourir* [1958] (Paris: Champs-Élysées, 1974), p. 8. See Magritte to Torczyner, Monday, July 1958, in Torczyner, *L'Ami*, p. 78.

15. Scutenaire, *Magritte*, pp. 33 and 48.

16. Melly, "Robbing Banks," *LRB*, 25 June 1992. The pretty girl was in fact Ann Robin Banks, an enamel artist of some renown.

17. Carroll, *Alice*, p. 274. *Alice au pays des merveilles* (London: Macmillan, 1869) appeared almost immediately.

18. Rex Stout, *The League of Frightened Men* (New York: Bantam, 1982), p. 139; Scutenaire, *Magritte*, p. 32. Used as the epigraph to Magritte's "Manifeste de l'amentalisme" (1947), in *EC*, p. 221. He would also have noted and endorsed the preceding sentence: "In these eleven days I have learned that psychology, as a formal science, is pure hocus-pocus." Scutenaire found the title of *Les Compagnons de la peur* (CR 499, dated 1942).

19. Scutenaire, *Mes Inscriptions, 1943–1944* (Paris: Editions Allia, 2007), pp. 130–31.

20. Paul Sacrez in Roisin, *Magritte*, pp. 134–35.

21. Roisin, *Magritte*, p. 198.

22. Old residents of Châtelet in ibid., p. 47.

23. Raymond Pétrus in Roisin, *Magritte*, p. 46.

24. Roisin, *Magritte*, p. 193.

25. Paul Sacrez in ibid., p. 192.

26. Scutenaire and Sacrez in Roisin, *Magritte*, pp. 26 and 193.

27. Homer, trans. Robert Fagles, *The Odyssey* (New York: Penguin, 2006), p. 102 (book 2, lines 306–10). Magritte read *L'Odyssée* in the celebrated translation by Leconte de Lisle.

28. Magritte's "Lifeline" was first published in English in "Surrealism in Belgium," *View* (New York, no 42 December 1946), pp. 21–23. The observation is Jean Dypréau's, in "René Magritte" (1967), in Dypréau, Delobel, and Martens, *Le Point de vision* (Auby sur Semois: Marot DL, 2013), p. 196. See Félix Fénéon, trans. Luc Sante, *Novels in Three Lines* (New York: NYRB, 2007).

29. *Le Rappel* (Charleroi), 25 February 1912.

30. *Le Rappel*, 13 March 1912.

31. Élise Mahy in Roisin, *Magritte*, pp. 79–80. Élise was Marie Nisolle's daughter-in-law, and a near neighbor of the Magrittes in the rue des Gravelles, in the house by the alley that ran from the street to the river.

32. Victor Frisque in Roisin, *Magritte*, pp. 51 and 56.

33. *Le Matin*, 8 May 1912, in Léon Sazie, *Zigomar peau d'anguille* (Paris: Lulu.com, 2014), p. 380.

34. Ibid., p. 88.

35. Mariën and Pétrus in Roisin, *Magritte*, pp. 56–57.

36. Pétrus and Frisque in Roisin, *Magritte*, pp. 55 and 57.

37. Jacques Cellard and Alain Rey (eds.), *Dictionnaire du français non conventionnel* (1980), cited by Mariën in Roisin, *Magritte*, p. 57.

38. A.E.D. [Ernest Degrange], "Surréalisme pas mort!" *Nouvelle Gazette de Bruxelles*, 9 January 1946, and "Ce mystérieux René Magritte," *Nouvelle Gazette de Charleroi*, 11 January 1963; Degrange's widow in Roisin, *Magritte*, p. 59.

39. Lempereur, Pétrus, and elderly Châtelettians in Roisin, *Magritte*, pp. 58–59. Cf. Lempereur, "Magritte à Châtelet," in *La Vie Wallonne*.

40. Beckett, *First Love* in *The Expelled/The Calmative/The End/First Love* (London: Faber and Faber, 2009), p. 61.

41. Frisque and Pétrus in Roisin, *Magritte*, pp. 54–55.

42. Albert Chavepeyer in Roisin, *Magritte*, p. 102.

43. René Passeron, "En écoutant Georgette Magritte," in Roisin, *Magritte*, p. 12; Scutenaire, *Magritte*, p. 19. "The maid Anaïs," according to Georgette.

44. Sacrez in Roisin, *Magritte*, p. 193.

45. Jacques Renard and Joseph Moisse in Roisin, *Magritte*, pp. 100–01.

46. Pétrus in Roisin, *Magritte*, p. 57.

47. CR, vol. I, p. 9; Pétrus in Roisin, *Magritte*, p. 75. Jeanne Verdeyen was not a direct witness; she was taken on only after Régina's death.

48. Jean-Marie Collard in Roisin, *Magritte*, p. 74. I am grateful to Jacques Roisin for retracing the history with me, on the ground, and for the opportunity to discuss it at length with other local experts, among them André Vandenbroucke, President of the Société Royale d'Histoire "Le Vieux Châtelet."

49. Pétrus in Roisin, *Magritte*, pp. 65–66.

50. Arnould Leroux in Roisin, *Magritte*, pp. 68–69. The circumstantial detail here is all from Leroux, as verified by Roisin. A contemporary report that the body was taken temporarily to the house of a certain "M. Missone" is evidently a mistranscription (or mishearing) of Nisolle. Albert Nisolle himself makes a fleeting appearance in Émile Lempereur's recollections, "Ceci est un Magritte," p. 147.

51. Roisin, *Magritte*, p. 69. *Les Rêveries du promeneur solitaire* (CR 124) was acquired by René Gaffé, and then by E. L. T. Mesens. It was first exhibited in 1933.

52. Jean-Jacques Rousseau, trans. Russell Goulbourne, *Reveries of the Solitary Walker* (Oxford: World's Classics, 2011). The introduction to this edition makes no bones about linking the painting to the book, and the art to the life. "The sense of isolation expressed by Rousseau . . . is here translated into a haunting visual image of a profound psychological trauma." "Magritte responds to his mother's suicide . . . by painting a bowler-hatted man, who was to become the iconic motif of his entire oeuvre and who effectively represents his alter-ego, with his back turned on his dead mother, who lies on a slab in the foreground." Slab or no slab, this robustly Freudian reading gains in straightforwardness what it loses in reductiveness. Magritte himself would surely have scorned it; but the well-defended truth is difficult to divine.

53. Samuel Beckett, *Stirrings Still* [1988] (London: Faber, 2009), p. 108.

54. Pétrus in Roisin, *Magritte*, p. 70.

55. Several of these numbers, including "Norine Blues" and "Marie Trombone Chapeau Buse," feature on the CD *Magritte's Blues* (Musique en Wallonie, 2010); the liner notes and the lyrics are at www.musiwall.ulg.ac.be. See also Robert Wangermee (ed.), *Dictionnaire de la chanson en Wallonie et à Bruxelles* (Liège: Mardaga, 1995); and "Paul Magritte poète et compositeur" on 7511christian.wix.com, with reproductions of the sheet music covers.

56. Scutenaire, *Mes Inscriptions, 1974–1980* (Paris: Le Pré aux Clercs), p. 114.

57. Mariën's observation, on hearing from Magritte that Paul had been declared unfit for military service, and demobilized. Magritte, *Destination*, p. 26.

58. *Le Savoir vivre* (Brussels: Le Miroir infidèle, 1946); Magritte, *Destination*, pp. 193ff.; CR, vol. II, pp. 127–28. These responses were edited by Mariën and Nougé. Nougé seems to have shortened the list of things he detested, cutting "dry cleaning, detergent, and great clear-outs," and slightly rephrased "a girl who runs in the street." Prompted by Magritte himself, Mariën cut something along the lines of "suffering for others."

59. Paul Magritte, *Les Travaux poétiques* (Brussels: A.S.B.L., 1974), p. 100.

60. Arlette Dupont-Magritte to Émile Lempereur, 13 March 1985, in Lempereur, "Ceci est un Magritte," p. 154. Paul Leroy, who knew Raymond in secondary school, from the age of twelve to fourteen, remembered him as pale and often ill. Roisin, *Magritte*, p. 124.

61. Waldberg, *Magritte*, p. 70, a remark dated to 1963. The deleted expletive was perhaps *con*, suggesting stupid, or something of the sort—"My brother's a berk."

62. *La Robe d'aventure* (CR 101), bought from Mesens in 1932, at the knockdown price of 50 Belgian francs, in the wake of the liquidation of La Centaure. Raymond bought three more at the same time, none as interesting as this one: *Il ne parle pas* (CR 94), *La Nourriture de l'ennemi* (CR 106), and *L'Esprit comique* (CR 259). On the liquidation and its consequences, see chapter 10. Around 1950, Magritte painted a realistic *Portrait of Arlette Magritte* (CR 752): a half-length, with bare shoulders.

63. Scutenaire, *Magritte*, p. 55.

64. Scutenaire and Betty in Roisin, *Magritte*, pp. 71–72; Georgette in Passeron, *Magritte* (Berlin: Rembrandt Verlag, 1971), p. 13.

65. Scutenaire, *Magritte*, pp. 69–70. See also p. 157. Magritte's compatriot Paul de Man (1919–83), the slippery literary theorist, offers an intriguing parallel. His mother committed suicide by hanging herself in the attic; he found her. He was seventeen. Years later, he told his wife, "Oh, you know how it is at this time: you are the object of great sympathy and you become the hero of the story." Evelyn Barish, *The Double Life of Paul de Man* (New York: Norton, 2014), p. 46. De Man himself wrote on the figure of *prosopopeia*, "the giving and taking away of faces," as he put it in a much-discussed article entitled "Autobiography as De-Facement," *Modern Language Notes,* vol. 94, no. 5 (Baltimore: Johns Hopkins University Press, December 1979); Paul de Man, *MLN*, vol. 94, no. 5, *Comparative Literature* (Johns Hopkins University Press, December 1979), pp. 919–30.

66. Sylvester, *Magritte*, pp. 13–14.

67. Georgette in conversation with Barbara Stoeltie (in 1985), in "Als hij een échte bourgeois was geweest . . . ," *Vrij Nederland*, 5 March 1988. This feature on Georgette at home is in Dutch; I am grateful to Paul Stoop for guidance on the translation. Georgette seems to speak more freely than usual. In the salient passage on Magritte's mother's suicide, she says, "They found her the next day. Because of the strong current, her nightgown had been pushed up. When they pulled her out of the water, her face was covered, as if shrouded by a wet veil. René did not see her again. Only years

later, he heard this story from a fireman. After that, he painted impressive subjects like *Les Amants*, the kiss of two veiled lovers."

68. *Gazette de Charleroi*, 13 March 1912.
69. Magritte to Mariën, n.d. [May 1943], in Magritte, *Destination*, p. 52. *L'Histoire centrale* (CR 249), first exhibited 1929.
70. *L'Inondation* (CR 254), first exhibited 1931.
71. "Nick Carter's Clever Decipher, or The Letters on the Floor," *Nick Carter*, no. 35. The front cover is reproduced in CR, vol. I, p. 296. The CRRP contain a selection of these serials. See also the untitled papier collé (CR 1619), dated 1926 or 1927, in which a clothed woman seems to sink through a wooden floor, her head concealed by a dark mass that may be a pall of smoke or a piece of fur, like the one in *Le Sens de la nuit* (CR 136), dated 1927, which was paired with the cover of a Nick Carter novel in *Variétés*, 16 May 1928, under the heading of "Mysteries."
72. Magritte, "Nick Carter," in *EC*, p. 41; *SW*, p. 19. According to Mariën, this text was originally destined for the review *Distances*; Magritte abandoned it in favor of one on Fantômas. See his "Notes sur Fantômas," dated 23 February 1928, *Distances* 2 (March 1928), in *EC*, pp. 48–49; *SW*, p. 24. On Magritte and Fantômas, see chapter 2.
73. Interview with Jean Stévo, 15 December 1961, in *EC*, p. 546. Stévo had interviewed him before, in 1954 and 1959, which may or may not have helped.
74. Georgette in Stoeltie, "Als hij een échte bourgeois."

2. NORMAL MADNESS

1. Interview with Jean Neyens, 19 January 1965, in *EC*, pp. 603–04.
2. Interview with Jan Walravens, 24 November 1961, in *EC*, p. 534. This important interview is incomplete in *SW*. Magritte usually spoke of "*la caisse*." There is a line in Apollinaire's poem "Ombre" ("Shadow"): "Caisson de regrets." In a letter to Rapin, discussing suicide, Magritte used the expression "*se faire sauter le caisson*" (commit suicide): 18 February 1958, in Magritte, *Rapin*, n.p.
3. Poe, "The Gold-Bug," *House of Usher* (London: Penguin Books, 2003), pp. 252–53; "Le Scarabée d'or," Poe, *Histoires Extraordinaire* (Paris: Gallimard, 2010), p. 145.
4. Valéry, *Cahiers/Notebooks*, vol. 1 (New York: P. Lang, 2000), p. 312. "Baudelaire's remark on Poe: 'This wonderful intellect, constantly alert . . . became as precious to me as a groaning treasure chest in the *Thousand and One Nights*."
5. *Gaspard de la nuit* (CR 1029 and 1584), dated 1965. Bertrand's poems were first published in 1842 and republished in 1925; Magritte had a copy in his library. Ravel's homage was first performed in 1909 and orchestrated by Eugène Goossens in 1942.
6. Magritte read it in the translation by Mardrus. Magritte to Nougé, n.d., extracted in CR, vol. II, p. 374. The letter is dated to 1946 by Mariën—a painting of the same title (CR 611) is also dated to 1946—though a new, affordable edition of the work was published by La Boétie, in Brussels, in 1947.
7. *Treasure Island* (CR 498), dated 1942; Scutenaire, *Magritte*, p. 21; Robert Louis Stevenson, *Treasure Island* [1883] (Oxford: World's Classics, 2011), p. 9. *L'Île au trésor* appeared almost immediately, in 1885. According to André Blavier, Magritte was also fond of *The Master of Ballantrae* (1889), published in French as *Le Maître de Ballantre*, trans. Théo Varlet (Paris: Editions de la Sirène, 1920).
8. *La Grande Nouvelle* (CR 78) and *L'homme célèbre* (CR 77), dated 1926; *Le Dormeur téméraire* (CR 217), dated 1928. In the CR this last is translated as *The Daring Sleeper*. In common with the Tate, I prefer *Reckless*.
9. Scutenaire, *Magritte*, pp. 22–23 and 51.
10. Interview with Walravens, *EC*, pp. 534–35; Scutenaire, *Magritte*, p. 157.

11. Holmes, *Falling Upwards* (London: William Collins, 2013), p. 1.

12. Drawn from a contemporary account by Georges Lahaye, in Sabatini, "La Jeunesse illustrée, ou la mémoire de Châtelet, Charleroi, Gilly dans l'oeuvre de René Magritte," in Chantal Mengeot, Anne Soumoy, eds., *Charleroi 1911–2011* (Charleroi: L'industrie s'associe à la culture, Septembre 2011), p. 450.

13. Magritte to Bosmans, 9 December 1964, in Magritte, *Bosmans*, p. 397, citing part of his response to Michaux, *En rêvant*, p. 13. Magritte read an earlier version of this text in the *Mercure de France* in 1964.

14. *La Tempête* (CR 336), dated 1931, apparently given to Georgette, until it was sold, around 1955. Magritte described it in these terms to Mariën, 3 October 1945, in Magritte, *Destination*, p. 153. The two blocks of sky are painted white, mixed with gray, but traces of paint visible underneath suggest that they started out light blue. The Lego Company was founded in 1932.

15. Magritte, "Lifeline," Catalogue Raisonné vol. V (Houston: The Menil Foundation / Philip Wilson Publishers, 1997), pp. 10–11.

16. See Camille Mauclair, *Le Peintre de la mer Wartan Mahokian* (Nice: L'Éclaireur de Nice, 1918). A postcard of *La Vague*, squared up by Magritte, was found among his effects. He appears to have used it for the first time in 1942, for *Le Beau navire* (CR 496). He was still using it twenty years later, for *La Grande famille* (CR 972) and *Le Grand air* (CR 985).

17. *Ciel-bouteille* (CR 697), dated c. 1943; *Les Compagnons de la peur* (CR 499), dated 1942; *L'Homme du large* (CR 135), dated 1927.

18. Magritte to Philippe Roberts-Jones, 26 April 1964, in *EC*, p. 596.

19. Samuel Beckett, *Watt* [1953] (London: Faber, 2009), p. 223, the concluding thought.

20. Nougé, "Pour illustrer Magritte" (1932–36), in *Magritte*, pp. 131–32.

21. Magritte, text on titles (1946), in *EC*, p. 261, and *SW*, p. 114, on *L'Éducation sentimentale* (CR 1216), dated 1946.

22. Magritte, "Variantes de tristesse" (1955), in *EC*, p. 411.

23. See Legrand, "Musées Royaux des Beaux-Arts de Belgique : trois oeuvres representatives du surréalisme," *Bulletin des Musées de Belgique*, vol. VI (Brussels: Musées Royaux des Beaux-Arts de Belgique, 1967), pp. 90–91.

24. *Un Peu de l'âme des bandits* (CR 910), whereabouts unknown, according to the CR; sold by Landau Fine Art at Art Basel 2013 for around $12 million. *Le Journal de Charleroi*, 30 April 1912; Albert Chavepeyer in Roisin, *Magritte*, p. 99. The author of the book was Émile Michon. *La bande à Bonnot* continue to capture the popular imagination. See, e.g., Jacques van der Heyden's film *En attendant Bonnot* (1975); and Patrick Pécherot, *L'homme à la carabine* (Paris: Gallimard, 2011).

25. Magritte, "Esquisse," in *EC*, p. 366; Hamoir, "Notes biographiques," in *Rétrospective René Magritte*, XXX (Charleroi: Salon du Cercle royal artistique et littéraire, 1956). The sweetshop was in the rue du Collège, opposite the École Moyenne; it was run by the Thomas sisters.

26. Frisque in Roisin, *Magritte*, p. 86. Caran d'Ache was founded a little later, in 1915, but this vivid memory serves to underline how well provisioned was the young Magritte.

27. *La Jeunesse illustrée* (CR 425), dated 1937.

28. Alexandre in Roisin, *Magritte*, p. 93. On the *vache* period, see chapter 10.

29. The first two, *Paysages campagnards avec chaumières* (CR vol. 1, figs. 8 and 9, p. 6), are also illustrated in Roisin, *Magritte*, p. 90. Sylvester appears to give them credence (*Magritte*, p. 35). The MRBAB has no record of them. The fourth was illustrated in the auction catalog: Hôtel des Ventes Mosan, Liège, 17 June 2004, lot 267, where the provenance is given as "Famille Fraipont à Paris. Descendance directe de Jules Gofin."

30. Frisque in Roisin, *Magritte*, p. 87.

31. Pétrus in Roisin, *Magritte*, p. 143. After a lengthy interval, the painting now resides at the same address, officially the Maison Magritte, Châtelet. I am grateful to Joëlle Janssen and Jacques Roisin for showing me round. "Les gens de la rue!"

32. Pétrus in Roisin, *Magritte*, p. 143. Pétrus himself recalled an earlier phase, after the coloring in but before the serious painting, when Magritte drew portraits of all his friends (ibid., p. 91). All his life Magritte testified to his father's support for his painting. See, e.g., his interview with Georis, 5 June 1962, in *EC*, p. 560.

33. *Cinéma bleu* (CR 68), dated 1925, eccentrically described by Magritte as "a Cubist picture" in his "The Esquisse autobiographiques." An alternative title, *Le Mannequin*, is deleted on the stretcher. The influence of *L'Inhumaine* is suggested by Mariën in an interview with Silvano Levy, 9 March 1981, in *Decoding Magritte* (Sansom & Co., 2015), p. 215.

34. Albert Chavepeyer in Roisin, *Magritte*, p. 99. Equipe cycliste Alycon won the team prize in the Tour de France from 1909 to 1912. Chavepeyer did become a poster designer. So did Magritte. See chapter 10.

35. *La Main coupée* (1911) is the tenth in the series, *Le Bouquet tragique* (1912) the twenty-third, *Le Jockey masqué* (1913) the twenty-fourth. The original covers are displayed, in sequence, on the website fantomas-lives.com, an excellent resource.

36. Blaise Cendrars, "Fantômas," *Les Soirées de Paris*, June 1914.

37. Raymond Queneau, "Fantômas," in *Bâtons, chiffres et lettres* [1950] (Paris: Gallimard, 1965), p. 259.

38. The mask is perhaps an homage to the last in the series, *Le Fin de Fantômas*, whose cover depicts a somewhat similar mask floating in the sea.

39. Allain and Souvestre, *Fantômas* (Paris: Marcel Allain and Pierre Souvestre, 1911), p. 1; Alexandre in Roisin, *Magritte*, pp. 92–93.

40. Interview with Jacques Goossens, broadcast on Belgian TV on 28 January 1966, in *EC*, p. 602; *SW*, p. 217.

41. Magritte, "Notes sur Fantômas," *Distances* (1928), in *EC*, pp. 48–49; *SW*, p. 24.

42. *Le Changement des couleurs* (CR 265), once owned by Mariën.

43. Joseph Conrad, *Lord Jim* [1900] (Oxford: World's Classics, 2002), p. 166. *Lord Jim* appeared in French in 1922.

44. "Beautiful stories," he wrote later, of Bizet's *Carmen* and Conrad's *Typhoon*, "but they do not challenge my conception (if I may say), my feeling of who we are." Magritte to Rapin, Samedi [22 March 1958], Magritte, *Rapin*, n.p. Gide's translation of *Typhoon* was first published in 1923.

45. Legrand, "Musées Royaux," p. 90. Marcel L'Herbier had made a film called *L'Homme du large* (1920), suggestively subtitled "Marine" (seascape). Magritte must have known L'Herbier's work, in particular *L'Inhumaine* (1924).

46. Conrad, *Lord Jim*, pp. 58 and 154–55; "The Secret Sharer," in *Typhoon and Other Tales* (Oxford: World's Classics, 2002), p. 181. "The Secret Sharer" was first collected in *Twixt Land and Sea* (London: J. M. Dent, 1912); it was translated by Georges Jean-Aubry as "Le Compagnon secret," a rather Magrittian title, in *Entre terre et mer* (Paris: Gallimard, 1929).

47. Thomson, "Louis Feuillade," in *A Biographical Dictionary of Cinema* (London: Secker and Warburg, 1975), p. 344; "*Fantômas*," in David Thomson, "*Have You Seen . . . ?*": *A Personal Introduction to 1,000 Films* (London: Penguin, 2008), p. 283.

48. Thomson, "Louis Feuillade," p. 344. Cf. Breton's *Anthologie de l'humeur noir* (1939).

49. This sequence is in *Vampires*, episode 7, "Satanas."

50. Resnais (quoting Lautréamont), "Il a porté mes rêves à l'écran," in Gauthier and Lacassin, *Feuillade, Maître du Cinéma Populaire* (Paris: Gallimard, 2006), p. 153; Franju, "Feuillade l'unique," in Andrew, *Mists of Regret: Culture and Sensibility in*

Classic French Film (Princeton, Princeton University Press, 1995), p. 33; Prévert in Gauthier and Lacassin, *Feuillade*, p. 119.

51. Desnos, "*Fantômas, Les Vampires, Les Mystères de New York,*" *Le Soir*, 26 February 1927, in Gauthier and Lacassin, *Feuillade*, p. 70. The special issue of *Variétés* (June 1929) on "Le Surréalisme en 1929" contains a tribute to Musidora.

52. Did *Le Retour de flamme* reply in some way to *La Flamme cachée*? Musidora published a memoir, "La Vie d'une vamp," *Ciné Mondial*, nos. 42–48 (June/July 1942) the year before the painting; but Colette does not appear in Magritte's library, or on his cultural radar.

53. Chavepeyer and Alexandre in Roisin, *Magritte*, pp. 93 and 100.

54. *La Voleuse* (CR 133), *La Supplice de la vestale* (CR 134), and *L'Homme du large* (CR 135), all dated 1927, leading to a canvas of altogether different scale and ambition: *L'Assassin menacé* (CR 137). See chapter 10.

55. Magritte to Lennep. 9 May 1967, Collection Jacques van Lennep, Belgium. The letter is reproduced in full in *Écrits Complet*, pp. 677–78. Magritte was responding to the text of Lennep's lecture on *L'Homme du large* at the Musée des Beaux-Arts in Brussels, sent to him by the author. Lennep had studied alchemy; he described himself as a specialist in that domain. His interpretation was informed by conversations with Marcel Lecomte, who was also alchemically inclined. The complete text has not survived; Lennep's article, "L'Homme du large," in *Fantasmagie* 27 (September 1968), pp. 3–4, is a kind of précis. Alchemy or no, Lennep believes that the man is about to open a window. I am grateful to Jacques Lennep for discussing all this with me. See also his interview with Françoise Brumagne, 22 May 2009, "La dernière lettre de René Magritte; interview de Jacques van Lennep," in L'industrie s'associe à la culture, *Charleroi 1911–2011* (Charleroi: Ville du Charleroi, 2011), pp. 473–80.

56. Walker Percy, *The Moviegoer* [1961] (London: Secker & Warburg, 1977), p. 7.

57. Magritte to Torczyner, 6 May 1961, in Torczyner, *L'Ami Magritte: correspondance et souvenirs* (Antwerp: Mercatorfonds, 1992), p. 186. *Stagecoach* (1939) was directed by John Ford.

58. Report of meeting, 12 April 1947, Miscellaneous Papers of Surréalistes-révolutionnaires, 990022, GRI.

59. He was a fan of early Chaplin, but not late Chaplin. See Magritte to Mariën, 10 December 1952 and 2 February 1953, in Magritte, *Destination*, pp. 302–03 and 305.

60. Magritte to Bosmans, 30 September 1959, in Magritte, *Bosmans*, p. 91, where the letter has been tidied up for publication. The original text is in *EC*, p. 500. *Coup dur chez les mous* (1956) was directed by Jean Loubignac; *Madame et son auto* (1958) by Robert Vernay. The synopsis of *Babette s'en va-t-en guerre* (*Babette Goes to War*, 1959), directed by Christian-Jaque, gives a flavor of these recommendations: "Beautiful housekeeper Babette (Brigitte Bardot) travels to England after the Nazis invade her home country of France. There, the British intelligence officers devise a plan for Babette to sneak back to France, where she could use her feminine charm on key Nazi officer Schultz, gleaning invaluable information for England. However, Babette, although willing and spirited, is naïve and untrained, making her less than ideal for matters of national security."

61. Magritte to Bosmans, 25 November 1960, in Magritte, *Bosmans*, p. 142.

62. Magritte to Bosmans, 23 July 1960, in Magritte, *Bosmans*, p. 120; James Agee, *Agee on Film* [1958] (New York: Modern Library, 2000), p. 292. "Mais quelle pensée postiche!"

63. *La Vierge retroussée* appeared in *SASDLR*, 15 May 1933, accompanying Nougé's uncompromising text on Magritte, "Des Moyens et des Fins" ("Ends and Means"), which was eventually incorporated into *Images défendues*, though not on its first pub-

lication in 1943. See Nougé, *Magritte*, p. 82. *La Vierge* is reproduced in CR, vol. II, p. 19.

64. Scutenaire, *Magritte*, p. 21.

65. The original manuscript list is held in the Musée Magritte in Jette, Brussels. I am grateful to André Garitte for a copy of it. It does not conform to the surrealist canon, inasmuch as that was enshrined in the journal edited by Adonis Kyrou, *L'Âge du cinema*, whose special issue on surrealism (August–November 1951) featured lists of directors "to see" (including Luis Buñuel, Charles Chaplin, Serge Eisenstein, Louis Feuillade, Fritz Lang, G. W. Pabst, and Robert Wiene) and "not to see" (including Carl Theodore Dreyer, Paul Deluc, Abel Gance, D. W. Griffith, Marcel L'Herbier, Carol Reed, and Preston Sturges). Among the proscribed (or the disdained), certain exceptions were made, including *Peter Ibbetson* (1935) by Henry Hathaway, a film much admired by Magritte. See chapter 5. Scutenaire's list is equally eclectic: "Mon cinéma," *Inscriptions 1945–1963*, pp. 34–35.

66. Magritte to Mariën, [31 May 1946], in Magritte, *Destination*, p. 193. *Les Visiteurs du soir* (1942), by Marcel Carné, concerns two of the devil's envoys to earth, who foil his schemes by falling in love.

67. See, e.g., "Introduction au cinéma" (1925), in Nougé, *Histoire*, pp. 34–38, which discusses the latest films of L'Herbier and Lang, among others, finding them "disappointing." He mentions in particular *L'Inhumaine* and *Die Nibelungen* (1924). Later he became interested in Hitchcock; his favorite was *Shadow of a Doubt* (1943), surely a title he would have liked to appropriate. The Keaton story is "D'Or et de Sable" (1927), in *Expérience*, pp. 175–76.

68. The proprietor of the Cabaret Maldoror was Geert van Bruaene, who became Magritte's friend and occasional dealer; see chapter 4.

69. See, e.g., his criticism of the casting of "an intellectual" (Artaud) in *The Threepenny Opera*, EC, p. 721. In 1951 he titled a painting *La Boîte de Pandore* (CR 772), which does not necessarily prove anything, though he was known to admire the film, and the characteristic figure in the painting bears some resemblance to the figure of Jack the Ripper slinking off into the night in the film.

70. Magritte to Mariën, 17 December 1951, in Magritte, *Destination*, p. 260. He aired these views in the course of a recorded discussion.

71. Thomson, "Fritz Lang," in *Biographical Dictionary*, p. 590. I am grateful to David Thomson for discussing Magritte and cinema with me.

72. Rilke, "Notes on the Melody of Things," in *Rilke in Paris* (London: Hesperus Press, 2012), p. 87.

3. CUPID'S CURSE

1. Passeron, "En écoutant Georgette Magritte," p. 12.

2. As Georgette confided to Jacqueline Nonkels. See Roisin, *Magritte*, pp. 188–89.

3. Magritte to Georgette, [17 March 1922], Book IV, p. 42. I am grateful to Peter Morris for access to the correspondence between them, and other documentation relating to the Berger family. Most of the letters are not dated. They are kept in albums (not necessarily in chronological order), usually identified by book and page number.

4. Georgette to Magritte, [24 March 1922], Book III, pp. 15–16. The present job was in the wallpaper factory of Peters-Lacroix, on which more below. On the tonsils, see Magritte to Flouquet, n.d., in Whitfield, "Three Unpublished Letters from René Magritte to Pierre Flouquet, 1920–21," *Burlington Magazine*, vol. 155, no. 1326, September 2013, p. 605.

5. Magritte to Georgette, [24 March 1922], Book IV, p. 25. Their correspondence sug-

gests that Jeanne Verdeyen took their part and even acted as occasional go-between. See, e.g., Georgette to Magritte, [1922], Book III, p. 70.

6. See *La Mémoire* (CR 505), dated 1942; *Les Marches de l'été* (CR 466), dated 1938 or 1939; *L'Avenir des statues* (CR 674), dated c. 1932; *Les Menottes de cuivre* (CR 678), dated 1936; and *Hommage à Pascal* (CR 701), dated 1945.

7. *L'Île au trésor* (CR 498), dated 1942; and *La Femme du soldat* (CR 590), dated 1945.

8. She traded mostly in gouaches: she sold *L'Homme et la nuit* (CR 1565) to an unnamed collector in 1964; she bought *Les Grâces naturelles* (CR 1172) from Jacqueline Nonkels around 1965, and later sold it to Margaret Krebs; she also sold *L'Enfant trouvé* (CR 1595) to Margaret Krebs, around 1968.

9. *Feu-bouteille* (CR 698), dated c. 1944; *Ceci n'est pas une pomme* (CR 989), dated 1964, the title derived from the inscription. In response to an enquiry from Van Hecke regarding loans for a retrospective, in 1964, she listed her holdings as follows: seven paintings (CR 90, 260, 570, 577, 591, 601, and 649), of which all but one were gifts; five gouaches (CR 1188, 1212, 1362, and two untitled), ditto; and three drawings.

10. Sylvester and Whitfield interviewed at the Menil, 18–19 September 2000, cassette recording AU2001-006 and 008.

11. Paul Simon to Georgette, [1983], CRRP MC, I/09. The song first appeared on the album *Hearts and Bones* (1983), then on *Negotiations and Love Songs* (1988), *Paul Simon 1964–1993* (1993), *The Paul Simon Anthology* (1993), *Greatest Hits* (2000), and *The Studio Recordings* (2004). It was inspired by Lothar Wolleh's photograph "René and Georgette Magritte with their dog" (1967), at https://www.flickr.com/photos/wolleh/3430361791.

12. Georgette undated conversation with Sylvester.

13. Response to questionnaire circulated by the *London Magazine* (1961), in Catherine Lampert, *Frank Auerbach: Speaking and Painting* (London: Thames and Hudson, 2015), p. 139. "He is affected by his circumstances, and by the standards and events of his time," continued Auerbach, "but he seems to me to be the sole coherent unit."

14. Passeron, "En écoutant Georgette Magritte," p. 12.

15. See *La Lecture défendue* (CR 400), dated 1936, and the short home movie known as *Le Dessert des Antilles* (1957). Hamoir is caught in the act in a still from the film in Ollinger-Zinque and Leen, *Magritte*, p. 289.

16. See, e.g., Bussy, *Les Surréalistes au Quotidien: Petits Faits Vrais* (Brussels: Les impressions nouvelles, 2007), pp. 68–69.

17. CR, vol. I, p. 35; Scutenaire, *Magritte*, p. 55; interview with Georis, 5 June 1962, in *EC*, p. 563; conversation in Houston, Texas, in 1965, based on notes taken by Dominique de Menil, in *EC*, p. 615. Sylvester suggests more than one miscarriage: "Early on, there was a miscarriage, and perhaps another." Sylvester, *Magritte*, p. 48. The first was said to be traumatic. *Observer*, 4 November 1973. Nougé's biographer reports the unverifiable story that Georgette had an abortion, carried out by Nougé himself, during a period when the Magrittes felt that they were too poor to support a child (the early 1930s?). There were complications; Nougé suspected an embolism. According to this account, it was he who made her promise never again to run the risk. Nougé is also said to have aborted his companion Marthe Beauvoisin. The story may appear improbable, but it is not completely fanciful. Nougé was a biochemist by profession, trained in clinical biology; he and Magritte were very close; apparently he examined the hypochondriac Magritte. Smolders, *Nougé, écriture et caractère. À l'école de la ruse* (Brussels : Labor, 1995), pp. 74–75; Scutenaire, *Magritte*, p. 55.

18. Cyril Connolly, *Enemies of Promise* [1938] (London: Penguin, 1961), p. 127.

19. Roisin, *Magritte*, p. 198, citing Betty Magritte, Jacqueline Nonkels, and Paul Sacrez. "*Mes* fils n'auront pas besoin de travailler."

20. Bussy, *Les Surréalistes*, pp. 68–69, citing Mariën.

21. *OPC*, vol. III, p. 97, citing the Scutenaires; Georgette to Sylvester, 18 November 1980, in CRRP C, IV/26. The CR records at least three works on paper, all apparently unfinished, which appear to have been signed by Georgette: CR 1279, 1322, and 1323.

22. Scutenaire, *Magritte*, pp. 42 and 64; Sante, *The Factory of Facts* (New York: Vintage Books, 1999), p. 160.

23. Valéry, *Tel quel* (Paris: Gallimard, 1944), p. 328.

24. Mariën, *Radeau*, p. 116. Magritte had the Fayard edition of *Chéri-Bibi*, first published in 1914 and republished in 1923. See Gaston Leroux, *Chéri-Bibi et Cécily* (Paris: Masque, 2011), p. 25.

25. "Différence entre l'esprit de géométrie et l'esprit de finesse." (Difference between the mathematical mind and the intuitive mind.) Pascal, *Pensées and other writings*, trans. Honor Levi (Oxford: Oxford University Press, 1995), p. 244. According to Ruth Spaak, the heads are based on Suzanne Spaak (Claude Spaak's first wife) and her son Paul-Louis, whose portraits Magritte had recently painted (CR 414 and 439).

26. Magritte, "Lifeline."

27. Pierre Bourgeois, "Retraite militaire," in *La Foi du doute* (Brussels: L'Équerre, 1922), p. 121. "After a canvas by René Magritte," a tempera of the same title (CR 1100), dated 1920.

28. Scutenaire, *Magritte*, p. 31, reversing the order of these two paragraphs in the book.

29. Madame Lux in Roisin, *Magritte*, pp. 119–20.

30. *L'Invention du feu* (CR 609), dated 1946. Magritte, notes on titles (1946), in *EC*, p. 259.

31. Magritte, "Esquisse," in *EC*, p. 366.

32. Fernand Richelet in Roisin, *Magritte*, p. 127.

33. F. T. Marinetti, trans. Carol Diethe and Steve Cox, *Mafarka the Futurist* (London: Middlesex University Press, 1998), p. 168. Magritte embellished the original French edition, *Mafarka le futuriste* (Paris: Sansot, 1909), p. 251. The page is reproduced in Roisin, *Magritte*, p. 181. Alexandre bought the book from the painter Ferdinand Schirren.

34. Brendan Gill, "Out of the Dark," *New Yorker*, 26 January 1953.

35. Bataille, *Les Larmes d'éros* (Paris: Pauvert, 1961), p. 205.

36. The illustrations were unpublished. They are reproduced in CR, vol. VI, p. 109. *Auch* is a contraction of *aux chiottes*; hence, Lord "To the Shithouse."

37. Elizabeth Bishop to Anne Stevenson, 8 January 1964, in *Poems, Prose, and Letters* (New York: Library of America, 2008), p. 861.

38. Waldberg, *Magritte*, p. 70; Jacques Delattre in Roisin, *Magritte*, p. 126. In the Greek tragedy by Euripedes, Phaedra falls in love with her stepson Hippolytus, with predictable consequences.

39. Robert Leclerq in Roisin, *Magritte*, pp. 103–04. Marie Molle was engaged in August 1912.

40. Alexandre in Roisin, *Magritte*, p. 174, linked to the house at 37 rue Depotter, in the *quartier* of the Gare du Nord, where they moved in November 1918. There is another version in the CR, vol. I, pp. 14–15, linked to the house at 43 rue François-Joseph Navez in Schaerbeek, where they moved in October 1917. The version in Roisin is a little more specific, and authentic, I think; it also squares better with the character of the area and the housing stock. Jeanne Verdeyen was engaged in July 1913.

41. Flaubert to Ernest Chevalier, 18 March 1839, in *Correspondance*, vol. I, Jan 1830–May 1851 (Paris: Bibliothèque de la Pléiade, Nouvelle Revue Française, 1973), p. 39.

42. Léon Pringels in Roisin, *Magritte*, pp. 174–75.

43. Flaubert to Louise Colet, undated, in Francis Steegmuller, *Flaubert in Egypt* (London: Penguin, 1972), pp. 9–10.

44. Gablik, *Magritte*, p. 20, a story told to her by Magritte.

45. Magritte to Flouquet, postmarked 22 September 1920, in Whitfield, "Unpublished Letters," p. 605, who notes the suggestion of conquest.

46. Raymond Pétrus and Walter Thibaut in Roisin, *Magritte*, pp. 151–52.

47. *River with Stormy Sky* (CR 1) and *Poplars by a River* (CR 2), "whereabouts unknown." According to Roisin, they were inherited first by Thibaut's daughter Denise, and then by his son Walter, who lived (and died) in Switzerland; according to Lempereur, Walter left them to "an international charity." Roisin, *Magritte*, p. 153; Lempereur, "Ceci est un Magritte," p. 168.

48. Roisin, *Magritte*, p. 151. *Une maladie d'amour* is one of several euphemisms commonly employed. Lempereur acknowledged the widespread conviction that Magritte suffered *un coup de pied de Vénus*, but took leave to doubt it, suggesting "Spanish flu" instead. Flu was indeed rife in the latter part of the war, but the denial does not sound very convincing. Lempereur, "Ceci est un Magritte," p. 167.

49. Maupassant to Robert Pinchon, 2 March 1877, in Henri Troyat, *Maupassant* (Paris: Flammarion, 1989), p. 51.

50. Around 1946, he wrote a curious little text on Francis Picabia. The epigraph, "The Pope's pox" (*La vérole du pape*, the word used by Maupassant), is attributed to F.P., but may well be an invention of Magritte's (or Mariën's). The text remained unpublished until 1973. It is reprinted in *EC*, p. 191.

51. Frisque in Roisin, *Magritte*, p. 146.

52. Pringels in Roisin, *Magritte*, p. 163. *Sourires de France* was most probably *Le Sourire de France* (or *Le Sourire*), which is perhaps better characterized as risqué, though it must have appeared very daring to a sheltered fourteen-year-old. The thrust of Pringels's testimony is incontrovertible, but he is not always reliable in detail (he is recalling events of sixty years ago), and he is sometimes too credulous when it comes to Magritte's big talk.

53. Pringels in Roisin, *Magritte*, p. 167.

54. Ibid., pp. 163–64.

55. Interview with Jacques Goossens, 28 January 1966, in *EC*, p. 624.

56. Magritte, "Esquisse," in *EC*, p. 366; Pringels in Roisin, *Magritte*, p. 166.

57. Interview with Georis, 5 June 1962, in *EC*, p. 560.

58. Alphonse Thibaut, *Le Fléau de Cupidon* (Châtelet: Thibaut, 1907), pp. 49ff.

59. Alexandre in Roisin, *Magritte*, p. 176.

60. Pringels in Roisin, *Magritte*, p. 168.

61. See ibid., pp. 169–70. On this occasion, the circumstantial detail seems to me to be entirely credible, down to the address given by Pringels, which would date it to sometime between July and November 1918.

62. Georges Eekhoud, *La Nouvelle Carthage* [1888] (Brussels: Espace Nord, 2015). The novel has a heroine called Régina, and a painter character with a trace of Courbet.

63. Georges Eekhoud, *Mes Communions* (Brussels: Kistemaeckers, 1895), p. 288.

64. Alexandre in Roisin, *Magritte*, pp. 171–72 and 177.

65. See André Baillon, *Un homme si simple* (1925) and *Délires* (1927). Magritte and the others would have read *Moi quelque part . . .* (1920), with a preface by Eekhoud, and the gripping *Histoire d'une Marie* (1921).

66. Pringels in Roisin, *Magritte*, pp. 167–68.

67. Magritte to Flouquet, 23 March 1920, in Whitfield, "Unpublished Letters," p. 605; Flouquet to Georgette, n.d. [1921], Magritte-Georgette correspondence, privately held.

68. Magritte painted a sort of post-cubist head on the reverse, and presented the double-sided canvas to an older painter he admired, Franz van Montfort, who gave it away. See CR, vol. I, p. 130.

69. "Esquisse autobiographique," EC, p. 387.

70. See, e.g., Magritte to Georgette [March 1922], Book IV, p. 50.

71. Magritte to Bosmans, 11 November 1958, in Magritte, *Bosmans*, pp. 19–20.

72. Some years later Magritte gave his copy of Gleizes's book to Éliane Souris, daughter of his friend André Souris. See Roisin, *Magritte*, p. 182.

73. Magritte to Georgette, Vendredi [1921], Book IV, pp. 19–20.

74. Flouquet to Magritte, May 1921, in CRRP MC, II/20.

75. Magritte to Flouquet, Vendredi [October 1921] and Lundi [November 1921], CRRP MC, II/20; excerpted in CR, vol. I, pp. 28–29.

76. Pringels in Roisin, *Magritte*, p. 175.

77. Alexandre in Roisin, *Magritte*, pp. 190–91.

4. THE AURA OF THE EXTRAORDINARY

1. Richard Cobb, "Ixelles" [1980], in *Paris and Elsewhere* (London: Murray, 1998), p. 202.

2. Bosmans to Francine Perceval, 3 August 1990, in Magritte, *Bosmans*, p. 32.

3. Magritte to Flouquet, n.d., in Whitfield, "Unpublished Letters," p. 605. For Coquiot and Lawrence, see Danchev, *Cézanne* (New York: Pantheon, 2012), pp. 347 and 387.

4. Magritte to Flouquet, Mardi [13 July 1920], Magritte Papers, 870435, GRI. See Jean Cocteau, *Le Coq et l'arlequin* (Paris: Stock, 2009), p. 77. Magritte recommended the edition first published by La Sirène, a copy of which remained in his library, together with Cocteau's *Picasso* (1923), though there is no telling when exactly he acquired the latter.

5. Magritte to Flouquet, Mardi matin, Magritte Papers, 870435, GRI; Baudelaire, trans. Martin Sorrell, *Paris Spleen* (Richmond: Oneworld, 2010), p. 5. These poems were inspired by Baudelaire's rereading of Bertrand's *Gaspard de la nuit*, another favorite of Magritte's. See chapter 2.

6. Magritte to Flouquet, n.d., Magritte Papers, 870435, GRI. The others were Georges Monier and E. L. T. Mesens, of whom more below.

7. Magritte to Flouquet, Lundi [March 1922], Magritte Papers, 870435, GRI.

8. See Roisin, *Magritte*, pp. 202–03, citing Léon Pringels (who had it from Flouquet at the time), Tom Gutt (who got to know Flouquet in the 1950s), and Jacqueline Nonkels. The Magrittes lived above the Nonkels family at 113 rue Steyls in Jette, in 1926–27, when Jacqueline would have been ten or eleven.

9. "Le Jour nul des Poètes," in *EC*, pp. 184ff.

10. "Les Cimetières jardins," *Reconstruction* 2 (November 1941), pp. 25–31.

11. See Follain diary, 3 September 1954, in *Agendas de Jean Follain* (Paris: Seghers, 1993), p. 178.

12. Magritte to Mariën (his accomplice in the satirical enterprise), [4 October 1946] and 26 March [1952], in Magritte, *Destination*, pp. 232 and 272; to Gaston Puel, 13 May 1955, in *EC*, p. 189; to Bosmans, 27 May 1963, in Magritte, *Bosmans*, p. 297.

13. *7 Arts*, 6 December 1923, 8 November 1925, and 1 May 1927. There was also a slighting reference to "Magritto" in 1934.

14. Baudelaire, trans. Jonathan Mayne, *The Painter of Modern Life and Other Essays* (London: Phaidon, 1995), p. 9. "Monsieur G." was Constantin Guys. From section III, "The Artist, Man of the World, Man of the Crowd, and Child." Poe's "man of the crowd" registered with Magritte.

15. Magritte to Mesens and Scutenaire, n.d. and 20 December 1965, in *EC*, pp. 168ff. Cf. Mesens, "René Magritte," in *Peintres Belges contemporains* (Brussels: Lumière, 1947), pp. 157–61. For the posthumous re-publication see, e.g., Mesens, "Magritte prophétique," in *René Magritte* (Lausanne: Fondation de l'Hermitage, 1987), pp. 27–31.

16. Mesens, unpublished MS, excerpted in CR, vol. I, p. 47.

17. Guggenheim, *Out of This Century: Confessions of an Art Addict* (London: Andre Deutsch, 1980), p. 178.

18. Scutenaire, *Mon ami Mesens* (Brussels: privately published, 1972), p. 28. A bar in the rue de la Fiancée, he reports, with a dash of local color.

19. According to Hortensia Gallemaert herself, Magritte gave her *L'Arlequin* (1919), still in the family, and "a Cubist picture representing a landscape," long gone; cf. CR 1098, dated 1920. Roisin, *Magritte*, pp. 184–85. *L'Arlequin* does not figure in the CR; cf. vol. I, p. 13.

20. Scutenaire, *Mon ami Mesens*, pp. 29–31. This is Mark Polizzotti's splendidly free translation, in Roegiers, *Magritte and Photography*, p. 122.

21. The solicitor Oliver Edwards, in James Boswell, *Life of Johnson* (Oxford: World's Classics, 1980), p. 957.

22. *OPC*, vol. III, p. 105.

23. Magritte, "Esquisse," in *EC*, p. 367.

24. Mesens, "Magritte prophétique," p. 28. This pen portrait was in his original draft article. Magritte objected, reasonably enough, "I have the impression that all this information on dress gives the impression of a ridiculous character and that the jokes that I could have played assume too much importance?"

25. Christine Vermander and Christiane Geurts-Krauss see it as a weapon. Sylvester sees the spoof poster as an advertisement for an assassin for hire. "Rising to the Occasion," in Ollinger-Zinque and Leen, *Magritte*, p. 118; Sylvester, *Magritte*, p. 218.

26. Magritte to Mesens, 26 November 1955, excerpted in CR, vol. III, p. 62. "Investigations of a Dog" was written in 1922, but only published long after Kafka's death.

27. Magritte to Mariën, postmarked 10 June 1944, in Magritte, *Destination*, p. 107.

28. Beckett, *Molloy* [1951] (London: Faber, 2009), p. 8, part of a longer riff on the peculiarities of the Pomeranian. ("Constipation is a sign of good health in Pomeranians.")

29. *EC*, p. 717.

30. Roisin, *Magritte*, p. 238.

31. *La Bonne Nouvelle* (CR 210), dated 1928. According to Georgette, the writing was done in their apartment in Paris when Van Bruaene visited them. The painting was bought from Magritte's dealer Iolas by Jean and Dominique de Menil, c. 1951; there is no earlier provenance. The CR speculates that it may have been sold soon after it was painted, by Goemans or by Van Bruaene himself.

32. Melly, "Robbing Banks."

33. Magritte, "Esquisse," in *EC*, p. 368.

34. Magritte to Nougé, n.d. [1930], in *LS*, no. 187.

35. Mesens to Magritte, 5 June 1930; Magritte to Mesens, 10 June 1930, in CR, vol. I, pp. 118–19. The pictures as described: respectively, *Le Faux Miroir* (CR 319), *Au seuil de la liberté* (CR 326), *L'Évidence éternelle* (CR 327), and *L'Annonciation* (CR 330). *Papier découpé* later became *Papier masqué*, a more poetic expression found by one of his accomplices. See Magritte to Kahmen, 8 July 1965, in CRRP, Menil Archives.

36. Milo in Roisin, *Magritte*, p. 249. Cf. Jean Milo, *Vie et survie du "Centaure"* (Brussels: Éditions Nationales d'Art, 1980), pp. 65–67.

37. According to the CR, Spaak took *La Rencontre* (CR 99), *Les Surprises et l'océan* (CR 144), *La Sortie de l'école* (CR 158), *La Musée d'une nuit* (CR 171), *Le Dor-*

meur téméraire (CR 217), *Les Chasseurs au bord de la nuit* (CR 228), *Les Fleurs de l'abîme* (CR 239), *La Voix des airs* (CR 241), *Les Jours gigantesques* (CR 294), and *L'Automate* (CR 298). He seems to have taken possession of some of these a little later. He continued to acquire others, including *L'Alphabet des révélations* (CR 304). His own account of the purchase and division of the spoils also highlights *Le Groupe silencieux* (CR 83), *L'Homme du large* (CR 135), and *L'Histoire centrale* (CR 249), but those three went to Mesens. All of the insider accounts were given forty or fifty years after the fact. See Spaak's introduction to *Magritte, Delvaux, Gnoli* (Maison de la Culture, Bourges, 1972); and the discussion in CR, vol. I, pp. 103–05, drawing on testimony from Blanche Charlet and Denis Marion, among others.

38. Alexandre and Pringels in Roisin, *Magritte*, p. 172.

39. CR, vol. VI, no. 1. The Comité Magritte commissioned a pigment analysis, which was consistent with the history of the work. I am grateful to Mia Vandekerckhove for her help on this project, and to Peter Vandenabeele for discussing the pigment analysis with me.

40. Mia Vandekerckhove has pointed to *Les Deux soeurs* (CR 71), dated 1925; *La Femme introuvable* (CR 208), dated 1928; and *L'Espion* (CR 215), also dated 1928. On the last, see chapter 7.

41. Nietzsche, trans. Josefine Nauckhoff, *The Gay Science* [1887] (Cambridge: Cambridge University Press, 2001), p. 152. Nietzsche uses much the same formulation as the subtitle for *Ecce Homo*: "How to become what you are." Magritte seems also to have read (or raided) *Beyond Good and Evil*; "L'Art pur" quotes from the translation by Henri Albert, *Par-delà le bien et le mal*, first published in French in 1913 and much reprinted. See *EC*, p. 20.

42. Magritte to Flouquet, Jeudi, and n.d., Magritte Papers, 870435, GRI.

43. Magritte to Flouquet and Dimanche, Magritte Papers, 870435, GRI.

44. Magritte to Flouquet, Dimanche, and Samedi, Magritte Papers, 870435, GRI.

45. Magritte to Flouquet, Mercredi, and Samedi, Magritte Papers, 870435, GRI. *Les Forgerons* (CR 16) is known only from a photograph found among Mesens's papers.

46. Flouquet to Mesens, [September/October 1921?], Mesens Papers, 920094, GRI. "Sept/ Oct 21?" is the date written on the letter in Mesens's handwriting.

47. Kafka, *Hunger Artist and Other Stories* (Oxford: Oxford University Press, 2012), pp. 201–02.

48. Magritte, "Lifeline."

49. Ernst, *Beyond Painting and Other Writings* (New York: Wittenborn, Schultz, 1948), p. 17.

50. See Mariën, "Survivre à Magritte" (1968), in Mariën, *Magritte*, p. 59. Magritte swapped *La Représentation* (CR 434), dated 1937, for *La Carmagnole de l'amour* (1926–27) with Paul Éluard, at Éluard's instigation. He disposed of the Ernst the following year. Shortly afterward Éluard sold his collection to Roland Penrose (for £1,500): one hundred paintings and objects, including forty Ernsts and four Magrittes.

51. Magritte to Waldberg, [1958], in Waldberg, *Max Ernst* (Paris: Pauvert, 1958), pp. 266–68.

52. Interview with Goossens, 28 January 1966, in *EC*, p. 623.

53. Simon Leys, trans. Donald Nicholson-Smith, "The Belgianness of Henri Michaux" [2007], in *Hall of Uselessness*, pp. 211–12. Simon Leys was the pen name of Pierre Ryckmans, himself a Belgian.

54. Alexandre in Roisin, *Magritte*, p. 198.

55. This was one of his favorites, originally published in *Au défaut du silence* (1925).

56. Respectively, A.D., "Exposition des jeunes peintres et sculpteurs," *Le Soir*, 26 January 1923; André de Ridder, "Le Salon des Arts Belges d'Esprit Nouveau," *Sélection*

(December 1923), and "La Peinture belge contemporaine," *La Nervie* (January–March 1925); and Van Hecke, "Défense de la peinture," *Sélection* (October 1926).

57. Magritte to Phil Mertens, 23 February 1967, CRRP MC, III/12; Magritte to Flouquet, n.d., CRRP MC, II/20; Pierre Bourgeois, "Les salons de la jeune peinture: Galerie Giroux," *7 Arts*, 25 January 1923. Cf. Interview with Goossens, *EC*, p. 624. According to Flouquet, the poet Jules Vingternier (another veteran of the campaign to defend Eekhoud) was also instrumental in introducing them to avant-garde art, especially his particular passion, cubism. *Suite d'images du mont des arts d'autrefois* (1961), quoted in Roisin, *Magritte*, p. 244.

58. In the exhibition catalog they are listed only by title. In the CR they are identified as CR 35, CR 38, or CR 44 (both called *Nocturne*), CR 40, and CR 42. *Le Boulevard* is CR 39.

59. Magritte to Mesens, Lundi [December 1921], Mesens Papers, 920094, GRI; Magritte to Flouquet, Mercredi [December] 1921, CRRP MC, II/20. See CR, vol. I, app. 21.

60. Magritte to Flouquet, postmarked 22 September 1920, in Whitfield, "Unpublished Letters," p. 605; [*Woman Seated in an Interior*], CR, vol. VI, no. 45.

61. Tanning, *Between Lives: An Artist and Her World* (New York: W. W. Norton, 2001), p. 256. Her account of the forced laugh is in CR 914; it is softened to "laughed gently" in her memoir. Filipacchi confirms that Magritte did not appreciate the joke.

62. Mariën, *Radeau*, p. 88. Magritte may have done more Ernsts. See Magritte to Mariën, postmarked 12 July and 15 August 1944, in Magritte, *Destination*, pp. 121 and 134. On his wartime fakes see chapter 9.

63. In addition to the portrait (CR 61, dated 1924), she bought *Roses de Picardie* (CR 70), dated 1925, and *Le Sang du monde* (CR 152), dated 1927. She would surely have bought more, but was murdered in 1928 by an unknown assailant.

64. Magritte to Alexandre, n.d., CRRP MC, II/01; Magritte to Mesens, 19 December 1922, AACB Mesens, 36353.

65. Sylvester, *Magritte*, p. 64; Bourgeois, "Les Salons." Cf. Magritte, "Lifeline."

66. Magritte's painting appears in the CR as "Three nudes in an interior" (CR 43), dated 1923; it may well be *Le Thé*, as listed in an inventory by Mesens, who may well have owned it over a long period. Léger's painting was reproduced in its first state in *L'Esprit nouveau* 13 (1921).

67. *L'Art pur* is printed in *EC*, pp. 13–20. It also makes (critical) reference to Gleizes's *Du cubisme*. Cf. Cocteau, *Le Coq*, p. 49.

68. Sylvester, *Magritte*, p. 71; CR, vol. I, pp. 38–40; *Les Feuilles libres* (May–June 1923), according to Mesens, who also mentioned a booklet on de Chirico published by Valori Plastici in 1919 (a source for Ernst). Magritte was certainly familiar with slightly later Valori Plastici publications, e.g., *Carrà on Derain* (1924). Mesens was in the habit of drawing Magritte's attention to sources he might have missed, e.g., reproductions of the latest works by Picasso in *Cahiers d'Art*. Mesens to Magritte, 5 October 1927, Archives Brachot. Apollinaire wrote of "the metaphysical landscapes of M. de Chirico" in his roundup of the 1913 Salon d'Automne, in *Les Soirées de Paris*, 15 November 1913, in *Apollinaire on Art: Essays and Reviews 1902–1918* (London: Thames & Hudson, 1972), p. 333.

69. Danchev, *Georges Braque: A Life* (London: Hamish Hamilton, 2005), p. 81.

70. See, e.g., the interviews with Georis, Fryns, and Mazars, in *EC*, pp. 562, 568, and 599.

71. Interview with Walravens, November 1962, in *EC*, p. 536. "Precious charm" was high praise in Magritte's language; see chapter 5.

72. Magritte to Bosmans, 5 December 1963, in Magritte, *Bosmans*, p. 328; Duchamp interviewed by James Johnson Sweeney, in 1946, in Lucy R. Lippard (ed.), *Dadas on Art* (Englewood Cliffs, NJ: Prentice-Hall, 1971), p. 142.

73. See Magritte, "Francis Picabia, la peinture animée" (1946), in *EC*, pp. 191–92, apparently a preface for an exhibition catalog, solicited by Picabia himself. The epigrams are in *391* 19 (October 1924). For a strong suggestion of Magritte's interest in Picabia see, e.g., *Vous ne saurez jamais* (CR 1600), a papier collé dated 1925.

74. Magritte to Bosmans, [28 March 1959], in Magritte, *Bosmans*, pp. 41–42. See also the interview with Walravens, in *EC*, p. 536. Of the paintings he mentioned, Dalí's *Girafe en feu* dates from 1937, or possibly 1935 (another variant). His own *L'Échelle de feu* (CR 358) is dated 1934, and *Découverte de feu* (CR 359) 1934 or 1935. However, a (toy) burning giraffe appeared in *L'Âge d'or* (1930), originally a collaboration between Buñuel and Dalí; it was illustrated in the last issue of *LSASDLR* (May 1933). It may be that the issue of plagiarism is not so clear-cut.

75. Magritte to Richard Dupierreux, [1946], in Gablik, *Magritte*, p. 13. Also reminiscent of Kafka: "What do I have in common with Jews? I barely have anything in common with myself." Diary, 8 January 1914, in Stach, *Kafka: The Decisive Years*, vol. II (Princeton: Princeton University Press, 2013), p. 357.

76. Quoted in Leys, "Michaux," p. 212.

77. Interview with Claude Vial, 6 July 1966, in *EC*, p. 642. Cf. his disquisition on Bosch and surrealism, in Gablik, *Magritte*, p. 13. Walberg's efforts to supply Magritte with a Belgian artistic heritage were mocked by Nougé as "false erudition." See Mariën, introduction to *AS*, p. 11.

78. See Magritte to Torczyner, 18 September 1965, in Torczyner, *L'Ami*, p. 327; Magritte to Van Hecke, 22 October [1928], Fonds Van Hecke, 117.468, AACB.

79. See *Le Palais d'une courtisane* (CR 291), dated 1928. *La Liseuse* (1853) is in the Musée Wiertz in Brussels.

80. Magritte to Lecomte, postmarked 1923, excerpted in CR, vol. I, p. 44.

81. Goethe, trans. John Gage, "Ruysdael the Poet" [1816], in *Goethe on Art* (London: Scolar, 1980), p. 213.

82. As reported by Scutenaire, in slightly variant forms, in CR 837; *EC*, p. 717; and Dypréau, "D'après" (1971), in *Le Point de vision*, p. 298.

83. Mariën interviewed by Silvano Levy, 9 March 1981, in *Decoding Magritte*, p. 216; Mesens in discussion with George Melly, BBC Third Programme, 7 March 1969, transcript in TGA, 200816; Magritte to Jacques Wergifosse, 8 May 1958, in catalog of Michel Lhomme sale, 2 December 1995, lot 380.

84. Interview with Eleanor Kempner Freed, in *EC*, p. 617. See chapter 10.

85. *La Revolution Surréalist* 1 (1 December 1924), "Dream," trans. Mark Polizzotti, in *Hebdomeros: and Other Writings* (Cambridge, MA: Exact Change, 1972), p. 223.

86. *LRS* 4 (15 July 1925). This issue also carried a laudatory article by Max Morise on de Chirico's exhibition at the Galerie de l'Effort Moderne. The poetry appeared in next issue, dated 15 October 1925.

87. Crevel, "La minute qui s'arrête ou le bienfait de Giorgio de Chirico," *Sélection* 7 (May 1924), in *Mon Corps et moi* (1925), in Sebbag, *Potence avec Paratonnerre: Surréalisme et Philosophie* (Paris: Hermann, 2012), p. 398.

88. Crevel, "Autobiographie," in *La Mort difficile* [1926] (Paris: Pauvert, 1991), pp. 237–38; *L'Esprit contre la Raison* [1927] (Paris: Tchou, 1969), pp. 45–46. See also his "Merci, Giorgio de Chirico," *Le Disque vert* 3 (December 1923).

89. Interview with Carl Waï, 2 April 1967, in *EC*, p. 664.

90. Magritte, "Lifeline."

91. Éluard to Mesens, 24 November 1933, Mesens Misc. Corr., 3/8, GRI. Éluard also owned *La Pureté d'un rêve* (1914) and *Le Rêve de Tobie* (1917).

92. Breton, *The Lost Steps*, trans. Mark Polizzotti (Nebraska: University of Nebraska Press, 1996), p. 66; trans. Richard Seaver and Helen R. Lane, in Danchev, *100 Art-*

ists' Manifestos, p. 249; Breton, Surrealism and Painting, trans. Simon Watson Taylor (New York: Harper & Row, 1972), pp. 12 ff. Les Pas perdus was first published in 1924; Magritte may well have read it soon afterward. Breton also owned L'Énigme d'une journée (1914) and Mystère et mélancolie de la rue (1914). In La Révolution surréaliste 11 (15 March 1928), Raymond Queneau's acid treatment of de Chirico's exhibition at the Galerie Surréaliste was a kind of obituary.

93. Breton, "Leave Everything" (1922), in Lost Steps, p. 79.

94. Magritte to Soby, 20 May 1965, Soby Papers, 3/20, GRI. Cf. interview with Goossens, in EC, p. 625.

95. Magritte to Torczyner, 18 September 1965, in Torczyner, L'Ami, p. 328, where he dates the revelation to 1925. When Soby requested Magrittes to illustrate the impact of de Chirico, he mentioned La Traversée difficile (CR 84) and Les Signes du soir (CR 100); Mesens sent the former and La Statue volante (CR 132), which he considered better for the purpose. Mesens also suggested the collage Les Rêveries du promenaire solitaire (CR 1617)—"it has a Chiricoesque echo." Soby to Mesens, 21 June 1954; Mesens to Soby, 1 July 1954, Mesens Papers, 920094, GRI.

96. Sylvester, Magritte, p. 110.

97. Magritte would have been familiar with André Breton's Nadja (1928)—there was a copy in his library—which has a resonant passage on de Chirico's objects and their arrangement. "As far as I am concerned," concludes Breton, "a mind's arrangement with regard to certain objects is even more important than its regard for certain arrangements of objects, these two kinds of arrangement controlling between them all forms of sensibility." Breton, Nadja (Paris: Gallimard, 1928), p. 16.

98. Les Soirées de Paris, 15 March 1914.

99. Le Mystère laïc (Giorgio de Chirico) (Paris: Quatres Chemins, 1928), p. 81.

100. Magritte to Pierre Andrieu, [November 1947], BK, MAG C5 9723.

101. Chirico, "Rêve," in LRS 1 (1 December 1924); trans. Margaret Crosland, The Memoirs of Giorgio de Chirico [1962] (New York: Da Capo, 1994), p. 61; Crevel in Sebbag, Potence, p. 398. "Perspective" looms large in Nietzsche, as Magritte may well have discovered. See, e.g., Ecce Homo, p. 76, where a talent for "switching perspectives" is linked with the "revaluation of values"; and Beyond Good and Evil, p. 35, where "perspectival valuations and appearances" are linked to "the world of appearances," and "values" are also painterly.

102. Nietzsche in Leys, Hall of Uselessness, p. 313, from Schopenhauer as Educator (1874) [cf. Untimely Meditations, p. 143].

103. Kafka, "Aphorisms," in Hunger Artist, p. 188, used as an epigraph in Mesens, "Magritte prophétique."

104. Interview with Goossens, in EC, p. 625.

5. CHARM AND MENACE

1. Magritte to Bosmans, 14 January 1965, in Magritte, Bosmans, p. 409; Magritte to Mariën, postmarked 24 May 1944, in Magritte, Destination, p. 103.

2. Le Roman populaire (CR 560), dated 1944. Probably based on a postcard of Léda et le cygne, a lost painting by Tony Robert-Fleury (1838–1912), found among Magritte's effects.

3. Magritte to Van Hecke (draft), 12 August 1944, in Magritte, Destination, pp. 135–36. Les bons jours de Monsieur Ingres (CR 546) was based on Ingres's La Source (1867), the title (found by Nougé) a play on Courbet's La Rencontre ou bonjour Monsieur Courbet (1854). Le Retour de flamme (CR 535) was based on the famous Fantômas poster, substituting a rose for the dagger (see chapter 2). Le Traité de la lumière (CR

521) was based on Renoir's *Les Grandes baigneuses* (c. 1918–19). All three are dated 1943.

4. Magritte to Trudi van Tonderen, 29 March 1962, [CRRP].

5. Text of 1959, in *EC*, p. 490, originally formulated in Magritte to Alphonse de Wae-lhens, 23 February 1959, CRRP MC, II/17. Used as a caption to *Souvenir de voyage* (CR 90) in 1966 PBA Charleroi exhibition.

6. Magritte to Breton, 11 August 1946, in *EC*, p. 201. Magritte was throwing Breton's words in his face. To provoke a "crisis of conscience" is held up as the fundamen-tal goal of surrealism in "*The Second Manifesto*," published in *LRS* 12 (15 Decem-ber 1929), the final issue. *Peter Ibbetson* (1935), directed by Henry Hathaway, was a favorite of the surrealists. Breton himself lauded it in *L'Amour fou* (Paris: Gallimard, Collection métamorphoses III, 1937), as Magritte would have known.

7. Magritte to Torczyner, 20 and 27 April 1959, in Torczyner, *L'Ami*, pp. 118–19. The book is in fact *Romance of the Pyrenees* (1803), by Catherine Cuthbertson, long attributed to Ann Radcliffe in France. It was originally translated in 1809; Magritte may well have owned a new "adaptation" by Yves Tessier (1946).

8. Magritte, "Lifeline."

9. Magritte, "Esquisse," and interview with Georis, in *EC*, pp. 367 and 561. Magritte's wallpaper designs are reproduced in Sylvester, *Magritte*, p. 55.

10. *L'Art pur*, in *EC*, p. 18.

11. Magritte to Rapin, 8 November 1956, in Magritte, *Rapin*, n.p.

12. *Psyché* (March 1925). The August and November 1925 issues also featured covers by Magritte.

13. Magritte, "Lifeline." Not only *Répétitions*, but also *Les Malheurs des immortels*, another Éluard/Ernst collaboration from the same year.

14. *L'Homme blanc* and *La Fenêtre* (CR 65 and 66), both dated 1925. The Derain models, *Portrait du chevalier X* (1914) and *La Table devant la fenêtre* (1913), were illustrated in Carlo Carrà, *Derain* (Rome: Valori Plastici, 1924), which Magritte surely knew. Ernst's hands often seem to be indebted to de Chirico's hands, e.g. his oil of 1923, *Au premier mode limpide*.

15. Probably accident. Magritte could not read English, and there is no evidence of delib-erate intent with regard to the lyrics. See CR 1599–1628. The one with cloud bilbo-quets is CR 1602, the other is CR 1603, both dated 1926. CR 1603 also boasts a gloved hand.

16. *Nocturne* (CR 1623), dated 1927. On *Campagne* (CR 148), see chapter 4. Fernand Quinet also acquired a papier collé (CR 1613), as did Paul Nougé (CR 1628).

17. Magritte to Nougé, [1931?], *LS*, no. 103.

18. *Il ne parle pas* (CR 94), dated 1926, acquired first by Mesens and then by Raymond Magritte. De Chirico's *Les Deux soeurs* (1915) is reproduced in the CR entry. For *L'Ombre et son ombre* (1932) see chapter 3.

19. Magritte, "Esquisse," in *EC*, p. 368.

20. *Le Jockey perdu* (CR 81, 1605, 1606), all dated 1926. Goemans, "La Jeune peinture belge," *Bulletin de la vie artistique* 1 (September 1926), the text illustrated by the painting; Van Hecke, "René Magritte," *Sélection* 6 (March 1927), and *Le Centaure* 7 (April 1927). "*S'égarer pour mieux courir*" is a play on "*reculer pour mieux sauter.*" The *isolato* (*l'isolé*) may be a reference to Melville's *Isolato*, in *Moby-Dick* (a favorite of the avant-garde), who did not acknowledge "the common continent of men" but lived on a separate continent of his own. The alternative title, *Le Jockey égaré* (who lost his way), was recorded by Pierre Janlet, the first owner of the earlier papier collé.

21. Dante, trans. C. H. Sisson, *The Divine Comedy* (Oxford: World's Classics, 1998), p. 47.

22. CR 1253, a gouache, dated 1948; the commentary written by Magritte and Wergifosse. See also CR 504, 1178, 1180, and 1435, probably dating from 1942 and 1957. The horse and jockey reappear, lost as ever, in *L'Enfance d'Icare* (CR 923), dated 1960.

23. Arp, "the medal rises . . . ," "The Air Is a Root," "Domestic Stones," and "Homage to Magritte," in *Collected French Writings*, pp. 23, 71, 183–84, and 426. First published in *LRS* 7 (15 June 1926), *LSASDLR* 6 (15 May 1933), *Le Siège de l'air* (1946), and the catalog of the Magritte exhibition at the Obelisk Gallery, London (1961).

24. Valéry, "Situation de Baudelaire" [1930], in *Variété I et II* (Paris: Gallimard, 2005), p. 233.

25. "Vous," *Adieu à Marie* (February/March 1927), in *EC*, p. 37. Magritte had sent the text of the original to Victor Bourgeois some time before. Cf. Pascal, *Pensées*, p. 42; in English, *Pensées*, p. 16. The proposition on forgotten painters is repeated (or détourned), word for word, in Nougé's preface to the catalog of Magritte's exhibition at the Galerie Le Centaure, dated 10 April 1927, where it is applied to his own painting. See Nougé, *Magritte*, p. 13.

26. Cf. *Hebdomeros*, p. 112.

27. Lautréamont, *Maldoror*, p. 240.

28. Scutenaire, *Inscriptions 1943–1944*, p. 134; Nougé, "Éloge de Lautréamont," 10 July 1925, in *Histoire*, p. 27.

29. Lautréamont, *Maldoror*, pp. 193, 234, and 242.

30. Nougé journal, 17 June 1941 and 23 December 1942, in *Journal* (Brussels: Didier Devillez, 1995), pp. 22 and 115.

31. Scutenaire, *Inscriptions 1945–1963*, p. 85; *Scut*, p. 480.

32. *Les Chants de Maldoror* (Brussels: La Boétie, 1948). Before that, *Le Viol* had been used as an illustration for his *Oeuvres completes* (Paris: GLM, 1938), the edition that remained in Magritte's library. Nougé's draft preface is in *Fragments* (Brussels: Editions Labor, 1995), pp. 47–48; Scutenaire's, in *Inscriptions 1945–63*, pp. 85–86.

33. Torczyner, *Signes*, p. 10.

34. Lautréamont, *Maldoror*, p. 244.

35. Nougé journal, 18 June 1941, in *Journal*, p. 26. In itself a reflection with an echo of Valéry, from *Monsieur Teste*: "The term *aberration* is quite often used in a pejorative sense. It is taken to be a departure from the norm, which leads to something worse, and is a symptom of the alteration and disintegration of the mental faculties manifest in perversions of taste, delirious notions, and strange, sometimes criminal practices." Valéry, *Monsieur Teste* (Paris: Gallimard, 1946).

36. See Nougé, "La Publicité transfigurée," 19 October 1925, in *Expérience*, pp. 291, 341, and 423.

37. The catalog is reproduced in Roque, *Ceci* (Paris: Flammarion, 1983), pp. 177–85.

38. *La Lumière du pôle* (CR 129), dated 1926 or 1927, and *Le Sens de la nuit* (CR 136), dated 1927. The CR identifies at least two other fur-related paintings: *Les Habitants du fleuve* (CR 125), dated 1926, and *Les Cicatrices de la mémoire* (CR 127), dated 1926 or 1927. On *L'Homme du large*, see chapter 2.

39. *Le Catalogue Samuel*, reproduced in Roque, *Ceci*, pp. 186–95.

40. These images are the second and the twelfth in the sequence of sixteen. By way of example, the block of wood (?) on the floor in the former resembles that in *Le Groupe silencieux* (CR 83), dated 1926; the grelots visible in the background of the eighth in the sequence seem to anticipate the grelots in *La Légende des guitares* (CR 209), dated 1928, and, most famously, *L'Annonciation* (CR 330), dated 1930.

41. See Magritte to Nougé, Vendredi [September 1927], in *LS*, no. 105.

42. Baudelaire, *Curiosités esthétiques* (Paris: Michel Lévy, 1868), p. 429.

43. Milo, *Centaure*, pp. 63 and 228. Apart from his disdain for Magritte's work, and criticism of his attitude, Milo also calls into question the sincerity of his politics. He is a little vague (and self-contradictory) about the terms of Magritte's contract, perhaps because it was made originally with Van Hecke himself, and not the gallery; he is more definite about the others.

44. Benjamin to Scholem, 4 February 1939, in Gershom Scholem (ed.), trans. Gary Smith and Andrew LeFevere, *The Correspondence of Walter Benjamin and Gershom Scholem* (Cambridge, MA: Harvard University Press, 1992), p. 243.

45. Cézanne to Bernard, 23 October 1905, in Danchev, *Cézanne Letters* (London: Thames & Hudson, 2013), p. 356. Cf. Derrida, *La Vérité en peinture* (Paris, Flammarion, 1978).

46. "Power of detection" (*pouvoir de détection*) is Scutenaire's phrase. Nougé was perhaps the only one of his acquaintance to elicit something like awe from that wry observer. See *Inscriptions 1943–1944*, p. 144.

47. Sontag journal, 21 June 1972, in *As Consciousness Is Harnessed to Flesh: Journals and Notebooks, 1964–1980* (New York, Picador, 2012), p. 327.

48. Herman Melville, *Billy Budd, Sailor* (Oxford: Oxford University Press, 1997), p. 335.

49. Nougé, "Notes sur les échecs," in *Journal*, p. 166. *Le Mat* (CR 408), dated 1936, was bought by the philosopher Chaim Perelman, a friend of Magritte's. Cf. Poe, "Murders," in *Tales*, p. 92. "Double assassinat dans la rue Morgue" is the first of the *Histoires extraordinaires* (Poe, NHE).

50. Ponge, "Paul Nougé," in *Le Grand recueil*, vol. I (Paris: Gallimard, 1961), p. 48. A tribute solicited by Mariën for Nougé, *Histoire* (1956), the first time any of Nougé's work had been collected. Ponge evidently talked about him in this vein. Follain's journal, 17 July 1966, contains a variant ("a brain like anthracite"), *Agendas*, p. 443. Ponge's account of his first meeting with Nougé in wartime Rouen is a further testament. *OC*, vol. II, pp. 1119 ff.

51. Valéry, *Monsieur Teste*, p. 17.

52. Nougé to Magritte, [November 1927], in Nougé, *Magritte*, p. 148. This stupendous letter, running to five or six printed pages, is also reproduced in *LS*, no. 114, and Nougé, *Histoire*, pp. 217–22. Magritte himself could be found quoting from the *Theses on Feuerbach* some years later. See chapter 8.

53. "La Conférence de Charleroi," delivered in 1929 but first published in 1946, in Nougé, *Histoire*, p. 211. Cf. *La Musique est dangereuse* (Brussels: Devillez, 2001), a collection of his writings on music, edited by Robert Wangermée.

54. The texts are reproduced in Nougé, *Histoire*, pp. 9ff., and translated in Jan Baetens and Michael Kasper, *Correspondance* (New York: Lang, 2015). See Orange 4, *Correspondance*, 20 December 1924, reproduced in Marcel Mariën, *L'Activité Surréaliste en Belgique (1924–1950)* (Brussels: Le Fil Rouge, Editions Lebeer-Hossman, 1979). Cf. Jean Paulhan, *Jacob Cow le pirate* [1921] (Paris: Deyrolle, 1997), p. 17.

55. Nougé to Lecomte, 10 October 1925, CRRP MC, IV/27.

56. Nougé to Bourgeois, 6 April 1925, FS, 47/203, AML.

57. Souris in *L'Accent grave*, 13 March 1968, in *FA*, 19–20 (1969).

58. Souris to Nougé, 25 April 1932, and Magritte to Souris, [April–May 1932], *LS*, pp. 105–06.

59. Scutenaire, *Inscriptions 1943–1944*, pp. 219–20.

60. Nougé to Paul Hooreman, 11 October 1926, in *LS*, no. 53.

61. Mariën, preface to Bussy, *Anthologie du surréalisme en Belgique* (Paris: Gallimard, 1972), p. 15.

62. Nougé to Breton et al., 2 March 1929, in Nougé, *Histoire*, p. 79. As Mariën pointed out, Nougé's stance could be located in a sort of genealogy of self-effacement: not only

Monsieur Teste, but also the hero of Poe's "Domaine of Arnheim," who pursues his idea that "in contempt of ambition is to be found one of the essential principles of happiness on earth." That tale is in his *Histoires grotesques et sérieuses,* trans. Charles Baudelaire (Paris: Calmann-Lévy, 1865).

63. Nougé, "La Solution de continuité" (1935), in *Histoire*, p. 110; interview with Christian Bussy, January 1967, in *L'Accent grave.*

64. "Der Dichter Franz Kafka" (1921), in Walter Benjamin, "Franz Kafka" (1934), trans. Harry Zohn, *Selected Writings,* vol. II, part 2 (Cambridge, MA: Harvard University Press, 1999), p. 798.

65. Nougé, *Images*, in *Magritte*, p. 85; Torczyner, *Signes*, p. 11. Cf. Magritte to Rapin, 20 October 1957, in Magritte, *Rapin*, n.p.; Magritte to Mariën, 4 March 1954, in Magritte, *Destination*, p. 310. Many artists drew sustenance from Nougé. See, e.g., Raoul Ubac interviewed by Jean Grenier, in *Entretiens avec 17 peintres non figuratifs* (Paris: Calmann-Lévy, 1963), p. 196.

66. "Dream-double" is the term used by Anne Umland in *Magritte: The Mystery of the Ordinary 1926–1938* (New York, The Museum of Modern Art, 2013), p. 37.

67. The notion of *"deux moi"* is perhaps most effectively worked out in "Fluctuations sur la liberté" (1938), in *Regards sur le monde actuel* (Paris: Librairie Stock, 1931), pp. 63–65, but it is anticipated elsewhere in his oeuvre, notably in *Monsieur Teste* (see, e.g., pp. 34, 78, and 125), and in his *Cahiers* (e.g., vol. XV, p. 645, quoted here). The witty notion of *"usage externe"* (Valéry uses the example of "my hat") may well be the inspiration for Magritte's image of a bowler hat with a label to that effect, in *Le Bouchon d'épouvante* (CR 1041), dated 1966. Baudelaire's "La Double vie" is in his much-reprinted collection, *L'Art romantique* (Paris: Michel Lévy, 1868).

68. See Conrad to Kazimierz Waliszewski, 5 December 1903, in *The Selected Letters of Joseph Conrad,* ed. Laurence Davies (Cambridge: Cambridge University Press, 2015), p. 172. He meant Polish and English, sailor and landlubber. Nougé was Belgian and French, scientist and revolutionist, among other things. In Poe's "MS Found in a Bottle," the narrator comes face-to-face with his mysterious double. "Manuscrit trouvé dans une bouteille" is in Poe, *NHE.*

69. Magritte to Harry Sundheim, 18 October 1960, excerpted in CR 129. *Le Double secret* (CR 164) and *L'Imprudent* (CR 139), both dated 1927.

70. Nougé, *Fragments*, p. 33.

71. Nougé to Magritte, [November 1927], in Nougé, *Magritte*, pp. 141–42. From Villiers de l'Isle-Adam, *Claire Lenoir* (1887), chapter 1. In January 1928, Magritte asked Georgette to send him a copy of Villiers's *L'Ève future* (Paris: Bibliothèque Charpontier, 1888). A little later he read Paul Claudel, *Le Soulier de satin* (Paris : Gallimard, 1929), on Nougé's recommendation. See Magritte to Nougé, [May 1930?], in *LS*, no. 187.

72. Nougé to Magritte, [November 1927], in Nougé, *Magritte*, p. 139. This seems to relate to *Le Ciel passe dans l'air* (CR 169), and then *La Parure de l'orage* (CR 170) and *Le Musée d'une nuit* (CR 171).

73. Magritte to Nougé, [19 August 1946], in *FA*, pp. 127–29.

74. Nougé, *Images*, in *Magritte*, p. 84.

75. Ibid., p. 72; Scutenaire, *Magritte*, p. 8.

76. *Le Soir*, 11 September 1983, excerpted in Ceuleers, *Magritte*, p. 89; Mariën, *Radeau*, p. 25. Some of Nougé's postcards from the 1930s survive in the Archives Brachot, with moves and occasional annotations (*"forcé en effet"*).

77. Nougé, "Images peintes" (1927), in *Magritte*, pp. 113–14. There is also the case of "Belle de nuit" (undated), in *Experience*, p. 39, and *Belle de nuit* (CR 346), dated 1932, though that text may be more of a prose poem than a scenario, as the CR suggests.

And there are at least two cases of correspondence or coincidence in the title, where the image itself appears to be unrelated to the text: "La Clairvoyance" (undated) and *La Clairvoyance* (CR 419), dated 1936; and "Ronde de nuit" (1924) and *Ronde de nuit* (CR 467), dated 1939. Cf. Nougé, *Expérience*, pp. 47–48 and 63. "Le Démon de la perversité" ("The Imp of the Perverse") is the lead tale in Poe's *NHE*.

78. Catalog preface, 10 April 1927, in Nougé, *Magritte*, p. 13.

79. Flouquet, "Au Centaure: René Magritte," *7 Arts*, 1 May 1927.

80. Chabrol, "Magritte a encore frappé," *Le Nouvel observateur*, 30 August–5 September 1985. Taking my cue from his speculations, I have enlarged on Chabrol in what follows.

81. Robbe-Grillet, *Belle Captive*, p. 22.

82. Berger, "Magritte and the Impossible" (1969), in *Selected Essays* (London: Bloomsbury, 2001), pp. 345–46.

83. Among other things, the criminals have turned into detectives. The still is from the end of scene 4 of *Le Mort qui tue*.

84. "Au Centaure: Magritte, peintre de la pensée abstraite," *Au Large* 2 (June 1927).

85. Catalog preface, 10 November 1930, in Nougé, *Magritte*, p. 29.

86. Nougé, *Images*, in *Magritte*, pp. 71–72; Clarisse Juranville, *Quelques écrits et quelques dessins* (Brussels: Henriquez, 1927), p. 18. The poems are republished in Nougé, *Expérience*, pp. 367ff.

87. Magritte to Nougé, [early April 1928], in *LS*, no. 137. *Les Jours gigantesques* (CR 225), dated March 1928: a closeup, as Sylvester says, followed a few months later by a medium shot (CR 247).

88. "La Conférence de Charleroi," in Nougé, *Histoire*, pp. 174–75 and 211.

89. Catalog postface, n.d., in Nougé, *Magritte*, p. 20.

90. Eemans lived a long life (1907–98), contentious to the end. See his 1989 interview with Koenraad Logghe and Robert Steuckers, on www.voxnr.com. His collaborationism under the Occupation and the vitriol he poured on Magritte and others during that period were never forgiven. See chapter 10. Lecomte, too, referred to Nougé as "a sort of Monsieur Teste," but in a spirit far removed from the vituperative Eemans.

91. This quotation was used as an epigraph to *L'Amitié* (1971), by Maurice Blanchot, Bataille's friend, as Jacques Derrida pointed out in *Politiques de l'amitié* (Paris: Éditions Galilée, 1994).

6. THE CUCKOO'S EGG

1. Magritte to Georgette. The letter is published in CR vol. 1, pp. 43–44. Georgette's reply makes clear that Magritte had been applying for jobs in Paris before he went; he had just received a rejection letter.

2. The lectures were "Expérience du surréalisme" (1949) and "René Magritte" (1956), collected in Goemans, *Écrits* (Brussels: Éditions Labor, 1992), pp. 166–92 and 193–227. *Magritte ou la leçon des choses* is available on the DVD *Art & Cinema* (Cinematek, 2013), a compilation of Luc de Heusch's documentaries on artists.

3. Breton, *Nadja*, p. 60.

4. Dalí, *The Secret Life of Salvador Dalí* (New York: Dial Press, 1942), p. 224.

5. Magritte to Lecomte, 13 July 1929, excerpted in CR, vol. I, p. 103.

6. Magritte to Nougé, [March/April 1928], in *LS*, no. 146. *Le Soupçon mystérieux* (CR 229) and *Les Objets familiers* (CR 226) are both dated 1928. *Le Barbare* (CR 188) was painted in 1927.

7. Marco Livingstone, *Patrick Caulfield: Paintings* (Aldershot: Lund Humphries, 2005), p. 76. Caulfield saw the painting at a Magritte show in London in 1973. It was then

said to represent the artist's brother Paul; the CR suggests the same. It seems to me to bear a much closer resemblance to Goemans. Apart from the fact that "the portrait of Goemans" by which Magritte set so much store is otherwise unexplained, it is also a much better fit with the figure of Goemans, in every sense.

8. Breton, "The First Dalí Exhibit," in *Break of Day*, trans. Mark Polizzotti (Nebraska: University of Nebraska Press, 1999), p. 53.

9. Danchev, *100 Artists' Manifestos: From the Futurists to the Stuckists* (London: Penguin Modern Classics, 2011), pp. 255 and 267.

10. Dalí, *Secret Life*, p. 338.

11. Aragon, *Une Vague de rêves* (1924), in *Oeuvres poétiques complètes*, vol. I (Paris: Gallimard, 2007), p. 95. Aragon's text was submitted to the journal *Commerce* in June and published in October 1924; it predates both the manifesto and the first issue of *LRS* (which adopted the formulation about a new declaration of the rights of man on its front cover). It was long forgotten, or deliberately ignored, though quoted by Breton in his lecture on surrealism in 1934 and by Goemans in his lecture on Magritte in 1956. It is translated by Susan de Muth in *Papers of Surrealism* 1 (Winter 2003), at www.surrealismcentre.ac.uk (accessed 11 April 2016).

12. Magritte to Nougé, [February 1930], *LS*, no. 181. The exhibition took place in March–April 1930. The work is CR 325.

13. Aragon, "La peinture au défi," in his *Écrits sur l'art modern* (Paris: Flammarion, 1981), p. 44. The standard translation by Pontus Hulten gives "the collaging of fabrics," yet the word used by Aragon is *illustrations*. Cf. "The Challenge to Painting," in *The Surrealists Look at Art* (Venice, CA: Lapis, 1990), p. 68.

14. Magritte to Nougé, n.d., in *LS*, no. 187.

15. Mesens to Magritte, 13 September 1938, excerpted in CR, vol. I, p. 71.

16. Goemans to Janlet, 22 January 1928, excerpted in CR, vol. I, p. 71. In retrospect, Goemans claimed to have reserved the right to a small part of Magritte's production while he was under contract with Van Hecke and Le Centaure. There is no evidence to support such a claim; it does not square with his private correspondence at the time. As late as July 1929, he was still swearing Janlet to secrecy vis-à-vis Le Centaure. Cf. Goemans, *Écrits*, pp. 219–20.

17. Goemans to Janlet, 31 August 1927, excerpted in CR, vol. I, p. 70.

18. And he continued to collect. The following year he bought *Point de vue* (CR 154) from Goemans for 800 Belgian francs. Goemans himself acquired it from the Galerie L'Époque in Brussels.

19. Artemidorus, trans. Henry Vidal, *La Clef des songes* (Paris: Sirène, 1921), likewise known in English as *The Interpretation of Dreams*. Freud's work of the same title dates from 1899.

20. "Théâtre en plein coeur de la vie," 23 January 1928, in *Distances* 1 (February 1928). *Distances* ran to only three issues, republished in facsimile in 1994.

21. "René Magritte ou la Révélation objective" (1936), originally published anonymously in *Les Beaux-Arts*, 1 May 1936, to accompany an exhibition at the PBA; reproduced in Nougé, *Magritte*, p. 35.

22. Derrida, *The Truth in Painting,* trans. Geoff Bennington and Ian McLeod (Chicago: University of Chicago Press, 1987), p. 334.

23. Janis to Mesens, in CR, vol. III, p. 46. The first purchase was *L'Usage de la parole* (CR 275); the orphan was *Le Palais de rideaux* (CR 305), reduced from 17,000 Belgian francs because it needed further restoration work, and subsequently donated to MoMA.

24. Magritte to Torczyner, 29 December 1958, in Torczyner, *L'Ami*, p. 91.

25. This dialogue is reproduced in *EC*, p. 497.

26. Johns saw *Le Mois des vendages* (CR 903) at a Magritte show in Paris in 1960; Robert Rauschenberg was with him. It went for 30,000 French francs at auction in 1963. He acquired *La Clef des songes* (CR 370) in 1965. Johns also owns six works on paper—one a gift from the dealer Leo Castelli in 1960, another a gift from Magritte himself in 1965—and an original Magritte letter. Letter to the author, 11 June 2015; Roberta Bernstein, "Jasper Johns and René Magritte," in Barron and Draguet, *Magritte and Contemporary Art*, pp. 109–23.

27. *Le Sens propre* (CR 309), dated 1929, and *L'Évidence éternelle* (CR 807), of which only three of the five sections have been traced (the head, the breasts, and the knees). Magritte gave the latter two to Suzi Gablik; she kept the knees and sold the breasts to Rauschenberg. He also owned four works on paper.

28. The word painting was *L'Apparition* (CR 220). He also acquired *La Loi de la pesanteur* (CR 200), *La Légende des guitares* (CR 209), *Le Parfum de l'abîme* (CR 280), *La Femme cachée* (CR 302), *L'Abandon* (CR 312), *Le Six éléments* (CR 321), the papier collé *Nocturne* (CR 1623), and the collage captioned "Paris en 1930" (see CR, vol. I, p. 110). All of these works date from the period 1927–30.

29. *L'Arbre de la science* (CR 317). Magritte also gave him *L'Automate* (CR 301).

30. Man Ray, *Self-Portrait* (London: Penguin Modern Classics, 1963), p. 108.

31. From Baudelaire, *Les Paradis artificiels* (Paris: Auguste Poulet-Malassis, 1860).

32. When Breton died, in 1966, Magritte offered a heartfelt tribute. It began: "In 1927 André Breton and I found ourselves staring one after the other at the advertisement for an aperitif hanging on a café wall. We exchanged glances that neither reason nor madness could have explained. We exchanged similar looks of complicity on another occasion, when I suggested that he had his face photographed with his eyes closed." *Les Lettres françaises*, October 1966, in *EC*, p. 653. Cf. Roland Barthes, *La Chambre Claire* (Paris: Gallimard, 1980), p. 27.

33. Aragon, *Le Paysan de Paris* (Paris: Éditions Gallimard, 1926), pp. 165–66; Breton, *Nadja*, pp. 39 and 72.

34. Breton to Magritte and Magritte to Breton, 31 May and 5 June 1961, in CR, vol. III, pp. 345–46. The gouache is CR 1459, dated 1959; the painting is CR 931, dated 1961.

35. Breton to Magritte, 11 September 1961, excerpted in CR, vol. III, p. 346.

36. Sylvester, *Magritte*, p. 208.

37. A sentiment quoted by the artist Marlene Dumas in "Valentine's Day" (1997), in *Sweet Nothings: Notes and Texts 1983–2014* (Cologne: Walther König, 2015), p. 120.

38. "Enquête," *LRS* 12 (15 December 1929). The questions and Magritte's responses are in *EC*, pp. 57–58. The preamble and questions, but not the responses, are translated in Pierre, *Investigating Sex*, pp. 157–58, a work first published under the surrealist rubric, *Recherches sur la sexualité* (Paris: Éditions Gallimard, 1990).

39. Breton and Aragon, "A suivre: petite contribution au dossier de certains intellectuels à tendances revolutionnaires," inserted in a special issue of *Variétés* (June 1929), "Le Surréalisme en 1929," republished in *L'Arc* 37 (1969), and in facsimile in 1994; the text is reproduced in Pierre, *Tracts surrealists et declarations collectives*, vol. I: *1922–1939* (Paris: Eric Losfeld, 1980), pp. 96–129.

40. "À suivre," in *Tracts*, p. 107.

41. "Friar Breton," wrote Ribemont-Dessaignes, "who has served up his sermon in a mustard sauce, never speaks except from the pulpit these days." Nadeau, *The History of Surrealism* (London: Macmillan, 1965), p. 183.

42. Nougé to Breton et al., 2 March 1929, in "A suivre," in Pierre, *Tracts*, p. 108, and Nougé, *Histoire*, p. 79; "The Second Manifesto," in *LRS* 12 (15 December 1929).

43. Breton, "The Mediums Enter" (1922), in *Lost Steps*, p. 90.

44. Nougé, *Conférence de Charleroi*, in Nougé, *Histoire*, pp. 207–08; Nougé, *Images*, in *Magritte*, p. 71. Cf. Breton, *Surrealism and Painting*, pp. 4ff. For Valéry's algebra of acts, see *Collected Works of Paul Valéry*, vol. 14: *Analects* (Princeton: Princeton University Press, 1969), pp. 607–08.

45. "À suivre," in *Tracts*, pp. 104 and 119; Nadeau, *Surrealism*, pp. 172–73.

46. Éluard was away from Paris for much of 1928–29 on account of his health. With regard to Magritte's integration, his absence was unfortunate.

47. Breton, "René Magritte's Breadth of Vision" (1964), in *Surrealism and Painting*, p. 403, quoting Apollinaire, *Le Poète assassiné* (1916). On *Le Modèle rouge*, see chapter 8.

48. An earlier, shorter version of "Les Couleurs de la nuit" is printed in *EC*, pp. 53–55. It seems to me to be rather pedestrian, though they clearly made efforts to give it a little erotic spice. The mislaid manuscript must have been at least three times longer than this version. Breton was suitably apologetic. It is impossible to gauge from his rejection letter whether the length was indeed an insurmountable obstacle or a convenient pretext.

49. Goemans, "La Charmeresse," in *Écrits*, pp. 64–65. Some of the poems were written out as verse, though published as prose.

50. Goemans to Nougé (unsent draft), 11 January 1929, in *LS*, no. 164.

51. Goemans to Nougé, Nougé to Goemans, 27 and 29 April 1927, in *LS*, nos. 78 and 81.

52. Breton to Ubac, [February 1940], excerpted in Magritte, *Destination*, p. 39.

53. Nougé to Baillon, 2 August 1920, in Baillon, *Un homme si simple*, p. 187.

54. Goemans to Nougé, [June?] 1927, in *LS*, no. 95 (my emphasis).

55. Goemans, "Magritte," in *Écrits*, p. 221. Magritte gave a markedly different account of this episode to Georgette (in Belgium): "Today I did a portrait of Madame Apfel (Éluard's girlfriend). She is taking it to Berlin and she thinks her friends there might commission others. She is very satisfied. I'm only half so. I made haste to finish the work. I wasn't keen to do it and she posed very badly. It took two hours and then we went swimming. She caused quite a stir at the pool, because her nails were painted red and were very noticeable. Afterwards she left, just as a great storm was about to break. I was rather on edge, so much so that I went down to the concierge. You see that without you, for my part, I'm not up to much." Magritte to Georgette, Vendredi soir [19 July 1929] (CR vol. 1, pp. 366–67). The portrait has not been traced. It may have been part of the collection that Eluard sold to Roland Penrose in 1938, though Penrose had no recollection of it. See CR, vol. I, app. 52 and 53.

56. Waldberg, *Magritte*, p. 144, citing Lecomte, who had it from Goemans, who was there. "Dites-moi, B, ce que vous pensez de J-C?"

57. Dalí, *Secret Life*, pp. 208–09.

58. Dalí, "Documental—Paris—1929," *La Publicitat*, 28 June 1929, the sixth of seven known articles. I am grateful to Paul Edson and Araceli Montero for verifying the references to Magritte in the original Catalan. In *Le Miroir vivant* (CR 295), dated 1928, the biomorphic shapes are designated "person bursting out laughing," "horizon," "wardrobe," and "bird cries." Dalí tended to exaggerate the recency of the recent work, as the CR points out.

59. Goemans, "Magritte," in *Écrits*, pp. 214–15.

60. Goemans to Nougé, 2 January 1928, in *LS*, no. 121.

61. Magritte to Nougé, [early November 1927], in *LS*, no. 112. The first metamorphic painting, therefore, was *Le Prince des objets* (CR 183); the one that showed the way was *La Saison des voyages* (CR 182).

62. Nougé to Magritte, [November 1927], in *LS*, no. 113.

63. Nougé to Magritte, [November 1927], in *LS*, no. 114; Nougé, *Histoire*, pp. 217–22; and Nougé, *Magritte*, pp. 144–50. Kafka's "Great Wall of China" was first published in 1931 (in German).

64. *Les Chasseurs au bord de la nuit* (CR 228), dated 1928.

65. Nougé to Magritte, [April 1928], in *LS*, no. 145, and *Magritte*, pp. 159–60.

66. Interview with Neyens, broadcast 19 January 1965, in *EC*, p. 604. *La Gravitation universelle* (CR 518), a painting that passed through the hands of Van Hecke, Mesens, and Labisse, an amateur of Magritte. See his eulogy, "Tel qu'en lui-même, enfin," *L'Aurore*, 18 January 1979.

67. *L'angoisse* is often translated as "anguish," which seems to me not quite right here— not what Magritte was trying to convey, nor how he saw himself. Magritte read Heidegger in French, where the original *Angst* is translated *angoisse*; he had several volumes (and several commentaries), including *Qu'est-ce que la métaphysique* (1951). Cf. Poe, "MS. Found in a Bottle," in *The Fall of the House of Usher* (London: Penguin, 2003), p. 52; Poe, *NHE*, p. 248.

68. Nougé to Magritte, [late April 1928], in *LS*, no. 144, and Nougé, *Magritte*, p. 158. In 1928 Magritte sent photographs of, e.g., *Les Impatients* (CR 223), *Les Jours gigantesques* (CR 225), *Les Chasseurs au bord de la nuit* (CR 228), *La Lectrice soumise* (CR 230), and *L'Inondation* (CR 254).

69. Nougé, "Images peintes," in *Magritte*, p. 116. *Jeune Fille . . .* (CR 145), dated 1927, also appeared in *Le Sens propre*, 16 February 1929, paired with a poetic text by Goemans, "La Statue errante," a text apparently unrelated to the painting.

70. *La Trahison des images* (CR 303), translated as "treachery" in the CR. The famous and almost contemporaneous work by Julien Benda, *La Trahison des clercs* (Paris: Les Cahiers Verts, 1927), is usually known as *The Treason of the Intellectuals*.

71. Dalí, "Documental—Paris—1929."

72. Breton and Éluard, "Notes sur la poésie," *LRS* 12. "La poésie est une pipe."

73. Alechinsky, "Bilz," p. 93, à propos figure 288 in Bilz. The most celebrated borrowing from Bilz is *L'homme au journal* (CR 270), dated 1928. Cf. Magritte to Bosmans, 6 December 1960, in Magritte, *Bosmans*, p. 143.

74. Robert Rosenblum, "Magritte's Surrealist Grammar," *Art Digest*, 15 March 1954.

75. Roland Barthes, trans. Richard Howard, *Camera Lucida* [1980] (London: Vintage, 1993), p. 5. Rudolph Arnheim was a rare dissenter: "Unfortunately a pipe is all it is." *Visual Thinking* (Berkeley: University of California Press, 1969), p. 141.

76. Wittgenstein, *Philosophical Investigations*, trans. G. E. M. Anscombe (Oxford: Basil Blackwell, 1968), pp. 4, 19, and 157.

77. Magritte to Nougé, [November 1927], in *LS*, no. 112. Wittgenstein, *Tractatus* (London: Routledge, 2001).

78. These propositions conform to those in "Les Mots et les images," as published in *LRS* 12 and reproduced in *EC*, pp. 60–61, except that in the lecture no. 13 was omitted, and no. 15 was worded slightly differently. In the text of the lecture they are not numbered, but they are listed in this order, which seems to settle the interesting suggestion made by Georges Sebbag, of three possible readings, vertical, horizontal, and diagonal, in favor of the vertical, column by column. In Magritte's original manuscript, reproduced in CR, vol. VI, no. 47, and Umland, *Mystery*, pp. 144–45, the propositions are in a different order (though still vertical). No doubt the manuscript was revised and rewritten for publication.

79. Breton, "The Automatic Message" (1933), in *Break of Day*, p. 143.

80. Breton, "Qu'est-ce que le surréalisme?," delivered on 1 June 1934; published in the

special surrealist issue of *Documents 34*, and as a booklet with a cover designed by Magritte, with *Le Viol* (CR 356) as centerpiece.

81. The Dictionnaire was originally conceived as the catalog to the Exposition internationale du surréalisme (1938); in the event it was published separately. It was republished in 1989. The complete text, with illustrations (including Magrittes), is in Éluard, OC, vol. I, pp. 719ff.

7. THROUGH THE KEYHOLE

1. Mirabelle Dors, conversation with Georgette Magritte, 7 January 1986, transcript in CRRP C, IV/24. The story is told by Dors, companion of Maurice Rapin; they had it from Breton.

2. This is Georgette's account, in conversation with Mirabelle Dors; it seems to me to be the fullest and frankest available, and also the most reliable, unfiltered by public reticence or the vagaries of translation. With minor variations in idiom, it accords with what she told José Vovelle, in perhaps the earliest account she gave, for an excellent précis of the Paris experience, "Un Surréaliste Belge à Paris," *Revue de l'art* 12 (1971), pp. 55–63. She gave a similar account to Silvano Levy in 1981, and a more highly colored one to Barbara Stoeltie in 1986.

3. That is the tenor of Buñuel's account in *Mon dernier soupir* (Paris: Robert Laffont, 1982), p. 136. In the conversation with Mirabelle Dors, Georgette laments such embellishments.

4. Goemans to Magritte, 15 December 1929, in CR, vol. I, p. 112. See also Sacha Heydeman (née Chigirinsky), "Ma vie avec Camille Goemans," *Espaces* 1 (Autumn 1973), p. 19.

5. Magritte to Souris, [mid-January 1930], in CR, vol. I, p. 113.

6. José Vovelle, "Un Surréaliste Belge à Paris," *Revue de l'art* 12 (1971), p. 56, citing a personal communication from Aragon in 1969. Aragon himself fell foul of the surrealists in 1932.

7. Ernst, "Au rendez-vous des amis," *LSASDLR* 4 (December 1931). He found room for Tanguy, Aragon, Giacometti, Dalí, Tzara, Péret, Buñuel, Éluard, Thirion, Char, Unik, Alexandre, Man Ray, Breton, Crevel, Sadoul, and, of course, Ernst.

8. Éluard to Mesens, n.d., in CR, vol. II, p. 19.

9. Reine Leysen, in Roegiers, *Magritte and Photography*, p. 122.

10. The pages from *Intervention surréaliste* are reproduced in Mariën et al., *René Magritte et le surréalisme en Belgique* (Brussels: Musées royaux des Beaux-Arts de Belgique, 1982), pp. 155–56. I am grateful to Ian Walker for his reflections on the photographic skirmishes, and his memories of interviewing the survivors in 1978.

11. Éluard to Mesens, [1933], in CR, vol. II, p. 36. Éluard's traffic with Mesens was unaffected by the contretemps with Magritte; the two men were very close. The latest addition to his collection was *L'Échelle du feu* (CR 1108), a gouache, dated 1934, reproduced in *Documents 34* (June 1934), one of the first solutions to a problem.

12. Éluard, trans. Man Ray, "René Magritte," also much reprinted, e.g., in *London Gallery Bulletin,* no. 1, April 1938, under Mesens's auspices. There is another version, by John Weightman, in CR, vol. II, p. 37. The original was published in *Cahiers d'art* 5–6 (1935) and collected in Éluard's *Les Yeux fertiles* (Paris: GLM, 1936) inscribed to Magritte, "L'arbre est teinté de fruits invulnerables, son ami, Paul Éluard," and in *Donner à voir* (Paris: Gallimard, 1939).

13. Éluard to Nougé, n.d., in *LS*, no. 209.

14. Magritte, "Le Fil d'ariane," in *EC*, p. 82; originally published in *Documents 34* (June

1934). The complete text is in Lippard, *Surrealists on Art* (New York: Prentice Hall, 1970), pp. 155–56.

15. Magritte to Éluard, [1935], in *La Moie,* ed. Marcel Mariën (Brussels: Les Lèvres nues, 1980), p. 75. *Facile* is available online at www.phlit.org (accessed 2 May 2016).

16. Magritte to Éluard, 4 December 1941, in Annick Lionel-Marie, *Paul Éluard et ses amis peintres* (Paris: Centre Pompidou, 1982), pp. 140 and 143; Éluard to Magritte, [December 1945], excerpted in CR, vol. II, p. 112. The poem was first published in *Voir* (1948). The gouache, *Exemples* (CR 1194), is dated 1946.

17. Kevin Jackson, *Humphrey Jennings* (London: Picador, 2004), p. 318, quoting his daughter, Mary-Lou Legg.

18. Cavalcanti owned *Le Miroir vivant* (CR 363), which Mesens sold to another collector by mistake; Mesens gave Calvacanti *L'Arbre savant* (CR 82) as compensation. Wright owned *La Belle captive* (CR 375) and *La Condition humaine* (CR 390).

19. Humphrey Jennings, "In Magritte's Paintings . . . ," in *London Bulletin* 1 (April 1938), reprinted in Kevin Jackson (ed.), *The Humphrey Jennings Film Reader* (Manchester: Carcanet, 1993), pp. 225–26. The plate of ham is a reference to *Le Portrait* (CR 379), the spooky image of the eye in the ham, sold by Mesens to Gordon Onslow Ford in 1940. Jennings also translated Nougé's text, "Dernières recommandations," in the same issue of *London Gallery Bulletin*.

20. Magritte to Nougé, [February 1930], in *LS*, no. 181. *L'Évidence éternelle* (CR 327), dated 1930. The way this passage is presented in the CR is confusing, because it elides Magritte's comments on canvases suitable for cutting up, such as this one (and CR 328 and 329), with canvases that are divided into sections but that would be completely ruined by cutting up, such as *Au seuil de la liberté* (CR 326), or *Grelots roses, ciel en lambeaux* (CR 331), or, for that matter, any version of *La Clef des songes*.

21. Nougé to Goemans, 19 February 1930, excerpted in CR, vol. I, p. 114.

22. Nougé, *Images*, in *Magritte*, p. 75.

23. Nougé, "Avertissement," 10 November 1930, in *Magritte*, pp. 27 and 29. This text is reproduced verbatim in Scutenaire, *Magritte*, pp. 14–16. It was written for the catalog of Magritte's show at the Salle Giso in Brussels in 1931.

24. Nougé, "Les Grands Voyages," in *Magritte*, p. 32.

25. Breton, *Le Surréalisme et la peinture*, p. 25; Pierre Reverdy, "Une aventure méthodique" (1950), in *Note éternelle du présent* (Paris: Flammarion, 1973), pp. 78–79.

26. Paulhan, *Braque le patron* (Geneva and Paris: Éditions des Trois Collines, 1947), pp. 126–27. On holding up in the wheat field, see p. 60.

27. Nougé journal, 4 and 6 October 1943, in *Journal*, p. 122. Nougé must have been reading Paulhan, "Georges Braque dans ses propos," *Comoedia*, 18 September 1943, and no doubt the trailer of the year before. See Danchev, *Braque*, chapter 7.

28. Pol Bury, "René Magritte ou le viol de la rétine," *Le Quotidien de Paris*, 14 November 1984.

29. John Richardson, "An Unforgettable Face," *Vanity Fair* (October 2013), p. 305.

30. Denis Healey, *Healey's Eye* (London: Cape, 1980), p. 15.

31. Jan Ceuleers, "René Magritte illustrateur de *Madame Edwarda*," *Cahiers Bataille* 2 (2014), pp. 147–77. The drawings are reproduced in CR, vol. VI, p. 109; a translation of the text is reprinted in *The Bataille Reader*, Fred Botting and Scott Wilson, eds. (Oxford: Wiley-Blackwell, 1997), pp. 223–36. The illustrations were commissioned by Gabriel Brissaud in Paris, but not published; according to Mariën, they were unsigned because the book was planned as a clandestine publication. They were later sold to Albert van Loock, and published posthumously in 1976.

32. Magritte to Lecomte, [January 1930], in CR, vol. I, p. 120.

33. Hamoir, *Boulevard Jacqmain* (Brussels: Terres et Visages, 1953), pp. 88–89.

34. *Golconde* (CR 787), dated 1953, the name of a ruined city of fabulous wealth in southeast India; the title found by Scutenaire. The identification with a row of four-story houses near the station in Verviers is made by Luc Sante, who was born there, in 1954, one year after the painting. Sante, *Factory*, p. 53.

35. Anne Carson, "One-Man Town," in *Plainwater* (New York: Vintage, 1995), p. 109.

36. Sante, *Factory*, p. 160. Jonathan Meades makes a similar observation in his program on Belgium (1994) on the DVD *The Jonathan Meades Collection* (2008).

37. Scutenaire, *Magritte*, p. 19. Ceuleers, *Magritte*, is a marvelous evocation of the dwelling and the locale. The house is now the René Magritte Museum. I am grateful to André Garitte for access to documentation held there, and to Jan Ceuleers for further information and discussion.

38. *L'Art pur*, in *EC*, p. 14, slightly misquoted in the manifesto, from *De l'Amour* (1822).

39. Magritte to Rapin, [13 November 1956], in Magritte, *Rapin*, n.p. The quotation is from *Lamiel* (1889). It is interestingly incomplete. Stendhal's sentence ends ". . . by my servant."

40. Magritte to Éluard, [December 1935], and Mesens, 30 November 1955, in CR, vol. II, p. 212.

41. Magritte to Mesens, 17 November 1938, excerpted in CR, vol. II, p. 65. Spaak also told Mesens that he himself could not undertake to buy more than 18,000 francs' worth of paintings per year from Magritte, and urged a reduction of 60 percent on his London prices (i.e., the prices set by Mesens).

42. Mesens to Magritte, 13 September 1938, excerpted in CR, vol. II, p. 64.

43. Nougé, "Pour illustrer Magritte" (1932–36), in *Magritte*, p. 134.

44. *Les Affinités électives* (CR 349), originally dated 1933, revised in the light of a newly discovered drawing of the same subject, securely dated 1932 (CR, vol. VI, no. 50). The title is borrowed from a celebrated novel by Goethe, *Die Wahlverwandtschaften* (1809), known in French as *Les Affinités électives,* trans. Antoine Sérieys and George Depping (Paris : S.-C. L'Huillier, 1810).

45. Magritte, "Lifeline."

46. Magritte acknowledged the force of Puel's description in his letter of 13 November 1953, MLMB. He also found especially felicitous Puel's formulation, "The calling into question of reality by reality itself." Two years later he might have added another example: *Le Chef d'orchestre* (CR 815), the solution to the problem of the squirrel.

47. *La Carte d'après nature* 1 (October 1952), in *EC*, pp. 326–67; excerpted in CR, vol. III, pp. 31–32. "In human constructions a particular cause has a particular effect," wrote Poe; "a particular intention brings to pass a particular object; but this is all; we see no reciprocity. The effect does not react upon the cause; the intention does not change relations with the object. In Divine constructions the object is either design or object as we choose to regard it—and we may take at any time a cause for an effect, or the converse—so that we can never decide which is which." This is from "Eureka," in *Science Fiction* (London: Penguin Classics, 1976), p. 292. Baudelaire's translation is faithful to the original; Magritte's quotation is more of a paraphrase. Magritte had a volume of *Aventures d'Arthur Gordon Pym,* trans. Charles Baudelaire (Paris: Éditions de la Banderole, 1921), which also contains "Eureka," "Philosophie de l'ameublement" ("The Philosophy of Furniture"), and "Genèse d'un poème" ("The Philosophy of Composition"); the date 1.10.38 was written in the back of the book. Here he draws chiefly from "The Philosophy of Composition," I think, on the basic proposition of combining two ideas, on "the circumscription of space" ("the force of a frame," as Poe puts it), and on "some amount of complexity, or more properly, adaptation," allied to "some amount of suggestiveness." In sum, Magritte's account of his

method seems to owe a good deal to Poe. See *Usher*, pp. 430–42; *Histoires grotesques*, pp. 267–86.

48. Wittgenstein, *Philosophical Investigations*, p. 141. This book was first published in English in 1953; it first appeared in French in 1961.

49. Magritte to Éluard, 27 November 1951, in *Manteau*, pp. 66–68, and Torczyner, *Signes*, p. 90 (complete with drawings). Éluard's "parricidal rose" was from *Blason des fleurs et des fruits* (1942). The quotation from Nougé omitted a word ("we suddenly become aware . . ."). Was he quoting from memory? The Fantômas picture was *Le Retour de flamme* (CR 535). The solution sketched in the letter showed the rose against a stone wall, rather than a seascape; evidently it was still provisional. Ever since 1940, it was always the same rose, as the CR points out.

50. See *La Réponse imprévue* (CR 350), originally dated 1933, and *La Réponse inattendue* (CR, vol. VI, no. 52), a drawing sent to Breton in January 1933. Magritte appears to have changed the title. Another version of the painting (CR 371), dated 1935, has a more jagged outline. Magritte's debt to the comic strip is underlined in the CR.

51. Magritte to Breton, 22 June 1934, online at www.andrebreton.fr (accessed 8 May 2016).

52. Breton to Magritte, 1 July 1934, in CR, vol. II, p. 30.

53. Breton to Magritte, 1 July 1934, in CR, vol. II, p. 30. His article on Giacometti, "Équation de l'objet trouvé," had just appeared in *Intervention surréaliste*. *Les Images défendues* appeared in book form in 1943. The second edition of *Le Surréalisme et la peinture* appeared in 1945, still without anything of substance on Magritte.

54. Stach, *Kafka: The Years of Insight,* vol. 3 (Princeton: Princeton University Press, 2013), p. 9.

55. *La Réponse imprévue* (CR 371) and *La Perspective amoureuse* (CR 385), both dated 1935; the commentary is in CR 385.

56. The scenario of this film was published in the *NRF* in November 1927. Dulac's work is variously suggestive for Magritte, from the categorical epigraph, "*non pas un rêve*," to the seashell-like bra catching fire on the floor. In a later sequence, the clergyman unlocks door after door, without seeming to get anywhere. The CR speculates that a sequence in a confessional, showing a woman's head suspended in space, may have influenced *L'Espion* (CR 215): see below.

57. *La Bonne aventure* (CR 1143), dated 1938 or 1939; *La Victoire* (CR 470), dated 1939; *Le Grand matin* (CR 1168), dated 1942; *La Place au soleil* (CR 1402), dated 1956; *Le Modèle vivant* (CR 790), dated 1953.

58. Kafka, "Before the Law," in *Hunger Artist*, p. 22.

59. *L'Espion* (CR 215), dated 1928. Based on a photograph: not Georgette, for once, but her friend Suzanne Dhout. Fritz Lang's *Spione* came out the same year. If Mesens is to be believed, Magritte acted out this role in London, a decade later, spying through the keyhole on Edward James's secretary in the bath. See chapter 8.

60. Kafka, *Castle* (Oxford: Oxford World's Classics, 2009), p. 36. I follow Ritchie Robertson, in the introduction to this edition, who in turn follows Carolin Duttlinger, *Kafka and Photography* (Oxford: Oxford University Press, 2007). Magritte had a copy of *Le Château* in his library. It was first published in French in 1938.

61. Scutenaire, *Magritte*, p. 34.

62. Kafka, "Aphorisms," in *Hunger Artist*, p. 200.

63. Calasso, *K*, trans. Geoffrey Brock (New York: Knopf, 2006), p. 119; Kafka, "Aphorisms," in *Hunger Artist*, p. 189.

64. Arthur Schopenhauer, trans. R. B. Haldane and J. Kemp, *The World as Will and Representation* [1818], vol. I (London: RKP, 1957), p. 128.

65. Kafka, *Trial* (Oxford: Oxford University Press, 2009), p. 160.

66. Magritte, "Texte de la Démonstration faite par René Magritte à Londres, à la London Gallery," 21/22 February 1937, in Scutenaire, *Magritte*, p. 36. The original typescript, with illustrations and handwritten corrections, is reproduced in *EC*, pp. 96–98; Scutenaire's version is fuller.

67. Interview with Guy Mertens, 26 May 1966, in *EC*, p. 636.

68. Kafka, "Prometheus," in *Great Wall*, p. 103.

69. Scutenaire, *Inscriptions 1964–1973* (Brussels: Brassa, 1981), pp. 26–27. The three paintings are CR 1032, 1042, and 1043, respectively, all dated 1966; their story is told in CR 1032. They are linked by Mariën to the death of Lecomte, and his ghostly overcoat: see *Magritte*, pp. 62–64. Scutenaire's text first appeared in the catalog to "Les Images en soi," Magritte's show at the Galerie Iolas, Paris, in 1967; it is reproduced in his *Magritte*, pp. 163–64.

70. Scutenaire, *Inscriptions 1964–1973*, p. 39.

71. Nougé, "La Glace sans tain" (1928), in *Histoire*, p. 59; Valéry, "Analecta," in *Tel quel*, p. 390.

72. Magritte to Bosmans, 10 August 1965 and Saturday [26 February 1966], in Magritte, *Bosmans*, pp. 429–30 and 446; to Iolas, 24 March 1966, in CR, vol. III, p. 423. Prompted by the difficulties with *La Clef de verre*, he offered some general reflections on titles in Magritte to Bosmans, le 7 du mois [March 1959], in Magritte, *Bosmans*, pp. 35–36. This was as close as he got to categorization.

73. Sylvester, *Magritte*, p. 174. The list also omits some other candidates whose contribution is harder to document, e.g., Goemans (as Sylvester himself suggests elsewhere), and Magritte's brother Paul.

74. Aragon, "La Peinture au défi," in *Écrits*, p. 42.

75. Foucault, *Ceci n'est pas une pipe* (Paris: Les Cahiers du Chemin, 1968), pp. 79–105.

76. Nougé, *Images*, in *Magritte*, pp. 63 and 78.

77. Thomson, *The Big Screen: The Story of the Movies and What They Did to Us* (London: Penguin, 2013) p. 231; email to the author, 1 June 2015.

78. Carroll, "The Walrus and the Carpenter" and "Jabberwocky," in *Alice Through the Looking Glass* (London, Macmillan, 1871). Aragon had written in praise of his oeuvre in "Lewis Carroll en 1931," in *LSASDLR* 3 (December 1931).

79. Nietzsche, *Zarathustra* (Oxford: Oxford University Press, 2008), p. 283 (emphases added). This passage was alive in French culture. "Night is also a sun" appears as the epigraph to Bataille's *L'Expérience intèrieure* (Paris: Gallimard N.R.F., 1943). Before that, it may well have spoken to Breton, in a line that Magritte liked to quote, "Si seulement il faisait du soleil cette nuit," from "L'Aigrette," in *Clair de terre* (Paris: Gallimard, 1923), a line familiar to the accomplices. It figures in a collage by Hamoir, dated 1928, in *Scut*, p. 26.

80. First published (self-published) in *Rhétorique* 12 (August 1964); quoted by Magritte himself in an interview with Eleanor Kempner Freed in the *Houston Post*, 26 December 1965, in *EC*, p. 617.

81. Sontag journal, 2 January 1979, in *Consciousness*, p. 481, after seeing it at the Centre Pompidou in Paris.

82. Valéry, *Introduction á la Méthode de Léonardo de Vinci* (Paris: Gallimard, 2010) p. 100; Mariën interviewed by Christian Bussy, in "L'Accent grave," *FA*, 19–20 (April 1969).

83. A later painting called *Le Siècle des lumières* (CR 1064), on a different theme, has been translated as *The Century of the Enlightenment*.

84. Magritte to James, 12 July 1939, in CRRP MC, III/05. As Magritte probably knew, one of Apollinaire's calligrams was entitled "La Colombe poignardée et le jet d'eau." That has been translated as "the bleeding-heart dove."

85. Bergson, *L'évolution créatrice* (Paris: Felix Alcan, 1908), p. 11; *Matière et mémoire*, p. 274.

86. Magritte owned *Essai sur les données immédiates de la conscience* (1889), known in English as *Time and Free Will*, which develops the theory of *la durée*; and *Le Rire: Essai sur la signification du comique* (1900), or *Laughter*. The latter was a celebrated work, much reprinted; Magritte had the twentieth edition (1918). He annotated both books, *Le rire* extensively.

87. Bergson, *Matière*, pp. 110–11.

88. Magritte, "Leçon des choses," *Rhétorique* 7 (October 1962), in *EC*, p. 335; Magritte to Lecomte, [1966], in *EC*, p. 377; Bergson, *Matière*, p. 173. Guerlac also points out that Magritte's use of the term *affinité* (as in the "elective affinity" of the bird and the egg) echoes Bergson's use of the term *parenté* in his analysis of attentive recognition of resemblance. "Useless Image," Guerlac, "The Useless Image: Bataille, Bergson, Magritte," *Representations* (Winter, 2007), pp. 44 and 54–55.

89. Bergson, *L'évolution créatrice*, p. 306. Cf. Magritte to Mariën, [end December 1943], in Magritte, *Destination*, p. 68.

90. Bergson, *Matière*, pp. 116–17. See *Les Vampires*, episode 7, *Satanas*.

91. "Ciel pommelé du Brabant" crops up in Michaux on Magritte: *En rêvant*, p. 63.

92. Valéry, "Analects," in *Tel quel*, pp. 422 and 432.

93. Valéry, *Cahiers/Notebooks*, vol. 5, pp. 280 and 283.

94. See, e.g., Joseph Cornell, *Wanderlust* (London: RA, 2015); Dawn Ades et al., *John Stezaker* (London: Ridinghouse, 2010). I am grateful to John Stezaker for discussing with me the influence of Magritte on his work.

95. Magritte to "Hornik," 8 May 1959 (a draft, the name of his correspondent mangled by Magritte), in *EC*, pp. 378–79. "*Time Transfixed* ne semble pas very fortunate" (in English in the original).

96. Interview with Neyens, 19 January 1965, in *EC*, p. 602.

97. Magritte to Felix Fabrizio, 3 September 1966, in CRRP MC, II/20.

98. Conversation between David Sylvester and Roger Shattuck, 18 December 1992, at the Menil Collection, from a recording in the Menil Archives.

8. SURFEIT AND SUBVERSION

1. James's third round of purchases, in 1939, bought him *La Durée poignardée* (CR 460), *La Domaine d'Arnheim* (CR 456), and *Stimulation objective* (CR 468). To these should be added several gouaches. His earlier purchases are discussed below.

2. George Melly, *Don't Tell Sybil* (London: Heinemann, 1997), p. 33; James to Carrington, 12 May 1954, in Ades, "James and Surrealism," in Coleby, *A Surreal Life: Edward James 1907–1984* (London: Philip Wilson, 2003), p. 90.

3. James, *Swans Reflecting Elephants: My Early Years* (London: George Weidenfeld & Nicolson, 1982), p. 63.

4. Magritte showed *La Traversée difficile* (CR 84), *Le Sens propre* (CR 306), *Au seuil de la liberté* (CR 326), *L'Annonciation* (CR 330), *Le Miroir vivant* (CR 363), *Le Modèle rouge* (CR 380), *Le Feu souterrain* (CR 386), and *La Condition humaine* (CR 390), together with some papiers collés and gouaches.

5. Phillip Purser, *Poeted: Final Quest of Edward James* (London: Quartet, 1991), p. 77; James to Magritte, 28 January 1937, excerpted in CR, vol. II, p. 51.

6. James to Mesens, 5 February 1937, excerpted in CR, vol. II, p. 51. According to Phillip Purser, "Edward had four tall looking-glasses with lunettes by Boucher depicting the four seasons. They had come from his father's town house in Bryanston Square. After Magritte had finished with them they were set up on the handsome staircase

at No. 35; visitors there remember vividly the moment when Edward would press a switch and what they had thought to be rather dark mirrors were suddenly lit from behind to reveal four new, and complementary, pictures by the Belgian." More circumstantial detail on the two-way mirrors, slightly garbled? *Poeted*, p. 77.

7. Melly, *Sybil*, p. 34. There is a lot of sky in *La Jeunesse illustrée*. On *L'Espion*, see chapter 7.

8. Sylvester, *Magritte*, p. 304, citing oral testimony from Matta. Cf. Melly, "Foreword," in James, *Swans*, p. xi.

9. *L'Avenir des statues* (CR 687). Magritte also gave him *La Malédiction* (CR 433).

10. Nougé, *Images*, in *Magritte*, p. 68, originally the catalog preface to Magritte's one-man show at the PBA in 1933.

11. Magritte to Malet, 7 February 1948, CRRP MC, III/08.

12. Magritte to Mariën, postmarked 29 May 1944, in Magritte, *Destination*, p. 104. The style is perhaps closer to Raymond Chandler: "I was neat, clean, shaved and sober, and I didn't care who knew it."

13. Magritte to Wahl, 3 February 1967, CRRP MC, IV/21. See *Traité de métaphysique* (Paris: Payot, 1953), p. 7, cited here from *The Philosopher's Way* (New York: Oxford University Press, 1948), p. xiii.

14. Magritte to Georgette, n.d., Book I, pp. 4, 7, and 11.

15. Magritte to the Scutenaires, Colinet (in English, typed by James's long-suffering secretary), and Georgette, postmarked 18 February and 12 March 1937, Book I, p. 17.

16. Magritte, "Lifeline." The original (CR 380) was painted in 1935. A variant (CR 382), also dated 1935, was the one used on the cover of *Le Surréalisme et la peinture*, and later *La Vérité en peinture* by Derrida. The one for James (CR 428) was the third.

17. There are also three gouaches, including CR 1249, dated 1947 or 1948, illustrated in Draguet, *Tout en papier: Collages, Dessins, Gouaches* (Paris: Éditions Hazan, 2006), p. 79, and in Jameson, *Postmodernism, or The Cultural Logic of Late Capitalism* (Durham, NC: Duke University Press, 1991). The debris in this gouache is a variation on the debris in the 1937 oil, the scrap of newspaper no longer legible.

18. Marx and Engels, *The Communist Manifesto* (Oxford: Oxford University Press, 2008), p. 5.

19. James to Magritte, 18 April 1937, excerpted in CR, vol. II, p. 53.

20. Krauss, *The Originality of the Avant-Garde and Other Modernist Myths* (Cambridge, MA: MIT Press, 1986), p. 91.

21. Nougé, "Dernières recommandations" (1938), in *Magritte*, p. 43; translated by Humphrey Jennings in the *London Bulletin*, 1 April 1938, for Magritte's show at the London Gallery, in April–May 1938.

22. Email to the author, 1 June 2015.

23. Ghène and Anrieu, *Paul Delvaux Raconte* (Brussels: Hayaux, 2005), p. 37.

24. Magritte to Gablik, Rapin, and Wergifosse, 19 May and 22 May 1958, in Gablik, *Magritte*, p. 111; Magritte, *Rapin*, n.p.; Lhomme, Vente publique, 2 December 1995, lot 280. *Les Vacances de Hegel* (CR 874), dated 1958.

25. See Magritte to Mariën, postmarked 15 September 1945, in Magritte, *Destination*, pp. 150–51, à propos *"l'histoire du verre d'eau."* He was referring to Lenin, "Encore une fois la question des syndicats, la situation actuelle et les erreurs des camarades Trotzki et Boukharine" (1921), in Max Raphaël, trans. Ladislas Gara, *La Théorie marxiste de la connaissance* (Paris: Gallimard, 1937), pp. 251–52, presented by Nougé under the title "Le Verre à boire," *Les Lèvres Nues* 1 (Brussels, April 1954). There was also the "glass of water theory" (rejected by Lenin), according to which, in communist society, satisfying sexual desire is as simple as drinking a glass of water.

26. Colinet, "Pour illustrer Magritte," *FA*, 56 (December 1971); Nougé, "René Magritte ou la Révélation objective," *Les Beaux-Arts*, 1 May 1936, in *Magritte*, p. 38.

27. *La Fissure* (CR 354), dated 1934. See Nougé, "Avertissement" (1930), in *Magritte*, p. 26. The banknote theme continues with CR 1281, dated 1948, and CR 1310, dated 1949, the latter with the $100 bill.

28. I follow Stephanie D'Alessandro and Allison Langley, in Umland, *Mystery*, p. 197. I am grateful to both for sharing their research with me.

29. Berger, "Magritte," p. 348.

30. Nougé, "Révélation objective," in *Magritte*, p. 38.

31. Magritte to the Scutenaires, 12 March 1937, reproduced in Torczyner, *Signes*, p. 80. This letter is in English; it was dictated to Edward James's typist, while Magritte was staying at his house in London. It was sent also to Colinet. With intimates, Magritte habitually employed *canon bibital* and its variants (*bibidal*, *bidalité*) as generic indications of sexual activity, ribaldry, or pornography.

32. Derrida, *Truth*, p. 314.

33. *La Philosophie dans le boudoir* (CR 633), dated 1947, the title found by Mariën, from the work of that title by the Marquis de Sade (1795); *In Memoriam Mack Sennett* (CR 420), dated 1936, a rare case of a brilliant title found by Magritte himself. On Mariën's first visit to Magritte, in 1937, the latter was on the easel (*Radeau*, p. 27). Magritte to Andrieu, 6 February 1948, excerpted in CR, vol. 2, p. 391; Wergifosse and Magritte, "L'Education sentimentale," *Le Vocatif* 11 (June 1973). For an example of such an archaic torso, see Cornelius C. Vermeule III et al., *Sculpture in the Isabella Stewart Gardner Museum* (Boston: ISG Museum, 1977), p. 11.

34. La Bruyère, *Caractères, ou Les Moeurs de ce Siècle* (Paris: Gallimard, 2011), p. 60. *L'Amour désarmé* (CR 381), dated 1935.

35. Jameson, *Postmodernism*, p. 10; Magritte, titles, in *EC*, p. 260, à propos *Les Fleurs du mal* (CR 601).

36. Nougé, *Magritte*, p. 28; Scutenaire, *Magritte*, p. 107. Nougé gave a similar answer for himself, in answer to the question "Why write?" "To disturb the reader, to unsettle his habits, large and small, *to take him out of himself*." "A beau répondre qui vient de loin" (1941), in Nougé, *Histoire*, p. 127.

37. Melly, *Sibyl*, p. 139.

38. Magritte to Iolas, 24 October 1952, in CR, vol. II, p. 192.

39. Nougé, "Avertissement" (1931), in *Magritte*, p. 28.

40. The digest appears as "La Ligne de vie II" in *EC*, pp. 142–46. Cf. Magritte to Mariën, n.d. [February 1940], in Magritte, *Destination*, p. 36.

41. "Lifeline," in *View* 7 (December 1946), pp. 21–23.

42. Rothman, "A Mysterious Modernism: René Magritte and Abstraction," *Journal of Art History,* vol. 76 (2007, issue 2), p. 227. See, e.g., Gablik, *Magritte*, pp. 183–87 (in a superior translation); and Lippard's widely used anthology, *Surrealists on Art*, pp. 157–61. The mutilated version continues to be reproduced, even after the publication of the CR, e.g., Caws, *Surrealist Painters and Poets: An Anthology* (Cambridge, MA: MIT Press, 2002), pp. 33–39; René Magritte, *Selected Writings,* eds. Kathleen Rooney and Eric Plattner, trans. Jo Levy (Richmond: Alma, 2016), pp. 58–67. The authority of the text usually goes unquestioned. See, e.g., Gablik, *Magritte*, pp. 18–19; Waldberg, *Magritte*, pp. 66–67.

43. See *Les Grands Voyages* (CR 104), a title found by Nougé, who thought very highly of this work; possibly an allusion to Jules Verne's *Histoire des grands voyages et des grands voyageurs* (Paris: J. Hetzel, 1870).

44. *EC*, p. 143; translated in *Surrealists on Art*, and elsewhere.

45. CR, vol. V, pp. 9–22. Contrary to the claims of the editor, the text designated "La

Ligne de vie I" in *EC*, pp. 103–13, is in fact the first draft and not the lecture as delivered; it includes the fugitive social and political comment, but not the propositions on words and images.

46. It was not restored in the invaluable compendium of Scutenaire's texts, *Avec Magritte*, published in 1985.

47. Magritte to Mesens, n.d. [November 1938], in CR, vol. II, p. 68.

48. Mariën, *La Destination*, p. 19; Magritte to Breton, 24 June 1946, in *EC*, p. 200; Magritte to Iolas, 4 December 1958, in CR, vol. III, p. 289.

49. From "Il n'y a pas à sortir de là," in *Clair de terre* (1923) in *OC*, vol. I, p. 169. Magritte, "Lifeline," part one.

50. "The Importance of Gold Now and After the Complete Victory of Socialism," *Pravda*, 6–7 November 1921, in Lenin, *Collected Works*, vol. 33, p. 113, as quoted in *SASDLAR* 3 (December 1931).

51. This quotation appears to be apocryphal. It was a favorite of Magritte's, repeated in "L'Art bourgeois," *London Bulletin* 12 (15 March 1939), in *EC*, pp. 132–33; *SW*, pp. 68–69.

52. Magritte, "Lifeline," part 3.

53. Nietzsche, *Will to Power*, p. 421 (book IV, section 800).

54. Magritte, "Lifeline," conclusion. In the final paragraph, the translation in the CR substitutes "gorgeous" for "rigorous" preliminary analysis. The misreading is repeated in the reconstruction of "Magritte's Lost Lecture" in the catalog of the centenary exhibition in Brussels: Ollinger-Zinque and Leen, eds., *Magritte 1898–1967* (Ghent: Ludion, 1998), pp. 41–48; it has been perpetuated ever since.

55. "L'Art bourgeois," in *EC*, pp. 132–33. Translated by Lucy Lippard (not Mesens, as recorded in *EC*), "Bourgeois Art," in *Surrealists on Art*, pp. 156–57; and by Jo Levy in *SW*, pp. 68–69.

56. Guggenheim, *Century*, p. 178.

57. Magritte, "L'Art bourgeois," in *EC*, pp. 132–33.

58. Marx, *Capital: A Critique of Political Economy*, vol. 1, trans. Ben Fowkes (New York: Penguin, 1990), pp. 163–64. For the diamond, see p. 177.

59. Response to a survey on the crisis in painting, *Les Beaux-Arts*, 17 May 1935, in *EC*, p. 85; *SW*, p. 46.

60. Interview with Claude Vial, *Femmes d'aujourd'hui*, 6 July 1966, in *EC*, p. 643.

61. Waldberg, *Magritte*, p. 150, citing a recent interview. Cf. Magritte to Bosmans, 14 December 1962, in Magritte, *Bosmans*, p. 278.

62. Havel, trans. Paul Wilson, "What I Believe," in *Summer Meditations* (London: Faber, 1992), p. 61.

63. Magritte to Mariën, n.d. [April and May 1944], in Magritte, *Destination*, pp. 92 and 94. He was clearly very low in this period, not least because of the war. Cf. Nougé journal, 26 May 1944, in *Journal*, p. 126.

64. Magritte to Rapin, 2 December 1957, in Magritte, *Rapin*, n.p.

65. Magritte to Torczyner, 21 November 1962, in Torczyner, *L'Ami*, p. 226.

66. Magritte to Louis Quiévreux, 1967, in *EC*, p. 253. Cf. interview with Carl Waï, *Le Patriote illustré*, 2 April 1967, in *EC*, p. 664; *SW*, p. 230.

67. Magritte to Éluard, December 1935, excerpted in CR, vol. II, p. 34.

68. *Le Drapeau noir* (CR 451), dated 1937, otherwise known as *Les Oubliettes de la nuit* (*Secret Dungeons of the Night*). Magritte to Breton, 24 June 1946, on www.andrebreton.fr (accessed 11 July 2016). There are at least two variants of this letter, both signed and apparently complete. The one quoted here, from Breton's papers, differs from the one in ML, 4579/60, AML, reproduced in *EC*, p. 200. The standard quotation from the latter in the CR entry and elsewhere tends to leave Magritte's dissatisfaction unex-

plained. Moreover, the context is important: it relates to Magritte's postwar espousal of "sunlit surrealism" and his critical reflections on prewar surrealism. See chapter 9.

69. Mesens to Magritte, 27 November 1938, Magritte to Mesens, 1 December 1938, in CRRP MC, III/14.

70. "L'Action immédiate," in *Intervention surréaliste* (June 1934), the special issue of *Documents 34*; reprinted in Nougé, *Histoire*, pp. 98–103. See also his disquisition, "Association révolutionnaire culturelle," 27 February 1936, in *Fragments*, pp. 54–58. The last issue of *Documents 35* carried a reproduction of *Le Modèle rouge* (CR 380). *Documents 36* never appeared.

71. *L'Échelle du feu* (CR 1108), dated 1934, the first of three versions. The commentary is from Magritte, "Lifeline." *Intervention surréaliste* also carried a reproduction of *La Fissure* (CR 354), the first on the theme of the cash nexus.

72. It is sometimes said that he joined and left (more than once) in the 1930s. There is no evidence for this in the Centre des archives Communistes en Belgique, or elsewhere, other than the retrospective testimony of Willem Pauwels, known as Wilchar, a prominent Belgian communist, who claimed that Magritte joined in 1932 and again in 1936, through him, which seems unlikely. Everything points to behavior association, followed by disillusion, in 1945–46.

73. Magritte to Malet, n.d. [late 1945], in CRRP MC, III/08.

74. According to Mariën, supplied in response to Magritte's request for a formula to set against the appellation "Surrealism." Mariën, "Les Pieds dans les pas" (1977), in *Magritte*, p. 110.

75. As like as not, Magritte read the *Thèses sur Feuerbach* in *Idéologie allemande*, in *Oeuvres philosophiques* (1937), translated by J. Molitor. This version differs slightly from that of the *"inscription murale"* in the exhibition, but it is much clearer. It is also clearer than the English version on www.marxists.org.

76. Lautréamont, *Maldoror*, p. 234.

77. Magritte to the CP, 1947, in *EC*, p. 242; record of meeting, 12 April 1947, Miscellaneous Papers of Surréalistes-révolutionnaires, 990022, GRI. As Magritte would have known, Breton had in the past envisaged a strike of intellectuals, poets, and painters. See "La Dernière grève," in *LRS* 2 (15 January 1925).

78. *L'Intelligence* (CR 604), dated 1946. Magritte, "Dix tableaux," *Le Miroir infidèle*, 22 June 1946, in *EC*, p. 175.

79. Magritte to CP members, n.d., published posthumously in *LN* 3 (September 1970), in *EC*, p. 247; *SW*, p. 107.

80. Mariën, "Avertissement," in Mariën, *Magritte*, pp. 78–79.

81. Waldberg, *Magritte*, p. 149.

82. Nougé, "Des Moyens et des fins" ("The Ends and the Means"), in *Magritte*, p. 82, a section of *Les Images défendues* that appeared in *LSASDLR* in 1933, but not in the book as published in 1943, presumably because it would have been considered seditious under the Occupation—a mortal danger for Nougé and Magritte alike. It was not restored until the publication of *Histoire* in 1956; in consequence, it has not been much discussed.

83. Mariën, *Radeau*, p. 32. Mariën was then twenty-one (roughly half Magritte's age); he had known Magritte for a little over a year.

84. Legge, "Statement," in Levy, *Sheila Legge: Phantom of Surrealism* (Rhos-on-Sea, Dark Windows Press, 2015), p. 53.

85. Legge, "I Have Done My Best," *Contemporary Poetry and Prose* (December 1936), in Levy, *Legge*, p. 59.

86. Penelope Rosemont, *Surrealist Women: An International Anthology* (Austin: University of Texas Press, 1998), p. 88.

87. The postcard is reproduced in Lévy, *Legge*, p. 70. It is of Rhodes House, Oxford. Mesens, a sprite with a curly tail, is perched on the roof. "*Se jette pour*" could be something like "falling for," literally and figuratively.

88. Melly, *Sybil*, p. 35.

89. Gascoyne interviewed by Mel Gooding, in Levy, *Legge*, p. 31. *Sheila* (1936) by Man Ray is reproduced in ibid., p. 30.

90. Magritte to Foucault, 4 June 1966, in *EC*, p. 640.

91. Melly, *Sybil*, p. 35. Sylvester is more cautious: "He became involved with a Londoner who . . . was the mannequin in the publicity stunt. . . . Magritte, in fact, fell in love with her." *Magritte*, p. 301.

92. Mesens interviewed by Melly, recorded by the BBC in March 1969. Transcript in Tate Gallery Archives: TGA 200816.

93. Legge (now Lodwick) to Gascoyne, 13 November 1945, in Levy, *Legge*, p. 90. Magritte was in Paris in January 1938 for the opening of the Exposition internationale du surréalisme at the Galerie Beaux-Arts, and in London in March 1938 for the opening of his one-man show at the London Gallery, but these were fleeting visits, with barely time to conduct an affair.

94. Magritte to James, 26 July 1938, excerpted in CR, vol. II, p. 61.

95. Nietzsche, *Will to Power*, p. 431 (book IV, section 814). Here in Kate Sturge's translation, in *Writings from the Late Notebooks*, p. 181; *Nietzsche: Writings from the Late Notebooks,* trans. Kate Sturge (Cambridge: Cambridge University Press, 2003).

9. THE TRUE AND THE FALSE

1. Georgette's letters to Magritte in February and March 1937 make regular mention of Colinet. See, e.g., Book III, pp. 50–60.

2. Mariën and Nonkels are the principal contemporary witnesses, the latter more of a participant-observer. See *Radeau*, pp. 32–33; CR, vol. III, p. 84; documentation in CRRP D, IV/03; Sylvester, *Magritte*, p. 35. Wergifosse appeared a little later. If Nonkels was Georgette's confidante, Wergifosse was Magritte's—he was known as Jackie, or Kiki, or Gigi, like the dog. His testimony postdates the CR and escapes the existing literature. He was one of the very few to elude Sylvester, though the CRRP was able to make limited use of his papers, sold at auction in 1995, rather late in the day. See Michel Lhomme, Vente publique, 2 December 1995; CR, vol. V, supplement. His writings and reminiscences are collected in three slightly eccentric volumes, *Oeuvre (presque) complète*.

3. Raymond Chandler, *The Simple Art of Murder* (New York: Houghton Mifflin Harcourt, 1950); Léo Malet, *La Vie est dégueulasse* (1948), in *Trilogie noire* (Paris: Losfeld, 1969), p. 151, with illustrations by Magritte; Magritte to Malet, 28 February 1948, CRRP MC, III/08.

4. Mariën, *Radeau*, p. 33. According to Scutenaire (*Magritte*, p. 111), Colinet had a hand in encouraging Magritte in his *vache* paintings, in 1948, by showing him comic book source material. See chapter 10.

5. See *OPC*, vol. III, pp. 71 and 98. His account of selling books from Magritte's library (some of which he bought himself) seems to be confirmed by Lhomme, Vente publique, 2 December 1995, lots 44–69.

6. Sylvester, *Magritte*, pp. 35 and 301; Magritte to the Scutenaires, 12 March 1937, CRRP MC, III/14. The transcription of this letter in Torczyner, *Signes*, p. 80, is slightly inaccurate.

7. Magritte to Colinet, 26 February 1937, in Archives Bussy, AML.

8. According to Mariën, Magritte gave it to Torczyner. *Radeau*, p. 33; see also "L'Encre

indélébile" (1985), in *Magritte*, pp. 162–63. In the 1980s, however, Scutenaire waved it in front of the young Xavier Canonne, who had the impression that Hamoir was not best pleased that her husband had produced it, or made any mention of it. It is not to be found in the copious documentary legacy left to the MRBAB by the Scutenaires. Hamoir may have destroyed it after Scutenaire's death; it may have been withheld by a discreet member of the museum staff. I am grateful to Xavier Canonne for discussion of this issue, and others, and for access to recently acquired documentary material at the Musée de la Photographie, Charleroi.

9. See Blistène and Scutenaire, *René Magritte la période "vache": les pieds dans le plat avec Louis Scutenaire* (Marseilles: Musée Cantini, 1992), p. 31. There is a rather similar sketch (the offending part unnamed) in Magritte to the Scutenaires, 6 April 1948, in CR, vol. II, 651, p. 406.

10. Scutenaire, *Inscriptions 1943–1944*, p. 35; *Scut*, p. 209.

11. Magritte to Colinet, n.d. [1934?], in *Manteau*, p. 7.

12. I follow Max Loreau, *La Peinture á l'Oeuvre et l'Enigme du Corps* (Paris: Gallimard, 1980), 268 an extended meditation on this painting. The stories are reproduced as "Jeux surréalistes," in *EC*, pp. 76–79; *SW*, pp. 43–44. The affinity is noted by Blavier.

13. Magritte to Colinet, n.d. [April 1957?], in *Manteau*, p. 31. *Le Réveille-matin* (CR 861) emerged in a similar dialogue around the same time. The dialogue extended to a joint interview with Jean Stévo on the occasion of Magritte's retrospective at the PBA in 1954 (*EC*, pp. 382–83; *SW*, pp. 157–58).

14. Magritte to Colinet, n.d. [c.1951], in *Manteau*, p. 36.

15. Colinet to Magritte, 25 September 1951, 2010.M.85, GRI.

16. Magritte to Colinet, n.d. [December 1957?], in *Manteau*, p. 40.

17. Colinet to Magritte, 1 July 1957, recommending Borges, trans. Paul and Sylvie Bénichou, *Enquêtes* (Paris: Gallimard, 1957); Magritte to Colinet, n.d., in *Manteau*, pp. 33, 37, and 46.

18. Mariën, "Survivre à Magritte," *L'Art belge* (January 1968), in *Magritte*, p. 61.

19. Pol Bury, "René Magritte ou le viol de la rétine," *Le Quotidien de Paris*, 14 November 1984; Magritte, *Destination*, p. 163.

20. Magritte to Penrose, 23 May 1940, excerpted in CR, vol. II, p. 81. Cf. Magritte to James, 24 May 1940, CRRP MC, III/05.

21. Arthur Koestler, *Scum of the Earth* (London: Victor Gollancz Ltd., 1941), p. 158.

22. Scutenaire, *Magritte*, p. 13.

23. Magritte to MoMA, 1947, excerpted in CR, vol. II, p. 81.

24. Bousquet to Stéphane Mistler, n.d. [c. 27 June 1940], in *Lettres à Stéphane et à Jean* (Paris: Michel, 1975), p. 127; Bousquet to Magritte, 29 September 1948, in *Correspondance* (Paris: Gallimard, 1969), p. 187.

25. Magritte to the Scutenaires, 18 July 1940, excerpted in CR, vol. II, p. 82; Bousquet to Puel, 23 February 1941, and Magritte to Puel, 18 November 1953, in *EC*, pp. 214–15. Marie José married Prince Umberto, the crown prince of Italy, so becoming the princess of Piedmont (and then, fleetingly, the last queen of Italy). According to Magritte, writing to her was Bousquet's idea, and writing to Pétain was Bousquet's invention. As he distanced himself from his erstwhile friend, he also insinuated that Bousquet himself had Pétainist sympathies.

26. Magritte to Penrose, 23 May 1940, excerpted in CR, vol. II, p. 81, James to Georgette, 17 June 1940, TGA, 8711.

27. Beckett, *First Love*, p. 67.

28. Magritte to Péret, 24 May 1940, Ms 34.686, GRI; Magritte to the Scutenaires, 31 May, Dimanche matin [early June], and n.d. [mid-June], excerpted in CR, vol. II, pp. 81–82.

29. Hamoir to Martha Wolfenstein, July 1975, in *Le Vocatif* 211 (June 1981), excerpted in CR, vol. II, p. 82.

30. Magritte to the Scutenaires, 4 August 1940, excerpted in CR, vol. II, p. 83.

31. In a letter to James of 5 September, he said that he had been home for about twenty days, that is, since c. 17 August 1940.

32. Magritte to Mariën, 21 August 1940, in Magritte, *Destination*, pp. 41–43. Beyond the conventional niceties, Magritte's emphasis on Georgette's health in letters around this time may stem from a worrying attack of angina in April 1938. Evidently she was also ill in January 1940. See Magritte to James, 9 April 1938, CRRP MC, III/05; Magritte to Mariën, n.d. [January 1940], in Magritte, *Destination*, pp. 35–36.

33. Magritte to Mariën, 16 November 1940, in Magritte, *Destination*, p. 43; Magritte to Spaak, 29 November 1940, CRRP MC, IV/11; Ubac to Mariën, 5 November 1940, CRRP MC, IV/27.

34. Raminagrobis owed his name to La Fontaine, who borrowed it from Rabelais, for whom it denoted a member of the venal, hypocritical legal profession. See the fable of "The Cat, the Weasel, and the Little Rabbit."

35. Magritte to James, 30 August and 16 October 1939, excerpted in CR, vol. II, p. 287.

36. Michaux, *En rêvant*, p. 62.

37. Magritte to Mariën, [May 1943], in Magritte, *Destination*, p. 53.

38. René Béart, "Une acte de sabotage sur le plan de l'esprit" and "Un mystificateur," *Le Pays réel*, 4 and 10 May 1941, reproduced in Mariën, *Magritte*, pp. 81–82.

39. Nougé, "L'Expérience souveraine" (1941), reused in "Aux écrivains publics," in *Le Salut public* (1945), in *Histoire*, pp. 125 and 169. Magritte's manifesto, "Le Surréalisme en plein soleil" (1946), was headed "L'expérience continue." See below.

40. *Le Pays réel*, 16 January 1944; *De SS-Man*, 28 October 1943; "Is dat nog kunst?" *Volk aan den Arbeid* (March 1944).

41. Mariën, "Autant en rapporte le vent" (1973); Eemans, "Une histoire parallèle du surréalisme en Belgique," *Nouvelles à la main* (1971–72), in *Magritte*, pp. 88 and 97. Eemans later claimed to have been instrumental in sparing Magritte from military service during the Occupation, for which he received no thanks.

42. *Portrait of Jacqueline Nonkels* (CR 571) and *Portrait of Eliane Peeters* (CR 573), modeled on *Portrait of Georgette Magritte* (CR 570), painted from life, as a present for her sister. All three works dated 1944. A little later Magritte asked the young Reine Leysen (later Reine Nougé) if she would pose nude. Like the others, she refused. Smolders, *Nougé*, p. 200.

43. Magritte to Malet, 11 February 1956, excerpted in CR, vol. III, p. 251. Anne-Marie was the daughter of Pierre Crowet, one of Magritte's first and most faithful collectors. The mask is CR 820, dated 1955; the portrait, CR 832, dated 1956, the first in a series. See Cruysmans, "Le Visage qui hantait Magritte," *L'Évantail* (February 1998).

44. Record of meeting, 12 April 1947, Miscellaneous Papers of Surréalistes-révolutionnaires, 990022, GRI.

45. Van Hecke to Mesens, April 1946, excerpted in CR, vol. II, p. 93; OPC, vol. III, p. 101. Cf. Breton to Magritte, 14 August 1946, excerpted in CR, vol. II, p. 133, on de Chirico; Magritte to Mariën, postmarked 12 July 1944, in Magritte, *Destination*, p. 121, for Gaffé's reaction.

46. Mariën, "Avertissement" (1972), in *Magritte*, pp. 72–73. Magritte studied books on Renoir by Germain Bazin, Charles Kunstler, Julius Meier-Graefe, and Charles Terrasse, together with *Couleurs des maîtres 1900–1940*, by George Besson (Lyons: Les Éditions Braun, 1942). See Magritte to Mariën, postmarked 23 April 1943, in Magritte, *Destination*, p. 51.

47. Thomson, *Biographical Dictionary*, p. 991.

48. Nougé, "Les Points sur les signes" (1948), in *Magritte*, p. 107; Bataille, "Les Pieds Nickelés" (1930), in *OC*, vol. I, p. 233.

49. Barnett Newman, "Art of the South Seas" (1946), in *Selected Writings and Interviews* (Berkeley: University of California Press, 1992), pp. 101–02.

50. Record of meeting, 19 April 1947, Miscellaneous Papers of Surréalistes-révolutionnaires, 990022, GRI.

51. Magritte to Nougé, in *FA*, 127–29 (1974), no. 24. The word was not mentioned either in Mariën's preface to the little book on Magritte published in 1943, "Regarde de tous tes yeux, regarde!," in *Magritte*, pp. 17–23. Magritte also tracked down the sequel to the orchids, *The Flesh of the Orchid* (1948).

52. This manifesto and related texts are printed in *EC*, pp. 194–228; *SW*, pp. 94–102. See also Wergifosse, "Le Surréalisme en plein soleil," in *OPC*, vol. I, pp. 204–34; and Mariën, "Magritte en plein soleil," 19 January 1947, in Mariën, *Magritte*, pp. 32–53.

53. Magritte to Mariën, [15 August 1946], in Magritte, *Destination*, p. 210.

54. Nougé, "Les Points sur les signes" (1948), in *Magritte*, pp. 107–08. See also "Élémentaires" (1946). These texts take issue with Breton's recent pronouncements in public and in private, notably his contemptuous dismissal of "that old Jesuit precept," the end justifies the means, and his animadversions on Magritte. Breton's invocation of means and ends was itself a riposte to Nougé's *Images défendues*, and perhaps other admonitions. See Nougé, *Magritte*, pp. 82 and 96.

55. Mariën, *Radeau*, p. 178; Waldberg, *Magritte*, p. 111.

56. Nougé journal, 11 March 1944, in *Journal*, p. 125; *L'Expérience*, p. 58.

57. Mesens to Magritte, 10 October 1946, excerpted in CR, vol. II, p. 135.

58. Magritte to Georgette, 18 June 1946, excerpted in CR, vol. II, p. 129.

59. Magritte to Breton, 24 June 1946, in *EC*, p. 200. This is the letter in which he drew attention to his premonitory picture of aerial terror, *Le Drapeau noir*. As a model for the transition from darkness to light, Magritte may have had in mind Lautréamont, and the transition from *Maldoror* to the *Poésies*. The exhibition forecast for October fell through.

60. Breton to Bousquet, 23 November 1940, excerpted in CR, vol. II, p. 136. See the interview with Jean Duché, *Le Littéraire*, 5 October 1946, in Breton, *Entretiens: 1913–1952* (Paris: Gallimard, 1952), pp. 242ff.

61. Breton, "Devant le rideau," in *Le Surréalisme en 1947* (Paris: Maeght, 1947), p. 15.

62. Magritte to Puel, 8 March 1955, excerpted in *EC*, pp. 227–28.

63. Rapin, *Aporismes* (1970), in *EC*, p. 228.

64. Mariën, *Radeau*, p. 87. On Dominguez and his fakes, see Brassaï, *Conversations with Picasso*, trans. Jane Todd (Chicago: University of Chicago Press, 1999), p. 360.

65. Mariën, *Radeau*, pp. 87–88.

66. Ibid., p. 87.

67. Magritte to Mariën, postmarked 12 July 1944, in Magritte, *Destination*, p. 121.

68. Magritte to Mariën, postmarked 7 July 1944, in ibid., p. 119. Similar veiled references may be found in the letters of 20 May and 20 June 1944 (pp. 102 and 109), the latter involving Mariën's brother-in-law.

69. Magritte to Mariën, [19 May and 3 June 1944], in Magritte, *Destination*, pp. 101 and 105.

70. See Mariën, *Radeau*, pp. 88–89. The work in question is no. 1167 in the Ernst *catalogue raisonné*. Sylvester evidently put Mariën's allegations to the author, Werner Spies, who confirmed in 1984 that he considered it to be authentic (CR, vol. II, p. 99). Since then, another *Forêt* authenticated by Spies has been shown to be a fake by Wolfgang Beltracchi, a prolific forger.

71. Magritte to Mariën, postmarked 7 July 1944, in Magritte, *Destination*, p. 119; Mariën, "Le Radeau dans le tempête," 19 March 1983, in *Radeau*, p. 276.

72. The Musée Picasso in Paris has no information on Magritte's fake Picassos, among the many fake Picassos.

73. Mariën, *Radeau*, p. 276. Louise Leiris was director of the Galerie Leiris in Paris.

74. Magritte to Mariën, 7 February 1953, in Magritte, *Destination*, pp. 306–07. See also Mariën to Magritte, 26 September 1952, in *Radeau*, p. 277. "*Crédit est mort*" may simply parrot a popular phrase—they were in business, after all—though there was a novel by Céline, *Mort à crédit* (Paris: Editions de Noël, 1936). Robert De Keyn had the distinction of owning one of Magritte's earliest extant works, known as "Nude by a Stream" (CR 1095), dated c. 1918, probably a gift from the artist; and the earliest known papier collé, *Nocturne* (CR 1599), dated 1925, possibly acquired from Geert van Bruaene, who sold him a number of Magrittes. He also owned, *inter alia*, *Le Miroir universel* (CR 465), dated 1938 or 1939; *Le Bonheur des images* (CR 537), dated 1943; *La Vie heureuse* (CR 553), dated 1944; *L'Ingénue* (CR 593), dated 1945; and *Le Carnaval du sage* (CR 615), dated 1947. He was well known to Magritte and his circle. See Magritte to Torczyner, 24 September 1966, in Torczyner, *L'Ami*, p. 367; Mariën, "La Sagesse des images," in *Magritte*, p. 175, where he is identified by the initials R.D.K.

75. Georgette to Sylvester, 2 September 1978, CRRP C, IV/26.

76. Sotheby's, "The Remaining Contents of the Studio of René Magritte," lot 951; Sylvester, *Magritte*, p. 315.

77. CR, vol. II, p. 99; Sarah Whitfield, *Magritte and His Accomplices*, in Whitfield, *Magritte* (London: The Hayward Gallery, 1992), p. 28. He may have been influenced by a study of the illustrations in Maurice Raynal's *Juan Gris et la métaphor plastique* (Paris: Feuilles Libre, 1920).

78. *OPC*, vol. III, p. 99. *Jeunesse* (CR 60), shrewdly dated ?1924. I am grateful to Pamela Pack at the BAM for further information. Their provenance simply shows Paul Magritte and Joachim Jean Aberback, New York, who gave it to the museum.

79. CR, vol. II, p. 99. Cf. Sylvester, *Magritte*, p. 315.

80. Mariën, *Radeau*, p. 306 (and also p. 87). Cf. Magritte, "L'Art bourgeois," in *EC*, p. 132; *SW*, p. 68.

81. Valéry, *Tel quel*, p. 100. See Mariën, *Radeau*, p. 301.

82. Mariën, *Radeau*, pp. 177–78.

83. Ibid., p. 178; "Avertissement" to *Croquer les idées* (1978), in Mariën, *Magritte*, p. 124. See *Georgette* (CR 441).

84. Ceuleers, "*Madame Edwarda*," p. 170.

85. *OPC*, vol. III, pp. 102–03. Mariën and Wergifosse are both concerned to emphasize its quality.

86. Magritte to André de Ridder, [1946], in *The Romantic Agony*, catalog 49, 16 November 2012, lot 264. Nearly 100 postcards from Mariën to Van Loock, mostly from 1941–42, came up in the same sale (lot 219); interestingly, Mariën writes of seeing both Colinet and Magritte in this period. I am grateful to Isabelle Chielens at the auction house The Romantic Agony for further information.

87. Ibid., lot 253. Here the painting is identified as "after two celebrated canvases by Titian, *Flora* and *Alphonse de Ferrare et Laura Dianti*."

88. In retrospect, the stance of the CR seems a little strange. It broached the issue, but did not pursue it. It published a reproduction of the painting—albeit rather murky—in which the posture of the woman clearly does not correspond with that of Flora (vol. II, p. 99); even here, it is possible to make out other appurtenances (a hand, a book, a mir-

ror) that do not belong to that work. For its repetition elsewhere, see e.g. Allmer, *Magritte*, pp. 48–49.

89. See Magritte to Mariën, postmarked 3 June 1944, in Magritte, *Destination*, p. 105.

10. 1948-1967

1. In the "Livre d'or" ("Visitors' Book") of the Galerie du Faubourg, Paris.
2. Magritte to Éluard, n.d., headed "Dimanche," Musée des lettres et des manuscrits.
3. E. L. T. Mesens to Magritte, 1 July 1946, in CR, vol. II, p. 130.
4. The de Chirico exhibition took place at the Galerie Allard. The works, painted by the surrealist painter Oscar Dominguez, were denounced as fake one month after the show opened. See website of the Fondazione Giorgio e Isa de Chirico.
5. Magritte to Léo Malet, 31 January 1948, in CR, vol. II, p. 159.
6. Magritte to Léo Malet, 28 February 1948, ibid.
7. See chapter 9. André Breton, "Devant le rideau," Exposition internationale du Surréalisme: le Surréalisme en 1947, Paris, Galerie Maeght, 1947.
8. Breton, "Devant le rideau."
9. Scutenaire, *Magritte*, p. 111.
10. *Lola de Valence*, 1862, Musée d'Orsay, Paris.
11. *Jean-Marie*, 1948, the subject of which is a man with a wooden leg, was based on a Parisian character known to Magritte who was both a painter and a renowned transvestite. According to Xavier Canonne, the tartan backgrounds are reminiscent of the oilcloth table coverings in common use at this period. See Xavier Canonne, *Surrealism in Belgium 1924–2000* (Brussels: Mercatorfonds, 2007), p. 66.
12. Scutenaire, *Magritte*, p. 115.
13. See chapter 2, note 90.
14. Camille Goemans, Marcel Mariën, ed., *Oeuvre 1922–57* (Brussels: De Rache, 1970), p. 233.
15. Copley, *Portrait of the Artist as a Young Dealer*, p. 20.
16. The *vache* paintings are now among Magritte's most sought-after works, a dramatic change in taste that has an equivalent in the work of the abstract expressionist painter Philip Guston, whose return to figuration in the early 1970s through an extravagantly comic style met with similar condemnation before finding wide critical acceptance.
17. Wergifosse, *OPC*, III, pp. 72–73.
18. Magritte to Scutenaire, 7 June 1948, CR, vol. II, p. 167.
19. Edouard Manet, *Le Balcon*, 1868, Musée d'Orsay, Paris.
20. Jacques-Louis David, *Madame Récamier*, 1800, Musée du Louvre, Paris.
21. François Gérard, *Portrait de Juliette Récamier*, c. 1805, Musée Carnavalet, Paris.
22. Jean-Auguste-Dominique Ingres, *La Source*, 1856, Musée d'Orsay, Paris.
23. Jean and Dominique de Menil returned the work to Iolas in the early 1960s. Its present whereabouts is unknown.
24. Iolas is referring to the New York socialite Fleur Cowles, the founder of *Flair*, a stylish and fashionable magazine that ran from February 1950 to January 1951. The issue of May 1950 featured roses on its cover.
25. Iolas to Magritte, in CR, vol. III, p. 8, undated [February 1951].
26. *Perspective: Manet's Balcony*, 1950, Museum van Hedendaagse Kunst, Ghent, Belgium (CR 721), is one of the first examples of Magritte making a new version for the European market of a work he had sold to Iolas, in this case a version of CR 710.
27. Iolas to Magritte, in CR, vol. III, p. 16, March 21, 1951.
28. Nelson Rockefeller bought CR 709; Mr. and Mrs. Joseph Pulitzer Jr. bought CR 758;

the de Menils bought many Magrittes from Iolas as well as from other sources (see note 39).

29. Nothing came of Iolas's plan for a collaboration with Balanchine. On 6 November 1953 Magritte wrote to his friend Jan-Albert Goris, "I like the ballet, on condition that it is classical. 'Avant-garde' artistic interventions in that area are, to my mind, useless and ridiculous."

30. Iolas to Magritte, 5 March 1953, in CR, vol. III, p. 43.

31. Iolas to Magritte, in CR, vol. III, p. 192, October 15, 1952.

32. See chapter 8.

33. Published in English in the catalog of an exhibition of Magritte's paintings at the Copley Galleries, Hollywood, September 1948. The text was almost certainly translated from the French by William Copley.

34. Laurie Monahan, "Rock Paper Scissors," *October* 107 (Winter 2004), pp. 95–113. An English translation of Einstein's article in *Documents* 4 by Charles W. Haxthausen, is published as "Etchings of Hercules Seghers," in *October* 107 (Winter 2004), pp. 154–57.

35. "La peinture inutile de M," 1953, in *EC*, no. 99.

36. Interview with Lindsey Talbot, *Harper's Bazaar*, 14 August 2013.

37. This observation is made by David Sylvester in *Magritte*, p. 14.

38. Luc Sante, "Magritte the Detective," *Threepenny Review* 56 (Winter 1994), p. 28.

39. David Salle, "Art in Free Fall," *New York Review of Books*, 8 February 2017, p. 39.

40. In 1953, Magritte painted a portrait in gouache of Madeleine Goris with her three cats. In 1958 he painted a companion portrait of her husband, Jan Albert Goris, also in gouache. CR, vol. IV, cats. 1368 and 1445. Both were done from photographs.

41. Anon., "The Iconoclastic Opinions of M. Marcel Duchamps [sic] Concerning Art and America," *Current Opinion* 59 (November 1915), p. 347.

42. The Copley Galleries opened with a Magritte exhibition on 9 September 1948. The small gallery was located in a renovated house at 257 North Canon Drive, Beverly Hills. Following exhibitions by Matta, Man Ray, and Max Ernst, it closed at the end of February 1949.

43. According to Copley, Ployardt "hated Disney and called himself a Surrealist." *Portrait of the Artist as a Young Dealer*, p. 5. (Original English text of a French essay in Paris–New York, Centre Georges Pompidou, Paris, 1977.)

44. Duchamp deployed his contacts extremely skilfully and always in the best interests of others. In the spring of 1961, for example, he raised funds for sending the American chess team abroad by persuading artists he knew to donate their works for an auction at Parke-Bernet, New York. See *The Times*, San Mateo, California, 10 May 1961, p. 27.

45. Theresa Papanikolas, "A Deliberate Accident: Magritte in the Collection of John and Dominique de Menil," in *Magritte and Contemporary Art: The Treachery of Images*, Los Angeles County Museum of Art, Los Angeles, 2006, p. 88.

46. Now in the Louise and Walter Arensberg Collection, Philadelphia Museum of Art.

47. Several writers and painters associated with surrealism acted as agents for each other facilitating sales. In 1960, for example, Breton gave two Magritte paintings to Victor Brauner to sell, which he did very successfully, to Jean and Dominique de Menil: *La Loi de la pesanteur* (CR 200) and *L'Abandon* (CR 312).

48. Marcel Duchamp, "A propos de moi-même" (1964), in Michel Sanouillet and Paul Matisse, *Duchamp du signe: suivi des Notes* cited in Cécile Debray, "Repression in Painting," in Dawn Ades and William Jeffett, eds., *Dalí/Duchamp* (London: Royal Academy of Arts, 2018), p. 23.

49. Pierre Cabanne, *Entretiens avec Marcel Duchamp,* cited in English in Ades and Jeffett, *Dalí/Duchamp,* p. 19.

50. Pierre Descargues, "René Magritte: Faire La Peinture qui se remarque le moins possible," *Tribune de Lausanne,* 15 January 1967. Cited in English in Sarah Whitfield, *Magritte and His Accomplices* in Whitfield, *Magritte,* p. 28.

51. Magritte to Torczyner, 10 March 1959 (letter no. 80), in Torczyner, *L'Ami* (New York: Abrams, 1977), p. 112.

52. Calvin Tomkins, *Marcel Duchamp: The Afternoon Interviews* (New York: Badlands Unlimited, 2013), p. 9.

53. Torczyner to Magritte, in Torczyner, *L'Ami,* p. 246.

54. Leo Castelli opened his first New York gallery on 10 February 1957 at 4 East 77th Street.

55. Quoted in John Russell's obituary of Leo Castelli, *New York Times,* 23 August 1999.

56. "In 1954 he [Leo Castelli] saw Mr. Rauschenberg's work for the first time. And it was while visiting Mr. Rauschenberg's studio shortly thereafter that he was taken to call on Mr. Johns, who lived in the same building. After many years of being badgered by interviewers for a firsthand account of that famous encounter, he sometimes began to sound, in the words of a close friend, 'like a wind-up toy.' " He once likened the visit to walking into the tomb of Tutankhamen and seeing the treasures there. Ibid.

57. Mesens was the only one of Magritte's friends, apart from Pierre Flouquet, who criticized his work in print. His condemnation of the artist's "impressionist" phase appeared in his book, *Peintres belges contemporains* (Brussels: Les Éditions Lumière, 1947), pp. 157–61.

58. Mesens, together with Roland Penrose, had taken over the London Gallery, 21 Cork Street, London, in April 1938.

59. Roberta Bernstein, "René Magritte and Jasper Johns: Making Thoughts Visible," in *Magritte and Contemporary Art: The Treachery of Images* (Los Angeles: Los Angeles Contemporary Museum of Art, 2007), p. 23, note 8.

60. Roberta Bernstein, "René Magritte and Jasper Johns: Making Thought Visible," in *Magritte and Contemporary Art: The Treachery of Images,* p. 123, note 8.

61. Lynn Zelevansky, "An Interview with Ed Ruscha," in *Magritte and Contemporary Art: The Treachery of Images,* p. 140.

62. Ibid., p. 143.

63. Ibid.

64. See chapter 5.

65. Canonne, *Surrealism in Belgium,* p. 111.

66. Jane Graverol, "Entretien avec José Vovelle," in Canonne, *Surrealism in Belgium,* p. 113.

67. Nougé slowly recovered. From 1964 he lived with Reine Leysen, who became his third wife. They married in 1967, a few months before his death. He attended Magritte's funeral, 18 August 1967.

68. Canonne, *Surrealism in Belgium,* p. 115.

69. Mariën had recently returned from the Caribbean, where, since December 1951, he had been working as a cook aboard a boat called the *Silver Ocean.*

70. Mariën to Michel Leiris, 29 December 1953. Brussels, Archives et Musée de la Littérature. Fonds Mariën. FS, 47/89.

71. Magritte to Gaston Puel, 6 February 1955, reprinted in *EC,* p. 402: reprinted in English in Canonne, *Surrealism in Belgium,* p. 124.

72. Francis De Lulle and Catherine De Croes, eds., *La Fidelité des images: Rene Magritte et le cinématographie et le photographie* (Brussels : Le Fil Rouge, 1976), p. 69.

73. CR, vol. III, p. 71.

74. See chapter 1.

75. Ibid.

76. These letters were published in Magritte, *Bosmans*.

77. According to Xavier Canonne, "No matter how much esteem Magritte had for Bosmans—which was no doubt dependent on the admiration that Bosmans had for the painter—Rhétorique was basically designed and conceived by René Magritte." See Canonne, *Surrealism in Belgium*, p. 193.

78. Ibid., p. 190.

79. Harry Torczyner was Belgian by birth. He had been at school in Antwerp with Gustave Nellens, with whom he later studied law at the Université Libre de Bruxelles. During World War II, he served with the radio division of the American Office for War Information and later became an expert in international law and political science. He served as national chairman of the Zionist Organization of America's commission on Israel and the Middle East. Together with Peter De Maerel, head of public relations for the Belgian airline Sabena, he founded the Belgian Art Foundation in the United States.

80. Torczyner, *Magritte: Ideas and Images* (New York: Abrams, 1977), p. 10.

81. Barnet Hodes was a partner in the Chicago law firm Arvey, Hodes and Mantynband.

82. Copley's network of friends and associates in the art world of the mid-1950s is summed up by the list of those acting as either advisers or officers and directors on the board of the William and Noma Copley Foundation, which was incorporated in 1954. The advisers were Jean Arp, Alfred Barr, Roberto Matta Echaurren, Max Ernst, Julien Levy, William Lieberman, Man Ray, Roland Penrose, and Herbert Read. The officers and directors were William and Noma Copley, Marcel Duchamp, Barnet and Eleanor Hodes, and Darius Milhaud.

83. Copley, *Portrait of the Artist as a Young Dealer*, p. 5.

84. Letter to Barnet Hodes, 8 April 1960, in CR, vol. III, p. 68.

85. The chandelier, installed by Gustave Nellens in 1949, had a diameter of 8.5 meters (28 feet) and a height of 6.5 meters (21 feet). Twenty-two thousand pieces of glass were used, together with 2,700 lamps. According to Nellens's son Roger, it was included in the *Guinness Book of Records*. It was removed from the Salle du Lustre following Nellens's death in 1971.

86. In 1966 Magritte took part in an experiment for a recently invented process of reproduction known as *Kamagraphie*, invented by a French chemist, Henri Cocard. The process could produce 250 identical canvases, an idea that greatly appealed to Magritte. Magritte wrote to Torczyner on 3 October 1966, "Thanks to this invention, impecunious museums will be able to assemble rooms of modern paintings such as they could not previously aspire to." See CR, vol. III, cat. 1048.

87. The French title, *L'Empire des lumières*, is often translated as *The Empire of Lights*. However, according to Mariën, the translation of *Empire* in the sense of "territory" misses the subtlety of Nougé's understanding of the word to mean "power" or "dominance." See CR, vol. III, cat. 709.

88. Quoted in Briony Fer, "Rothko and Repetition," in Glenn Phillips and Thomas Crow, eds., *Seeing Rothko* (London: Tate Publishing, 2006), p. 160.

89. *The Exorcist* opened on 26 December 1973. Friedkin has described how he "began to recompose" *The Dominion of Lights* as one of the scenes. "I saw a powerful light shining from Regan's bedroom window down to a silhouetted figure standing near the streetlamp. The man would be Father Merrin [played by Max von Sydow] arriving at the Georgetown house. Magritte's painting is an example of how he juxtaposed realistic but unrelated objects. In the film it became a real house, on a real street, an upstairs bedroom in which a young girl is possessed by a demon. To achieve the

effect of light from the bedroom window we had to construct a platform behind the extension built onto Mrs. Mahoney's house. On the platform was an arc light aimed directly at Merrin as he emerged from a taxicab. Prospect Avenue was wetted down and we used a fog machine to enhance the mood. We put our own streetlamp in front of the house. I had a taxi come down Fifth Street, make a U-turn on Prospect, and pull up in front of the house. This meant Owen [Roizman] had to light two streets and produce the surreal effect from the bedroom window. We set aside a full day and night to light this one shot and photographed it the next night in one take." *The Friedkin Connection: A Memoir* (New York: Harper Collins, 2013), pp. 261–62.

90. Ibid., p. 302.
91. Magritte to Felix Fabrizio, 3 September 1966, private collection.
92. Sylvester, *Magritte*, p. 254.
93. Anon., "The Enigmatic Visions of René Magritte," *Life* 60, no. 16, 23 April 1966, n.p.
94. Suzi Gablik, "Conversation with René Magritte," Studio International, March 1967, n.p.
95. The friend was the dramatist Claude Spaak. See CR, vol. II, cat. 383.
96. Passeron, "En écoutant Magritte," p. 12.
97. *Where Euclid Walked*, 1955, Minneapolis Institute of Arts, William Hood Dunwoody Fund.
98. CR, vol. III, cat. 974.
99. *EC*, p. 613.
100. Michel Leiris, "Alberto Giacometti," *Documents 4* (September 1929). Cited in Whitfield, *Magritte,* 1992, cat. no. 29.
101. By the spring of 1960, Magritte was asking Torczyner's advice about exchanging American dollars for Swiss francs. It was probably around then that he opened a Swiss bank account. See Torczyner, *L'Ami*, p. 143.
102. CR, vol. III, cat. 1089.
103. See Whitfield, *Magritte,* 1992, cat. 167, note 3.
104. Guy Carels and Charles van Dam, *Paul Delvaux* (St. Idesbald, Koksijde: Paul Delvaux Foundation, 2004), p. 107.
105. John Updike, "Magritte the Great," in *Always Looking: Essays on Art* (New York: Knopf, 2012), p. 163.
106. Sylvester, *Magritte*, p. 309.
107. Magritte met Iolas in Milan on 21 June and they drove to the GiBiEsse Foundry in Verona, where it appears that only two of the wax casts were ready for Magritte to inspect; *La Joconde* and *La Folie des grandeurs*. "I have to see if my instructions have been followed 'to the letter' which is all I ask," he advised Torczyner. Torczyner, *Letters*, p. 151.
108. The Arkansas Art Center, a small museum founded by the politician and philanthropist Winthrop Rockefeller, opened in May 1963.
109. Three notebooks among the William C. Seitz papers held by the Archives of American Art, Smithsonian Institution, Washington, D.C., show that Seitz made trips to London, Paris, Brussels, New York City, and Chicago between 10 June and 1 July in order to secure loans for the exhibition.
110. James Thrall Soby, *The Early de Chirico* (New York: Dodd Mead and Co., 1941), p. 96. Later he regretted what he had written, saying, "Of the modern artists whom I misjudged badly in my youth the one about whom I feel most repentant is René Magritte." "The Changing Stream," in *The Museum of Modern Art at Mid-Century: Continuity and Change* (Museum of Modern Art, New York, 1995), p. 220.
111. In a letter of 12 February 1964, Torczyner informed Magritte, "Next Monday I'm having lunch with one of the Museum's curators, and I shall perhaps get some details

on the 'manner of presenting Magritte's work' these gentlemen are considering. This news is (for the moment) confidential." Torczyner, *Letters*, p. 94. Magritte was not entirely happy with the selection of works made by the museum. As he complained to Torczyner, in a letter of 30 September 1965, "The list was drawn up by the authorities and reflects the differences between their expertise and mine. I am not at all happy with this way of envisaging an exhibition with regard to which, I feel, I should have a say—at the very beginning when there was first question of such an exhibition." Torczyner, *Letters*, p. 123.

112. Magritte had no time for Dalí's flaming giraffes. In a letter of 28 March 1959 he told Bosmans, "Dalí is superfluous: the burning giraffe, for example, is a caricature of an animal, an unintelligent exaggeration—since it is facile and unnecessary—of the image I painted showing a flaming piece of paper and a flaming key, an image I later made more precise by showing only a single object in flames: a trumpet." The works Magritte refers to are in CR, vol. IV, cat. 1108, *L'Echelle du feu* (*The Ladder of Fire*), 1934; vol. II, cat. 358, *L'Echelle du feu* (1934); and vol II, cat. 359, *La Découverte du feu* (*The Discovery of Fire*), 1934 or 1935.

113. Magritte to Torczyner, 1 July 1965, in Torczyner, *L'Ami*, p. 126.

114. Torczyner held a party for Magritte. According to a local gossip columnist he "removed from his walls all non-Margritte (sic) canvases and put them in a closet." *The Post-Standard*, Syracuse, New York, 24 December 1965, p. 18. Other events included a dinner at the Iolas Gallery; a cocktail party given by Ambassador Forthomme, the consul general of Belgium; and a trip to the country house of James Thrall Soby in New Canaan, Connecticut, to see his collection of works by de Chirico.

115. Magritte to Torczyner 25 August 1963, letter no. 287, in Torczyner, *L'Ami*, p. 252.

116. Ibid.

117. 97 rue des Mimosas. Magritte made only minor alterations to the house. According to André Bosmans, Magritte made sure that no door had the same handle on both sides. See CR, vol. III, p. 85.

118. Magritte to Torczyner, 27 February 1964, in Torczyner, *Letters*, p. 95.

119. Magritte decided to return the Lancia, with minor dents and scratches, to the garage where he had bought it. See Torczyner, *L'Ami*, pp. 222–23.

120. The photomontage was made by Leo Dohmen, a close friend of Mariën's. On 4 July 1962, Dohmen wrote to Mariën urging him to remain anonymous as long as possible and adding, "If we can succeed in this there will even be a way later to publish an entire book with fake Magrittes, I'm sure it will sell well." Dohmen's role in "*Grande Baisse*" did not remain a secret for long. Breton obviously knew about it when he wrote a dedication in Dohmen's copy of *Young Cherry Trees Secured Against Hares*, "To Léo Dohmen: The hand in the act of taking at the same time as letting go, like it seized the bank-note 12716.B.47017.11.58 too finely made to be legal tender." See Jan Ceuleers, *Leo Dohmen 1929–1999: Look! Think! Win!* (Antwerp: Ronny van de Velde, 1999), p. 54 (original French), p. 91 (English translation, slightly altered here).

121. *Le Radeau de la Mémoire* (Brussels: Le Pré aux Clercs, 1983) was published in spite of a lawsuit brought by Georgette Magritte to prevent publication. The account of the counterfeit money is given in chapter 70, pp. 175–80. For Georgette's reaction see also Torczyner, *L'Ami*, p. 410.

122. CR, vol. IV, cat. 1301b.

123. Around June 1959 Torczyner got wind of a fake Magritte being circulated in France and asked a fellow lawyer to track it down. See Torczyner, *L'Ami*, p. 142.

124. Bernard Blistène, "The Roguish Language of Magritte's," in *Bad Painting, Good Art* (Vienna: Museum Moderner Kunst Stiftung Ludwig, 2008), p. 144.

125. Mariën admitted to his part in "Grande Baisse" in 1966.

126. *EC*, p. 731.

127. This incident is recorded by André Blavier in an undated letter to Raymond Queneau, September 1963, published in Raymond Queneau and André Blavier, Jean-Marie Klinkenberg (ed.), *Lettres croisées 1949–1976* (Brussels: Labor, 1988).

128. Irène Hamoir in conversation with David Sylvester and Sarah Whitfield. See CR, vol. III, p. 124.

129. After turning up for an interview with a Belgian television program in January 1966, Magritte informed Torczyner, "Once again I was repelled by the reporters: the one (from TLV), who apparently 'meant well,' made sure to ask me a last question with a ghastly pun that revealed his innermost nature: 'May I express the hope that you'll have Surrealism as a dada [i.e., as a hobby] for a long time to come?' Which left me completely dumbfounded, as I always am when confronted with self-satisfied stupidity." Torczyner, *Letters*, p. 131.

130. Cited in Whitfield, *Magritte,* 1992, p. 39.

131. *EC*, pp. 431–42. See also CR, vol. III, p. 81, for English translation.

132. Alphonse de Waelhens, *La philosophie de Martin Heidegger* (Louvain: Éditions de l'Institut Supérieure de Philosophie, 1942) and *Phénoménologie et vérité: Essai sur l'évolution de l'idée de vérité chez Husserl et Heidegger* (Paris: Presses Universitaires de France, 1953).

133. *EC*, p. 675. English translation in CR, vol. III, p. 674.

134. Ibid., p. 496. English translation in CR, vol. III, p. 76.

135. Georgette Magritte, "En écoutant Magritte," in René Passeron, *René Magritte* (Paris: Filipacchi, 1970), p. 12.

136. Sylvester, *Magritte*, p. 317.

137. Mariën 1968, English translation in Whitfield, *Magritte,* 1992, p. 43.

138. Magritte to Torczyner, 14 March 1960, in Torczyner, *L'Ami*, p. 143.

139. The exhibition of recent work was shown at the Galerie Rive Droite, Paris.

140. Magritte to Torczyner, in Torczyner, *L'Ami*, p. 182.

141. In mid-April 1965 Magritte took a "cure" at Casa Micciola Terme in Ischia: "As for the treatment, it takes a good hour: 1st, mud bath, 2nd a dip in mountain water, 3rd rest, 4th massage. It is administered around 8 am, and on an empty stomach. So far no improvement in the Brussels health status. I have to make an effort to write, sit, lie down, etc." Torczyner, *Letters*, p. 101.

142. Postcard to André Bosmans, dated 7 June 1966. Leonardo's painting had a history of damage long before World War II.

143. The title, *L'Aimable vérité*, suggested by Scutenaire, was probably derived from Boileau's dictum: "Rien n'est beau que le vrai: le vrai seul est aimable." (Nothing is beautiful but the truth: only the truth is endearing.) See CR, vol. III, cat. 1044.

144. Torczyner told the authors of the CR that according to Amiel Najar, the wall in *L'Aimable vérité* was inspired by Magritte's memory of the walls of the old city of Jerusalem, which he had seen from his room at the King David Hotel during his stay there in April. See CR, vol. III, cat. 1044.

145. Gablik, *Magritte*, 1967, pp. 128–31.

146. Raymond Art was contacted by telephone by the authors of the CR when they were working on the final stages of the catalog. He said he was unable to help and put down the phone.

147. In a letter to Torczyner dated 24 January 1966, Magritte told him that having his wrist in plaster prevented him from writing easily. In a telephone conversation with Torczyner he said that "for the first time while painting he had got some paint on his hand." Torczyner, *Letters*, p. 130.

148. Ibid., p. 15.
149. Interview with Stan Lauryssens, *Panorama*, Antwerp, August 6 1974.
150. Written by either Jacques Wergifosse or André Bosmans.

MAGRITTIANA

1. Hamoir, "Notes biographiques," n.p. See Roisin, *Magritte*, p. 89, citing Tom Gutt.
2. Magritte to Mesens, n.d., in *FA*, 101 (November 1973). Cf. Mesens, "René Magritte," in *Peintres Belges contemporains*, pp. 157–61. Mesens republished the essay in extended form after Magritte's death, complete with almost all of the passages to which he had taken exception. See, e.g., "Magritte prophétique," in *René Magritte*, pp. 27–31.
3. Magritte to Van Hecke, 29 May 1965, in *LM*, p. 71; CR, vol. III, p. 135. Cf. Waldberg. The patrons were Gustave Nellens and Paul-Gustave Van Hecke.
4. Magritte to Soby, 4 June 1965, Soby Papers, 3/20, GRI; CR, vol. III, pp. 130–32. Cf. James Thrall Soby, *Magritte* (New York: MoMA, 1965).
5. Waldberg, *Magritte*, p. 111.
6. David Sylvester, "Curriculum Vitae," in *About Modern Art* (London: Pimlico, 1997), p. 30.
7. Sarah Whitfield, address to Menil Symposium, "Beyond the Image, Beneath the Paint," 1 March 2014.
8. CRRP BDF C 04 and D II/18. The inventory is not as complete as it might be; in any event it is only a snapshot. Other items were lent or sold or lost, over time, or simply unrecorded. See, e.g., "Ouvrages provenant de la bibliothèque de René Magritte," Michel Lhomme auction catalog, 2 December 1995.
9. See Christiane Geurts-Krauss, *E. L. T. Mesens* (Brussels: Labor, 1998); Phillip van den Bossche (ed.), *The Star Alphabet of E. L. T. Mesens* (Ostend: Mu.ZEE, 2013); Melly, *Sybil*; E. L. T. Mesens, *Moi, je suis musicien* (Brussels: Devillez, 1998).
10. Waldberg, *Magritte*, p. 70 (a remark dated to 1963). The deleted expletive was perhaps "*con*" ("berk," or something like it). Cf. Torczyner, *Signes*, p. 16.
11. See "Property from the Collection of Arlette Magritte" (Raymond's daughter), at Christie's in London on 25 June 2001. Other works from the collection were sold piecemeal, before and since.

Index

Page numbers in *italics* refer to illustrations; "CP" refers to color plates.

Abandon, L' (Magritte), 392n28, 411n47

abstract expressionism, 325

Académie des Beaux-Arts (Brussels), 62, 75–81, 84, 89, 121, 368n3

"Action immédiate, L' " (Nougé and Magritte), 260

Administration Communale of La Louvière, 205

advertising, xxxiii, 120–3, 131, 133

Affinités électives, Les (Elective Affinities) (Magritte), 213, *213*, 217, 397n44

Âge d'or, L' (film), 384n74

Agee, James, 56

Aimable Vérité, L' (The Endearing Truth) (Magritte), 348–50, *349*, 416n143, 416n144

Alechinsky, Pierre, 189, 313

Alexandre, Charles, 46, 52, 70, 72–3, 75, 78–81, 85–6, 101, 104, 107, 108, 378n33

Alexandre, Maxim, 169, *169*

Alice's Adventures in Wonderland (Carroll), xxvii–xxviii, 8, 119

Allain, Marcel, 44, 49

Alphabet des révélations, L' (The Alphabet of Revelations) (Magritte), 198, 381–2n37

Amants, Les (The Lovers) (Magritte), 28, CP7, CP8

Amicale des Artistes communistes de Belgique, L', 262

Amitié, L' (Blanchot), 390n91

Amour, Georgette, L' (photograph), 65

Amour désarmé, L' (Love Disarmed) (Magritte), 246, *247*

Annonciation, L' (The Annunciation) (Magritte), 200, 202, 222, *222*, 323, 387n40, 400n4, CP30

Apfel, Alice, 179–80, 393n55

Apollinaire, Guillaume, 44, 116, 372n2, 383n68, 399n84

Apparition, L' (Magritte), 392n28

Aragon, Louis, 51, 133, 161–2, 168, 169, *169*, 170, 176, 182, 192, 194, 195, 225, 391n11, 391n13

Arbre de la science, L' (Magritte), 392n29

Arbre savant, L' (Magritte), 396

Arc-en-ciel, L' (The Rainbow) (Magritte), 75

Arensberg, Louise, 324

Arensberg, Walter, 324

Arlequin, L' (Magritte), 106, 381n19

Arnheim, Rudolph, 394n75

Arp, Jean, 127–8, 158, *159*, 160, 164, 176, 300, 413n82

Arrest of Sherlock Holmes, The (Magritte), 279

Art, Raymond, 332, 350, 416n146

Artaud, Antonin, 44, 376n69
"Art bourgeois, L" (Magritte and
 Scutenaire), 255–6, 304
Art de vivre, L' (Magritte), 312, CP44
Artemidorus, 164
Art et la paix, L', exhibition, 263
Art pur, L': défense de l'esthétique
 (Magritte), 109, 120, 210
Aspiration (Russolo), 113
Assassin menacé, L' (The Murderer
 Threatened) (Magritte), 146–51, 147,
 167, 188, 200
Association Révolutionnaire Culturelle
 (ARC), 260
Athénée Royal (Charleroi, Belgium), 58,
 69–70
Auerbach, Frank, 63
Au seuil de la liberté (On the Threshold
 of Freedom) (Magritte), xxxiii, 144,
 195, 200, 202–3, 234, 244, 396n20,
 400n4, CP2
Automate, L' (Magritte), 381–2n37, 392n29
automatism, 175, 183
Au Volant (review), 80
Avenir des statues, L' (The Future of
 Statues) (Magritte), 62, 236
Aventures d'Arthur Gordon Pym (Poe),
 397–8n47
Aventures de Paul enlevé par un ballon,
 Les (Bruno), 35
Avenue at Middelharnis, The (Hobbema),
 300
Avery, Tex, 312
Avionne meurtrière, L' (The Killer Plane)
 (Magritte), 103

Bachelard, Gaston, 229
Baillon, André, 81, 178
Balanchine, George, 318, 411n29
Balcon, Le (The Balcony) (Manet), 314
Baldovinetti, Alesso, 112
Balestrieri, Lionello, 112
Balthus, 205
Banks, Ann Robin, 97, 369n16
Barbare, Le (The Barbarian) (Magritte), 45,
 45, 159, 390n6
Barr, Alfred, 413n82
Barthes, Roland, 170, 189–90
Bataille, Georges, 71, 136, 153, 175, 206–7,
 208, 292, 390n91, 399n79

Baudelaire, Charles, 88, 92, 128, 129, 130,
 133, 142, 143, 170, 188, 200, 249, 286,
 314, 372n4, 380n5, 389n67
Baudhier, Antoinette, 4
Beau Navire, Le (Magritte), 373n16
Beau Ténébreux, Le (Tall, Dark, and
 Handsome) (Magritte), 341
Beauvoisin, Marthe, 144, 196, 293, 377n15
Beckett, Samuel, 17, 22, 29, 37, 96, 284,
 321
Beckford, William, 118–19
Belgium:
 Communist Party of, 138, 255, 260–2,
 327, 404n72
 German invasion/occupation of, xxix,
 59, 70, 79, 91, 251, 274, 281–3, 288,
 298, 305, 404n82
 national character of, 87, 104, 111–12,
 143, 178
Belle Captive, La (Magritte), 396n18
Belle Captive, La (Robbe-Grillet), 148
Belle de nuit (Magritte), 389–90n77
Bellmer, Hans, 294
Benda, Julien, 394n70
Benjamin, Walter, 136, 220
Berger, Florent Joseph, 61, 98
Berger, John, xxxiii, 149, 244, 245
Berger, Léa Payot, 61
Berger, Léontine, 61–2, 89, 98, 236, 282,
 377n8, 377n9, 407n42
Bergson, Henri, 227–32, 400n86, 400n88
Bernard, Yvonne, 162, 181
Bertinchamps, Albert, 10, 21, 27, 35
Bertinchamps, Alfred, 12
Bertinchamps, Émilie Éloïse Nisolle, 12
Bertinchamps, Florine Nisolle, 12, 35
Bertinchamps, Gaston, 35
Bertinchamps, Georges, 35
Bertinchamps, Victor Joseph, 12
Berton, Germaine, 170
Bertouille, Suzanne, 301
Bertrand, Aloysius, 32, 372n5
Betjeman, John, 233
Beyond Good and Evil (Nietzsche), 382n41,
 385n101
Bilz, F. E., 189, 394n73
Bishop, Elizabeth, 71
Blanchard, Sophie, 34
Blanchot, Maurice, 390n91
Blum, Léon, 253
Bockstael, Albert, 368n3

Boijmans Van Beuningen Museum (Rotterdam), xxx, 346
Boîte de Pandore, La (Magritte), 376n69
Bonheur des images, Le (Magritte), 409n74
Bons Jours de Monsieur Ingres, Les (Monsieur Ingres's Good Days) (Magritte), 118, 291, 385–6n3
Bonnard, Pierre, 77
Bonne Aventure, La (Fortune Telling) (Magritte), 220, 398n57
Bonne Nouvelle, La (Good News) (Magritte), 97–8, 381n31, CP22
Bonnot, Jules Joseph, 40, 41, 43, 195, 373n24
Borges, Jorge Luis, 280
Borzage, Frank, 143
Bosch, Hieronymus, 112, 296
Bosmans, André, 32, 55, 82, 83, 87, 111, 225, 330, 348, 413n77
Botticelli, Sandro, 112
Bouchon d'épouvante, Le (Magritte), 389n67
Boulevard, La (Magritte), 105
Boulevard Jacqmain (Hamoir), 22, 24, 208
Bouquet, Le (Magritte), 156
Bouquet tout fait, Le (The Ready-Made Bouquet) (Magritte), 112
Bourgeois, Pierre, 68, 79, 80, 94, 104–5, 106, 108, 139
Bourgeois, Victor, 79, 80, 104, 108, 387n25
Bousquet, Joë, 283, 284, 285, 293, 296, 406n25
Brancusi, Constantin, 93, 288
Brandt, Bill, xxxi
Braque, Georges, 110, 164, 202, 203–4, 214, 259, 298–301, 305
Braque le patron (Paulhan), 204
Braudel, Fernand, 229
Brecht, Bertolt, 328
Brélia, Évelyne (Evelyne Bourland), 107, 122, 383n63
Breton, André, xxviii–xxix, 38, 51, 53, 62, 115, 119, 124, 133, 136, 138, 149, 157, 160–1, 168–72, *169*, 174–83, 189, 192, 193–5, 203, 217–19, 221, 225, 236, 249, 253, 259, 283, 292–7, 301, 311–13, 316, 324, 344–5, 384–5n92, 385n97, 386n6, 391n11, 392n28, 392n32, 392n41, 393n48, 404n77, 408n54, 411n47
Brod, Max, 141

Broodcoorens, Pierre, 79, 80
Broodthaers, Marcel, xxxii, xxxiii
Bruno, Jean, 35
Brussels, Belgium, xxviii–xxix, 59, 61, 73, 75, 77, 94, 155, 156, 174, 192, 196, 202, 284–5, 297, 314, 319, 327–8
Buchan, John, 203
Buñuel, Luis, 57–8, 169, *169*, 182, 192, 349, 376n65, 384n74
Burroughs, Floyd, *244, 245*

Camera Lucida (Barthes), 189–90
Campagne (Magritte), 100, 124
Canonne, Xavier, 330, 405–6n8
Capital (Marx), 256
capitalism, 239, 244, 248, 255
Cappiello, Leonetto, 74–5
Caractères, Les (La Bruyère), 246
Carcassone, France, 283–5
Carmagnole de l'amour, La (Magritte), 382n50
Carnaval du sage, Le (Magritte), 409n74
Carné, Marcel, 57, 376n66
Carrà, Carlo, 104, 386n14
Carrefour (Ray), 195
Carroll, Lewis, xxvii–xxviii, 8, 118, 226, 274
Carson, Anne, 208
Carte d'après nature, La (review), 214, 328
Carter, Nick (fictional character), 28–9, *29*, 41, 372n71
Casino Knokke, 91, 151, 332, *333*, 339, 340, 343, 344, 413n85
Castelli, Leo, 325, 392n26, 412n54, 412n56
Castle, The (Le Château) (Kafka), 221, 398n60
Cattier, Edmond, 80
Caulfield, Patrick, 160, *160*, 390–1n7
Caupenne, Jean, 169, *169*
Cavalcanti, Alberto, 200, 396n18
Ceci est un morceau de fromage (This Is a Piece of Cheese) (Magritte), xxxii, 276, *276*
Ceci n'est pas une pipe (Foucault), 189
Ceci n'est pas une pomme (Magritte), 62, 377n9
Celmins, Vija, 257, *257*
Cendrars, Blaise, 44
Centre d'Art (Brussels), 82, 92, 94, 104
Ceuleers, Jan, 208, 305

Cézanne, Paul, 52, 87–8, 102, 103, 110, 112, 136, 189

Chabrol, Claude, 148–9

Chambre d'écoute, La (The Listening-Room) (Magritte), 276, 319, 322

Chandler, Raymond, 272, 401n12

Changement des couleurs, Le (Change of Color) (Magritte), 47–8, 47

Chant d'amour, Le (The Song of Love) (de Chirico), 110, 113–17, 120, 287, CP24

Chant de la violette, The (The Song of the Violet) (Magritte), 276, 319, 321

Chant de l'orage, Le (The Song of the Storm) (Magritte), 210

Chants de Maldoror, Les (Lautréamont), xxxii, 129–30, *130*, 367n9, 408n59

Chaplin, Charlie, 55, 56, 226, 375n59, 376n65

Char, René, 294

Charleroi, Belgium, 4, 6, 19, 34, 40, 42, 43, 58, 73, 85, 101, 152, 156, 182, 313, 330

"Charmeresse, La" (Goemans), 177

Chasseurs au bord de la nuit, Les (The Hunters at the Edge of Night) (Magritte), *186, 187,* 381–2n37, 394n68

Château des Pyrénées, Le (The Castle in the Pyrenees) (Magritte), 119

Château hanté, Le (The Haunted Castle) (Magritte), 319

Châtelet, Belgium, 10, 12, 14–18, 21, 34, 35, 40, 42, 43, 52, 58, 70, 74, 75, 77, 85, 208

Chavepeyer, Albert, 42, 43, 52, 374n34

Chavepeyer, Émile, 43

Chavepeyer, Hector, 43

Checkmate (Magritte), 137, 145

Chef d'orchestre, Le (Magritte), 397n46

Chemin de Damas, Le (The Road to Damascus) (Magritte), 224–5

Chenoy, Léon, 79

Chevalier du couchant, Le (The Knight of the West) (Magritte), 141–2, *142*

Chevaux affolés fuyant une écurie en feu (Frightened Horses Fleeing a Burning Stable) (Magritte), 42

Chigirinsky, Sacha, 162

Choix de poèmes (Éluard), 199

Cicatrices de la mémoire, Les (Magritte), 387n38

Ciel passe dans l'air, Le (Magritte), 389n72

Cinema Bleu (Charleroi, Belgium), 58, 59

Cinéma bleu (Magritte), 43, 118, 374n33, CP14

Cinq Mélodies Orientales (Quinet), 122

Civilisateur, Le (The Civilizer) (Magritte), 96, 97

Clairvoyance, La (Magritte), *205,* 389–90n77

Claudel, Paul, 389n71

Clef des songes, La (The Interpretation of Dreams) (Magritte), xxvii, xxxiii, 164–7, *165, 167,* 202, 224, 288, 326, 392n26, 396n20

Clef de verre, La (The Glass Key) (Magritte), 223, 225, 399n72

Cobb, Richard, 87

Cobra group, 313

Cocteau, Jean, 88, 117, 287, 380n4

Colette, 51, 375n52

Colinet, Paul, 22, 23, *90,* 114, 225, 241, 269, 271–80, 272, 282, 285, 289, 304, 316, 328–30, 332, 405n1, 405n4

Collard, Jean-Marie, 20

Combaz, Gisbert, 77

Comité de Vigilance des Intellectuels Antifascistes, xxix, 122, 281

Comité Magritte, 101, 382n39

Communist Manifesto, The, 239, 256

Communist Party, xxix, 138, 178, 183, 255, 257, 260–4, 327, 404n72

Compagnons de la peur, Les (The Companions of Fear) (Magritte), 286, 287, 369n18, CP39

Condition humaine, La (Magritte), 396n18, 400n4

Conférence de Charleroi, 137–8, 152, 292

Conklin, Chester, 55

Connolly, Cyril, 64

Conrad, Joseph, 48, 142, 374n44, 389n68

constructivism, 104, 109

Copley, Noma, 413n82

Copley, William, 7, 313, 323, 331, 411n33, 413n82

Copley Galleries, 411n42

Coq et l'arlequin, Le (Cocteau), 88, 109, 380n4

Coquille et le clergyman, La (film), 220

Coquiot, Gustave, 87–8

Corbusier, Le (Édouard Jeanneret), 109

Cornelis, Jef, xxxi

Cornell, Joseph, *230, 231*

Correspondance (Goemans), 158

Correspondance (review), 138, 139, 176, 314

"Couleurs de la nuit, Les" (Magritte and Goemans), 176, 393n48

Coup au coeur, Le (The Blow to the Heart) (Magritte), 214–17, *215*

"Coup de théâtre, Un" (Magritte), 46–7

Courbet, Gustave, 291, 300, 324, 385–6n3

Cowles, Fleur, 410n24

Crevel, René, 113–14, 117, 195

Critique de la raison pure (Kant), 114

Crowet, Anne-Marie, 289–90, *289*, 407n43

Crowet, Pierre, 407n43

Crox, Emilie, 68

cubism, 83, 101, 104, 109, 113, 202, 253, 298, 383n57

Cubisme et des moyens de le comprendre, Du (Gleizes), 83, 380n72

Cuthbertson, Catherine, 120, 386n7

Dadaism, 50, 92–3, 94, 104, 140, 153, 182, 236

Dalí, Gala, 182, 313, 340

Dalí, Salvador, 57, 111, 115, 159, 160–1, 169, *169*, 180–2, 188, 205, 219, 233, 234, 235, 265, 313, 340, 384n74, 393n58, 415n112

Dallessandro, Joe, 98

dandyism, 92

Danse, La (The Dance) (Magritte), 291

David Jacques-Louis, 314, 319, 348

Deauville, Max, 91

de Chirico, Giorgio, 110–11, 113–17, 118, 123, 125, 126, 128, 141, 164, 170, 179, 225, 287, 290, 298–301, 305, 310–11, 322, 383n68, 385n92, 385n97, 386n14, 410n4, 415n114

Declercq, Aimé, 79–81

Découverte (Discovery) (Magritte), 100, 184–5, CP27

Découverte du feu (The Discovery of Fire) (Magritte), 384n74, 415n112

de Croës, Catherine, xxxi

Defoin, Félicien, 75

Degrange, Ernest, 16

De Greef, Peter, 81–2, 106

Degrelle, Léon, 281, *281*, 288

de Heusch, Luc, xxxi, 157, 167, 294

Dehoy, Gaston, 153

De Keyn, Robert, 303, 409n74

Deknop, Evelyn, 225

Deknop, François, 225

Delchevalerie, Lucien, 42

Delcourt-Nonkels, Jacqueline, 62, 89–90, *90*, 205, 271–2, *272*, 289, 377n8, 380n8, 405n1, 407n42

Deluc, Paul, 376n65

de Lulle, Francis, xxxi

Delvaux, Paul, 78, 92, 100, 128, 240, 332, 338

de Man, Paul, 371n65

de Menil, Dominique, 316, 323, 339, 340, 381n31, 410–11n28, 410n23, 411n47

de Menil, Jean, 316, 323, 340, 381n31, 410–11n28, 410n23, 411n47

Démon de la perversité, Le (Magritte), 145

Denis, Jacques (Jacques Michel), 293

Derain, André, 123, 128, 386n14

de Ridder, André, 101

Derrida, Jacques, 136, 166, 245–6, 401n16

de Sade, Marquis, 195, 402n33

Desaunois, Firmin, 6

Desaunois, Maria Marguerite Ghislaine Magritte, 6

Descartes, René, 80, 129, 141

Deschryver, Honorine, 94, *112*

de Smet, Gustave, 135

Desnos, Robert, 44, 51

De Stijl, 104

Destructeur, La (Magritte), *186*

Deux Mystères, Les (The Two Mysteries) (Magritte), xxxiii

Deux Soeurs, Les (Magritte), 382n40, 386n18

de Waelhens, Alphonse, 346

Dhout, Suzanne, 398n59

Dialectique de la durée, La (Bachelard), 229

Dictionnaire abrége du surréalisme (Breton and Éluard), 192, 395n81

Dierickx, Alphonse, 83

Dimanche des oiseaux, Le (Bird Sunday) (Magritte), 276

Distances (magazine), 164, 220, 372n72, 391n20

Divine Comedy, The (Dante), 126

Documents (quarterly), 195–6, 219, 260, 319, 394–5n80, 404n70

Dohmen, Leo, 415n120

Domaine d'Arnheim, Le (The Domain of Arnheim) (Magritte), xxvii, 400n1

"Domaine of Arnheim" (Poe), 388–9n62

Dominguez, Óscar, 298, 410n4

Dormeur téméraire, Le (The Daring Sleeper) (Magritte), 33, 381–2n37

Dors, Mirabelle, 330

Dotrement, Christian, 54, 290

Dotremont, Philippe, 166–7

Double secret, Le (The Secret Double) (Magritte), 100, 143, 153

Drapeau noir, Le (The Black Flag) (Magritte), 259, *260*, 403–4n68, 408n59

Drapeau rouge, Le (The Red Flag) (publication), xxix, 255, 262, 327

Dreyer, Carl Theodore, 57, 376n65

Dr. Mabuse the Gambler (film), 58

Dubuffet, Jean, 313

Duchamp, Marcel, xxxi, 93, 110–11, 123, 176, 249, 296, 323–5, 331, 411n44, 413n82

Ducrot, Auguste-Alexandre, 3–4

Dulac, Germaine, 220, 398n56

Durée poignardée, La (Time Transfixed) (Magritte), 227–32, *233*, 400n1, CP1

Ecce Homo (Nietzsche), 382n41, 385n101

Échelle du feu, L' (Ladder of Fire) (Magritte), 260, *261*, 384n74, 395n11, 404n71, 415n112

École Moyenne (Châtelet, Belgium), 42, 58, 70–1

Écrits complets (Magritte), xxxii

Eekhoud, Georges, 77, 79–81, 379n62, CP19

Eemans, Marc, 153, 288, 390n90, 407n41

Einstein, Carl, 319

Eisenstein, Sergei, 57, 376n65

Elizabeth, the Queen Mother, 262–3

Éluard, Nusch, 199

Éluard, Paul, 104, 115, 123, 138, 149, 162, 169, *169*, 176, 179, 180, 181–2, 183, 189, 192, 193, 195, 196–200, 211, 216, 225, 249, 259, 283, 310, 312–13, 368n12, 382n50, 386n13, 393n46, 393n55, 395n11, 395n12

Embarras de la peinture, Les (The Predicaments of Painting) (Magritte), 340–1

Empire des lumières, L' (The Empire of LIght) (Magritte), xxvii, 144, 226–7, 232, 307, 334–5, 337, 413–14n89, 413n87, CP32

Emplit, Zénon, 43

Enfance d'Icare, L' (Magritte), 387n22

Enfant trouvé, L' (Magritte), 377n8

Énigme de la fatalité, L' (de Chirico), 116

Énigme d'une journée, L' (de Chirico), 385n92

Ensor, James, 312

Ernst, Max, xxxii, 94, 97, 102–3, 106–7, 110, 111, 113, 115, 123, 124, 128, 149, 158, 162, 164, 169, *169*, 176, 179, 195, 196, 225–6, 249, 300, 305, 323, 331, 382n50, 383n68, 386n13, 386n14, 408n70, 411n42, 413n82

Espion, L' (The Spy) (Magritte), 221, *221*, 235, 382n40, 398n56, 398n59

Esprit comique, L' (Magritte), 371n62

Esprit de géométrie, L' (The Mathematical Mind) (Magritte), 67, CP18

Esprit nouveau, L' (journal), 109, 383n66

État de veille, L' (The Waking State) (Magritte), 335, *336*

Éternité, L' (Eternity) (Magritte), 211, *211*

Evans, Walker, *244, 245*

Évidence éternelle, L' (The Eternally Obvious) (Magritte), xxvii, 168, 201, *201*, 204–5, *204*, 289, 326, 392n27, 396n20, CP31

Evolution créatrice, L' (Bergson), 228

Exorcist, The (film), 334–5, 413–14n89

Expérience continue, L' (Nougé), 327, 389–90n77

Expérience du miracle, L' (Magritte), 184

Exposition internationale du surréalisme (Paris), 171, 395n81, 405n93

expressionism, 104

Facile (Éluard and Ray), 199

Fair Captive, The (novel and film), xxxii

Famine, La (The Famine) (Magritte), 312, CP45

Fanatiques, Les (The Fanatics) (Magritte), 276

Fantômas, 22, 43–53, 55–6, 57, 58, 75, 116, 132, 141, 159, 161, 217, 291, 305, 372n72, 374n35, 374n38, 385–6n3, CP15

Fantômas (film), 49, 52, 149, *150*
Fantômas (Gris), 45, *45*
Fantômas (Tanguy), 45
fascism, xxix, 161, 251, 261, 281, 283, 288
Faux Miroir, Le (False Mirror) (Magritte), xxxiii, 144
Fée ignorante, La (The Ignorant Fairy) (Magritte), 289, *289*
Female Eunuch, The (Greer), 247
Femme au corbeau, La (The River) (Borzage), 143
Femme ayant une rose à la place du coeur, La (The Woman with a Rose Instead of a Heart) (Magritte), 118
Femme cachée, La (The Hidden Woman) (Magritte), 168–73, *169*, 202, 392n28, CP26
Femme du soldat, La (The Soldier's Wife) (Magritte), 62, 289
Femme introuvable, La (Magritte), 382n40
Femmes (Women) (Magritte), 105, *108*, 109
Femme voilée, La (The Veiled Woman) (Magritte), *see Histoire centrale, L'*
Fenêtre, La (The Window) (Magritte), 107, 118, 123, 385n14
Festival Mondial du Film et des Beaux-Arts Bruxelles, 122
Feuillade, Louis, 49–54, 149, 228, 240, 376n65
Feu souterrain, Le (Magritte), 400n4
Fidelité des images, La (The Faithfulness of Images) (Magritte), xxxi
"Fil d'Ariane, Le" ("Ariadne's Thread") (Magritte), 198
Fils de l'homme, Le (The Son of Man) (Magritte), xxxii, 322–3
Fissure, La (Magritte), 244, 307, 404n71
Flag (Johns), 168
Flair magazine, 410n24
Flaubert, Gustave, 73
Flesh (film), 98
Fleurs de l'abîme, Les (Magritte), 381–2n37
Fleurs du mal, Les (Baudelaire), 128, 247
Flora (Titian), 300, 303, 307–9, 409n87, CP41
Flouquet, Pierre, 79–84, 87, 88–92, 101–4, 106, 108, 147, 154, 273, 412n57
Flûte! (Drat It!) (Magritte), 312
Folie des grandeurs, La (Megalomania) (Magritte; painting), 171

Folie des grandeurs, La (Megalomania) (Magritte; sculpture), 337, 338, 414n107
Fontaine de jouvence, La (The Fountain of Youth) (Magritte), 276
Force of Habit (Magritte), 106
Fôret, La (The Forest) (Ernst), 106–7, 300, 301, 408n70
Forgerons, Les (The Blacksmiths) (Magritte), 102, 382n45
forgery, 42, 298–309, 339, 343–5, 408n70, 410n4, 415n120, 415n123
Foton, Louis, 312
Foucault, Michel, xxxii, 136, 189, 226, 267
Fourrier, Marcel, 162, 169, *169*
France:
 leftist politics and, 259–61
 national character of, 178
 in World War II, 280–6
Franco, Francisco, 161
Francquart, Ursule, 4
Franju, Georges, 50
Freud, Sigmund, 33, 132, 164, 170, 195, 245, 391n19
Friedkin, William, 334–5, 413–14n89
Frisque, Victor, 14, 15, 17, 41, 42, 75
From the Earth to the Moon (Verne), 319
Fumière, Camille, 155
Fumière, Germaine, 155
futurism, 68, 70, 92, 104, 105, 108, 113, 253

Gablik, Suzi, 240, 335, 349, 392n27
Gaffé, René, 163, 298
Galerie Allard (Paris), 410n4
Galerie Charpentier (Paris), 97
Galerie de la Vierge Poupine (Brussels), 158
Galerie des Editions de la Boétie (Brussels), 261
Galerie du Faubourg (Paris), 311, 316
Galerie Georges Giroux (Brussels), 104, 107
Galerie Goemans, 158–63, 200
Galerie Iolas (Paris), 399n69
Galerie Le Centaure (Brussels), 98, 99, 109, 133–5, 143, 146–7, 149, 152–3, 159, 163, 200, 371n62, 387n25, 391n16
Galerie L'Époque (Brussels), 153, 327, 391n18
Galerie Maeght (Paris), 296, 311
Galerie Pierre (Paris), 311, 331
Galerie Rive Droite (Paris), 326, 416n139

Galerie Surréaliste (Paris), 176, 178, 183, 385n92

Galet, Le (Magritte), *289, 290*

Gallemaert, Hortensia, 94, 106, 381n19

Gallery of Modern Art (New York), 340

Gance, Abel, 57, 376n65

Garçonne, La (The Bachelor Girl) (Margueritte), 3, 368n1

Gardener Who Saw God, The (James), 233

Gare, La (The Station) (Magritte), 105–6, *105,* 107, 108

Gascoyne, David, 266, 267, 269

Gaspard de la nuit (Gaspard the Nightwalker) (Bertrand), 32, 380n5

Géant, Le (Magritte), *156*

Géante, Le (The Giantess) (Magritte), 210

Genius of Crime, The (Souvestre and Allain), 44

Genre nocturne, Le (The Nocturnal Kind) (Matisse), 177, *177*

Gérard, François, 314

Giacometti, Alberto, 219, 398n53

Gide, André, 48, 283, 285

Gilly, Belgium, 6, 9–10, 12, 34

Giovanelli, Felix, 250

Girafe en feu (Dalí), 384n74

Giraffes on Horseback Salad (Dalí), 160

Giron, Robert, 212, 299–301

Glass Key, The (film), 223–4

Glass Key, The (Hammet), 223, 272

Glaube (Walden), 91

Gleizes, Albert, 83, 92

Goemans, Camille, 125–6, 131, 132, 138, 153, 157–64, *158,* 168, 169, *169,* 174, 176–83, 192, 194, 196, 201, 300, 310, 313, 345, 381n31, 390–1n7, 391n11, 391n16, 391n18, 394n69, 399n73

Goethe, Johann Wolfgang von, 79, 112, 397n44

Goffin, Jules, 42

Golconde (Golconda) (Magritte), xxvii, *xxviii,* 397n34

"Gold-Bug, The" (Poe), 31–2, 237

Goossens, Jacques, 46, 76, 79

Goris, Jan Albert, 323, 411n40

Goris, Madeleine, 411n40

Gorky, Arshile, 52

Grâces naturelles, Les (The Natural Graces) (Magritte), 337, 377n8

Gramsci, Antonio, 258

Grand Déjeuner, Le (The Big Lunch) (Léger), 109, 383n66

Grande Air, Le (Magritte), 373n16

Grande Famille, La (The Great Family) (Magritte), 337, 373n16, CP49

Grande Guerre, La (The Great War) (Magritte), xxx, xxxii

Grande Nouvelle, La (Sensational News) (Magritte), 32, 38

Grandes Baigneuses, Les (Renoir), 290–1, 385–6n3

Grand Masturbateur, Le (Dalí), 205

Grand Matin, La (The Early Morning) (Magritte), 220–1, 398n57

Grands Voyages, Les (Magritte), 100, 250, 402n43

Graverol, Jane, 327, 328

Gravitation universelle, La (Magritte), *186,* 187–8, 394n66

Greer, Germaine, 247

Grelots roses, ciel en lambeaux (Magritte), 396n20

Griffith, D. W., 57, 376n65

Gris, Juan, 45, 300, 303

Groupe silencieux, Le (Magritte), 381–2n37, 387n40

Guerlac, Suzanne, 228

Guernica (Picasso), 259

Guggenheim, Peggy, 94, 167, 255, 283, 334, 337

Guggenheim Museum (New York), 341

Guston, Philip, 410n16

Habitants du fleuve, Les (Magritte), 387n38

Hals, Frans, 81

Hammet, Dashiell, 223, 237, 272

Hamoir, Irène, 22, 31, 64, 66, 157–8, 196, 208, 225, 249, 273, 282, 284–5, 328, 329, 345, 348, 377n15, 399n79, 405–6n8

Hathaway, Henry, 376n65, 386n6

Havel, Vável, 258

Healey, Denis, 208

Hegel, Georg Wilhelm Friedrich, 195, 241, 251

Heidegger, Martin, 188, 346, 394n67

Hirst, Damien, 350

Histoire centrale, L' (Magritte), 28, 381–2n37, CP5

Histoire de l'oeil (Bataille), 71
Histoire de ne pas rire (Nougé), 327
Histoires extraordinaires (Poe), 32, 47, 188
Hitchcock, Alfred, xxxii, 52, 55–6, 240, 376n67
Hitler, Adolf, 161, 251, 253, 281, *281*
Hobbema, Meindert, 300, 306
Hodes, Barnet, 331, 413n81
Hodes, Eleanor, 413n82
Holmes, Richard, 34–5
Hommage à Pascal (Magritte), 52
Homme au journal, L' (Man with a Newspaper) (Derain), 123, 386n14, 394n73
Homme blanc, L' (Man in White) (Magritte), 123, 386n14
Homme célèbre, L' (The Famous Man) (Magritte), 32–3
Homme du large, L' (film), 164, 374n45
Homme du large, L' (The Man from the Sea) (Magritte), 37, 48, 53, 132, 375n55, 381–2n37, CP11
Homme et la nuit, L' (Magritte), 377n8
Hoyez-Berger, Pierre, 62, 209, 282
Hugnet, Georges, 195
Hugo Gallery (New York), 317, 324
Huygens, Leon, 69
Huysmans, J.-K., 87

Île au trésor, L' (Treasure Island) (Magritte), 62
Illumination, L' (Magritte), 279
Il ne parle pas (He Is Not Talking) (Magritte), 125, 371n62, 386n18
Image en soi, L' (The Image in Itself) (Magritte), 171–2, *171*
Images défendues, Les (Nougé), 145, 175, 195, 202, 204, 217, 219, 236–7, 375–6n63, 398n53, 404n82, 408n54
Impatients, Les (Magritte), 394n68
Impressionism, 290–1, 296, 297, 314
Imprudent, L' (Foolhardy) (Magritte), 143
Ingénue, L' (Magritte), 409n74
Ingres, Jean-Auguste-Dominique, 112, 291, 296, 314, 348
Inhumaine, L' (L'Herbier), 43, 374n45
In Memoriam Mack Sennett (Magritte), 205, 246, 281, 402n33
Inondation, L' (The Flood) (Magritte), 28, 394n68, CP6

Inscriptions (Scutenaire), 8–9
Intelligence, L' (Intelligence) (Magritte), 262
International Surrealist Exhibition, xxix, 234, 265, 266, 295, 400n4
Interpretation of Dreams, The (Freud), 391n19
Intervention surréaliste, 195, 398n53, 404n71
Introduction to the Method of Leonardo da Vinci (Valéry), 226–7
Invention du feu, L' (Magritte), 69
Iolas, Alexander, xxxiii, 247–8, 257, 316–18, 323–6, 330, 331, 337, 339, 350, 381n31, 410–11n28, 410n23, 410n26, 411n29, 414n107
Iolas Gallery (New York), 289, 316, 415n114
Israel Museum, 340
Ithyphallic firefighter drawing (Magritte), 306, *306*

Jackie (RM's dog), xxxi, 285
Jacob, Max, 44
James, Edward, 62, 227, 233–6, *236*, 238, 239, 269–70, 273, 276, 282, 283, 286, 398n59, 400–1n6, 400n1, 401n16, 402n31
Jameson, Fredric, 247
Janis, Sidney, 166–7, 325
Janlet, Max, 299, 300
Janlet, Pierre, 163, 164, 166, 386n20, 391n18
Jean, Marcel, 294
Jean-Marie (Magritte), 312, 410n11
Je ne vois par la (femme) cachée dans la forêt (Magritte), 168–70, *169*
Jennings, Humphrey, 200, 238, 269, 396n19
Jesus Christus (Max), 101, CP23
Jette-Sainte-Pierre, Belgium, 35, 60, 208, 319, 380n8
Jeune Fille (Girl) (Magritte), 105, 107–9, *107*
Jeune Fille mangeant un oiseau (Magritte), 188, CP28
Jeunesse (Youth) (Magritte), 303
Jeunesse illustrée, La (Youth Illustrated) (Magritte), 41, 210, 234, 237, 239, 276, CP13
Jewish Cemetery, The (van Ruysdael), 112

Jockey perdu, Le (The Lost Jockey) (Magritte), 107, 115, 125–6, *127*, 386n20

Joconde, La (Mona Lisa) (Magritte), 337, 339, *339*, 414n107

Johns, Jasper, xxxiii, 167, 168, 325, 326, 392n26, 412n56

Joueur secret, Le (The Secret Player) (Magritte), 147–8, 151, 200

Journal des Poètes, Le, 90

Journal intime (Private Diary) (Magritte), 320–1, *321*

Jours gigantesques, Les (The Titanic Days) (Magritte), 152, *152*, 239, 381–2n37, 390n87, 394n68

Julien Levy Gallery (New York), xxix, 189, 198

Juranville, Clarisse, 151–3

Kafka, Franz, 44, 96, 102, 117, 141, 142, 149, 185, 220–3, 274, 290, 384n75, 394n63

Kamagraphie, 413n86

Kandinsky, Wassily, 97

Kant, Emmanuel, 114, 237

Keaton, Buster, 57, 274, 314

Kerels, Henri, 79

Kid, The (film), 226

Klee, Paul, 97, 113, 126, 300, 301, *302*, 303, 344

Koestler, Arthur, 282

Kokkelkoren, Arthur, 70

Koons, Jeff, xxxiii, 322, 326–7, 350

Lady Vanishes, The (film), 56, *56*

La Fleur en Papier Doré gallery (Brussels), 97, 98, 306, *307*

Lang, Fritz, 52, 57, 58, 87, 148, 223, 290, 376n65, 376n67, 398n59

Langdon, Harry, 55

Large Glass, The (Duchamp), 324

Larmes d'éros, Les (Batailles), 71

Last Gangster, The (film), 227

Last Supper, The (Leonardo da Vinci), 348, 349, 416n142

Laurel and Hardy, 55, 314

Lautréamont, Comte de (Isidore Ducasse), xxxii, 129–31, 189, 195, 262, 387n32, 408n59

Lawrence, D. H., 88

League of Frightened Men, The (Stout), 8, 287

Lecomte, Marcel, 38, 48, *90*, 104, 112, 123, 138, 153, 157, 158, 159, 208, 225, 272, 279, 291, 375n55, 399n69

Leçon de politesse, La (Lesson in Politeness) (Magritte), 276

Lectrice soumise, La (Magritte), 394n68

Lecture défendue, La (Magritte), 65

Ledel, Dolf, 79

Légende des guitares, La (Magritte), 387n40, 392n28

Léger, Fernand, 109, 383n66

Legge, Rupert, 267

Legge, Sheila, 265–70, *265*, 273, 405n91

Leiris, Louise, 301

Leiris, Michel, 301, 328, 337

Lemereur, Émile, 16–17

Lenin, Vladimir, 195, 241, 249, 254, 328, 401n25

Lennon, John, xxxiii

Leonardo da Vinci, 236, 348, 349, 416n142

Leroux, Arnould (Nounoul), 21, 26–7

Les Auteurs Associés publishers, 298

Lessines, Belgium, xxviii, 9, 12, 34

L'Étoile Scellée gallery, 301

Let Us Now Praise Famous Men (Agee and Evans), *244*, 245

Lèvres Nues, Les (Naked Lips) (magazine), 328

Levy, Julien, 212, 220, 413n82; *see also* Julien Levy Gallery

Leys, Simon, 103–4, 382n53

L'Herbier, Marcel, 43, 57, 164, 374n45, 376n65, 376n67

Lhote, André, 92

Liaisons dangereuses, Les (Magritte), *278*, 279

Liberté de l'esprit (Freedom of Mind) (Magritte), xxxiii

Liberté des cultes, La (Freedom of Worship) (Magritte), 295, *295*

Libre Académie de Belgique, 346, 347

Lichtenstein, Roy, 325

Lieberman, William, 413n82

"Lifeline" ("La Ligne de vie") (Magritte), 12, 36–7, 67, 95, 98, 103, 113, 114, 116, 120, 123, 125, 150, 166, 190, 213, 225, 249–56, 259, 336–7, 402–3n45, 402n42, 403n54

Linder, Max, 55
Locomotive, The (Magritte), 108
Loi de la pesanteur, La (Magritte), 392n28, 411n47
Lola de Valence (Magritte), 312
London Bulletin, 200, 255
London Gallery, 259, 266, 267, 269, 325, 405n93, 412n58
Loren, Sophia, 131
Loulou (RM's dog), xxxi, 96, 97, 98, 156, 182
Louvre (Paris), 112, 236, 291, 308
Lumière du pôle, La (Polar Light) (Magritte), 131–2, *132*, 387n38
Lunette d'approche, La (The Field Glass) (Magritte), 337, CP48
Lynch, David, xxxii

M (film), 58
Madame Edwarda (Bataille), 71, *207*, 208, 306, 396n31
Madame Edwarda drawings (Magritte), *207*
Madame Récamier de David (Magritte), 337, *338*
Maes, Karel, 88–9, 104, 105–6
Mafarka Le Futuriste (Marinetti), 70, 378n33
Magie blanche, La (White Magic) (Magritte), 199, *199*
Magritte (Magritte), 298
Magritte, Adeline Isabelle Régina Bertinchamps, xxx, 6, 9, 12–14, 19–22, 25–30, 67, 86, 90
Magritte, Albert-Joseph, 5–6
Magritte, Aline, 5
Magritte, Arlette, 25
Magritte, Elizabeth van de Gevel (Betty), 25, 67, *146*, 209, 303
Magritte, Fernand Albert Ghislain, 10
Magritte, Flora Théophénie Marie Ghislaine, 6–7, 67, 369n11
Magritte, Georgette Marie Florence Berger:
 affair with Colinet, 271–4, 289, 405n1
 appearance of, 67
 Arp and, 127
 Breton and, 193–4
 character of, 63, 64
 Dalí and, 181–2
 death of, xxxiii, 303, 351
 dogs and, 96–8
 employment of, 61–3
 family of, 61–2, 67
 health of, 285, 407n32
 marriage of, xxviii, xxxi, 61, 63–7, 84–5, 86, 107, 233, 237, 265, 268, 269, 270, 280, 350–1
 miscarriage of, 64, 377n17
 in Paris, 153, 154–7, 179, 192, 201–2
 photographs of, *65, 68, 90,* 125, *145, 146, 156, 196, 272*
 RM's art and, xxix, 30, 64, 124, *124,* 170, 200, 213, 236, 289, 290, 300–1, 303, 305, 310, 313, 335–6, 378n21, 393n55, 407n42, 415n121
 RM's courtship of, 58–61, 73, 82, 83, 84
 RM's mother's suicide and, 20, 22, 25, 27, 371–2n67
 RM's treatment of, 89–90, 343, 347–8
 singing lessons of, 107
 travels with RM, 340–1, 348
 during World War II, 282, 283–5
Magritte, Jean-Baptiste, 5
Magritte, Joséphina Vandaelem, 25
Magritte, Léopold François Ghislain, 6, 9–14, 18, 19–22, 27, 42, 47, 58, 60–1, 64, 71–3, 84, 85–6, 90, 94, 127, 338
Magritte, Louis-Joseph, 5
Magritte, Marie Françoise Rose, 6
Magritte, Martin, 5
Magritte, Nicolas Joseph Ghislain, 6
Magritte, ou la leçon des choses (Magritte, or the Lesson of Things) (documentary), xxxi
Magritte, Paul Alphonse Ghislain (Popol), xxx, 7, 10, 18, 19, 20, 22–5, 64, 67, 73, 83, 94, 107, 124, 125, 156, 209, 279, 303, 313, 343–4, 371n57, 390–1n7, 399n73
Magritte, Pierre, 4
Magritte, Raymond Firmin Ghislain, 10, 19, 25, 61, 67, 71–4, 86, 100, 209, 371n60, 371n62, 386n18
Magritte, René:
 alcohol use and, 19
 ambition of, 101, 103, 128
 American interest in, 323, 325–6, 337, 339–40
 appearance of, xxx

Magritte, René (continued):
 artistic associates of, xxix, 75–6, 79–81,
 104, 108, 153, 176, 192, 195–6, 238,
 253, 274, 284–5, 293, 304, 315–16,
 327–30, 328, 347, 392n32
 artistic identity of, 102–17, 128, 183
 artistic philosophy of, xxxii, 139–40,
 255–7, 259, 312, 324, 335, 346–7
 artistic process of, 37–8, 102–3, 115–16,
 119–20, 175, 185–8, 212–17, 220–3,
 231–2, 253, 279–80, 286, 350,
 397–8n47
 art supplies used by, 62, 81, 85, 332
 art training of, 40–2, 70, 75–81, 101
 auction of studio contents, 301
 authentication of paintings by, 65–6, 101,
 378n21
 birth of, xxviii, 9
 book illustrations by, 118–19, 130, 130,
 151, 195, 199, 206–7, 208, 217–19,
 367n9
 casino mural by, 332, 333, 339, 344
 catalogue raisonée of, 42, 64, 74, 101,
 106, 213, 227, 250–1, 268, 303, 308,
 409–10n88, 416n146
 character of, xxviii, xxx–xxxi, 16–17, 76,
 92, 101, 180, 234
 childhood of, 9, 11, 14–21, 40, 67–71
 collaborations with, 105–7, 271, 274–9,
 316–17, 328, 330
 collectors of works by, xxviii–xxix,
 xxxiii, 25, 62, 94, 99, 100, 107, 124,
 144, 166, 176, 196, 209, 210, 211, 322,
 323, 325, 326, 331, 392n26, 392n28,
 396n18, 397n41, 400n1, 407n43,
 410–11n28
 commercial artwork of, xxx, xxxiii, 23,
 23, 74–5, 99, 101, 121–5, 121, 122,
 124, 126, 131–3, 134, 209–10, 212
 courtship of Georgette by, 59–61, 82
 cut-up canvases by, 200–1, 202, 204–5,
 204, 289, 396n20
 death of, xxx, 27, 300, 350–1, 412n67
 detective stories and, 7–8, 28–9
 dogs and, xxviii, xxxi, 63, 96–7, 98, 156,
 182, 269, 280, 285
 dreams and, xxxiii, 31, 34–5, 37, 47
 early works of, 41–3, 47–8, 74, 75, 77, 83,
 107, 123, 125, 374n32, 409n74
 education of, 14, 19, 22, 58, 69–70, 77–81

 employment of, 84–5, 120–3, 154, 376n4,
 390n1
 erotic interests of, 67–75, 77, 78, 170,
 272–3, 279
 exhibitions by, xxix, 42, 61, 81–2, 91–2,
 133–5, 146–53, 159, 161, 162, 166–7,
 171, 189, 200–1, 203, 205–8, 234, 241,
 261–3, 281, 296, 310–11, 316, 317,
 323, 324, 325–6, 339–40, 387n25,
 396n23, 399n69, 400n4, 405n93,
 411n42, 414–15n111, 416n139
 family of, 3–30, 85
 Fantômas and, 44–9, 53, 55–6, 372n72
 films as interest of, xxxi, 43, 49, 52–8, 87,
 156, 348–9, 375n60, 376n65, 376n69,
 398n56
 films by, xxxi, 279, 329–30
 finances of, 98–101, 122–3, 134, 201, 210,
 212, 258, 259, 269–70, 323, 341–3,
 347, 414n101
 forgery and, 298–309, 339, 343–5,
 409–10n88, 415n120, 415n123
 friendships of, xxix, 14, 15, 18, 43, 66,
 80, 88–92, 327–30, 412n57
 gallery representation of, 98, 159, 162–4,
 183, 310–11, 325, 391n16
 health of, 74, 75, 78, 258, 341, 348,
 350–1, 379n48, 416n141, 416n147
 home design and, 341, 347, 415n117
 honors received by, 346
 humor of, 7–8, 16, 18–19, 24, 94, 95, 98,
 106–7, 180, 239–40, 274, 314, 329,
 383n61
 images used by
 animals, 96
 apples, xxxiii, 322
 balloons, 31, 33–5, 37, 38, 39, 40, 43,
 47–8
 bowler hats, xxvii, xxx, 10, 45, 49, 326,
 370n52, 389n67
 boxlike objects, 28, 31–4, 319, 323
 cages, 213, 223
 cannons, 50, 99, 194–5, 200, 201, 228,
 245
 doors/keyholes, 217, 220–3, 336–7
 doubles, 141–3, 148, 389n67
 eggs, 213, 279
 feet/shoes, 238, 244–7
 fog/mist, 335
 glass of water, 240–1

jockeys, 126
pipes, 188–90, 226, 240, 295
roses, 118–20, 214–17, 316, 398n49
sky/ceilings, 35–7, 248
sources of, 37–41, 104, 125, 189, 232
stones, 322, 323
tubas, 28
influence of, xxvii, xxxiii, 153, 325–6, 340
influences on, 109, 110–17, 141, 143–5, 227–8, 400n86, 407n46
in Jette, 35, 60, 208–9
marriage of, xxviii, 61, 63–7, 84–5, 89–90, 107, 265, 269–70, 271–80, 283–5, 289
military service of, 60, 77, 82–4, 87, 273, 281, 407n41
mother's suicide and, 21–2, 25–30, 370n52, 371n65
papiers collé by, 123–4, 133, 147, 162, 386n15, 387n40
in Paris, xxviii, 24, 98, 104, 124, 135, 153, 154–64, 179, 182–3, 192, 193–4, 200–2, 310
patrons of, 62, 94, 212, 233–8, 269–70, 273, 287
pessimism of, 141, 258–9, 286, 319
photographs of, ii, xxxi, xxxiv, 45, 49, 63, 65, 90, 93, 125, 145, 146, 155, 169, 196, 196–7, 201, 205, 272, 333, 349
photography by, xxxi, 65, 156, 156, 157, 202, 281
politics of, xxix, 64, 173–6, 183, 239, 248–64, 288, 388n43, 404n72
portraits of, 82, CP20
as poster designer, xxx, 74–5, 79, 106, 120, 124–5, 155, 209, 264, 281, 281, 374n34
problem painting by, 212–19, 228
productivity of, xxxii, 101, 118, 122, 133–5, 162, 164, 183, 202, 208, 212, 330
reading habits of, 28, 48, 87–8, 101, 114, 129, 237, 246, 267, 280, 369n27, 372n7, 389n71, 398n60, 400n86, 401n12
relationship with Sheila Legge, 265–70, 273, 405n91, 405n93
religion and, 8, 14, 17–18, 70, 90, 111, 180, 254, 323

replicas produced by, 317, 331–4, 339, 410n26, 413n86, CP43
reputation of, 128, 136, 145, 150, 202, 239–40, 286, 310, 323, 346, 347
retrospectives of works of, xxix–xxx, 95, 115, 151, 330, 339–40, 346, 377n9
rift with Breton and Éluard, 193–200, 221
sales of paintings by, 98–100, 107, 159, 163, 164, 166–7, 189, 200, 201–2, 211–12, 220, 311, 316, 317, 318, 337, 342, 343, 397n41, 411n47
sculptures by, 337–9, 350
as stage designer, 91
on success, 347–8
"sunlit" period of, xxix, 290–8, 311, 314, 403–4n68
as surrealist, xxvii–xxviii, xxxiv, 57, 91, 99, 110, 119, 129, 172–83, 192, 194–6, 201, 208, 250, 252–3, 291–8, 311–13, 327–8, 330, 340, 344, 403–4n68, 404n74, 416n129
themes used by
 eroticism, 68–70, 78, 108, 109
 metamorphosis, 139–40, 320
 mystery, xxx, xxxiv, 29–30, 31, 32, 53–4, 114, 119, 143, 323, 345, 372n2
titles for paintings by, 40, 116, 144, 145, 185, 202–3, 212, 223–32, 236, 240, 244, 276, 279, 286, 287, 329, 385–6n3, 399n72, 402n33
travels abroad by, 340–1, 348
vache paintings of, 41, 274, 311–14, 316, 326, 329, 405n4, 410n16
Walloon culture and, xxix, 7, 111, 182, 288, 311, 313
word paintings by, 164–70, 165, 181, 181, 183, 188–92, 202, 288
work habits of, xxviii, 350
World War II and, xxix, 281–5, 288, 310
writing by, xxxii, 144, 190–2, 198–9, 202, 249, 330–1, 345–6; see also "Lifeline"
Magritte ou la leçon des choses (documentary), 157, 167–8
Magritte: The Middle Class Magician (documentary), xxxi
Magritte: Word vs Image exhibition, 166–8, 189, 325
Mahy, Élise, 370n31

Main heureuse, La (The Happy Hand)
 (Magritte), 214, *215*
Maison Berger, 62
Makhokhian, Vartan, 37
Mal du pays, Le (Homesickness)
 (Magritte), 286–7, 335, CP38
Malet, Léo, 260, 272
Malheurs des immortels, Les (Éluard),
 386n13
Manet, Edouard, 312, 314, 316, 317, 319,
 348
Manifesto of Surrealism, The, 115, 161
Margueritte, Hubert, 4
Margueritte, Jean-Auguste, 3, 4
Margueritte, Jean-Baptiste, 4
Margueritte, Paul, 3
Margueritte, Victor, 3
Marie (review), 53, *53,* 128, 140
Mariën, Marcel, xxix, 7, 15, 28–9, 112, 118,
 225, 227, 237, 249–51, 263, 264–5,
 271–4, 285, 288, 291, 293, 298–308,
 314, 315–16, 324, 327–8, 330, 343–5,
 347, 371n58, 388n50, 402n33, 405n2,
 409n86, 412n69, 415n120, 416n125
"Marie Trombone Chapeau Buse," 23, *23,*
 279, 371n55
Marinetti, F. T., 70, 92
Marion, Denis, 100, 209
Marlier, Georges, 45
Marx, Karl, 137, 195, 239, 241, 249, 255,
 256, 262
Marx Brothers, 54, 160
Matière et mémoire (Bergson), 228
Matisse, Henri, 92, 300, 301, 312, 336
Matta, Roberto, 238, 323, 331, 411n42,
 413n82
Maupassant, Guy de, 74
McCartney, Linda, xxxiii
McCartney, Paul, xxxiii
Mélancolie d'une belle après-midi
 (Melancholy on a Beautiful Day) (de
 Chirico), 114, 115
Méliès, George, 319
Melly, George, xxxi, 8, 97, 98, 235, 248,
 268, 270
Melville, Herman, 136, 386n20
Mémoire, La (Memory) (Magritte), 115,
 286, 287, CP40
Menottes de cuivre, Les (The Copper
 Handcuffs) (Magritte), 62, 236

Mesens, Édouard Léon Théodore (E.L.T.),
 91–9, 100–1, 104, 106, 108, 113, 117,
 128, 140, 150, 151, 153, 163, 166–7,
 174, 192, 195–6, 198, 200–2, 210–11,
 234–5, 248, 249, 251, 253, 255, 259,
 260, 266–70, 287, 290, 294, 310,
 324, 325, 381–2n37, 381n24, 383n66,
 385n95, 386n18, 395n11, 396n18,
 405n87, 412n57, 412n58, CP21
Météore, Le (The Meteor) (Magritte), 96
Meuse–La Lanterne, La, 351
Mica Magritte (Cornell), *230*
Michals, Duane, xxxi, 63
Michaux, Henri, xxxiii, 36, 103–4, 111,
 287
Michel, Jacques (Jacques Denis), 293
Might as Well Be Dead (Stout), 7–8, 369n14
Milhaud, Darius, 413n82
Miller, Jonathan, xxxi
Milo, Jean, 99, 100, 135, 388n43
Miró, Joan, 115, 127, 164, 176, 179, 180,
 182, 192, 238, 240, 312
Miroir universel, Le (Magritte), 409n74
Miroir vivant, Le (Magritte), 181, *181,*
 393n58, 396n18, 400n4
Modèle rouge, Le (The Red Model)
 (Magritte), xxvii, 144, 176, 234,
 238–41, 244, 245, 247, 248, 316, 324,
 400n4, 401n16, 401n17, 404n70,
 CP33–5
Modèle vivant, Le (The Living Model)
 (Magritte), 221, 398n57
Moderna Museet (Stockholm), xxx
modernism, xxix, 94, 105, 110, 350
Modigliani, Amedeo, 300
Mois des vendages, Le (The Month of the
 Grape Harvest) (Magritte), 167–8,
 168, 326, 392n26
Moisson, La (The Harvest) (Magritte), 291
Molle, Marie, 72, 378n39
Mona Lisa (Da Vinci), 111, 112, 236
Monde invisible, Le (The Invisible World)
 (Magritte), 336, CP46
Monet, Claude, 112, 324
Monsieur Teste (Valéry), 137, 142, 153, 231,
 387n35, 388–9n62, 389n67
Montagnard, Le (The Mountain Dweller)
 (Magritte), 312
Montald, Constant, 77, 80
Moore, Henry, 238

Moralité du sommeil (Éluard), 199
Morot, Aimé, 3
Mort qui tue, Le (film), 49, 52, 149
Mots et les choses, Les (The Order of Things) (Foucault), 189
"Mots et les images, Les" (Magritte), 190–2, *191*, 202, 394n78
Mouvement perpétual, Le (Perpetual Motion) (Magritte), 198
"Murders in the Rue Morgue, The" (Poe), 136, 143
Muscles célestes, Les (The Muscles of the Sky) (Magritte), 36, 100
Musée des Beaux-Arts (Brussels), 41, 157, 305
Musée des Beaux-Arts (Liège), 330
Musée d'une nuit, La (Magritte), 381–2n37, 389n72
Museum of Modern Art (New York), xxix, 115, 151, 339–40, 346, 391n23, 414–15n111
"Music Is Dangerous" (Nougé), 137–8
Musidora, 51, *51*, 375n51, 375n52
Mystère et mélancolie de la rue (de Chirico), 385n92
Mysterious Suspicion, The: After Magritte, October 1974 (Caulfield), 160, *160*
"Mystery of the Ordinary, The" exhibition, 151

Nadja (Breton), 170–1, 385n97
Naissent en Hiver, Les . . . (Magritte), 201, *201*
Nécessités de la vie ou les conséquences des rêves, Les (Éluard), 199
Negotiable Space I (Stezaker), *231*
Nellens, Gustave, 332, 339, 413n79, 413n85
Newman, Barnett, 292
Nietzsche, Friedrich, 101, 117, 175, 226, 249, 254, 264, 270, 382n41, 385n101
Nisolle, Albert, 21, 27, 370n50
Nisolle, Marie, 14, 90, 370n31
Nisolle, Placide, 12
Nocturne (Magritte), 105, 124, 392n28, 409n74
Nonkels, Jacqueline, *see* Delcourt-Nonkels, Jacqueline
"Norine Blues," 22–3, *23*, 107, 371n55
Norine Blues (Brélia), 122

Norine fashion house, xxviii, 91, 122, *122*, 125, *126*, 131, CP25
"Notes on Chess" (Nougé), 136–7
"Notes on Fantômas" (Magritte), 48
Nougé, Marthe, *146*
Nougé, Paul:
 abortions and, 377n17
 artistic philosophy of, 130–1, 140–1, 155, 198, 232, 247, 264, 266, 388–9n62, 402n36
 as collector of RM's work, 100, 386n16
 as *Distances* editor, 164
 employment of, 158
 erotic works of, 71
 film and, 57
 identity of, 389n68, 390n90
 influence of, 388n50, 389n65
 personal problems of, 140, 293–4, 327, 412n67
 photographs of, *145*, *146*, *156*, 169, *169*, 195–6, *196*, 205
 politics of, 259–60, 281, 288, 327
 postcards of, 389n76
 reading recommended by, 87, 280
 relationship with RM, xxix, 32, 136–53, 157, 202, 253, 304, 330, 371n58
 on RM's art, 37, 50, 96, 130, 132–3, 166, 185, 187, 203, 204–5, 213, 240, 241, 245, 314
 RM's financial straits and, 99, 162
 Scutenaire and, 388n46
 as surrealist, 174–8, 183–8, 190, 201, 261, 263, 274, 288, 291–4, 315, 324, 328
 titles of RM's works and, 62, 124, 202, 217, 225–7, 229, 244, 249, 385n3
 written works of, 129, 204, 236, 327, 388n50
Nougé, Reine Leysen, 407n42, 412n67
Nourriture de l'ennemi, La (Magritte), 371n62
Nouvelle Médication naturelle, La (Bilz), 189
"Nude by a Stream" (Magritte), 409n74

Objets familiers, Les (Magritte), 159–60, *159*, 390n6
Odyssey (Homer), 12, 369n27
Oiseau de Ciel (Sky Bird) (Magritte), xxxiii

Ombre et son ombre, L' (Nougé), 65
Oneirocritica (Artemidorus), 164
Ono, Yoko, xxxiii
Origine du monde, L' (Courbet), 300
Origines du langage, Les (The Origins of
 Language) (Magritte), 276
Other Inquisitions (Borges), 280
Ozenfant, Amédée, 109

Pabst, G. W., 57, 376n65
Palais de rideaux, Le (Magritte), 391n23
Palais des Beaux-Arts (Brussels), 95, 151,
 189, 205–8, 210, 212, 241, 281, 299,
 300, 334
Panique au moyen âge (Panic in the Middle
 Ages) (Magritte), 205
Pansaers, Clément, 153
Parfum de l'abîme, Le (Magritte), 392n28
Paridant, Valentine, 212
Paris, France:
 art scene in, 92, 93, 101, 113, 155, 178
 Belgians and, 178, 183
 foreign accents in, 182
 surrealists in, 110, 171, 180, 189, 196,
 210, 311, 313
"Paris en 1930" collage (Magritte), 392n28
"Parisian Cubism" exhibition, 101–2, 113
Parure de l'orage, La (Magritte), 389n72
Pascal, Blaise, 67, 128, 129, 130
Pas perdus, Les (Breton), 384–5n92
Paulhan, Jean, 71, 138, 204, 214, 283
Paulus, Pierre, 74
Pauwels, Willem (Wilchar), 404n72
Paysage de Baucis, Le (Baucis's Landscape)
 (Magritte), 224–5
Paysages campagnards avec chaumières
 (Magritte), 373n29
Paysan de Paris, Le (Aragon), 170
Peeters, Eliane, 289, 407n42
"Peinture au défi, La" (Aragon), 161–2
"Pêle-Mêle de Scutenaire, Le"
 (photomontage), 195–6, 196
Pèlerin, Le (The Pilgrim) (Magritte),
 224–5
Penrose, Roland, 266, 282, 283, 382n50,
 393n55, 412n58, 413n82
Pensées, The (Pascal), 67, 128–9
Perelman, Chaim, 388n49
Péret, Benjamin, 176
Perspective amoureuse, La (Magritte), 220

Perspective: Le Balcon de Manet
 (Perspective: Manet's Balcony)
 (Magritte), 315, 316, 317, 410n23,
 410n26
Perspective: Madame Récamier de David
 (Magritte), 314
Perspective: Madame Récamier de Gérard
 (Magritte), 314
Peter Ibbetson (film), 119, 376n65, 385n6
Peters, Ruth, 211
Peters-Lacroix, xxx, 84, 109, 121, 376n4
Petite anthologie poétique du surréalisme
 (Hugnet), 195
Pétrus, Raymond, 11, 15, 16–17, 20, 22,
 42–3, 71, 74
Peu de l'âme des bandits, Un (A Little of
 the Outlaws' Souls) (Magritte), 40,
 373n24, CP12
Philosophie dans le boudoir, La
 (Philosophy in the Boudoir)
 (Magritte), 245–6, 246, 402n33
Picabia, Francis, 93, 111, 225, 294, 384n73
Picasso (Cocteau), 380n4
Picasso, Pablo, 44, 123, 170, 175, 263,
 298, 300, 301, 302, 305, 318, 344,
 383n68
Place au soleil, La (The Place in the Sun)
 (Magritte), 221, 398n57
plagiarism, 129, 130–1, 147, 189, 384n74
Plaisir, Le (Pleasure) (Magritte), see Jeune
 Fille mangeant un oiseau
Ployardt, John, 323, 411n43
Poe, Edgar Allan, xxxii, 31–2, 47, 58,
 136, 142–3, 145, 179, 188, 216, 225,
 237, 249, 372n4, 388–9n62, 389n68,
 397–8n47
Poésies (Lautréamont), 129, 130, 408n59
Point de vue (Magritte), 391n18
Ponge, Francis, 137
Pont-à-Celles, Belgium, 4–6
Pont d'Héraclite, Le (Magritte), 210, 211,
 335
Ponti, Carlo, 131
pop art, 325, 326
Portrait, Le (Magritte), 396n19
Portrait de E. L. T. Mesens (Magritte),
 95–6, CP21
Portrait de Paul Nougé (Magritte), 141–2,
 142
Portrait du chevalier X (Derain), see
 Homme au journal, L'

Portrait of Arlette Magritte (Magritte), 371n62

Portrait of Eliane Peeters (Magritte), 407n42

Portrait of Georges Eekhoud (Magritte), 80, CP19

Portrait of Georgette Magritte (Magritte), 407n42

Portrait of Jacqueline Nonkels (Magritte), 407n42

Portrait of Magritte (Flouquet), 82, CP20

Position politique du surréalisme (Breton), 259

postcards, 37, 41, 71, 95, 101, 112, 113, 116, 214, 291, 389n76

posters, xxx, 43, *44*, 74–5, *75*, 77, 79, 107, 120, 123–5, 131, 209, 264, 374n34, 385–6n3

Prester John (Buchan), 203

Prévert, Jacques, 50

Primavera (Botticelli), 112–13

Prince des objets, Le (Magritte), *184*, 393n61

Principe de plaisir, Le (The Pleasure Principle) (Magritte), 276, 277

Pringels, Léon, 75–9, 81, 89, 101, 106, 379n52

Proust, Marcel, 228, 231

Psyché (magazine), 122, *122*

Puel, Gaston, 214, 328, 397n46

purism, 109, 253

Purnal, Suzanne, 100, 212

Quatre Cents Coups, Les (film), 55

Quelques airs de Clarisse Juranville mis au jour par André Souris (Souris), 151–2

Quelques écrits et quelques dessins (Juranville), 151

Queneau, Raymond, 45, 384n92

Quinet, Fernand, 107, 122, 386n16

Race blanche, La (The White Race) (Magritte), 337

Radcliffe, Ann, 119–20, 386n7

Radeau de la Mémoire, Le (The Raft of Memory) (Mariën), 343, 415n121

Raminagrobis (RM's cat), 285, *286*, 407n34

Rapin, Maurice, 121, 210, 241, *243*, 258, 297, 330, 346

Rauschenberg, Robert, xxxiii, 168, 325, 326, 392n26, 392n27, 412n56

Ravel, Maurice, 32, 372n5

Ray, Man, xxxi, 45, 93, 113, 169, 174, 195, 198, 199, 267, 323, 411n42, 413n82

Raynal, Maurice, 44, 409n77

Read, Herbert, 413n82

Récital, Le (Magritte), 106

Reconnaissance infinie, La (Reconnaissance Without End) (Magritte), 274–6, *275*

Reconstruction (journal), 91

Recontre, ou Bonjour Monsieur Courbet, La (Courbet), 291, 385–6n3

Reed, Carol, 57, 376n65

Reine Sémiramis, La (Magritte), *157*

Rencontre, La (Magritte), 381–2n37

"Rendez-vous de chasse, Le" ("The Gathering of the Hunt"), 196, *197*

"René and Georgette Magritte with Their Dog After the War" (Simon), xxxi, 63, 377n10

"Rene Magritte" (Éluard), 196–9, 395n12

René Magritte (Scutenaire), 26, 251, 367n7

René Magritte, cinéaste (documentary), xxxi

René Magritte Museum (Brussels), 397n37

René Magritte: The Pleasure Principle exhibition, 208

Renoir, Auguste, xxix, 290–1, 296, 309, 314, 324, 348, 385–6n3, 407n46

Répétitions (Éluard), 123, 386n13

Réponse imprévue, La (The Unexpected Answer) (Magritte), 217, *218*, 274, 398n50

Réponse inattendue, La (Magritte), 398n50

Représentation, La (Magritte), 382n50

Resnais, Alain, 50

Retour de flamme, Le (The Flame Rekindled) (Magritte), 45–6, 118, 375n52, 385–6n3, 398n49, CP16

Réveille-matin, Le (Magritte), 406n13

Reverdy, Pierre, 203–4

Rêveries du promeneur solitaire, Les (The Musings of a Solitary Walker) (Magritte), 21–2, 163, 385n95, CP3

Révolution, La (Magritte), 212

Révolution surréaliste, La (journal), 113, 149, 168, 169–72, 174, 189, 190, 192, 195, 202, 385n92

Revolver à cheveux blancs, Le (Breton), 195

Rhétorique (review), 330, 413n77
Ribemont-Dessaignes, Georges, 93, 176, 392n41
Richardson, John, 208
Richelet, Fernand, 69–70
Rien qu'un homme (Deauville), 91
Rimbaud, Arthur, 129, 195, 255
Rivière bordée de peupliers (Poplars by a River) (Magritte), 74, 379n47
Rivière sous un ciel nuageux (River with Stormy Sky) (Magritte), 74, 379n47
Robbe-Grillet, Alain, xxxii, 148
Robe d'aventure, La (The Garment of Adventure) (Magritte), 25, 38, 100, 103, 371n62, CP4
Robert, Yves, 57
Robert-Fleury, Tony, 385n2
Roisin, Jacques, 16, 20, 21, 25, 42, 74, 97, 368n5, 369n9
Roman Catholicism, 17–18, 81, 87, 90, 140, 180, 349
Roman populaire, Le (The Novelette) (Magritte), 118, 119, 385n2
Ronde de nuit (Magritte), 389–90n77
Rosenblum, Robert, 189
Roses, Les (Magritte), 59, *60*
Roses de Picardie (Magritte), 383n63
Rothko, Mark, xxxiii, 334
Roughton, Roger, 266
Rousseau, Jean-Jacques, 22, 297, 370n52
Roussel, Raymond, xxxii, 266, 267–8, 368n12
Ruscha, Ed, 326
Russolo, Luigi, 113

Sacrez, François, 9
Sacrez, Paul, 9, 11, 18
Sadoul, Georges, 169, *169*
Saison des voyages, La (Magritte), *184*, 393n61
Salle, David, 323
Salle Giso (Brussels), 150, 396n23
Samuel et Cie., 131, 132–3, *134*, 141, 152–3
Sang du monde, Le (Magritte), 383n63
Sang d'un poète, Le (Cocteau), 287
Sante, Luc, 66, 209, 397n34
Satie, Erik, 93
Savoir vivre, Le (Good Manners), 24, 307
Sazie, Léon, 14

Schaerbeek, Belgium, 61, 79, 86, 101, 319, 341, 351, 378n40
Schopenhauer, Arthur, 223
Schwarzenberg, Walter, 100, 163
Scutenaire, Louis, xxix, xxxi, 6, 8–9, 22, 23, 25–9, 33–4, 40, 64, 66, 68–9, 129–30, 140, 145, 153, 157, 187, 196, 208, 209, 224–5, 247, 251, 253, 273, 274, 282–7, 293, 311–14, 316, 328–30, 344, 347, 350, 368n1, 388n46, 405–6n8
Second Manifesto of Surrealism, The, 174–5, 179, 386n6
Secret Beyond the Door, The (film), 223
Séducteur, Le (The Seducer) (Magritte), 214, *214*
Seghers, Hercules, 319
Seitz, William C., 339–40, 414n109
Sélection (review), 101, 113, 122, 178
Sélection Atelier d'Art Contemporain (gallery), 101
Sennett, Mack, 55
Sens de la nuit, Le (The Meaning of the Night) (Magritte), 132, *132*, 372n71, 387n38
Sens propre, Le (leaflets), 176–7, 394n69
Sens propre, Le (The Literal Meaning) (Magritte), 168, 326, 392n27, 400n4
Servranckx, Victor, 84, 97, 104, 108, 109, 121
Shoes (Van Gogh), 244–5, *244*
Sidney Janis Gallery (New York), 166, 325
Siècle des lumières, Le (The Century of Enlightenment) (Magritte), 399n83
Signes du soir, Les (Magritte), 385n95
Simenon, Georges, 5, 7, 71
Simon, Paul, xxxi, 63, 377n10
Simpsons, The (TV show), xxxii
Six Éléments, Les (The Six Elements) (Magritte), 324, 392n28
Soby, James Thrall, 115, 340, 346, 385n95, 414n110, 415n114
Soeurs Vatard (Huysmans), 87
Sontag, Susan, 136, 226
Sortie de l'école, La (Magritte), 381–2n37
Soulier de satin, Le (Claudel), 389n71
Soupçon mystérieux, Le (Magritte), 159, 160, 390n6
Source, La (Ingres), 112, 291, 314, 385–6n3
Sourires de France, 76, 379n52

Souris, André, 139, 151–3, 174, 194, 195, 196, 380n72
Sous le manteau de Magritte (Mariëns), 305
Souvenir du voyage (Memory of a Journey) (Magritte), 319, *320, 321–2, 336*
Souvestre, Pierre, 44, 49
Spaak, Claude, 100, 195, 210–12, 283, 285, 381–2n37, 397n41, 414n95
Spaak, Paul-Henri, 210
Spaak, Suzanne, 211, 378n25
Spectre, Le (The Specter) (Magritte), 343, *343*
Spleen de Paris, Le (Baudelaire), 88
Stagecoach (film), 54, 375n57
Stallone, Sylvester, 291
Starobinski, Jean, 292
Statue volante, La (Magritte), 385n95
Stendhal, 209–10, 397n39
Stezaker, John, 231, *231*
Stiernon, Joseph, 71
Stimulation objective (Magritte), 400n1
St. John, Al ("Picratt"), 55
Stout, Rex, 7–8, 287, 369n14
Stropiat, Le (The Cripple) (Magritte), 312, 313
Studio Dongo, xxx, 209, 212
Sturges, John, 57
Sturges, Preston, 376n65
Supplice de la vestale, Le (The Torturing of the Vestal Virgin) (Magritte), 53, 132
Surprises et l'océan, Les (Magritte), 381–2n37
surrealism:
 advertising and, 133
 in America, 323
 Apollinaire and, 116
 art forgery and, 303–4
 artists, 127, 168–9, *169,* 176–82, 411n47, CP26
 in Belgium, 98, 106, 138, 153, 174, 195–6, *197, 297, 307, 314, 327–8, 328*
 collectors and, 331
 Dalí and, 160–1
 de Chirico and, 114–15
 in England, 238, 266–7, *267*
 exhibitions, xxix, 234, 261, 265, 295, 311
 films and, 50, 54, 57–8, 376n65
 in France, 110, 153, 171, 178, 180, 189, 196, 210, 311, 313
 galleries featuring, 162

Legge and, 265–6
Mariëns and, 305
music and, 152
Nougé and, 137, 138, 141, 142, 288, 292, 327
Paul Magritte's role in, 24
photomontages, 195–6
political engagement and, 173–6, 178, 253–4, 262
publications, 113, 149, 168, 169–72, 174, 189, 190, 192, 195, 202, 255, 386n6
sexuality and, 172–3
sources for, 129, 337, 367n9
see also Magritte, René, as surrealist
Surréalisme au service de la révolution, Le, 195
"Surréalisme en plein soleil, Le" ("Surrealism in Full Sunlight"), 293, 294
Surréalisme et la peinture, Le, 115, 174, 176, 203, 219, 324, 398n53, 401n16
Survivant, Le (The Survivor) (Magritte), 263, CP37
Sylvester, David, 26, 27, 46, 63, 66, 108, 172, 202, 225, 232, 268, 273, 303, 335, 338–9, 347, 373n29
syncretism, 110

Table devant la fenêtre, La (Derain), 386n14
Tahon, Albert, 83
Tanguy, Yves, 45, 159, 169, *169,* 174, 340
Tanning, Dorothea, 106
Tate Gallery (Liverpool), 208
Tempête, La (The Tempest) (Magritte), 36, 373n14, CP10
Temps menaçant, Le (Threatening Weather) (Magritte), 35–6, 182, CP9
Tentative de l'impossible (Attempting the Impossible) (Magritte), 64, 200, CP17
Thé, Le (The Tea) (Magritte), 109, 383n66
Thérapeute, La (The Healer) (Magritte; painting), 276
Thérapeute, La (The Healer) (Magritte; sculpture), 337
Theses on Feuerbach (Marx), 137, 256, 262, 388n52, 404n75
Thibaut, Alphonse, 74, 78
Thibaut, Denise, 379n47
Thibaut, Walter, 74, 379n47

Thirion, André, 169, *169*
Thiry, Georges, xxxi
This Wouldn't Be a Pipe (film), xxxii
Thomson, David, 49, *50*, 52, 58, 226, 240
Thousand and One Nights, The, 32, 38, 372n6
Tilman, Georges, 72
Time Transfixed (Magritte), xxvii
Titania (Magritte), 312
Titian, 300, 303, 306–9, 344, 409–10n88, 409n87
Toilette de Cathy, La (Balthus), 205
Tombeau des lutteurs, Le (The Tomb of the Wrestlers) (Magritte), 337, 341, CP47
Torczyner, Harry, 5, 38, 54, 115, 119, 130, 259, 279, 324–5, 326, 330–1, 332, 340, 341, 347, 348, 350, 413n79, 414–15n111, 415n114, 415n123
Trahison des clercs, La (The Treason of the Intellectuals) (Benda), 394n70
Trahison des images, La (The Treachery of Images) (Magritte), xxvii, *xxviii*, xxxii, 188–9, 240, 394n70, CP29
Traité de la lumière, Le (Treatise on Light) (Magritte), 118, 290–1, 385–6n3
Travaux d'Alexandre, Les (The Labors of Alexander) (Magritte), 337
Traversée difficile, La (Magritte), 385n95, 400n4
Treasure Island (Stevenson), 31, 32, 372n7
Trial, The (Kafka), 149, 221, 223
Trois Prêtres, Les (Magritte), 264
Trotsky, Leon, 175, 176, 261
Truffaut, François, 55
Truth in Painting, The (Derrida), 136
Tzara, Tristan, 92–3, 182, 324

Ubac, Agui, 289
Ubac, Raoul, xxxi, 282, 284, 285, 288, 289
Ubu, Père, 82–3
Uffizi Gallery (Florence, Italy), 112–13, 300
Updike, John, 338
Usage de la parole, L' (Magritte), 391n23

Vacances de Hegel, Les (Magritte), 240–1, *242*, *243*
Vague, La (The Wave) (Makhokhian), 36, 37, 373n16
Valentin, Albert, 169, *169*

Valéry, Paul, 32, 66, 128, 129–30, 137, 142, 175, 225, 226, 229–31, 249, 304, 387n35, 389n67
Valeurs personnelles, Les (Personal Values) (Magritte), 247–8, 256–7, 318–19, CP36
Vampires, Les (The Vampires) (film), 49, 50–3, *51*, 228
Van Bruaene, Geert, 95, 97–8, 144, 158, 163, 189, 293, 306, 376n68, 381n31, 409n74
Van Damme-Sylva, Emile, 76–7, 79
Vandekerckhove, Mia, 101, 308
Van den Berghe, Frits, 112, *112*, 135
Vander Poorten, Henry-Valéry, 81–2
Vanderveken, Jef, 42
Van de Weghe, Prosper, 101
van Doesburg, Theo, 104
van Gogh, Vincent, 244–5, *244*
van Hecke, Paul-Gustave, 94, 98, 99, 100, 101, 112, *112*, 118, 126, 134, 147, 150, 163, 287, *287*, 290, 332, 377n9, 388n43, 391n16
van Lennep, Jacques, 375n55
Van Loock, Albert, 306–8, 396n31, 409n86
Van Loock, Claude, 307
Van Loock, Elisabeth, 307
van Montfort, Franz, 380n68
van Ruysdael, Jacob, 112
Vantongerloo, Georges, 104
Variante de la tristesse (A Variation on Sadness) (Magritte), 279
Variétes (magazine), 122, 176, 188, 372n71
Vases communicants, Les (Breton), 217
Vathek (Beckford), 118–19
Vengeance, La (Magritte), 279
Venice Biennale, 151
Vep, Irma (fictional character), 51, 52, 53, 132
Verdeyen, Jean-Baptiste, 72
Verdeyen, Jeanne, 20, 27, 72–3, 83, 86, 370n47, 376–7n5, 378n40
Vérité en peinture, La (Derrida), 401n16
Verne, Jules, 98, 319, 320, 402n43
Verougstraete, Willem, 149–50
Verres fumes, Les (Smoked Glasses) (Magritte), 276
Victoire, La (The Victory) (Magritte), 220, 398n57
Vie est dégueulass, La (Life Is Lousy) (Malet), 272

Vie heureuse, La (Magritte), 409n74
Vie immédiate, La (Éluard), 195
Vierge corrigeant l'enfant Jésus devant trois témoins, La (Ernst), 149, *150*
Vierge retroussée, La (Magritte), 56, 56, 264, 267, 375–6n63
Villiers de l'Isle-Adam, Auguste, 143–4, 190, 389n71
Vingternier, Jules, 79, 383n57
Viol, Le (The Rape) (Magritte), xxx, 205, *206*, 208, 217–19, 261, 262, 288, 387n32, 394–5n80
Viridiana (film), 349
Visit to Magritte (Michals), 63
Vitrine du posticheur, La (The Wigmaker's Shop Window) (Magritte), 276–9
Voix active, La (Magritte), 322, *322*, 336
Voix des airs, La (The Voice of the Air) (Magritte), 283, 381–2n37
Voleuse, La (The Thief) (Magritte), 53, 132
Volkoff, Alexandre, 57
Voyage dans la Lune, Le (film), 319
Voyantes, Les (Magritte), *157*
Vriamont, Georges, 209

Wahl, Jean, 237
Waiting for Godot (Beckett), 321
Waldberg, Patrick, 72, 257, 263, 368n12
Walden, Herwarth, 91
Walloon language/culture, xxix, 7, 11, 143, 182, 288, 311, 313

"Walrus and the Carpenter, The" (Carroll), 226
Warhol, Andy, xxxiii, 98, 325, 350
Wayne, John, 54, 92
Ways of Seeing (Berger), xxxiii
Weekend with Mr. Magritte, A (documentary), xxxi
Weill, Kurt, 44–5
Welles, Orson, 57
Wergifosse, Jacques, 241, 271, 272–3, 290, 293, 306, 313, 335, 343, 405n1
What Is Surrealism? (Breton), xxx, 217, 219
What's Buzzin' Buzzard? (cartoon), 312
Whitfield, Sarah, 303
Wiene, Robert, 57, 376n65
Wiertz, Antoine, 112
Wilder, Billy, 57
Will to Power, The (Nietzsche), 254, 270
Wittgenstein, Ludwig, xxvii, 190, 216
Wolleh, Lothar, 377n11
Woman at the Piano (Gleizes), 83
Woman by a Garden Seat (Magritte), 77
Woman with a Mirror (Titian), 308, CP42
World as Will and Representation, The (Schopenhauer), 223
World War II, 90–1, 280–6, 288, 299
Wright, Basil, 200, 396n18
Wright, Frank Lloyd, 341

Zigomar, 14–15, *15*, 19, 22, 48

A Note About the Author

Alex Danchev (1955–2016) had Belgian roots: his paternal grandmother came from Liège. He was the author of a number of widely acclaimed biographies, among them *Cézanne: A Life* and *Georges Braque: A Life*. He also wrote the essay collections *On Art and War and Terror, 100 Artists' Manifestos*, and *On Good and Evil and the Grey Zone*, and was a regular contributor to *The Times Literary Supplement* and *Times Higher Education*, as well as *The Guardian, The Independent*, and *The Literary Review*. At the time of his death, he was Professor of International Relations at the University of St. Andrews.

A Note on the Type

The text of this book was set in Sabon, a typeface designed by Jan Tschichold (1902–1974), the well-known German typographer. Based loosely on the original designs by Claude Garamond (ca. 1480–1561), Sabon is unique in that it was explicitly designed for hot-metal composition on both the Monotype and Linotype machines as well as for filmsetting. Designed in 1966 in Frankfurt, Sabon was named for the famous Lyons punch cutter Jacques Sabon, who is thought to have brought some of Garamond's matrices to Frankfurt.

Typeset by North Market Street Graphics, Lancaster, Pennsylvania
Printed and bound by Friesens, Altona, Manitoba
Designed by Maria Carella